Learning Photoshop CS4

by

Pete Watkins

Publisher
The Goodheart-Willcox Company, Inc.
Tinley Park, Illinois
www.g-w.com

The Goodheart-Willcox Company, Inc. Brand Disclaimer: Brand names, company names, and illustrations for products and services included in this text are provided for educational purposes only, and do not represent or imply endorsement or recommendation by the author or the publisher.

The Goodheart-Willcox Company, Inc. Safety Notice: The reader is expressly advised to carefully read, understand, and apply all safety precautions and warnings described in this book or that might also be indicated in undertaking the activities and exercises described herein to minimize risk of personal injury or injury to others. Common sense and good judgment should also be exercised and applied to help avoid all potential hazards. The reader should always refer to the appropriate manufacturer's technical information, directions, and recommendations; then proceed with care to follow specific equipment operating instructions. The reader should understand these notices and cautions are not exhaustive.

The publisher makes no warranty or representation whatsoever, either expressed or implied, including, but not limited to, equipment, procedures, and applications described or referred to herein, their quality, performance, merchantability, or fitness for a particular purpose. The publisher assumes no responsibility for any changes, errors, or omissions in this book. The publisher specifically disclaims any liability whatsoever, including any direct, indirect, incidental, consequential, special, or exemplary damages resulting, in whole or in part, from the reader's use or reliance upon the information, instructions, procedures, warnings, cautions, applications, or other matter contained in this book. The publisher assumes no responsibility for the activities of the reader.

Library of Congress Cataloging-in-Publication Data

Watkins, Pete.
 Learning Photoshop CS4 / by Pete Watkins.
 p. cm.
 Includes index.
 ISBN 978-1-60525-168-4
 1. Computer graphics. 2. Adobe Photoshop. I. Title.

T385.W3765523 2009
006.6′86--dc22 2009009409

Introduction

Photoshop: A Powerful Image-Editing Program

Open an image in Adobe® Photoshop® CS4, and endless possibilities await you. You can adjust the color, brightness, or contrast of the image. You can create a variety of special effects, such as making a photo look like it is covered with plastic wrap, or making it look like it is underwater. You can remove scratches from an old photo, or make out-of-place hairs disappear from a portrait. You can add text to an image or even create artwork from scratch with a wide variety of painting and drawing tools.

Photoshop has an amazing collection of tools, options, and commands. Often, there is more than one way to accomplish the same task. After you become more comfortable with the program, you will develop favorite tools and techniques. However, you should continue to experiment with other tools and techniques, because flexibility will help you create innovative designs.

This book is written for beginning to intermediate Photoshop users. As you become a more serious Photoshop user, you can keep building your knowledge by tuning in to the thousands of tips and tricks other Photoshop users discover and share on websites. You can also find such Photoshop tips in magazines related to digital photography or other publications written at the intermediate to advanced level.

Apple Computer Users

The illustrations in this book are from a Windows version of Photoshop CS4, but the Mac version is almost identical. Occasionally, there are slight differences between the menu selections in the Windows version of Photoshop and the Mac version. Such cases are pointed out throughout the text. The following key combinations are also different for Apple and Windows users. In the text, the first three instances of each alternate keystroke are noted for Apple users. After the third instance, a note may no longer be added:

Windows Action	Equivalent Mac Action
Right click	[Ctrl] + click
[Alt] + click	[Option] + click
[Ctrl] + click	[Command] + click

About the Author

When Pete Watkins started teaching Photoshop several years ago, he searched for a Photoshop textbook written at a beginning level that included a substantial amount of easy-to-follow tutorials. Seeing a need for such a book, Pete began working on this project.

Pete is an Adobe Certified Expert in Photoshop CS4. He holds a master's degree in Instructional Technology from Utah State University. Pete has taught technology-related subjects at the high school level for over a decade. He currently teaches Photoshop to students enrolled in his Digital Photography and 3D Animation classes at Bear River High School in Garland, Utah.

Using This Book

Since you are reading a book about a specific computer program, it is assumed that you already have basic computer skills, including the ability to use a mouse, open and close computer applications (such as Photoshop), and open, save, and close files within an application.

Whether you are a beginner or intermediate-level Photoshop user, this book will help you understand Photoshop's tools and commands. You will learn a variety of image-editing techniques. The fundamentals of graphic design will also be discussed.

Each chapter includes a number of tutorials so you can apply the techniques you have learned in the chapter. The tutorials are presented in a two-column format. Step-by-step instructions appear in the left-hand column. Figures that show the tutorial project being completed appear in the right-hand column. In these figures, arrows with corresponding step numbers point out the important tools, objects, and icons for many of the steps.

Using the Companion Web Site

The *Learning Photoshop CS4 Student Companion Web Site* includes a variety of resources to help students learn Photoshop. These materials include the images necessary to complete the tutorials in the textbook, Chapter Review Questions, Tool Review Worksheets, and Related Web Links. To access the Student Companion Web Site, type www.g-wlearning.com/VisualArts into your web browser's address box and press [Enter]. In the Visual Arts home page, either click on the Learning Photoshop CS4 Student Companion Web Site link on the left side of the screen or click the textbook cover image on the right side of the screen.

Student Materials

The following is a brief description of the student resources that are included on the Student Companion Web Site.

Tutorial Image Files

The tutorial images are the files you need to complete the textbook tutorials. These files will be in TIF, JPEG, or PSD format and will open in Photoshop CS4. Some instructors may choose to distribute the image files to students either by installing them on local computers or by providing network access to the files. As an alternative, the required image files can be downloaded by individuals from the *Learning Photoshop CS4 Student Companion Web Site*. The image files are arranged by tutorial and can be downloaded in a single convenient ZIP file for broadband users, or on a chapter-by-chapter basis for users with slower Internet connections.

Tool Review Worksheets

The Tool Review Worksheets are note-taking aids designed to help you record the information you learn. When filled out, these worksheets are also valuable study tools. There is one Tool Review Worksheet for each chapter of the book. These worksheets contain images of the important tools presented in the chapter and provide lined spaces for writing down information about those tools. As you progress through the *Learning Photoshop CS4* textbook, fill in information about the tools using your own words. This process will help you retain the information you learn, and the worksheets will serve as valuable review material when you prepare for the final exam.

When you select a Tool Review Worksheet from the drop-down list, the PDF opens in a new browser window. You can then print the worksheet or save it to your hard drive. In order to access the Tool Review Worksheets, you must have Adobe Reader installed on your computer. If you do not have Adobe Reader installed, you can download it through the link provided.

Chapter Review Questions

The Chapter Review Questions from the textbook are provided in DOC and PDF format on the Student Companion Web Site. You can open the DOC files in Microsoft Word and type your answers directly into the document. After typing in your answers, you can choose File > Print to print out the questions and your answers. As an alternative, you can open the PDF files, print them out, and write in your answers by hand.

To access the Chapter Review Questions, click on the Chapter Review Questions button in the left column. In the right column, scroll and click on the desired chapter. The selected file will open in either Microsoft Word or in Adobe Reader, depending on which format you selected.

Related Web Links

The Related Web Links section of the Student Companion Web Site includes a list of websites that you may find useful. These websites include such things as user tips, additional tutorials, sample art, and lists of sources for royalty-free images.

To access the list of website links, click on the Related Web Links button on the home page or left-hand navigation bar. In the window that appears, scroll and click on the desired website. Your web browser will open and connect to the Internet, and the site will be automatically loaded.

Note: Goodheart-Willcox is not associated with the websites listed and is not responsible for their content.

Brief Contents

Table of Contents

Chapter 3—Selection Tools 75

Chapter 6—Painting Tools and Filters 233

Chapter 7—Erasing, Deleting, and Undoing 287

Chapter 10—Advanced Color-Correction Techniques 415

Chapter 11—Additional Layer Techniques 469

Chapter 12—File Management and Automated Tasks 519

Glossary 541

Index 551

The Work Area

Learning Objectives

After completing this chapter, you will be able to:

- Identify different features of Photoshop's work area, including menus, tools, tool options, and panels.
- Use a variety of methods to rearrange Photoshop's work area.
- Explain how to reset Photoshop's work area.
- Explain how to change and reset the foreground and background colors.

Introduction

Photoshop has a vast number of tools and commands, and many of them are hidden from view until you need them. This chapter will acquaint you with Photoshop's work area—the toolbars, menus, and *panels* (small windows that contain various settings) you see when you first open the program. You will find there are many different ways to arrange the work area to fit your work style.

The Default Work Area

If you open Photoshop just after it has been installed, you will see the *default* work area, **Figure 1-1**. Default means "how a computer program looks before any settings are changed."

> **Note**
> If your work area does not look like the example in Figure 1-1, it is recommended that you restore Photoshop's default settings before working through this book. This procedure is explained in a tutorial at the end of this chapter.

The Tools Panel

The **Tools** panel (also called the **Toolbox**) contains many of Photoshop's tools. The **Tools** panel can be displayed one of two ways: as a long, single row of tools or a shorter version with two rows of tools. To switch back and forth between these two views, click

Figure 1-1. _____
If you have not changed any of Photoshop's default settings, the work area looks like this.

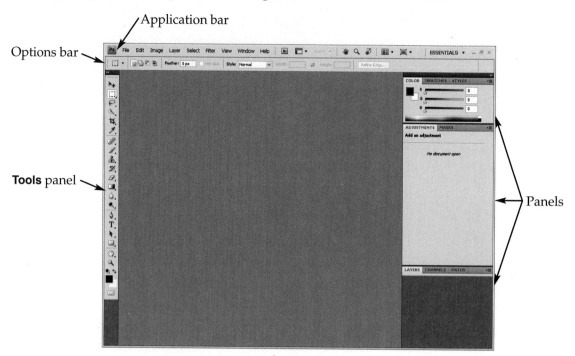

Application bar

Options bar

Tools panel

Panels

the double-arrow at the top of the **Tools** panel, Figure 1-2. The **Tools** panel can be moved to any location on your screen by clicking the bar at the top of the panel and dragging the panel to a new location. When the panel is relocated, a **Close** button appears at the top of the panel, and clicking it accidentally will hide the **Tools** panel from view. If this happens, choose **Tools** from the **Window** menu to display the panel again.

Note In this book, the **Tools** panel will be shown in two-column mode when it appears by itself in a figure and in one-column mode when it is shown as part of the overall Photoshop work area.

Most of the tool buttons have a small arrow in the lower-right corner. This arrow tells you that additional tools will appear if you click and hold the mouse button on the tool button. For example, when you click and hold the mouse button on the **Brush Tool** button, the **Pencil Tool** and **Color Replacement Tool** appear, no longer hidden from view, Figure 1-2. These tools will remain visible on the **Tools** panel until you click the mouse button.

Foreground and Background Colors

While working in Photoshop, you should be aware of two colored boxes near the bottom of the **Tools** panel, Figure 1-3. These two boxes show what colors are currently selected for the foreground and background colors. The *foreground color*, the top color box, is used by Photoshop's painting and drawing tools. The *background color* (the bottom color box) appears when you create a new Photoshop document or when you open an image and erase part of it.

Figure 1-2. _____
This is Photoshop's **Tools** panel. Some tools are hidden until they are chosen. For example, the **Pencil Tool** can be found "underneath" the **Brush Tool**. Note that the **Tools** panel has been moved, causing the **Close** button to appear on the top bar.

Figure 1-3. _____
The **Foreground Color** box and **Background Color** box are used to define the colors used by Photoshop.

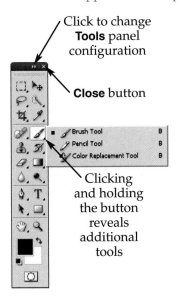

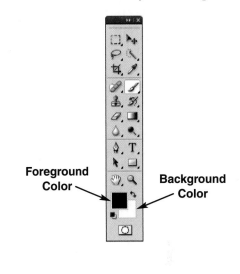

To change either the foreground color or the background color, click on the corresponding color box in the **Tools** panel. This opens the **Color Picker** dialog box, **Figure 1-4**. Next, click on the desired hue in the color slider. Then, click on the desired shade of color in the color field. Notice that a preview of the selected color appears in the **Color Picker** dialog box. Directly below the preview of the selected color is a sample of the original color so you can compare the two. You can adjust the hue by picking a new color in the color slider, and you can adjust the shade by picking a different point in the color field.

The other settings in the **Color Picker** dialog box will be discussed in a later chapter.

Figure 1-4. _____
The **Color Picker** provides an interface for defining a new color.

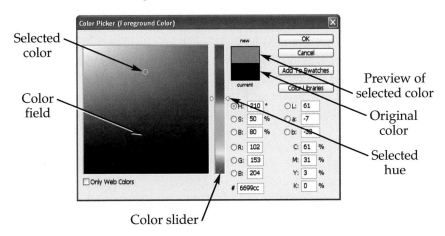

Resetting the Colors to Black and White

In Photoshop, "white" means "no color." When you print a Photoshop project, white areas are not printed. Instead, the white paper shows through. This is why Photoshop's default background color is white. You can think of your image's white background as the paper itself as you create your project.

Black is frequently used as a foreground color when creating objects such as text or lines. Furthermore, techniques such as layer masking (discussed in a later chapter) use black and white to mask, or protect, areas of an image. Because the combination of black and white is used frequently, Photoshop provides an easy way to reset the foreground color to black and the background color to white. This is done by clicking the **Default Foreground and Background Colors** icon, Figure 1-5.

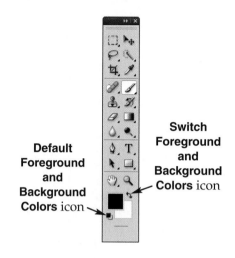

Figure 1-5.
Clicking the **Default Foreground and Background Colors** icon in the **Tools** panel resets the foreground color to black and the background color to white. These can be switched by clicking on the **Switch Foreground and Background Colors** icon.

Switch Foreground and Background Colors icon

Default Foreground and Background Colors icon

Switching Foreground and Background Colors

The other small icon next to the foreground and background color boxes is the **Switch Foreground and Background Colors** icon. This handy icon looks like a curved arrow and, when it is clicked, causes the foreground and the background colors to switch places.

The Options Bar

The *options bar* is located just below Photoshop's menus. When you click on any tool in the **Tools** panel, the tool's options (or settings) appear here. If you hold the cursor for two seconds over any section of the options bar, a *tooltip* appears. A tooltip is a brief description of an option. See Figure 1-6.

At the far left side of the options bar, the current tool's *icon* appears. An icon is a picture or symbol that represents the selected tool. If you right-click on the tool icon, you can reset the tool to its default settings by selecting **Reset Tool** from the pop-up menu. And, if you click the small arrow pointing downward (right next to the icon), the **Tool Preset** dialog box appears, Figure 1-7. As you grow comfortable with Photoshop and find that you are setting options the same way over and over, you can use the **Tool Preset** dialog box to save your favorite settings and quickly recall them any time.

Panels

Panels are small windows that contain a variety of settings. There are several ways to display and group them. After arranging panels in your workspace to your liking, you can save your customized settings and recall them at any time.

Figure 1-6. _____
In this example, the **Horizontal Type Tool** (text tool) has been clicked in the **Tools** panel. The options bar shows the settings for this tool, including font style, font size, justification, etc.

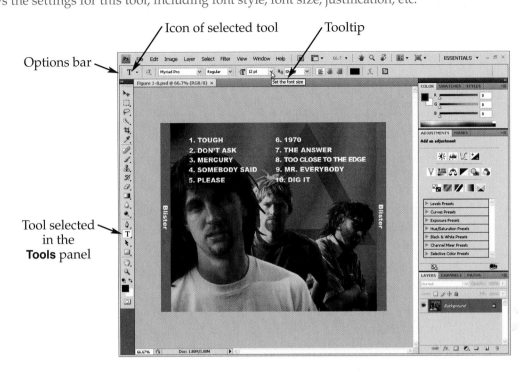

Figure 1-7. _____
When the **Create new tool preset** button is clicked, all of the settings in the options bar are saved, and you are asked to name the settings. You can retrieve your saved settings at any time by clicking the small down arrow next to the selected tool's icon in the options bar and selecting the desired preset.

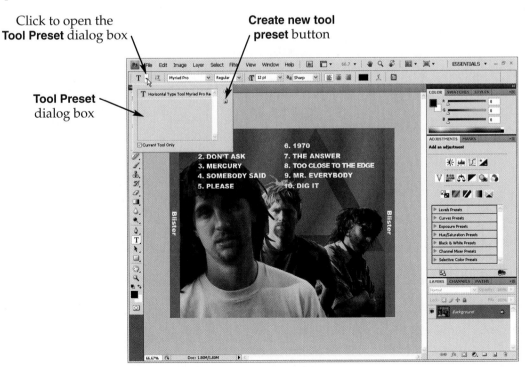

The **Window** menu shows a list of all of the panels. Each panel can be turned on or off using the **Window** menu. If there is a check mark next to a panel's name, it is displayed somewhere on your screen. The **Window** menu includes the **Tools** panel, options bar, and Application bar as items that can be turned on or off.

Arranging Panels

There are several ways to arrange panels on your screen. To keep your workspace from being cluttered, you can hide the ones you do not use very often. The name of each panel appears on a *tab*, just like a tab on a folder in a filing cabinet. See **Figure 1-8**.

- Hide or display panels by choosing them from the **Window** menu.

- Panels can be moved to another location by clicking and dragging their tab.

- Panels can be *zipped shut* and restored by double-clicking on their tab. When a panel or group of panels is zipped shut, its window is minimized and only the panel tab(s) are visible.

- An individual panel can be *closed* by right-clicking its tab and choosing **Close** from the right-click menu.

- Some panels can be *stretched* taller by dragging their bottom-right corners to resize them.

- A panel can be *grouped* with another panel by dragging its tab just to the right of the other panel's tab. A panel can be *separated* from a stack by dragging its tab clear of the other panel's window.

Figure 1-8. _____

The **Window** menu can be used to hide or display panels. Each panel has a tab that displays its name.

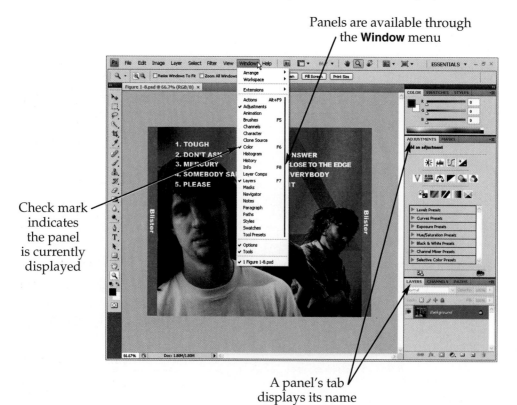

Panels are available through the **Window** menu

Check mark indicates the panel is currently displayed

A panel's tab displays its name

- To save space, a panel or a group of panels can be collapsed into small icons by clicking the double-arrow in the upper right corner. Click the same double-arrow button again to restore the panels to their previous size.

- Regardless of whether panels are full-sized or collapsed into icons, when a panel (or a group of panels) is dragged to the extreme right or left edge of your screen, it becomes *docked*. As docked panels are placed above and below each other, they are automatically arranged in neat columns. These columns can be collapsed into icons by clicking the double arrow at the top right of the column of panels. This conserves more space on your screen. Any panel that has been collapsed in this manner can be displayed and hidden again by clicking on its icon, **Figure 1-9.**

Note You can horizontally resize a column of panels by clicking and dragging the edge of the column, even to the point that only the panel's icon is visible.

The Application Bar

For Windows users, the *Application bar* contains Photoshop's menus and several other commonly-used tools that help you easily manage your workspace. On a Mac, the menus are not attached to the Application bar, allowing Mac users the option of dragging the Application bar to another location.

Figure 1-9. _____
Columns of docked panels can be collapsed and expanded by clicking the double arrows at the top of the column. In this image, two columns of panels are collapsed. The column of panels on the left is sized so that only the icons appear. The column on the right is sized so that the panel icons and names appear.

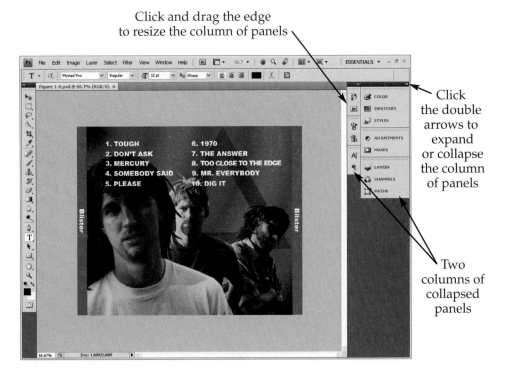

Menus

As a general rule, each of Photoshop's *menus* contain commands that are related to each other. For example, the **View** menu contains commands that help you *see* things by displaying a grid, or by displaying a ruler around the border of your image, or by causing your image to fill the entire screen so you can see it better. Zooming commands are also found in this menu.

Some entries in a menu will have an arrow to their right. This arrow tells you that entry is not a command, but a subcategory that contains a cascading submenu. When you position the cursor over such an entry, a submenu appears that lists all of the commands available in that subcategory, **Figure 1-10**.

Keyboard Shortcuts

Many commands found on the menus can also be executed by pressing a combination of keys, known as keyboard shortcuts. In Figure 1-10, the menu command **View > Show > Grid** is being chosen. The keyboard shortcut **Ctrl+'** appears to the right of the **Grid** command. This means that instead of using the menu, you can turn the grid on and off by pressing the control key and the apostrophe key at the same time, [Ctrl][']. If you are working on a project and need to show and hide the grid again and again, using this keyboard shortcut will save you a lot of time.

Note	In this text, menu selections are indicated by the menu title, subcategory (if applicable), and command separated by greater-than signs. In the example of **View > Show > Grid**, you would select the **View** in the menu bar, then the **Show** subcategory in the menu, and finally the **Grid** command from the cascading submenu.

Figure 1-10. ———————————————————————————————————————
The **View** menu is shown here with **Show** cascading submenu open. If a keyboard shortcut is available for a menu command, it appears at the right side of the menu.

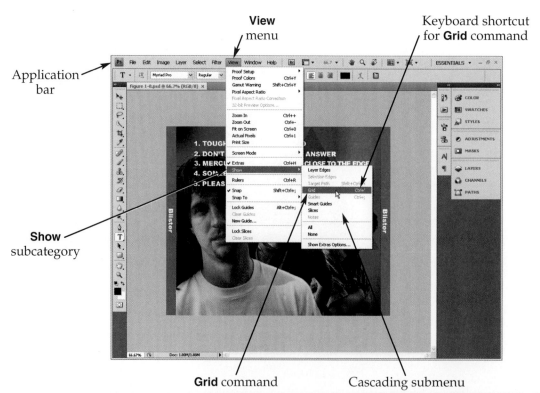

Photoshop offers many other time-saving keyboard shortcuts that are *not* listed in the menus. You will become familiar with many of these shortcuts as you progress through this book. Users that are more comfortable with Photoshop can customize menus and keyboard shortcuts to fit their particular work style. This can be done by selecting **Edit > Keyboard Shortcuts** or by choosing **Edit > Menus** and then picking the **Keyboard Shortcuts** tab.

Note	In this text, keyboard keys are identified by the character or function of the key enclosed in brackets. For example, [Ctrl] indicates the control key, [Shift] indicates the shift key, [P] indicates the P key. If a combination of keys appear side by side, such as [Ctrl][Shift][P], it indicates that all of the corresponding keyboard keys should be pressed at the same time.

Other Tools on the Application Bar

The first button on the Application bar is a shortcut that opens Bridge, Adobe's file browser application that is bundled with Photoshop (discussed in Chapter 12). Next to that is the **View Extras** button, which opens a drop-down menu used to turn on and off Photoshop's rulers, guides, and grid (explained in Chapter 4). This is followed by tools you will find useful in many situations: the **Zoom Level** drop-down list, which allows you to choose from different zoom percentages; the **Hand Tool** and **Zoom Tool** (discussed in Chapter 2); and the **Rotate View Tool**. The **Rotate View Tool** can tilt your view of your image one way or another, in case you find that helpful. See **Figure 1-11**.

The remaining tools on the Application bar help you manage Photoshop's workspace, so they will be discussed here.

Arrange Documents

If you have more than one image file open in Photoshop, the **Arrange Documents** button opens a menu that lets you instantly arrange the documents in many different ways, **Figure 1-12**. This menu contains five rows of icons. Each icon shows you how your images will be arranged if you click on that particular icon. The icons that are available depends on the number of images that are open.

The first icon looks like a single image, but if you click this button, your images will be stacked like tabbed folders in a filing cabinet, sharing a single image window. You can change the image that is displayed in the window by clicking on another image's tab. You can separate an image from the stack by dragging its tab, creating a new image window in the process.

Figure 1-11. _____
The Application bar contains a number of tools that are helpful in many situations.

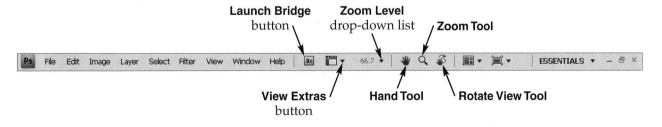

Figure 1-12. _____
Six image files have
been opened at the same
time. **A**—Choosing the
Consolidate All icon in the
Arrange Documents menu
causes all images to share
a single window. You can
switch the image that
is displayed by clicking
different image tabs at
the top of the window.
B—The same six image
files are rearranged by
choosing a different
icon from the **Arrange
Documents** menu. The
appearance of the icon
indicates the way the
image windows are
arranged. Note that three
images are sharing the
window on the right side
of the workspace.
C—The same image
files are rearranged by
choosing **Float All in
Windows** from the menu.
Note that each image is
given its own window
and the title bar for each
is visible.

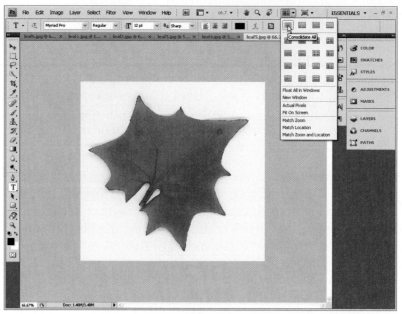

A

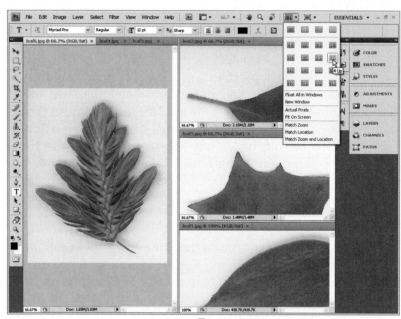

B

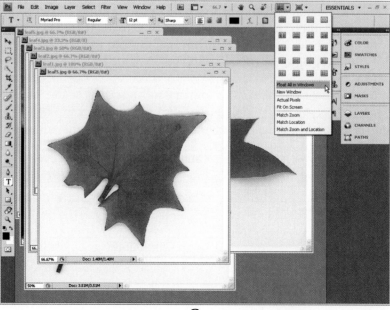

C

If you select one of the other icons in the **Arrange Documents** menu, multiple image windows will be created. If there are more open documents than there are windows created, some images will be forced to share windows. You can switch between images in the shared windows by clicking the desired image's tab in the title bar at the top of the window.

There are several other commands in the **Arrange Documents** menu. No matter how your documents are arranged, the **Float All in Windows** command rearranges them into a neat pile, stacked in cascading fashion so each image's title bar is visible.

The **New Window** command opens a second copy of an image that is already open and active (in other words, the image's title bar is not grayed out). From time to time, you may find it useful to have your image display at actual size on one side of your screen, while working in a close-up view of the same image on the other side of your screen. The changes you make in one image appear in the other image.

The **Fit on Screen** command zooms the image large enough so you can see the entire image. The **Actual Pixels** command zooms an image to 100%, which is helpful information for web designers. See Chapter 2 for more about this command.

If several images are open, the **Match Zoom** command will look at the zoom percentage of the active file and automatically zoom the other open files to the same setting. If you are working with several images that are the same size, you can zoom into the same area with the **Match Location** command. First, zoom in as desired into one of the images, then choose this command. All images will show the same area, but the zoom will not be the same unless you choose the **Match Zoom and Location** command instead.

At the bottom of the **Window** menu, you will find a list of all the images that are currently open, **Figure 1-13**. If several images are open, they will likely be in a big pile on your screen. Selecting the file you want from the **Window** menu causes that image to jump to the top of the stack.

Figure 1-13. ───
If the work area is cluttered with images, you can use the **Window** menu to choose the image file you want to work on.

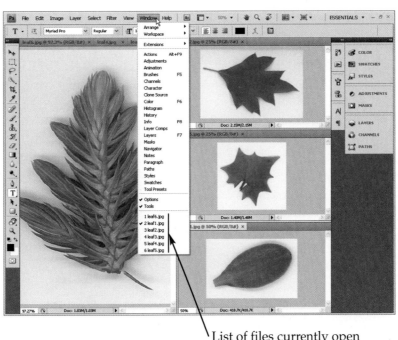

List of files currently open

Screen Modes

The **Screen Mode** button appears next to the **Arrange Documents** button in the Application bar. Click and hold the mouse button to reveal three different screen modes that arrange Photoshop's workspace in slightly different ways. You can also press [F] to cycle through these modes. The **Standard Screen Mode** option activates the default setting, which you are already familiar with. The Application bar and menus, the options bar, panels, and all open files are all displayed on your screen.

The **Full Screen Mode with Menu Bar** option creates a gray background around the file you are working on, causing any other files you have open to be hidden. Also, the title bar and frame of the image window are hidden, **Figure 1-14**.

The **Full Screen Mode** hides everything except for the current image file. A black area appears around your image, making it easy to concentrate on your image. See **Figure 1-15**. You can return to **Standard Screen Mode** by pressing [F] or [Esc]. When using any of these screen modes, you can temporarily hide or unhide the options bar and all of the panels by pressing [Tab].

Note	Mac users who do not want the desktop to be visible while running Photoshop can display the **Application Frame (Window > Application Frame)**. This command places a gray background behind images open in Photoshop. The **Application Frame** also protects a Mac user from accidentally clicking the desktop while working and thus hiding Photoshop.

Resetting or Saving a Workspace Arrangement

If your workspace becomes cluttered, you can reset it using the **Workspace** menu at the far right of the Application bar. Clicking this button displays a menu that lets you choose from several preset workspaces, including **Essentials**, which resets the workspace to its default appearance. See **Figure 1-16**.

Figure 1-14. _____

The **Full Screen Mode with Menu Bar** option resizes your image window so it fills the entire screen. The title bar, frame, and scroll bars of the image window are hidden.

Figure 1-15. _____
The **Full Screen Mode** option hides the Application bar, options bar, and panels.

You may wish to save an arrangement of panels that fit your particular work style. To do this, click the **Workspace** button and choose **Save Workspace...** from the menu. You will be asked to name your workspace configuration, and it will then appear in the **Workspace** button's menu. When saving and naming a workspace, you will notice that you can also customize keyboard shortcuts and menus to your liking and save those changes along with your panel configuration. For more information on customizing menus and keyboard shortcuts, see Photoshop Help.

Figure 1-16. _____
The **Workspace** button is located on the far right side of the Application bar and displays the name of the currently selected workspace. Various predefined workspaces can be loaded and custom workspaces can be saved using this menu.

Note The commands available through the **Workspace** button can also be accessed from the **Window > Workspace** submenu.

Using the Help Menu

The **Help** menu contains a vast amount of information about Photoshop. However, some Photoshop users find the writing style to be quite technical and not at a beginning level. That is why textbooks such as this one are written—to explain Photoshop in simpler terms.

If you would like further clarification on a Photoshop tool or topic, or would like to explore any feature not covered by this book, choose **Help > Photoshop Help...** to open the Photoshop Support Center in a web browser window. Enter keywords in the **Search** text box near the top-left corner of the dialog box. Photoshop's help files are Internet-based, so an Internet connection is needed to utilize Help. See **Figure 1-17**.

Using the Undo and Step Backward Commands

As you continue through this book, you will try out your skills as you complete the tutorials that follow each chapter. Any time you make a mistake while using Photoshop, be aware that you can always undo it by choosing **Edit > Undo** or pressing [Ctrl][Z] (or [Command][Z] for Mac users). If you want to undo more than one mistake, choose **Edit > Step Backward** or press [Ctrl][Alt][Z] (or [Command][Option][Z] for Mac users). The **Step Backward** command can erase up to 19 actions by default. If your computer has plenty of RAM, you can raise this to a higher number by selecting **Edit > Preferences > Performance...** (Mac users: **Photoshop > Preferences > Performance**). When the **Preferences** dialog box opens, change the value in the **History States** text box and pick the **OK** button.

Figure 1-17. _____
Choosing **Help > Photoshop Help...** opens the Photoshop Support Center in a web browser window. Search for relevant articles or visit the Forums for some peer-to-peer advice.

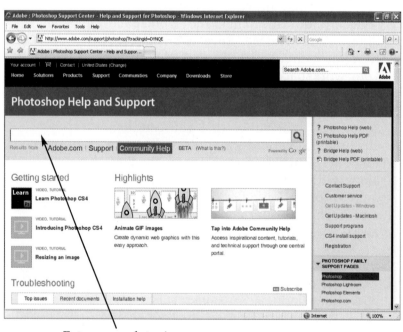

Enter a search topic

GRAPHIC DESIGN

An Introduction

A *graphic designer* arranges images, illustrations, and text to effectively and creatively communicate some kind of message, **Figure 1-18**. Graphic designers work in many different industries and design projects that will be presented in many different formats. They create advertisements that appear in magazines and newspapers. They also create web pages and animations, brochures, posters, logos, signs, product packaging, in-store displays, greeting cards, and much more.

As you progress through this textbook, you will be introduced to several graphic design techniques that can help your designs become more visually interesting. You will encounter strategies for using color effectively, guidelines for arranging design elements in attractive ways, and tips for using text effectively in a design.

There is never one correct way to create a design, and there are occasions where designers do not follow recommended techniques. The fundamental rule of graphic design is this: if the design is interesting and pleasing to the eye and the reader can glean the intended message with little or no effort, a good design has been created.

The first step a graphic designer must take before beginning any design is to *understand clearly what the design needs to communicate*. Most designers work for **clients** (businesses or individuals that hire outside services). It is important to communicate with the client throughout the design process. Often, clients do not know exactly what they want at the beginning of a project. However, at your first meeting, you should try to get as clear of a picture as possible of what they

Figure 1-18. _____
Graphic designers often use two computer displays, allowing them to easily switch between computer applications.

envision. Then, effective communication (such as sending proofs or samples of your work via e-mail) throughout the design process saves time-consuming and costly do-overs later.

A graphic designer must *become familiar with various professional printing techniques*. Photoshop has tremendous power and flexibility when it comes to preparing images for printing presses. You will learn some fundamentals about the printing industry as you progress through this textbook. Thankfully, you do not have to know everything about the professional printing industry to be a successful graphic designer. Professional printers at the printing service center with whom you do business will be happy to answer your questions—after all, you will be bringing them business!

Summary

You are now familiar with Photoshop's workspace, and you have learned several ways to arrange panels and image windows on your screen. The more you use Photoshop, the more you will want to control the workspace environment to make your work style as efficient as possible.

CHAPTER TUTORIALS

In the tutorials that follow, you will learn how to reset Photoshop to its default settings. You will try out some of the commands discussed in this chapter. You will also be introduced to the **Navigator** panel.

Tutorial 1-1: Resetting Photoshop's Default Preferences

In this tutorial, you will restore Photoshop's tools and panels to their default condition.

1. To reset Photoshop's default preferences, hold down three keys on your keyboard immediately after double-clicking on the Photoshop CS4 icon on the desktop to launch the program:

 - For Windows users, hold down [Ctrl][Alt][Shift].

 - For Mac users, hold down [Command][Option][Shift].

2. In the **Delete the Adobe Photoshop Settings File** dialog box, click **Yes**.

 If this dialog box did not appear, close Photoshop and try step 1 again.

3. If another message appears, asking if you want to set up your monitor, click **No**.

 Photoshop CS4 should now be open and using default settings.

Tutorial 1-2: The Work Area

In this tutorial, you will become familiar with Photoshop's work area. You will use the **Navigator** panel to move around the open image. You will also explore ways to arrange multiple image windows.

1. Locate the Tutorial0102 folder. Open all six leaf files in this folder.

2. By default, the leaves open into a single tabbed window. Click on each of the tabs.

3. On the Application bar, click on each of the window configuration icons found in the **Arrange Documents** drop-down menu.

4. Choose **Float All in Windows** from the **Arrange Documents** drop-down menu.

 This causes your images to "cascade", or appear stacked in a way that lets you see their title bars.

5. If the red leaf (leaf3.jpg) is not on top of the other images, select **Window > 4 leaf3.jpg**.

6. Choose **Window > Navigator** to display the **Navigator** panel.

7. Drag the **Navigator** panel tab away from the other panel tabs to separate the panel.

8. Hide all of Photoshop's panels except for the **Navigator** panel.

 Use the **Window** menu to turn off panels OR separate them by dragging their tabs and then click the **Close** button that appears.

9. Drag the **Navigator** panel to the location shown.

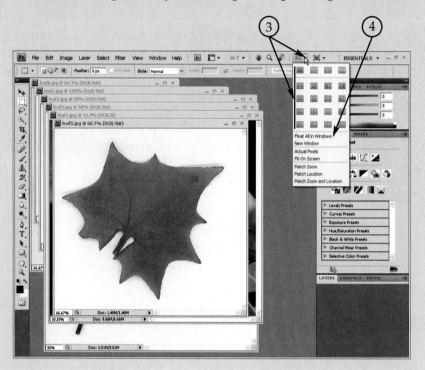

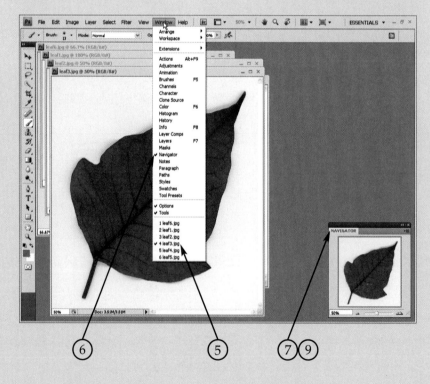

10. In the **Navigator** panel, click the **Zoom In** button.

 The **Zoom In** button is on the right end of the **Zoom** slider and looks like two large mountains. The **Zoom Out** button is on the left side of the **Zoom** slider and looks like two smaller mountains.

11. Click the **Zoom In** button two more times.

12. Position the cursor over the red box in the **Navigator** panel and click and hold the mouse button. Drag the red box around the image.

 Moving the red box allows you to scroll around your image.

13. On the Application bar, click the **Arrange Documents** drop-down window and click one of the **6-Up** buttons.

14. Position the red box over the tip of the red leaf.

15. Now, choose **Match Zoom and Location** from the **Arrange Documents** drop-down menu.

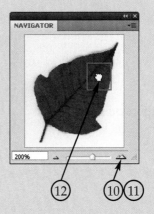

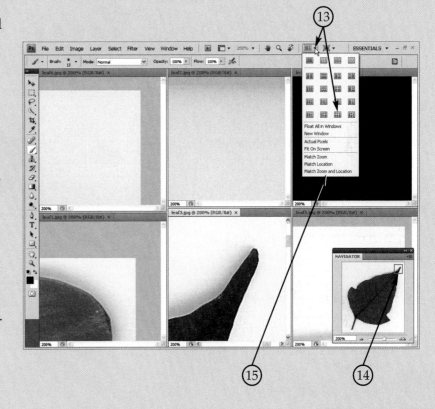

16. A small box that shows the zoom percentage can be found in the lower-left corner of the **Navigator** panel. Change the value in the zoom percentage text box to 25% and press [Enter].

 This is another way to quickly zoom in and out.

17. Once again, choose **Match Zoom and Location** from the **Arrange Documents** drop-down menu.

18. From the **Arrange Documents** drop-down menu, click the **Consolidate All** button.

19. Close all of the leaf images except for leaf3.

20. In the **Navigator** panel, enter 300% in the **Zoom Percentage** text box to magnify the image again.

21. Choose the **Hand Tool** in the **Tools** panel (or press the [Spacebar] to temporarily use the **Hand Tool**).

22. From the **Arrange Documents** drop-down menu, choose **New Window**.

23. From the **Arrange Documents** drop-down menu, click the **2-Up** button that arranges your images tiled horizontally, as shown.

24. Using the **Hand Tool** or the **Navigator** panel, adjust the view of the magnified (300%) leaf until it looks like the example.

25. Click the **Brush Tool** in the **Tools** panel.

26. Click the **Foreground Color** button and change the color. Choose a color other than black or white.

27. Paint a few lines in the 300% magnified view of the leaf.

 Notice that both image windows display your work.

28. Choose **Edit > Undo Brush Tool**.

 This command erases the last line of paint you created.

29. To erase the rest of the paint, choose **Edit > Step Backward**. Notice a keyboard shortcut for this command is shown at the right side of the menu. Continue stepping backward until all the paint is gone.

30. Close the new window that you created (the window that is *not* magnified at 300%).

31. On the Application bar, click the **Screen Mode** button and select the **Full Screen Mode** option from the pop-up list. If a message appears, click the **Full Screen** button.

32. Press the [Spacebar] to temporarily activate the **Hand Tool**. Scroll (adjust the view) until your image looks like the example.

33. Press the [Tab] key to show the panels. Then press it again.

34. Press the [Esc] key (or the [F] key) to return to standard screen mode.

35. Click the **Default Foreground and Background Colors** button to change the colors back to black and white.

36. Click the **Essentials** drop-down menu on the Application bar and choose **Essentials**. This resets the workspace to its default condition.

37. Most of the tutorials in this book will ask you to save your changes. This tutorial, however, is an exception. Close the leaf3.jpg files without saving changes.

Key Terms

Application bar	foreground color	panels
background color	graphic designer	separated
clients	grouped	stretched
closed	icon	tab
default	menus	tooltip
docked	options bar	zipped shut

Review Questions

Answer the following questions on a separate piece of paper.

1. What does the term *default* mean?

2. Some of the tool buttons found on Photoshop's **Tools** panel have a small arrow in their lower-right corner. What does that arrow tell you?

3. The background color appears when a new Photoshop document is created. What is something else you can do in Photoshop that causes the background color to appear?

4. How do you reset Photoshop's foreground and background colors to black and white?

5. What are tooltips, and how do you get them to appear?

6. How do you reset a tool back to its default settings?

7. How can you zip a panel shut and unzip it again?

8. What menu shows a list of all of Photoshop's panels, allowing you to hide or unhide them?

9. When you click the **View** menu, how many of the entries have additional cascading submenus available?

10. What happens if you choose **New Window** from the **Arrange Documents** drop-down menu?

11. If several image files are open in Photoshop, what menu can you use to choose a particular image and bring it to the "top of the pile?"

12. What key can you press to cycle through Photoshop's three different screen modes?

13. What key can you press to hide (or unhide) all of Photoshop's tools, panels, and the options bar?

14. How do you reset Photoshop's workspace to its default condition?

15. What is the difference between **Edit > Undo** and **Edit > Step Backward**?

2 Resolution

Learning Objectives

After completing this chapter, you will be able to:
- Explain the relationship between pixels and resolution.
- Use the **Zoom Tool** and **Hand Tool** to magnify and scroll around an image.
- Use multiple methods to resize images.
- Explain the difference between resizing and resampling an image.
- Use the **Crop Tool** to trim images.
- Use the **Crop Tool** to resize or resample portions of images.
- Differentiate between image resolution and printing resolution.
- Use a scanner to capture an image at a desired resolution.
- Use a digital camera to capture an image at a desired resolution.

Introduction

When you work with images in Photoshop, they will have different *resolutions*, or quality levels. Resolution is a complicated topic, and many Photoshop users struggle to understand it. An average person may need to read this chapter more than once before feeling knowledgeable about resolution.

Will the Image Be Printed or Displayed on a Computer Screen?

Many people use Photoshop to create images that will be *printed*. But some images are meant to only be *displayed on a computer screen*, such as an image on a web page.

If you look closely at a computer monitor when it is turned on, you will notice that the screen is made of thousands of tiny, colored, glowing dots, **Figure 2-1**. If you opened a beautiful, sharp photographic image on your computer, printed it to a good inkjet printer, and compared the printout with the on-screen example, you would notice the printed image will look sharper. Inkjet printers create images with microscopic dots of ink, invisible to the human eye. Computer monitors display images using glowing dots that are much larger, causing the image to look slightly rougher by comparison. Therefore, images created for onscreen use are created as low-resolution images in Photoshop, because that is the only quality level that a computer screen can display.

Figure 2-1. _____
A—A monitor displays an image by illuminating tiny groups of red, green, and blue dots.
B—A digital image is made up of tiny blocks of color called pixels.

A

B

Creating images that will be printed is a more difficult challenge. The printing industry is amazingly complex. There are many different kinds of commercial-grade printers and printing presses. Furthermore, different projects are printed at different resolutions. For example, a newspaper ad is printed at a lower resolution than a typical magazine. Full-color books and brochures are printed at higher resolutions.

To use Photoshop effectively, you will need to know how to set and adjust, if necessary, the resolution of your images. If you plan on creating a lot of work that will be professionally printed, you will also need to regularly communicate with your printing company. They will help you understand what resolution settings you should use when preparing your images for a particular project.

Image Capture Devices

When you take pictures with a digital camera, the light that shines into the camera is converted into a *digital* format (an image that a computer can recognize). Then, the digital data is stored in some kind of computer memory, such as a compact flash card, **Figure 2-2**. Digital cameras are *image capture devices*. The term "capture" means "to cause data to be stored in computer memory."

A *scanner* is another image capture device. A scanner is a digital copy machine: it shines a strong light on an image and analyzes the image with its sensors. A digital version of the image is created, which can be saved into computer memory, **Figure 2-3**.

Later in this chapter, you will learn more about using digital cameras and scanners, but first, you will learn what digital images are made of.

Figure 2-2. —————————————————————————————————————

The Nikon D70 digital camera (front and rear views) and a compact flash memory card are shown here.

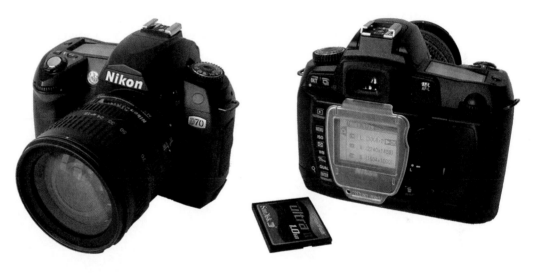

Figure 2-3. —————————————————————————————————————

A flatbed scanner is used to capture printed images or photographs.

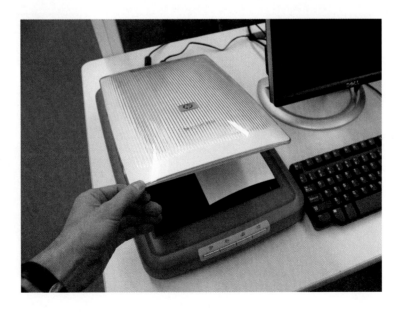

Pixels and Resolution

Any image that is captured by a digital camera or a scanner is made up of tiny, colored squares called *pixels*. The word "pixel" was created from two words: "picture" and "element". Computers have to keep track of what color each pixel is and where it belongs in the image. There can be *millions* of pixels in an image, so file sizes can be very large.

If an image has a **high resolution**, its pixels are so small that the human eye cannot make out the individual pixels when the image is printed. On the other hand, **low-resolution** images look fine when displayed on a computer screen, but when printed, they appear a little rough and out of focus. This is because the pixels are large enough to be visible. If your eye can see pixels in an image, the image is *pixelated*, **Figure 2-4**.

High-resolution images are used in professionally printed projects, such as books, magazines, and brochures. Some of these files can be too large to attach to an e-mail, so they must be delivered to print service providers in other ways, such as submitting them on CD or using Internet FTP (file transfer protocol) accounts or other web upload services to transfer them.

If you are using Photoshop to create an image for a web page or to send to a friend over e-mail, you need to set the image's resolution to a lower setting. Low-resolution images display quickly on web pages and can be sent quickly over e-mail because of their small file size.

Figure 2-4. _____
As the zoom percentage increases, the difference between high-resolution and low-resolution images becomes more pronounced. **A**—This is a high-resolution image of an ostrich. **B**—When you zoom in on a high-resolution image, the image remains crisp. **C**—When a low-resolution image is zoomed the same percentage, the pixels become noticeably larger and the image loses some of its quality.

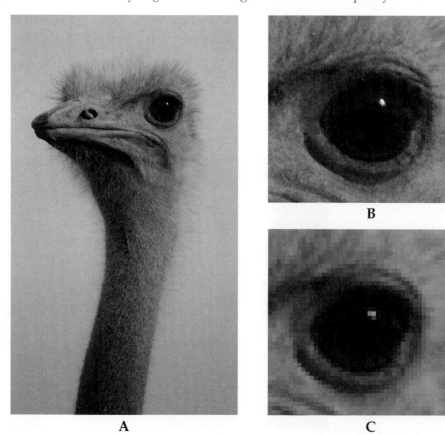

A B C

The Zoom Tool

The **Zoom Tool** is used to magnify an image so you can see it better. Each time you click on your image with the **Zoom Tool**, you can zoom in (make your image appear larger) or zoom out (make your image appear smaller). Zooming does not change the *actual size* (print size) of your image, it only changes *your view* of the image.

Zoom Percentage

When an image file is open in Photoshop, the title bar shows the *zoom percentage*, which can be between .1—3200%, **Figure 2-5**. A zoom percentage of 100% *is not the actual print size* of the image. Instead, it shows how large the image will appear in a web browser, based upon the current screen resolution settings for your display adapter (graphics card). These settings can be adjusted in the Display Properties dialog box in Windows and in System Preferences in a Mac. If you do not use Photoshop to create images for the web, think of zooming to 100% as a quick way to view the image at a manageable size.

Print Size

If you are creating large projects such as posters or banners, you will not have an accurate picture of how your design will look unless you occasionally view your project onscreen at its actual size. To see how large your image will be when printed, click the **Print Size** button on the **Zoom Tool**'s option bar, or choose **View > Print Size**. Your monitor size and settings may cause the print size setting to be a bit inaccurate, but it is usually close to actual size.

Note	To see the actual measurements that the printed image will have, choose **View > Rulers**. This will display rulers along the top and left side of the image window. By comparing an inch onscreen to an actual inch, you can estimate how much larger or smaller your printed image will be compared to the one displayed at print size onscreen. This ratio will be the same for any image displayed at print size on that monitor.

Figure 2-5. _____
The zoom percentage always appears in the title bar of an open image.

Zoom percentage

Zoom Tool Options

In the tutorial at the end of Chapter 1, you learned that the **Navigator** panel can be used to zoom in and out on an image. The **Zoom Tool** offers additional options. When you click on the **Zoom Tool** either in the **Tools** panel or on the Application bar, the options bar displays the available options, **Figure 2-6.**

The Zoom In and Zoom Out Buttons

The **Zoom In** and **Zoom Out** buttons allow you to change the function of the **Zoom Tool**. When the **Zoom In** button is pressed, you will magnify your image every time you click on it. The **Zoom Out** button has the opposite effect. To quickly switch between zooming in and zooming out, you can press [Alt] instead of clicking the buttons on the options bar.

Regardless of whether the **Zoom In** or **Zoom Out** button is selected, the location of the **Zoom Tool** cursor is the center point of the zooming operation. When you click the mouse button, the image is zoomed and repositioned in the window so that the cursor's location is as close as possible to the center of the window. If you click in the center of your image, the center area of your image will be zoomed. If you click in a corner, the corner area will be zoomed.

Resize Windows to Fit

When the **Resize Windows To Fit** check box is checked, the image window increases or decreases in size as the image is zoomed. The image window is resized with every zoom operation until the available space is filled up or the window has reached its minimum usable size.

If the **Resize Windows To Fit** check box is left unchecked, the image window will not change sizes as you zoom in and out. Leaving this setting off is recommended, especially if you have two or more image files open.

Zoom All Windows

The **Zoom All Windows** option is available if you have two or more image files open. When this check box is checked, zooming in or out on one image causes the other images that are currently open to be affected the same way.

Figure 2-6.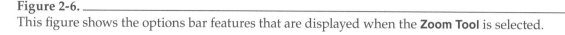
This figure shows the options bar features that are displayed when the **Zoom Tool** is selected.

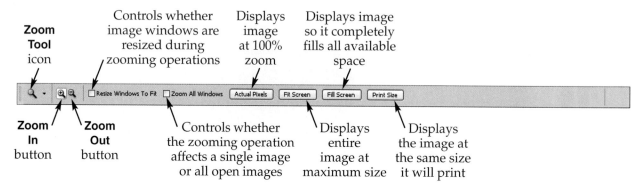

The Actual Pixels Button

Click the **Actual Pixels** button to view the image at 100% zoom. The phrase "actual pixels" means that the pixels in the image are the same size as the tiny glowing dots on the computer screen. Web designers view images at 100% when they want to see how large the image will appear in a browser. Double-clicking the **Zoom Tool** in the **Tools** panel will also reset the zoom magnification to 100%.

The Fit Screen and Fill Screen Buttons

Clicking the **Fit Screen** button quickly zooms your image so it appears onscreen at the maximum size possible, without any portion of the image being hidden within the window. The image window is also resized until it fills all the space available horizontally or vertically.

The **Fill Screen** button creates a larger view of your image, zooming the image to the point that it fills all of the available space. For most images, this causes the sides of the image (or top and bottom) to be hidden from view.

When either the **Fit Screen** or **Fill Screen** button is clicked, the image window is resized, regardless of whether the **Resize Windows to Fit** check box is checked or not.

The Print Size Button

Click the **Print Size** button to see the actual size of your image. When you click on the **Print Size** button, the image appears onscreen at approximately the same size as it would if it were printed. For more information about print size, refer to the "Print Size" section presented earlier in this chapter.

Zooming In by Dragging a Box

Perhaps the easiest way to zoom in to an exact location is to *drag a box* in your image with the **Zoom Tool**. To zoom in on an area of the image, begin by making sure the **Zoom In** button is selected on the options bar. Next, position the cursor at one corner of the area you want to zoom in on. Click and hold the mouse button and drag the cursor to the opposite corner of the area you want to zoom in on. Whatever you include in the box will be magnified. The zoom percentage will depend on the resolution of the image and the size of the box you create.

The Hand Tool

When you are zoomed in close to your image, or if your image is too large to fit in a window, *scroll bars* (sliders that allow you to reposition the image in the window) appear at the side and bottom of the image window, Figure 2-7. Say you wanted to stay zoomed in on the ostrich shown in Figure 2-7, but you wanted to see his beak instead of his eye. One way to adjust the view is to move the scroll bars on the image window. However, there is a faster way to do this. The **Hand Tool** lets you "grab" your image and move it around. Another name for this is *panning* your image.

Photoshop provides a convenient keyboard shortcut for the **Hand Tool** because the tool is so frequently used. Hold down the [Spacebar] to temporarily activate the **Hand Tool**. When you release the [Spacebar], the tool you were previously using becomes active again.

Figure 2-7. _____
If the view of your image is larger than the image window, you can adjust the view with the **Hand Tool** (simplest method) or by dragging the scroll bars.

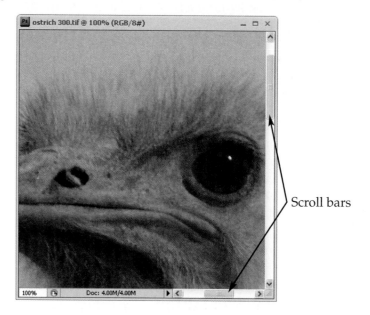

Scroll bars

Hand Tool Options

Using the [Spacebar] shortcut for the hand tool is convenient if you want to make a quick adjustment. However, if you want to access the options available with the **Hand Tool**, you must select the tool from either the **Tools** panel or the Application bar. When the **Hand Tool** is clicked in the **Tools** panel, its options display in the options bar. See **Figure 2-8**.

The **Scroll All Windows** option is available if you have two or more image files open. If this check box is checked, as you adjust one image with the **Hand Tool**, the other images that are currently open are affected the same way.

The **Actual Pixels, Fit Screen, Fill Screen,** and **Print Size** buttons are the same buttons found on the **Zoom Tool**'s options bar. The functions of these buttons were described in "The Zoom Tool" section of this chapter.

Figure 2-8. _____
Most of the **Hand Tool**'s options are also found on the **Zoom Tool**'s option bar.

Zooming options

**Hand When this check box is
Tool checked, the Hand Tool
icon affects all open images**

Animated Zoom and Other Optional Features

Some of Photoshop CS4's zooming and viewing options do not work unless your computer's graphics card is powerful enough. It is not absolutely necessary to use these features; you can get along just fine without them. Several of them are listed below.

- Animated Zoom: As you zoom in or out, the image changes size smoothly, making it seem like you are flying toward it or away from it. You can even zoom without clicking multiple times—just press and hold the mouse button.

- Bird's Eye View: While you are zoomed into an image (and with the **Zoom Tool** still active), you can instantly jump back to a view of the entire image by holding the [H] key and clicking the mouse. A rectangle appears on your image, showing you the area you were previously zoomed into. With the [H] key still held down, you can grab that rectangle and drag it to another location, release the mouse button, and instantly zoom into the new area.

- Flick Panning: When using the **Hand Tool** to scroll around an image, the panning effect continues briefly after releasing the mouse.

- **Rotate View Tool**: Occasionally, you will work with images that contain content that is at an angle. If desired, you use the **Rotate View Tool** to rotate your view of an image without altering the pixels in your image in any way. The **Rotate View Tool** is grouped with the **Hand Tool** in the **Tools** panel. It is also found on the Application bar. You can use this tool to grab your image and rotate it to any angle, or you adjust the angle of rotation in the options bar. Photoshop's tools can be used to edit the image while your view of it is rotated. When you close an image that has been rotated, however, the rotation settings are reset to 0.

Note	If you experience problems while using these features or if you want to learn more about this topic, search for "GPU features" in Help.

Image Resolution and Size

When you are working with digital images, resolution is measured by *pixels per inch (ppi)*. If you measure an image and count a single row of pixels along one inch, you know the image's resolution, or ppi. Photoshop shows you what an image's resolution is when you choose **Image > Image Size…**.

The standard resolution for images on websites is 72 ppi. In **Figure 2-9**, Photoshop's built-in *rulers* help illustrate that there are 72 pixels along one inch. As you zoom in on an image, the rulers adjust accordingly. The rulers can be displayed by choosing **View > Rulers** or using the **View Extras** shortcut button on the Application bar. If desired, you can change the units of measurement on the ruler by choosing **Edit > Preferences > Units & Rulers…** (Windows) or **Photoshop > Preferences > Units & Rulers…** (Mac).

The Image Size Dialog Box

Choose **Image > Image Size…** to display the **Image Size** dialog box, **Figure 2-10**. These settings, if adjusted, will change the size and/or resolution of your image. There are several ways to do this. First, notice that the dialog box is divided into two sections, with three options at the bottom.

Figure 2-9. _____
A—This is the original 72 ppi image. **B**—This is a close up view of the same image, showing
72 pixels between the 0" and 1" marks on the ruler, both horizontally and vertically.

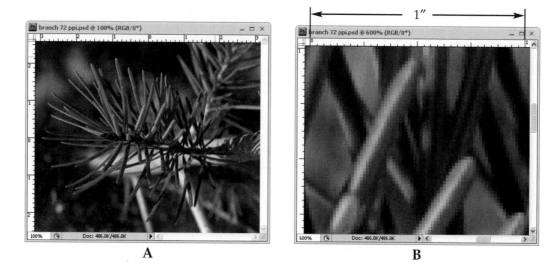

A B

Figure 2-10. _____
The **Image Size** dialog box shows the size and resolution of an image.

Scales styles to match
resized image

Forces width and height to
be scaled at the same ratio

When this option is on, the total
number of pixels changes when
the image is resized

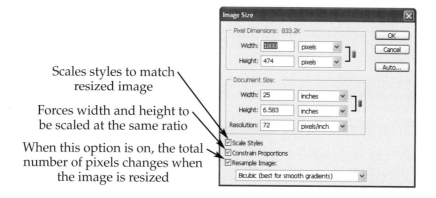

The **Pixel Dimensions** section shows how many pixels wide and tall your image is.
This is helpful information for web designers, because images that will be displayed on
a computer screen are measured by pixels, not inches. You can change the value from
pixels to percent if you are resizing the image (explained later). The current *file size* is
also displayed at the top of the **Pixel Dimensions** section.

The **Document Size** section shows the actual size of the image. Actual size refers
to the size of the image when it is printed. You can view the size of your image in
inches, centimeters, millimeters, and other units of measurement used by the printing
industry. The resolution of the image is also listed here. You can display the resolution
in pixels/inch or pixels/centimeter.

The **Constrain Proportions** option is usually left on. This option prevents you
from "squishing" or stretching your picture when you resize it. When the **Constrain
Proportions** check box is checked, a chain link appears to the right of the **Width** and the
Height settings, reminding you that the two settings are locked together and Photoshop
will force the image to stay in proportion. If you change the width of your image to a
smaller size, for example, Photoshop automatically changes the height for you.

The **Scale Styles** option is also left on most of the time. It is only available if the **Constrain Proportions** option is also on. Styles are special effects that you can add to an image, such as shadows or borders. When the **Scale Styles** check box is checked, any styles you have added are resized along with your image. Styles will be discussed in greater detail in a later chapter.

The final check box available in the **Image Size** dialog box is the **Resample Image** check box. *Resampling* is the term for changing the total number of pixels in an image. For more information, see the "Resizing an Image (Resampling On)" section in this chapter.

The **Auto...** button, on the upper right side of the **Image Size** dialog box, is used as a calculator to determine certain resolution settings. For more information about how to use the **Auto...** button, refer to the "Printing Resolution" section in this chapter.

Resizing an Image (Resampling Off)

As a Photoshop user, it is important to know how to use the **Image Size** dialog box to resize, or change the actual size of, images. The most common resizing tasks are resizing images captured with a digital camera or a scanner. In these situations, *begin by turning the **Resample Image** option off* before changing any other settings. Resizing occurs when you enter new size values in either the **Document Size** section or the **Pixel Dimensions** section of the **Image Size** dialog box.

The following changes are made to an image when you resize it with the **Resample Image** option turned off. In both cases, the number of pixels making up the image remains the same:

- In the **Document Size** section, you can change the resolution of your image to a higher or lower quality. When you do this, the actual size of your image will become larger if you select a lower resolution, or smaller if you select a higher resolution.

- You can change the width and height of your image to a larger or smaller size, using either the **Document Size** or **Pixel Dimensions** section. If you do this, the resolution of your image will increase if you make the image smaller and decrease if you make the image larger.

Before capturing an image, digital cameras let you choose between several image sizes and different levels of quality (compression). If you capture several images at different sizes and open them in Photoshop, you may find they all have the same resolution, but are different sizes in inches. For example, some digital cameras capture images at one resolution: 72 ppi. What if you wanted a high-quality, 300 ppi image from your digital camera? First, you would adjust your digital camera so it captures a large image size. Then, after downloading the image to your computer, you would use Photoshop to change the resolution to 300 ppi, making sure the **Resample Image** option is off. All of the pixels would become smaller, causing the width and height of the image to shrink accordingly. Your much smaller image would become a high-quality, 300 ppi image, with pixels too small to be seen individually by the human eye. The trick is to start with a large-enough image size setting on your digital camera so you end up with your desired size after you change the resolution.

What if your image is still too large (in inches) after changing the resolution to 300 ppi? You could enter a higher resolution to cause the image to become smaller, but resolutions above 300 ppi for photographic images are not really necessary unless they contain extremely fine details, such as tiny text characters. Another option is to place a check mark in the **Resample Image** check box immediately after resizing the image, and

change either the width or height to a smaller value. Leave the **Constrain Proportions** option turned on when you do this. The resolution stays the same in this case, but the image (and thus, the file size) would be smaller. Resampling is explained further in the next section.

Resizing an Image (Resampling On)

The following changes are made to an image when you resize it with the **Resample Image** option turned on.

- You can change the resolution of your image to a higher or lower quality. When you do this, your image size will remain the same (unless you change it also).

- You can change the width and height of your image to a larger or smaller size. When you do this, the resolution of your image will remain the same (unless you change it also).

Another word for "resampling" is "recalculating." When you use this option, Photoshop adjusts the resolution or size of your image. However, to do so, Photoshop must add or remove pixels from the image.

What will happen if you open a low-quality, 72 ppi image, turn on the **Resample Image** option, and change the resolution to 300 ppi? Photoshop *will not* change the size of the image when you enter 300 as the resolution. Instead, a large number of new, tiny pixels will be created. In other words, Photoshop must create the image again, using much smaller pixels than before. When this happens, images usually end up looking fuzzy, since Photoshop has to do some guessing. Sharpening the image (discussed in a later chapter) can help, but the resampled image will never look as good as the original. The bottom line is, *you cannot make a usable high-resolution image from a low-resolution image of the same size.*

Next to the **Resample Image** check box is a drop-down list that contains several resampling methods. Suggestions are made in parentheses, helping you determine which methods are best in particular situations. The differences between each of the resampling methods are subtle. In most cases, you will be in good shape if you leave this setting on **Bicubic**, which is the highest-quality resampling method.

Note Caution! Resampling usually weakens the quality of your image. If you want to change the resolution of an image to a higher quality, the best method is to capture your image at a large size, leave the resampling option off, and change the resolution to a higher quality. However, if you prepare images for the printing industry, you may need to occasionally resample images so they print at optimal resolution. In these situations, consult with your print service provider.

The Crop Tool

The term *crop* means "to cut off." The **Crop Tool** is used to make a document smaller by cutting away parts of it. The **Crop Tool** can also be used to straighten an image that was placed crookedly on a scanner.

The **Crop Tool** also has built-in resizing and resampling capabilities. You can choose *a portion* of an image to resize while trimming away the rest. By comparison, using the **Image Size** dialog box to resize/resample affects your *entire* image, and no trimming occurs. The following are examples of tasks that can be accomplished with the **Crop Tool**.

- **Crop images to an exact size:** Have you ever ordered digital prints (8″ × 10″s, for example) either online or using a kiosk in a store, and found that part of the image was cut off unexpectedly? This happens if the width and height of your original image are not the same proportions as an 8 × 10 rectangle, and you did not specify which part of the image should be trimmed as you prepared the order. Using the **Crop Tool** to resize and trim images is a flexible and exact method of preparing the images to be printed at larger sizes. By resizing and cropping the images prior to having them printed, you eliminate the possibility that your images will be improperly cropped when you receive the prints.

- **Resize and resample images:** Suppose you are working on a huge Photoshop project—a 34″ × 24″ poster that advertises the U.S. Mint's 50 State Quarters Program. The poster contains a map of the U.S. and has a resolution of 300 ppi. Since your intent is to sell the poster, you have obtained permission from the U.S. Mint to use the high-resolution images of quarters that are available for download from their website. After downloading the quarter images, you find that they are not all the same size. They are not the same resolution, either. Some of them are 300 ppi, and some were scanned at resolutions higher than this. No problem! You set the **Crop Tool**'s **Width** and **Height** setting to 1.5″ and the **Resolution** setting to 300 ppi. Then, you drag a box snugly around each quarter and crop each image. You end up with 50 quarter images that are exactly the same size and resolution, and they look great on your poster.

Crop Tool Options, Part I: Resizing and Resampling

Earlier in this chapter, you read about how the **Image Size** dialog box is used to resize images. If the **Resample Image** check box is disabled when you resize an image, the pixels in the image grow smaller or larger, but the image is not resampled. The values entered in the **Crop Tool**'s options bar determine whether the **Crop Tool** resamples the image or not, **Figure 2-11**. If the **Crop Tool** is used to resize images, the image can be resized without resampling by entering *only* **Width** and **Height** settings *or only* **Resolution** settings *(but not both)*.

Enter values in the **Width** and **Height** boxes *only* if you want to specify an exact size for the crop. If you enter an exact size for the crop, the resolution of the image will change to accommodate the new size. On the other hand, you can enter a new value in the **Resolution** text box to change the resolution of the cropped image. The size of the cropped image will be adjusted to accommodate the new resolution.

Figure 2-11. _____
The values entered in the **Crop Tool**'s options bar determines whether the image will be resampled. In the example shown here, values are entered in both the **Width** and **Height** text boxes and the **Resolution** text box. This will cause the image to be resampled when it is cropped.

The **Crop Tool** will resample your image if you enter *both* **Width** and **Height** *and* **Resolution** settings. In some cases, this is desirable, such as the poster project mentioned in the previous section.

Between the **Width** and **Height** text boxes, there is a button with two arrows on it. This button is used to switch the values entered in the two text boxes. If you have entered 8 in and 10 in for your **Width** and **Height** settings and you open a landscape-style image after processing several portrait-style images, clicking this button is a much easier way to reorient your crop rather than typing in new values by hand. To quickly delete the values in the **Width, Height**, and **Resolution** textboxes, click the **Clear** button.

The **Front Image** button is used to copy the **Width, Height**, and **Resolution** settings from another image. If you want to crop an image so it is exactly the same size and resolution as another image you have already edited, open the edited image first and click the **Front Image** button. The width, height, and resolution data is copied into the options bar. Close the image file. Open the file you want to crop. The **Width, Height**, and **Resolution** settings remain in the options bar from the previous image, and will be applied when you use the **Crop Tool**.

Cropping an Image

Begin the cropping process by dragging a rectangle cropping box on your image, without worrying about its size. When you release the mouse button, the options bar changes, revealing additional options, which will be discussed shortly. Small squares called *handles* appear around the selected area, **Figure 2-12**. You can click and drag those handles until the rectangle is exactly the size you want. If you specified a crop size before drawing the crop box, you will be able to adjust only the size of the box, not its width-to-height ratio. The area outside of the crop box is covered with a partially-transparent black shield, indicating what will be deleted. Then, press [Enter] or [Return], or click the **Commit** (check mark) button on the options bar to crop the image.

If an image was scanned crookedly and needs to be straightened, drag a rectangle close to the desired size. Then, position the cursor just outside one of the corner handles until the cursor turns into a curved arrow. Click and hold the mouse button, then drag the crop box until it has rotated to the desired position.

Crop Tool Options, Part II

As mentioned earlier, when you draw a cropping box, the options bar changes, **Figure 2-13**. The shield settings are among the new options that become available after the cropping box is drawn. The shield can be turned on or off by checking or clearing the **Shield** check box. The **Color** swatch appears to the right of the **Shield** check box. Clicking on this swatch opens the **Color Picker** dialog box, from which a new shield color can be selected. The value entered in the **Opacity** slider (to the right of the **Color** swatch) determines how solid the shield appears. As the **Opacity** value decreases, the shield becomes more transparent.

The **Cropped Area** settings control whether the area outside of the cropping box is discarded or not. Usually, the **Delete** option is used, causing pixels to be deleted when cropped. The **Hide** option retains what has been cropped but adjusts the image size of your document, making it so you cannot see the cropped content unless you drag the layer with the **Move Tool** or choose **Image > Reveal All**. The **Cropped Area** radio buttons are available only if the active layer is unlocked. You will learn about locking and unlocking layers in Chapter 4, *Introduction to Layers*.

Figure 2-12. _____
Trimming away unwanted portions of an image is made easy with the **Crop Tool**. **A**—With the
Crop Tool selected, drag a cropping box and press [Enter] to crop the image. **B**—The portion of the
image within the crop box is retained, the rest is discarded.

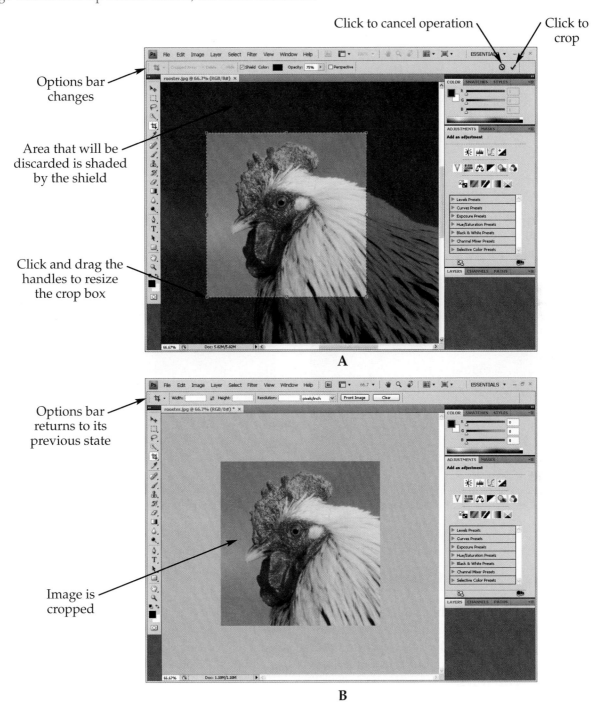

When the **Perspective** check box is checked, you can adjust the cropping box to an
unusual shape before cropping. When the crop is performed, the final result is resam-
pled to fit in a rectangular shape. The perspective looks like it has changed, but as you
can see in **Figure 2-14**, too much adjustment causes the result to be noticeably distorted.
The **Perspective** option is only available when the **Delete** option is selected.

Figure 2-13. _____

The **Crop Tool**'s second options bar appears after the cropping box has been drawn.

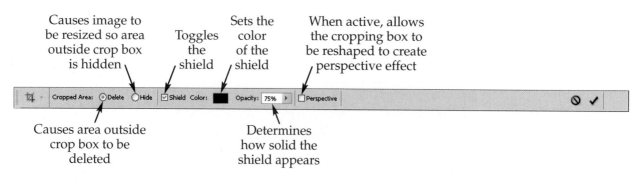

Causes image to be resized so area outside crop box is hidden

Toggles the shield

Sets the color of the shield

When active, allows the cropping box to be reshaped to create perspective effect

Causes area outside crop box to be deleted

Determines how solid the shield appears

Figure 2-14. _____

After the crop box is drawn, checking the **Perspective** check box in the options bar allows you to create a perspective effect. **A**—The perspective effect is created by adjusting the cropping box handles. **B**—When [Enter] is pressed, everything within the crop box is resampled to fit into a rectangular area, creating a perspective look.

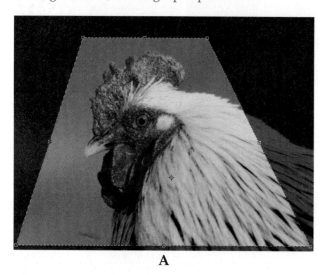

A

B

Printing Resolution

Up to this point in the chapter, you have been reading about image resolution. Printing resolution is a bit different. ***Printing resolution*** refers to the quality level that a printer produces. A printed image is made up of tiny dots of ink. These specks of ink can be round, but they can also be other shapes. Printer resolution is measured one of two ways, dots per inch (dpi) or lines per inch (lpi), depending on the printer.

There are many different kinds of printers. ***Inkjet printers*** create an image by spraying microscopic dots of ink on paper. If you have ever shopped for one of these printers, you probably noticed that the printer's maximum resolution is advertised. For example, some printers have a maximum resolution of 4800 × 2400 dpi. However, a printing resolution of 1200 × 1200 dpi is adequate to produce a high-quality print.

Dye-sublimation printers create very high-quality prints by heating dyes, causing them to melt into smooth, microscopic specks, which blend and solidify on the printed page.

Commercial *printing presses* produce images that are made of rows of tiny dots, and depending on the process used, these dots can be different shapes (such as square, diamond-shaped, circular, and even cross-shaped). These small shapes are often printed at an angle. This is called *halftone* printing, and it is measured in lines per inch (lpi). Lpi is measured just like dpi or ppi, by counting how many dots are along one inch, **Figure 2-15**.

Resizing Images for Printing

Your goal should be to create Photoshop files that have an image resolution that is appropriate for the printing resolution. Newspapers are printed at resolutions of 85–100 lpi. Magazines and brochures are printed at roughly 133–170 lpi. So, what if you were using Photoshop to create a newspaper ad? Photoshop has a built-in calculator to help you convert lpi into ppi. Your first step should be to check with the company that will print the newspaper and ask them what resolution the image will be printed at.

Assume for a moment the answer to that question is 85 lpi. To convert this to pixels per inch, choose **Image > Image Size…**. Before continuing, you should know that you will be changing the resolution of your image as you progress through the following steps. To avoid changing the actual size of your image during this process, make sure the **Resample Image** check box is checked. Then, click the **Auto…** button. See **Figure 2-16**. In the **Auto Resolution** dialog box, enter 85 in the **Screen** text box. Make sure that **lines/inch** is selected

Figure 2-15._____
This is a magnified view of a grayscale (black, white, and shades of gray) halftone print, showing thousands of tiny diamond-shaped dots. This image has a resolution of 85 lpi.

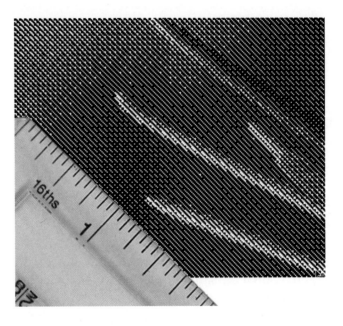

Figure 2-16._____
In the **Auto Resolution** dialog box, enter the resolution at which the image will be printed and the desired output quality and pick the **OK** button. Photoshop will automatically calculate the required settings.

Resolution at which the image will be printed

Scale that the print resolution is measured in

Quality level desired for the printed image

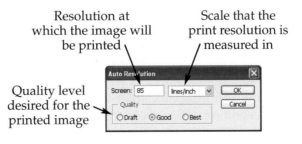

in the drop-down list and then choose a radio button in the **Quality** area of the dialog box. Again, check with your print provider in order to select the appropriate quality level. When you click the **OK** button the **Auto Resolution** dialog box closes, and Photoshop automatically enters the adjusted values in the **Width**, **Height**, and **Resolution** text boxes in the **Image Size** dialog box. The **Auto Resolution** dialog box shows that for the best quality output at a print resolution of 85 lpi, the image should have a resolution of 170 ppi.

As a general rule, Photoshop documents with a resolution of 300 ppi are capable of producing a print of the highest quality. Professional photographers may choose to use higher resolutions than this as they prepare their images for printing. Their decision is influenced by how much fine detail is in the image and the type of printer that will be used. For the majority of projects, it can be argued that there is really no need to use resolutions higher than 300 ppi, because at this resolution, pixels are already microscopic in size. Some photographers are perfectly happy printing and exhibiting work that is considerably less than 300 ppi. If you are printing your own Photoshop projects, experiment and decide what your eye likes the best. Even an image with a resolution of 150 ppi may look quite good when printed.

If you are preparing images for professional printing, you should consult with the printer for the exact image resolutions needed. In most cases, 300 ppi will be adequate, but projects that contain extremely fine detail, such as tiny text characters, may need to be created at a higher resolution. Keep in mind that you can always reduce an image's resolution, but you cannot turn a low-resolution image into a high-resolution image and expect satisfactory results.

> **Note** As a general rule of thumb, an image intended for halftone printing should have a resolution of at least *twice* the resolution at which it will be printed. Lower resolutions will result in poorer print quality.

Scanning Tips

When you prepare to scan an image, you can set the image resolution before you scan. This is the same image resolution that Photoshop recognizes—how many pixels are along one inch. The technical term for scanner resolution is *samples per inch (spi)*, but it is usually called *dots per inch (dpi)* or pixels per inch (ppi) instead. These three terms are used interchangeably.

The image resolution setting is found in the software program that operates your scanner. Some consumer-level scanners will not ask you to enter a resolution setting. They will scan at the same resolution (often a medium quality, like 150 dpi) unless you find the setting and change it.

Say you want to scan a 4″ × 5″ photo, but you need it to be larger when you add it into a Photoshop project you are working on. If you know the actual size and image resolution that you want to end up with, you can set your scanner resolution setting appropriately. Study the following table carefully, **Figure 2-17**. Use it as a guide when you scan images at other sizes and resolutions.

If your goal is to retouch or repair damaged photos (discussed in a later chapter), you should scan at a resolution of at least 300 dpi. When repairing photos, you often need to zoom in on your image to repair tiny scratches, dust marks, and other problems. The higher the resolution, the smoother your repairs will look. Keep in mind, you can always reduce the resolution after the photo is repaired.

Figure 2-17. _____
This table explores the relationship between scan size and resolution and print size and resolution.

If the image you are scanning is this size...	...and you want the actual printed size of the image to be...	...and you want the image to have this resolution...	Printer you will use...	Set the scan resolution to...
4″ × 5″ photo	4″ × 5″—same size as the original	300 ppi	Inkjet	300 spi/dpi
4″ × 5″ photo	8″ × 10″ (twice as big)	300 ppi	Inkjet	600 spi/dpi
35 mm slide	4 times bigger than the original	300 ppi	Inkjet	1200 spi/dpi
35 mm slide	4 times bigger than the original	150 ppi	Inkjet	600 spi/dpi
4″ × 5″ photo	4″ × 5″—same size as the original	Good quality (for a halftone print)	Printing press with resolution set at 135 lpi	270 spi/dpi (multiply the lpi by 2 to find an adequate ppi setting), *or* use the **Auto...** button in the **Image Size** dialog box to figure this out
4″ × 5″ photo	8″ × 10″ (twice as big)	Good quality (for a halftone print)	Printing press, 135 lpi	540 spi/dpi (multiply the lpi by 2 to find an adequate ppi setting), *or* use the **Auto...** button in the **Image Size** dialog box to figure this out

Digital Camera Tips

When you use a digital camera, you will not find a resolution setting. Instead, your camera will let you select from several different *image sizes* (measured in pixels). Image size settings can be described in two different ways in your camera's user manual. The first method is to simply list the width and height of an image, in pixels. For example, the largest image size setting on a particular camera is 4272 × 2848.

A more common way to describe image size is to state the total number of pixels (by multiplying the width by the height), and then rounding the answer to the nearest million. If the largest image size setting on a camera is 4272 pixels wide and 2848 pixels high, an image captured at these settings will contain 12,166,566 total pixels. Instead of writing this large number, it is described as a 12.2 megapixel (or 12.2M) setting. The term *megapixel* means "one million pixels." When shopping for digital cameras, a camera's megapixel rating tells you the largest image size the camera is capable of capturing.

Suppose you capture a 12.2 megapixel image with a Canon EOS Rebel xsi digital camera, download it to your computer, and open it in Photoshop. If you choose **Image > Image Size**, you will notice the image resolution is only 72 ppi, but the size of the image is almost 60 × 40 inches! To increase the resolution of this image, you need to resize it—in other words, make all of the pixels smaller. As the pixels shrink, so does the overall size of your image. You can use either the **Image Size** dialog box or the **Crop Tool** to do this.

The Canon EOS Rebel xsi's image size settings are shown in the following table, **Figure 2-18**. The table illustrates what the final print size of images will be when resized to 200 ppi (an acceptable resolution for printing many images) and 300 ppi (a high-quality resolution).

Figure 2-18. ———
This table lists the image size settings for the Canon EOS Rebel xsi digital SLR camera. These settings vary from camera to camera.

Image size setting on the Canon Rebel EOS xsi digital camera	Image size at the default resolution of 72 ppi:	If resolution is changed from 72 to 200 ppi, the actual printed size will be approximately:	If resolution is changed from 72 to 300 ppi, the actual printed size will be approximately:
4272 × 2848 (12.2 M)	59.3″ × 39.6″	21.4″ × 14.2″	14.2″ × 9.5″
3088 × 2056 (6.3 M)	42.9″ × 28.6″	15.4″ × 10.3″	10.3″ × 6.9″
2256 × 1504 (3.4 M)	31.3″ × 20.9″	11.3″ × 7.5″	7.5″ × 5″

Images for E-mail, Websites, and Portable Devices

You have read that images that will be displayed on a computer screen are most often created with a resolution of 72 ppi. To adjust an image for display on a computer screen, you can manually resize the image to 72 ppi using the **Image Size** dialog box. However, Photoshop has a command called **Save for Web & Devices** that makes it easy to convert any image into a 72 ppi image and optimize it for use on the web.

The Save For Web & Devices Dialog Box

The **Save for Web & Devices** command is used to quickly adjust images so they display well on a website and portable devices such as cell phones or handhelds. In this section, our focus will be using this command to optimize images for use on web pages or as attachments to e-mail.

To begin, open the image you want to adjust. Then, choose **File > Save for Web & Devices…** to display the **Save For Web & Devices** dialog box, **Figure 2-19**. The **Save For Web & Devices** dialog box includes controls for displaying the original image and optimized variations of the image, adjusting image properties, and selecting a file format.

The Display Tabs

Four display tabs appear at the top of the **Save For Web & Devices** dialog box. When the **Original** tab is selected, the original image is displayed in a single frame in the dialog box. The filename and file size are displayed below the image. Changes made to the image properties settings on the right side of the dialog box do not affect the original image, but changes made to the image size settings do.

When the **Optimized** tab is selected, an optimized version (a small, compressed version that still exhibits decent quality) of the original image is displayed in a single frame in the dialog box. The appearance of this image is based on the settings made on the right-hand side of the dialog box. Information about the optimized image is displayed at the bottom of the frame, including file format, size, approximate download time (time it would take to display in a web browser), and color and dithering information. A small pop-up menu next to this information allows you to choose different connection speeds, ranging from typical dial-up to typical broadband. As you select a connection speed from this menu, the approximate download time for the current image is displayed.

When the **2-Up** tab is selected, the original image is displayed on the left, and a view of how it will look when it is changed appears on the right. The appearance of the optimized image on the right is based on the settings made in the controls to the far

Figure 2-19. _____
The **Save For Web & Devices** dialog box is a quick way to optimize an image for use on a website.

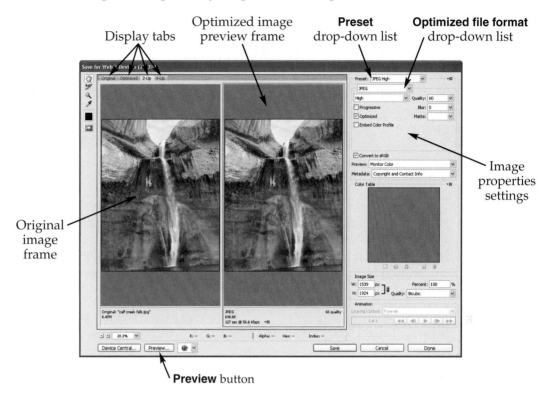

Display tabs Optimized image preview frame **Preset** drop-down list **Optimized file format** drop-down list

Original image frame

Image properties settings

Preview button

right of the dialog box. In Figure 2-19, the image has been automatically changed to a 72 ppi image and then manually converted to JPEG format and further adjusted to optimize it for use on the web. Information about the original image and optimized image appear at the bottom of each frame.

When the **4-Up** tab is selected, the original image and three different optimized versions appear in separate frames in the dialog box. Changes made to the image properties settings on the right side of the dialog box affect only the currently selected image. For this reason, the **4-Up** option can be used to compare the results of various image settings.

Image Properties Settings

In this section, you can save the image in a file format that will compress the image, making its file size even smaller. The image file format can be selected in the **Preset** drop-down list at the top of this section or from the **Optimized file format** drop-down list, below it and to the left. The **Preset** drop-down list provides a number of predefined image formats and settings to choose from. Using this list, you can convert to one of the following file formats:

- **GIF** or **PNG-8:** These formats are used to optimize nonphotographic images (such as logos and other graphics).

- **JPEG:** This is the most common file format used to optimize digital photos for display on the web. You can compress JPEG files in a low, medium, or high quality level. If you compress a JPEG image at a low level, the file size becomes very small, but the loss in image quality is very noticeable. You will learn more about the JPEG file format in a later chapter.

- **PNG-24:** This format is used to optimize images that contain areas of transparency.

Beneath the **Preset** drop-down list is a group of drop-down lists, check boxes, and sliders that allow you to tailor the image properties to your needs. The types of settings available depends on the image format selected in either the **Preset** drop-down list or the **Optimized file format** drop-down list. These settings can be adjusted to modify one of the presets or to define file properties from scratch.

Note WBNP is a black-and-white format that is available in the **Optimized file format** drop-down list. This format is used to optimize images for cell phones and other hand-held devices.

The Color Table Section

If a GIF or PNG-8 image file format is selected, colors that are used in the newly-optimized image are displayed in the **Color Table** section. If you select a color in the table and double-click, you can select a new color in the **Color Picker** dialog box. The original color will be replaced with the newly selected color. You can also edit a color by selecting it in the table and picking one of the tool buttons at the bottom of the section, **Figure 2-20**.

The Image Size Section

In the **Image Size** section, you can adjust the pixel dimensions or percentage of the image, just as if you were using the **Image Size** dialog box. Since the image being saved is optimized for web use, all resizing performed in this section is done with resampling.

Creating Images for Portable Devices

Many cell phones and other hand-held devices have screens that display images with a typical resolution of 72 dpi. Photoshop CS4 makes it easy to create images such as wallpaper or user interface designs for these screens. **Device Central** is an easy-to-use interface that provides technical data along with images of actual devices, which can be used to "preview" Photoshop documents you create, **Figure 2-21**. When previewing an

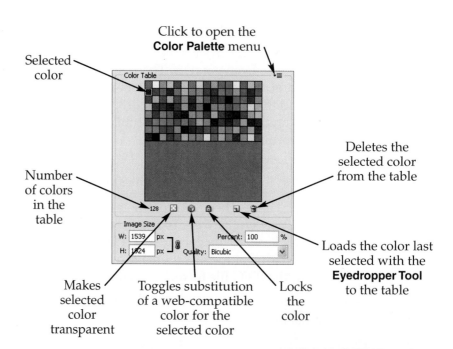

Figure 2-20.
All of the colors used in the optimized image are displayed in the **Color Table** section.

Click to open the
Color Palette menu

Selected color

Number of colors in the table

Deletes the selected color from the table

Loads the color last selected with the **Eyedropper Tool** to the table

Makes selected color transparent

Toggles substitution of a web-compatible color for the selected color

Locks the color

Figure 2-21.
Device Central can be used to create a new document that is properly sized for use in portable devices. It can also be used to preview the way an image will appear in the device. **A**—When you open device central from the **File** menu, a **New Document** tab appears in the dialog box. Browse the Online Library for devices and add them to your Local Library. Select one of them and adjust the settings in the **New Document** tab, and click the **Create** button to create a new image properly sized for the selected device. **B**—When you open **Device Central** from the **Save For Web & Devices** dialog box, the **Emulator** tab appears in the dialog box. You can use the controls in this tab to preview the way your image will look in the portable device.

image on a device, simulated reflections on the handheld screen from various lighting sources can be toggled on and off. You will need an Internet connection when using **Device Central** because Adobe's database of handheld devices is online.

It is quite simple to create a new document that is the appropriate size for a particular handheld. Choose **File > Device Central** or choose **File > New** and click the **Device Central** button in the **New** dialog box. Once **Device Central** opens, browse for the device in the Online Library. Add devices to your computer by dragging them to the **Local Library** list. After a device is double-clicked in the **Local Library** list, technical information (such as what file formats the device can support, along with other capabilities) can be viewed by clicking the **Devices Profiles** tab subheadings: **General, Flash, Bitmap,** and **Web**. To create the new document, click the **New Document** tab and then the **Create** button in the lower right corner. A new document is created at the appropriate size, with a resolution of 72 dpi.

You can copy and paste content into the new image window or use Photoshop's painting and drawing tools to create an original design. After the document is complete, you can then choose **File > Save for Web & Devices** and choose which format the file will be saved in, along with other compression settings, if desired. If you want to get an idea how the new image will look on the device's screen, you can open **Device Central** from the **Save For Web & Devices** dialog box, and click the **Emulator** tab. Using the controls on the right side of the dialog box, you can adjust the scaling and lighting effects applied to the image.

Creating Images for Video

You learned earlier in this chapter that a computer monitor has thousands of tiny, glowing dots that produce an image. These glowing dots are often referred to as pixels, but should not be confused with pixels that make up a digital image (also introduced earlier in this chapter). The glowing pixels on a computer monitor are typically square in shape. Because any Photoshop document or digital photo is made up of perfectly square pixels, computer monitors accurately display these images with their tiny, glowing square-shaped pixels.

The pixels on video displays (such as televisions or video monitors) are more rectangular in shape. With that in mind, images created in Photoshop that will appear in a video production or a television broadcast must be adjusted or they will appear out of proportion.

Pixel aspect ratio describes how wide a pixel is compared to how tall it is. You can use the **View > Pixel Aspect Ratio** submenu to instantly convert an image into a number of different video formats. Pixel aspect ratios are presented in simplified form on this menu. If the pixels on a particular type of TV are two times wider than their height (a ratio of 2:1), the pixel aspect ratio will be expressed as 2 (the first number divided by the second number) on the **View > Pixel Aspect Ratio** submenu. You can also specify a custom pixel aspect ratio using this menu.

GRAPHIC DESIGN

The Mood of a Design

After you understand exactly what message a design needs to communicate, the next step is to plan on what kind of mood and feel the design will have. Just as a

musician can create different moods using various combinations of rhythms, chords, scales, instruments and even silence, a graphic designer can manipulate *design elements* (images, graphics, text, colors, and empty space on the page) to create different feelings or moods. Designs can portray many different moods, including:

- Happiness or sadness.

- Creativity or boredom.

- Tension or relaxation.

- Energy or calm.

- Stability or chaos.

- Beauty or ugliness.

Two different designs for a CD insert are shown in **Figure 2-22**. These designs were created for the same band. Version A of the design gives the viewer the impression that the band is somewhat experimental and unpredictable. Version B paints a picture of a rock band that is more aggressive, loud, and full of attitude. The text in each design is the primary element that helps establish these moods. The colors in each design help a bit, too.

As you learn more about graphic design fundamentals (look for a section at the end of each chapter), you will discover specific tips about how both text and color can be used to enhance the mood of a design.

Figure 2-22. _____
Do you agree with the author's description of the different moods that these designs create?

A B

Summary

Resolution is a very technical subject. Many readers will not understand everything they have read in this chapter after reading it only once. Give yourself time to review this information and experiment, especially with resizing images. It is particularly important to understand the difference between resizing with the resampling option *on* and with the resampling option *off*.

CHAPTER TUTORIALS

Note The files needed to complete the tutorials in this book can be downloaded from the *Learning Photoshop CS4 Student Companion Web Site*. Refer to the "Using the Companion Web Site" section of the book's Introduction for more information.

As you complete the following tutorials, you will become familiar with the **Image Size** dialog box as you compare the same image at two different resolutions. You will also use the **Save for Web & Devices** dialog box to prepare an image for use on a website. Lastly, you will resize an image taken with a digital camera. These tutorials will help you become more comfortable with many of the concepts introduced in this chapter.

Tutorial 2-1: Image Resolution

In this tutorial, you will use the **Zoom Tool** and other commands to compare two images. One image has a resolution of 72 ppi, and the other has a resolution of 300 ppi.

1. Open the file named oak300.jpg.

2. Click the **Zoom Tool** in the **Tools** panel.

3. With the **Zoom Tool** active, drag a box around the stem. Click and drag from point A to point B to create the box.

4. Click the **Zoom Out** button on the options bar.

5. Zoom out by clicking on the leaf five times.

6. Click the **Zoom In** button on the options bar.

 As you perform the next step, watch the title bar in the image window.

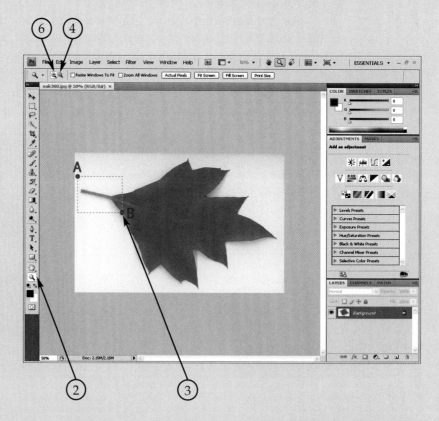

7. Zoom in (click) on the stem until the title bar displays 3200%.

Now that you have zoomed in, you can see that this image is made up of thousands of small squares. These squares are called pixels, or dots.

8. Click the **Fit Screen** button on the options bar. The oak300.jpg window fills the empty area on your screen, and the image is zoomed out so that it fits entirely in the window.

The oak300.jpg file was created by placing a leaf on a scanner and setting the resolution setting to 300 spi (or dpi). As the scanner passed over the leaf, it created 300 pixels per inch, both across and down!

On the right, the scanned oak300.jpg image is shown at actual size. One square inch (the area within the dotted lines) contains 90,000 pixels! "Resolution" means "how many pixels are in one square inch." But instead of saying that the oak300.jpg file has a resolution of 90,000 pixels, it is correct to say that it has a resolution of 300 pixels per inch (ppi). It should be noted that many people use the terms dpi and ppi interchangeably.

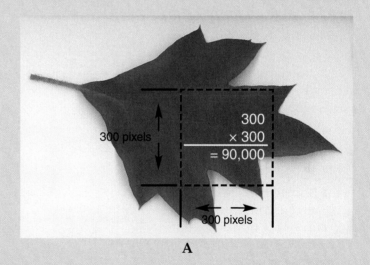

A

9. Choose **Image > Image Size...**. This opens the **Image Size** dialog box.

The **Pixel Dimensions** section shows how many pixels are in the image. Multiply the width (1078) by the height (696) to discover the total number of pixels in this image: 750,288!

The **Document Size** section shows that this image is 3.593" wide and 2.32" tall.

10. Click the **Cancel** button.

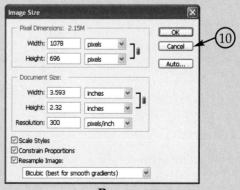

B

11. Without closing oak300.jpg, open the file named oak72.jpg.

The oak72.jpg image has a resolution of 72 ppi.

12. Click the **Arrange Documents** button, and then select the **2-Up** option that arranges the image windows horizontally.

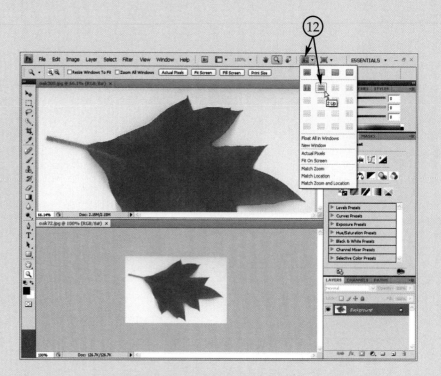

The oak72.jpg image should be active. When an image is referred to as *active*, that means it is selected and ready to work on. To make a image active, click on its title bar.

13. Enter **275** in the zoom text box at the bottom-left of the image window and press [Enter]. This is another way to quickly zoom in or out.

Now the leaves are about the same size on your screen. Notice the difference in quality between the two leaves. The oak300.jpg leaf looks more in focus.

14. With the oak72.jpg image active, choose **Image > Image Size....**

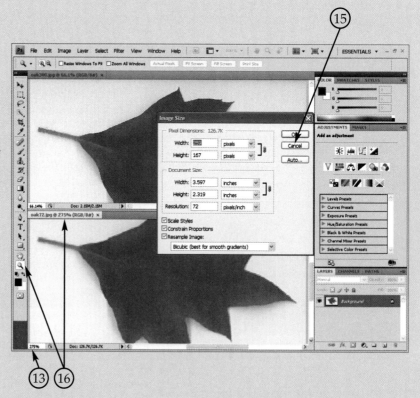

In the **Document Size** section of the **Image Size** dialog box, notice that this image is exactly the same size as the oak300.jpg image: about 3.6" wide and 2.3" tall. This section also shows the image has a resolution of 72 ppi.

The **Pixel Dimensions** section shows this image is 259 pixels wide and 167 pixels high, for a total of 43,771 pixels. Remember, the oak300.jpg image contained over 750,000 pixels!

15. Click the **Cancel** button.

16. Make sure the **Zoom Tool** is still selected and the oak72.jpg is still active.

17. Click the **Print Size** button on the options bar.

 The print size refers to the actual size of the image when its printed. This image is 3.5" wide and 2.3" tall, but it may appear a bit larger or smaller than this, depending on your monitor display settings.

18. Click on the oak300.jpg image tab to make the image active.

19. Click the **Print Size** button again.

 Both images are displayed at their actual size.

20. Click on the oak72.jpg image tab and then use the **Zoom Tool** to drag a box around the stem in the oak72.jpg image, as shown.

21. Activate the oak300.jpg image and use the **Zoom Tool** to drag a box around the stem. Make sure the box is the same size and in the same relative location as the one you drew around the stem in the oak72.jpg image.

 Look closely at the pixels. Notice that a pixel contains only one shade of color. In the oak72.jpg image (A), the pixels (dots) are quite large. Because the pixels are so large, you cannot see any detail on the stem.

 Note that in the oak300.jpg image (B), you can see individual hairs on the stem. The pixels are much smaller in this image—that is why it is sharper and more detailed.

A

B

22. Now, zoom in on the oak300. jpg image until you can see individual square pixels.

 Because it has so many pixels, the oak300.jpg file takes up sixteen times more disk space than the oak72.jpg file.

23. With the oak300.jpg image active, click the **Actual Pixels** button.

24. Activate the oak72.jpg image and click the **Actual Pixels** button again.

 Clicking the **Actual Pixels** button is a quick way to zoom to 100%. This causes each pixel to appear at the same size as a single glowing square on your monitor. Your images should look like the example.

25. Close both files. If you are asked if you want to save changes, click **No**.

Tutorial 2-2: Resizing a Large Digital Image

Your digital camera's largest image size setting is probably 6 megapixels or greater. In most cases, it is a good idea to leave your camera set at its largest image size setting, unless you are just capturing snapshots. You can quickly resize (and resample, if necessary) a large image to any smaller size. Remember, you cannot get good results if you do the opposite: resize a small image to a larger size.

1. Open the file named clover_in_fall.jpg.

 This image was captured with a digital camera with the image size setting at 8M (8 megapixels).

2. Choose **View > Fit On Screen.**

3. Choose **Image > Image Size...** to open the **Image Size** dialog box. Look at the values in the **Pixel Dimensions** section of the dialog box.

 If you multiply 3264 × 2448, you get approximately 8 million pixels. Therefore, this is an 8 megapixel image.

4. Look at the numbers in the **Document Size** section. Notice that the actual size of this image is huge (45″ × 34″), but the resolution of the image is only 72 dpi.

5. Make sure the **Resample Image** check box is unchecked.

6. Enter 300 in the **Resolution** text box.

7. Click the **OK** button.

8. Choose **Image > Image Size...** to open the **Image Size** dialog box. Look at the **Document Size** section again. The size of this image is now just over 8″ × 10″.

 The image is smaller now because all of the pixels got smaller—small enough for 300 of them to fit in a 1″ width.

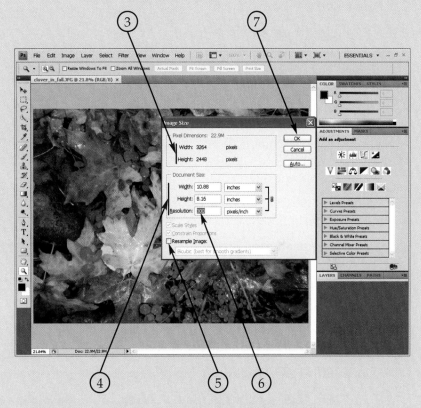

9. Click the **OK** button in the **Image Size** dialog box.

10. Choose **File > Save As....**

11. In the **Save As** dialog box, name the file clover300, pick a location in which to save the file, and click the **Save** button.

12. In the **JPEG Options** dialog box, accept the defaults by picking the **OK** button.

13. Close the clover300.jpg file.

Tutorial 2-3: Using the Crop Tool to Resize and Resample a Large Digital Image

The **Crop Tool** has built-in image size settings. You can resize, resample, and trim away parts of an image all at the same time with the **Crop Tool**. In this tutorial, you will quickly turn a large digital image into a 5″ × 7″ photo with a resolution of 300 dpi.

1. Open the clover_in_fall file again.

2. Choose **View > Fit on Screen**.

3. Click the **Crop Tool** in the **Tools** panel.

4. In the options bar, enter 7 in the **Width** text box and 5 in the **Height** text box. Make sure there is no setting in the **Resolution** text box.

5. Starting in the upper left corner, use the **Crop Tool** to drag a box around as much of the image as you can.

 This image does not quite match the same proportions as a 5″ × 7″ rectangle, so you will not be able to select all of it with the **Crop Tool**.

6. Press [Enter] or click the **Commit** button on the options bar.

7. Choose **Image > Image Size...** and look at the settings.

 The image is now 5″ × 7″, but the resolution is much higher than what you need.

8. Click **OK**.

9. Choose **Edit > Step Backward**. This resets the image to its original condition.

10. In the **Crop Tool**'s options bar, enter 300 dpi in the **Resolution** text box.

11. Drag the same size crop box that you did in step 5 and press [Enter].

12. Your image is now 5″ × 7″ with a resolution of 300 dpi.

 It does not matter what size of crop box you draw; your image will be resized and resampled to the settings you entered in the options bar.

13. In the options bar, click the **Clear** button to remove the settings.

14. Choose **File > Save As...**.

15. In the **Save As** dialog box, name the file clover5x7, pick a location in which to save the file, and click the **Save** button.

16. In the **JPEG Options** dialog box, accept the defaults by picking the **OK** button.

17. Close the clover5x7.jpg file.

Tutorial 2-4: Crop and Rotate an Image

In this tutorial, you will use the **Crop Tool** to straighten and discard unwanted portions of an image.

1. Open the file named bball.jpg.

 This damaged photo was scanned at a resolution of 300 dpi, but it was placed crookedly on the scanner. It needs to be cropped and rotated.

2. Click the **Crop Tool** in the **Tools** panel and drag a box in the image as shown.

3. Move the cursor just beyond the lower-right corner handle until the rotate cursor appears.

4. Rotate the crop selection box slightly until the edges of the crop box are parallel to the edges of the image.

 You can change the position of the crop selection by clicking inside the crop area and dragging the selection or by using the arrow keys. You can resize the crop selection as needed by clicking and dragging the handles surrounding the selection.

5. Click the **Commit** (check mark) button at the far right of the options bar *or* press [Enter] to crop and rotate the image.

6. Choose **File > Save As...**. In the **Save As** dialog box, name the file 02bball and select **Photoshop (*.PSD, *.PDD)** from the **Format** drop-down list. Click the **Save** button to save the image.

7. Close the 02bball.psd image.

Tutorial 2-5: The Save For Web & Devices Dialog Box

It is recommended that all digital images used for e-mail and web pages on the Internet have a resolution of 72 ppi. Images at this resolution look good on a computer screen, and 72 ppi images do not take up much file space, so they attach quickly to e-mail messages and display quickly on a web browser. This tutorial will demonstrate a quick way to change an image to 72 ppi so it is ready to attach to an e-mail message or be uploaded to a web page.

1. Open the oak300.jpg file.

2. Choose **File > Save for Web & Devices...**.

 This opens the **Save For Web & Devices** dialog box.

3. Click the **Original** tab.

 The oak300.jpg image is shown. Near the lower left corner, the size of the oak300.jpg file is displayed. The image file is 2.15 MB (megabytes).

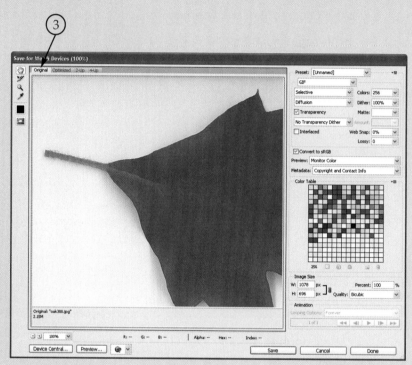

4. Click the **2-Up** tab.

 The original image is shown on the left. The right side will show any changes that are made to the file.

5. In the **Optimized file format** drop-down list, choose **JPEG**.

 Photographs (whether scanned or captured with a digital camera), are often saved as JPEG files before e-mailing or using them on a website. This makes their file size smaller. When an image is saved as a JPEG file, it can be compressed to make the file size even smaller.

6. In the **Compression quality** drop-down list, choose **Low** (low quality).

 Note that selecting **Low** in the **Compression quality** drop-down list also changes the value to 10 in the **Quality** slider. If you want to change the quality from that provided by the preset value, you can enter a new value in the **Quality** slider.

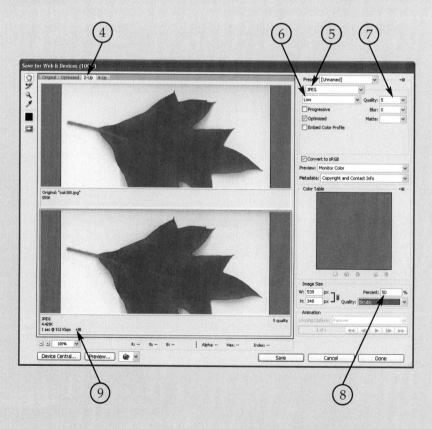

7. Enter a new value of 5 in the **Quality** slider.

 You can do this by typing a new value in the text box or by picking on the arrow button and then clicking and dragging the slider to the desired value. Click away from the slider to hide it again. This lowers the compression quality from the **Low** preset level of 10.

8. In the **Image Size** section near the bottom right side of the **Save For Web & Devices** dialog box, enter 50 in the **Percent** text box to make the image width and height 50% smaller.

 The image on the bottom now looks blurry, because the quality is so low. The new file size and the time the file would take to load through a 28.8 Kbps (dial-up) Internet connection is displayed at the bottom of the optimized image's window.

9. Click the **Select Download Speed** button at the bottom of the image you just adjusted and choose a different Internet connection speed.

 The new connection speed and load time are displayed in the lower-left corner of the image window.

10. Change the compression quality setting to 40 (see step 7).

 Note that the level selected in the **Compression quality** drop-down list changes from **Low** to **Medium**.

11. Click the **Save** button.

 This opens the **Save Optimized As** dialog box.

12. Name the file 02web and choose a location in which to save it. Then, click the **Save** button to save the file and close the dialog box.

 When the optimized image is saved, the **Save For Web** dialog box automatically closes.

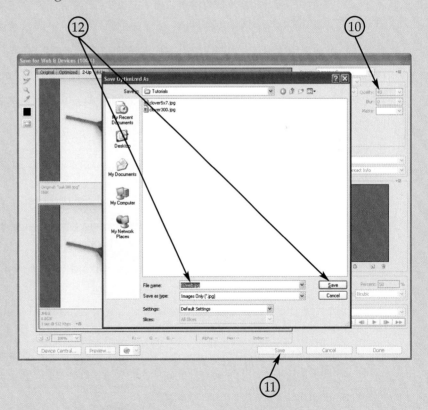

13. Close the oak300.jpg image. If asked to save changes, click **No**.

14. Open the 02web.jpg file you just created.

15. Choose **Image > Image Size…**. In the **Document Size** section of the **Image Size** dialog box, notice the resolution of the 02web.jpg file has been automatically changed to 72 ppi.

16. Click the **Cancel** button to close the **Image Size** dialog box.

17. Choose **File > Close** to close the 02web.jpg file.

Key Terms

crop
design elements
digital
dots per inch (dpi)
drag a box
dye-sublimation printers
halftone
handles
high resolution

image capture device
inkjet printers
low resolution
megapixel
panning
pixel aspect ratio
pixelated
pixels
pixels per inch (ppi)

printing presses
printing resolution
resampling
resolutions
rulers
samples per inch (spi)
scanner
scroll bars
zoom percentage

Review Questions

Answer the following questions on a separate sheet of paper.

1. A digital camera is an image capture device. What does "capture" mean?

2. What are *pixels*?

3. What is a *pixelized* or *pixelated* image?

4. Why does a low-resolution image not use as much file space as a high-resolution image?

5. When an image's zoom percentage is at 100%, what does it mean?

6. What button (or menu command) shows you how large your image will be when printed?

7. List two ways you can reset the zoom magnification of an image to 100%.

8. The book suggests that the easiest way to zoom in on a specific area of an image is to do what?

9. Using the **Hand Tool** is the same as doing what?

10. If you are using another tool, what keyboard shortcut enables you to temporarily use the **Hand Tool**?

11. What is the standard resolution for images on websites?

12. What are two ways to display (or hide) Photoshop's rulers?

13. If you change the width of an image in the **Image Size** dialog box and the **Constrain Proportions** option is on, what happens to the height of the image?

14. Explain how to resize an image in the **Image Size** dialog box without changing the total number of pixels in the image.

15. If you change the width and height of an image to a smaller size with the **Resample Image** option turned off, what will happen to the pixels in your image?

16. With the **Resample Image** option on, if you change the width and height of an image to a smaller size and leave the resolution setting the same, what will happen to your image?

17. What is another term for *resampling*?

18. What are the small squares called that appear around the perimeter of a crop box?

19. Briefly describe how to use the **Crop Tool** to resize part of an image without resampling it.

20. If you know the lpi that an image will be printed at, how can you use Photoshop to help you figure out a compatible image resolution?

21. If you are scanning a 4″ × 5″ photo, and want to use Photoshop to resize it to 12″ × 15″ at a resolution of 300 ppi, at what resolution (spi/dpi) should you scan the image?

22. Since digital cameras do *not* have a resolution setting, how can you control the resolution of images that you capture with your digital camera?

23. If a camera can take a photo that is 4000 × 3000 pixels, what megapixel rating does that camera have?

24. What two things happen to an image file when JPEG compression is applied to it?

25. If a TV has a pixel aspect ratio of 2, what does this mean?

Notice the difference between the various resolutions shown here. Most high-quality print jobs require image resolutions between 170 and 300 dpi.

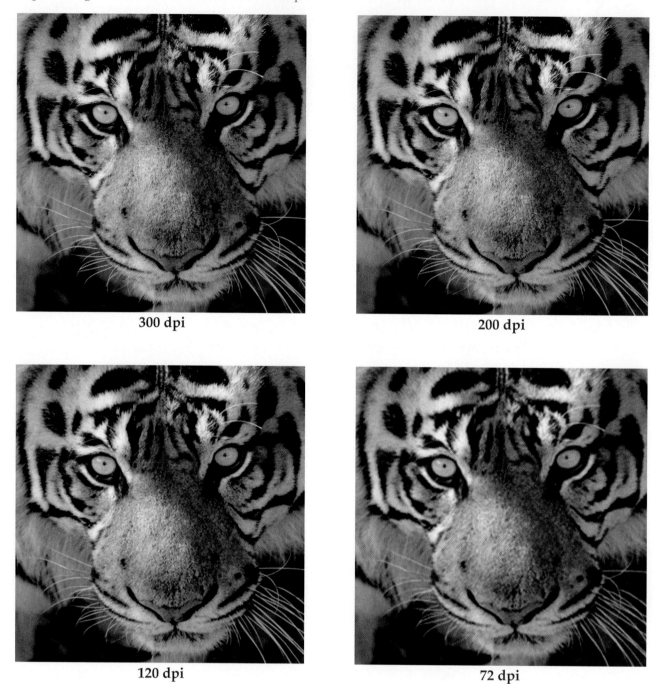

300 dpi

200 dpi

120 dpi

72 dpi

3

Selection Tools

Learning Objectives

After completing this chapter, you will be able to:

- Explain the purpose of Photoshop's selection tools.
- Explain how to use the **New selection**, **Add to selection**, **Subtract from selection**, and **Intersect with selection** buttons that most selection tools have.
- Identify situations in which you may want to feather a selection.
- Use the **Refine Edge** command to create a feathered selection.
- Explain what anti-aliasing does to the edge of a selection.
- Use the **Rectangular Marquee Tool** to create rectangular and square selections.
- Use the **Elliptical Marquee Tool** to create oval and circular selections.
- Use the **Lasso Tool**, **Polygonal Lasso Tool**, and **Magnetic Lasso Tool** to create selections.
- Recognize the situations in which each of the three lasso tools would be the best choice to create a selection.
- Use the **Quick Selection Tool** to select similarly colored areas of an image.
- Use the **Magic Wand Tool** to select similarly colored areas.
- Identify the selection commands found in the **Select** menu.
- Explain how the **Defringe** command removes a fringe from a selected portion of an image.

Introduction

Photoshop's selection tools are used to choose an area in your document that you want to edit. After you select part of your image, the selected area is surrounded with a moving, dashed line. In **Figure 3-1**, a selection border has been created around the leaf, making it the *active* part of the file. Any of Photoshop's tools or commands will affect the selected leaf, but not the white background behind it. Since the white background is not selected, it is protected until the selection border is removed, or *deselected*.

Selection Options

Each selection tool offers a different way to choose part of an image. Before discussing each selection tool in detail, it is important to notice that most selection tools

Figure 3-1. A selection border is a dashed line that surrounds a portion of your file.

share some of the same options. If you click on the **Lasso Tool**, for example, the options bar contains options that most of the other selection tools have as well, **Figure 3-2**. We will discuss these commonly-shared options before explaining the differences between each selection tool.

Fine-Tuning Selections

Most of the selection tools have the following buttons on their options bar. The four buttons, in order, are called **New selection**, **Add to selection**, **Subtract from selection**, and **Intersect with selection**:

- Click the **New selection** button when you want to create a new selection.

- To make an existing selection larger, click the **Add to selection** button and use the selection tool to add more area to the current selection. The keyboard shortcut for this button is [Shift].

- To make an existing selection smaller, click the **Subtract from selection** button and use the selection tool to specify what areas should be removed from the current selection. The keyboard shortcut for this button is [Alt] (or [Option] for Mac).

- The **Intersect with selection** button is used to create a second selection that overlaps one that already exists. The area where the two selection borders overlap is kept as the final selection. This option is not used frequently, but it may come in handy occasionally.

Figure 3-3 shows an example of the way the **Subtract from selection** button is used. The image of the red floppy disk was created by scanning the disk on a flatbed scanner.

Figure 3-2.
These options are shared by most of the selection tools.

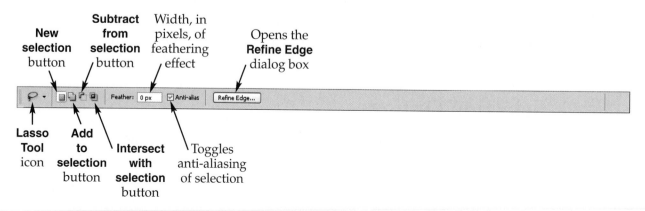

Figure 3-3.
The **Subtract from selection** button makes it easy to create an irregularly shaped selection.
A—First, a square-shaped selection is drawn around the entire disk with the **Rectangular Marquee Tool**. **B**—After zooming in on a corner, the **Polygonal Lasso Tool** is chosen, and the **Subtract from selection** button is clicked. The **Polygonal Lasso Tool** draws a triangular selection at the corner of the floppy disk. **C**—The triangular selection is removed from rectangular selection.

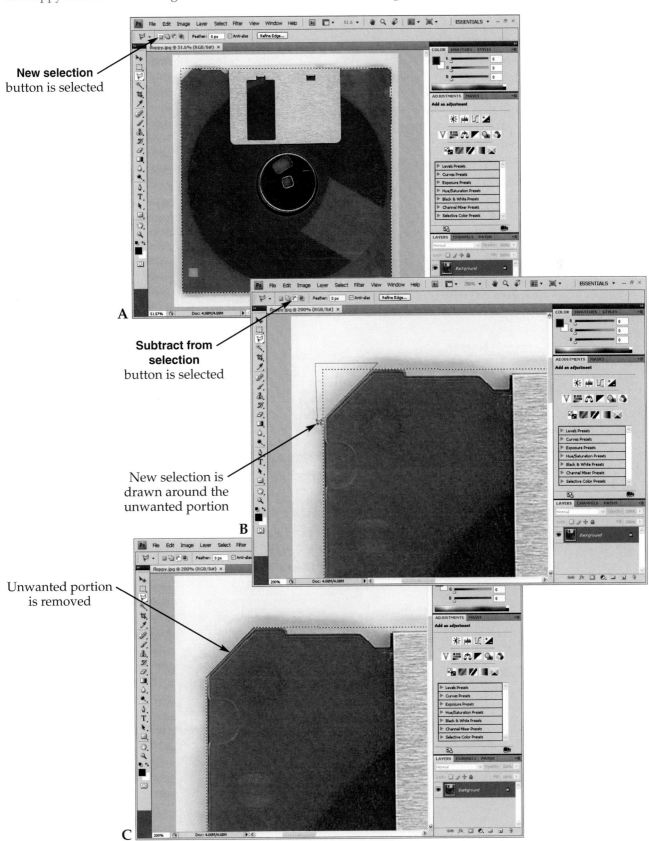

New selection
button is selected

Subtract from selection
button is selected

New selection is
drawn around the
unwanted portion

Unwanted portion
is removed

A

B

C

Unfortunately, there is a shadow around the edges of the disk that needs to be excluded from the selection. It is quicker and easier to draw rectangular selection around the entire disk and then subtract the unwanted portions than it is to draw an accurate selection from scratch.

The Refine Edge Button

All of the selection tools have a **Refine Edge** button that appears on their options bar. This command is also available by choosing **Select > Refine Edge**. The **Refine Edge** dialog box contains several sliders that can be used to adjust the edges of a selection, **Figure 3-4**. The best way to become familiar with these sliders is to view the helpful information built into the **Refine Edge** dialog box. User-friendly explanations and visual examples appear at the bottom of the dialog box as you hold the cursor over any slider or button. Next to the explanation of each slider, a sample image appears, split in two. The left side of the sample shows what would happen to a selected portion of an image if the slider was dragged all the way to the left. The right side of the sample shows how the same image would look if the slider were moved all the way to the right. These descriptions and examples can be hidden by clicking the double-arrow button at the top-left of the **Description** section of the dialog box.

Note	It should be noted that the default setting of 0% in the **Contrast** slider creates a heavily smoothed selection. A setting of 50% is the neutral point for this slider.

Figure 3-4.

The **Refine Edge** dialog box contains five sliders that allow you to fine-tune the edges of your selection. Five preview modes are available, so you can display your selection in the most effective way for a given application. When you move your cursor over a slider or preview mode button, a description of the feature appears at the bottom of the dialog box.

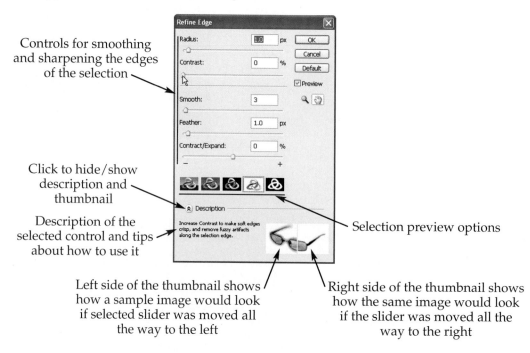

Controls for smoothing and sharpening the edges of the selection

Click to hide/show description and thumbnail

Description of the selected control and tips about how to use it

Selection preview options

Left side of the thumbnail shows how a sample image would look if selected slider was moved all the way to the left

Right side of the thumbnail shows how the same image would look if the slider was moved all the way to the right

Another way to become familiar with the **Refine Edge** controls is to select part of an image, click the **Refine Edge** button, and start dragging sliders while keeping an eye on your image. Near the bottom of the dialog box, another row of buttons allows you to preview your adjusted selection against a dark background, against a light background, as a quick mask (introduced later in this chapter), or as a mask (explained in Chapter 11). You can toggle between these preview options as you experiment with the sliders.

Feathered vs. Normal Selections

One of the most commonly-used sliders in the **Refine Edge** dialog box is the **Feather** slider, which creates a faded-out effect at the edges of the selection, **Figure 3-5**. Leaving the **Feather** setting at 0 creates a crisp-looking edge around the selection. When the **Feather** setting is set to 10, the actual fade-out effect is a total of twenty pixels wide (ten pixels in either direction of the selection). When the feather option is used, the selection you see in your image actually shows the *midpoint* of the feather effect.

Figure 3-5.

Increasing the **Feather** setting in the **Refine Edge** dialog box creates a gradiated, or feathered, edge between the selection and the area around it. **A**—The red button is selected. **B**—When [Delete] is pressed, the button is cleanly removed. Clicking the **Refine Edge** button reveals that the **Feather** setting is set to 0. **C**—When the **Feather** value is adjusted to 10 px in the **Refine Edge** dialog box, a fade-out effect results.

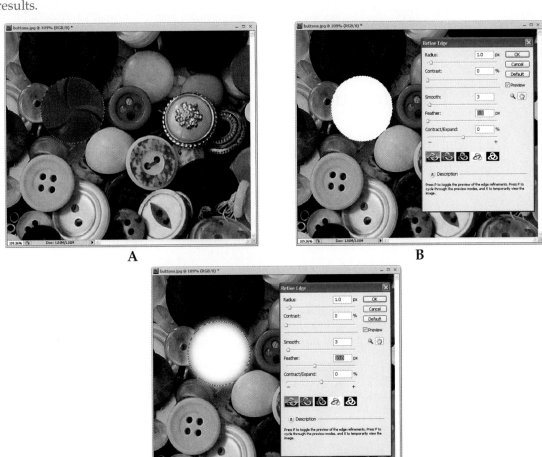

Most of Photoshop's selection tools have the same *feathering* option in their options bar. In most cases, it is much easier to use the **Feather** slider in the **Refine Edge** dialog box to feather a selection. If you use the **Feather** option in the options bar instead, you must remember to enter the feathering value *before* selecting in your image. Additionally, you must remember to set this option back to 0 when you are finished, so you do not accidentally feather your next selection.

Anti-Aliasing

Most of the selection tools have an option called ***anti-aliasing***, which creates a slight smoothing effect around the edges of the selection. Since pixels are square, whenever you create a selection with curved edges, those edges will be rough. You may have to zoom in to see the rough edges if your image has a high resolution (large number of pixels per inch).

Anti-aliasing helps selected pixels look less jagged at the edges by filling in related colors to create a blended look along the edge of a selection, **Figure 3-6**. Think of anti-aliasing as a feather effect that is one pixel wide. For most of your selection work, keep this option turned on for best results. However, anti-aliasing is not necessary for the **Rectangular Marquee Tool** because it produces square and rectangular selections. Selections made with this tool will perfectly follow the square shape of pixels, so edges will not look jagged.

> **Note** An effect similar to anti-aliasing can be achieved in the **Refine Edge** dialog box by setting the contrast slider below 50%, and increasing the **Smooth** slider setting.

The Marquee Selection Tools

The word ***marquee*** refers to a large sign surrounded by blinking lights—something you might see at a movie theater. The marquee tools create selections shaped like rectangles, squares, circles, and ***ellipses*** (ovals). When you create a selection, it slowly "blinks and moves" to help you clearly see it.

To access all of the available marquee tools, position the cursor on the marquee selection tool button near the top of the **Tools** panel and click and hold the mouse button . The four marquee selection tools appear, grouped together in a pop-up menu, **Figure 3-7**.

Figure 3-6. _____

Two close-up views of the buttons image are shown here. The **Feather** setting is set to 0 in both examples. **A**—A button has been selected and deleted with anti-aliasing on. **B**—The same button has been selected and deleted with anti-aliasing off. Notice that the edge appears more jagged.

A B

Figure 3-7. _____
The **Marquee Selection Tools** are available
in a pop-up menu.

Box appears
next to currently
selected tool

The Rectangular Marquee Tool

The **Rectangular Marquee Tool** is used to create rectangular or square selections. When the **Rectangular Marquee Tool** is active, the options bar appears as shown in **Figure 3-8**. Notice that the **Anti-alias** check box is grayed out.

When the **Style** option is set to **Normal**, you can create selections a number of different ways. See the table in **Figure 3-9**.

The second setting listed in the **Style** drop-down list, **Fixed Ratio**, allows you to control the proportion of rectangles. When this option is selected, the **Width** and **Height** text boxes become available. Enter the proportions that you want the selection to maintain in these text boxes. For example, if you enter 2 in the **Width** text box and 1 in the **Height** text box, you will only be able to drag a rectangle that is twice as wide as it is high.

When you select the **Fixed Size** option in the **Style** drop-down list, you are able to enter an exact width and height for the selection. For example, to create a 1″ square selection, enter "1 in" in both the **Width** and **Height** text boxes, then click in your image and move the selection where you want it. To specify width and height in pixels instead of inches, enter px instead of in. Other possible units of measurement are centimeters (cm), points (pt), and picas (pica).

> **Note** Both the **Rectangular Marquee Tool** and the **Crop Tool** (discussed in Chapter 2) create rectangular-shaped selections, but keep in mind that the **Crop Tool** is used to *trim away* parts of an image. The **Rectangular Marquee Tool** does not affect the size of an image; it can only be used to *select* part of an image.

Figure 3-8. _____
The options available for the **Rectangular Marquee Tool** appear in the options bar.

Width
text box
Height
text box

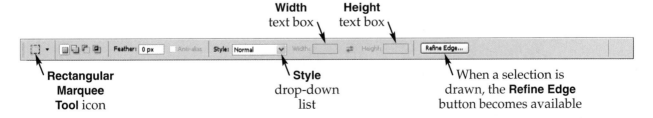

**Rectangular
Marquee
Tool** icon

Style
drop-down
list

When a selection is
drawn, the **Refine Edge**
button becomes available

Figure 3-9. _____

This chart describes the different ways to create and move selections with the **Rectangular Marquee Tool**.

Selection Method	Keyboard/Mouse Actions
Create a rectangular selection, corner-to-corner.	Click and drag with the mouse.
Create a rectangular selection, center-to-corner.	Press [Alt] (Windows) or [Option] (Mac) after you begin clicking and dragging with the mouse.
Create a square selection, corner-to-corner.	Press [Shift] while clicking and dragging.
Create a square selection, center-to-corner.	Press [Shift][Alt] (Windows) or [Shift][Option] (Mac) after you begin clicking and dragging.
Move and resize a selection while it is being created.	Press the [Spacebar] after you begin clicking and dragging.
Move a selection after it has been created (without moving the selected pixels).	1. Use the arrow keys for 1-pixel movements. 2. Press [Shift] and use the arrow keys for 10-pixel movements. 3. Click and drag inside of the selected area (make sure the **Rectangular Marquee Tool** is active).

The Elliptical Marquee Tool

This **Elliptical Marquee Tool** is used to create elliptical (oval) or circular selections. When this tool is active, the options bar offers the same options as those in the **Rectangular Marquee Tool**'s options bar, with one exception: the **Anti-alias** check box is available, **Figure 3-10**.

The table in **Figure 3-11** explains various ways to create elliptical or circular selections with the **Elliptical Marquee Tool**. These methods are almost identical to the **Rectangular Marquee Tool**'s methods.

The Single Column and Single Row Marquee Tools

These two tools are specialized rectangular marquee tools. They create a rectangular-shaped column or row that is only one pixel wide. These tools can be used to create "picture-frame" effects around images, since their width and height can easily be expanded by using the **Select** menu (discussed later in this chapter).

Clicking the mouse button once creates a column or row that extends from one edge of your document to the other. If you hold the mouse button down, you can drag the column or row you just created to another location.

Because the **Single Column Marquee Tool** can only draw a selection that is one pixel wide and the same height as the image, and the **Single Row Marquee Tool** can only draw a selection that is one pixel high and the same width as the image, most of the options are unavailable (grayed out) on the options bar, **Figure 3-12**.

Figure 3-10. _____

The **Elliptical Marquee Tool**'s options bar is almost identical to the options bar for the **Rectangular Marquee Tool**.

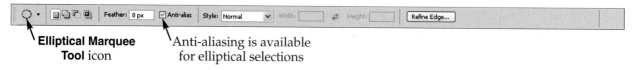

Elliptical Marquee Tool icon Anti-aliasing is available for elliptical selections

Figure 3-11.
This chart describes the methods of creating and moving circular and elliptical selections.

Selection Method	Keyboard/Mouse Actions
Create an elliptical selection, corner-to-corner.	Click and drag with the mouse. You may wish to display Photoshop's grid (**View > Show > Grid**).
Create an elliptical selection, center-to-corner.	Press [Alt] (Windows) or [Option] (Mac) after you begin clicking and dragging with the mouse.
Create a circular selection, corner-to-corner.	Press [Shift] while clicking and dragging.
Create a circular selection, center-to-corner.	Press [Shift][Alt] (Windows) or [Shift][Option] (Mac) after you begin clicking and dragging.
Move and resize a selection while it is being created.	Press the [Spacebar] after you begin clicking and dragging.
Move a selection after it has been created (without moving the selected pixels).	1. Use the arrow keys for 1-pixel movements. 2. Press [Shift] and use the arrow keys for 10-pixel movements. 3. Click and drag inside of the selected area (make sure the **Elliptical Marquee Tool** is active).

Figure 3-12.
Few options are available in the options bar when the **Single Row Marquee Tool** is selected. It should be noted that although the **Feather** option is available, it does not work with the **Single Row Marquee Tool** or the **Single Column Marquee Tool**, because the selections are only one pixel wide.

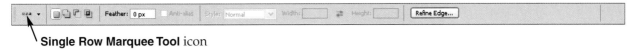

Single Row Marquee Tool icon

The Lasso Tools

Instead of creating fixed-shape selections like the marquee selection tools, the lasso selection tools create freehand-drawn selections.

The Lasso Tool

The **Lasso Tool** draws a selection beginning where you click the mouse and following the cursor as you drag the mouse, **Figure 3-13**. If you let go of the mouse button while selecting with this tool, Photoshop automatically finishes the selection for you by drawing a straight line from the point where you release the mouse button to the starting point. For best results, you should zoom in 200% or more so you can draw selections as accurately as possible. Use the **Add to selection** and **Subtract from selection** buttons to clean up any mistakes.

The Polygonal Lasso Tool

The **Polygonal Lasso Tool** is similar to the **Lasso Tool** and has the same available selection options. The major difference between the tools is that the **Polygonal Lasso Tool** creates only straight lines. Every time you click the mouse, you can change directions and create another straight line segment.

Figure 3-13. _____

To create a selection with the **Lasso Tool**, hold the mouse button and drag the mouse. The selection border is created along the cursor's path.

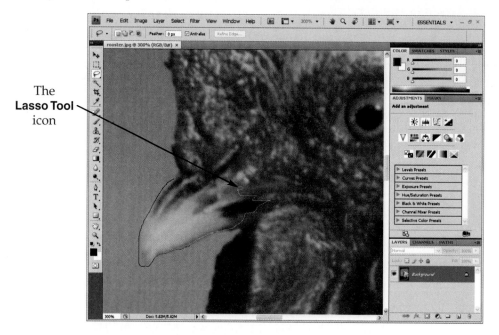

The **Lasso Tool** icon

To finish creating a selection with the **Polygonal Lasso Tool**, you can click exactly where you began, the starting point of the selection. A small circle appears at the lower-left corner of the **Polygonal Lasso Tool** cursor when it is positioned over the starting point, making it easier to select. See **Figure 3-14**. Another way to complete the selection is to press [Enter] or [Return]. A straight line will be drawn between the cursor's position and the starting point, closing the selection.

Figure 3-14. _____

These three windows have been selected using the **Add to selection** option in the **Polygonal Lasso Tool**'s options bar. The small circle at the bottom of the cursor indicates that clicking the mouse will complete the selection.

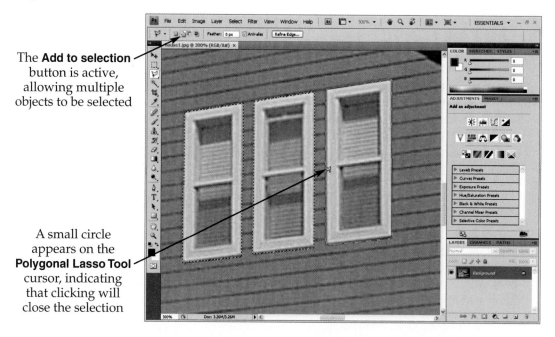

The **Add to selection** button is active, allowing multiple objects to be selected

A small circle appears on the **Polygonal Lasso Tool** cursor, indicating that clicking will close the selection

The Magnetic Lasso Tool

The **Magnetic Lasso Tool** finds the edge of objects in an image. This tool works well only if the area you want to select does not blend in with the colors around it. The **Magnetic Lasso Tool** looks for places where there are contrasting colors, and draws a selection where the two colors meet.

As you create a selection border, the **Magnetic Lasso Tool** generates *fastening points*, which hold the selection border in place, **Figure 3-15**. If the **Magnetic Lasso Tool** seems to get a bit confused, press [Delete] or [Backspace] as you backtrack the cursor over the selection. Then, move forward again, keeping the **Magnetic Lasso Tool** on track by clicking the mouse at key points along the object, such as the apex of curves or places where the selection path must change directions sharply. This creates additional fastening points.

As with the **Polygonal Lasso Tool**, you can complete the selection by clicking the starting point of the selection. A small circle appears at the lower-left corner of the **Magnetic Lasso Tool** cursor when it is positioned over the starting point of the selection. You can also complete the selection by pressing [Enter] or [Return]. This draws a straight line between the cursor's position and the starting point, closing the selection.

The Magnetic Lasso Tool Options Bar

The **Magnetic Lasso Tool** has all of the selection options available for the **Lasso Tool** and **Polygonal Lasso Tool**. In addition to these options, the options bar for the **Magnetic Lasso Tool** also contains several settings that control the tool's sensitivity, **Figure 3-16**.

Figure 3-15. _____

The **Magnetic Lasso Tool** creates fastening points. The fastening points hold the selection border to the edges in the image.

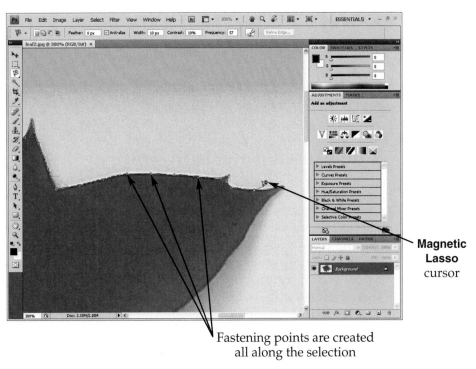

Magnetic
Lasso
cursor

Fastening points are created
all along the selection

Figure 3-16. _____

The **Magnetic Lasso Tool**'s options bar has controls for adjusting the tool's edge detection sensitivity and the frequency at which it creates fastening points.

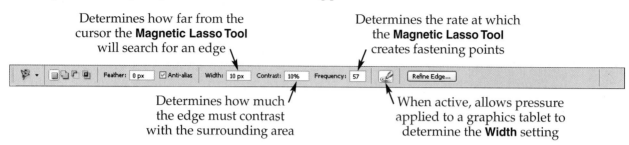

Determines how far from the cursor the **Magnetic Lasso Tool** will search for an edge

Determines the rate at which the **Magnetic Lasso Tool** creates fastening points

Determines how much the edge must contrast with the surrounding area

When active, allows pressure applied to a graphics tablet to determine the **Width** setting

The **Width** setting determines how wide of an area the **Magnetic Lasso Tool** analyzes while trying to find an edge to select. For example, if the **Width** value is set at 10 px, the **Magnetic Lasso Tool** tries to find an edge within ten pixels (in all directions) of itself. Edges more than ten pixels away are not detected in this case.

Enter a high percentage in the **Contrast** setting if the area you wish to select contrasts sharply with the color of the background behind it. This lowers the sensitivity of the **Magnetic Lasso Tool** and makes it work a bit more efficiently. Enter lower percentages if you are trying to select areas of your image that do not contrast as much with surrounding colors.

A high number (up to 100) entered in the **Frequency** text box causes fastening points to be created more frequently. More fastening points can be helpful when selecting an area that does not sharply contrast with the colors around it.

The **Use tablet pressure to change pen width** button is provided for Photoshop users who use a graphics tablet instead of a mouse. When this button is active, the **Width** setting can be changed by varying the pressure applied to the graphics tablet.

Useful Keyboard Shortcuts for the Lasso Tools

As you work with the lasso selection tools, you will occasionally need to change options or make changes to the selection. The table in **Figure 3-17** describes some helpful keyboard shortcuts that can be used when creating selections with the lasso selection tools.

The Quick Selection Tool

The **Quick Selection Tool** works like a paintbrush, but it does not apply any color. Instead, it selects whatever colors you "paint." As you click and drag with this tool, Photoshop senses the colors you paint, creates a selection, and expands this selection automatically to include all similar colors nearby. In other words, it attempts to figure out what you want to select after you drag the paintbrush over a sample area. This tool works well if the areas you wish to select are noticeably different in color from their surroundings.

To create an accurate selection, you will need to change the **Quick Selection Tool**'s brush size as you work. The easiest way to do this is to tap the left and right bracket keys. For more precise brush size control, click the **Open Brush Picker** button on the options bar. In the **Brush Picker** dialog box, you can adjust the diameter, hardness (of the edge

Figure 3-17. _____

This chart describes various selection methods for the lasso tools and their keyboard shortcuts.

Selection Method	Keyboard/Mouse Actions
Lasso Tool	
Add to a selection (keyboard shortcut for the **Add to selection** button in the options bar).	Press [Shift].
Subtract from selection (shortcut for the **Subtract from selection** button in the options bar).	Press [Alt] (Windows) or [Option] (Mac).
Switch from the **Lasso Tool** to the **Polygonal Lasso Tool** and back again while creating a selection.	While creating a selection, press [Alt] (Windows) or [Option] (Mac) and then release the mouse button. Hold the [Alt] button while using the **Polygonal Lasso Tool**. To switch back to the **Lasso Tool**, hold the mouse button and release [Alt]. If you release both [Alt] and the mouse button, the selection closes.
Polygonal Lasso Tool	
Add to a selection (keyboard shortcut for the **Add to selection** button in the options bar).	Press [Shift].
Subtract from selection (shortcut for the **Subtract from selection** button in the options bar).	Press [Alt] (Windows) or [Option] (Mac).
Switch from the **Polygonal Lasso Tool** to the **Lasso Tool** and back again while creating a selection.	While creating a selection, press and hold [Alt] (Windows) or [Option] (Mac) and the mouse button. Drag the mouse to change to the **Lasso Tool**. Release the mouse button or [Alt] to return to the **Polygonal Lasso Tool**.
Back up (erase line segments and fastening points) while drawing a selection.	Press [Delete] or [Backspace]. This must be done before the selection is closed.
Magnetic Lasso Tool	
Back up (erase line segments and fastening points) while drawing a selection.	Press [Delete] or [Backspace] and move the mouse backward along the selection path.
Switch to the **Lasso Tool** and back again while creating a selection.	Click and hold the mouse button, press and hold [Alt] (Windows) or [Option] (Mac). Drag the mouse to switch to the **Lasso Tool**. To return to the **Magnetic Lasso Tool**, release [Alt] and then release the mouse button. Note: if you release the mouse button first, the **Polygonal Lasso Tool** is activated. Click the mouse and release [Alt] to return to the **Magnetic Lasso Tool**.
Switch to the **Polygonal Lasso Tool** and back again while creating a selection.	Press and hold [Alt] (Windows) or [Option] (Mac) and click the mouse button. To return to the **Magnetic Lasso Tool**, release [Alt] and click the mouse button.

of the brush), angle, and roundness of the brush. The **Size** setting is for graphics tablet users. They can specify whether pressure from the stylus pen or movement of the stylus wheel on the pen changes the brush size.

The options bar contains buttons with familiar names: the **New selection** button, **Add to selection** button, and **Subtract from selection** button. However, they have a new look. They work in the same way as the similarly-named buttons found on the options bar of the other selection tools. The **Add to selection** button is selected automatically after the first time you click and drag with the **Quick Selection Tool**, because Photoshop assumes you are going to add more to the selection, **Figure 3-18**.

Figure 3-18. _____

The **Quick Selection Tool** makes it extremely quick and easy to select objects that stand out against their background. **A**—The **New selection**, **Add to selection**, and **Subtract from selection** buttons look different in the **Quick Selection Tool**'s options bar, but they perform the same function as they do for the other selection tools. **B**—When making intricate selections with the **Quick Selection Tool**, you may need to adjust the brush size to select small areas. You may want to activate the **Auto-Enhance** option to smooth your selection.

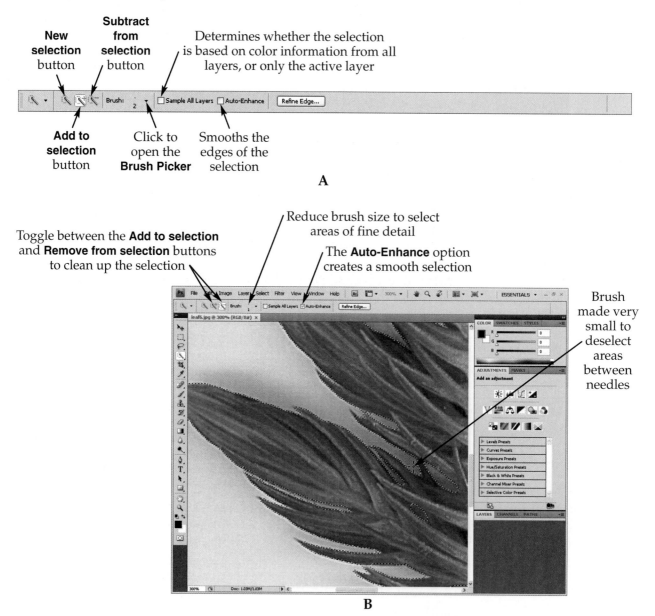

When the **Sample All Layers** button is clicked, Photoshop analyzes the colors of all layers in an image and uses that information as the basis of the selection. If this button is not selected, the selection will be based on the pixels on the active layer only. The **Auto Enhance** option softens the edge of your selection slightly by automatically applying some of the settings available in the **Refine Edge** option.

If you find this tool does not work well, the area you are selecting is probably too complicated. You can try zooming in and reducing the brush size to select the fine detail. If that does not work, you will need to use a more precise selection tool, such as the **Lasso Tool**, **Magic Wand Tool**, or quick mask mode.

The Magic Wand Tool

The **Magic Wand Tool** is similar to the **Quick Selection Tool**, except it is used to click on a single pixel. When you click on the pixel, Photoshop looks for other pixels that are similar in color and selects them as well. This tool enables you to select complicated areas of similarly-colored pixels, such as blue sky showing through tree branches. However, for this tool to work well, the colored areas you select need to contrast with their immediate surroundings.

The **Tolerance** setting on the options bar controls how "tolerant" the **Magic Wand Tool** is of different shades of color. See **Figure 3-19.** If a low value is entered and you click on a pixel, only pixels that are very similar in color are selected. Entering the maximum **Tolerance** value of 255 would result in all pixels being selected, no matter what color they were. **Tolerance** settings from 5 to about 75 are most commonly used.

Pixels that are touching or bordering each other are *contiguous*. When the **Contiguous** check box is checked, the **Magic Wand Tool** selects similar-colored pixels only if they are touching each other, **Figure 3-20.** When the **Contiguous** check box is unchecked, similar colors in the entire image are selected. Notice that with contiguous option turned off, the blue sky showing between the branches was selected along with the open sky. Unfortunately, part of a window that is blue-gray was selected too. This could easily be fixed by choosing the **Lasso Tool**, clicking the **Subtract from selection** button, and selecting the problem area to remove it from the selection.

A Photoshop image can be made up of several layers (layers will be discussed in detail in Chapter 4, *Introduction to Layers*). When the **Sample All Layers** check box is checked, the **Magic Wand Tool** will select pixels of similar color on all visible layers. When **Sample All Layers** check box is unchecked, pixels will be selected only on the active layer.

Quick Mask Mode

The quick mask mode enables you to select an area in a very different way. You use Photoshop's **Brush Tool** or other painting and drawing tools, with their various brush styles, to "paint" a semitransparent color over your image. This colored area is really a protective shield called a mask, and it is painted over the portions of your file that you do *not* want to select. You can use quick masking together with any combination of selection tools to create a single selection.

Figure 3-19. _____

The controls in the **Magic Wand Tool**'s options bar determine how sensitive the tool is. A higher tolerance setting will allow a greater range of colors to be selected than a low tolerance setting.

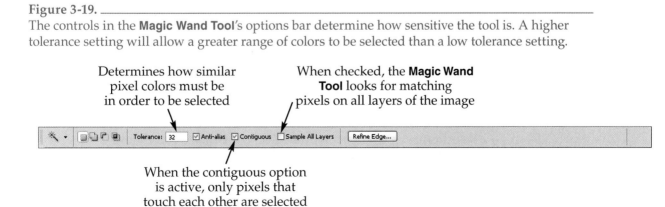

Determines how similar
pixel colors must be
in order to be selected

When checked, the **Magic Wand Tool** looks for matching pixels on all layers of the image

When the contiguous option
is active, only pixels that
touch each other are selected

Figure 3-20. _____

The **Magic Wand Tool** was used to select the blue sky near the top of the house in both of these examples. **A**—The blue sky was selected using the **Magic Wand Tool** with the **Contiguous** option off. Areas of blue in the window and showing through the tree were selected along with the open sky. **B**—When the same color is clicked with the **Contiguous** setting on, only the open sky is selected.

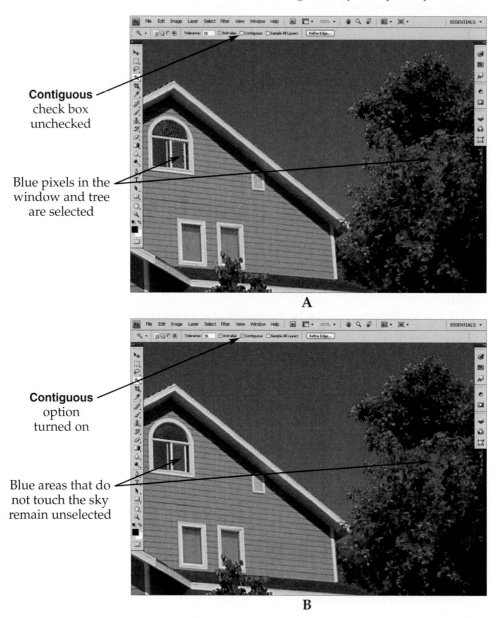

Contiguous check box unchecked

Blue pixels in the window and tree are selected

A

Contiguous option turned on

Blue areas that do not touch the sky remain unselected

B

To enter quick mask mode, click the **Edit in Quick Mask Mode/Edit in Standard Mode** toggle near the bottom of the **Tools** panel, **Figure 3-21**. Click the **Edit in Quick Mask Mode/Edit in Standard Mode** toggle again to change the selection mode back to standard mode. As you create a selection, you can jump back and forth between standard mode and quick mask mode at any time.

To create a selection in quick mask mode, select the **Brush Tool**, choose a brush style and diameter, and set black as the foreground color to paint the mask, **Figure 3-22**. The **Brush Tool** will be discussed in detail in Chapter 6, *Painting Tools and Filters*. For the purpose of drawing a mask, simply click the **Brush Tool** in the **Tools** panel, and then select the

Figure 3-21. _____

The **Edit in Quick Mask Mode/Edit in Standard Mode** toggle is used to switch between quick mask mode and standard mode. Standard mode is the mode in which selections are made using the selection tools such as the lasso tools, the marquee tools, and the **Magic Wand Tool**.

Edit in Quick Mask Mode/Edit in Standard Mode toggle

Figure 3-22. _____

This image is being edited in quick mask mode. The **Brush Tool** is being used to paint a mask, telling Photoshop what part of the image should *not* be selected.

Click to select a brush

Black set as foreground color

Toggle is depressed, indicating that quick mask mode is active

Brush Tool cursor

desired brush from the **Brush Presets** drop-down list in the options bar. When selecting a brush preset, keep in mind that "soft" brush styles create a feathered selection.

Zoom in close (200% or more) to paint your mask accurately. To erase parts of the mask, if necessary, change the foreground color to white. When the foreground color is set to white, the **Brush Tool** acts as an eraser. When you have finished creating the mask, the entire image except for the areas that are covered by the mask are selected.

Note You can partially select an area by painting the quick mask with a shade of gray rather than black. Some pixels within the area will be selected while others will not. As the darkness of the gray used to create the mask increases, the percentage to which the area is selected decreases. If a light shade of gray is used, the masked area may not be surrounded by an animated selection border in standard mode.

Double-clicking on the **Edit in Quick Mask Mode/Edit in Standard Mode** toggle brings up the **Quick Mask Options** dialog box, **Figure 3-23**. In this dialog box, you can specify whether the mask represents selected areas instead of nonselected areas (default setting), select a new color for the mask, and adjust the transparency of the mask.

The Type Masking Tools

The **Horizontal Type Mask Tool** and the **Vertical Type Mask Tool** create selections shaped like text. These tools are accessed by clicking on the **Horizontal Type Tool** (or other active type tool) button in the **Tools** panel and holding the mouse button until the other type tools appear in a pop-up menu.

After selecting the desired type masking tool from the pop-up menu, you set the font, size, and style in the options bar. The options available are the same as those available for the other text tools. These options are discussed in detail in Chapter 5, *Text, Shapes, and Layer Styles*. Using these options, you can change the font, change font style, adjust the font size, select an anti-aliasing method, change justification, warp the text, and fine-tune a number of typesetting properties.

A pink mask appears as you click on your image and begin to enter your text. Notice that the text is cut out of the mask, meaning that it will be selected. After you finish entering the text, click the **Commit** button (check mark button) in the options bar to turn the text into a selection, **Figure 3-24**.

The Select Menu

The **Select** menu contains commands that can adjust selections in many useful ways. The following sections explain the commands found in this menu and how they can be used to create, modify, and save selections.

The All Command

The **All** command selects the entire image. However, if your file is made up of several layers, only the contents of the active layer are selected. This command is useful if you want to select large areas of the drawing. With one menu selection, you can select the entire image, and then use the selection tools or quick mask option to deselect (by using the **Subtract from selection** button) the areas you do not want included.

Figure 3-23. _____

You can adjust the properties of quick mask mode in the **Quick Mask Options** dialog box.

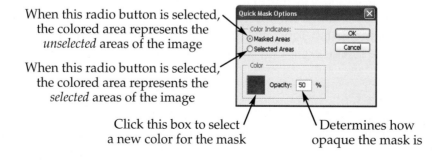

When this radio button is selected, the colored area represents the *unselected* areas of the image

When this radio button is selected, the colored area represents the *selected* areas of the image

Click this box to select a new color for the mask

Determines how opaque the mask is

Figure 3-24. _____
The type mask tools create selections shaped like text.

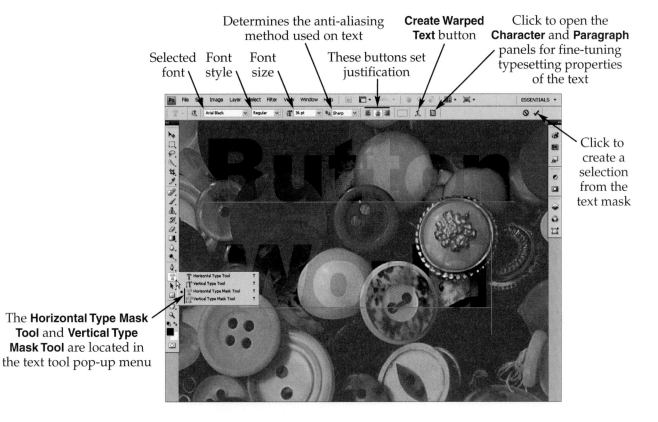

The **Horizontal Type Mask Tool** and **Vertical Type Mask Tool** are located in the text tool pop-up menu

The Deselect Command

The **Deselect** command clears any selections in your image. This command is used frequently, so it is useful to memorize the keyboard shortcut, [Ctrl][D]. Occasionally, you will try to use one of Photoshop's tools and it will not seem to work. It is easy to forget that a part of your file may be selected, preventing Photoshop's tools from working anywhere else in the image. Choosing **Select > Deselect** clears up this problem.

The Reselect Command

If you deselect an area, the **Reselect** command can bring it back for later use. You can use this command to restore a selection any time after it has been deselected but before a new selection is created. Since this command is often used with the **Deselect** command, you will want to learn its keyboard shortcut, [Shift][Ctrl][D].

The Inverse Command

The term *inverse* means "the opposite of." With some images, it is easier to select the parts you do not want to include first, and then invert the selection. For example, the leaf in **Figure 3-25** can be quickly selected by first using the **Magic Wand** to select all of the white background and then choosing **Select > Inverse** to invert or "flip" the selection so it surrounds the leaf instead of the background.

Figure 3-25. _____

The **Inverse** command is used to quickly select this leaf. **A**—The **Magic Wand Tool** is used to select the white background. **B**—After choosing **Select > Inverse**, the leaf is selected and the background is not.

A

B

Selecting by Color Range

The **Color Range** command is similar in function to the **Magic Wand Tool**. When you choose **Select > Color Range...**, the **Color Range** dialog box appears and your cursor becomes an **Eyedropper Tool**, Figure 3-26. Click on a color in your image, and a preview of your selection appears in the dialog box. Click on the **Add to Sample** (eyedropper with a plus sign) button and then click on additional colors in the image to add more shades of color to your selection. Click on the **Subtract from Sample** (eyedropper with a minus sign) button and pick colors in the image to remove from the selection.

The **Select** drop-down list at the top of the dialog box can be used instead of the eyedroppers to select a range of color. This list also lets you select shadows (the darkest areas of an image), highlights (the lightest areas), midtones (colors that are neither shadows or highlights), or out-of-gamut colors (shades of color that cannot be perfectly produced by a printer).

The **Localized Color Clusters** setting, when checked, prevents "in-between" colors from being selected. For example, if you select a red pixel with the **Eyedropper Tool** and then a blue pixel with the **Add to Sample Eyedropper Tool**, colors that are a combination of red and blue (purple and magenta) will also be selected unless **Localized Color Clusters** is checked.

After making a selection with the eyedropper tools, the **Range** slider becomes available only if the **Localized Color Clusters** check box is checked. When this slider is all the

Figure 3-26.

The **Color Range** dialog box is used to select parts of an image based on color. It is similar in function to the **Magic Wand Tool** with the **Contiguous** option turned off.

Allows only pixels within a specified range of the sample point to be selected

Determines how similar colors must be in order to be selected

Click to create a new selection

Click to add to a selection

Click to subtract from a selection

Sets the selection range

Use the **Eyedropper Tool** cursor to select the desired color in the image

Preview of selection

Determines how the selection is previewed in the image window

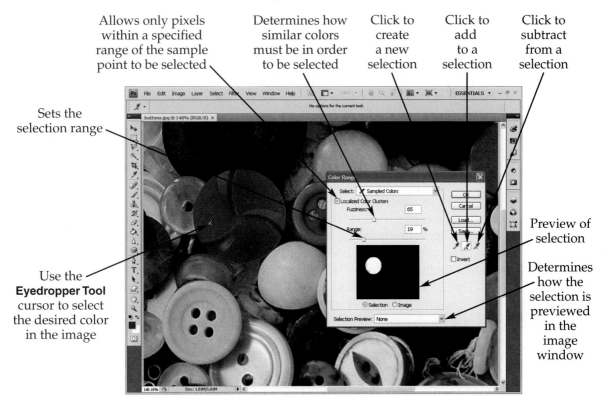

way to the right, Photoshop selects similar colors throughout the entire image. As this slider is dragged to the left, the selected area becomes smaller and smaller, eventually becoming only slightly larger than the areas you clicked with the eyedropper tools. You can see the effect of this slider in the preview box as you drag the slider.

If you want to include a smaller range of colors with each selected color, drag the **Fuzziness** slider to the left. If you want to include a greater range of colors in the selection, drag the **Fuzziness** slider to the right. You can see the effects of the **Fuzziness** setting in the preview window.

The **Selection Preview** drop-down list offers four different ways to preview your image as you use the eyedropper tools and adjust the sliders. By default, this setting is **None**, but depending on the type of image you are working with, choosing either the **Grayscale**, **Black Matte**, **White Matte**, or the **Quick Mask** option may help you more clearly see which colors are being selected.

When you click the **OK** button, the **Color Range** dialog box closes and the colors are selected in your image. Be aware that high **Fuzziness** settings cause some pixels to be only *partially* selected (similar to the effect created by feather-selecting an area). These partially selected areas may not have a visible selection border around them when you click **OK**. Partially selected areas will be partially affected by Photoshop's tools and commands.

The Refine Edge Command

The **Refine Edge** command in the **Select** menu becomes available once a selection is made. This command performs the same function as the **Refine Edge** button on a selection tool's options bar: it opens the **Refine Edge** dialog box. As described earlier in the chapter, the controls in the **Refine Edge** dialog box are used to adjust the edges of a selection.

The Modify Submenu

The **Select > Modify** submenu contains five helpful commands that are used to adjust selections. These commands can be used to create a border from a selection, smooth or feather a selection, or change the size of a selection.

The **Border** command is used to modify a selection by creating two new edges, one inside and one outside of the edge of the original selection, creating a border effect. Choosing this command opens the **Border Selection** dialog box. The **Width** setting in this dialog box determines how far apart the new edges will be. Clicking **OK** in the **Border Selection** dialog box selects the area between the pair of new edges and deselects everything else. For example, if you enter a setting of 6 in the **Width** text box and click **OK**, the outside edge of the border is located three pixels out from the edge of the original selection. A new inside edge is created three pixels in from the original selection's edge. Only the area between the two new edges is selected. If the existing selection has more than one edge, a pair of new edges is created for each edge of the existing selection.

The **Smooth** command is used to smooth out sharp angles and corners on a selection. Choosing this command opens the **Smooth Selection** dialog box. The value entered in the **Sample Radius** text box of this dialog box is the radius used to round the corners.

The **Expand** command makes the selection larger (based on the original shape). Choosing this command opens the **Expand Selection** dialog box. The selection grows outward by the value entered in the **Expand By** text box. It should be noted that in addition to increasing the size of the selection, the **Expand** command also has a smoothing effect on the selection.

The **Contract** command makes the selection smaller. Choosing this command opens the **Contract Selection** dialog box. The selection shrinks by the amount entered in the **Contract By** text box.

The **Feather** command is yet another way to feather a selection. In most cases, the **Feather** command is easier to use than the **Feather** option found on a selection tool's options bar, but not quite as easy as the **Feather** setting in the **Refine Edge** dialog box.

If you would like to use this command to feather a selection, begin by making the selection. Next, choose **Select > Modify > Feather...**. This opens the **Feather Selection** dialog box. Enter a value in the **Feather Radius** text box and pick the **OK** button. The **Feather Selection** dialog box closes and, in the image window, your selection is adjusted for the new feathering setting. The animated selection border around the selection indicates the midpoint of the feathering effect.

The Grow and Similar Commands

The **Grow** and **Similar** commands are directly related to the **Magic Wand Tool**. In fact, the **Tolerance** setting in the **Magic Wand Tool**'s options bar controls these two commands. The **Grow** command functions like the **Magic Wand Tool** with the **Contiguous** setting on. The **Similar** command works like the **Magic Wand Tool** with the **Contiguous** setting turned off (similar colors are selected throughout the entire file). One advantage of these commands over the **Magic Wand Tool** is that they can be used to select numerous colors at one time.

To use these commands, begin by creating a selection that contains the color or colors that you want to select. Next, click the **Magic Wand Tool** in the **Tools** panel and set the **Tolerance** setting in the options bar to the desired value. Then, choose either **Select > Grow** or **Select > Similar**. The colors in the original selection are included in the new selection, just as they would have been if they had been individually added to a selection with the **Magic Wand Tool**.

The Transform Selection Command

The **Transform Selection** command creates small, square handles around your selection. These handles allow you to adjust the scale (by holding [Shift] and dragging a corner handle) or size (by dragging any handle) of your selection. If you position the cursor outside of the selection, the cursor will change into a rotation cursor (curved arrow). You can then rotate the selection by clicking and holding the mouse button and dragging the mouse until the selection is rotated to the desired position, **Figure 3-27**.

When you select the **Transform Selection** command, the options bar contains settings that allow you to input precise width and height scaling amounts, angle of rotation, skewing (distorting) amounts, and actual location of the selection in the file (X and Y reference points).

While you are transforming a selection, right-click (or [Ctrl]+click for Mac) to bring up a menu that lists additional transformation options.

Saving and Loading a Selection

Some complicated selections take hours to create, and you may need to save your work and continue refining your selection later. To save a selection for further use, choose the **Select > Save Selection…** command. In the **Save Selection** dialog box, enter a name for the selection in the **Name** text box and pick the **OK** button. The saved selection is stored in the **Channels** panel, which is discussed later in this book. See **Figure 3-28**.

If you have previously saved a selection, you can add the current selection to the saved selection. To do this, choose **Select > Save Selection….** In the **Save Selection** dialog box, select the name of the saved selection from the **Channel** drop-down list.

Figure 3-27. _____

After choosing **Select > Transform Selection**, you can rotate the selection by positioning the cursor outside the selection, clicking the mouse when the rotate cursor appears, and then dragging the selection border to the desired position.

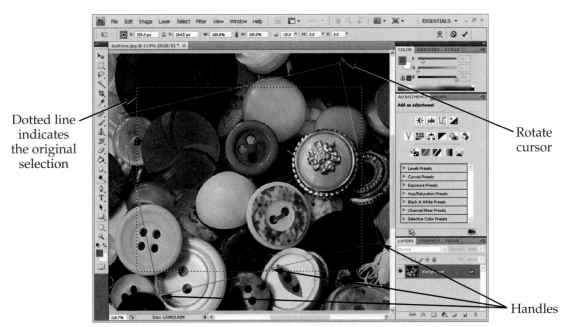

Dotted line indicates the original selection

Rotate cursor

Handles

Figure 3-28. _____
This selection is being saved as a new channel. Note that another selection has previously
been saved.

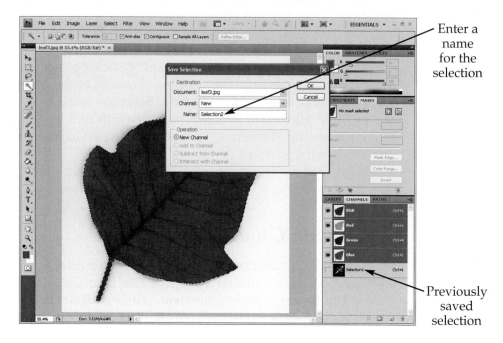

In the **Operation** section of the dialog box, select the appropriate radio button. If you
select the **Replace Channel** radio button, the new selection replaces the saved selection.
If you select the **Add to Channel** radio button, a single selection is created by adding
the new selection to the saved selection. If you select the **Subtract from Channel** radio
button, a single selection is created by removing the area in the new selection from the
saved selection. If you select the **Intersect with Channel** radio button, a single selection
is created by keeping overlapping areas from both selections and discarding areas that
do not overlap.

Each time you save a selection, you also need to save the image in order to record
the new channel containing the selection. When you save the file, make sure your file is
saved in Photoshop (PSD) format. The PSD file format saves the channel containing the
selection without changing the image. TIFF or PDF formats can also be used. If the file
is saved in a format other than PSD, TIFF, or PDF, the selection will be lost.

When you open your file to continue adjusting the selection, choose **Select > Load
Selection…**. In the **Load Selection** dialog box, choose the selection from the **Channel**
drop-down list. You can invert the selection by checking the **Invert** check box. If there
is currently no selection in the image window, simply click the **OK** button to load the
saved selection into the image window.

However, if you currently have a selection in the image window, there are four
different ways you can load the saved selection. In the **Operation** section of the **Load
Selection** dialog box, choose the appropriate radio button. Choosing the **New Selection**
radio button will completely replace the current selection with the saved selection.
Choosing the **Add to Selection** radio button will combine the saved selection and the
current selection. Choosing the **Subtract from Selection** radio button will remove the
area included in the saved selection from the current selection. Choosing the **Intersect
with Selection** radio button causes the overlapping areas of the saved and current
selections to remain selected, but areas of both selections that do not overlap are dese-
lected. Once you have selected the appropriate radio button, click the **OK** button to
load the saved selection.

Temporarily Hiding a Selection

When you have made a selection and it blocks your view (sometimes that animated selection border gets in the way), you can temporarily hide it by choosing **View > Show > Selection Edges**. The selection will be hidden until you choose this command again.

Removing a Fringe

The leaf in **Figure 3-29** was selected and copied to another image that has a different background. Part of the white background along the leaf's edge was selected along with the leaf, causing a fringe or halo to be visible when the leaf was placed against the different background. In situations such as this, you may be able to remove the fringe by selecting **Layer > Matting > Defringe...**. In the leaf example, the **Defringe** command copies green pixels from the leaf and expands them outward, replacing the light colors in the fringe. You specify the distance (in pixels) in the **Defringe** dialog box. Usually a distance of one or two pixels is enough to remove a fringe.

Figure 3-29. _____

In many cases, a light-colored fringe can be easily removed from a pasted-in selection. **A**—This leaf was selected and moved to another file with a contrasting background. White pixels along the edge are clearly visible. **B**—The **Defringe** command replaces the light-colored pixels with green pixels, eliminating the fringe.

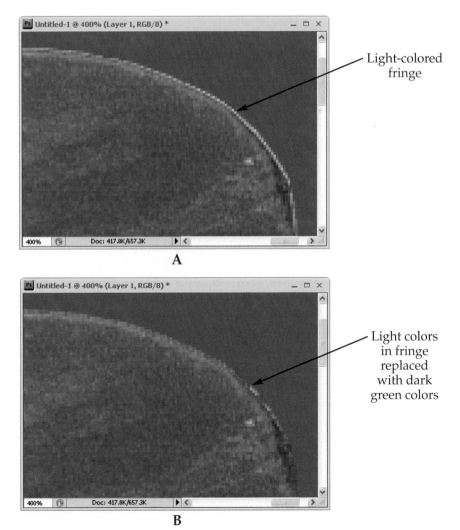

Light-colored fringe

A

Light colors in fringe replaced with dark green colors

B

GRAPHIC DESIGN

Choosing Photographic Images

Photographic images that are used in graphic designs must be chosen with care. Some designers capture their own images. Many designers purchase images from *stock photo agencies*. Stock photo agencies are companies that keep large libraries of images, usually categorized by subject, that can be purchased for use. At times, professional photographers are hired to capture needed images.

The following are factors that should be considered when selecting images.

- **Focus:** Images should be clearly in focus, unless a blurred effect is desired. Photoshop can only sharpen images with very minor blur problems (discussed in a later chapter).

- **Lighting:** If the photograph has a main subject, the lighting should adequately illuminate it. In other words, details in the image should not appear washed out because the lighting is too bright or the shadows are too black. The lighting in an image should fit the overall mood and strategy of the design. If several photographs are to be used in the same design, the lighting in each photograph should be similar.

- **Posing of the subject:** Look for images where the subject is posed in a way that allows the designer some flexibility when incorporating the image into the design. Keep in mind that images can influence the actual format of the design. For example, tall subjects (such as skyscrapers or statues) in an image may influence the designer to create a more vertically-oriented design.

- **Image composition:** In the photographic sense, composition means "what the photographer chose to include in the image." As you select photos, keep in mind that a photo's appearance may be improved if it is cropped or rotated. If an entire photo will be used in a design, judge the photo by how well-composed it is. If you are not familiar with tips for creating better photos, search the web using "photographic composition" as keywords for more information.

The band members shown in **Figure 3-30** wanted a CD insert design that had a "backstage" look and feel. The photographer captured images of the band members outdoors, just before sunset. The summer sun was low in the sky and shining through a bit of haze, creating warm-colored side lighting on each band members' face—a lighting condition that would fit well with a stage lighting design scheme. One of the band members was posed sideways to avoid a redundant, forward-facing trio. This gives the designer more flexibility—the image could be flipped either way as the designer arranged the images with the other design elements.

Lighting conditions can make an incredible difference in image quality. The ostrich image on the left in **Figure 3-31** was captured in the early morning hours, just after sunrise. The early morning sun was filtering through some clouds, causing the ostrich to be illuminated by very soft light. There are no bright highlights or dark shadows on the ostrich, unlike the second photo which was shot around noon on a hot, cloudless summer day. You can see some detail on the ostrich's neck, but most of the subject's detail is drowned out in harsh, bright highlights or black shadow areas.

Figure 3-30. _____
The photos of these band members were captured in a parking lot early on a summer evening.

Figure 3-31. _____
These images show the dramatic effects that different lighting can offer. **A**—Soft lighting preserves the details of a subject. **B**—Harsh lighting drowns out image detail.

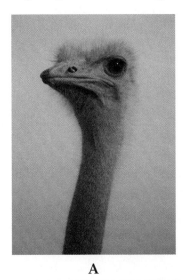 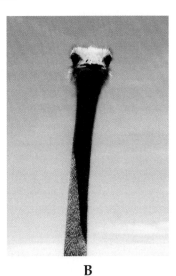

A B

Summary

Using the selection tools discussed in this chapter is a fundamental Photoshop skill. Take the time to review the keyboard shortcuts—they can make a selection task much easier. For example, when creating a selection around a circular object in an image (such as a coin), you may find yourself holding down three different keys simultaneously: [Shift] to force a circle, [Alt] to create the selection from a center point, and the [Spacebar] to adjust the position of the circular selection as you create it.

CHAPTER TUTORIALS

Note The files needed to complete the tutorials in this book can be downloaded from the *Learning Photoshop CS4 Student Companion Web Site*. Refer to the "Using the Companion Web Site" section of the book's Introduction for more information.

In the tutorials that follow, you get a chance to practice using the selection tools discussed in this chapter. You will use these tools to begin creating projects, which you will continue to refine as you progress through this book.

Tutorial 3-1: The Elliptical Marquee Tool

In this tutorial, you will use the **Elliptical Marquee Tool** to draw a selection around a quarter in an image. You will then copy the quarter and paste a clone onto another layer in the image. You will use the **Move Tool** to reposition the copy of the quarter.

1. Open the quarter.jpg file.

2. Select the **Zoom Tool** from the **Tools** panel.

3. Click on the quarter until the title bar shows you have zoomed to 100%.

 You can now more accurately place a selection around the edge of the quarter.

4. Select the **Elliptical Marquee Tool** from the **Tools** panel.

5. Press and hold the [Shift] key and drag a selection about the same size as the quarter. If you need to start over, choose **Select > Deselect** and try again.

 If you press [Alt][Shift] (or [Option][Shift] for Mac users), you can begin selecting the quarter from the center instead of from the side.

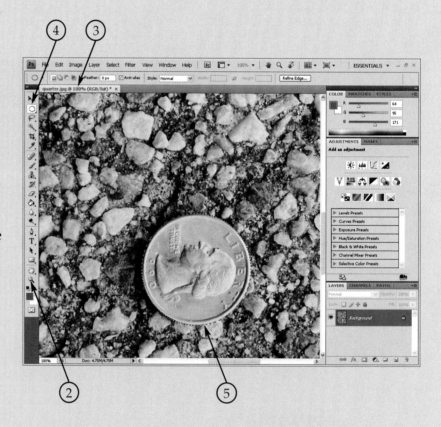

6. If the selection is not exactly on top of the quarter, keep the [Shift] key held down and use the [Spacebar] to move the selection if necessary. Continue this process until the selection fits perfectly around the quarter.

7. Choose **Edit > Copy**.

8. Choose **Edit > Paste**.

 This creates a copy of the quarter and places it on a new layer. You will learn more about layers in the next chapter.

9. Select the **Move Tool** in the **Tools** panel and then tap the up arrow key until the new quarter has been moved above the original quarter.

 Press [Shift] while tapping the arrow key to move the quarter faster.

10. Choose **File > Save As....** In the **Save As** dialog box, name the file 03quarters and select **Photoshop (*.PSD, *.PDD)** from the **Format** drop-down list. Click the **Save** button to save the image.

11. Close the 03quarters.psd image.

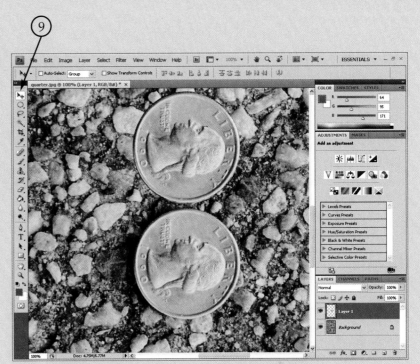

Tutorial 3-2: Create a Vignette Effect

In this tutorial, you will feather-select an image to create a vignette effect. A vignette is a soft, faded-out edge around an image.

1. Open the Henry.jpg file.

2. Select the **Elliptical Marquee Tool** from the **Tools** panel and use it to create the selection shown.

 Use the [Spacebar] as needed to help you create the selection.

3. Click the **Refine Edge** button in the options bar.

4. In the **Refine Edge** dialog box, drag the **Feather** slider and observe the changes to the selection. After experimenting with a wide range of values, set the **Feather** slider to a value between 8 and 14.

5. Press [F] (or click the buttons near the bottom of the **Refine Edge** dialog box) to cycle through the five different preview modes.

6. Click **OK** in the **Refine Edge** dialog box to feather the selection.

7. Choose **Select > Inverse**.

8. Press [Delete].

9. Choose **File > Save As...**. In the **Save As** dialog box, name the file 03vignette and select **Photoshop (*.PSD, *.PDD)** from the **Format** drop-down list. Click the **Save** button to save the image.

10. Close the 03vignette.psd file.

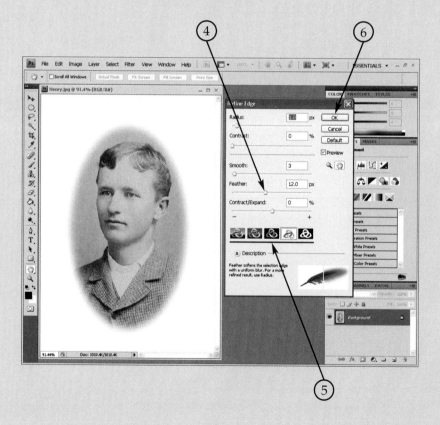

Tutorial 3-3: Leafy Design

This tutorial is divided into several parts. In each part, you will practice using a different selection tool. You will select several images of leaves and then move each leaf to a new file. In later chapters, you will create a design out of the selected leaves.

Part 1: The Lasso Tool

The **Lasso Tool** is typically used to create selections that are more complicated than the selection in this example. However, following these steps will strengthen your **Lasso Tool** skills.

1. Open the file named leaf1. jpg. When the image window appears, choose **View > Fit on Screen**.

 If you make a mistake as you work on this file, choose **Edit > Undo**.

2. Click the **Lasso Tool** in the **Tools** panel.

3. Click the **New selection** button on the options bar.

4. Using the mouse, draw a selection border near the edge of the leaf.

 Do not worry about making a smooth selection or getting the selection as close as possible to the edge of the leaf. You will improve the accuracy of the selection in the steps that follow.

5. Click the **Zoom Tool** in the **Tools** panel.

6. Drag a box to zoom in on the stem as shown.

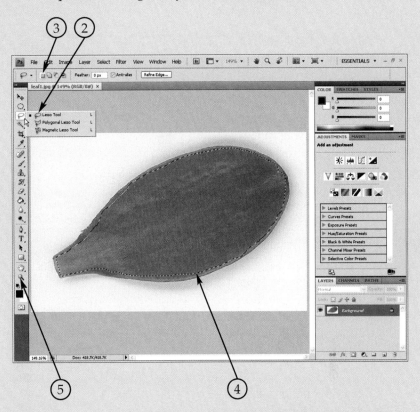

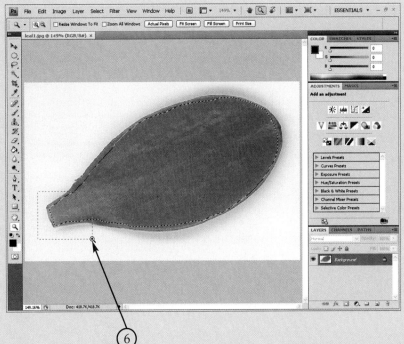

7. Click the **Lasso Tool**.

8. Click the **Add to selection** button in the options bar.

9. Draw a selection border around the part of the stem shown. Be accurate when you select along the edge of the stem.

 Your selection border is now larger. The new selection should be combined with the original selection.

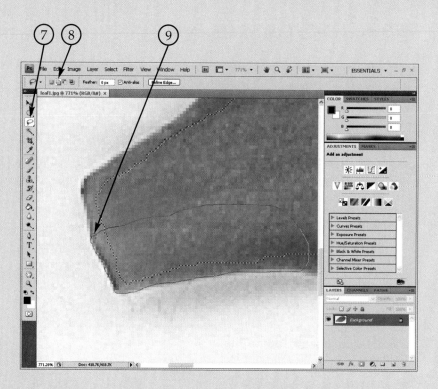

10. The **Add to selection** button should still be active. Continue adding small areas to your selection border. You may need to press the [Spacebar] to temporarily activate the **Hand Tool** so you can pan the image.

11. If you make the selection border too big, click the **Subtract from selection** button, and create a selection around the portion of the selection that you wish to remove.

 The newly created selection is subtracted from the original selection.

12. Continue using the **Add to selection** and **Subtract from selection** buttons until you have adjusted the selection border snugly around the leaf.

 Use the **Hand Tool** or the **Navigator** panel to move around your leaf as you work.

13. Choose **View > Actual Pixels** to zoom in at 100%.

14. Without closing the leaf1.jpg image, choose **File > New....**

15. In the **New** dialog box, enter the settings shown.

16. Click the **OK** button.

You have just created a new file, named 03leafy, that is 7" tall by 7" wide. Your selection border in the leaf1.jpg image window has disappeared, but do not worry—it is still there.

17. Move the 03leafy image window to the position shown by clicking and dragging its title bar.

18. Click once anywhere on the title bar of the leaf1.jpg image to make it active.

19. Select the **Move Tool**.

20. Click on the leaf, drag it over to the 03leafy image, and release the mouse button.

The leaf appears smaller here because the files are zoomed differently.

21. Choose **File > Save**. In the **Save As** dialog box, make sure the image is named 03leafy. Select **Photoshop (*.PSD, *.PDD)** from the **Format** drop-down list.

22. If you are going to continue on with the other tutorials in this chapter, leave the 03leafy.psd file open. If you are not going to continue on with the other tutorials in the book right away, close the 03leafy.psd file.

23. Close the leaf1.jpg file. Do not save changes.

Part 2: The Magnetic Lasso Tool

When making selections, the **Magnetic Lasso Tool** is a better choice than the **Lasso Tool** in many situations. In Part 2 of this tutorial, you will gain some experience in using the **Magnetic Lasso Tool** to create a selection.

1. If the 03leafy.psd file you created in Part 1 of this tutorial is not open, open it now.

2. Open the leaf2.jpg file.

3. Choose **Image > Image Rotation > 90° CCW** (counterclockwise).

 The image is rotated so the stem of the leaf is more or less pointed at the bottom of the screen.

4. Choose **View > Fit on Screen**.

 The image window increases in size to fill the vertical workspace available. The image is zoomed to fill the image window.

5. Click and hold the mouse button on the **Lasso Tool** in the **Tools** panel. When the pop-up menu appears, choose the **Magnetic Lasso Tool**.

6. Enter the following settings in the options bar:

 • Click the **New selection** button.

 • **Width:** 8 px

 • **Contrast:** 40%

 The edge of the green leaf contrasts with the white background behind it. However, the **Magnetic Lasso Tool** might become confused where the shadow is darkest. The settings you entered increase the width and decrease the edge contrast required for a selection. This makes it easier to select the edge of the leaf in shadowed areas.

7. Click anywhere at the leaf's edge.

8. Release the mouse button and move the mouse cursor slowly around the leaf's edge.

 If the **Magnetic Lasso Tool** makes a mistake, you can backtrack by pressing [Delete] or [Backspace] repeatedly while moving the cursor backward along the selection path.

9. Press [Enter] after you have moved the **Magnetic Lasso Tool** all the way around the leaf.

 The selection is closed and the familiar animated selection border appears at the selection border. Your selection border will probably not be perfect. The **Magnetic Lasso Tool** gets "confused" in places, such as the leaf tips (which are less than eight pixels wide) and the stem.

10. Zoom in, switch to the **Lasso Tool**, and use the **Add to selection** and **Subtract from selection** buttons to fix the selection border where necessary.

11. Use the **Move Tool** to drag the selected leaf over to the 03leafy.psd file.

12. Close the leaf2.jpg file. Do *not* save changes.

13. With the 03leafy.psd image active, choose **File > Save**.

14. If you are going to continue on with the other tutorials in this chapter, leave the 03leafy.psd file open. If you are not going to continue on with the other tutorials in the book right away, close the 03leafy.psd file.

Part 3: The Magic Wand Tool

As you will see in this tutorial, the **Magic Wand Tool** is useful for selecting objects that have a limited range of colors. It is even more useful if the object to be selected appears against a strongly contrasting background.

1. If the 03leafy.psd file you created in Parts 1 and 2 of this tutorial is not open, open it now.

2. Open the file named leaf3.jpg.

3. Choose **View > Fit on Screen**.

4. Click the **Magic Wand Tool**.

5. Make sure the **New selection** button is activated in the options bar.

6. In the options bar, change the **Tolerance** setting to 20 and make sure the **Contiguous** check box is unchecked.

7. Click on the leaf in the general area shown.

 When you click with the **Magic Wand Tool**, it looks at the color of the pixel you clicked on. Then, it selects similar colors around that pixel.

8. Choose **Select > Deselect**.

9. Change the **Tolerance** setting to 50.

10. Click in the same place you did in step 7.

The **Magic Wand Tool** now selects a broader range of red pixels because the **Tolerance** setting is higher. However, there are still parts of the leaf that are not selected. You can continue to pick colors with the **Add to selection** button selected in the options bar until you have selected all of the colors in the leaf, but there is an easier way. In the following steps, you will pick the background and then invert the selection.

11. Make sure the **New selection** button is selected in the options bar. Change the **Tolerance** setting to 100.

By increasing the **Tolerance** setting, you are allowing more colors to be selected at one time. A high tolerance setting is required to include the pink shadow areas around the edge of the leaf in the selection. Fortunately, the leaf and the background contrast enough that parts of the leaf will not be selected by mistake.

12. Click on a white or near-white part of the background.

The entire background is selected and the leaf remains unselected.

13. Choose **Select > Inverse**.

The leaf becomes selected and the background is unselected.

14. Check the leaf for any small areas that did not get selected. Use the **Lasso Tool** and the **Add to selection** option to add these areas to the selection.

15. Use the **Move Tool** to drag the selection over to the 03leafy. psd file.

16. Close the leaf3.jpg file. Do not save the changes.

17. With the 03leafy.psd image active, choose **File > Save**.

18. If you are going to continue on with the other tutorials in this chapter, leave the 03leafy. psd file open. If you are not going to continue on with the other tutorials in the book right away, close the 03leafy. psd file.

Part 4: Quick Mask Mode

Quick mask mode allows you to use the **Brush Tool** to paint a selection. This is helpful when selecting portions of an image that has similar colors throughout, making other selection tools more difficult to use.

1. If the 03leafy.psd file you worked on in Parts 1–3 of this tutorial is not open, open it now.

2. Open the leaf4.jpg file.

3. Choose **View > Fit on Screen**.

4. Click the **Lasso Tool** in the **Tools** panel.

5. Click the **New selection** button on the options bar.

6. With the mouse, draw a selection around the outside of the longest leaf.

7. Click the **Edit in Quick Mask Mode/Edit in Standard Mode** toggle to activate quick mask mode. A pink mask covers the area of the image that is not selected.

8. Make sure that black is selected as the foreground color at the bottom of the **Tools** panel.

9. Click on the **Brush Tool** in the **Tools** panel.

10. In the options bar, click on the **Brush Presets** (arrow) button.

11. Hold your mouse over any of these brushes for two seconds, but do not click. A brief description of the brush appears.

12. Click on the brush with the description **Soft round 13 pixels**.

"Soft" means the brush will have a feathery edge. The feather effect will be slight, however, because the brush size is small.

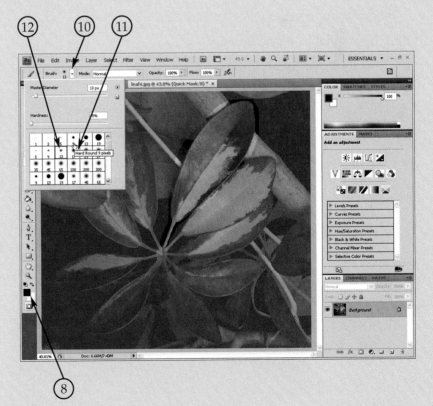

13. Click the **Zoom Tool**.

14. Zoom in on the stem of the leaf.

15. Click the **Brush Tool** again. Paint the area around the leaf, right up to its edge.

 If you make a mistake, change the foreground color to white. Then, the **Brush Tool** will act like an eraser. Switch the foreground color back to black to resume painting the mask. Change to a smaller brush size as needed to paint accurately. Use the **Hand Tool** or the **Navigator** panel to grab and move your leaf as you continue to paint.

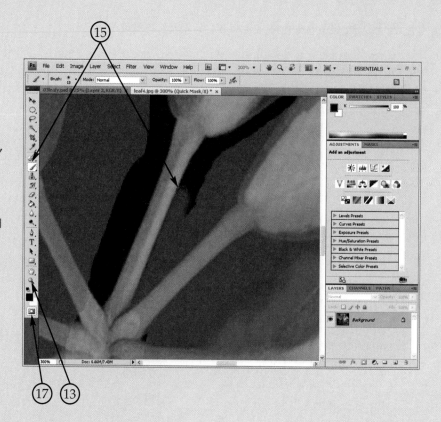

16. When you have painted a mask around the entire leaf, zoom in even further and check your work.

17. When the area surrounding the leaf is cleanly masked (painted with pink), click the **Edit in Quick Mask Mode/Edit in Standard Mode** toggle.

 Everything that was not masked is now selected.

18. Choose **View > Fit on Screen**.

19. Use the **Move Tool** to drag the leaf over to the 03leafy.psd file.

20. Click anywhere on the leaf4.jpg image to make it active and then close the file. Do *not* save the changes.

21. With the 03leafy.psd image active, choose **File > Save**.

22. If you are going to continue on with the other tutorials in this chapter, leave the 03leafy.psd file open. If you are not going to continue on with Part 5 of this tutorial right away, close the 03leafy. psd file.

Part 5: The Quick Selection Tool

This tool is the easiest tool to use when selecting an object that stands out plainly from its background. Most of the leaf images you have worked with so far fall into this category. The **Quick Selection Tool** has not been introduced until this point in the tutorials so you could get some practice with the other selection tools.

1. If necessary, open the 03leafy.psd file.

2. Open the leaf5.jpg file.

3. Choose **View > Fit on Screen**.

4. Click the **Quick Selection Tool** in the **Tools** panel.

5. In one motion, drag this tool over part of the leaf. As you drag the cursor, include some brown colors near the stem, some lighter green colors, and some darker green shades.

 This helps Photoshop understand what part of the image you wish to select. Once enough colors have been sampled, Photoshop will automatically select the entire leaf.

6. Check to see if the entire leaf was selected. If not, choose **Select > Deselect** and try again.

7. Use the **Move Tool** to drag the leaf over to the 03leafy.psd file.

8. Click anywhere on the leaf5. jpg image to make it active and then close the file. Do *not* save the changes.

9. With the 03leafy.psd image active, choose **File > Save**.

10. If you are going to continue on with the other tutorials in this chapter, leave the 03leafy. psd file open. If you are not going to continue on with Part 6 of this tutorial right away, close the 03leafy.psd file.

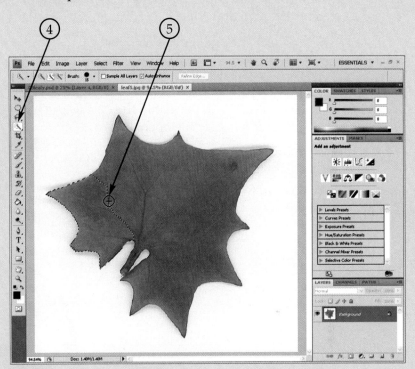

Part 6: Select and Move the Last Leaf

In this part of the tutorial, you will gain experience evaluating an area that needs to be selected, choosing the best selection tool for that area, and using the tool to make the selection.

1. If necessary, open the 03leafy.psd file.

2. There is one more leaf image (leaf6.jpg) that needs to be selected and moved to the 03leafy.psd image. Use any method you have learned to select the leaf.

 Remember, you can switch between selection tools to create a single selection.

3. Click the **Move Tool**.

4. In the options bar, click to place a check mark in the **Auto Select** check box and make sure **Layer** is selected in the drop-down list.

 Normally, the **Move Tool** will only affect objects on the selected layer. When the **Auto Select Layer** option is active, the **Move Tool** will affect objects regardless of which layer they are on.

5. Use the **Move Tool** to drag and drop the leaf into the 03leafy.psd image.

6. When you are done copying the leaf to the 03leafy.psd image, close leaf6.jpg without saving the changes. Keep the 03leafy.psd file open.

7. Use the **Move Tool** to arrange the leaves as shown.

8. Save and close your 03leafy.psd file.

 You will use this file in the next chapter.

Key Terms

active	ellipses	inverse
anti-aliasing	fastening points	marquee
contiguous	feathering	stock photo agencies
deselected		

Review Questions

Answer the following questions on a separate piece of paper.

1. When making a selection, if you set the **Feather** option to 6 px, how wide will the total feathered effect be?

2. If you create a feathered selection using the setting on the options bar instead of using the **Refine Edge** command's **Feather** slider, what two things do you need to remember?

3. Define *anti-aliased*.

4. Explain why the **Rectangular Marquee Tool** does not have an **Anti-Alias** option.

5. When using the **Rectangular Marquee Tool**, what two keys do you hold down to create a perfectly square selection from the center outward?

6. When using the **Rectangular** or **Elliptical Marquee Tools,** how do you move a selection while it is being created?

7. When using the **Rectangular** or **Elliptical Marquee Tools,** which option lets you create a marquee selection at an exact size that you specify?

8. When using the **Rectangular** or **Elliptical Marquee Tools,** which option must you use if you want to click and drag a selection freely, without any size or ratio restrictions?

9. How is the **Rectangular Marquee Tool** different from the **Crop Tool** (introduced in Chapter 2)?

10. How do you move a selection after you have created it? List two ways.

11. Describe the areas selected by the **Single Row Marquee Tool** and the **Single Column Marquee Tool**.

12. When creating a selection with the **Lasso Tool**, what is the minimum recommended zoom percentage you should use?

13. How is the **Polygonal Lasso Tool** different from the **Lasso Tool**?

14. What keyboard shortcut lets you add to a selection?

15. What keyboard shortcut lets you subtract from a selection?

16. Which options bar setting changes the rate at which the **Magnetic Lasso Tool** creates fastening points?

17. If you make a mistake while selecting with the **Magnetic Lasso Tool**, how do you backtrack without starting over?

18. How does the **Tolerance** setting affect the **Magic Wand Tool**?

19. Define the term *contiguous* as it applies to pixels.

20. How is quick mask mode different from all of the other selection tools?

21. When you use either of the type masking tools to create a selection that looks like text, what appears when you click to begin entering text?

22. What command clears all selections in a document?

23. What happens when you choose **Select > Inverse**?

24. There are three commands found in the **Select** menu that are directly related to the **Magic Wand Tool**. What are they?

25. How do you save a selection in Photoshop?

In later tutorials, you will combine the leaves you have isolated into a composite design.

Introduction to Layers

Learning Objectives

After completing this chapter, you will be able to:

- Create a new file.
- Explain how the **Move Tool** is associated with layers.
- Use a variety of methods to transform layers, selected areas, and images.
- Use Photoshop's grid, guides, and **Snap** command to line up elements of a design.
- Use several different methods to create layers.
- Use several different methods to organize layers in the **Layers** panel.
- Explain the difference between grouping, linking, and merging layers.
- Differentiate between merging layers and flattening an image.
- Use the **Opacity** setting to control the visibility of a layer.
- Explain how to protect layers by locking their content.

Introduction

A Photoshop file can be made up of several *layers*. Layers keep different parts of your design separate from each other. In **Figure 4-1**, each ostrich is on a separate layer. This makes it possible to move, edit, or delete each ostrich without affecting the rest of the design.

There are several different kinds of layers. In this chapter, you will be introduced to standard layers, which contain pixels. As you progress through the book, you will learn more about working with standard layers. You will also learn about more specialized types of layers. In Chapter 5, you will be introduced to type layers and shape layers, which are automatically created when you create text and shapes. There are also fill layers, which fill an entire layer with a color or pattern (explained in Chapter 6), and adjustment layers, which give you more flexibility when adjusting colors in an image (explained in Chapter 9).

There are often different ways to accomplish a task in Photoshop, and working with layers is no exception. For example, you will find the **New Layer** command on two different menus *and* as a button on the **Layers** panel.

Figure 4-1. _____
This partially-completed project is made of six layers. Each ostrich is on a different layer, and a white Background layer is behind all of the ostrich layers.

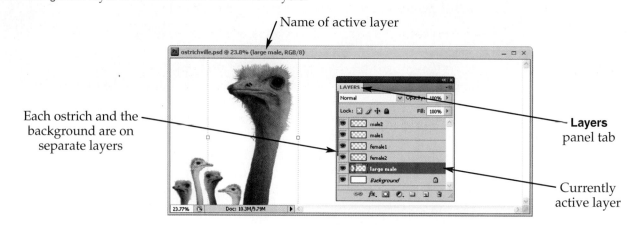

The Layers Panel

A layer must be active before you can make any changes to it. To make a layer active, it must be highlighted in the **Layers** panel. When a single layer in the image is made active, the name of the active layer is displayed in the title bar of the image window. In Figure 4-1, the layer named "large male" is active. That is the only layer that can currently be edited with Photoshop's tools. It is possible to highlight more than one layer in the **Layers** panel, but when this occurs, most of Photoshop's tools and commands become unavailable until only a single layer is again highlighted in the **Layers** panel. Also, when multiple layers are selected, the names of the active layers are _not_ displayed in the title bar of the image window.

The **Layers** panel is one of Photoshop's most frequently used panels. If a project has more than one layer, you should keep the **Layers** panel visible on your screen. If you find that one of Photoshop's tools is not working the way you expect, check the **Layers** panel first to see if the correct layer is active.

There are many Photoshop commands that relate to layers. This chapter will cover the basics. More advanced techniques will be discussed in a later chapter. But before discussing layer basics, we need to discuss two fundamental Photoshop skills: creating a new file and using the **Move Tool**.

Creating a New File

When you create a new Photoshop file by choosing **File > New...**, it only has one layer. As you progress through this chapter, you will find there are several ways to create additional layers in a Photoshop file.

The "ostrichville" design you will see throughout this chapter is intended to be placed on a billboard. The actual size of the billboard is 30' wide by 12' high. The best way to begin this project is to create a much smaller file that will help the client and the designer choose the final design for the billboard. A file that is 10" wide by 4" high has the same proportions as the billboard, and is much easier to work with. A resolution of 300 ppi will ensure high-quality printouts to show the client. This requires that a new image file be created.

Choosing **File > New...** brings up the **New** dialog box, **Figure 4-2**. Use this box to specify any of the following:

- In the **Name** text box, enter a name for the new file.

- The **Preset** and **Size** drop-down lists are optional ways to enter common document sizes. For example, if you choose **Photo** from the **Preset** drop-down list, the **Size** drop-down list will display four common photo sizes: 2×3, 4×6, 5×7, and 8×10, along with a choice of landscape or portrait orientation. When you select any of these subcategories, the appropriate sizes are entered in the **Width** and **Height** text boxes. Other categories that can be chosen from the **Preset** drop-down list include **U.S. Paper** (common paper sizes), **Web** (common sizes for web page graphics, measured in pixels), **Film & Video** (common video sizes), and **Clipboard** (creates an image that is the same size as the image currently saved in the temporary memory known as the *clipboard*). If applicable, you can choose one of these preset sizes instead of entering width and height information. If you want to enter your own size, leave this list set to **Custom**.

- The values entered in the **Width** and **Height** text boxes specify the size of the new image. When entering width and height values, be sure that the desired units of measurement are chosen in drop-down lists directly to the right of the **Width** and **Height** text boxes. When you create a new document, you have a choice of several units of measurement: pixels, inches, centimeters, millimeters, points, picas, and columns.

- In the **Resolution** text box, enter the resolution you want the project to be. You must also specify the units of measure from the drop-down list directly to the right of the **Resolution** text box. If your project will be in inches, choose the **pixels/ inch** setting. For projects using metric units of measurement, choose the **pixels/cm** option.

Figure 4-2. _____

The specifications for a new image, such as image size, color mode, color bit depth, and background color, are set in the **New** dialog box.

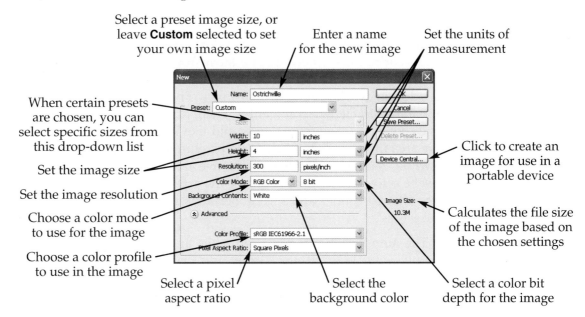

Select a preset image size, or leave **Custom** selected to set your own image size

Enter a name for the new image

Set the units of measurement

When certain presets are chosen, you can select specific sizes from this drop-down list

Set the image size

Set the image resolution

Choose a color mode to use for the image

Choose a color profile to use in the image

Click to create an image for use in a portable device

Calculates the file size of the image based on the chosen settings

Select a pixel aspect ratio

Select the background color

Select a color bit depth for the image

- In the **Color Mode** drop-down list, choose the color model that you want to use in the new image. In most cases, you will choose **RGB Color** for new files that will be full color. Use **Grayscale** for files that will be black and white. In the drop-down list directly to the right of the **Color Mode** drop-down list, specify a color depth for the image. *Color depth* is total number of colors that can be used in the image. This is expressed as the number of bits of data used to describe each color. For now, leave this drop-down list set to **8 bit**. There are several different color modes and bit depths available, and they will be explained in a later chapter.

- The **Background Contents** drop-down list controls the color of the Background layer that is created when you create a new file. Remember that "white" means "no color" in Photoshop. For this reason, **White** is usually the preferred background color, because many projects are printed on white paper, and printers simply ignore white areas of your image. If you select the **Background Color** option, your new file will be created using whatever color is currently selected in the **Background Color** box (see Chapter 1, *The Work Area*). Selecting **Transparent** creates an invisible background.

- If you are creating an image that will be displayed on a portable device, click the **Device Central** button, choose a device, and click the **Create** button to create a new file at the appropriate size.

- The **Image Size** area, in the lower-right corner of the dialog box, will automatically adjust to show you how much file space your new file will consume. The file size of the image will vary depending on the settings chosen.

- Clicking the **Advanced** toggle reveals the **Color Profile** drop-down list and the **Pixel Aspect Ratio** drop-down list. In the **Color Profile** drop-down list, you can choose from various color profiles (ICC profiles). ICC profiles will be discussed further in a later chapter. In the **Pixel Aspect Ratio** drop-down list, you can choose the pixel aspect ratio to use in the image, which may be necessary if you are preparing an image to be included on some type of video production. See Chapter 2, *Resolution* for more information on pixel aspect ratios.

The Move Tool

The **Move Tool** can be used to grab and move a selected area of an image, an entire layer, or an entire image. Because the **Move Tool** is used often, you can temporarily switch to it by pressing [Ctrl] (or [Command] in Mac).

A good strategy when moving anything in Photoshop is to use the **Move Tool** to drag content *approximately* where you want it. Then, use the arrow keys on your keyboard to nudge the content *exactly* where you would like it. Each time an arrow key is pressed, the active area in your file is moved one pixel in the direction of the arrow. If [Shift] is pressed while using the arrow keys, the active area moves ten pixels at a time. The **Move Tool** must be active in the **Tools** panel for the arrow keys to work in this way.

There are two options and several odd-looking buttons on the **Move Tool**'s options bar, **Figure 4-3**:

- The **Auto Select** option is used when an image has more than one layer. This option has two settings: **Group** and **Layer**. These settings are similar. When the **Layer** setting is active, clicking in a multi-layered Photoshop document causes the **Move Tool** to look at the pixel you clicked on, determine what layer

Figure 4-3. _____
The **Move Tool**'s options bar contains tools that help arrange layers or selections.

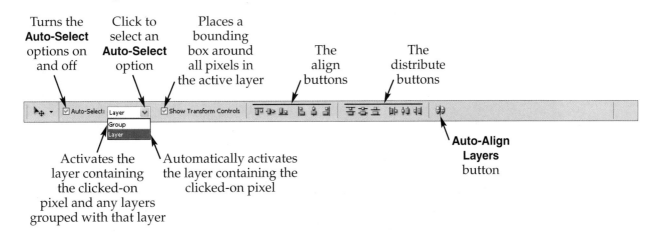

Turns the **Auto-Select** options on and off

Click to select an **Auto-Select** option

Places a bounding box around all pixels in the active layer

The align buttons

The distribute buttons

Auto-Align Layers button

Activates the layer containing the clicked-on pixel and any layers grouped with that layer

Automatically activates the layer containing the clicked-on pixel

that pixel is assigned to, and activate that layer in the **Layers** panel. The **Group** setting activates the appropriate layer _and_ any layers that have been grouped with the selected layer. Grouping layers is discussed later in this chapter.

- In complex projects with many layers, you may have trouble clicking on the right layer. In those cases, you may need to hide other layers that may be "on top" of the layer you are trying to click on. More information about hiding layers is found in the "Layer Visibility" section of this chapter.

- When the **Show Transform Controls** option is on, a rectangular box appears around all of the pixels in the layer or layers highlighted in the **Layers** panel. This is called a _bounding box_, and it shows you which layer is active. It also helps you transform the active layer's content in several different ways. Transforming layers is discussed later in this chapter.

- The next twelve buttons are the **Align** and **Distribute** commands, which are available only when you are aligning and distributing layers. Using these commands is discussed in Chapter 11, _Additional Layer Techniques_.

- A pair of human faces appears on the **Auto-Align Layers** button. This command is used to line up two similar layers as closely as possible, and it is also explained in Chapter 11.

As you read the remainder of this section, you will discover that the **Move Tool** affects a Photoshop document in different ways, depending on the situation. Several common scenarios are presented in the next four sections. Familiarize yourself with the way the **Move Tool** works in each of these common scenarios.

Scenario 1: Using the Move Tool to Move Selected Pixels within an Image

Place the **Move Tool** _inside_ the selected area and drag the selected pixels to another location. In a single-layer image, this leaves behind a hole that will either be the background color shown on the **Tools** panel or a transparent area if the layer transparency is not locked (locking layers is discussed later in this chapter). Transparent areas in Photoshop appear as a checkerboard pattern. See **Figure 4-4.**

Figure 4-4. _____

When a selected area of a single-layer image is moved, the background color appears in the hole where the selection used to be. **A**—The ostrich is selected. **B**—When the selected ostrich is moved, the white background shows through. **C**—If a checkerboard pattern appears, the area behind the ostrich is transparent. This occurs when layer transparency is not locked.

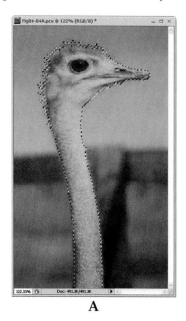 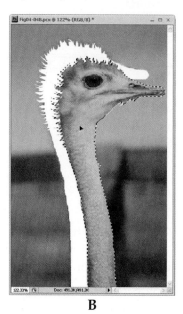 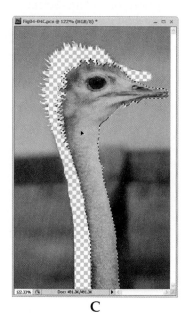

A B C

Note Be aware that if the **Move Tool** is placed *outside* of a selected area and then dragged, the selected area is ignored. The entire image will be moved, if the layer is not locked.

Scenario 2: Using the Move Tool to Copy and Paste Selected Pixels

Hold down [Alt] (or [Option] for Mac) while dragging a selected area to make a *copy* of the selected area. The original selected area will remain as it appeared before. An alternative is to choose **Edit > Copy** and then **Edit > Paste**. The copied pixels are automatically placed on a new layer, which can then be easily moved. See the section in this chapter called "Using the Cut, Copy, and Paste Commands" for further explanation.

Note If *no* part of a layer is selected, Holding down [Alt] and dragging with the **Move Tool** will automatically *duplicate* (copy) the entire layer. Later in this chapter, several ways to duplicate a layer are discussed.

Scenario 3: Using the Move Tool to Copy a Selected Area or an Entire Image to Another File

If each image is in a separate image window, drag the selected area and release it on top of the *destination image*, the image to which you want to copy the selection. If

multiple images are sharing a single image window (consolidated image windows), drag the selection to the destination image's tab at the top of the image window and hold the cursor there. When the destination image opens, move the cursor into the image window and release the mouse button. The selected area is automatically copied and placed on a new layer created in the destination image. In the original image, the selected area remains unchanged. See **Figure 4-5**. If the destination image is zoomed differently (or if it is a different resolution) than the original image (you can tell by checking the magnification percentage in each image's title bar), your copied pixels will appear larger or smaller than the original.

Note If the **Move Tool** is placed *outside* a selected area and then dragged, the entire image will be copied over to the destination image.

You may find that as you move something with the **Move Tool**, it jumps around, preventing you from moving it exactly where you want to. When this happens, Photoshop's snap function needs to be turned off. Refer to the section in this chapter called "Using Snap to Align Layers."

Transforming with the Bounding Box

A bounding box allows you to *transform* the active part of your image in several different ways. The active part of your image can be either an active, unlocked layer or a selected area of a particular layer. Rotating, bending, or making the active part of your image larger or smaller (scaling) are common transformation commands.

Figure 4-5. _____

When the **Move Tool** is used to drag content from one image to another, the pixels are copied in the original image and pasted onto a new layer that is automatically created in the destination image.

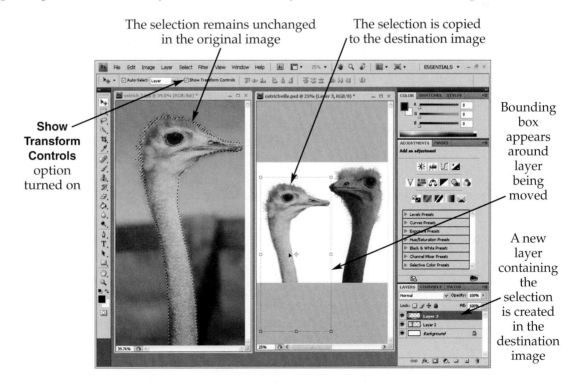

The selection remains unchanged in the original image

The selection is copied to the destination image

Show Transform Controls option turned on

Bounding box appears around layer being moved

A new layer containing the selection is created in the destination image

A bounding box appears around a layer when it is clicked with the **Move Tool**, provided the **Show Transform Controls** option is on, as shown in Figure 4-5. You can also choose **Edit > Free Transform** or **Edit > Transform > (desired transformation)** to display the bounding box. Remember, if part of your image is selected, the bounding box will only appear around that selected area.

The Transform Options Bar

If you click on or near any of the square handles at the sides and corners of the bounding box, the **Transform** options bar appears. There are numerous controls on the **Transform** options bar, **Figure 4-6**. You can change these settings by dragging on top of the small icons on the options bar or by clicking in the boxes and entering exact values. Many of the tasks that can be performed in the **Transform** options bar can also be performed by manipulating the bounding box. In the following section, the options available in the options bar are explained. If the same task can be performed by manipulating the bounding box, that alterative method is also explained.

The Transform Icon

The **Transform** icon simply shows you that a transform command is currently active. If you cause the **Transform** options bar to appear by mistake, click the **Cancel** button or press [Esc].

The Reference Point Locator

By clicking one of the nine squares on the **Reference point locator**, you can change the point around which transformations are made. By default, the center of the bounding box is the reference point, and all transformations are centered on that point. For example, if you leave the center box clicked and rotate your layer, the layer will pivot around the center of the bounding box. You can pick a corner or side of the bounding box to be your reference point instead, if desired. When a new reference point is selected, the reference point icon is automatically relocated in the image window.

The Reference Point Coordinate Text Boxes

The **X** and **Y** text boxes show how far the current reference point is from the left edge and top edge of your image (or document). In these boxes, you can enter an exact location, in either pixels (px) or inches (in), for a new reference point. Instead of using the left and top of your file to generate reference values, you can click the triangle-shaped

Figure 4-6. _____

The **Transform** options bar replaces the **Move Tool**'s normal options bar when a selection is being transformed.

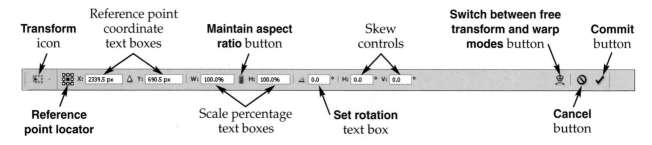

button. Photoshop looks at the handle you have selected as a reference point and resets the **X** and **Y** values to 0, 0. This allows you to reposition the reference point relative to its current location rather than to the upper-left corner of the image.

You can also adjust the reference point by dragging the center point of the bounding box anywhere in the image. The values in the **X** and **Y** text boxes are automatically updated to match the new reference point location. Often, Photoshop users drag this center point by mistake while using the **Move Tool** to move the active layer. If this happens, you can reset the reference point location by clicking one of the small boxes on the **Reference point locator**. As an alternative, you can press [Esc] or click the **Cancel** button on the **Transform** options bar. However, pressing [Esc] or the **Cancel** button will close the transform mode. You will need to reselect the transform command or click on one of the small squares on the bounding box to reload the **Transform** options bar.

The Scale Controls

The term *scale* means to make larger or smaller, **Figure 4-7**. Scaling is done by entering percentages in the **W** and **H** text boxes. For example, if you want to make something half as large as it currently is, enter a percentage of 50%. In most cases, the width and height should be the same percentage to avoid a stretched or squashed look. Clicking the **Maintain aspect ratio** (chain link) button between the **W** and **H** text boxes forces the image to stay in proportion—whatever value is entered in one box is automatically entered in another.

You can also use the bounding box to scale your image. If you drag a corner handle of the bounding box, the **Transform** options bar will appear and the scaling width and height values in the **W** and **H** text boxes will automatically change. Hold down [Shift] after you start dragging to keep the image in proportion. Forgetting to hold [Shift] during this process is one of the most common errors made by new Photoshop users.

Figure 4-7. _____

Scaling is used to reduce or increase the size of the content in the selection or layer. **A**—The original layer is shown here. **B**—After scaling the width and height to 25%, the resulting image is one-quarter the size of the original.

A B

Content-aware scaling (**Edit > Content-Aware Scale**) is a more advanced scaling method, because it allows you to scale a certain part of an image while leaving other areas untouched. It is discussed in Chapter 11, *Additional Layer Techniques*.

Note When you scale part of your image to a larger size, you are really resampling it. This will result in a loss of image quality. Remember, it is always better to start with a larger image and make it smaller.

Set Rotation Text Box

To rotate a selection, enter a value from 0° to 360° in the **Set rotation** text box. For counterclockwise rotation, enter a negative value. All of the pixels contained within the bounding box will be rotated around the reference point you have chosen.

As an alternative, you can use the bounding box to rotate your image. Position the cursor just outside any of the bounding box handles, and it will turn into a curved arrow. When the rotate cursor appears, click and drag to rotate your image, **Figure 4-8**. Holding down [Shift] as you drag causes the bounding box to rotate in 15° increments.

The Skew Controls

Skew means "to slant at an angle." Skewing can make an image look like the perspective has changed. You can skew a selection by entering values in the **H** and **V** text boxes. The image is skewed by moving the selected edge of the image and leaving the opposite edge stationary. The value entered in the **H** text box determines the angle of the slant along the vertical edges, created when the selection is skewed horizontally.

Figure 4-8.
The bounding box is being rotated, using the center of the bounding box as the reference point (center of rotation).

The angle of rotation is automatically updated in the **Set rotation** text box

Rotate cursor

Reference point (center of rotation)

Active layer

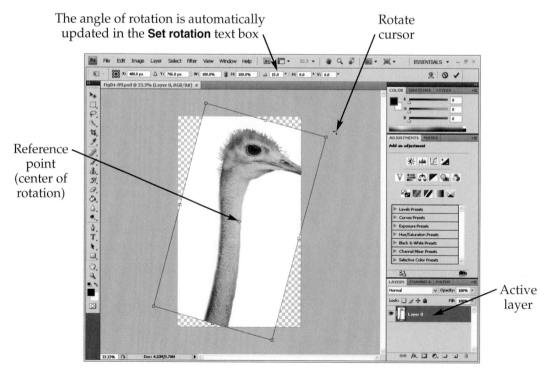

The value entered in the **V** text box determines the angle of slant of the horizontal edges, created when the selection is skewed vertically. Enter an amount in degrees from –180 to 180 in these text boxes.

You can also use the bounding box to skew the selection. With the **Transform** options bar active, right-click anywhere in the image window. Select **Skew** from the shortcut menu. Position your cursor over a side handle to skew the selection vertically, or a top or bottom handle to skew the selection horizontally. The cursor will change to an arrow with double arrowheads. Then, click and drag the mouse up or down or left or right to skew the selection, **Figure 4-9.**

Figure 4-9.
The bounding box is being skewed, using the center of the bounding box as the reference point. **A**—If the image is skewed vertically, the skew angle describes how far the top and bottom edges are rotated away from horizontal. **B**—If the image is skewed horizontally, the skew angle describes how far the left and right edges are rotated away from vertical.

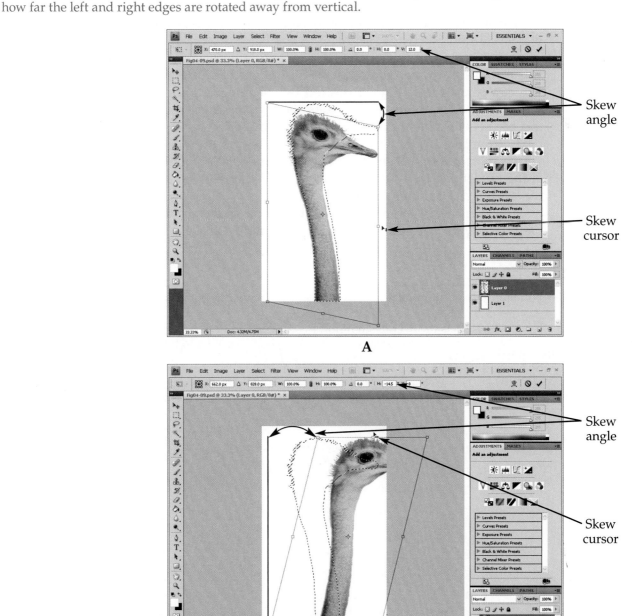

Note You can also grab a corner handle after selecting **Skew** from the shortcut menu. However, this will cause you to scale and skew the image at the same time, resulting in a nonsymmetrical effect. The effect is identical to choosing **Edit > Transform > Distort**.

Switching between Free Transform and Warp Modes

Clicking the **Switch between free transform and warp modes** button jumps you back and forth between transform mode and warp mode. Warp mode is extremely useful when adjusting a layer so it "wraps" to the surface of an object on another layer (such as applying a design on a cup).

In warp mode, a grid appears over your layer instead of the bounding box. Four boxes appear at the corners of the grid. These boxes can be clicked and dragged to a new location. The selection can also be adjusted by moving the two Bezier handles attached to each of the boxes. By moving these handles, you can adjust the curvature of the edges of the selection. See **Figure 4-10**.

In warp mode, a new options bar appears. You can choose from several predefined warps in the **Warp** drop-down list on the options bar. After selecting the desired warp, you can adjust the settings if desired by changing the numbers in the **Bend**, **H**, and **V** text boxes. The **Bend** text box sets the overall strength of the warp. The **H** and **V** text boxes determine the amount of perspective effect applied to the image. The **H** text box setting controls the horizontal perspective and the **V** text box setting controls the vertical perspective. When the **Change warp orientation** button is unselected, the effect of the predefined warp is applied vertically. When this button is selected, the effect of the warp is applied horizontally.

Clicking the **Switch between free transform and warp modes** button again returns Photoshop to the transform mode, with the bounding box and the **Transform** options bar.

Figure 4-10.
Warp mode lets you manipulate your image almost any way you want by adjusting the warp grid.

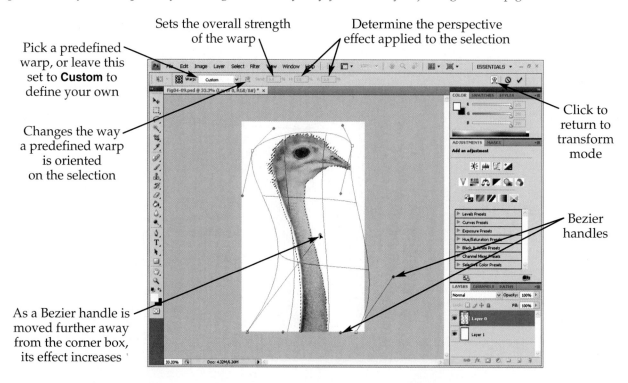

Pick a predefined warp, or leave this set to **Custom** to define your own

Sets the overall strength of the warp

Determine the perspective effect applied to the selection

Changes the way a predefined warp is oriented on the selection

Click to return to transform mode

Bezier handles

As a Bezier handle is moved further away from the corner box, its effect increases

The Cancel and Commit Buttons

After applying any of the transforming commands, press [Enter] or [Return] on your keyboard *or* click the **Commit** button, which looks like a check mark. To cancel any transform command, press [Esc] or click the **Cancel** button next to the **Commit** button.

The Edit > Transform Submenu

Choosing the **Edit > Transform** submenu brings up a list of all of the transform commands. This menu choice is not available unless an unlocked layer is active or part of your image is selected. Some of the commands listed in the **Edit > Transform** submenu are not found on the **Transform** options bar. A brief description of these commands follows.

The Again Command

Choosing the **Again** command duplicates the last transformation that was applied to the selection. The effects of the transforms are cumulative. For example, if you scale the selection to 50%, and then choose **Edit > Transform > Again**, the selection will be one-quarter of its original size.

The Distort Command

Choosing the **Distort** command lets you move one or more of the selection's bounding box handles in any direction. To distort the image, choose **Edit > Transform > Distort**. Click a corner handle on the selection box and drag it to the desired position. Keep in mind that too much distortion can result in a low-quality image, because of the amount of resampling Photoshop has to do. See **Figure 4-11**.

Figure 4-11. _____

To distort an image, each of the bounding box's handles can be dragged as desired.

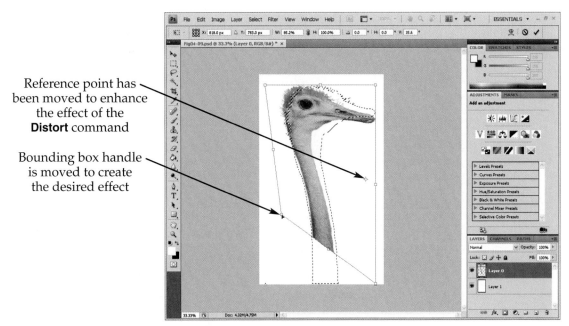

Reference point has been moved to enhance the effect of the **Distort** command

Bounding box handle is moved to create the desired effect

Note If you click a side, top, or bottom handle instead of a corner handle after choosing the **Distort** command, you will scale or skew the selection rather than distort it. You must choose a corner handle in order to distort the selection.

The Perspective Command

The **Perspective** command is similar to the **Distort** command. The difference is that when a corner handle is dragged, the opposite corner handle is also moved proportionally, **Figure 4-12**. If you click a side, top, or bottom handle instead of a corner handle, the selection is skewed rather than having the perspective effect applied.

The Rotating and Flipping Commands

Also listed in the **Edit > Transform** submenu are rotating and flipping commands. The **Rotate 180°** command turns the contents of a bounding box upside down. You can also choose to rotate the selection using the **Rotate 90° CW** command, which rotates the selection 90° clockwise, or the **Rotate 90° CCW** command, which rotates the selection 90° counterclockwise.

To *flip* an image in Photoshop means to mirror the image, so it appears as if you were looking at it from the other side. As you might expect, the **Flip Horizontal** command flips a selection horizontally and the **Flip Vertical** command flips the selection vertically. See **Figure 4-13**.

Note To rotate or flip an entire image, including all layers that make up the image, choose **Image > Image Rotation** and either the **Flip Canvas Horizontal** or **Flip Canvas Vertical** command.

Figure 4-12. _____
The **Perspective** command is used to change the perspective of an image.

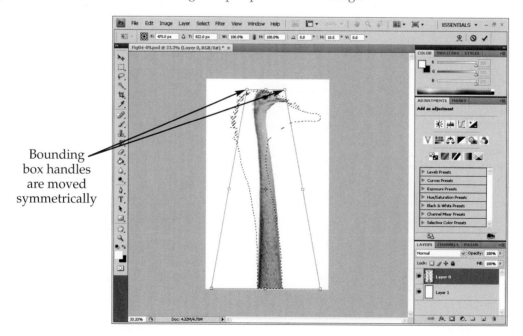

Bounding
box handles
are moved
symmetrically

Figure 4-13. _____
When content is flipped, a mirror image replaces the original. **A**—The original ostrich image is shown here. **B**—The ostrich has been flipped horizontally. **C**—The ostrich has been flipped vertically. Note that flipping the ostrich vertically is _not_ the same as rotating it 180°. The ostrich faces in a different direction.

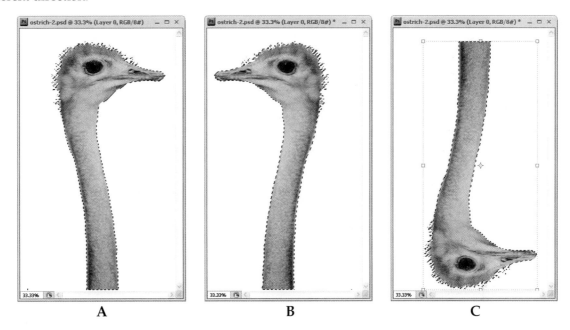

A B C

Using the Cut, Copy, and Paste Commands

Photoshop's **Edit** menu contains **Cut**, **Copy**, and **Paste** commands. These commands are similar in function to the same commands found in a word-processing program. They are most often used to copy and paste a selected area.

Once you have made a selection, you can copy it by selecting **Edit > Copy** or pressing [Ctrl][C]. The selected area on the active layer is copied to the clipboard, but remains unchanged in the image.

The **Cut** command is similar to the **Copy** command, but removes the selected area from the active layer, revealing whatever is behind the selection. Choosing **Edit > Cut** or pressing [Ctrl][X] cuts the selected area from the active layer and copies it to the clipboard.

Once you have copied a selection to the clipboard with the **Copy** or **Cut** command, you can paste it by choosing **Edit > Paste** or pressing [Ctrl][V]. When the selection is pasted into the image, a new layer is automatically created. If you are copying and pasting on the same image file, the new, pasted layer is sometimes placed exactly on top of the old area. It looks like nothing happened unless a bounding box appears around the pasted selection. For this reason, it is a very good idea to enable the **Show Transform Controls** option in the **Move Tool**'s options bar. After pasting, immediately move the new layer as desired so you do not forget it is there!

The **Layer > New > Layer via Copy** and **Layer > New > Layer via Cut** commands are similar to the **Copy** and **Cut** commands. These commands are used to copy or cut a selected area and place the result on a new layer. Unlike the **Cut** and **Copy** commands, they do not require the **Paste** command; the selection is automatically pasted. Also, these commands can only be used to copy a selection back into the same image, whereas the **Cut** and **Copy** commands can be used to copy a selection from one image to another.

If an image has several layers, **Cut** and **Copy** commands only work for one layer at a time, unless you make an exception. If you want to copy and paste content from *all* the different layers simultaneously, select the area and choose **Edit > Copy Merged**. The selected area in all layers are combined and copied to the clipboard as a single selection, which can then be pasted into an image as a single layer.

Aligning Image Elements Using Grids, Guides, Rulers, and Snaps

If your project contains several small shapes that need to be lined up perfectly, Photoshop's grid or guides can help you quickly accomplish this. The use of rulers and snaps makes it easy to position selections or layers exactly where you want them.

Grids, guides, and rules can be turned on and off easily by using the **View Extras** drop-down menu on the Application bar. These commands can also be turned on and off using the **View** menu. Several snap-related commands are also accessed via the **View** menu.

The Grid

Photoshop's *grid* is a pattern of horizontal and vertical lines that appears on your screen but does not print. The grid is turned on or off using the **View Extras** drop-down menu or choosing **View > Show > Grid**. You can control the spacing and appearance of the gridlines by choosing **Edit > Preferences > Guides, Grid & Slices...** (or **Photoshop > Preferences > Guides, Grid & Slices...** for Mac). Set the desired grid properties in the **Grid** section of the **Preferences** dialog box, **Figure 4-14**.

- Using the **Color** drop-down list, you can change the color of the gridlines. You can select one of the preset colors, or choose **Custom** to select your own color in the **Color Picker** dialog box. You can also create a custom color by clicking in the color swatch to the right of the **Color** drop-down list and defining the new color in the **Color Picker** dialog box.

- In the **Style** drop-down list, you can choose between three styles of gridlines: solid lines, dashed lines, or dots that show where the gridlines intersect.

- The **Gridline every** setting controls the number of major gridlines on your screen. The value entered into this text box determines the exact distance between major gridlines. You can set the grid to display in inches, millimeters, or numerous other units of measurement.

- The **Subdivisions** setting determines the number of empty spaces that are created between major gridlines. These spaces are created by adding minor gridlines between the major gridlines. The minor gridlines appear lighter than the major gridlines. The number of minor gridlines added to the grid will be equal to the **Subdivisions** setting minus one.

Rulers

Photoshop's rulers are often used with the grid. They are displayed or hidden by using the **View Extras** drop-down menu or choosing **View > Rulers**. You can specify what units of measurement appear in the ruler (inches, centimeters, pixels, etc.) by

Figure 4-14. _____
To make the grid useful for projects of all sizes, its settings can be adjusted in the **Preferences** dialog box. **A**—These grid settings work well for projects using inches as the unit of measurement. **B**—With the **Subdivisions** setting at 4, minor gridlines appear every 1/4".

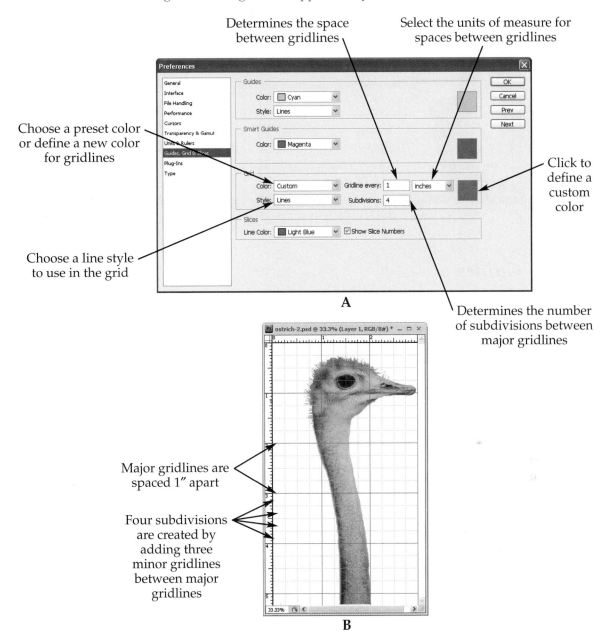

selecting **Edit > Preferences > Units & Rulers...** (or **Photoshop > Preferences > Units and Rulers...** for Mac). In the **Units** section of the **Preferences** dialog box, select the desired units from the **Rulers** drop-down list. You can also change the units of measurement for a particular image by right-clicking on either the horizontal or vertical ruler and selecting the desired units from the shortcut menu.

The zero point on each ruler can be adjusted by clicking and the small square in the upper-left corner of the rulers, dragging it to the desired location in the image, and releasing the mouse button. If you make a mistake while doing this, you can reset the rulers by double-clicking the same small square in the upper-left corner of the image window. See **Figure 4-15.**

Figure 4-15. _____

The zero point can be moved to a different location on the ruler. **A**—By default, the ruler's zero point aligns with the upper-left corner of the image. **B**—The zero point can be changed by dragging the upper-left corner of the rulers onto your file.

The default zero point aligns with the upper-left corner of the image

Click in this box and drag the cursor to the desired location for the new zero point

New zero point

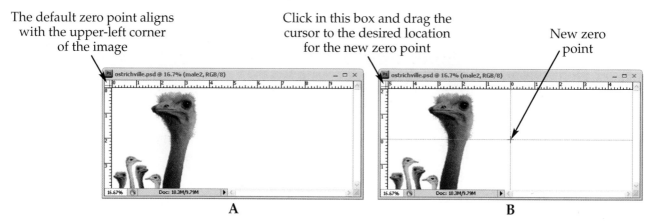

A B

Guides

Guides are similar to the grid, but do not clutter your image as much. To use Photoshop's guides, you must first display the rulers. Then, create as many guides as you wish (horizontally and/or vertically) by clicking on one of the rulers and dragging the guide into your image. After placing the guides in your image, you can adjust their position by clicking and dragging them to the desired location with the **Move Tool**.

A guide can be placed at a precise distance from the left or top edge of the image by choosing **View > New Guide...**. In the **Orientation** section of the **New Guide** dialog box, select either the **Horizontal** or **Vertical** radio button, depending on which way you want the guide to run. In the **Position** text box, enter the distance you want the guide to be from the edge of the image. For horizontal guides, this setting determines the distance between the top edge of the image and the guide. For vertical guides, this setting determines the distance between the left edge of the image and the guide. The position of a guide will always be measured from the top-left corner of the image, regardless of whether the zero point for the rulers has been moved or not. Rulers do not need to be displayed in order to create guides with the **New Guide** command.

Guides can be locked into place so they cannot be moved accidentally. To do this, choose **View > Lock Guides**. If you need to reposition locked guides, you will need to unlock them first by selecting **View > Lock Guides** again.

To remove a single guide from your image, simply drag it back to the ruler and release the mouse button. To remove all of the guides from the image, disable them by clicking the **View Extras** button and unchecking the **Show Guides** option in the pop-up menu or by choosing **View > Clear Guides**.

If desired, you can change the color and appearance of the guides by selecting **Edit > Preferences > Guides, Grid & Slices** and making the desired changes in the **Guides** section of the **Preferences** dialog box.

Smart Guides

Smart guides are temporary guides that help you quickly line up two or more layers according to the centers or edges of their bounding boxes. As you drag a layer close to another layer with the **Move Tool,** these guides appear automatically. When the

guides are visible, they help you snap the layer you are dragging to the center or edge of another layer. Once you release the mouse button, the guides disappear. Smart guides can be turned on or off by choosing **View > Show > Smart Guides**.

Smart guides will also appear when you drag a selection or draw shapes with any of the shape tools, if at least one other shape or layer already exists in the Photoshop document.

Using the Snap Command to Align Layers

If you hold a magnet close to a piece of metal, the magnet snaps, or jumps, over to the metal and sticks to it. When Photoshop's **Snap** command is turned on, you can use the **Move Tool** to snap the bounding box that appears around a layer's content to gridlines, guidelines, or the edges of your image (called the *document bounds*). When using this feature, make sure the **Move Tool**'s **Show Transform Controls** option is on, or choose **View > Show > Layer Edges**.

The **Snap** command does not affect how the arrow keys on your keyboard move the contents of a layer. You can always use the arrow keys to precisely adjust the location of a layer's content.

To turn the **Snap** command on or off, choose **View > Snap**. The **Snap** command is *toggled* (turned off and on) frequently, so you will probably find it helpful to memorize the keyboard shortcut, [Shift][Ctrl][;].

The **View** menu also contains the **Snap To** submenu, Figure 4-16. From this submenu, you can choose exactly what object the **Snap** command will snap to. For example, you can specify that only guides are snapped to—not gridlines or the edges of your image (document bounds). You can also choose to snap to *slices*, which are invisible boundaries that are placed on web images.

Note	In addition to using the snaps to accurately place image content, you can also use the snaps to create accurate selections. This technique is especially helpful when you are using the **Rectangular Marquee Tool** or the **Elliptical Marquee Tool**.

Figure 4-16. _____
The **Snap** command toggles snapping on and off. The options in the **Snap To** submenu allow you to pick the things that a layer or selection will snap to.

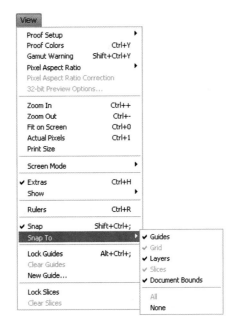

Working with Layers in the Layers Panel

The **Layers** panel is packed with features. It is used to organize multi-layered projects in several different ways. It also shows information about styles and layer masks (discussed in later chapters) that have been applied to layers. And instead of using Photoshop's **Layers** menu, you can access many commonly used layer commands by using the buttons at the bottom of the panel, by right-clicking on different areas of the panel, or by using the panel menu.

Making Layers Active

More than one layer can be active at the same time. You can select more than one layer in the **Layers** panel by holding down [Ctrl] (or [Command] for Mac) as you click. If you press [Shift], you can select an entire group of layers by clicking on the first layer you want included and then clicking on the last layer you want included. All layers in between the two selected layers become selected automatically.

You can also select multiple layers by choosing **Select > All Layers**, and then pressing [Ctrl] (or [Command] for Mac) and clicking all the layers you did *not* want to select. You can select all similar types of layers by choosing **Select > Similar Layers**. This command is useful for selecting all type layers, all adjustment layers, all fill layers, or all layers that contain pixels in an image.

Another way to select multiple layers is to drag a box in your document with the **Move Tool**. All layers that are touched by the box will be highlighted in the **Layers** panel, except for a locked background layer. It should be noted that this method only works when the **Move Tool**'s **Auto-Select** option is turned on.

Occasionally, you may want *none* of your layers to be active. There are a number of ways to do this. First, you can press [Ctrl] (or [Command] for Mac) and click the active layer to deselect it. You can also choose **Select > Deselect Layers** to deselect all layers. The final method is to click the blank area in the **Layers** panel just below the bottom layer. You may need to zip-up other docked panels or undock and stretch the **Layers** panel to create a blank area beneath the bottom layer.

Some, but not all, of Photoshop's commands can be applied to more than one active layer simultaneously. These commands include transforming, moving, copying and pasting, applying layer styles, and aligning. Commands that can only affect one layer at a time include color correction and painting.

Selecting the Content of a Layer

In Chapter 3, you learned that to select something in Photoshop means to create a selection border around it. Yet, when you work with layers, making a layer active is almost the same as selecting it. However, there are occasions where you may need to create a selection border around the content of a layer instead of only a bounding box.

This is done by holding down [Ctrl] ([Command] for Mac) and placing the cursor over the appropriate layer thumbnail (small image that represents the layer content) in the **Layers** panel. When you see the cursor change to a hand with a square-shaped selection over it, click the layer thumbnail. This places a selection around the layer content in your Photoshop document. See **Figure 4-17**.

Figure 4-17.
Hold [Ctrl] and position the cursor over the layer's thumbnail. When the special cursor appears, click on the thumbnail to select the layer's contents.

Selection surrounds all non-transparent areas on the layer

When this cursor appears, click on the thumbnail to select all objects on the layer

Duplicating a Layer

There are several ways to duplicate, or copy, a layer. A simple way to duplicate a layer is to drag the layer from its place in the **Layers** panel to the **New Layer** button at the bottom of the **Layers** panel, Figure 4-18. You will know when to release the mouse button because the cursor will change into a fist. A new layer appears in the **Layers** panel directly above the layer that was copied, and the content is placed in the image exactly on top of the layer that was duplicated.

Another easy way to duplicate a layer is to press [Alt] and drag the layer with the **Move Tool**, either in the document window (if the **Auto-Select** option is enabled) or in the **Layers** panel. If you want to duplicate a layer by pressing [Alt] and dragging the layer in the image window, first make sure that there are no active selections in the image. If there is an active selection, the selected layer will not be duplicated. Instead, the selected area will be duplicated and pasted into the current layer.

Figure 4-18.
Dragging a layer on top of the **New Layer** button is the fastest way to duplicate a layer.

When the cursor changes to a fist, release the mouse button

The layer to be duplicated is clicked and dragged to the **Create a new layer** button

You can also duplicate a layer by choosing **Layer > Duplicate Layer…**. This opens the **Duplicate Layer** dialog box. In the **As** text box, enter a name for the new layer you are creating. In the **Document** drop-down list, specify the image that you want to copy the layer to. All of the currently open image files are listed in this drop-down list. You can also choose to create a new document and save the layer to that document. If you choose to create a new document, you must enter a name for the new image in the **Name** text box.

If you need to copy a layer from one file to another, simply drag the layer from the **Layers** panel and release it on top of the destination image's window. The copied layer appears in the destination image and is listed in the destination image's **Layers** panel. If no layers are selected in the destination image when the layer is copied over, the copied layer is placed at the top of the layer stack. However, if a layer is selected, the copied layer is placed immediately above the selected layer. This is important to remember because an existing layer in the destination image could hide the copied layer from view.

Layer Properties: Renaming and Color-Coding Layers

The **Layer Properties** dialog box helps you keep your layers better organized by allowing you to rename them with descriptive names. For large projects that contain many layers, you can also color-code layers to keep them better organized.

To display the **Layer Properties** dialog box, do one of the following:

- If you are creating a new layer, choose **Layer > New > Layer…**. The **New Layer** dialog box appears. This dialog box is essentially an expanded version of the **Layer Properties** dialog box. Some of the settings on this expanded dialog box will be discussed in a later chapter.

- For existing layers, right-click (or [Ctrl]+click for Mac) a layer in the **Layers** panel and choose **Layer Properties…** from the right-click menu.

- For existing layers, make sure the correct layer is active and choose **Layer > Layer Properties…**.

Once you have opened the **Layer Properties** dialog box, simply type a new name for the layer in the **Name** text box, **Figure 4-19**. The name of the layer automatically changes in the **Layers** panel as you type. If you want to assign a different color code for the layer, click the **Color** drop-down list and select the desired color. The selected color appears in the **Layer visibility** toggle in the **Layers** panel. Click the **OK** button in the **Layer Properties** dialog box to accept the changes.

The easiest way to rename a layer is to double-click on its name in the **Layers** panel and then type a new layer name. Press [Enter] or click on another layer to complete the renaming process. You can quickly assign a new color code to a layer by right-clicking the layer's **Layer visibility** toggle in the **Layers** panel. Then, select the desired color from the shortcut menu that appears.

Changing the Stacking Order of Layers

Layers are "stacked in a pile." The layer that appears at the bottom of the list in the **Layers** panel appears behind all of the other layers in the image window. A locked **Background** layer will always be at the bottom of the stack, and you will not be able to move it from that position unless you unlock it (discussed later in this chapter).

To change how layers are stacked, simply click and drag them to a different location in the **Layers** panel. For best results when dragging layers to a new location, release the mouse when the cursor is on the borderline between two layers.

Figure 4-19. ———
A layer's name and color code can be changed in the **Layer Properties** dialog box.

Enter a new name
for the layer

Select a new color
code for the layer

Click **OK** to
apply the
changes

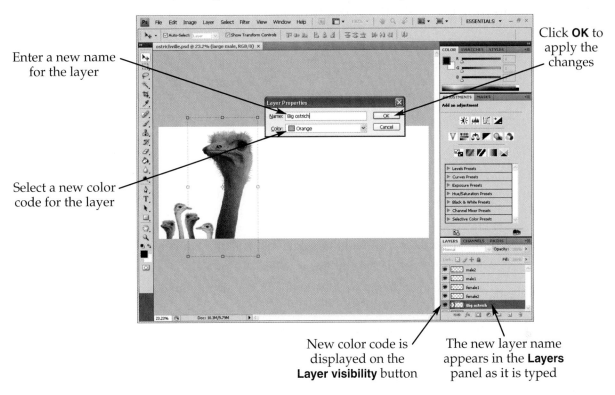

New color code is
displayed on the
Layer visibility button

The new layer name
appears in the **Layers**
panel as it is typed

The way the layers appear in the image window depends on the way they are listed in the layer stack. Each layer in the stack appears in front of every other layer that is listed after it. The layer at the top of the list appears in front of all other layers in the list. In **Figure 4-20**, the layer named large male is first shown *behind* the smaller ostriches and then *in front* of the smaller ostriches.

Figure 4-20. ———
A layer's position in the layer stack determines whether it appears in front or behind other layers in the image window. **A**—The large male layer is listed below the other four ostrich layers in the **Layers** panel. As a result, the large ostrich appears behind the other ostriches in the image window. **B**—When the large male layer is dragged to the top of the stack in the **Layers** panel, the large ostrich appears in front of the other ostriches in the image.

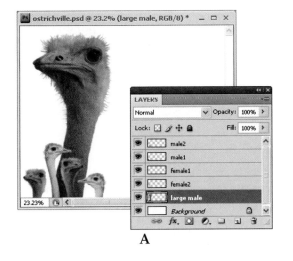

A

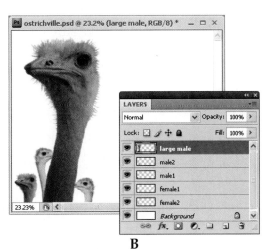

B

Another way to change the stacking order of layers can come in handy with projects that contain many layers. The **Layer > Arrange** submenu contains commands that move layers forward or backward. Choosing **Layer > Arrange > Bring to Front** causes the selected layers to move to the top of the **Layers** panel, appearing in front of all of the other layers in your file. The **Bring Forward** command moves the selected layers up one place in the stack. The **Send to Back** command moves the selected layers to the bottom of the stack, but in front of the locked **Background** layer. The **Move Backward** command moves the selected layers down one place in the stack. The **Reverse** command reverses the order of the selected layers, but does not affect the unselected layers in the stack.

Creating a New, Blank Layer

Layers are automatically created when you use the **Cut**, **Copy**, and **Paste** commands, when you drag and drop a selection onto a different document, or when you copy a selection by pressing [Alt] and dragging it with the **Move Tool**. However, you will occasionally need to create a new, blank layer and add content to it. To create a new layer, use one of the following techniques:

- Click the **Create a new layer** button on the **Layers** panel. It is just to the left of the **Delete layer** (trash can) button.

- Choose **Layer > New > Layer...**. In the **New Layer** dialog box, enter a name for the new layer and pick the **OK** button to create the new layer.

A newly created layer always appears just above the layer that was previously active. Just before creating a new layer, you should make the *topmost* layer in the **Layers** panel active. The new layer will be created above it, at the very top of the stacking order. This ensures that the content you add to your new layer will not be hidden by any layers in front of it. You can then move the new layer to the desired position in the layer stack.

Deleting a Layer

The following are five different techniques for deleting a layer (and all of its contents) using the **Layers** panel.

- Make sure the layer you wish to delete is active in the **Layers** panel. Make sure there is no selection in the image window. Then, press [Delete] on your keyboard. This is the quickest way to delete a layer.

- Click and drag the layer on top of the **Delete layer** (trash can) button. When the cursor changes to a fist, release the mouse button, **Figure 4-21.**

- Make sure the correct layer is active in the **Layers** panel. Click the **Delete layer** button. Click **Yes** in the dialog box that appears.

- Right-click (or [Ctrl]+click for Mac) the layer and choose **Delete layer** from the shortcut menu. Click **Yes** in the dialog box that appears.

- Make sure the layer you want to delete is active, then choose **Layer > Delete > Layer**.

Layer Visibility

If your project becomes too cluttered as you work, you can temporarily hide layers by clicking the **Layer visibility** (eye) toggles next to the layers on the **Layers** panel, **Figure 4-22.** To show the layer again, click the button to make the eye and the layer reappear.

Figure 4-21. _____

One way to delete a layer is to drag it on top of the **Delete layer** button in the **Layers** panel.

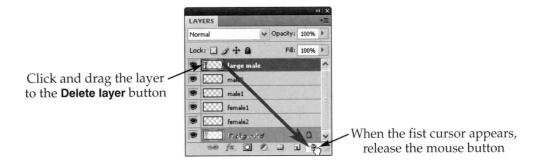

Click and drag the layer
to the **Delete layer** button

When the fist cursor appears,
release the mouse button

Figure 4-22. _____

The large male layer has been temporarily hidden by clicking the **Layer visibility** toggle.

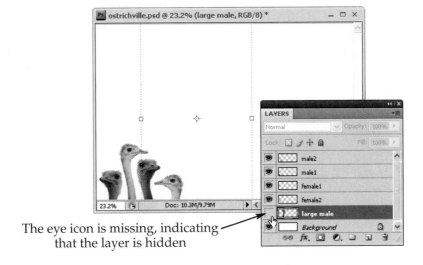

The eye icon is missing, indicating
that the layer is hidden

Grouping Layers

Since large projects can contain numerous layers, a lot of time can be wasted scrolling up and down in the **Layers** panel, searching for the correct layer. Placing layers into groups is a quick way to organize the **Layers** panel. A *layer group* is really a folder that can be created in the **Layers** panel. Layers can be dragged to this folder, and, for organizational purposes, the folder can be collapsed or expanded at any time by clicking the small triangle next to it, **Figure 4-23**. Perhaps the biggest advantage of layer groups is that by clicking on the group, all layers within that group may be moved or transformed simultaneously.

To create a layer group, select one of the layers you want to include in the group, and then click the **Create a new group** (folder) button on the **Layers** panel. When the group appears in the **Layers** panel, double-click on it and type a new name. To add layers into this new group, drag them on top of the new group folder in the **Layers** panel. You can rename and color-code the group by right-clicking (or [Ctrl]+click for Mac) on it in the **Layers** panel and choosing **Group Properties** from the menu that appears. Choosing **Layer > New > Group** lets you create a group in the same manner.

Figure 4-23. _____

The grouped layers appear together in a folder. More room can be created in the **Layers** panel by collapsing the group. This is done by clicking the small triangle next to the folder.

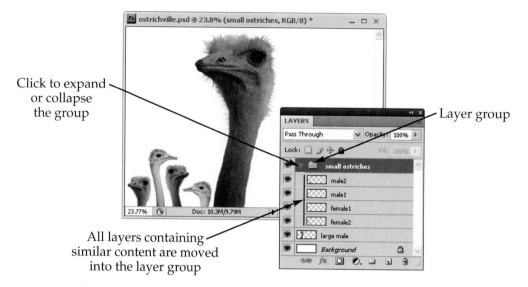

Click to expand or collapse the group

Layer group

All layers containing similar content are moved into the layer group

Another way to create a new layer group is to first select the layers to be grouped by holding down [Ctrl] (or [Command] for Mac) as you click. Next, choose **Layer > New > Group from Layers....** The selected layers are automatically placed in the new group folder.

In Figure 4-23, a new layer group was created to hold all the layers containing small ostriches. Any changes made to this layer group, such as turning off layer visibility or duplicating the group, will affect all layers within the group.

Layer groups can easily be duplicated and edited. The pattern of small ostriches in Figure 4-24 was created by following these simple steps:

1. The small ostriches group was duplicated four times. The group can be duplicated by selecting it in the **Layers** panel and choosing **Layer > Duplicate Group...** or by right-clicking the group in the **Layers** panel and selecting **Duplicate Group**. Each group was then moved to a new location.

2. Two of the duplicated groups were flipped horizontally and moved downward slightly. To flip the layers, select them in the **Layers** panel to make them active and then choose **Edit > Transform > Flip Horizontal**.

Linking Layers

Linking layers is an alternative way to group layers without organizing them into folders. Once layers are linked, they can be moved or transformed simultaneously. Linking and unlinking layers is not difficult, but many Photoshop users will find that grouping layers into folders is a bit more user-friendly.

To link layers, hold down [Ctrl] (or [Command] for Mac) as you click on the layers that you want to link in the **Layers** panel. Then, click the **Link layers** (chain) button at the bottom left of the **Layers** panel. The link icon appears at the right side of each linked layer. To unlink layers, make sure they are active, and then click the **Link layers** button at the bottom of the **Layers** panel again.

Figure 4-24.
This pattern of small ostriches was quickly created by duplicating the small ostriches layer group.
Then, each group was repositioned.

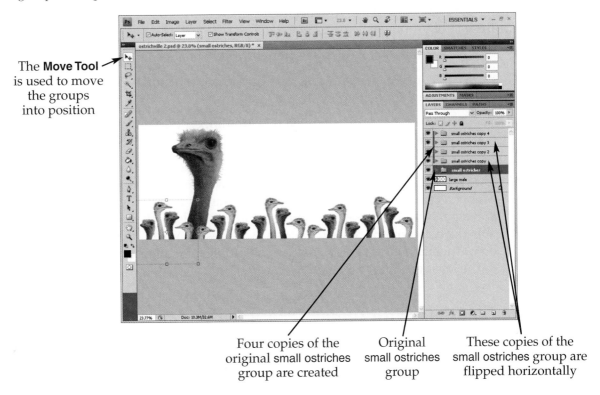

The **Move Tool**
is used to move
the groups
into position

Four copies of the
original small ostriches
group are created

Original
small ostriches
group

These copies of the
small ostriches group are
flipped horizontally

Merging Layers

Merging layers in Photoshop means to combine two or more layers into one. Merging layers is similar to grouping layers. However, when layers are merged, they become joined *permanently*. There are three ways to merge layers.

The first method is simple. Select multiple layers in the **Layers** panel by holding [Ctrl] (or [Command] for Mac) as you click on each layer. Then, choose **Layer > Merge Layers**. The contents of the selected layers are copied into the selected layer that is closest to the top of the layer stack, and the other selected layers are removed. The same result can be achieved by selecting the layers in the **Layers** panel, right-clicking, and selecting **Merge Layers** in the shortcut menu.

Another way to merge layers is to click the **Layer visibility** toggles in the **Layers** panel to hide all of the layers you do *not* want to merge. Then, choose **Layer > Merge Visible** to combine all the visible layers into one layer. This command will not work unless one of the visible layers is active. If only one of the visible layers is active, the content from other visible layers is copied into that layer and the other visible layers are deleted. If two or more visible layers are selected, the content from all of the visible layers is copied into the selected layer that is highest in the layer stack, and the other visible layers are deleted. The same effect can be achieved by right-clicking one of the visible layers and selecting **Merge Visible** in the shortcut menu.

If you want to quickly merge two layers that are next to each other in the layer stack, select the uppermost layer you want to merge and choose **Layer > Merge Down**. This combines the currently active layer with the layer directly below it on the layer stack. The same effect can be achieved by selecting the layer you want to merge in the **Layers**

panel, right-clicking, and selecting **Merge Down** in the shortcut menu. Remember, you can reorganize the layers in the layer stack by clicking and dragging them to the desired location before merging them.

The same pattern of small ostriches shown in Figure 4-24 can be created by merging instead of grouping. See **Figure 4-25**.

1. The four small ostriches were merged onto one layer.

2. The newly merged layer was duplicated four times. The duplicated layers were moved to their approximate locations.

3. Two of the duplicated layers were flipped horizontally and moved downward slightly.

Is it better to combine layers using merging techniques or to group them into layer groups? The answer depends on how you want to edit the merged or grouped layers. Most of Photoshop's color correction commands and many of the tools found in the **Tools** panel will only work on one layer at a time. In such cases, merging layers is probably the better option. Layer groups are the best choice to combine layers if you are only concerned about moving, transforming, duplicating, aligning, or applying layer styles to the layer group as a whole.

Flattening an Image

Images that contain layers take up a lot of file space. Images with layers can only be saved in three file formats: PSD, TIFF, and PDF. Photoshop format (PSD) is the default format that layered Photoshop images are saved in. File formats are discussed in detail in Chapter 12, *File Management and Automated Tasks*.

Figure 4-25. _____

This pattern of small ostriches was created by merging, duplicating, and renaming layers.

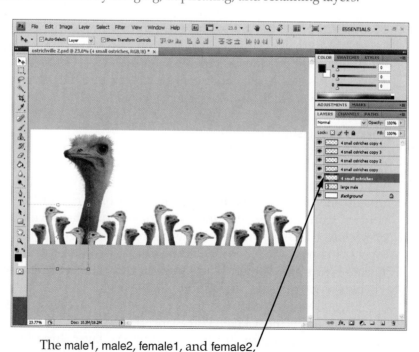

The male1, male2, female1, and female2, layers are merged into a single layer

If you choose to save your file in any format that does not support layers, such as JPEG and GIF, the image will be automatically *flattened*. To flatten an image means to merge *all* of the layers. As mentioned, this is done automatically when the file is saved. It can also be done manually by choosing **Layer > Flatten Image**. Photoshop files with layers take up a lot of file space, so file sizes become a lot smaller when an image is flattened.

Once you save and close your file in a flattened condition, you can never get your layers back again. All Photoshop users would agree that you should always save an unflattened backup copy of a file before you flatten it or save it in a format that does not support layers. This allows you to easily make changes to the file if necessary. Such unexpected changes are required when mistakes or color problems are found just before a design is ready to be printed or when a client requests last minute adjustments to the look and feel of the design.

Layer Opacity

Opacity refers to an object's ability to block light. In Photoshop, the term opacity refers to how visible an image element is. If a layer has 100% opacity (its default setting), it appears completely solid, not transparent. A layer with 0% opacity is completely transparent, or invisible. Opacity values between 0% and 100% create layers that are see-through to some degree.

To change the opacity of a layer or a layer group, first select the layer or group in the **Layers** panel to make it active. Next, adjust the **Opacity** slider to the desired value. There are actually two sliders that can control opacity: the **Opacity** slider and the **Fill** slider, **Figure 4-26**. The difference between them is that the **Fill** slider does not change the opacity of effects that are associated with the layer, such as blending modes or layer styles.

Figure 4-26. ⎯⎯⎯
The opacity of the ostrich groups has been set (from left to right) to 100%, 80%, 60%, 40%, and 20%. The opacity of the large ostrich has been set to 0%.

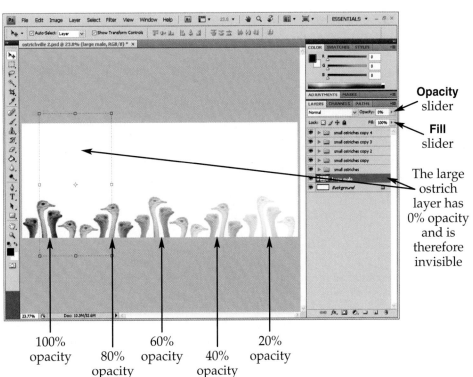

Layer Transparency

In **Figure 4-27**, the Background layer, which contains the white pixels, has been hidden. A checkerboard pattern remains. Whenever you see this checkerboard pattern, it tells you that the area is transparent—there is nothing there.

The appearance of the checkerboard pattern can be changed by choosing **Edit > Preferences > Transparency and Gamut...** (or **Photoshop > Preferences > Transparency and Gamut...** for Mac). In the **Preferences** dialog box, you can change the size of the checkerboard pattern by selecting a new option from the **Grid Size** drop-down list. You can adjust the color and shading used in the checkerboard pattern by selecting a scheme from the **Grid Colors** drop-down list. A preview on the right side of the dialog box shows how your choices affect the transparency pattern. Pick **OK** to accept the changes.

Layer transparency is available when working with files saved in Photoshop (PSD) format. Be aware that if you save a file that has transparent areas in another format (such as JPEG), the transparent areas will not be preserved. If the file is going to be used on the web, the transparent areas can be preserved by saving files in GIF or PNG formats.

Locking Layers

To *lock* a layer means to "protect it from being changed." When you begin a new Photoshop project, the Background layer is locked automatically. It can be unlocked by double-clicking on it and giving it a new name. It can also be unlocked by selecting it and then choosing **Layer > New > Layer from Background....** It (or any other layer) can be locked again by selecting the layer in the **Layers** panel and choosing **Layer > New > Background from Layer**.

To lock or unlock a layer, other than the Background layer, first make it active. Then click one of the four different locking buttons on the **Layers** panel. See **Figure 4-28**.

Figure 4-27. _____

The white background layer has been hidden. It is the only layer in this project that does not contain transparent areas (shown by the checkerboard pattern).

The large ostrich appears in front because the layer has been moved to the top of the stack

The Background layer has been hidden

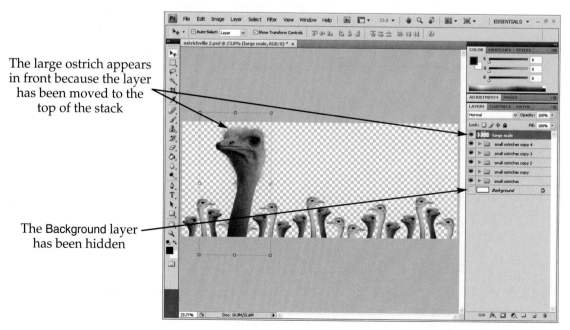

Figure 4-28. _____
The lock buttons are located on the **Layers** panel. This chart describes the function of each of the buttons.

Lock button (found on the **Layers** panel):	What it protects:
Lock transparent pixels Lock:	The transparent parts of the layer are protected; nothing can be added on top of them. However, the pixels on the layer can still be edited.
Lock image pixels Lock:	Prevents the pixels from being edited, but the layer can be moved. The transparent parts of the layer can be edited.
Lock position Lock:	Prevents the layer from being moved, but it can still be edited.
Lock all Lock:	No changes can be made to the layer. All three of the previous locks are applied to the layer.

Layers Panel Menu

The **Layers** panel has a menu that makes it easy to execute layer-related commands. The menu is accessed by clicking the small arrow at the top right of the panel, **Figure 4-29**. Most of the commands on this menu are also listed in the **Layer** menu. However, the **Panel Options** command is available only from the **Layers** panel menu.

Layers Panel Options

Choosing the **Panel Options** command displays the **Layers Panel Options** dialog box, **Figure 4-30**. In the **Thumbnail Size** section of this dialog box, you can select a radio button to reduce or enlarge the size of the layers' *thumbnails*, the small pictures of what is contained on the layers. For large projects with many layers, change this option to a smaller size or no thumbnail image at all.

Figure 4-29. _____
Many of the commands listed in the **Layers** pull-down menu can also be accessed through the **Layers** panel menu. The **Layers** panel menu is displayed by clicking the small arrow in the upper-right corner of the panel.

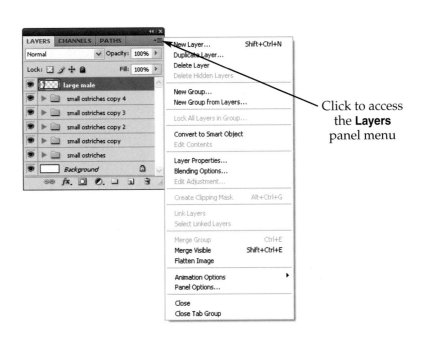

Click to access the **Layers** panel menu

Figure 4-30. _____
The appearance of the layer thumbnails can be changed in the **Layers Panel Options** dialog box.

In the **Thumbnail Contents** area, you can select the **Layer Bounds** radio button to display only the content of the layer enlarged to fill the thumbnail. This option gives you the best view of the layer's content, but provides no indication of where the layer content is located in the image. Choosing the **Entire Document** causes the thumbnail to display the layer's content in relation to the extents of the image. In cases where you have many overlapping layers and position is critical, the **Entire Document** option is usually better.

The **Expand New Effects** check box is on by default. When you add layer styles to a layer, those styles are listed (or expanded) underneath the layer. For large projects with many layers, you may wish to disable this setting so space is used more efficiently in the **Layers** panel. When the **Expand New Effects** setting is disabled, you can still access the names of any layer styles you have added to a layer by clicking the down-arrow next to the **fx** button on the appropriate layer in the **Layers** panel. Layer styles are discussed in detail in Chapter 5, *Text, Shapes, and Layer Styles.*

When the **Use Default Masks on Fill Layers** check box is checked, a layer mask is automatically applied to any new fill layers that are added to the image. For more about fill layers, see Chapter 6, *Painting Tools and Filters.* Adding a mask to a fill layer allows you to limit the area affected by the fill. To block the fill color or pattern in certain parts of the image, select the mask in the **Layers** panel and then paint over the areas you want excluded. If you do not paint on the mask, the fill color or pattern is applied to the entire image, as if the mask was not there at all. In most cases, you will want to leave this option turned on. For more about masks, see Chapter 11, *Additional Layer Techniques.*

Right-Clicking on the Layers Panel

Many of Photoshop's panels display contextual menus, or shortcut menus, when you right-click (or [Ctrl]+click for Mac) on them. A *contextual menu* is a quick way to view several menu commands that are directly related to the panel you happen to be right-clicking on.

The **Layers** panel is somewhat unique—there are up to four different contextual menus that can be displayed, depending on where you right-click. You will get a different menu when clicking on each of the following: the layer thumbnail, the layer name, the layer visibility column, and, if a layer mask has been added, the layer mask thumbnail.

GRAPHIC DESIGN

Text Basics

In the next chapter, you will learn how to create and manipulate text in Photoshop using the type (text) tools. Photoshop also has two panels that control the appearance of text: the **Paragraph** panel and the **Character** panel.

As a graphic designer, you will create *headings* (titles and subtitles), *lists* (bulleted or numbered groups of items), and *body text* (complete sentences and paragraphs). One of the first issues to consider is what kind of text *justification* is best. Justification refers to the way the words in the paragraph align with the edges of the document. You can choose between left-aligned, center-aligned, right-aligned, or justified. Notice that Photoshop offers four slight variations of justified text. See **Figure 4-31** and **Figure 4-32**.

When creating body text, lines of text should be broken (hyphenated) in well-thought-out places. Consider the two examples in **Figure 4-33**. At first glance, both of these paragraphs look fine—the right side of each is not too ragged in appearance. In the first example, however, two wildflower names have been broken between two lines. In the second example, no words or names are broken, making it easier for the reader to quickly comprehend the information.

Figure 4-31.

There are several text justification options available in most software programs. Photoshop's text alignment buttons are shown here, however, the text alignment buttons in most other software will look very similar. Note that Photoshop has four slightly different variations of justified text.

Type of justification:		Notes
Left-aligned		Use for body text and lists. Easiest for U.S. and European audiences to read.
Center-aligned		Good for headlines and titles. Difficult to read when used for lists or body text.
Right-aligned		Some countries read from right to left. Right-aligned text is difficult for U.S. and European audiences to read.
Justified		A good alternative when creating body text. Tends to create uneven spacing and channels of white space in a paragraph.

Figure 4-32.

Can you spot two or three white space channels in this justified paragraph?

When justified text is created, irregular spacing occurs between the words. Additionally, distracting channels of white space frequently appear in justified paragraphs. Both of these problems can be adjusted using Photoshop's **Character** panel. When justified text is created, irregular spacing occurs between the words. Additionally, distracting channels of white space frequently appear in justified paragraphs. Both of these problems can be adjusted using Photoshop's **Character** panel.

Too much text per line can make it difficult to quickly absorb information from a graphic design. When creating body text, limit words per line to no more than twelve, and no fewer than four. Reading either of the examples in **Figure 4-34** is more difficult than reading example B in Figure 4-33.

Figure 4-33. _____
Line breaks affect the readability of text. **A**—The line breaks in this text have split two flower names, decreasing the readability of the text. **B**—In this example, care was taken not to split the flower names. Notice that it appears neater and is more readable.

There are hundreds of beautiful wildflower species found in the Rocky Mountains. Shown on the front: *Greenstem Paper-flower, Spring Beauty, Mountain Forget-Me-Not. Back: Car-men Gilia, Dusty Penstemon.*

A

There are hundreds of beautiful wildflower species found in the Rocky Mountains. Shown on the front: *Greenstem Paperflower, Spring Beauty, Mountain Forget-Me-Not. Back: Carmen Gilia, Dusty Penstemon.*

B

Figure 4-34. _____
Having too many or too few words per line also decreases the readability of the text. **A**—This example has too many words per line. **B**—This example has too few words per line. Both examples are slightly more difficult to read than Figure 4-33B.

There are hundreds of beautiful wildflower species found in the Rocky Mountains. Shown on the front: *Greenstem Paperflower, Spring Beauty, Mountain Forget-Me-Not. Back: Carmen Gilia, Dusty Penstemon.*

A

There are hundreds of beautiful wildflower species found in the Rocky Mountains. Shown on the front: *Greenstem Paperflower, Spring Beauty, Mountain Forget-Me-Not. Back: Carmen Gilia, Dusty Penstemon.*

B

Photoshop measures text in points (pt) format by default. For example, when you choose a font size of 12, it will actually be 12 point text, unless you change the type preferences. A *point* is a tiny unit of measure—1/72 of an inch. With that in mind, graphic designers should be aware of these recommended font sizes:

- Headings in a graphic design should be 14 points and up. Keep in mind that many designs (such as posters) should be easy to read from several feet away.

- Body text in a graphic design should be no smaller than 10–12 points.

Summary

You have studied layers and selections in the previous two chapters. As you have experimented with Photoshop, you may have noticed that selections are independent of layers. In other words, if you have created a selection, you can switch to a different layer and use the same selection again.

You have learned that there are many ways to manipulate and organize layers. In this chapter, you have been introduced to the basics. Later in this book, you will encounter another chapter that will acquaint you with more advanced layer techniques, including methods of blending layers together.

CHAPTER TUTORIALS

> **Note** The files needed to complete the tutorials in this book can be downloaded from the *Learning Photoshop CS4 Student Companion Web Site*. Refer to the "Using the Companion Web Site" section of the book's Introduction for more information.

The following tutorials will show you how to create a symmetrical design using the layer techniques discussed in this chapter. You will also create a postcard design and the "ostrichville" billboard design discussed in this chapter. After completing the tutorials, you will save your designs and make further modifications to them later.

Tutorial 4-1: Create the Leafy Design

This tutorial will give you experience creating, organizing, and transforming layers in order to create a composite design. You will also use the grid to help you position the elements that make up the design.

Part 1: Introduction to Layers

In this part of the tutorial, you will open a previous tutorial and rename the layers containing the leaves.

1. Open Photoshop.

2. Open the 03leafy.psd file that you created in an earlier chapter.

3. Click on the **Layers** panel tab and drag it until it is next to the 03leafy.psd image window. Click and drag the bottom edge of the panel to resize it as needed.

 Each leaf is on a separate layer. Every time you dragged a leaf over to the 03leafy.psd file, a new layer was automatically created.

4. Click the **Move Tool**.

5. In the options bar, place a check mark in the **Auto-Select** check box.

6. In the options bar, place a check mark in the **Show Transform Controls** check box.

7. Use the **Move Tool** to click on each of the leaves.

 As you click on a leaf, a box (transform controls) appears around the leaf and the leaf's layer is highlighted (auto-selected) in blue in the **Layers** panel.

8. With the **Move Tool**, click on the large dark green leaf in the top center of the image window.

 The layer that contains the leaf is highlighted in the **Layers** panel.

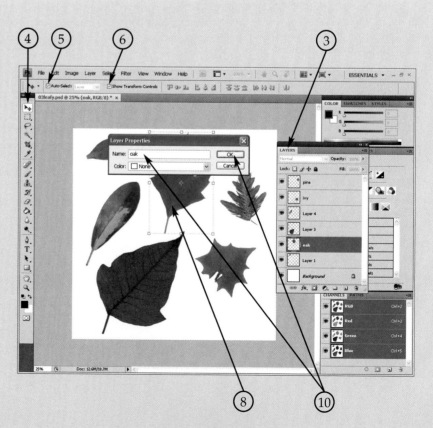

9. Choose **Layer > Layer Properties…**.

 This opens the **Layer Properties** dialog box.

10. Enter oak as the name of the layer and click **OK**.

11. Continue to rename the layers, using the names shown.

12. Click on the arrow in the upper right corner of the **Layers** panel and choose **Panel Options…** from the menu.

13. If a smaller size thumbnail option is available, select it and click **OK**. If no smaller thumbnail option is available, click **Cancel**.

 If you selected a smaller thumbnail option, each layer appears a little smaller in the **Layers** panel.

14. If you are not going to continue with the remaining parts of this tutorial, save your work.

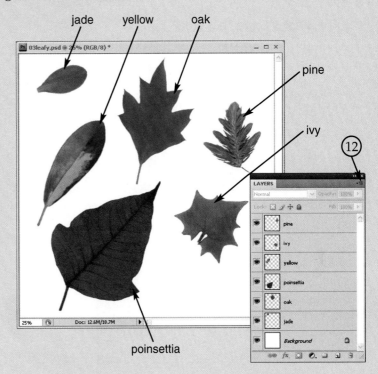

Part 2: Using the Grid

In this part of the tutorial, you will set up and display the grid to assist you in creating the design. You will also experiment with moving a layer with snap on and with snap off.

1. If necessary, open the 03leafy.psd image.

2. Choose **View > Show > Grid**.

 This makes the grid appear on your image.

3. Choose **Edit > Preferences > Guides, Grid & Slices…** (or **Photoshop > Preferences > Guides, Grid & Slices…** for Mac).

4. In the **Preferences** dialog box, enter the settings shown and click **OK**.

5. Use the **Move Tool** to slowly drag the jade leaf to the bottom-left corner.

 As you perform this step, do not click and drag the symbol in the center of the bounding box that surrounds the jade leaf. It is used to rotate objects. If you move this symbol by mistake, press [Esc].

 Do you notice the jerky movement of the leaf as you drag it? The leaf is trying to line up with the gridlines as it is moved—this is called snapping to the grid.

6. Choose **View > Snap To > Grid**.

 This turns off the snap-to-grid option. You can tell the option is no longer active because the check mark is removed from the **Grid** option in the **Snap To** submenu.

7. Choose **View > Snap To > Layers**.

 This turns off the snap-to-layers option. If left on, the snap-to-layers option may also interfere with the movement of the leaf.

8. Move the jade leaf a little. Notice it moves smoothly now.

 Another way to move a selected layer is to use the arrow keys on your keyboard. When you use the arrow keys to move a selection, the snaps settings do not affect the movement.

9. With the **Move Tool** active, use the arrow keys to move the jade leaf so it is in the position shown. You may need to reposition the other leaves to make room.

10. In the **Layers** panel, click on the layer named yellow to make it active.

 You know the layer is active because it is highlighted in blue in the **Layers** panel.

11. Press [Ctrl] (or [Command] for Mac) and click the pine layer.

 The yellow and pine layers should both be highlighted in blue in the **Layers** panel.

12. Click the **Move Tool**.

13. Experiment with moving the leaves around a little.

 The leaves stick together as they are moved.

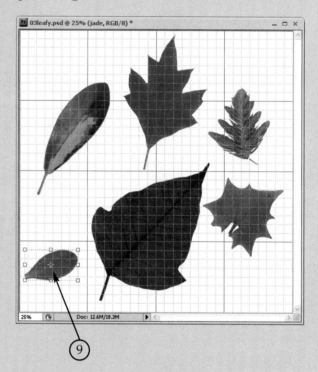

14. Move the two layers upward, as shown.

15. If you are not going to continue with the remaining parts of this tutorial, save your work.

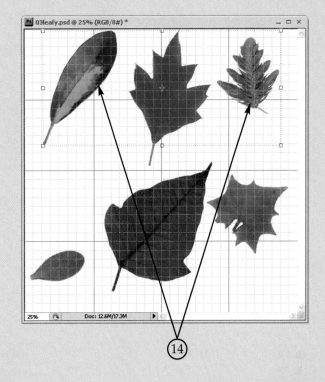

Part 3: Layer Visibility

In this part of the tutorial, you will experiment with hiding layers to unclutter your work area. Toggling visibility on and off is also useful for selecting layers to merge.

1. If necessary, open the 03leafy.psd image.

2. Click the **Layer visibility** (eye) toggle next to each layer.

 This hides all of the layers.

3. Click on the jade layer to make it active.

4. Restore the visibility of the jade layer by clicking the **Layer visibility** toggle again.

5. Turn on the Background layer by clicking its **Layer visibility** toggle.

6. Move the jade leaf to the center of the 03leafy.psd image.

7. If you are not going to continue with the remaining parts of this tutorial, save your work.

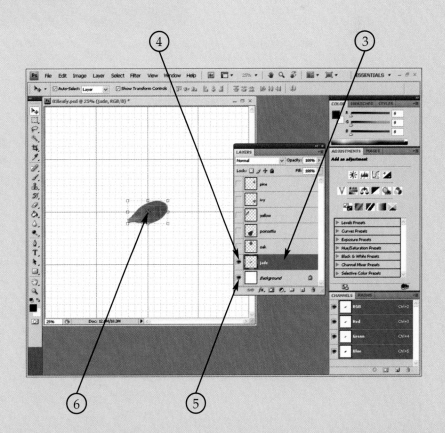

Part 4: Rotate (Transform) a Layer

In this part of the tutorial, you will rotate a layer using the transform controls associated with the **Move Tool**.

1. If necessary, open the 03leafy.psd image.

2. Zoom in on the jade leaf by dragging a zoom box around the leaf.

3. Make sure the jade layer is active and click the **Move Tool**.

4. Position the cursor outside one corner of the leaf's bounding box and keep it there until the rotate cursor appears.

5. Click and drag the cursor until the jade leaf is rotated –85°.

 As the leaf rotates, it pivots around the reference point. The options bar shows you how many degrees the leaf has been rotated. You can also enter an exact amount.

6. Press [Enter] or [Return] or click the **Commit** button on the options bar to end the rotate command.

 If you make a mistake and need to start over press [Esc] or click the **Cancel** button.

7. If you are not going to continue with the remaining parts of this tutorial, save your work.

Part 5: Duplicate a Layer

In this part of the tutorial, you will duplicate and transform a layer.

1. If necessary, open the 03leafy.psd image.

2. With the jade layer active, choose **Layer > Duplicate Layer...**.

3. Name the new layer jade 2.

4. Click **OK**.

 A new layer is created just above the jade layer in the **Layers** panel, and a new jade leaf is created exactly on top of the old one.

5. Rotate the new leaf 31° and press [Enter] or [Return] or click the **Commit** button to complete the rotation.

6. Use the arrow keys to move it to the location shown.

 The leaves should barely touch where the X appears.

7. If you are not going to continue with the remaining parts of this tutorial, save your work.

Part 6: Merging Layers

In this part of the tutorial, you will create a repeating pattern by duplicating, transforming, and then merging layers.

1. If necessary, open the 03leafy.psd image.

2. Hide the Background layer by clicking its **Layer visibility** (eye) toggle.

 The jade and jade 2 layers should be visible. All other layers should be hidden.

3. Make sure the jade 2 layer is active (highlighted in blue).

4. Choose **Layer > Merge Visible**.

 This command merges both leaves onto a single layer.

5. Choose **Layer > Duplicate Layer…**. In the **Duplicate Layer** dialog box, click **OK** to accept jade 2 copy as the name.

6. Zoom and adjust your view as needed. Then, rotate the new layer 60° and move it to the position shown.

 Pressing and holding [Shift] while rotating an object causes the object to be rotated in 15° increments.

7. Press [Enter] or [Return] or click the **Commit** button to complete the rotation.

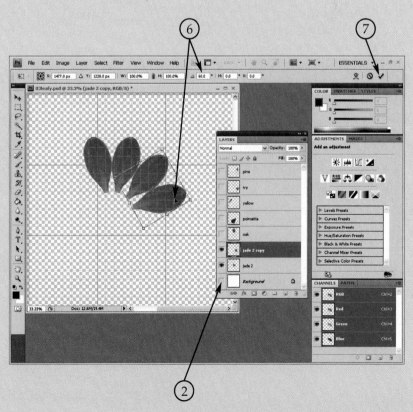

8. Choose **Layer > Merge Visible**.

 Now, all four leaves should be on the same layer.

9. Choose **Layer > Properties…**.

10. In the **Layer Properties** dialog box, name this layer 4 jade leaves and click **OK**.

 At this point, you may want to reposition the jade leaves on the grid so that a major gridline passes between the first and second leaves and along the bottom of the fourth leaf. This will make it easier to check the leaf wreath for symmetry as you continue to assemble it.

11. Choose **Layer > Duplicate Layer…**.

12. In the **Duplicate Layer** dialog box, click **OK** to accept 4 jade leaves copy as the name.

13. Hold down [Shift] and rotate this new layer until the **Rotate** text box in the options bar shows 120°.

14. Move the 4 jade leaves copy layer to the position shown.

15. Press [Enter] or [Return] or click the **Commit** button on the options bar.

16. Choose **Layer > Duplicate Layer…**.

17. In the **Duplicate Layer** dialog box, click **OK** to accept 4 jade leaves copy 2 as the name.

18. Adjust your view as needed, and then rotate the layer 120° and move it to the position shown.

 Move and rotate each layer as needed until your file looks like the example.

19. Press [Enter] or [Return] or click the **Commit** button on the options bar.

20. Choose **Layer > Merge Visible**.

21. Choose **Layer > Layer Properties…**.

22. In the **Layer Properties** dialog box, name the layer jade leaves.

23. If you are not going to continue with the remaining parts of this tutorial, save your work.

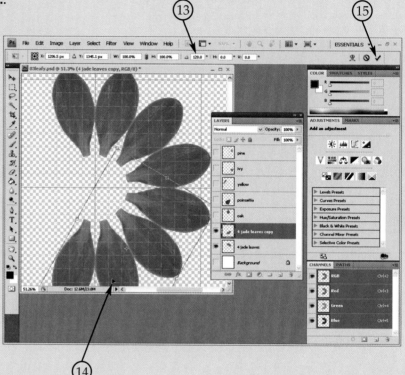

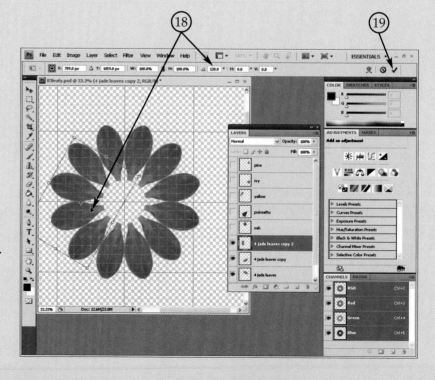

Part 7: Changing the Stacking Order of Layers

In this part of the tutorial, you will experiment with changing the stacking order of the layers. This will help you see how the stacking order changes the way the image appears in the image window.

1. If necessary, open the 03leafy.psd image.

2. Make the Background layer visible.

3. If you have not yet done it, move the jade leaves layer to the middle of the image. Use the grid as a guide.

4. Make the poinsettia layer visible by clicking its **Visibility** toggle.

5. In the **Layers** panel, click and drag the poinsettia layer so it is just below the jade leaves layer in the layer stack.

 Now, the poinsettia leaf appears to be behind the jade leaves in the image window.

6. If you are not going to continue with the remaining parts of this tutorial, save your work.

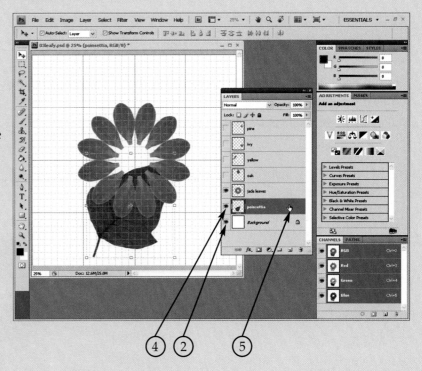

Part 8: Scale (Transform) a Layer

In this part of the tutorial, you will resize and reposition the poinsettia leaf used in the design.

1. If necessary, open the 03leafy.psd image.

2. Make sure the poinsettia layer is active.

3. Choose **Edit > Transform > Scale**.

 The option menu displays transform settings.

4. In the scaling area of the options bar, enter 60 in the **W** (width) text box and 60 in the **H** (height) text box.

 The poinsettia leaf is now 60% of its former size.

5. Press [Enter] or [Return] or click the **Commit** button to end the scaling process.

6. Move the poinsettia leaf to the location shown.

7. If you are not going to continue with the remaining parts of this tutorial, save your work.

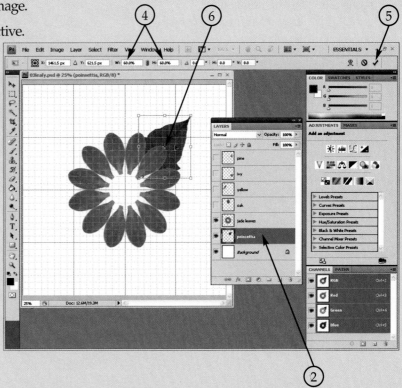

Part 9: Adding More Leaves to the Design

In this part of the tutorial, you will apply the techniques you have learned in the chapter to duplicate, transform, and merge layers to add the remaining leaves to the design.

1. If necessary, open the 03leafy.psd image.

2. Make sure the poinsettia layer is active.

3. Right-click (or [Ctrl]+click for Mac) on the poinsettia layer in the **Layers** panel and choose **Duplicate Layer** from the shortcut menu that appears.

4. In the **Duplicate Layer** dialog box, click **OK** to accept poinsettia copy as the name for this new layer.

5. Choose **Edit > Transform > Rotate 90° CCW**.

 This rotates the new layer 90° in the counterclockwise direction.

6. Move the new layer to the location shown.

7. In the **Layers** panel, drag the layers until they are in the order shown.

8. Click the poinsettia copy layer to make it active.

9. Choose **Layer > Merge Down**.

 This is another way to merge layers. The active layer merges with the layer just below it.

10. Now that the two poinsettia leaves are on the same layer, right-click on the poinsettia layer in the **Layers** panel and choose **Duplicate Layer**.

11. In the **Duplicate Layer** dialog box, click **OK** to accept the poinsettia copy name.

12. Choose **Edit > Transform > Rotate 180°**.

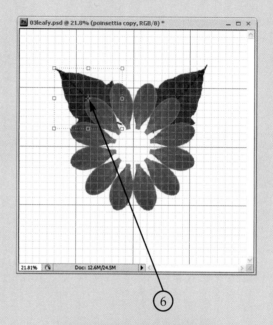

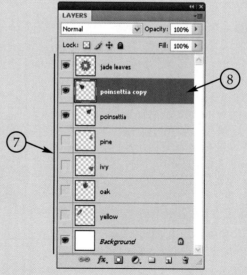

13. Move the new layer to the location shown.

14. Merge the two layers that contain poinsettia leaves.

15. Rename this layer poinsettia leaves.

16. Make the oak layer visible.

17. Rotate and move the oak layer so it is positioned at the top of the jade leaf ring. Adjust the zoom and your view as needed.

18. Click the **Lasso Tool** in the **Tools** panel.

19. Make sure the **New selection** button is pressed and that **Feather** is set to 0 in the options bar.

20. Create a selection border around the oak leaf stem, like the one shown.

21. Press [Delete].

 Only items on the oak layer are deleted, because it is the active layer.

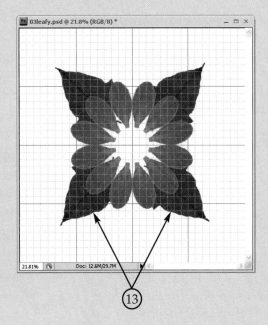

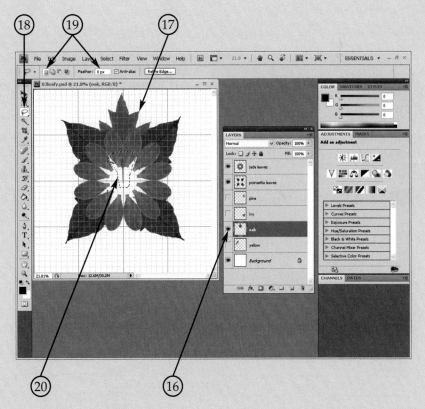

22. Continue duplicating, rotating, scaling, and merging layers until your design looks like the one shown.

 After adding the yellow leaves, use the **Elliptical Marquee Tool** to remove any stems that extend into the star-shaped center of the arrangement.

23. Choose **View > Show > Grid**.

 This turns off the grid.

24. Choose **File > Save As…**. In the **Save As** dialog box, name the file 04leafy.psd. You will add more to it later.

25. Close the 04leafy.psd image.

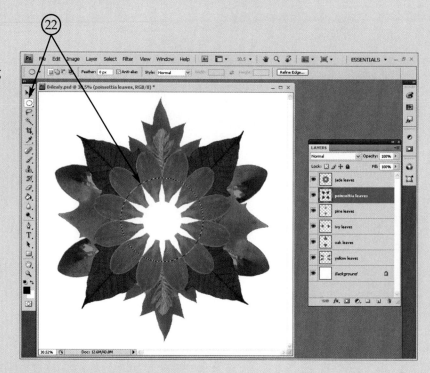

Tutorial 4-2: Create a Postcard Design

In this tutorial, you will combine various photos to create the front and back of a postcard. You will create and edit layers in a variety of ways, including lowering a layer's opacity setting to mute an image. This creates a popular effect you will find in many designs.

Part 1: Using Layers and Selection Tools to Design the Back of a Postcard

In this part of the tutorial, You will open an image that will serve as the primary image in a postcard design. You will create a new layer, fill it with white, and then convert it to a background layer. You will use the selection tools and layer commands to add new layers to the design. You will lower the opacity level of a layer to visually mute it and allow the white background to show through.

1. Open the file named Gilia.jpg.

2. In the **Layers** panel, double-click the Background layer.

3. In the **New Layer** dialog box, enter the name flowers and click **OK**.

 This step is necessary because you will be adding a new, white background layer in the following steps. Layers allow you to keep different parts of your design separate from each other.

4. Select **Layer > New > Layer…** and name the layer white fill. Then, click **OK** in the **New Layer** dialog box.

5. Choose **Edit > Fill…**.

6. In the **Fill** dialog box, select **White** from the **Use** drop-down list. Then, click **OK** to fill the layer with white pixels.

7. With the white fill layer still active, select **Layer > New > Background From Layer**.

 The white fill layer becomes the locked Background layer and is moved underneath the flowers layer.

8. Choose **Edit > Preferences > Guides, Grid & Slices…** (**Photoshop > Preferences > Grids, Guides, & Slices…** for Mac users).

9. In the **Grid** section of the **Preferences** dialog box, enter 1 in the **Gridline every** text box and select **inches** from the drop-down list. Enter a value of 4 in the **Subdivisions** text box.

10. Click the **OK** button.

11. Choose **View > Show > Grid** to turn on the grid.

 1" squares appear, subdivided into 1/4" sections.

12. Choose **View > Snap To > Grid**. A check mark should now appear next to the **Grid** command in the submenu. If not, choose **View > Snap To > Grid** again.

 This turns on grid snap, which will make it easy to position your selections exactly where you want them.

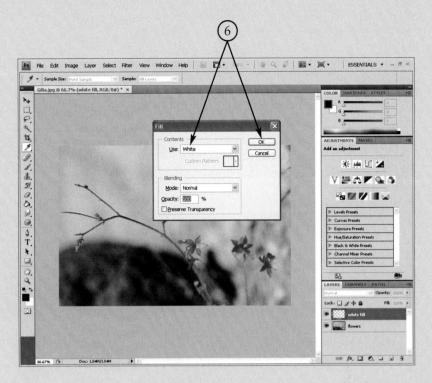

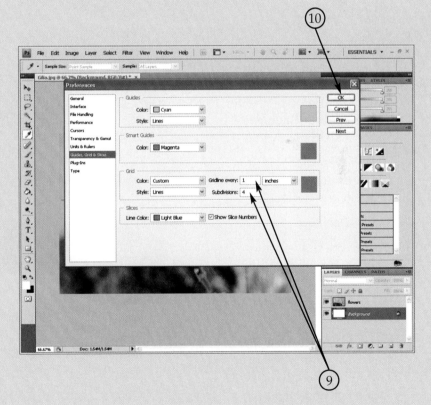

13. Click the **Rectangular Marquee Tool** in the **Tools** panel.

14. Select the flowers layer in the **Layers** panel, and then drag a selection border the same size and in the same location shown.

15. With the **Rectangular Marquee Tool** still active, tap the **down arrow key** on your keyboard 18 times. Then, tap the **right arrow key** 18 times.

 This positions the selection so three corners are off screen. When you feather and delete the selection in the following steps, the top and left edges will be feathered and the bottom and right edges will be clean.

16. Choose **Select > Modify > Feather…**. In the **Feather Selection** dialog box, enter 10 in the **Feather Radius** text box and click **OK**.

 The rectangular selection now has rounded corners because of the feather effect.

17. Press [Delete].

 Part of the flowers layer is deleted, causing a white area to be visible. This area will be for the postal service to print a bar code.

18. Choose **Layer > New > Layer…**. In the **New Layer** dialog box, name the layer stamp box and click **OK**.

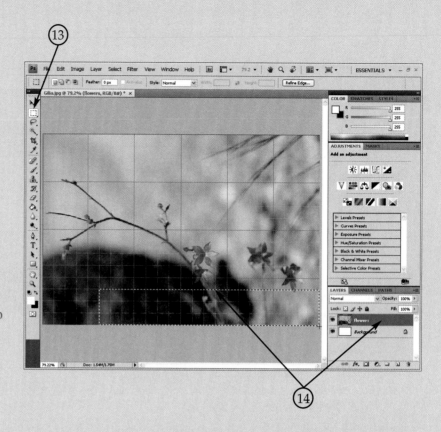

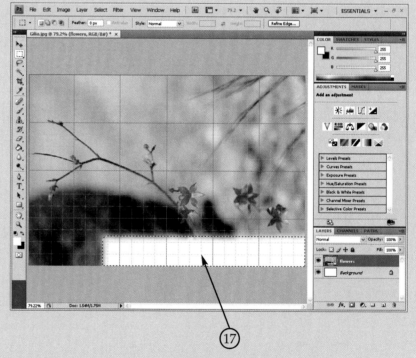

19. The **Rectangular Marquee Tool** should still be active. In the options bar, choose **Fixed Size** from the **Style** drop-down list.

20. In the **Width** text box, enter .65 in ("in" is an abbreviation for inches). In the **Height** text box, enter .9 in.

21. Click to place the rectangular selection, then move it so the top-right corner of the selection is one grid line from the top and one grid line from the right edge of the image. To move the selection, use the arrow keys or click inside the selection and drag.

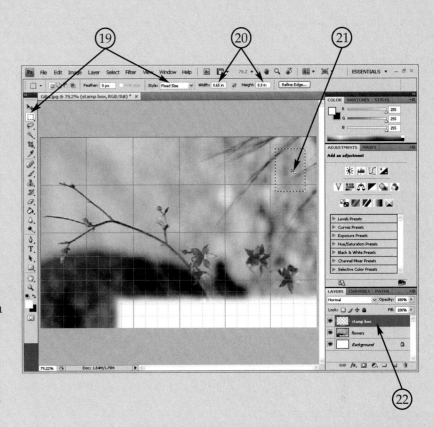

22. Make sure the stamp box layer is still selected in the **Layers** panel.

23. Choose **Edit > Fill...**. In the **Fill** dialog box, select **White** from the **Use** drop-down list and click **OK** to fill the layer with white pixels.

24. Choose **Select > Modify > Border...**.

25. In the **Border Selection** dialog box, enter a value of 5 in the **Width** text box and click **OK**.

26. Choose **Edit > Fill...**. In the **Fill** dialog box, select **Black** from the **Use** drop-down list and click **OK** to fill the border with black pixels.

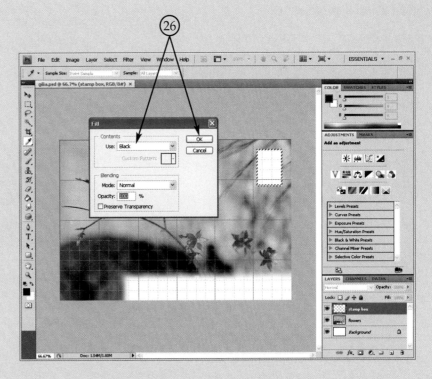

The black color bleeds outside of the selection. This is because the **Border** command automatically applies a slight feather effect.

27. Choose **File > Save**. Name the file 04cardback and choose the PSD format.

28. Without closing the Gilia.jpg file, open the Dusty.jpg file.

29. Click the **Elliptical Marquee Tool** in the **Tools** panel.

 Remember that the **Elliptical Marquee Tool** is accessed by clicking on the **Marquee Tool** button and holding the mouse button until the additional tools appear.

30. Create a oval-shaped selection around the flower. Press the [Spacebar] as you create the selection to move it to the location shown.

31. Click the **Move Tool** in the **Tools** panel.

32. In the options bar, place a check mark in the **Auto Select** check box and select **Layer** from the drop-down list.

33. Put a check mark in the **Show Transform Controls** check box.

34. Choose **Edit > Copy**.

35. Click on the 04cardback.psd image window tab to make it active.

36. Choose **Edit > Paste**.

 When you use the **Paste** command, a new layer is automatically created.

37. Choose **Edit > Transform > Scale**.

38. In the options bar, enter 24% in both the **W** (width) and **H** (height) text boxes.

39. Click the **Commit** (check mark) button at the far right end of the options bar to complete the **Scale** command.

40. Click inside the bounding box and drag the purple flower to the location shown.

41. Click the **Close** button on the Dusty.jpg image window tab. Do *not* save the changes.

 The Gilia.jpg image should now be active.

42. Choose **File > Save As…**. In the **Save As** dialog box, name this file 04cardback and select **Photoshop (*.PSD, *.PDD)** from the **Format** drop-down list. Pick the **Save** button to save the file.

43. Click on the flowers layer in the **Layers** panel.

44. In the **Layers** panel, set the **Opacity** slider to 30%.

 The white background shows through, causing the image to appear lighter.

45. Choose **File > Save**.

46. Select the **Rectangular Marquee Tool** in the **Tools** panel and then select **Normal** from the **Style** drop-down list.

 Since the **Rectangular Marquee Tool** had been set to **Fixed Size**, this step restores the **Rectangular Marquee Tool** to the more familiar style of clicking and dragging to make selections.

47. Close the 04cardback.psd file. You will add more to it later.

Part 2: Using Layers and Selection Tools to Design the Front of a Postcard

In this part of the tutorial, you will open an image that will serve as the background of your design. You will use the **Elliptical Marquee Tool** to select content on two other images, and then drag and drop that content into separate layers on the postcard design. You will then scale and move those layers.

1. Open the Paper.jpg file.

 This 6″ × 4″ image will become the front of a postcard.

2. Open the Beauty.jpg file.

3. Click the **Elliptical Marquee Tool** in the **Tools** panel.

4. Hold down [Shift] and drag a circle around some of the pink flowers, as shown.

5. Use one of these methods to copy the pink flowers to the Paper.jpg file:

 Method 1:

 • Select the **Move Tool.**

 • Drag the selected pink flowers on top of the Paper.jpg image window tab and hold the cursor on top of the tab until the Paper.jpg image opens.

 • Move the cursor down into the Paper.jpg image and release the mouse button to copy the selected pixels.

 Method 2:

 • Choose **Edit > Copy**.

 • Click on the Paper.jpg image window tab and choose **Edit > Paste**.

6. Close the **Close** button on the Beauty.jpg image window tab. If asked, do not save changes.

 The Paper.jpg image becomes active.

7. Choose **Edit > Transform > Scale.** In the options bar, enter 60% in the **W** and **H** text boxes.

8. Click inside the bounding box and drag the pink flower layer to the location shown. Click the **Commit** button to complete the transformation.

 The opacity of the Background layer has been lowered for illustration purposes. The Background layer in your image will look slightly different.

9. Open the file named Mountain.jpg.

10. Create a circular selection around the purple flowers.

11. Use any method to copy the purple flowers and paste them onto the Paper.jpg image.

Note: Background muted for illustration purposes only.

12. Use the **Edit > Transform > Scale** command to scale the selection to 50%. Then, move it next to the pink flowers.

Again, the opacity of the Background layer has been lowered for illustration purposes. The Background layer in your image will look slightly different.

13. Close the Mountain.jpg file and do *not* save the changes.

14. Choose **View > Show > Grid** to turn off the grid.

15. The Paper.jpg image should still be on your screen. Choose **File > Save As...**.

16. In the **Save As** dialog box, name this file 04cardfront and select **Photoshop (*.PSD, *.PDD)** from the **Format** drop-down list. Pick the **Save** button to save the file.

You will add more to this file in later tutorials.

17. Close the 04cardfront.psd file.

Note: Background muted for illustration purposes only.

Tutorial 4-3: Create the "Ostrichville" Billboard Design

In this tutorial, you will create a repeating-pattern design using the grouping and transforming techniques you learned in this chapter.

1. Open the file named ostrichville.psd.

2. Using the techniques learned in this chapter, create the design shown. Organize your layers using grouping techniques instead of merging techniques.

3. After completing the design, choose **File > Save As...** and name the file 04ostrichville.psd.

4. Close the 04ostrichville.psd image. You will add more to it later.

Key Terms

body text
bounding box
clipboard
color depth
contextual menu
destination image
document bounds
flatten
flip

grid
headings
justification
layer group
layers
linking
lists
lock

merging
point
scale
skew
slices
smart guides
thumbnails
toggled

Review Questions

Answer the following questions on a separate sheet of paper.

1. What is an *active layer*?

2. What keyboard shortcut lets you temporarily switch to the **Move Tool**?

3. What does the **Move Tool**'s **Auto-Select** option do?

4. When does the **Move Tool** automatically create a new layer?

5. If you move a layer over to another file, and the content you moved appears smaller, what caused this?

6. How can you cause the transform options bar to appear without choosing any menu commands?

7. What are two different ways of changing the bounding box's reference point?

8. What does the **Maintain aspect ratio button** do when clicked?

9. When using the bounding box to scale an image, what happens if you do not hold down [Shift] after you begin to drag a corner of the bounding box?

10. How can you rotate a bounding box in increments of 15°?

11. You can only copy and paste from one layer at a time unless you use what command?

12. What is the difference between **View > Snap** and **View > Snap To** menu choices?

13. How do you place a selection border around the content of a layer without manually drawing the selection?

14. For a layer to appear "in front" of all other layers in your file, where should it be listed (or stacked) in the **Layers** panel?

15. When a new layer is created, where is it listed (or stacked) in the **Layers** panel?

16. Which method of deleting a layer is the fastest?

17. If you hide a layer (turn off its visibility), how do you show it again?

18. What is the difference between grouping and linking layers?

19. What is the difference between grouping and merging layers?

20. What does flattening do to an image?

21. What is the difference between the **Opacity** and **Fill** sliders in the **Layers** panel?

22. What file formats let you save (preserve) transparent areas of an image?

23. How do you unlock a Background layer?

24. What is the difference between the **Lock image pixels** button and the **Lock transparent pixels** button on the **Layers** panel?

25. What are *layer thumbnails*?

5
Text, Shapes, and Layer Styles

Learning Objectives

After completing this chapter, you will be able to:

- Explain the differences between vector and bitmap graphics.
- Use the type tools to enter and edit text.
- Explain how to find special text characters and insert them into your file.
- Use the type masking tools to create a selection.
- Use the **Character** and **Paragraph** panels to fine-tune the appearance of text.
- Explain why it is sometimes necessary to rasterize text and shapes.
- Use the shape and pen tools to create simple and complex shapes.
- Explain how to create your own custom shapes.
- Use the **Paths** panel to convert paths into other Photoshop features.
- Use both the **Layer** menu and the **Styles** panel to apply layer styles to your projects.

Introduction

In this chapter, you will learn about using Photoshop to draw vector graphics. With vector graphics, you can create any shape you can imagine and fill it with a color or pattern.

You will also learn how to manipulate text in many different ways. As you read through the chapter, you will discover that you can apply a variety of effects such as drop shadows and beveled edges (called *styles*) to text or shapes. See **Figure 5-1**.

Figure 5-1.
Various combinations of Photoshop's styles have been applied to a circle shape and a text example. The **Styles** panel, discussed at the end of this chapter, was used to instantly apply these effects.

Two Kinds of Graphics: Vector vs. Bitmap

Any image captured by a digital camera or scanner is called a *bitmap graphic* (also called a *raster graphic*). Bitmap graphics are made up of pixels. You learned in Chapter 2, *Resolution*, that as a bitmap image is enlarged, it loses quality because its pixels get larger.

Vector graphics are different. If you draw a circle that is a vector graphic, you can resize it and it will not lose any quality. Vector graphics are *not* made up of pixels—they are composed of lines that are controlled by mathematical formulas. These lines can be edited easily or filled with colors or patterns.

Text in Photoshop

Text is similar to a vector graphic—it can be changed to various fonts, sizes, and styles. But unlike a true vector graphic, the shape of each text character cannot be changed.

Type is a word borrowed from the printing industry. It refers to individual text characters that were set by hand, inked, and pressed against paper in the early days of the printing industry. Adobe chose to call text-related tools *type tools* instead of text tools. There are four type tools, the **Horizontal Type Tool**, the **Vertical Type Tool**, the **Horizontal Type Mask Tool**, and the **Vertical Type Mask Tool**.

The Horizontal Type Tool and the Vertical Type Tool

The **Horizontal Type Tool** and **Vertical Type Tool** are used to add text to an image. If you have done any graphic design or desktop publishing work on a computer, you have probably already been exposed to tools that are very similar to these.

Once you select the appropriate type tool, click in the image, set the options, and enter text with your keyboard. Controls in the tools' options bars allow you to adjust the text properties.

The Type Tool Options Bar

The options bar is the same for all of the type tools. See **Figure 5-2**. At the far left of the options bar is an icon that indicates which type tool is selected. Immediately to the right of this icon is the **Change the text orientation** button. Clicking this button changes the text orientation from horizontal to vertical or vice versa.

The font that the type tool uses is selected in the **Set the font family** drop-down list. When you click on the arrow, a list of available fonts appears. You can use the up and down arrow keys to scroll through the list.

The style of the font is selected in the **Set the font style** drop-down list. Common font styles include regular, italic, bold, and bold italic, but will vary from font to font.

Next, select the size of the font in the **Set the font size** drop-down list. Common font sizes are included in the list. However, you can enter a custom size in the text box if the size you want is not listed.

Figure 5-2. _____

The options bar for all four text tools look almost identical.

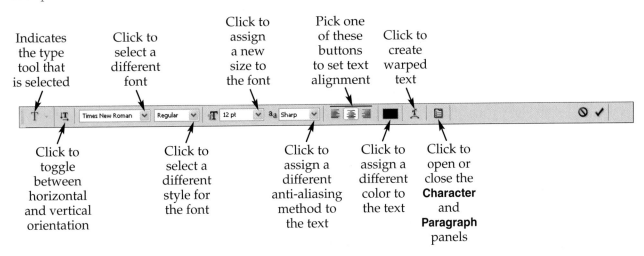

The Set the anti-aliasing method drop-down list is located to the right of the **Set the font size** drop-down list. This setting controls how "soft" the edges of your text will appear. A setting of **None** creates the sharpest edge, and a setting of **Smooth** creates the softest edge. The default setting is **Sharp**, and it works well in most cases.

Next to the **Set the anti-aliasing method** drop-down list are three buttons that allow you to set the justification (alignment) of the text. The three text-alignment options available on the options bar are **Left align text**, **Center text**, and **Right align text**.

There is a small color box on the options bar. Clicking on this box opens the **Color Picker**. In the **Color Picker**, you can choose a new color for the text.

The **Create warped text** button looks like a letter T with a curved line under it. Warp effects are added after text has been created. To add warp effect to text, make sure the layer containing the text is active. Then, click the **Create warped text** button or choose **Layer > Type > Warp Text...**. This opens the **Warp Text** dialog box. Choose a warp style from the **Style** drop-down menu, and experiment with the **Bend, Horizontal Distortion,** and **Vertical Distortion** slider settings to change the warp effect. See **Figure 5-3.**

Figure 5-3. _____

Interesting effects can be added to text by warping it. **A**—The **Warp Text** dialog box contains the settings for warping text. **B**—Select a warp style from the **Style** drop-down list. **C**—The top line of text is normal. A fish warp has been applied to the bottom line of text.

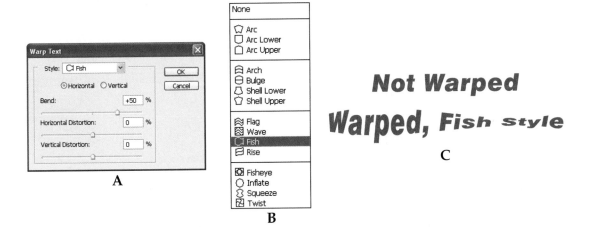

Clicking the **Toggle Character and Paragraph panels** button will display or hide the **Character** and **Paragraph** panels, which contain many controls for fine-tuning text. The **Character** and **Paragraph** panels are explained in more detail later in this chapter.

Entering and Editing Text

There are two ways to enter text using the **Horizontal Type Tool** or the **Vertical Type Tool**. For short text entries, click anywhere in your image and start typing. You can move the text after typing because the cursor turns into a **Move Tool** automatically when you move the cursor away from the text. For longer text entries, such as a paragraph, drag a box with the cursor. The selected area becomes a bounding box. The edges of the box serve as margins, which can be adjusted by dragging the bounding box handles. To add text, simply start typing.

When you create text, a new text layer is automatically created. You can easily spot a text layer in the **Layers** panel because a large letter T is displayed where the thumbnail would be on a normal layer. See **Figure 5-4**. When you are finished adding text, click the **Commit** button at the far right end of the options bar. Clicking the **Commit** button completes the text layer. If you click in your file and start typing again after clicking the **Commit** button, a new text layer will be created. Clicking the **Cancel** button is similar to choosing **Edit > Undo**.

You can easily edit a text layer. As a general rule, if you want to change the color, size, font, etc., of text after it has already been created, make sure the correct text layer is active. Then, adjust the settings in the options bar. If for any reason you have trouble doing this, try highlighting the text before changing it. To highlight the text, begin by making sure the proper type tool is active. Check to see that the correct text layer is active. Then, place the cursor on top of the first or last text character, click and hold the mouse button and drag the cursor over the text you want to highlight.

Figure 5-4.

The letter T appears next to each text layer in the **Layers** panel.

The bounding box determines the extents of the text

Commit button

A large T in the thumbnail indicates this is a text layer

Two other familiar word processing commands, **Check Spelling** and **Find and Replace Text**, are found in the **Edit** menu. These commands will search all text layers in your file, no matter what layer is currently active.

The Type Masking Tools

The **Horizontal Type Mask Tool** and **Vertical Type Mask Tool** do not create text. Instead, they create a selection that is shaped like text. When you select one of these tools and click in your file, a pink mask covers your entire document. After entering text and clicking the **Commit** button, a selection is created in the image window, **Figure 5-5**. This procedure is similar to using quick mask mode, explained in Chapter 3, *Selection Tools*.

Why would you ever want to create a selection shaped like text? One situation might be to create a cutout effect by placing the text selection over an image and then pressing [Delete].

Inserting Special Text Characters

You will often need to insert special text characters such as bullets (• ◊ ❖), the copyright symbol (©), the degree symbol (°), etc. To do this, first make sure the layer containing the text you want the symbol inserted into is active. Next, select the **Horizontal Type Tool** and click in the text line where you want the symbol to be inserted. Make sure the cursor is at the position where you want the symbol inserted. Use the arrow keys to move it if it is not.

Next, if you are using a computer with a Windows operating system, minimize Photoshop and choose **Start > (All) Programs > Accessories > System Tools > Character Map** from Window's **Start** menu. In the **Character Map** dialog box, select the appropriate font from the **Font** drop-down list. Locate and click the desired symbol in the symbol window. Next, click the **Select** button. The character will appear in the **Characters to copy** text box. Finally, click the **Copy** button. Press [Alt][Tab] or pick the Photoshop icon at the bottom of the taskbar to return to your Photoshop file. Make sure the correct font is selected in the type tool's options bar before choosing **Edit > Paste**.

If you are running Photoshop on a Mac using OS 10.3 or later, use the application called Keyboard Viewer to select, copy, and paste characters. If your computer is

Figure 5-5. ——
The type masking tools create type-shaped selections. **A**—A pink mask covers the image as you enter text with the type mask tools. **B**—A selection is left behind after clicking the **Commit** button.

A **B**

running OS 10.2x or earlier, use the application called Key Caps. If you have trouble finding Key Caps or Keyboard Viewer, press [Command][F] and search for it. When using either of these applications, begin by choosing a font. Then, press a "modifier key" (such as [Option], [Command], [Ctrl], or [Shift]) to see what additional characters are available. When you copy and paste characters into your Photoshop document, be sure to choose the same font in the type tool's options bar before choosing **Edit > Paste**.

The Character Panel

You can access the **Character** panel two different ways: by clicking the **Toggle the Character and Paragraph panels** button on the options bar or by choosing **Window > Character**, Figure 5-6. Once you are done adjusting your text, you can click the double arrow button at the top-right of the panel to collapse it again.

The **Character** panel contains many settings that help you precisely control how your text appears. A description of each setting is found in the following table, Figure 5-7. Some of these settings will be familiar because they are also present in the type tools' options bar. However, you will see that the additional controls in the **Character** panel provide much greater control over the text.

The Character Panel Menu

At the top of the **Character** panel is a small arrow button with three lines next to it. Clicking this button opens the **Character** panel menu, Figure 5-8.

Figure 5-6. _____

The **Character** panel is used to adjust the appearance of text. It can be accessed a number of different ways.

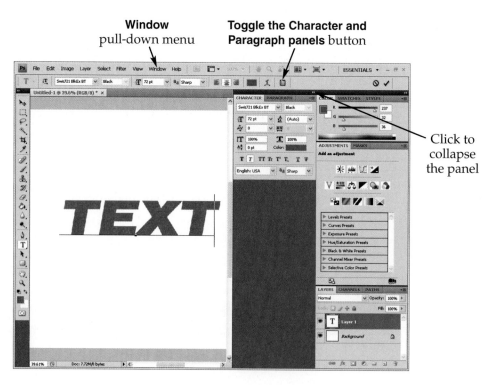

Figure 5-7.
This chart contains brief descriptions of the settings found on the **Character** panel.

Location on the Character panel	Description of the option	How to use the option	Examples
	Font, Style, and **Size** These settings are also found on the options bar of any type tool.	If you want to change text that you have already created, highlight it first.	Font, style, and size **Font, style, and size** *Top: Times New Roman 12 pt regular style.* **Bottom:** *Changed to Helvetica 14 pt bold oblique style.*
	Leading Controls the space between lines of text. The **Auto** setting creates a line spacing that is the same height as the text plus 20% more.	Highlight the text and do one of the following: A) drag the leading icon, B) enter a new value in the text box, or C) select one of the presets from the drop-down list.	**Leading controls the space between lines.** **Leading controls the space between lines.** *Top: Leading's* **Auto** *setting.* **Bottom:** *Leading increased.*
	Kerning Controls the space between *two* text characters.	Click between the letters and drag the kerning icon, enter a new value in the text box, or select one of the presets from the drop-down list.	Kerning Kerning *Top: No Kerning.* **Bottom:** *Kerning has been adjusted between the "k" and "e" and "n" and "g".*
	Tracking Controls the space between *all* highlighted text characters.	Highlight the text and drag the tracking icon, enter a new value in the text box, or select one of the presets from the drop-down list.	**Tracking setting: 0** **Tracking setting: 75** *Top: Default tracking setting.* **Bottom:** *Tracking increased.*
	Vertical and Horizontal Scaling Makes text larger or smaller, vertically or horizontally.	Highlight the text that needs to be scaled. Drag the scaling icon or enter a new percentage in the text box.	Scaling Scaling *Top: No scaling.* **Bottom:** *Vertical scaling at 200%.*
	Baseline Shift Moves the baseline (bottom reference point) of the text up or down.	Highlight the text and drag the baseline shift icon or enter a new value in the text box.	$3x_2 + x = 3y$ $3x^2 + x = 3y$ *Top: The "2" was changed to a smaller font size.* **Bottom:** *The baseline of the number "2" has been shifted.*

(Continued)

Figure 5-7.
Continued.

Location on the **Character** panel	Description of the option	How to use the option	Examples
	Text Color This setting is identical to the color box on the options bar of any type tool.	Highlight the text first. Click the box, and then select a color from the **Color Picker**.	**Text color** **Text color** *Top:* The font is the default black. *Bottom:* A different color is assigned to the font.
	*The next eight entries refer to the text style buttons found on the **Character** panel.*		
	Faux Bold Applies a bold style to fonts that do not normally have a bold option.	Highlight the text before clicking this button.	*Regular Text* *Faux Bold* *Top:* The only style available for this font is regular. *Bottom:* The faux bold option simulates a bold font style.
	Faux Italic Applies an italic style to fonts that do not normally have an italic option.	Highlight the text before clicking this button.	Regular Text *Faux Italic* *Top:* Comic Sans font in the regular style. *Bottom:* The faux italic option simulates an italic font style.
	All Caps Changes text to capital letters.	Highlight the text before clicking this button.	Regular Text ALL CAPS *Top:* Text displayed in uppercase and lowercase. *Bottom:* The **All Caps** option changes all characters to uppercase.
	Small Caps Changes all letters to uppercase and uses smaller uppercase letters for the letters that were lowercase.	Highlight the text before clicking this button.	Regular Text SMALL CAPS *Top:* Text displayed in uppercase and lowercase. *Bottom:* Text created with the **Small Caps** option.

(Continued)

Figure 5-7.
Continued.

Location on the **Character** panel	Description of the option	How to use the option	Examples
T T TT Tr T¹ T, T ₸	**Superscript** Makes text smaller and raises its baseline.	Highlight the text before clicking this button.	**$25.37** **$25.³⁷** *Top: A price written with regular text.* *Bottom: The dollar sign and cents are changed to superscript. This is a common practice.*
T T TT Tr T¹ T, T ₸	**Subscript** Makes text smaller and lowers its baseline.	Highlight the text before clicking this button.	**Regular Text** **₍sub₎script** *Top: Regular text.* *Bottom: Subscript option used on the prefix. Subscript can be useful when designing simple logos.*
T T TT Tr T¹ T, T ₸	**Underline** Places an underline below text.	Highlight the text before clicking this button.	**$25.³⁷** **$25.³⁷** *Top: A price written with superscript dollar sign and cents.* *Bottom: An underline effect is placed under the cents in the price. This is a common technique.*
T T TT Tr T¹ T, T ₸	**Strikethrough** Places a line through text.	Highlight the text before clicking this button.	**$19.95** **$~~25.37~~** *Top: The price written with regular text.* *Bottom: Strikethroughs can be used to cross out "old" prices on an advertisement.*
[Character panel image]	**Language Setting** Selecting the appropriate language ensures that the **Check Spelling** command works properly.	Click on the drop-down list and select the appropriate language.	
[Character panel image]	**Anti-Aliasing** These settings are also found on the options bar of any type tool.	Click the drop-down list and select the appropriate anti-aliasing method.	

Figure 5-8. _____
The **Character** panel menu contains a number of options for adjusting text style.

Click to access the **Character** panel menu

The **Change Text Orientation** command switches text from horizontal to vertical, or vice versa. When horizontal text is switched to vertical, the characters remain vertically oriented as long as the **Standard Vertical Roman Alignment** toggle is active. If this option is turned off, the characters for vertical text are aligned horizontally instead of vertically. See **Figure 5-9**.

The **Character** panel menu also contains the **OpenType** submenu. This submenu is only available if you are using certain OpenType fonts, designated by an "O" in the font list, **Figure 5-10**. OpenType fonts are cross-compatible with both Windows and Mac operating systems. Some (but not all) OpenType fonts have more features than other fonts, such as fractions, *ligatures* (blending two letters together), *ordinals* (the small, raised letters found in 1st, 2nd, etc.) and other alternatives. These additional features are selected from the **OpenType** submenu in the **Character** panel menu. You can choose these options before you begin typing, or edit them after the text has already been entered.

Figure 5-9. _____
The **Change Text Orientation** and **Standard Vertical Roman Alignment** options can be used together to change the alignment of the text. **A**—This text was created with the **Horizontal Type Tool** with the **Change Text Orientation** option off. **B**—This text was created with the **Horizontal Type Tool** with the **Change Text Orientation** and **Standard Vertical Roman Alignment** options active. **C**—This text was created with the **Horizontal Type Tool** with the **Change Text Orientation** option active, and the **Standard Vertical Roman Alignment** option off.

Figure 5-10. ———
The O next to a font means it is an OpenType font, compatible with both Windows and MacOS.
A—The three main types of fonts can be identified by the icon that appears in front of them in the
font list. **B**—An OpenType font was used to enter this text. After highlighting the text, **OpenType
> Fractions** and **OpenType > Stylistic Alternates** were chosen from the **Character** panel menu. The
style of the fraction was automatically updated and the text characters were replaced with more
stylized versions. The same basic process can be used to apply the other OpenType options as well.

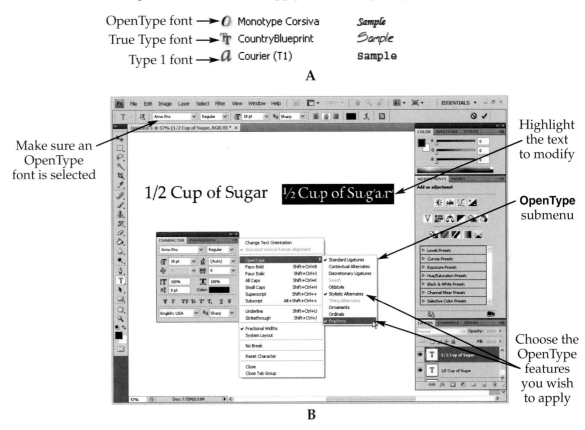

Beneath the **OpenType** submenu, you will see eight styles listed, beginning with
Faux Bold and ending with **Strikethrough**. These styles should be familiar from the
discussion of the buttons in the **Character** panel. Choosing one of these options in the
Character panel menu creates the same effect as picking the corresponding button in
the **Character** panel.

The **Fractional Widths** setting allows spacing between text characters to be less than
one pixel wide in certain places. This setting is usually left on. Making the **System
Layout** option active will reset any tracking and kerning to zero. It also sets the anti-
aliasing method to **None**. Activate the **No Break** option in situations where you do not
want words to break between one line and the next. The **Reset Character** command, at
the bottom of the menu, resets the font to its default settings.

The Paragraph Panel

By default, the **Paragraph** panel is grouped with the **Character** panel. To access
the **Paragraph** panel, click the **Toggle the Character and Paragraph panels** button on
the options bar and then click on the **Paragraph** tab inside the panel group. You can
also access the **Paragraph** panel by choosing **Window > Paragraph** or by clicking the
collapsed **Paragraph** panel icon.

When editing text using the settings on the **Paragraph** panel, **Figure 5-11**, you do not need to highlight any text. Instead, just click anywhere inside the paragraph you want to edit before changing the settings on the panel.

Using the **Paragraph** panel, you can select between several justification options. These options are similar to those found in any word-processing program.

The middle section of the panel contains some self-explanatory controls: the **Indent left margin**, **Indent right margin**, and **Indent first line** text boxes. You can enter a new value in the text box or click and drag the icon to change the values.

Below the margin and indent settings are two text boxes that adjust how much of a gap appears between two paragraphs: the **Add space before paragraph** and **Add space after paragraph** text boxes. As with the margin and indent controls, you can adjust the settings by entering new values or by clicking and dragging the icons.

The **Hyphenate** check box determines whether words can be broken at the end of lines. If this check box is checked, words can be hyphenated and split between lines of text where needed. If this check box is unchecked, words will not be broken between lines of text.

The Paragraph Panel Menu

You can access the **Paragraph** panel menu by clicking the arrow at the top right of the **Paragraph** panel, **Figure 5-12**. This menu contains controls that allow you to fine-tune the way a paragraph is structured, including the way the paragraph is justified and the way words are broken at the ends of lines.

The **Roman Hanging Punctuation** option is a toggle that, when active, allows some punctuation marks (such as quotation marks, hyphens, commas, dashes, and others) to appear outside of the paragraph margins. When this option is inactive (unchecked), all punctuation is placed inside the margins.

Clicking the **Justification** entry opens the **Justification** dialog box. In this dialog box, you can fine-tune the way Photoshop justifies text. When the preview check box is checked, the selected text is updated in the image window according to the new settings. Click **OK** to accept the changes, or the **Cancel** button to discard the changes and return the text to its original settings.

You can adjust the hyphenation created by word breaks by choosing the **Hyphenation** entry in the **Paragraph** panel menu. This opens the **Hyphenation** dialog box. The value entered in the **Words Longer Than** text box determines the minimum number of letters a word must have before it is allowed to be hyphenated. The location

Figure 5-11. _____

The **Paragraph** panel contains controls for adjusting the entire body of text.

Provide text alignment options

Click to access the **Paragraph** panel menu

Sets left margin

Sets right margin

Sets first line indent

Sets amount of space above the paragraph

Sets the space after the paragraph

When active, allows words to be split with hyphens at the end of lines

Figure 5-12. _____
The **Paragraph** panel
menu contains additional
options that affect the
appearance of text.

Click to open the
Paragraph panel menu

of the break within the word is influenced by the **After First** and **Before Last** text box settings. The **After First** setting sets the minimum number of letters that must appear before the hyphen. The **Before Last** text box setting determines the number of letters that must appear after the hyphen. The **Hyphen Limit** text box setting determines the maximum number of consecutive lines of text that can end with a hyphen. The **Hyphenation Zone** setting determines how big a gap must be at an end of a line of unjustified text before a word is allowed to be broken. When the **Preview** check box is checked, the new settings are applied to the text in the image window. Click the **OK** button to accept the new settings or **Cancel** to restore the original settings and close the dialog box.

The two composer options are different strategies Photoshop uses for structuring paragraphs as you type them. Select the **Adobe Single-line Composer** option for short text entries and the **Adobe Every-line Composer** when entering long paragraphs.

The next control available in the **Paragraph** panel menu is the **Reset Paragraph** command. This command sets the **Paragraph** panel to its default settings. The **Close** command closes the **Paragraph** panel, but leaves other panels in the tab group open. The **Close Tab Group** command closes the **Paragraph** panel and any other panels in the same tab group.

Rasterizing Text

Rasterize means "to convert a vector graphic into a bitmap graphic." For some projects, you will never need to rasterize text. However, many of Photoshop's tools and commands will work only on *bitmap* graphics. These tools and commands include the painting tools and filters, and merging layers.

Note If you merge text layers or flatten an image containing text layers, the text layers are automatically rasterized. No warning occurs.

How do you know when you should rasterize a layer? A good approach is to go about your business as usual. Photoshop will display an error message if you try to do something that requires a rasterized text layer, **Figure 5-13**.

When a type layer is rasterized, you can no longer change the font, size, or style. Instead of text, you have thousands of pixels that *look* like text. Be sure to save a backup copy of your file before rasterizing, just in case you need to change a font, size, or style later.

To rasterize a layer, just click the **OK** button in the error message dialog box. If you would rather rasterize the layer at a later time, click the **Cancel** button in the dialog box. Then, when you are ready to rasterize the layer, simply right-click on it in the **Layers**

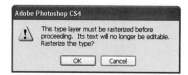

panel and choose **Rasterize Type** from the shortcut menu. You can also rasterize the layer
by making it active and choosing **Layer > Rasterize > Type**. A rasterized type layer looks
just like any other layer that contains pixels, **Figure 5-14**.

Shape Tools

Shapes are vector graphics. They can be resized as often as desired with no loss of
image quality. Similar to text, shapes must be rasterized in some situations.

The shape tool button in the **Tools** panel looks like a rectangle, unless you have previ-
ously selected another shape. The **Tools** panel displays the last shape tool that was used.
When you click and hold the mouse button on the shape tool button, a pop-up menu
with six different shape tools appears, **Figure 5-15**.

The Options Bar for Shape Tools

When you click on one of the shape tools in the **Tools** panel, its options bar appears.
There are only slight differences in the options bar for each shape tool, **Figure 5-16**. We

Figure 5-14. _____
This text layer has been rasterized. The T symbol has disappeared from the **Layers** panel. The text
can no longer be edited using "word processor" techniques.

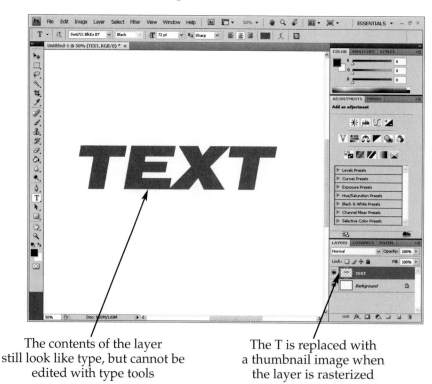

The contents of the layer
still look like type, but cannot be
edited with type tools

The T is replaced with
a thumbnail image when
the layer is rasterized

will discuss the options that are available on all shape tools' options bars first. Then, we will discuss the unique options found on each tool's options bar. The options that are specific to a particular shape tool are found in the center of the options bar.

The first three buttons on the options bar represent three different ways that shapes can be created. The creation mode that is selected here also determines some of the options that are available on the options bar.

The Shape Layers Button

The **Shape layers** option is the most flexible and commonly-used option. When this button is selected, you click and drag to create a shape, which is filled with the foreground color. An outline of the shape, called a path, is also created.

Figure 5-15. _____
There are six shape tools that can be accessed by clicking and holding briefly on the currently selected shape tool in the **Tools** panel.

When a shape is created using the **Shape layers** option, a layer thumbnail is added to the **Layers** panel. This thumbnail is filled with the foreground color, and double-clicking it opens the **Color Picker**, Figure 5-17. From the **Color Picker**, you can select a new fill color for the layer. There is also a thumbnail of the shape you created to the right of the layer thumbnail. This is called a vector mask thumbnail. When you create a shape with the **Shape layers** option active, a new layer is added that is completely filled with the foreground color. A vector mask is then added to hide all areas of the layer outside of the mask. You will learn more about vector masks in Chapter 11, *Additional Layer Techniques*.

Figure 5-16. _____
The options bars for the various shape tools look nearly identical.

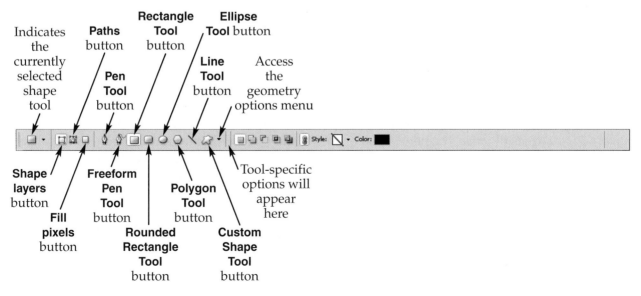

Figure 5-17. _____
You can double-click the layer thumbnail to access the **Color Picker**.

Options available for the
Shape layers creation method

The **Shape layers**
button is selected

The shape is
filled with the
selected color

The shape is
surrounded by
a path

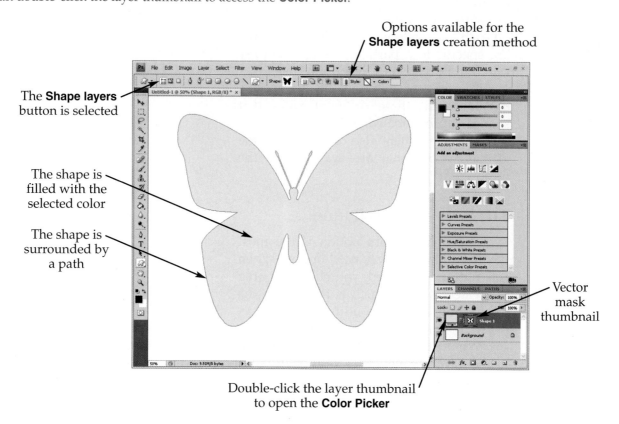

Vector
mask
thumbnail

Double-click the layer thumbnail
to open the **Color Picker**

Also, when you click the **Shape layers** button, five buttons to control the way shapes are combined appear on the right side of the options bar. The first four of these buttons, **Create new shape layer**, **Add to shape area (+)**, **Subtract from shape area (-)**, and **Intersect shape areas** should look familiar from your study of the selection tools. These buttons look and act basically the same as their counterparts for the selections tools. The fifth button available, the **Exclude overlapping shape areas** button, does not appear with the selection tools, but is similar in function to the **Intersect shape areas** button.

When the **Create new shape layer** button is active, each new shape is created on a new layer. This is the only option that is initially available. After one shape has been drawn, the other options become available in the options bar. Switching to the **Add to shape area (+)** button combines each new shape with the previous shape(s) on the existing layer. Switching to the **Subtract from shape area** button causes each new shape to be cut out of the existing shape(s) on the layer. Selecting the **Intersect shape areas** button saves only those areas of the new shape that overlap with the existing shape. Areas of either the new shape or the existing shape that do not overlap are discarded. Switching to the final button in this area, the **Exclude overlapping shape areas** button, discards the areas of the new shape and existing shape(s) that overlap and keeps those that do not overlap.

Styles are a quick and easy way to apply special effects to shapes or text. You can access the **Styles** panel and **Styles** panel menu by clicking on the **Style** box or by clicking the **Click to open Style picker** button to the right of the box. The **Styles** panel is discussed later in this chapter.

At the far right of the options bar is the **Color** box. Clicking this box opens the **Color Picker**, from which you can pick a new color for the shape layer. Keep in mind that the new color will be applied to all of the shapes on the layer, not just the next shape created.

The Paths Button

The **Paths** option creates only an *outline* of the shape. This outline, called a *path*, is adjustable. When the **Paths** option is active, the outline is added to the current layer. A new layer is not created. If the **Shape Layers** option is chosen again, the outline disappears from the image window, but is still available in the **Paths** panel. Paths are discussed in more detail in the "Paths, Pen Tools, and Selection Tools" section of this chapter.

The **Create new shape layer** button, **Style** box, and **Color** box disappear when you click the **Paths** button, **Figure 5-18**.

The Fill Pixels Button

The **Fill pixels** option is really a painting tool. When you draw a shape, it is filled with the foreground color. An adjustable path does *not* appear around the edge of the shape, and a new layer is *not* created automatically. You should create a new layer before adding a shape using this option.

When you click the **Fill pixels** button, a **Mode** drop-down list, an **Opacity** slider, and an **Anti-alias** check box replace the settings found in the options bar when the **Shape layers** or **Paths** shape creation methods is selected, **Figure 5-19**. These settings are discussed further in Chapter 6, *Painting Tools and Filters*.

Note The **Fill pixels** option is not available if the **Pen Tool** or **Freeform Pen Tool** is active.

Figure 5-18. ———
When you click the **Paths** button, the **Create new shape layer** button, **Style** box, and **Color** box are removed from the options bar.

The **Paths** button is selected

The **Create new shape layer** buttons, **Style** box, and **Color** box are not available

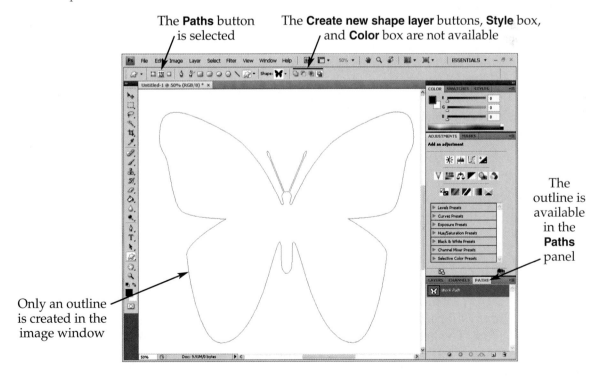

The outline is available in the **Paths** panel

Only an outline is created in the image window

Figure 5-19. _____

When you click the **Fill pixels** button, the controls on the options bar are replaced with controls for raster-based graphics, including a **Mode** drop-down list, an **Opacity** slider, and an **Anti-alias** check box.

The **Fill pixels** button is selected

These controls appear when the **Fill pixels** option is active

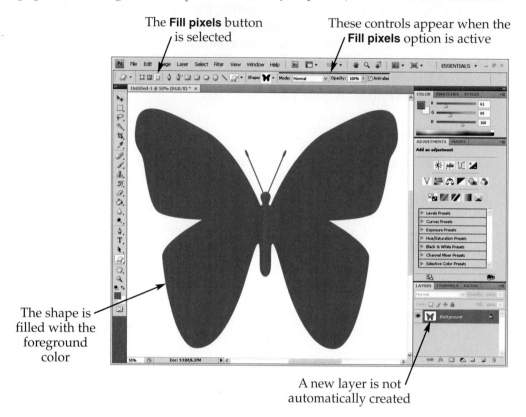

The shape is filled with the foreground color

A new layer is not automatically created

Pen Tool Buttons

Next on the options bar, you will see two buttons that activate pen tools. These buttons override the shape tool selection made in the **Tools** panel. If you click the **Pen Tool** button, you can create a shape by clicking anchor points and adjusting the curvature of the line passing through those points. If you click the **Freeform Pen Tool**, you can draw any shape you desire by clicking and dragging the mouse. Pen tools are discussed in more detail later in this chapter.

Shape Tool Buttons

The next six buttons on the options bar activate the various shape tools. As with the two pen tool buttons, clicking on one of these buttons overrides the tool selection made in the **Tools** panel. The options bar changes accordingly.

The Geometry Options Menu

Just to the right of all of the shape tools on the options bar, you will see a small down-arrow labeled **Geometry options**. Clicking on this arrow reveals additional options for each shape. The example in **Figure 5-20** shows the geometry options for the **Rectangle Tool**. The geometry options for the **Rounded Rectangle Tool**, **Ellipse Tool**, and **Custom Shape Tool** are very similar to those for the **Rectangle Tool**:

- The **Unconstrained** option lets you draw a shape of any size.

Figure 5-20. _____
The geometry options for
the **Rectangle Tool, Rounded
Rectangle Tool**, **Ellipse Tool**,
and **Custom Shape Tool** are
nearly identical.

- The **Square** (or **Circle** for the **Ellipse Tool** or **Defined Proportions** for the **Custom Shape Tool**) option forces the shape to be drawn with a preset height to width ratio. In the case of the **Rectangle Tool**, this creates a square. In the case of the **Ellipse Tool**, it creates a circle. For the **Custom Shape Tool**, this setting creates a shape that has standard proportions.

- The **Fixed Size** option lets you enter values in the **W** (width) and **H** (height) text boxes. A shape with those dimensions is created by clicking once in your file.

- The **Proportional** option is used when you want a shape that is, for example, two times wider than it is high. For this example, enter 2 in the **W** text box and 1 in the **H** text box. Then, click in the image window and drag to create the shape.

Note The **Proportional** option is not available for the **Custom Shape Tool**. Instead, this tool has a **Defined Size** option. This option creates a shape with predefined size and proportions.

- The **From Center** check box determines whether the shape will be created from a center point instead of a corner as you click and drag. When this check box is checked, the location clicked in the image window becomes the center point of the shape. When the check box is unchecked, the location clicked in the image window becomes one corner of the shape's bounding box.

- When the **Snap to Pixels** check box is checked, the edges of the shape will align perfectly with pixels in the image—not cover pixels partially.

The geometry options available for the **Polygon Tool** and the **Line Tool** are considerably different than those available for the other tools. The **Polygon Tool**'s geometry options include a **Radius** setting. The value entered in this text box determines the size of the shape that is created when you click in the image window. The **Polygon Tool**'s geometry options also include the **Smooth Corners** check box. When this check box is checked, the corners of the shape are radiused, or rounded off. When the **Star** option is active, the center points of the sides of the polygon are drawn in toward the center of the polygon, creating a star shape. The value entered in the **Indent Sides By** text box determines how deeply indented the sides are, or, in other words, how pointy the star is. See **Figure 5-21**.

The **Line Tool**'s geometry options let you add _arrowheads_ to your lines and control their size. The **Start** and **End** check boxes determine on which end of the line the arrowhead is created. If both check boxes are checked, arrowheads are created at both ends of the lines. The value entered in the **Width** text determines how wide the arrowhead is in relation to the width of the line. The value entered in the **Length** text box controls how long the arrowhead is. Lastly, the **Concave** setting determines how far the back of the arrow is pushed in. See **Figure 5-22**.

Figure 5-21. _____
Star shapes can be easily created using the **Polygon Tool**'s geometry options. This illustration shows the shapes that can be created by adjusting the geometry options for a three-sided polygon.

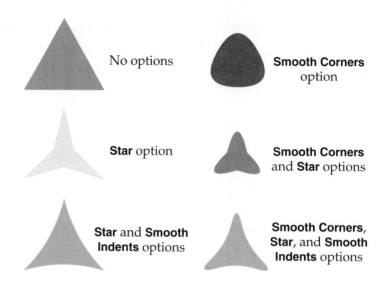

No options

Smooth Corners option

Star option

Smooth Corners and **Star** options

Star and **Smooth Indents** options

Smooth Corners, Star, and **Smooth Indents** options

Figure 5-22. _____
Arrowheads can be added to lines using the **Line Tool**'s geometry options. **A**—The **Arrowheads** dialog box contains the settings that determine the appearance of the arrowheads. **B**—The effects of the arrowhead settings are shown here. **1) Start** option active. **2) End** option active. **3) Start** and **End** options active. **4) Width** setting increased. **5) Length** setting increased. **6) Concavity** setting increased.

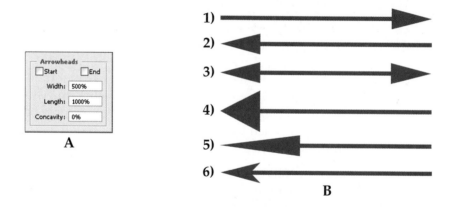

| Arrowheads |
| Start End |
| Width: 500% |
| Length: 1000% |
| Concavity: 0% |

A

1)
2)
3)
4)
5)
6)

B

Note The arrowhead's **Length** setting does not affect the overall length of the line. When you click points to create a line, you are specifying the overall length of the line *including* the arrowheads. However, it does affect the minimum length that the line can be. The line must be at least long enough to accommodate the arrowhead. If you attempt to draw a line shorter than the length of the arrowhead, the line is cut out of the arrowhead, as shown here.

Tool-Specific Options in the Options Bar

Now that you have learned about the options bar settings available for all shape tools, we will discuss the additional controls available in the options bar of certain shape tools. These additional settings appear in the center section of the options bar, and they control the unique geometry created by the different shape tools.

- The **Rectangle Tool** and the **Ellipse Tool** have no special controls in the options bar.

- The **Rounded Rectangle Tool**'s **Radius** option controls the appearance of the rounded corners. The value entered in this text box determines the radius of the rounded corners of the rectangle.

- The **Polygon Tool**'s **Sides** option lets you create a polygon based on how many sides it has. For example, if you want to draw an octagon, enter 8 in the **Sides** text box.

- The **Line Tool**'s **Weight** text box determines the thickness of the line that is created. When you enter a width, be sure to specify the units to be used, pixels (px) or inches (in). For example, type 3 px—do not just type 3, or your line might be three *inches* wide. (It depends on the ruler setting in Photoshop's preferences.) When drawing lines, hold down [Shift] to create straight lines or lines at a 45° angle. If you create a very thin line, only one or two pixels wide, you may not be able to see it unless you zoom in.

- When the **Custom Shape Tool** is active, a **Shape** box appears in the options bar. This box displays a thumbnail image of the custom shape currently selected. Clicking on the thumbnail opens the **Custom Shape Picker**, which allows you to select from a variety of shapes. The **Custom Shape Picker** is explained in detail in the following section. When drawing a custom shape, you may need to hold down [Shift] to keep the shape in proportion.

The Custom Shape Picker

When you click on the **Custom Shape Tool**, the last of the shape tool buttons, the **Shape** box appears in the options bar. As mentioned earlier, this box displays a thumbnail image of the currently selected shape. Click on the box or the down-arrow next to it to display the **Custom Shape Picker**. A variety of custom shapes appear in the **Custom Shape Picker** by default, Figure 5-23. Other shapes can be added here as well.

Figure 5-23. _____
The **Custom Shape Picker** provides many predefined shapes that can be placed in the image. Additional shapes can be loaded through the **Custom Shape Picker** menu.

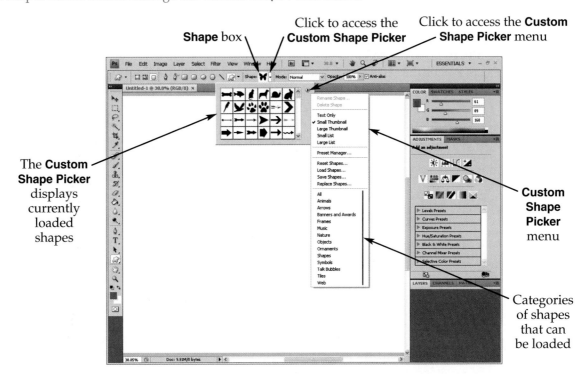

Shape box Click to access the **Custom Shape Picker** Click to access the **Custom Shape Picker** menu

The **Custom Shape Picker** displays currently loaded shapes

Custom Shape Picker menu

Categories of shapes that can be loaded

The **Custom Shape Picker** has a menu that appears when the arrow pointing to the right is clicked. The bottom section of the menu lists several categories of shapes, such as music, nature, and symbols that can be loaded into the picker.

To load a category of shapes into the **Custom Shape Picker**, click on the category in the list. A dialog box appears, asking if you want to replace or append the currently loaded shapes. If you click the **OK** button, the shapes currently loaded into the **Custom Shape Picker** are deleted and then the new shapes are loaded. If you click the **Append** button, the new shapes are added to the currently loaded shapes.

The first two commands in the **Custom Shape Picker** menu, **Rename Shape** and **Delete Shape**, are only available if you click on a shape in the **Custom Shape Picker** before opening the menu. These commands are self-explanatory and affect only the shape currently selected in the **Custom Shape Picker**.

The second section of the panel menu lists several ways that the shapes can appear in the **Custom Shape Picker**. The **Text Only** command displays only the names of the loaded shapes. The **Small Thumbnail** and **Large Thumbnail** commands display only thumbnail images of the loaded shapes. The **Small List** command displays the names (in small type) and small thumbnails of the loaded shapes. The **Large List** command displays the names of the loaded shapes in larger type and with larger thumbnails.

Selecting the **Preset Manager** command in the **Custom Shape Picker** menu opens the **Preset Manager** dialog box. The **Preset Manager** dialog box provides an optional way to organize shapes—it shows all of the shapes that are currently in the **Custom Shape Picker**. You can use the **Preset Manager** to delete and load different shapes, if desired.

Choose the **Reset Shapes** command to restore the **Custom Shape Picker** to its default state. When you modify shapes and organize them your own way in the **Custom Shape Picker**, you can use the **Save Shapes** command to save them into a file that can be loaded later using the **Load Shapes** command. The **Replace Shapes** command is very similar to the **Load Shapes** command. The difference is the old shapes are replaced (deleted) instead of appended (added to) as the new shapes are loaded into the picker.

You can create your own custom shapes and load them into the **Custom Shape Picker** by first drawing a shape using one of the shape or pen tools with the **Shape layers** or **Paths** option active. After creating the shape, choose **Edit > Define Custom Shape....** If you want *text* to be part of a custom shape that you create, first convert the text to a shape by choosing **Layer > Type > Convert to Shape**. After the text is converted, choose **Edit > Define Custom Shape....** The ability to define custom shapes gives you the freedom to create a number of simple shapes and text on separate layers, save them as custom shapes, and then use the **Custom Shape Tool** with the **Add to shape area**, **Subtract from shape area**, **Intersect shape areas**, and **Exclude overlapping shape areas** buttons to combine them into a single complex shape.

You can modify a shape before using it to define a custom shape by choosing **Edit > Transform Path** and then one of the commands in the submenu. This allows you to use all of the transform controls you learned about in Chapter 4, *Introduction to Layers* to create the shape you want.

Remember that if Photoshop alerts you that you need to rasterize a shape layer, make sure the shape is exactly the way you want it. Save a backup copy of your file at this point, if necessary. Once a shape layer is rasterized, you will not have as many editing options available to manipulate its appearance.

Paths, Pen Tools, and Path Selection Tools

In this section, you will learn about paths, the pen tools, and the path selection tools, **Figure 5-24**. The options bars for these tools will be discussed shortly, but first, some background knowledge is necessary.

The pen tools are used to draw paths. Paths are lines that have anchor points on them. The anchor points can be added, deleted, or adjusted to change the appearance of the path. Paths are vector shapes that do not print. Instead, they are used to create other features. In order to manipulate paths, they must first be selected with special tools.

Earlier in this chapter, you learned that shapes have a path around their edges (unless the shape was created in **Fill pixels** mode). So, one approach to creating a path is to use a shape tool to create a basic shape, like a rectangle, and then switch to the pen tools to edit the rectangular path. Text also can be converted to a path by choosing **Layer > Type > Create Work Path**.

Once you have created a path, it can be converted into any of the following items. This is explained in more detail later in this chapter, after the **Paths** panel is introduced:

- A *shape* by filling the path with color.

- A *brush stroke* that follows the perimeter of the entire path.

- A *selection*. You can also do the opposite: convert a *selection to a path*.

- A *clipping mask*. Clipping paths and clipping masks are discussed in Chapter 11, *Additional Layer Techniques*.

The pen tools can create paths three different ways: in straight segments, in curved segments, or freehand. You can use any combination of these three methods to create a single path, and you can adjust a path after you draw it.

Figure 5-24. _____

The pen tools are used to create and edit paths, which can only be selected with the path selection tools. **A**—Click on the currently selected pen tool and hold the mouse button briefly to reveal the other tools available. **B**—There are two different path selection tools available.

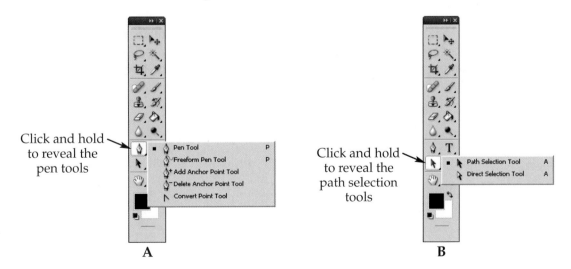

Creating a Path with the Pen Tool

Paths can be *closed* or *open*. **Closed paths** are fully enclosed shapes. They do not have a beginning or end. An **open path**, on the other hand, is a path that is not closed, such as a zigzag line. To create a closed path, you finish by simply clicking your beginning point, just like when you use the **Magnetic Lasso Tool**.

To create a straight segment of a path, select the **Pen Tool** and make sure the **Paths** option is selected in the options bar. Then, use the **Pen Tool** to *single-click* points in the image window to create anchor points. As you create anchor points, lines automatically appear between the points, **Figure 5-25**. You can use the grid and snap settings to help you create precise shapes, if desired.

To create a curved segment of a path, click and hold the mouse button instead of just single-clicking. When you click and hold the mouse button, an anchor point is placed at the location and a double handle is created that controls the curvature of the path through the anchor point, **Figure 5-26**. To adjust the curvature of the path, just move the handles without releasing the mouse button. The handles move as a pair. Move them away from the anchor point to increase the length of the curve or closer to the anchor point to shorten the curve. Move them around the anchor point to change the direction of the curve. Hold [Shift] to rotate the handle in 45° increments. Release the mouse button when you have the segment's curvature set the way you want. Repeat the process to add additional segments to the path.

The type of segment that is created, curved or straight, depends on the type of anchor points that are created. If the anchor points at both ends of the segment are corner-producing anchor points, the segment will be straight. However, if one or both of the anchor points are curve-producing anchor points, the segment created between them will be curved.

If you want to create two or more **subpaths** (unconnected path fragments), press [Esc] before creating more anchor points. This causes the **Pen Tool** to create a new subpath rather than connecting the new anchor points to the existing path.

The Pen Tool's Options Bar

The **Pen Tool**'s options bar is almost identical to the **Shape Tool**'s. There are two options that are unique, however. See **Figure 5-27**.

The **Auto Add/Delete** option allows the **Pen Tool** to add an anchor point by clicking on a path. This option will also allow you to delete an anchor point by clicking on it. In other words, using this option replaces the need for the **Add Anchor Point Tool** and the **Delete Anchor Point Tool**. Editing a path using the **Pen Tool** with the **Auto Add/Delete** option active is discussed in detail later in this chapter.

Figure 5-25. _____
This path was created by clicking to place each anchor point (tiny square). The lines appeared automatically.

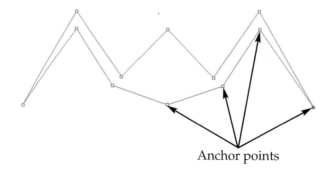

Anchor points

Figure 5-26. _____

Straight segments are created by single-clicking to place anchor points. Curved segments are created by clicking and dragging to create curve-producing anchor points.

Single-click to create a
corner-producing anchor point

Drag the handle to create
the desired curvature

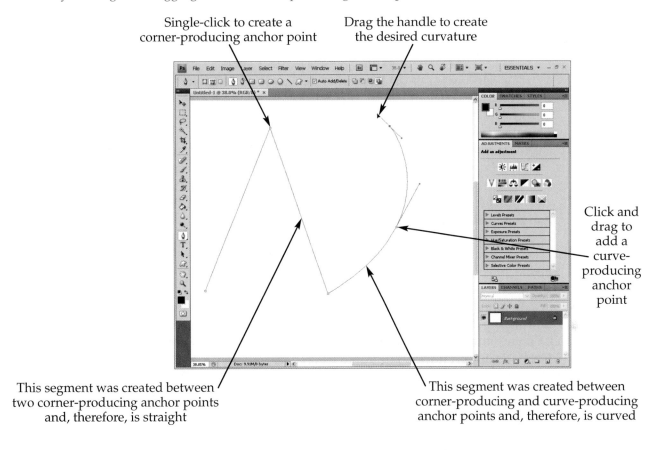

Click and
drag to
add a
curve-
producing
anchor
point

This segment was created between
two corner-producing anchor points
and, therefore, is straight

This segment was created between
corner-producing and curve-producing
anchor points and, therefore, is curved

Figure 5-27. _____

The options bar for the **Pen Tool** is nearly identical to the shape tool option bars. There are, however, two settings that are unique to the **Pen Tool**.

Click to access the
Rubber Band option

The **Auto Add/Delete** option gives the **Pen Tool**
the additional functions of the **Add Anchor
Point Tool** and **Delete Anchor Point Tool**

The **Rubber Band** option is accessed by clicking the **Geometry options** (down-arrow) button on the options bar. When clicking to create anchor points, this option causes the path to stretch from one anchor point to another instead of appearing suddenly.

Creating a Path with the Freeform Pen Tool

You can also create a path with the **Freeform Pen Tool**. To create a path with this tool, simply click and drag the mouse. The **Freeform Pen Tool** creates anchor points along the path as you draw, although you cannot see them.

The **Freeform Pen Tool** starts a new subpath every time you click and drag rather than connecting the new segments to the existing path. If you want to connect the new segments to the existing path, position the cursor over the end of the existing path. When a small diagonal line appears at the bottom right of the cursor, click and drag to add to the path.

The Freeform Pen Tool's Options Bar

The options bar of the **Freeform Pen Tool** has a **Magnetic** option, Figure 5-28. When this option is active, it causes this tool to find edges of objects just like the **Magnetic Lasso Tool**, which was discussed in Chapter 3, *Selection Tools*. Clicking the **Geometry options** (down-arrow) button in the **Freeform Pen Tool**'s options bar reveals settings that control the sensitivity of this tool.

The **Curve Fit** option controls how many anchor points appear in curves that are drawn with the **Freeform Pen Tool**. You can enter a value between 0.5 and 10. Entering a higher value causes some automatic smoothing to occur after you draw a curved path, and your path contains only a few anchor points. Entering a lower value creates a more complex path that contains more anchor points.

The remaining geometry options are identical to the controls found in the **Magnetic Lasso Tool**'s options bar. See the "Magnetic Lasso Tool" section of Chapter 3 if you need a refresher on these options.

Imagine you want to create a custom shape that looks like an elephant. Instead of drawing it from scratch, you could open an image of an elephant and trace it. If the elephant image stands out well from the background, the **Freeform Pen Tool,** with the **Magnetic** option turned on, would be an excellent choice to do this kind of work.

Modifying a Path with the Path Selection Tools

Once you have created a path, you cannot use the **Move Tool** to move it. Instead, use the **Path Selection Tool**. This tool has several options, which are described in the next section of the chapter. The main purpose of this tool is to select and move a path.

To adjust a path's anchor points, choose the **Direct Selection Tool**. Its purpose is to select and move anchor points. If the entire path has been selected, all of the anchor points will be selected. You will need to click away from the path with the **Direct Selection Tool** to reset the path. Then click and move the desired anchor point, Figure 5-29.

Figure 5-28. _____
The **Freeform Pen Tool** can be used to trace objects in an image. The **Magnetic** option causes it to function like the **Magnetic Lasso Tool**. The effects of this option can be adjusted in the **Freeform Pen Options** dialog box, accessed by clicking the **Geometry options** button in the options bar.

Figure 5-29. _____

The **Direct Selection Tool** is used to move one anchor point at a time.

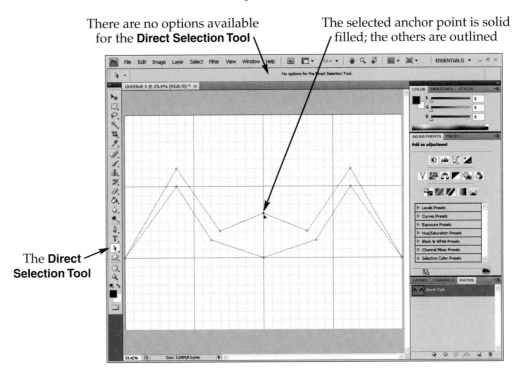

The Direct
Selection Tool

There are no options available
for the **Direct Selection Tool**

The selected anchor point is solid
filled; the others are outlined

The Path Selection Tool Options Bar

The **Direct Selection Tool** does not have any options in its options bar, but the **Path Selection Tool** does, Figure 5-30.

The **Show Bounding Box** option lets you transform a path by dragging bounding box handles or choosing commands from the **Edit > Transform Path...** submenu. Transforming commands are discussed in Chapter 4, *Introduction to Layers*.

Similar to the shape tools and many of the selection tools, the **Path Selection Tool** has the **Add to shape area, Subtract from shape area, Intersect shape areas**, and **Exclude overlapping shape areas** buttons on the options bar. When you work with subpaths, which are explained in "The Paths Panel" section of this chapter, you can select them (and move them, if desired) with the **Path Selection Tool**. Then you can use the add, subtract, intersect, and exclude processes to modify their shape. It is a bit confusing to do this, because all of the path lines remain visible on your screen, no matter what modifier buttons you press in the options bar. You can see the changes applied to your paths, however, by watching the appropriate thumbnail in the **Paths** panel.

Figure 5-30. _____

The **Path Selection Tool** options bar.

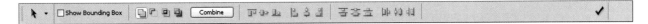

The **Combine** button on the **Path Selection Tool**'s options bar lets you convert two or more subpaths into a single path. To do this, select the desired subpaths while holding [Shift], then click the **Combine** button.

The next two sections of the options bar contain the align and distribute buttons. These buttons are used to line up and arrange objects in Photoshop. They will be discussed in detail in Chapter 11, *Additional Layer Techniques*. You can also use Photoshop's grid or guides to aid you in arranging objects.

The **Dismiss target path** (check mark) button at the far right of the options bar deselects and hides a path in the **Paths** panel. You can also deselect a path (but not hide it) by using the **Path Selection Tool** to click next to, but not on, one of your paths.

Modifying a Path with the Pen Tools

Sometimes as you create a path, you realize that you would like to go back and add or remove an anchor point. If the **Auto Add/Delete** option is active, you can perform these functions with the **Pen Tool**. If the **Auto Add/Delete** is not active, you can perform the same tasks using the **Add Anchor Point Tool** and **Delete Anchor Point Tool**.

Using the Pen Tool to Add or Delete Anchor Points

If you want to remove an anchor point, simply make sure the path is selected and then place the **Pen Tool** cursor over the anchor point. When a small minus sign appears at the bottom right of the cursor, click to remove the anchor point. The two anchor points on either side of the deleted anchor point are adjusted to compensate for the deleted one.

If you want to add an anchor point to a path, make sure the path is selected and then place the **Pen Tool** cursor over the path at the location where you want to place the new anchor point. When the small plus sign appears at the bottom right of the cursor, click and hold the mouse button. Adjust the handles to produce the desired curvature through the anchor point by dragging the mouse. When the curvature is right, release the mouse button.

Using the Pen Tool to Adjust Curvature through an End Anchor Point

You can continue to add or remove anchor points as described, or you can continue drawing the path. To continue drawing the path, simply make sure the path is selected and then continue clicking points at which to place anchor points. However, if you deselected the path at any time after adding the last anchor point, you must position the **Pen Tool** over the endpoint from which you want to resume drawing, wait for the anchor point symbol to appear at the bottom right of the cursor, and then click the endpoint. After clicking the endpoint, you can resume drawing the path.

Sometimes you may want to go back and adjust the handles of the end anchor point before continuing to create the path. This is especially true if you accidentally single-clicked the last anchor point, which would create a sharp corner through that anchor point when you resume drawing the path.

You can change the curvature that the end anchor point will create by positioning the **Pen Tool** cursor over it, waiting for the small diagonal line to appear at the bottom right of the cursor, and then clicking and dragging to position the handle that is created.

As mentioned earlier, this technique can be used to adjust the end anchor point's handles or to transform the anchor point from a corner-producing anchor point into a curve-producing anchor point.

Using the Convert Point Tool

The **Convert Point Tool**'s sole purpose is to change an anchor point from a curve-producing anchor point into a corner-producing anchor point or vice versa. To change a corner-producing anchor point into a curve-producing anchor point, choose the **Convert Point Tool** in the **Tools** panel and *click and drag* on the desired point. As you drag, a double handle appears. After converting the anchor point, you can easily adjust the curve by dragging either end of the handle. To convert a curve-producing anchor point into a corner-producing anchor point, simply click the anchor point.

Using the Add Anchor Point Tool and Delete Anchor Point Tool

After creating a path, you can add more anchor points or delete existing anchor points to help you fine-tune it. As you learned earlier, this can be done with the **Pen Tool**, if the **Auto Add/Delete** option is active. If the **Auto Add/Delete** option is not active, you can still add more anchor points or delete existing points, but must use other pen tools. To add anchor points, choose the **Add Anchor Point Tool** in the **Tools** panel and click anywhere along the path that needs more adjustment. Then, drag to adjust the points as necessary.

The **Delete Anchor Point Tool** can adjust the path by removing anchor points, if necessary. To delete existing anchor points, begin by choosing the **Delete Anchor Point Tool** from the **Tools** panel. Then, position the cursor over the anchor point that you want to remove and click the mouse button to delete the anchor point. The path automatically adjusts for the removed anchor point.

Note One advantage of the **Add Anchor Point Tool** and the **Delete Anchor Point Tool** is that these tools do not require a path or subpath to be selected before they can be used. They are capable of editing a subpath whether it is currently selected or not.

The Paths Panel

The **Paths** panel looks like the **Layers** panel, but it works differently. The **Paths** panel is used to convert a path into a filled shape, a brush stroke, a selection, or a clipping mask. You can also organize your paths using this panel.

Look at the thumbnails in the **Paths** panels in **Figure 5-31**. In Part A of the figure, both paths are grouped together as a path called Work Path. In this state, the two paths are called subpaths. However, in Part B of the figure, each shape is a separate path. To create a new path rather than a subpath in the existing path, click the **New Path** button next to the **Delete current path** (trashcan) button at the bottom of the **Paths** panel before you begin drawing. This helps keep the paths better organized. You can move a subpath to a different existing path by selecting the subpath with the **Path Selection Tool**, cutting or copying it, selecting a new path in the **Paths** panel, and then pasting it into that path. If you deselect all paths in the **Paths** panel and then paste the subpath, it is added as a new path. To rename a path, double-click it in the **Paths** panel, type a new name, and press [Enter].

Figure 5-31.

Additional path segments can be drawn on the same layer or on separate layers. **A**—If you do not click the **New Path** button before drawing new path segments, subpaths are added to the existing path. **B**—An entirely new path is created if you click the **New Path** button before drawing with a pen tool. You should note that a subpath can be copied and pasted as a new path or as a new subpath in a different path.

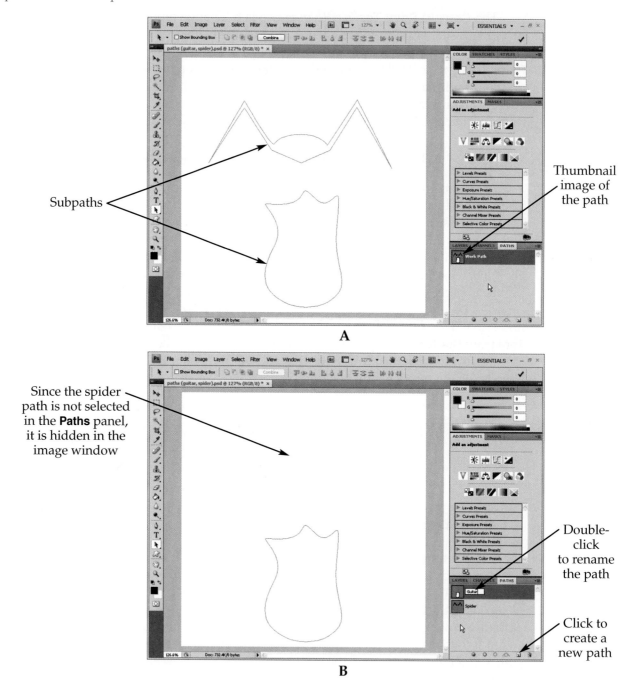

Subpaths

Thumbnail image of the path

A

Since the spider path is not selected in the **Paths** panel, it is hidden in the image window

Double-click to rename the path

Click to create a new path

B

Note If you create a path on a shape layer or text layer that has *not* been rasterized, you cannot convert it to a brush stroke, a selection, or a filled shape. One solution to this problem is to create a new layer first, then create a path on the new layer, and then convert the path to one of the options mentioned.

Converting a Path into Brush Strokes

With practice, you can use the pen tools to create paths exactly the way you want them to appear. One way to create your signature in Photoshop, for example, is to use the **Freeform Pen Tool** to sign your name in a 300 dpi-or-greater document (a graphics tablet would be easier to use than a mouse in this case). Then, adjust the anchor points as desired until your signature looks perfect to you. You can then cover your path with a stroke that applies the **Brush Tool**'s settings. You can also choose a different tool, such as the **Eraser Tool**, to create a stroke along a path.

To convert a path into a brush stroke, follow these steps. Refer to **Figure 5-32**:

- Create a new layer in the **Layers** panel. Your brush stroke will eventually appear on this new layer.

- Select the path you want to cover with a brush stroke. Use the **Path Selection Tool** or select it in the **Paths** panel (if it is not grouped with other subpaths).

Figure 5-32. ──
Paths can be easily converted into brush strokes. **A**—After creating a layer for the brush stroke, select a path in the **Paths** panel. Then, select **Stroke Path** in the **Paths** panel menu. **B**—Select the desired tool from the **Tool** drop-down list in the **Stroke Path** dialog box. When applying a brush stroke to a path, you can choose from any of Photoshop's tools that use brushes. **C**—The brush stroke follows the path.

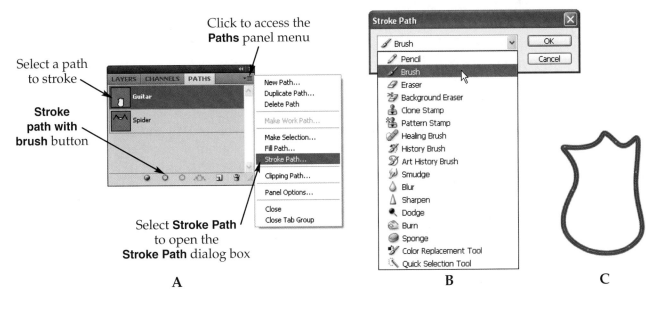

- Choose **Stroke Path** from the **Paths** panel menu. As an alternative, you can right-click on the path in the **Paths** panel and select **Stroke Path** from the shortcut menu. This opens the **Stroke Path** dialog box.

- Choose the tool that you want to apply along the path from the **Tool** drop-down list in the **Stroke Path** dialog box. The tool's current settings will be used. If necessary, select the tool in the **Tools** panel and change the settings *before* stroking the path.

Another way to stroke the path is to select the desired tool in the **Tools** panel, select the path in the **Paths** panel, and then click the **Stroke path with brush** button at the bottom of the **Paths** panel.

Converting a Path into a Filled Shape

Filling a closed path with the foreground color is a way to create your own custom shape. You might use this technique when drawing large block letters from scratch, for example. To convert a path into a filled shape, follow these steps:

- Create a new layer in the **Layers** panel. Your filled shape will appear on this new layer.

- Select the path you want to fill. Use the **Path Selection Tool** or select it in the **Paths** panel (if it is not grouped with other subpaths).

- Choose **Fill Path** from the **Paths** panel menu. As an alternative, you can right-click on the path in the **Paths** panel and select **Fill Path** from the shortcut menu. This opens the **Fill Path** dialog box.

- Change the settings as desired and click **OK**.

You can also fill the path by selecting the desired foreground color in the **Tools** panel, selecting the path, and then clicking the **Fill path with foreground color** button at the bottom of the **Paths** panel.

Converting a Path into a Selection

Photoshop users who become experienced with the pen tools occasionally choose to bypass the selection tools and use the pen tools to create a selection. This technique is useful when selecting objects that have a variety of straight and curved edges. First, a path (and subpaths, when necessary) are created around an object. The path(s) can quickly be converted to a selection by following these steps:

- Select the appropriate path.

- Click the **Load path as a selection** button at the bottom of the **Paths** panel or choose **Make Selection** from the **Paths** panel menu. You can also right-click on the path in the **Paths** panel and select **Make Selection** from the shortcut menu.

Note If you attempt to convert an open path into a selection, Photoshop automatically closes the path, adding an unwanted segment to your selection.

Text on a Path

Text can follow a path, **Figure 5-33**. To add text that follows a path, begin by creating a path with either the pen tools or the shape tools. To add text along a path that is either open or closed, select one of the type tools and position the cursor over the path. When a zigzag line appears through the bottom of the text cursor, click on the path and start typing. To fill a closed path with type, position the text cursor inside the path. When the dotted square around the cursor changes to a circle, click and start typing.

Type can be moved to a different location along a path. To do this, make sure the text layer is selected in the **Layers** panel. Then, use the **Path Selection Tool** to click at the beginning of the text. The cursor changes to a text cursor with an arrow next to it, and type will move as you click and drag. You can also drag type so it follows either the inside or outside of a path.

Note	As you drag the text, follow the path. If you veer off the path with the cursor, the text may jump to a different location on the path.

Layer Styles

Layer styles are special effects such as drop shadows, beveled edges, and colorful outlines that can quickly be applied to an entire layer. Layer styles can cause one-dimensional graphics such as *text* and *shapes* to appear three-dimensional, helping them stand out in a design.

To apply a layer style to a layer, make sure the correct layer is active. Then, choose **Layer > Layer Style** and select a particular style from the submenu. This opens the **Layer Style** dialog box, **Figure 5-34**, allowing you to adjust the settings for each style.

The table in **Figure 5-35** shows three examples of each layer style. For example, a drop shadow is shown applied to text, a custom shape, and an image. The settings for each example have been adjusted differently in the **Layer Style** dialog box to give you a sense of the possible effects you can create.

You can use more than one style per layer to create interesting combinations of effects, **Figure 5-36**. To do this, begin by selecting the style on the left side of the **Layer Style** dialog box. Then, click the check box to activate the style. Adjust the settings on the right side of the dialog box as desired, and then repeat the process for each style you want to add.

Figure 5-33.⎯⎯⎯⎯⎯
Text can follow a closed path (left), follow an open path (center), or fill a closed path (right).

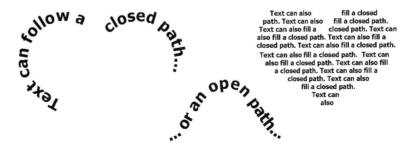

Figure 5-34. _____

The **Layer Style** dialog box appears when you select any of the layer styles listed in the **Layer > Layer Style** submenu.

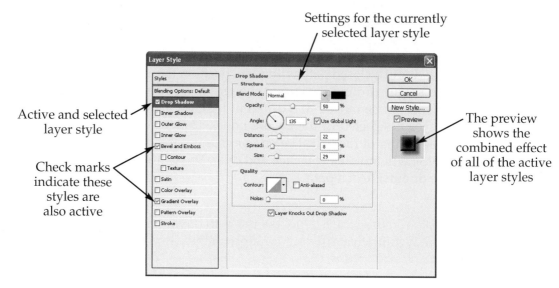

Settings for the currently selected layer style

Active and selected layer style

Check marks indicate these styles are also active

The preview shows the combined effect of all of the active layer styles

Figure 5-35. _____

This table shows three samples for each layer style. The name of the layer style and a brief description appear in the left column. The center column shows the layer effect applied to text and to a filled shape. The right column shows the layer effect applied to an actual image.

Name and Description of Layer Style	Text and Shape Examples	Image Example
Settings in the **Blending Options** section are discussed in Chapter 11, _Additional Layer Techniques_.		
The **Drop Shadow** style helps an object stand out. It can also be used to create shadows in the background behind an image that has not been flattened.		
The **Inner Shadow** style makes text and shapes look hollow, creating a moon crater effect.		
The **Outer Glow** style makes an object appear to be luminous. If you use a light color for an outer glow, you need to change the background to a dark color.		
Use the **Inner Glow** style for intense backlighting effects.		

(Continued)

Figure 5-35. _____
Continued.

Name and Description of Layer Style	Text and Shape Examples	Image Example
The **Bevel and Emboss** style adds shadows to make objects appear to be thicker and with rounded or beveled edges.	Bevel & Emboss	
The **Satin** style is a darkening technique that also adds highlights to create a soft, satin look.	Satin	
The **Color Overlay** style adds a color on top of the layer.	Color Overlay	
The **Gradient Overlay** style adds a gradient on top of the layer. Gradients are two or more colors that blend together. You will learn more about gradients in Chapter 6, *Painting Tools and Filters*.	Gradient Overlay	
The **Pattern Overlay** style places a pattern on top of the layer. Photoshop has many predefined patterns to choose from. You can also create your own patterns. You will learn more about patterns in Chapter 6, *Painting Tools and Filters*.	Pattern Overlay	
The **Stroke** style places a border of contrasting color, a gradient, or pattern around an object's edge.	Stroke	

The Styles Panel

You have learned that you can combine several different layer styles to create interesting effects. Photoshop's **Styles** panel is a collection of ready-made effects that are built from layer styles. To display the **Styles** panel, choose **Window > Styles** or find the **Styles** tab and click on it.

Figure 5-37 shows a custom shape with a style from the **Styles** panel applied to it. The **Custom Shape Tool**'s options bar includes a thumbnail showing the currently selected style. Clicking this thumbnail or the small down-arrow button to the right of it opens a pop-up version of the **Styles** panel. All of the shape tools have this shortcut.

Figure 5-36.

Adding more than one layer style can create complex effects. **A**—Light yellow shape. **B**—Inner shadow added. **C**—Bevel added. **D**—Pattern overlay added.

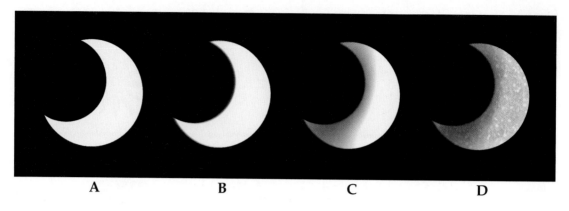

A **B** **C** **D**

Figure 5-37.

The **Styles** panel can be accessed by clicking the **Styles** panel tab or clicking the **Style** thumbnail in the options bar of any of the shape tools.

Click the down-arrow button or thumbnail to access a pop-up version of the **Styles** panel

Click to access the **Styles** panel menu

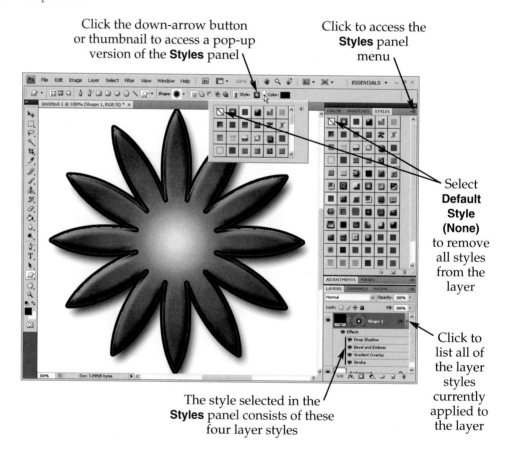

Select **Default Style (None)** to remove all styles from the layer

Click to list all of the layer styles currently applied to the layer

The style selected in the **Styles** panel consists of these four layer styles

Selecting any of the styles in the panel applies that style to the selected layer and to any new layers that are created. Selecting the **Default Style (None)** entry removes all of the styles currently assigned to the layer.

In the example shown, the style just to the right of **Default Style (None)** has been selected in the **Styles** panel and applied to the star shape. In the **Layers** panel, the small "*fx*" symbol appears to the far right of the layer name. This indicates that one or more

layer styles has been applied to the layer. The small down-arrow next to the *"fx"* symbol is an indication that each layer style effect that was used to build a particular style is listed below the layer. This arrow can be clicked to hide the individual layer styles.

The Styles Panel Menu

Clicking the button in the upper-right corner of the **Styles** panel accesses the **Styles** panel menu, Figure 5-38. The **Styles** panel menu is set up the same way as the **Custom Shape Picker** menu discussed earlier in the chapter. There are several categories of styles at the bottom of the menu. When you click on one of these groups of styles, a dialog box appears giving you the option of replacing the current styles with these new styles or appending (adding) them to the current styles in the **Styles** panel. You can also use this menu to reset the **Styles** panel or create your own combinations of layer styles and save them so they can be loaded into the **Styles** panel in the future.

You can also access the **Styles** panel menu by clicking the arrow button on the top-right of the pop-up version of the **Styles** panel. However, the **New Style** command is missing from that version of the panel menu, so you cannot use it to create a new style.

Figure 5-38. _____
The **Styles** panel menu is accessed by clicking the arrow button in the **Styles** panel. From this menu, you can load other preset styles or create your own styles from combinations of layer styles.

Different ways styles can be displayed in the **Styles** panel

Different groups of styles that can be loaded into the **Styles** panel

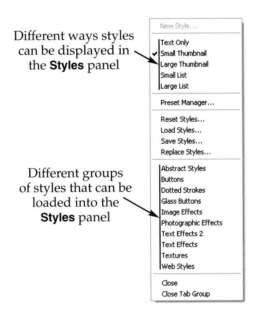

GRAPHIC DESIGN

Fonts

A *font* is a named set of text and numeric characters that share the same look and feel. Fonts that are available in Photoshop are the same fonts that are installed on your hard drive. Additional fonts can easily be purchased and downloaded online, if desired. Many fonts can be downloaded for free. Newly-acquired fonts must be placed in the correct folder on your hard drive. For more information, enter "install fonts" in Photoshop Help's search box.

Fonts can be placed into several general categories, Figure 5-39. When choosing appropriate fonts for a given situation, there are some guidelines to keep in mind. These guidelines are generally applicable to entire categories of fonts.

Figure 5-39. _____

The four categories of fonts are shown here. **A**—In a serif font, such as Times New Roman, individual text characters have small decorative flares, or serifs, at the end of each stroke. **B**—Sans serif means "no serifs." Sans serif fonts are generally plain and easy to read. **C**—Decorative fonts help create different moods in a design. As you can see, the appearance of decorative fonts can vary widely. **D**—Symbol fonts are used to add specialized characters to a design.

A Times New Roman is a serif font.

B Arial is a sans serif font.

C { Comic Sans is a decorative font.

 CommercialScript is a decorative font.

D 🎁 ✦ ? 🚒 🚲 🚭 ◀ ✦ ‖

Serif Fonts

- *Serifs* are small flares or "tails" that decorate text characters. If you have never noticed serifs before, look at the bottom of the capital T in Times New Roman sample in Figure 5-39. A small tail projects from either side of the base of the T.

- Many designers agree that serif fonts are a bit easier on the eye when reading body text—the serifs help the text characters visually flow into one another.

- Serif fonts tend to create a traditional, simple, or formal mood.

- Slab serif and hairline serif are terms that are sometimes assigned to varieties of serif fonts. They describe how large or thin the serifs are.

Sans Serif Fonts

- "Sans" means "without," so *sans serif fonts* are fonts that have no serifs. In general, they have a cleaner, simpler appearance because the individual text characters do not have any added decoration. The Arial sample in Figure 5-39 is an example of a typical sans serif font.

- Sans serif fonts are good for titles and headings.

- Sans serif fonts can also be used for body text, even though many designers prefer using serif fonts for this purpose.

Decorative Fonts

- *Decorative fonts* can be serif or sans serif, but they are nontraditional in appearance. There is a huge variety of decorative fonts available, including the Comic Sans and CommercialScript samples in Figure 5-39.

- Most decorative fonts are *not* easy to read when used for body text.

- Decorative fonts can easily help create mood in a design. For example, the Comic Sans font creates a friendly, casual, pleasant mood because it almost looks like neat handwriting. Script fonts that look like calligraphy (such as CommercialScript) create an elegant mood.

Symbol Fonts

- *Symbol fonts* are used in special circumstances in design work. Instead of text characters, symbols are inserted. The Webdings sample at the bottom of Figure 5-39 is an example of a symbol font.

Font Families

A *font family* is a group of fonts that share the same name and characteristics, yet they vary slightly from one another. For example, Arial, Arial Black, and Arial Narrow make up a font family.

Effective Use of Fonts

Using too many different fonts in a single design tends to be distracting. Here are some proven suggestions about how to limit the number of fonts in a single design:

- Avoid mixing similar-type fonts. Do *not* use different serif fonts, for example. Instead, use one serif font with different styles (bold, italics, etc.).

- Do *not* use more than two different font families in a design.

- Avoid using all capital letters for body text. This should be avoided because readers recognize both individual text characters and the *shape* of words as they read. Using all capital letters changes the familiar shape of words, resulting in slower word recognition. Also, using all capital letters is called "shouting," because of the bold, aggressive mood that is created.

Summary

You have learned that Photoshop offers many ways to add high-quality text and vector graphics to your projects. You have seen that vector graphics can be edited by adjusting the anchor points that appear around their path. You have also learned that layer styles can be applied to enhance the appearance of text or shapes.

CHAPTER TUTORIALS

As you work through these tutorials, you will refine previously-created projects by adding text and layer styles to them. You will also create a new design using the shape tools and create a new custom shape and store it in the **Custom Shape Picker**.

Tutorial 5-1: The Horizontal Type Tool

In this tutorial, you will use the **Horizontal Type Tool** to add text to a design.

1. Open the 04ostrichville.psd file you worked on in an earlier chapter.

2. Choose **Window > Workspace > Essentials**. This resets Photoshop's workspace.

3. Choose **Window > Arrange > Float in Window** and then **View > Fit on Screen**. Next, drag the **Layers** panel to the location shown. If you make a mistake, repeat the previous step.

4. Click the **Horizontal Type Tool** in the **Tools** panel.

5. In the options bar, choose **Verdana** as the font.

6. Choose **Bold** as the style.

7. Type 65 in the **Set the font size** text box and press [Enter].

8. Click in the image window to place the text cursor.

9. Move the mouse away gradually until it turns into a **Move Tool** cursor. Now, you can move the text cursor exactly where you want. Move your text cursor until it is in the position shown.

10. Click the color box in the options bar.

The **Color Picker** dialog box appears.

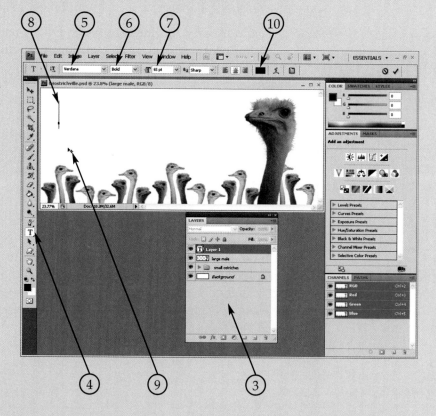

11. Move the color slider in the **Color Picker** dialog box to the green range.

12. Click in **Select text color** window to select a medium shade of green.

13. Click **OK**.

 This closes the **Color Picker** dialog box. The selected color will be assigned to any new text.

14. The text cursor should still be blinking. Enter Ostrichville as the text.

 Notice that a new text layer has been automatically added to the **Layers** panel.

15. If your text is not in the location shown, move your cursor just below the text until the **Move Tool** cursor appears. Click and drag to reposition the text.

16. Click the **Commit** button to accept your text settings.

 The **Cancel** button (to the left of the check mark) is used if you wish to delete what you have entered and start over.

17. Choose **File > Save**. If you are going to continue with the tutorials in this chapter, leave the file open. Otherwise, close the file.

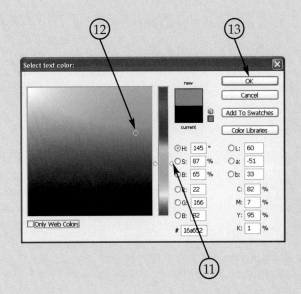

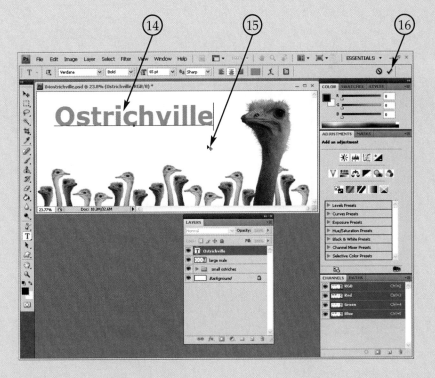

Tutorial 5-2: Layer Styles and the Styles Panel

In this tutorial, you will assign layer styles to enhance the appearance of the text you created in the previous tutorial. This will draw more attention to the text. Using the right combination of layer styles can really make text "pop out" of the design, drawing viewer attention to the most important parts of the design.

1. If necessary, open the 04ostrichville.psd file.

2. Select the text layer in the **Layers** panel.

3. Choose **Layer > Layer Style > Drop Shadow....**

 This opens the **Layer Style** dialog box and selects the **Drop Shadow** layer effect.

4. If necessary, arrange the **Layer Style** dialog box so you can also see the text you have created.

5. In the **Structure** section of the **Layer Style** dialog box, enter 60 in the **Angle** text box, move the **Distance** slider to 22, set the **Spread** slider to 0, and move the **Size** slider to 10. Notice the changes to your text.

6. Click **OK** to create the drop shadow.

7. Double-click the "*fx*" symbol at the far right of the text layer entry in the **Layers** panel.

 This opens the **Layer Style** dialog box.

 Next, you will disable the drop shadow and try one of Photoshop's styles instead.

8. In the **Layer Styles** dialog box, remove the check mark from the **Drop Shadow** check box.

9. Pick **OK** to close the **Layer Style** dialog box.

10. Make sure the Ostrichville text layer is still active.

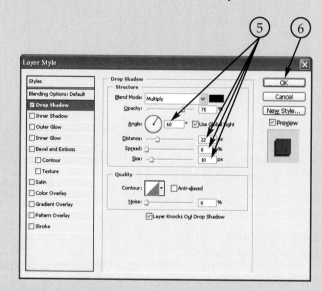

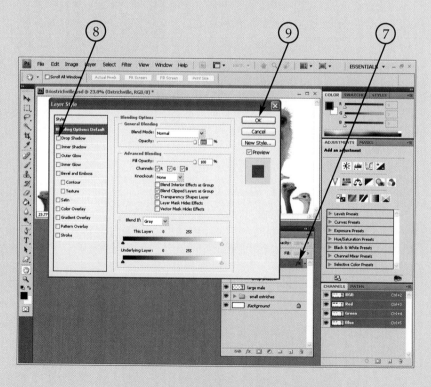

11. Click the **Styles** panel tab. If you cannot find it, choose **Window > Styles** to make the **Styles** panel visible.

12. Click the button at the upper-right corner of the **Styles** panel to access the **Styles** panel menu.

13. Choose **Text Effects 2** from the bottom section of the panel menu.

14. In the dialog box that appears, click **Append**.

 This choice will add the Text Effects 2 styles to the styles currently loaded in the **Styles** panel.

15. Find the style named Double Green Slime and click on it.

 To find the names of the styles, hold the mouse over each thumbnail until the description pops up.

16. If your **Layers** panel does not look like this example, click the small arrow button next to the "*fx*" symbol on the **Layers** panel.

 The **Layers** panel shows that the Double Green Slime style is really a combination of three different layer styles.

17. In the **Layers** panel, double-click the **Bevel and Emboss** effect. In the **Layer Style** dialog box that appears, change the **Angle** setting to –144 and click **OK**.

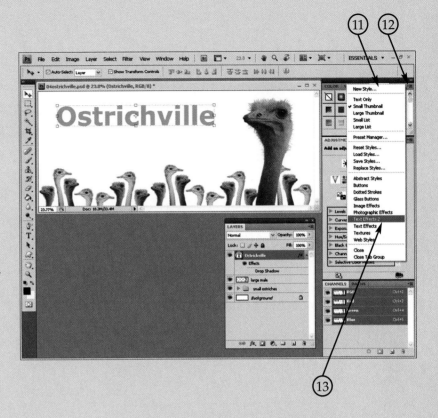

18. In the **Layers** panel, double-click the **Stroke** effect. In the **Layer Style** dialog box that appears, change the size setting to 15 px and click **OK**.

19. Make sure the **Horizontal Text Tool** is selected and the text layer is active.

20. In the options bar, change the font size to 70.

 Both the text and layer styles adjust to the larger font size.

21. Click the **Move Tool** in the **Tools** panel and use it to center the text.

22. Click the **Horizontal Text Tool** and click just under the Ostrichville text to create a new text layer.

23. In the options bar, set the style to **Bold**, the size to 22, and the color to black. Enter this text: 1,000 Acre Ostrich Ranch.

24. Move the text as shown and click the **Commit** button in the options bar.

25. Click to start a new line of text. In the options bar, set the style to **Italic** and the size to 18. Enter this text: Shuttle Tours • Restaurant • Gift Shop.

 Note: To insert the bullet symbol, refer to the section in this chapter entitled "Inserting Special Text Characters."

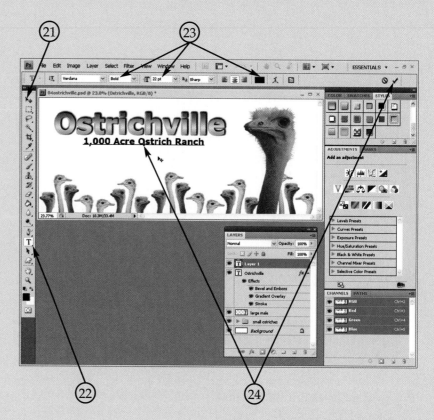

26. Highlight the text you just created and change the text color to a bright red. Click the **Commit** button when you are finished.

27. Click the **Move Tool** in the **Tools** panel, and use it to position the text as shown.

28. Select one of the text layers you just created in the **Layers** panel. Choose **Layer > Styles > Drop Shadow...**. In the **Layer Style** dialog box, click **OK** to accept the default settings and create the drop shadow. Repeat this step for the other text layer.

29. If you are going to continue on with the other tutorials in this chapter, leave the 04ostrichville.psd file open. If you are not going to continue on with the remaining tutorials right away, save and then close the 04ostrichville.psd file.

Tutorial 5-3: Warped Text, Transformed Text, and Custom Shapes

In this tutorial, you will add warped text to your design. Warped text should be used with caution. It must never be difficult for viewers to read.

1. Open the 04ostrichville.psd image if necessary.

2. Click the **Horizontal Text Tool** in the **Tools** panel.

3. Click in the lower-left corner of the image window to create a new text layer.

4. In the options bar, enter the following settings:

 - **Font:** Verdana
 - **Style:** Bold
 - **Font Size:** 14
 - **Justification:** Center
 - **Color:** Black

5. Enter this text: World's (press [Enter] or [Return]) Biggest (press [Enter] or [Return]) Eggs.

6. Click the **Commit** button.

7. Click the **Zoom Tool** in the **Tools** panel and zoom in on the new text.

8. Select the **Horizontal Text Tool** and make sure the new text layer is selected in the **Layers** panel.

9. Click the **Create warped text** button on the options bar or choose **Layer > Type > Warp Text…**.

10. In the **Warp Text** dialog box, choose **Inflate** from the menu.

11. Adjust the warp settings until your text looks like the example. Then, click **OK**.

12. Choose **Layer > Layer Style > Drop Shadow…**. In the **Layer Style** dialog box, click **OK** to create a drop shadow around the warped text using the default settings.

13. Click the **Zoom Tool** and zoom out so the entire design is displayed in the image window.

14. Select the **Horizontal Text Tool** in the **Tools** panel. Click in the lower-right corner of the image window to create a new text layer.

15. In the options bar, change the font size to 28.

16. Click the color box. Instead of choosing a color from the **Color Picker**, move your cursor over the green Ostrichville text and click a dark shade of green with the **Eyedropper Tool** that appears.

17. Enter the following text:

Next Exit

18. Click the **Commit** button to create the text.

19. Click the **Move Tool** in the **Tools panel**. Use the **Move Tool** to move the text layer you just created to the position shown.

20. Make sure the Next Exit text layer is active.

21. Choose **Layer > Layer Style > Stroke…** and change these settings:

- **Size:** Set the slider to 6.

- **Color:** After clicking the color box, use the eyedropper to a select a very light green color in the Ostrichville text and then click **OK** in the **Color Picker**.

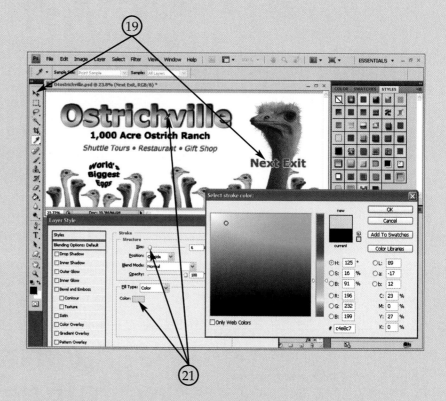

22. The **Layer Styles** dialog box should still be active. Click **Outer Glow** in the left-hand column of the dialog box.

23. Click the small color box and use the eyedropper to select a light tan color from the neck of one of the female ostriches. Click **OK** in the **Color Picker**.

24. Change the **Size** setting to 105.

25. Click **OK** to close the **Layer Styles** dialog box.

26. Choose **Edit > Transform > Skew**.

27. Enter –15 in the **Set Horizontal Skew** (**H**) text box in the options bar.

28. Click the **Commit** button to apply the transformation.

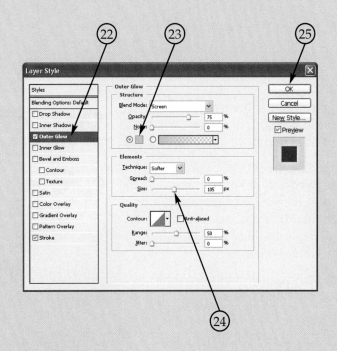

29. Choose the **Custom Shape Tool** from the **Tools** panel.

30. Make sure the **Shape layers** button is selected on the options bar.

31. Click the color box. Click with the **Eyedropper Tool** on the dark green color in the Next Exit text that you recently created and then click **OK** in the **Color Picker**.

32. Click the arrow that opens the **Custom Shape Picker**.

33. Choose the 3rd arrow on the top row and draw an arrow in the location shown.

34. In the **Layers** panel, hold down the [Alt] key while clicking and dragging the Next Exit layer's "*fx*" symbol on top of the Shape 1 layer. When you release the mouse button, the stroke and outer glow layer styles are copied to the arrow.

You can also drag the "fx" symbol on top of the arrow in the image window. Holding down [Alt] is not necessary when using this method.

35. Choose **File > Save As...** and name this file 05ostrichville.psd. Then, close the image window.

Your billboard design is finished.

Tutorial 5-4: Stroking a Border around a Photo

In this tutorial, you will add a **Stroke** layer style to an image in order to draw attention to it and help it stand out from the background.

1. Open the 04cardfront.psd file you created in an earlier chapter.

2. Arrange the layers in the **Layers** panel so the purple flowers are on top of the pink flowers. The yellow flowers should be below the purple and pink flowers.

3. In the **Layers** panel, click the layer that contains the (pink) "beauty" flowers to make it active.

 The pink, "beauty" flowers should be on Layer 1.

4. Choose **Layer > Layer Style > Stroke…**.

5. In the **Layer Style** dialog box, enter 4 in the **Size** text box.

6. Click on the **Color** box. In the **Color Picker**, select a deep, bright red color, and click **OK**.

7. Click **OK** to close the **Layer Style** dialog box.

8. In the **Layers** panel, click the layer that contains the (purple) "mountain" flowers.

 The purple, "mountain" flowers should be on Layer 2.

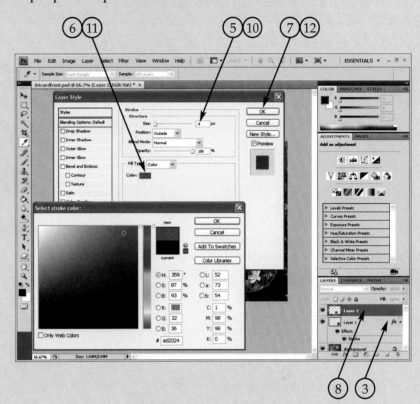

9. Choose **Layer > Layer Style > Stroke…**.

10. In the **Layer Style** dialog box, enter 4 in the **Size** text box.

11. Click on the **Color** box. When the **Color Picker** opens, move the cursor into the image window, where it will change to the **Eyedropper Tool** cursor. Click on the stroke that was created around the pink flower inset. Click **OK** to close the **Color Picker**.

12. Click **OK** to close the **Layer Style** dialog box.

 The stroke around the "mountain " flowers could have also been created quickly and easily by copying the layers styles from Layer 1 to Layer 2.

13. Choose **File > Save…**. If you are going to continue with the other tutorials in this chapter, keep the file open. Otherwise, close the file.

Tutorial 5-5: Adding the Text

In this tutorial, you will add text to a design. You will increase the visual impact of the text by using different colors and assigning layer styles.

1. If necessary, open the 04cardfront.psd file.

2. Click the **Horizontal Type Tool** in the **Tools** panel.

3. Enter the following settings in the options bar:

 - **Font:** Arial
 - **Style:** Bold
 - **Font Size:** 40 pt
 - **Justification:** Left

4. Click on the color box in the options bar.

5. If necessary, reposition the **Color Picker** dialog box so you can see at least a small portion of the red borders around the flower insets.

6. Move the mouse cursor over to the image window.

 The cursor changes to an **Eyedropper Tool**.

7. Place the end of the **Eyedropper Tool** on the red border around the flowers and click.

8. Click the **OK** button in the **Color Picker** dialog box.

 The same red color now appears in the color box in the options bar.

9. Type the word Wildflowers and move it approximately to the location shown.

10. Click the **Commit** button in the options bar.

11. Choose **Layer > Layer Style > Drop Shadow…**.

12. In the **Layer Style** dialog box, set the **Opacity** slider to 75%, the **Angle** to 120°, the **Distance** slider to 7, the **Spread** slider to 0, and the **Size** slider to 5. Click **OK** to create the shadow.

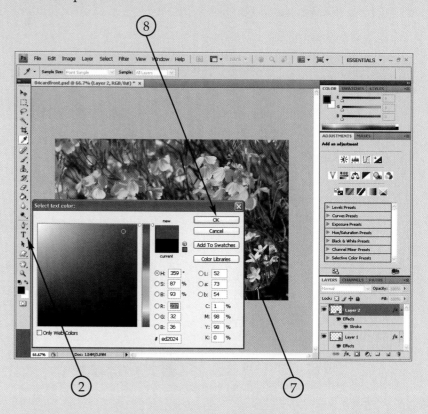

13. If the **Horizontal Type Tool** is not selected, click it.

14. Click just to the right of the Wildflowers text to create another text layer.

15. In the options bar, change the font size to 12 pt.

16. Click on the color box in the options bar and select a bright, golden-yellow color in the **Color Picker** dialog box. Click **OK** to close the **Color Picker** dialog box.

17. Add this text: of the Rocky Mountains.

18. Choose **Window > Character** to display the **Character** panel.

19. Drag the **Character** and **Paragraph** panel tab group to the location shown so it is out of the way.

20. Highlight the text you entered and adjust the tracking setting until the text fills the space between the Wildflowers text and the edge of the design. A setting of 180 is about right.

 If your text does not display correctly, make sure the two text layers are at the top of the list in the **Layers** panel.

21. Add a drop shadow to the text layer you just created. Use the same settings used to create the drop shadow for the Wildflowers text.

22. Choose **File > Save As...** and name this file 05cardfront.psd. Then, close the file.

Tutorial 5-6: Rasterizing Text Layers

In this tutorial, you will add text to a design. You will then rasterize and merge the text layers. Layers must be rasterized before they can be merged.

1. Open the file 04cardback.psd file that you created in an earlier chapter.

2. Select the Stamp Box layer in the **Layers** panel.

 This will cause the text layers to appear above the stamp box.

3. Use the **Horizontal Type Tool** to add the words "Place Stamp Here" on three different layers. Use 10 pt Arial type, bold style, and set the color to black.

 Adjust the tracking setting in the **Character** panel as needed. To create the text on three different layers, click the **Commit** button after typing each word.

4. Use the **Move Tool** or arrow keys to center the words inside the box.

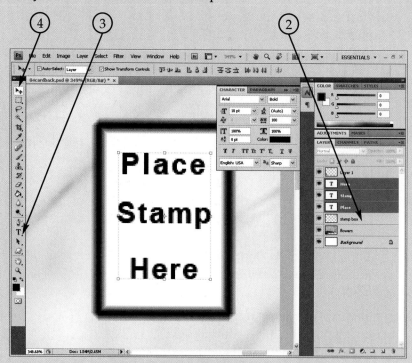

5. Right-click on one of the text layers in the **Layers** panel. Choose **Rasterize Type** from the shortcut menu.

 You can also rasterize the text by choosing **Layer > Rasterize > Layer**. The term "rasterize" means "to convert into pixels." You must rasterize text before you can use certain Photoshop features, such as merging (step 8).

6. Rasterize the other two text layers.

7. Hide all layers except for the three text layers and the Stamp Box layer by clicking their eye icons.

8. Make sure the Stamp Box layer is selected, and then choose **Layer > Merge Visible**.

 You now have a layer that can easily be copied to other postcards that you may create.

9. In the **Layers** panel, select the Stamp Box layer and set its **Opacity** slider to 75%.

10. Make the hidden layers visible by clicking the boxes where their eye icons were.

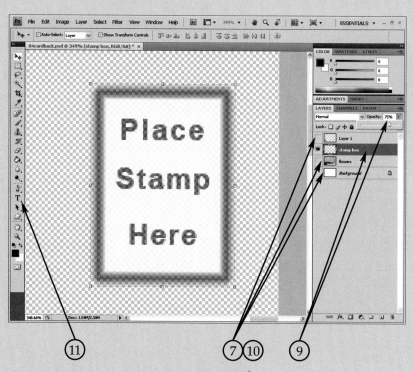

11. Click the **Horizontal Type Tool**. Change the text size setting to 5 pt and set the text style to Bold Italic.

12. Click anywhere in the image window and enter text that reads "Published by" followed by your name and address *or* an imaginary design company's name and address.

13. Choose **Edit > Transform > 90° CCW** and move the text to the location shown.

 You may need to adjust the **Tracking** and **Horizontal Scale** settings in the **Character** panel to make the text fit.

14. Add the remaining text. Put the new text on three separate layers. Refer to the image at the end of the tutorial for the wording, text settings, and proper positions for the additional text.

 Again, you may need to adjust the settings in the **Character** panel to make the text fit properly.

15. Add a drop shadow to the small oval-shaped image of the purple flowers. Set the **Angle** to 120°, the **Distance** slider to 10, the **Spread** slider to 0, and the **Size** slider to 10.

16. The back of the postcard is finished. Choose **File > Save As…**, name this file 05cardback.psd, and then close it.

Arial 6pt Regular

Arial 6pt Bold

Arial 5pt Bold Italic—
transformed 90° CCW

⑬

Arial 5pt Italic—
set the tracking to 260

Rocky Mountain Wildflowers

There are hundreds of beautiful wildflower species found in the Rocky Mountains. Shown on the front: *Greenstem Paperflower, Spring Beauty, Mountain Forget-Me-Not.* Back: *Carmen Gilia, Dusty Penstemon.*

Published by Bear River Photography Anytown, USA 54321

Place
Stamp
Here

U.S. Postal Service Bar Code will be printed in the area below. Please leave it blank.

Tutorial 5-7: Use Shapes to Create a Design

In this tutorial, you will create a design for a CD jewel case insert by drawing, adding, and subtracting various shapes. These techniques come in handy when creating your own custom shapes.

1. Choose **File > New....** In the **New** dialog box, assign the file the name 05CDfront and enter the settings shown.

 Do not forget to select inches after entering the **Width** and **Height** settings.

2. If the rulers are not visible, choose **View > Rulers**.

3. Choose **View > Fit on Screen**.

4. Click the small square in the upper-left corner of the rulers and hold down the mouse button. Drag the mouse until the crosshairs are exactly in the center of the image (2 3/8" across and 2 3/8" down).

5. Release the mouse button.

 When you release the mouse button, the zero point should be centered horizontally and vertically. If you made a mistake, double-click the square in the upper-left corner of the rulers and try again.

6. Select the **Rectangle Tool** in the **Tools** panel.

7. Click the **Geometry options** button in the options bar.

8. In the **Rectangle Options** dialog box that appears, activate the **Fixed Size** and **From Center** options.

9. Enter 3.75 in the **W** (width) and **H** (height) text boxes.

10. Close the **Rectangle Options** dialog box by clicking the **Rectangle Tool** again.

11. In the options bar, make sure the **Shape Layers** button is selected. Next, click the **Color** box. Choose a deep blue color in the **Color Picker** dialog box and click **OK**.

12. Without clicking, move the mouse until the crosshairs symbol is in the center of the image.

 Watch the rulers—little guidelines will show you exactly where your crosshairs are.

13. When you are in the center of the image, click to place a 3.75" square.

 The **Layers** panel shows a new layer has been automatically created.

14. On the options bar or in the **Tools** panel, click the **Ellipse Tool**, which can be used to draw circles.

15. Click the **Geometry options** button on the options bar.

16. In the **Ellipse Options** dialog box, activate the **Fixed Size** and **From Center** options.

17. Enter 4.25 in the **W** (width) and **H** (height) text boxes.

18. Make sure the **Shape layers** button is selected.

19. Click the **Add to shape area** button on the options bar.

20. Move the cursor to the exact center again and click.

 The circle is added to the square. The thumbnail image of Layer 1 in the **Layers** panel is updated to show the addition of the circle.

21. Choose **Layer > Rasterize > Layer**.

 As with text, you must rasterize layers that contain shapes. If you do not do this, some of Photoshop's commands will not work on shape layers.

22. The next shape needs to be on a separate layer, so click the **Create new shape layer** button on the options bar.

23. With the **Ellipse Tool** still active, click the **Geometry options** button on the options bar.

24. In the **Ellipse Options** dialog box, activate the **Unconstrained** option. The **From Center** option should still be selected.

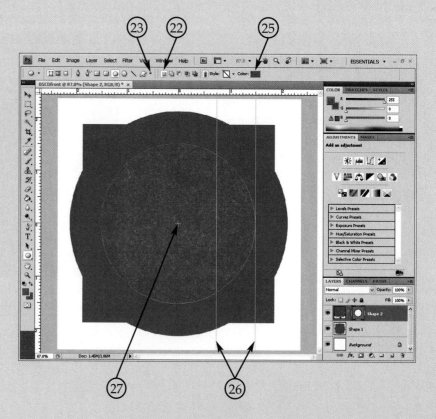

25. Click the **Color** box on the options bar. In the **Color Picker** dialog box, choose a bright red color.

26. Click on the ruler on the left side of the image window and drag a guide to the 1.5″ mark on the right side of the image window. Then, click and drag a guide to the .75″ mark.

 These guides will help you create circles of the proper sizes in the steps that follow.

27. Position the cursor in the center of the image. When the cursor is centered, click and drag to create a circle with a radius of 1.5″.

 Since you have activated the **Unconstrained** option in the **Ellipse Options** dialog box, you must hold down [Shift] as you draw the circle. This will create a perfect circle instead of an oval.

28. Click the **Subtract from shape area** button on the options bar.

29. Starting from the center, drag another circle with a radius of .75″.

 The second circle is subtracted from the first, allowing the blue shape behind to show through.

30. Right-click on this new layer in the **Layers** panel and choose **Rasterize Layer** from the shortcut menu.

31. Save the 05CDfront.psd image and then close the image window.

 You will add more to this file later.

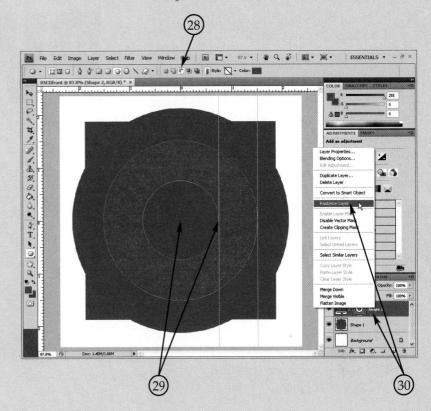

Tutorial 5-8: Create a Custom Shape

In this tutorial, you will create a design that can be loaded into the **Custom Shape Picker** and quickly inserted into any document using the **Custom Shape Tool**.

1. Choose **File > New…**. In the **New** dialog box, name the new file 05initials and enter the settings shown.

2. Click the **Horizontal Type Tool** in the **Tools** panel.

3. For best results, choose a font and style that creates simple, thick letters.

4. Enter 100 in the font size text box and set the text color to black.

5. Click in the image window and enter your initials. Click the **Commit** button in the options bar when you have entered your initials.

6. Choose **Layer > Type > Convert to Shape**.

7. Click the **Path Selection Tool**.

8. Hold down [Shift] and click on each of your initials to select the path that surrounds them.

9. Click the **Ellipse Tool**.

10. In the options bar, make sure the **Shape layers** button is selected.

11. Click the **Subtract from shape area** button in the options bar.

12. Make your initials look like Swiss cheese by creating a number of small holes of various sizes through the initials.

 If the **Unconstrained** option is selected in the **Ellipse Options** dialog box, hold down [Shift] to create perfect circles with the **Ellipse Tool**.

13. Choose **Edit > Define Custom Shape…**.

14. In the **Shape Name** dialog box, name your custom shape Initials and click **OK**.

 This adds the shape to the very end of the list of available shapes in the **Custom Shape Picker**.

15. Click the **Custom Shape Tool** in the **Tools** panel or options bar.

16. In the options bar, click the **Shape** box to access the **Custom Shape Picker.**

17. Select the Initials shape you just added to the **Custom Shape Picker.** Click the **Custom Shape Tool** button in the options bar to close the **Custom Shape Picker.**

18. Click the **Create new shape layer** button on the options bar.

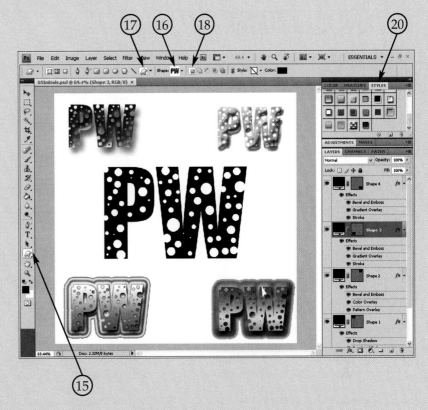

19. Using the **Custom Shape Tool,** add your initials four more times into your image.

If the **Unconstrained** option is selected in the **Custom Shape Options** dialog box, press and hold [Shift] after you begin drawing your initials to keep them in proportion. If you press [Shift] before you begin drawing, you will accidentally toggle the **Add to shape area** option.

20. Using the **Styles** panel, add a different style to each of your custom shapes.

Styles can be assigned to the shapes by clicking and dragging the style thumbnail onto the shape in the image window, or by selecting the shape layer in the **Layers** panel and then clicking the desired style in the **Styles** panel.

21. Close and save your 05initials.psd file.

Key Terms

bitmap graphic	open path	shapes
closed paths	ordinals	styles
decorative fonts	path	subpaths
font	raster graphic	symbol fonts
font family	rasterize	type
layer styles	sans serif fonts	vector graphics
ligatures	serifs	

Review Questions

Answer the following questions on a separate sheet of paper.

1. What is the difference between vector and bitmap graphics?

2. What is another name for a bitmap graphic?

3. How can you create multiple lines of text on separate layers?

4. What program would you use to insert the copyright symbol (©) in the text in your image?

5. How are the type mask tools different from the other two type tools?

6. What setting on the **Character** panel would you adjust to create a double-spaced look between several lines of text?

7. What is the difference between the kerning and tracking settings on the **Character** panel?

8. How can you access OpenType font features such as ordinals, ligatures, and fractions?

9. What is the **Baseline Shift** setting in the **Character** panel used for?

10. What does the term *rasterize* mean?

11. When using the **Line Tool**, if you want to create a line that is 10 pixels thick, what *exactly* should you enter in the **Weight** text box in the options bar?

12. When the **Unconstrained** option is active, how do you keep a **Custom Shape** in proportion as you draw it?

13. When using the shape or pen tools, what is the difference between the **Shape layers** and **Paths** options?

14. When using the shape or pen tools, what is the difference between the **Shape layers** and **Fill pixels** options?

15. Where can you find the settings that change a polygon into a star shape?

16. As you draw shapes, each of them will appear on a separate layer if what button is pressed in the options bar?

17. Explain the steps required to add the custom shapes in the Animals category to the **Custom Shape Picker.**

18. How do you modify a shape using Photoshop's transform and warp features?

19. A path can be converted into four different features. What are they?

20. What do you need to do differently with the **Pen Tool** to create a curved path instead of a straight path?

21. What tools are used to select paths and anchor points?

22. Describe one situation when you would use the **Freeform Pen Tool** with its **Magnetic** option turned on.

23. What are two purposes of the **Paths** panel?

24. If you are using a light-colored outer glow layer style, what must you do to the background color of your file?

25. Each of the effects on the **Styles** panel is a unique combination of what?

6

Painting Tools and Filters

Learning Objectives

After completing this chapter, you will be able to:

- Use the **Brush Tool** to apply paint to an image.
- Compare the effects of different blending modes.
- Use the **Brush Preset Picker** and the **Brushes** panel to select and modify brush styles.
- Compare the **Image Size** and **Canvas Size** commands.
- Use the **Pattern Stamp Tool** to paint patterns in an image.
- Use the **Pattern Picker** to select and organize patterns.
- Explain the difference between the **Brush Tool** and **Pencil Tool**.
- Use the **Eyedropper Tool** to sample a color in an image.
- Use the **Gradient Tool** to create different styles of gradients.
- Use the **Gradient Editor** to edit a gradient.
- Use the **Paint Bucket Tool** to fill an area with color.
- Use the tools found in the **Liquify** filter to manipulate an image.

Introduction

You have probably used a simple painting program on a computer. Most painting programs allow you to spread color on your screen with a variety of tools, such as a paintbrush, a pencil, or a paint bucket.

Photoshop's painting tools have an incredible amount of brush styles to choose from. There are brushes that imitate any traditional art style that you can think of. There are square brushes, calligraphy brushes, and special effect brushes that let you paint anything from stars to grass, **Figure 6-1**. You can even create your own brushes, or download brushes created by other artists.

Photoshop's painting tools are used for more than just painting color on your screen. For example, in Chapter 3, *Selection Tools*, you learned that while in quick mask mode, the **Brush Tool** is used to create a mask. The shape and size of many of Photoshop's other tools are controlled by choosing from the same assortment of brushes used by the **Brush Tool**.

Figure 6-1.
This simple painting was completed in under one minute. The **Gradient Tool** was used to create the sky, and a brush shaped like a blade of grass was used to paint the grass.

Photoshop offers more than one hundred *filters*. Filters are special effects that can be applied to all or part of a file. For example, one filter makes an image look like it is coated with plastic wrap, another modifies an image so it looks like a stained glass window, and another causes a photo to appear as if it was created by an artist using colored pencils.

The Brush Tool

The primary function of the **Brush Tool** is to paint with the foreground color shown in the **Tools** panel. Painting occurs as you might expect: by clicking and dragging the mouse or using a graphics tablet. Straight lines can also be created with this tool if you click the start point, then press [Shift] and click the end point of the line. If you want to add additional segments to the existing line, continue clicking points while holding [Shift]. If you want to start an entirely new line, release the [Shift] key, click the new starting point, then press and hold [Shift] and click the desired end point.

The options that appear on the **Brush Tool**'s options bar are also found on the options bar of several other painting tools. See **Figure 6-2**. The current brush size (its diameter, in pixels) and style are shown. Next to it is a small, downward-pointing arrow that opens the **Brush Preset Picker.** The **Brush Preset Picker** is used to change the size and style of the brush. Since brush sizes are usually changed frequently while you work, you may find it more convenient and quicker to change brush sizes by pressing

Figure 6-2.
The **Brush Tool**'s options bar is shown here.

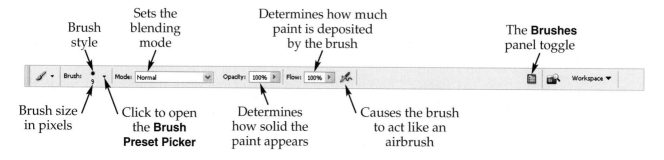

the bracket keys ([,]) instead of using the **Brush Preset Picker**. The right bracket (]) increases the brush size, the left bracket ([) decreases it. Another method is to press and hold [Alt] and then right-click and drag the mouse to resize the brush (Mac users hold down [Ctrl][Option] while clicking and dragging the mouse). Since pressing the [Alt] key activates the **Color Sample Tool**, you must be careful not to inadvertently sample a new color before right-clicking.

The **Mode** setting lets you choose from several blending modes. Blending modes control the way the brush color blends with the image beneath it. Because there is a long list of modes, they will be explained a bit later in this chapter.

The **Opacity** setting determines how solid (opaque) the paint appears. An **Opacity** setting of 100% means you will not be able to see through the paint that the brush leaves behind. Entering a lower percentage causes the paint to appear less solid. A value of 1% in this setting results in paint that is very nearly transparent.

When using a lower **Opacity** setting, you can get different results if your painting strokes *overlap*. If you release the mouse button as you paint several strokes, the paint will appear darker where the overlap occurs. See **Figure 6-3**. Holding down the mouse button continuously as you paint avoids this effect.

The **Flow** setting determines how much paint is deposited in the image at any given time. If the **Flow** setting is lower than 100%, the amount of paint produced by the **Brush Tool** is restricted. For example, if the **Flow** setting is changed from 100% to 50%, only half as much paint will be produced by the **Brush Tool**.

Clicking the airbrush button causes the **Brush Tool** to act like an airbrush. An airbrush forces paint through a nozzle using compressed air. This setting causes paint to keep spraying out as long as you are holding down the mouse button. You will really notice this effect if you move the mouse very slowly or stop moving it while you paint.

At the far right of the options bar is the **Brushes** panel toggle. Activating this toggle displays the **Brushes** panel. The settings in the **Brushes** panel are more detailed than those in the **Brush Preset Picker**.

The Brush Preset Picker

The **Brush Preset Picker** displays when you click on the small downward-pointing arrow on the options bar. See **Figure 6-4**. From the **Brush Preset Picker**, you can quickly change the size (diameter) and hardness of the brush. The **Hardness** setting controls how sharp and crisp the edge of the brush looks. A setting of 0% produces a soft, feathery edge.

Figure 6-3.——————
When the **Opacity** setting is less than 100%, painting in one continuous stroke does not cause a darkened overlap effect (left). Releasing the mouse button and then painting additional strokes darkens the paint in areas that overlap (right).

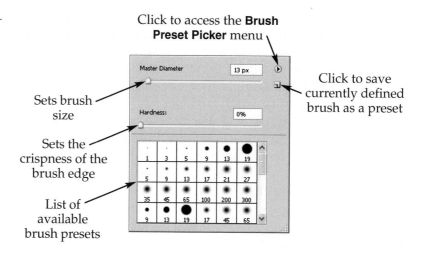

Figure 6-4. _____
The **Brush Preset Picker** is used to change the size and hardness of the brush.

Click to access the **Brush Preset Picker** menu

Sets brush size

Sets the crispness of the brush edge

List of available brush presets

Click to save currently defined brush as a preset

Note The hardness setting can be changed as you paint by pressing [Alt][Shift] while dragging the mouse ([Ctrl][Option][Command] + click and drag for Mac users). This option only works if your graphics card (GPU) is capable enough, and the **Enable Open GL Drawing** option is activated in **Preferences > Performance**.

Beneath the **Brush Preset Picker** menu button is the **Create a new preset from this brush** button. As its name indicates, this button is used to save the current brush settings as a preset. After you name the new preset, it appears at the bottom of the presets list in the **Brush Preset Picker**.

Note Keep in mind that several other tools use the same **Brush Preset Picker** to choose the size, style, and shape of the tool.

The Brush Preset Picker Menu

The **Brush Preset Picker** menu is structured just like the **Custom Shape Picker** menu that you learned about in Chapter 5, _Text, Shapes, and Layer Styles_. Most of Photoshop's picker menus are structured in the same way. See **Figure 6-5**.

The **New Brush Preset** command lets you save your current settings as a new brush in the **Brush Preset Picker**. This command is identical in function to the **Create a new preset from this brush** button in the picker. After it is named, the new preset appears at the bottom of the list of available presets in the picker.

The two commands in the next section of the menu allow you to delete and rename presets. To rename a brush preset, select the preset in the **Brush Preset Picker** and then select **Rename Brush** from the **Brush Preset Picker** menu. To delete a preset, select the brush in the picker and then choose **Delete Brush** from the **Brush Preset Picker** menu.

Figure 6-5. _____
The **Brush Preset Picker** menu is similar in layout and function to other picker menus.

New Brush Preset...

Rename Brush...
Delete Brush

Text Only
✓ Small Thumbnail
Large Thumbnail
Small List
Large List
Stroke Thumbnail

Preset Manager...

Reset Brushes...
Load Brushes...
Save Brushes...
Replace Brushes...

Assorted Brushes
Basic Brushes
Calligraphic Brushes
Drop Shadow Brushes
Dry Media Brushes
Faux Finish Brushes
Natural Brushes 2
Natural Brushes
Special Effect Brushes
Square Brushes
Thick Heavy Brushes
Wet Media Brushes

The third section of the menu lists several ways the brushes can be displayed in the picker. The **Stroke Thumbnail** option is the most informative because you can see a sample brush stroke along with the small thumbnail image of the brush tip.

Choosing the **Preset Manager** command opens the **Preset Manager** dialog box. This dialog box displays all of the brushes that are currently in the picker. You can use the **Preset Manager** to delete and load different brushes, if desired.

Choosing the **Reset Brushes** command restores the picker to its default state. When you modify brushes, you can use the **Save Brushes** command to save the current condition of the **Brush Preset Picker** to a file. This file can be retrieved later by using the **Load Brushes** command. The **Replace Brushes** command is very similar to the **Load Brushes** command. The difference is the old brushes are replaced (deleted) instead of appended (added to) as the new brushes are loaded into the picker.

The last section of the menu lists all of the available brush categories. When you click one of these categories, a dialog box asks if you want to replace or append the current brushes. If you click **OK**, the new brushes are added, but all of the brushes that were previously in the picker are deleted. If you click **Append**, the new brushes are added to the brushes already listed in the picker.

Brush Tool Blending Modes

Remember the **Mode** setting on the **Brush Tool**'s options bar? Blending modes control how the **Brush Tool** behaves when adding color to an image. You will find these same modes on the options bar of several other painting tools (although some modes are not available with certain tools). Modes are also found on the **Layers** panel and control how layers blend with one another. This is discussed further in Chapter 11, *Additional Layer Techniques*.

The blending modes available with the **Brush Tool** are briefly explained in **Figure 6-6**. The examples that appear in the table show the result of using a soft, round brush with a medium blue color as the foreground color. The **Opacity** setting is 100% in all examples.

As you read about the modes in Figure 6-6, remember that you should always *create a duplicate layer before painting an image* so that the original image is always preserved. Your results will vary depending on the color of the original image and the color of the paint. You should also be aware that using black and white paint with blending modes creates unpredictable results.

The Brushes Panel

The **Brushes** panel contains many more options than the **Brush Preset Picker**. From this panel, you can customize brushes in a variety of ways. The **Brushes** panel can be displayed by clicking the **Toggle the Brushes** panel button on the options bar or by choosing **Window > Brushes**.

The **Brushes** panel contains a panel menu that is similar to the menu found on the **Brush Preset Picker**, except it contains more commands. When the **Expanded View** option is selected, the **Brushes** panel appears as shown in **Figure 6-7**. When the **Expanded View** option is not enabled, the **Brushes** panel looks very similar to the **Brush Preset Picker**.

When the **Brushes** panel is open in expanded view, the section on the left displays the different categories of controls that can be adjusted in the panel. Clicking on one of these categories places a check mark in its check box to show that it is active. The various options available for the selected category of controls are displayed on the right side of the panel. A preview window at the bottom of the panel shows the effects the current settings will have on the brush strokes.

Figure 6-6. _____

Each brush stroke in the following examples use medium blue as the brush color (otherwise known as the blending color). The blending modes are found in the options bar of several tools. They are also found on the **Layers** panel.

Mode and Explanation	Examples
Normal mode is what you would expect—the brush paints according to the settings you have chosen.	
Dissolve causes the edges of the brush stroke to appear speckled and "noisy."	
Behind mode is only available if there are *transparent areas* in the layer you are painting on. Only the transparent areas can be painted.	
Clear mode is like using the **Eraser Tool**—it creates transparent areas. The *Layer Transparency should be unlocked* when using this mode.	
(From left to right) **Darken, Multiply, Color Burn, Linear Burn,** and **Darker Color** modes cause the paint color to *darken* the image in different ways. For explanations on the subtle differences between these modes, search for "blending modes" in **Help > Photoshop Help....**	

(Continued)

Figure 6-6.
Continued.

Mode and Explanation	Examples
(From left to right) **Lighten**, **Screen**, **Color Dodge**, **Linear Dodge**, and **Lighter Color** modes cause the paint color to *lighten* the image in different ways. Again, refer to Photoshop's help file if you would like an explanation of the differences between each mode.	
(From left to right) **Overlay**, **Soft Light**, **Hard Light**, **Vivid Light**, **Linear Light**, **Pin Light**, and **Hard Mix** are found in the next section of the **Mode:** drop-down menu. Most of these modes will either darken or lighten pixels below it, depending on how dark or light the *blend color* (the color you are painting) is. The final results are computed in a slightly different manner for each of these modes.	
The **Difference** (left) and **Exclusion** (right) modes are similar. They create a lighter effect because they subtract the base and blend colors from each other.	
(From left to right) The **Hue** mode changes an object's color while preserving shadows and highlights (light areas). **Saturation** mode changes the saturation, or intensity, of an object's color. **Color** and **Luminosity** modes are opposite of each other. These modes combine characteristics of the base color with the blend color.	

The Brush Tip Shape Settings

When the **Brush Tip Shape** entry is clicked in the left section of the panel, the right side of the panel displays each brush tip that is currently loaded. Here, you can change the brush diameter or flip or rotate the brush tip, and adjust the spacing between brush marks.

Figure 6-7.
The **Brushes** panel (shown in expanded view) and its panel menu.

Settings or options available
for the selected category

Click to access
the panel menu

Brushes
panel menu

Categories
of settings
that can be
adjusted

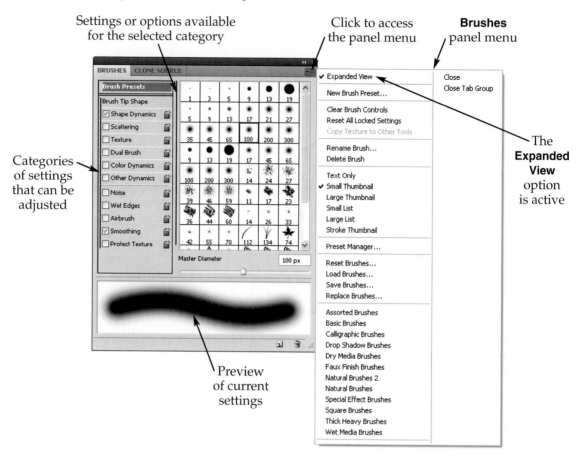

The
**Expanded
View**
option
is active

Preview
of current
settings

In the example in Figure 6-8, one of the special effect brushes, **Dune Grass**, is selected and its spacing has been changed so that fewer grass clumps are generated while painting. The individual patterns of paint created by the brush, in this case clumps of grass, are referred to as *brush marks*. When a paint tool is being used, brush marks are created at regular intervals in the brush stroke. These intervals are called *steps*. The **Spacing** setting determines the distance between steps in the brush stroke. A path with steps that are closer together will look more solid or continuous than a stroke in which the steps are spaced widely apart. In other words, you could create a dashed line effect by controlling the **Spacing** setting. The example you see at the bottom of the **Brushes** panel shows how the brush stroke will appear as you click and drag with the mouse.

Shape Dynamics Settings

When the **Shape Dynamics** entry is clicked on the left side of the **Brushes** panel, the right side of the panel displays a group of settings that are used to add some variance to the brush stroke. The shape dynamics settings can be used in combinations to achieve the desired result.

The first control is the **Size Jitter** slider and text box. The term *jitter* means "random fluctuation." Increasing the **Size Jitter** setting causes different sizes of brush marks (grass clumps for example) to appear. See Figure 6-9. When this value is set to 100, the stroke is the full brush size at its widest point and the minimum allowable width

Figure 6-8. _____

The design, diameter, orientation, and spacing of brush tips can be changed in the **Brush Tip Shape** section of the **Brushes** panel.

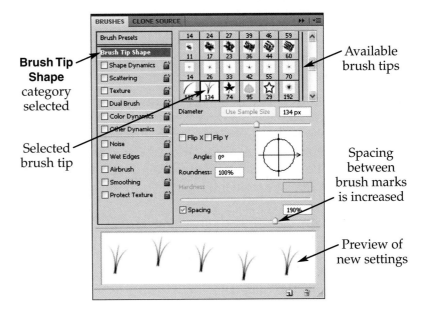

Brush Tip Shape category selected

Selected brush tip

Available brush tips

Spacing between brush marks is increased

Preview of new settings

Figure 6-9. _____

The size jitter effect in **Shape Dynamics** section of the **Brushes** panel can be used to introduce some variation into the size of the brush marks making up the brush stroke. A preview of how the brush will paint appears at the bottom of the **Brushes** panel.

The stroke tapers down from full size to 25% over the first 28 brush marks

Brush marks vary in size from full size to 25% (**Minimum Diameter** setting)

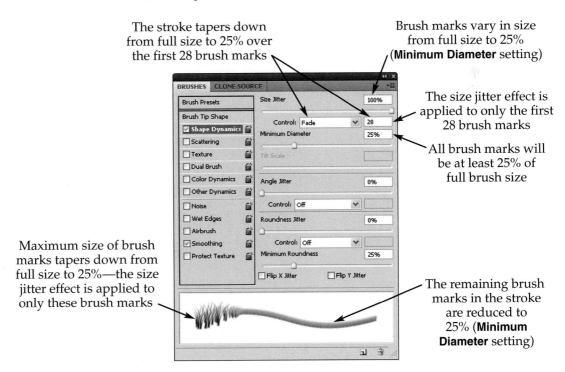

The size jitter effect is applied to only the first 28 brush marks

All brush marks will be at least 25% of full brush size

Maximum size of brush marks tapers down from full size to 25%—the size jitter effect is applied to only these brush marks

The remaining brush marks in the stroke are reduced to 25% (**Minimum Diameter** setting)

(determined by the **Minimum Diameter** slider setting) at its narrowest point. When the slider is set to 50, the sizes of the brush marks may vary up to 50%. A setting of 0 results in brush marks that do not vary in size.

Note If the **Size Jitter** setting is higher than the **Minimum Diameter** setting, the **Minimum Diameter** setting determines how much the brush marks can vary in size.

The **Control** drop-down list offers a few options for varying the stroke width. Only the **Off** and **Fade** options work without a pressure-sensitive tablet and stylus. When the **Off** option is selected, the maximum stroke width remains constant and the size jitter effect is applied to the entire stroke. When the **Fade** option is selected, the maximum width of the stroke tapers down from full size down to the minimum size over the number of steps (increments) specified in the text box to the right of the **Control** drop-down list.

The **Fade** option also causes the size jitter effect to gradually diminish over the specified number of steps. Beyond the specified number of steps, the size jitter effect is not applied because all brush marks are already at their minimum allowable size.

The **Minimum Diameter** slider determines the *minimum* width that a brush mark is allowed to be. The value set with this slider represents a percentage of the full brush size.

The **Angle Jitter** setting causes random fluctuation in the angles of the steps (grass clumps). The **Control** drop-down list below the **Angle Jitter** slider provides several options for applying the angle jitter effect and for changing the angles of stroke marks, only a few of which are available without a pressure-sensitive tablet and stylus. The **Initial Direction** and **Direction** options subtly change the way the angle jitter effect is applied. When the **Fade** option is selected, the brush marks are progressively rotated from 0° to 360° over the specified number of steps. Therefore, if 10 is entered in the text box, the first ten brush marks are rotated in progressive increments of 36°. Beyond the specified number of steps, the angle jitter is applied normally. See **Figure 6-10**.

Figure 6-10. _____
The angle jitter effect randomly tilts brush marks forward and backward.

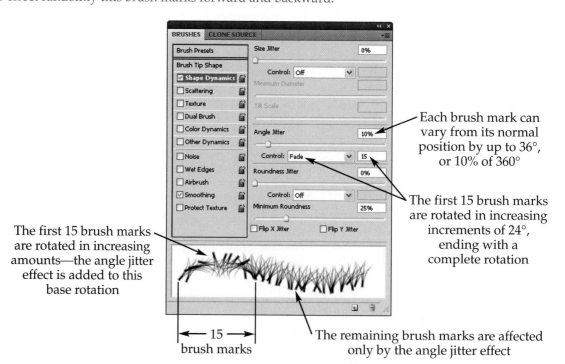

The first 15 brush marks are rotated in increasing amounts—the angle jitter effect is added to this base rotation

Each brush mark can vary from its normal position by up to 36°, or 10% of 360°

The first 15 brush marks are rotated in increasing increments of 24°, ending with a complete rotation

← 15 →
brush marks

The remaining brush marks are affected only by the angle jitter effect

Roundness jitter changes the perspective of each brush mark. As a brush mark's roundness setting decreases, it appears as though it is rotated toward the viewer, **Figure 6-11**. The **Roundness Jitter** slider sets the amount of variation in the roundness setting of the individual brush marks. The limits of the roundness jitter effect are set with the **Minimum Roundness** slider, and the roundness setting can gradually be applied using the **Fade** option in the **Control** drop-down list. These controls are very similar to their counterparts for the size jitter effect.

Activating the **Flip X Jitter** check box causes some of the brush marks to be mirrored horizontally. Placing a check mark in the **Flip Y Jitter** check box causes some of the brush marks to be mirrored vertically. See **Figure 6-12**.

Scattering Settings

When you click the **Scattering** entry on the left side of the **Brushes** panel, a set of controls appear that allow you to adjust how the brush marks are distributed in the area around the brush. Increasing the **Scatter** setting causes brush strokes to apply paint in a ragged line instead of a straight path. If the **Both Axes** check box is checked, the brush marks will be scattered above, below, in front, and behind the cursor. If this check box is unchecked, the brush marks are distributed in a straight line perpendicular to the brush path. The **Count** setting determines the maximum number of brush marks that can be created at each step in the brush stroke. The **Count Jitter** setting determines how much variation there is in the number of brush marks created. The effect of these settings can be gradually decreased by selecting the **Fade** option from the **Control** drop-down lists and entering a number of steps in the text box to the right. See **Figure 6-13**.

Figure 6-11. _____
The roundness jitter effect makes the marks randomly appear to be tilted toward or away from the viewer.

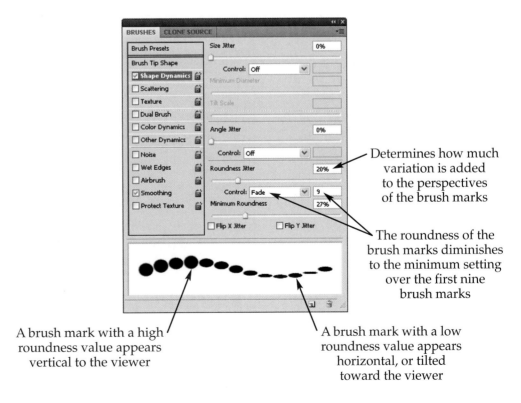

Determines how much variation is added to the perspectives of the brush marks

The roundness of the brush marks diminishes to the minimum setting over the first nine brush marks

A brush mark with a high roundness value appears vertical to the viewer

A brush mark with a low roundness value appears horizontal, or tilted toward the viewer

Figure 6-12. _____

The flip X jitter effect mirrors random brush marks vertically. The flip Y jitter effect mirrors random brush marks horizontally. Some brush marks will be affected by both options.

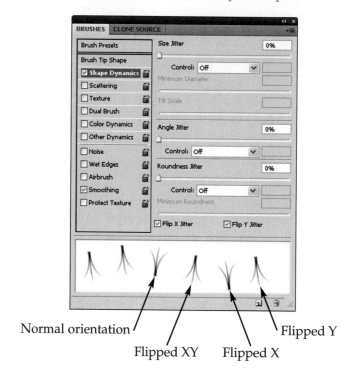

Normal orientation

Flipped XY Flipped X Flipped Y

Figure 6-13. _____

Increasing the **Scattering** and **Count Jitter** settings causes paint to be applied in a more random fashion.

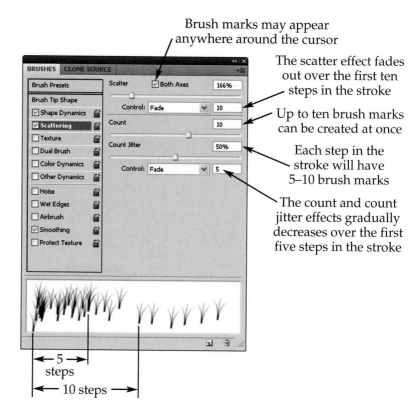

Brush marks may appear anywhere around the cursor

The scatter effect fades out over the first ten steps in the stroke

Up to ten brush marks can be created at once

Each step in the stroke will have 5–10 brush marks

The count and count jitter effects gradually decreases over the first five steps in the stroke

← 5 →
steps

← 10 steps →

Texture Settings

When you click the **Texture** entry on the left side of the **Brushes** panel, a group of controls appear on the right that allow you to combine a texture file with the brush tip. This adds a textured look to the paint. See **Figure 6-14**. For example, with the right settings, paint can look like it was applied to a real canvas. Using texture files are discussed in more detail in the "Pattern Stamp Tool" section in this chapter.

Clicking the down arrow next to the texture preview opens the pattern picker, from which a pattern is selected for the texture. Activating the **Invert** check box reverses the effect of the pattern's color on the resulting texture. The **Scale** slider setting determines the size of the texture. When the **Texture each tip** check box is checked, the texture is applied to each brush mark individually, when it is unchecked the texture is applied to the stroke as a whole. The difference between these settings can be subtle.

The **Depth** settings control to what degree the texture file is combined with the brush stroke. They work together to control the appearance of the image in much the same way as the other groups of controls you have studied in the **Brushes** panel.

Dual Brush Settings

In the **Dual Brush** section of the **Brushes** panel, a second brush tip can be combined with the first. Paint will appear where the two brush tips overlap. Similar to the **Texture** section, this is another way to increase the complexity of a brush tip.

To use the dual brush option, begin by defining the first brush in the **Brushes** panel. Once you have selected and adjusted the brush and activated the desired options, click the **Dual Brush** entry on the left side of the **Brushes** panel.

Figure 6-14. _____

The controls in the **Texture** section of the **Brushes** panel can be used to add a three-dimensional appearance to the brush stroke.

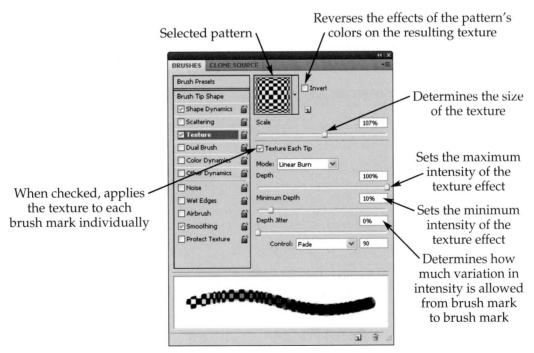

Selected pattern

Reverses the effects of the pattern's colors on the resulting texture

Determines the size of the texture

When checked, applies the texture to each brush mark individually

Sets the maximum intensity of the texture effect

Sets the minimum intensity of the texture effect

Determines how much variation in intensity is allowed from brush mark to brush mark

Select the desired brush tip for the second brush from the picker window. Adjust the size of the second brush using the **Diameter** slider. Click the **Use Sample Size** button if you want the brush tip to be the same size as the image selected in the brush tip picker. (The size appears under the brush tip image in the picker window.) Set the method that you want to use to combine the brushes from the **Mode** drop-down menu. Activate the **Flip** check box if you want to mirror the image being used for the brush tip.

Set the distance between stroke steps for the second brush using the **Spacing** slider. Set the desired **Scatter** value. Keep in mind that only the overlapping areas of the first and second brush will be visible. So, if you have selected a small brush size for the first brush and a high scatter value for the second brush, many of the brush strokes may not be visible.

Finally, use the **Count** slider to set the number of brush marks that you want to appear at each step of the stroke. Each additional brush mark created at a given step will be rotated slightly compared to the previous brush mark. You can see how the first and second brushes interact in the preview window at the bottom of the **Brushes** panel. See **Figure 6-15**.

Color Dynamics Settings

The **Color Dynamics** section of the **Brushes** panel contains jitter settings that create random color fluctuations. The leaf pattern in **Figure 6-16** was created by starting with a leaf-shaped brush and setting orange as the foreground color and brown as the background color. The **Foreground/Background Jitter** setting was increased, causing the brush marks to be varying blends of the foreground color and the background color. The **Hue Jitter** was increased very slightly, allowing the leaves to have just a hint of different colors. This produces the occasional leaf that is slightly more green or yellow than the others. A higher setting would cause the brush to occasionally produce colors that are not as closely related to the selected foreground and background colors, such as a bright blue or magenta. The **Saturation Jitter** and **Brightness Jitter** settings were also

Figure 6-15. _____

The controls in the **Dual Brush** section of the **Brushes** panel are used to combine two different brushes to create a single stroke. Paint is only applied to the areas where the two brushes overlap.

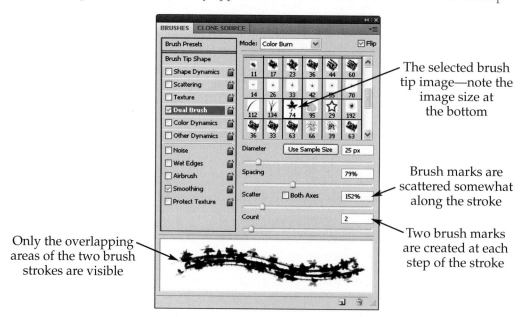

The selected brush tip image—note the image size at the bottom

Brush marks are scattered somewhat along the stroke

Two brush marks are created at each step of the stroke

Only the overlapping areas of the two brush strokes are visible

Figure 6-16. _____
This leaf pattern was painted in only a few seconds. The jitter and scattering effects create a naturally random look to the leaves.

Determines how much the paint color can vary from the foreground/background blend colors

Causes the brush to paint with a varying blend of foreground and background colors

Determines how much the intensity of color is allowed to vary from leaf to leaf

Determines how much the shade (darkness) of color can vary from leaf to leaf

Sets the overall saturation (color intensity) level for colors used in the brush

increased. The saturation jitter effect causes the intensity of the colors to vary, and the brightness jitter effect causes the lightness and darkness of the colors to vary. The **Purity** slider was not adjusted. The **Purity** slider setting adjusts the saturation for all of the color created by the **Brush Tool**; the **Saturation** slider setting just sets the variation.

In addition to the changes made to the **Color Dynamics** settings, the brush was modified by changing the **Shape Dynamics** and **Scattering** settings. The **Angle Jitter** setting and **Size Jitter** settings were bumped up, as were the **Scatter** and **Count** settings.

Other Dynamics Settings

The left side of the **Brushes** panel contains one more entry, called **Other Dynamics**. Clicking this entry reveals the **Opacity Jitter** and **Flow Jitter** settings on the right side of the panel. Increasing the **Opacity Jitter** setting causes the **Brush Tool** to create brush marks with varying degrees of transparency. Increasing the **Flow Jitter** setting causes the pen to produce an inconsistent stroke. The result is very similar to the effect created by increasing the opacity jitter.

Other Options in the Brushes Panel

The **Noise**, **Wet Edges**, **Airbrush**, **Smoothing**, and **Protect Texture** create different appearances to painted strokes. These are not further sections of the **Brushes** panel like

the **Shape Dynamics** and the other entries already discussed. Rather, these are single options that are always available, no matter what other settings have been changed.

Activating the **Noise** option creates a blotching effect in the soft areas of the brush. This effect could simulate the type of spray pattern that comes from a can of spray paint that has not been shaken enough.

Turning on the **Wet Edges** option causes the paint to thin out (become somewhat transparent) in the center of the brush stroke and pool at the edges. This effect could be used to simulate excessively thinned paint, watercolors, or a coffee stain.

The **Airbrush** option, when activated, causes the brush to continue to lay down paint as long as the mouse button is held. This option works the same as its counterpart on the options bar.

When the **Smoothing** option is activated, the curves in the brush stroke are smoothed out. This option is most noticeable when you are painting with a pressure-sensitive tablet and stylus.

If you have adjusted the texture settings on various brushes, the **Protect Texture** option forces any of these brushes to use the same scale and pattern settings. This causes a uniform-looking "canvas" to appear under a painting as you switch from brush to brush.

To reset all of the settings in the **Brushes** panel, choose **Clear Brush Controls** from the **Brushes** panel menu.

Creating a Custom Brush Tip

It is simple to create a new brush tip. To create a flower-shaped brush, for example, use either of the following methods. First, you create a new file (3 inches square and 200 pixels per inch are reasonable settings). Using black as your color, use the **Pen Tool** or shape tools to create the flower shape. Rasterize the shape layers, and then convert them to a brush by choosing **Edit > Define Brush Preset…**. Name the new flower-shaped brush, and click **OK**. It is added to the **Brush Preset Picker**.

Another method is to select a flower from a photograph. Once the flower is selected (apply a feather effect for smoother edges), convert it into a brush by choosing **Edit > Define Brush Preset…**. During this process, Photoshop converts the flower you selected into a grayscale image—an image that controls how the new brush tip applies paint. Parts of the flower that are gray apply paint semi-transparently, depending on how light or dark the shade of gray is. Black parts of the brush apply paint at full strength.

Many custom brush tips are available for free download from websites like Adobe's Exchange.

The Pencil Tool

The **Pencil Tool** is found behind the **Brush Tool** in the **Tools** panel. The **Pencil Tool** is a painting tool that creates a *hard-edged* brush stroke. It does not matter what the **Hardness** setting is in the **Brush Preset Picker**. In contrast, the **Brush Tool** creates an anti-aliased, softer edge, even when the **Hardness** setting is changed to 100% in the **Brush Preset Picker**. Compare the two brush strokes in **Figure 6-17**. The first was created with the **Pencil Tool** with the **Hardness** set at 100%. The second stroke was created with the **Brush Tool** with the **Hardness** set at 100%.

The **Pencil Tool**'s options bar contains options you are already familiar with, plus one more, **Figure 6-18**. When the **Auto Erase** option is on, the **Pencil Tool** can "erase" what you have painted, but it does not actually delete any pixels. Instead, it paints the background color on top of areas you have painted with the foreground color. This is similar to how the **Eraser Tool** works on a locked layer. The **Auto Erase** option only works, however, if

Figure 6-17. _____
Compare these two
examples carefully by
looking at the edges. The
Pencil Tool creates hard-
edged brush strokes (left),
while the **Brush Tool**
creates softer edges (right).

Figure 6-18. _____
The **Pencil Tool**'s options bar is shown here.

the exact center of your brush is over a painted area before you click the mouse button to erase. The erase mode will continue until you release the mouse button.

Straight lines can be created with the **Pencil Tool** by clicking the starting point, then holding [Shift] while clicking the end point of the line.

> **Note** The remaining tool grouped with the **Brush Tool** in the **Tools** panel is the **Color Replacement Tool**. This tool will be discussed in Chapter 9, *Introduction to Color Correction*.

The Pattern Stamp Tool

The **Pattern Stamp Tool** paints a *pattern* instead of a solid color. The **Pattern Stamp Tool** is found behind the **Clone Stamp Tool** in the **Tools** panel. The **Clone Stamp Tool** will be discussed in Chapter 8, *Restoring and Retouching Photos*.

The Pattern Stamp Tool's Options Bar

The options bar for the **Pattern Stamp Tool** contains all of the **Brush Tool**'s options, plus a **Pattern Picker**, **Figure 6-19**. The **Pattern Picker** behaves just like the **Brush Preset Picker**. It contains a panel menu that controls the display of the picker and lets you load, save, replace, or reset patterns. The bottom section of the panel menu lists nine different pattern categories that can be replaced or appended into the **Pattern Picker**.

There are two additional settings on the **Pattern Stamp Tool**'s options bar. When the **Aligned** option is on, the pattern repeats itself over and over, side by side, as you paint it. This is called a *tiled* pattern. If the **Aligned** option is turned off, clicking the mouse occasionally as you paint creates a pattern that does not repeat—or in other words, blends the pattern into itself. Activating the **Impressionist** option causes the **Pattern Stamp Tool** to create brush marks that have the same colors as the pattern, but not the structure of the pattern.

Figure 6-19.

The **Pattern Stamp Tool** is located behind the **Clone Stamp Tool** in the **Tools** panel. It shares many of the **Brush Tool**'s options and includes a **Pattern Picker**.

The **Pattern Picker**

Pattern created with the **Aligned** option active

The **Pattern Stamp Tool**

The **Pattern Picker** panel menu

Pattern created with the **Aligned** option inactive

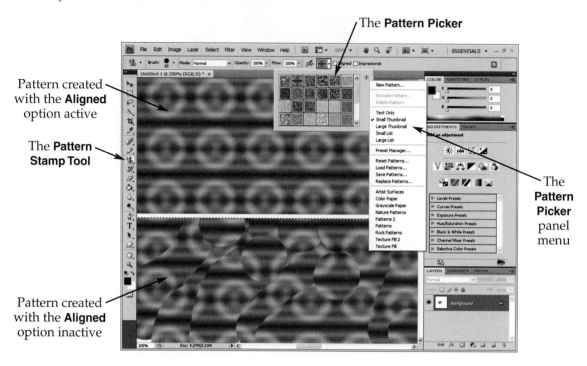

Defining Your Own Patterns

You can also create your own patterns by opening an image file, selecting part of it with the **Rectangular Marquee Tool**, and choosing **Edit > Define Pattern...**. After you name the pattern and click **OK**, the pattern appears at the end of the list in the **Pattern Picker**.

The Gradient Tool

A *gradient* consists of two or more colors that gradually blend together. Gradients are used to create colorful backgrounds or shapes. They can also be used to create more complex effects, such as shadows or fade-out effects. In this chapter, you will be introduced to the basics of gradients. You will see more examples of advanced gradient effects in a later chapter.

The options bar of the **Gradient Tool** contains the **Gradient Picker**, which functions like Photoshop's other pickers, **Figure 6-20**. When the default gradients are loaded in the **Gradient Picker**, the first gradient is always a combination of the foreground and background color, and the second gradient is always a combination of the foreground color and a transparent area. The rest of the gradients are preset colors which can be replaced, deleted, or edited.

You can right-click (Mac: [Ctrl] + click) on any gradient and use the shortcut menu that appears to delete, rename, or add a new gradient to the picker. The **Gradient Picker** menu, which is opened by clicking the small arrow at the top right of the **Gradient Picker**, can be used to accomplish the same tasks as the shortcut menu. In addition, the **Gradient Picker** menu lists several categories of preset gradients that can be replaced or appended into the picker. You can also use the **Gradient Picker** menu to save your own collection of gradients so they can be loaded again at a later time.

Figure 6-20. _____
The **Gradient Picker** is set up just like the **Brush Preset Picker** and **Pattern Picker**.

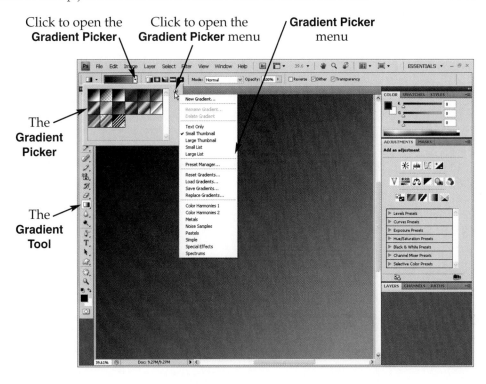

Before learning about the rest of the **Gradient Tool**'s options, you need to know how to use the **Gradient Tool**. Creating a gradient is simple—you drag a line at any angle on your screen and release the mouse button. Dragging a *long* line creates a more gradual gradient. If you drag a *short* line, the transition between colors is more abrupt. See **Figure 6-21**.

In the options bar, you can choose from several styles of gradients by clicking the buttons next to the **Gradient Picker**. The example in the Figure 6-21 was created with the first gradient style, called **Linear Gradient**, applied at an angle. Examples of all five gradient styles are shown in **Figure 6-22**.

Figure 6-21. _____
The appearance of a gradient depends on how long of a line you draw when creating it. **A**—A long line creates a gradient with a gradual shift from the first color to the second. **B**—A shorter line creates a more abrupt shift from the first color to the second.

A B

Figure 6-22. _____
Five different styles of
gradients can be created.

Gradient Style	Button	Example
Linear Gradient		
Radial Gradient		
Angle Gradient		
Reflected Gradient		
Diamond Gradient		

When you add a gradient to an image, you can choose from several different blending modes in the **Mode** drop-down list. You can control how transparent the gradient is by changing the **Opacity** setting.

The **Reverse** option switches the gradient colors. In **Figure 6-23**, a two-color gradient (green and blue) was applied to a custom shape. Before the **Gradient Tool** would work, each shape layer had to be rasterized and selected.

The **Dither** option should be left on in most cases. It blends the gradient by adding "noise," making it appear smoother.

Some gradients have transparent areas, represented by a checkerboard pattern. The **Transparency** option, if turned off, will not allow those transparent areas to be created. In most cases, leave this option turned on.

Note Since gradients are gradual blends of color, they do not look very good in low-resolution files. Pixelation makes the blended areas look distorted.

Editing Gradients

You can easily change a preset gradient's appearance or create and save your own gradient presets. To edit a gradient, click on whatever gradient appears on the options bar (not in the **Gradient Picker**). This causes the **Gradient Editor** to appear, **Figure 6-24**. Also, the **Eyedropper Tool** is activated automatically and is ready to use.

Figure 6-23.
The effect of the **Reverse** option is obvious when applied to a simple two-color gradient. **A**—The original gradient. **B**—The gradient after using the **Reverse** option.

A B

Figure 6-24.
In the **Gradient Editor**, color stops are used to color the gradient and opacity stops are used to create transparent areas.

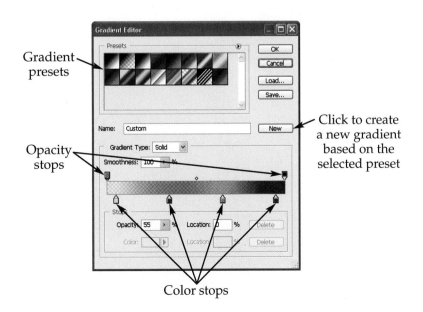

Gradient presets

Click to create a new gradient based on the selected preset

Opacity stops

Color stops

You can choose any preset gradient in the **Gradient Editor**, just like you can in the **Gradient Picker**. The **Gradient Editor** menu and the **Gradient Picker** menu are almost identical. After you click on the gradient you want to edit, click the **New** button to create a copy that is ready for you to adjust.

Adjusting Color Stops

The **Gradient Editor** has *color stops* that appear along the bottom of the sample gradient box. These color stops each represent one color in the gradient and indicate where the color shifts begin and end within the gradient. The colors in the gradient blend from one color stop to the next. Each color stop can be dragged to a different location on the sample gradient box to change the appearance of the gradient. Color stops can be deleted by dragging them downward. A color stop can be added by clicking right beneath the sample gradient box. The color of a color stop can be changed by double-clicking on it. This causes the color picker to appear, from which the new color can be selected. Remember that the **Eyedropper Tool** is automatically activated when you open the **Gradient Editor**, so you can easily choose a color from an image file, if desired.

When a color stop is clicked, two tiny diamond-shaped handles appear on either side of it. These diamonds show the midpoint between two colors. You can adjust the location of these midpoints by dragging them.

Solid and Noise Gradient Types

In the **Gradient Editor**, you can also choose between two gradient types from the **Gradient Type** drop-down list. The **Solid** option creates a gradient with gradual blends of color. The **Smoothness** setting lets you fine-tune how one color blends into another.

Selecting the **Noise** option creates gradients that blend colors randomly, making the gradient look choppy. See **Figure 6-25**. A noise-type gradient does not use color stops to determine the colors used in the gradient. Instead, the colors that will be used in the gradient are determined by first selecting a color mode from the **Color Model** drop-down list. Once you have selected a color model, a series of sliders appear under the **Color Model** drop-down list. Adjust these sliders to achieve the desired colors and note the changes in the sample gradient box.

Note The **HSB** (hue, saturation, brightness) color model is especially good for creating monochromatic gradients. The **LAB** (luminosity, red-green, yellow-blue) color model is best for creating pastel gradients. The **RGB** (red, green, blue) color model is good for multicolor gradients.

Figure 6-25. _____
This radial gradient was created using the **Noise** gradient type.

You can adjust the appearance of noise by changing the **Roughness** setting, which appears when you choose the **Noise** gradient type. You can further refine the gradient by activating the **Restrict Colors** and **Add Transparency** check boxes. The **Restrict Colors** option, when active, limits the saturation of the colors in the gradient so they are not overly intense. The **Transparency** option, when active, varies the opacity of the colors randomly, creating a gradient that fades in and out.

The Paint Bucket Tool

The **Paint Bucket Tool** is found in the **Tools** panel behind the **Gradient Tool**. The **Paint Bucket Tool** provides a quick way to paint—it dumps the foreground color into either a selected area or an entire layer.

On the **Paint Bucket Tool**'s options bar, Figure 6-26, you can choose to dump a pattern into an area instead of the foreground color. The **Pattern Picker** appears when you choose this option.

Just like the **Brush Tool**, the **Paint Bucket Tool** has a **Mode** setting that controls how the paint blends with the colors underneath it. The **Opacity** setting controls how transparent the paint is.

Because the **Paint Bucket Tool** is used to fill an area that already contains other colors, it has a **Tolerance** setting that controls how sensitive the **Paint Bucket Tool** is when spreading its color on other colored pixels. If the **Tolerance** is set low, when a pixel is clicked with the **Paint Bucket Tool**, only similar-colored pixels are filled with the new color. This effect can be seen when dumping white on a gradient, Figure 6-27. To quickly fill a selected area, regardless of the color of the pixels in it, set the **Tolerance** setting to its maximum: 255.

The **Anti-alias** option is useful if the filled area contains diagonal lines or curves. Activating this option smoothes the edges of the filled area, which would normally be jagged.

Pixels that are touching or bordering each other are called *contiguous*. When the **Contiguous** option is turned on, the **Paint Bucket Tool** dumps color onto similarly colored pixels only if they are touching each other. When the **Contiguous** option is turned off, similar colors throughout the image are selected.

Activating the **All Layers** option allows you to simultaneously fill similarly colored pixels on different layers in the image. If this option is not active, you must select each layer individually to fill the desired pixels on those layers. It should be noted that when the **All Layers** option is active, paint is applied only to the selected layer. If the currently selected layer is at the top of the layer list, then when the paint is applied by the **Paint Bucket Tool**, it hides similarly colored pixels on other layers. However, if the currently

Figure 6-26. _____

The **Paint Bucket Tool**'s option bar is shown here.

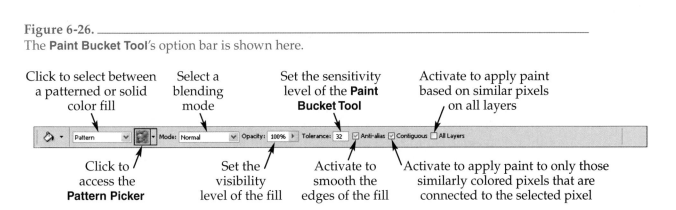

Click to select between Select a Set the sensitivity Activate to apply paint
a patterned or solid blending level of the **Paint** based on similar pixels
color fill mode **Bucket Tool** on all layers

Click to Set the Activate to Activate to apply paint to only those
access the visibility smooth the similarly colored pixels that are
Pattern Picker level of the fill edges of the fill connected to the selected pixel

Figure 6-27. _____

The **Tolerance** setting determines how wide of a color range is affected by the **Paint Bucket Tool**. A—This is the original image. B—The **Paint Bucket Tool** with the **Tolerance** set to 32 has dumped paint in the center of the gradient. C—The **Paint Bucket Tool** with the **Tolerance** set to 80 has dumped paint in the same location on the gradient. Note that a wider range of pixel colors are affected.

selected layer is lower in the layer stack, the similarly colored pixels on layers above the selected layer will hide the paint applied by the **Paint Bucket Tool**. For this reason, you may want to create and select a new layer at the top of the layer stack before using the **Paint Bucket Tool** with the **All Layers** option active.

The Fill Command

Choosing **Edit > Fill…** is very similar to using the **Paint Bucket Tool**. In fact, using the **Magic Wand Tool** to select an area and then using the **Fill** command to fill it provides identical results to using the **Paint Bucket Tool**.

To use the **Fill** command, begin by making the desired selection. If you do not make a selection, the **Fill** command will fill the entire layer. Next, choose **Edit > Fill…**. The **Fill** dialog box opens, letting you choose from several color options, a pattern, or history. Choosing the history option restores the area you selected to the way it looked when you first opened the image. If you are working on a new image rather than a previously saved image, selecting the **History** option will erase any content in the selected area.

In the **Blending** section of the **Fill** dialog box, you will find the **Mode** and **Opacity** settings. The **Mode** setting determines how the fill is blended with the existing image. The **Opacity** setting determines how visible the fill is. The **Preserve Transparency** option prevents the **Fill** command from filling the transparent portions of the selected area. This option should be active if you are working with an image that has transparent areas and you do not want those areas to be filled.

The **Layer > New Fill Layer** submenu contains three commands that let you create a new layer that is filled with a color, a pattern, or a gradient.

The Smudge Tool

Imagine using real paints to create a painting. Before letting the paint dry, you smear it with your finger. That is the effect that the **Smudge Tool** creates. You probably will not use this tool very often. This tool can be used to streak the edges of an object, making it look like it is moving very fast.

The **Smudge Tool** is found behind the **Blur Tool** in the **Tools** panel. The controls found in the **Smudge Tool**'s options bar are similar to those found in the options bar of other painting tools. The available options include a **Brush Preset Picker, Mode** settings, and a **Strength** setting, which controls how "hard" the finger smears the paint. See **Figure 6-28**.

When the **Sample All Layers** option is checked, all pixels under the cursor are smudged, no matter what layer they are on. The **Finger Painting** option, when turned on, adds some of the foreground color to each smudging stroke, creating a slightly messier look.

> **Note** The **Blur Tool** and **Sharpen Tool**, which are grouped with the **Smudge Tool** in the **Tools** panel, will be discussed in Chapter 8, *Restoring and Retouching Photos.*

The Eyedropper Tool

The **Eyedropper Tool** is grouped with the **Ruler Tool, Color Sampler Tool**, and **Note Tool** in the **Tools** panel. The **Measure Tool** and **Color Sampler Tool** are discussed in Chapter 10, *Advanced Color-Correction Techniques.* The **Note Tool** is covered in Chapter 12, *File Management and Automated Tasks.*

The **Eyedropper Tool** is used to *sample*, or choose, a foreground color. With only two options in its options bar, this is one of Photoshop's simplest tools to use. The first setting that is adjustable for the **Eyedropper Tool** is the **Sample Size** drop-down list. From this drop-down list, you can select **Point Sample**, which will sample the color of the single pixel directly under the cursor. You can also choose **3 by 3 Average**, which looks at the nine pixels surrounding the cursor, averages their colors, and assigns the resulting color to become the new foreground color. The remaining options work the same way as the **3 by 3 Average** setting, but calculate the average color of larger areas, up to 101×101 pixels.

It is highly recommended that if you change the **Sample Size** setting, set it back to **Point Sample** when you are done with the **Eyedropper Tool**. Why? Because the setting you choose from the **Sample Size** drop-down list also affects the performance of the **Magic Wand Tool, Paint Bucket Tool**, and several other tools you have not yet been introduced to: including the **Magic Eraser Tool** and the eyedroppers found in the **Levels** and **Curves** commands.

Figure 6-28. _____
The **Smudge Tool**'s options bar is shown here.

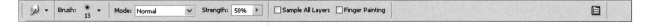

Imagine you want to create text that is similar in color to the purple flowers shown in **Figure 6-29**. The following is an explanation of the recommended procedure:

- Choose **Window > Arrange > New Window for (filename)** to create a second view of your file (or zoom in on your original file).

- Zoom in on the second view until you can see individual pixels.

- Choose the **Eyedropper Tool** and choose one of the **Sample Size** options in the options bar.

- Position the tip of the **Eyedropper Tool** cursor over a pixel with the desired color. Click to set the foreground color.

- Now, you are ready to choose the **Type Tool** and enter purple text.

The **Sample** drop-down list usually does not need to be switched from the **All Layers** option to the **Current Layer** option. Use the **Current Layer** option and select the appropriate layer in the **Layers** panel in situations where layers blend together or a layer you want to sample is hidden from view by another layer.

> **Note** You will find that the **Eyedropper Tool** appears automatically when using some of Photoshop's features, such as editing gradients. These automatic versions of the **Eyedropper Tool** work the same as the tool selected in the **Tools** panel, but they may be used to sample a color other than the foreground color.

The Canvas

A painter paints on a *canvas*. In Photoshop, the canvas is the entire area of an image. You have already learned about the image size setting in Chapter 2, *Resolution*. But what happens when you try to combine images that are different sizes? Imagine

Figure 6-29. _____

It is helpful to see individual pixels when using the **Eyedropper Tool** to pick a color from an image.

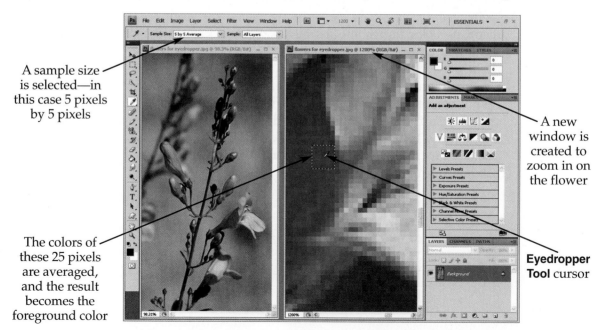

A sample size is selected—in this case 5 pixels by 5 pixels

The colors of these 25 pixels are averaged, and the result becomes the foreground color

A new window is created to zoom in on the flower

Eyedropper Tool cursor

you are working on a Photoshop document that is 4″ high and 6″ wide. Then, you open an image that is 8″ × 10″, with the same resolution. You copy it to your original document by dragging it over with the **Move Tool**. What happens? The portions of the 8″ × 10″ image that overlap the 4″ × 6″ canvas are no longer visible. All of the 8″ × 10″ image is still there (and can be moved around with the **Move Tool**), but the 4″ × 6″ canvas is not large enough to display all of it at one time. You have a couple of choices in this situation. You can use the **Image Size** dialog box to reduce the size of the 8″ × 10″ image before dragging it over, or you can enlarge the 4″ × 6″ document by adjusting the size of its canvas.

The **Canvas Size** command is most often used to create more usable space in an image by expanding its borders. With this command, you can specify a new size for the canvas and to which side of the image the additional, empty canvas will be added. Unlike the **Image Size** command, this command does not resize the contents of the image, only the space that the image occupies.

Note	Making an image *smaller* using the **Canvas Size** command is the same as cropping the image. It is a little easier to use the **Crop Tool** to make the canvas size smaller.

The canvas size can be made larger or smaller by choosing **Image > Canvas Size….** This opens the **Canvas Size** dialog box, **Figure 6-30**. The current size of the image is displayed in the top section of the dialog box. Enter the desired size for the canvas in the **Width** and **Height** text boxes in the **New Size** section. Be sure to select the proper units from the drop-down lists next to these text boxes.

The **Relative** check box provides you with an alternative way to enter the desired increase in canvas size. When this check box is checked, you use the **Width** and **Height** text boxes to enter the amount of canvas that you want to *add* rather than the desired *overall size* of the canvas.

You also need to tell Photoshop what direction to expand the canvas. This is done by clicking the squares in the **Anchor** section until the arrows display the desired direction(s) of expansion.

The last thing Photoshop asks for is what *color* the new canvas extension should be. Select a color from the **Canvas extension color** drop-down list or click the color box next to select a color in the **Color Picker**. This option is only available if the image has a Background layer.

You can rotate the canvas clockwise or counterclockwise. You can also flip the canvas horizontally or vertically. The commands for these actions are found under the **Image > Rotate Canvas…** submenu and should be self-explanatory.

Filters

Filters are special effects that can be applied to a layer. Some filters are similar to layer styles that you have already learned about. But most of them create much more complicated effects, such as transforming an image so it looks like a stained glass window. There are approximately one hundred filters, and one of Photoshop's menus is devoted entirely to them.

When applying a filter to a layer, your image can change drastically. So, it is a good idea to duplicate a layer before applying a filter to it. Another option is to use the feature called **Smart Filters**. This technology lets you apply a filter *non-destructively* to a layer. In other words, even though your layer looks like it has been changed by a filter, the filter effect is kept separate by Photoshop. Smart Filters are discussed further in Chapter 11, *Additional Layer Techniques*.

Figure 6-30. _____
Increasing the canvas size of an image requires entering larger dimensions, specifying an anchor point, and choosing a color for the new space. **A**—The original file is 5″ × 5″. **B**—The result of changing the canvas size to 6″ × 6″ with the anchor point in the upper-left corner is shown here.

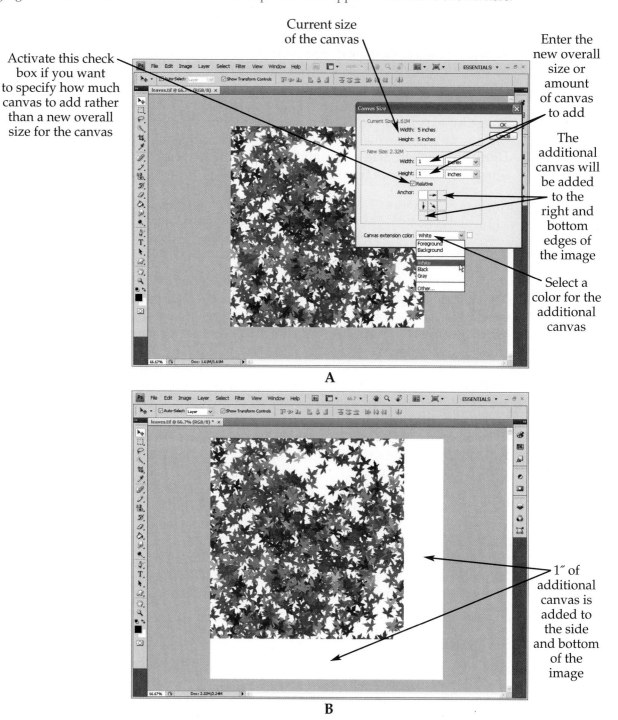

The Filter Menu

The **Filter** menu is used to apply a filter. More than one filter can be used on the same layer. Also, the same filter can be applied to a layer multiple times.

The very first item displayed in the **Filter** menu is the last filter that was used (in case you want to apply it a second time). If you choose this filter (instead of choosing

the filter from its original category), the same filter settings entered previously will be applied to your image again—you *will not* have the opportunity to adjust the settings.

The second item listed in the **Filter** menu is **Convert for Smart Filters**. Smart filters are kept separate from the layers they are applied to and, therefore, can be adjusted repeatedly without affecting the original layer. Smart filters are discussed in Chapter 11, *Additional Layer Techniques*.

The third section of the **Filter** menu contains the **Filter Gallery** command, which is really a user-friendly interface that makes it easy to explore and use most of Photoshop's filters. Two setting-intensive filters (**Liquify** and **Vanishing Point**) are also contained in this section. The **Liquify** filter will be explained in this chapter, and the **Vanishing Point** filter will be discussed in Chapter 8, *Restoring and Retouching Photos*.

The fourth section of the menu lists filters by category. The **Artistic, Brush Strokes**, and **Sketch** filter categories imitate traditional art practices. The **Video** category contains a filter that adjusts images for use in video (**NTSC Colors**) and a filter that corrects images captured from video (**De-Interlace**).

All of the other filter categories contain an incredible variety of special effects and image-tweaking power. There are thousands of different textures and patterns that can be created with different combinations of filters. There are many free tutorials on the Internet that will show you how to use filters in creative ways. For beginners, a good way to become acquainted with filters is to try them out, one by one. You will be asked to try out each filter and save your results in the tutorial section of this chapter.

What happens when you select a filter depends on the filter that is selected. If the filter is very basic, like the **Blur** filter, it is applied immediately, without any further user input. Some filters with adjustable settings open a dialog box containing the filter controls. This is usually the case for filters that are relatively simple (such as the **Unsharp Mask** filter) or filters that are relatively complex (such as the **Lighting Effects** filter). All other types of filters open the **Filter Gallery** when they are selected.

The Filter Gallery

When certain types of filters are selected, the **Filter Gallery** appears, **Figure 6-31**. In order to display the **Filter Gallery** correctly, the display resolution of your computer must be set to 1024 × 768 or higher.

If you click the small double arrow button to the left of the **OK** button, the **Filter Gallery** displays some of the available filters. All of the filters in the **Artistic** category appear in the **Filter Gallery**'s filter list, but this is not true for some of the other filter categories. Some filters are too complex or too simple to be displayed in the **Filter Gallery**. Be aware that the **Filter** menu is the only place you will see all of the filters.

The filter list in the **Filter Gallery** shows thumbnail examples of what each filter does. When you choose a specific filter, its adjustable settings appear in the section at the right. For example, in Figure 6-31, the colored pencil filter's settings are displayed. This filter is designed to make a digital image look like it was created with colored pencils. You can control how fat the pencil strokes are (**Pencil Width**), how hard the pencils are pressed (**Stroke Pressure**), and whether the paper is black, gray, or white (**Paper Brightness**).

After adjusting the settings as desired, click **OK** to apply the filter. Filters are not automatically created on a new layer, so a safe habit is to always create a duplicate layer before applying a filter, leaving your original image untouched.

Figure 6-31. _____
The **Filter Gallery** displays many, but not all, of Photoshop's filters.

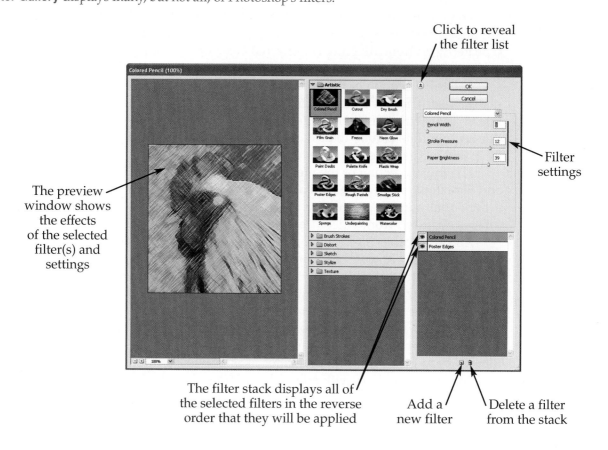

Click to reveal the filter list

The preview window shows the effects of the selected filter(s) and settings

Filter settings

The filter stack displays all of the selected filters in the reverse order that they will be applied

Add a new filter

Delete a filter from the stack

Assigning Multiple Filters in the Filter Gallery

If you want to add multiple filters in the **Filter Gallery** at the same time, click the **New effect layer** button instead of the **OK** button. This creates a copy of the currently selected filter and settings at the top of the filter stack. To change a filter into a different type of filter, simply select that filter in the filter stack and click the thumbnail of the desired filter in the filter list to the left. Make the necessary changes to the filter settings and observe the results in the preview window. At this point you can adjust the filter stacking order, click **OK** to accept the filters as they are, or add yet another filter.

The order that the filters appear in the filter stack influences the effect produced by the filter combination. To change the order of filters in the stack, simply click and drag them above or below each other as you learned to do with layers in the **Layers** panel. The filters are applied in order, beginning with the filter at the bottom of the stack and working upward. To remove a filter from the stack, simply select it and click the **Delete effect layer** button. When the combined filter effect is the way you want it, click the **OK** button to apply the filters to the image.

The Liquify Filter

The **Liquify** filter is complex enough to be a separate item in the third section of the **Filter** menu. This filter has several bizarre tools that let you manipulate pixels. The **Liquify** filter is often used for humorous purposes, such as modifying someone's face, but you can also use this filter to make subtle, precise adjustments to images. This filter includes tools that are used to mask (protect) areas of your image to ensure accuracy.

The Liquify Filter Tools

At the left side of the **Liquify** dialog box, is a collection of new tools, **Figure 6-32**. They are briefly described here, in order from top to bottom:

- The **Forward Warp Tool** is used to grab pixels and push them to another location.

- The **Reconstruct Tool** changes the image back to its original state. If necessary, use this tool as an "eraser."

- The **Twirl Clockwise Tool** twists pixels in a clockwise direction as you press the mouse button (hold down the [Alt] or [Option] key for counterclockwise).

- The **Pucker Tool** causes an area of pixels to appear to shrink as you press the mouse button. The effect decreases in intensity from the center of the brush out to its edges.

- The **Bloat Tool** causes an area of pixels to look larger as you press the mouse button. Again, the effect decreases in intensity from the center of the brush outward.

- The **Push Left Tool** stretches and moves an area to the left, creating a stretched look (hold down the [Alt] or [Option] key to push pixels the opposite direction).

Figure 6-32. _____

The **Liquify** filter allows you to easily apply a variety of distortions to selected portions of your image while leaving the rest unaffected. **A**—The original portrait is shown here. **B**—The nose and lip areas have been manipulated with the **Liquify** filter's **Bloat Tool**. **C**—The nose, lips, and eyes have been modified with the **Pucker Tool**.

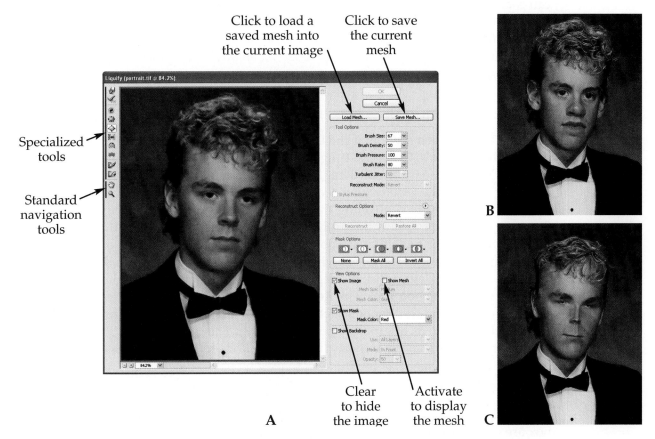

- The **Mirror Tool** creates a reflection. If you drag from bottom to top, it reflects whatever is at the left of the brush. If you drag from top to bottom, it reflects whatever is at the right of the brush. A similar situation occurs when dragging horizontally—the direction you drag determines whether the area above or below the brush will be reflected.

- The **Turbulence Tool**, when applied in short strokes, is similar to the **Forward Warp** tool, but the outcome is not quite as smeared. When the tool is applied by clicking and holding over one area in the image, the tool creates a bubbling effect in the mesh, and, with prolonged use, can even tear the mesh, resulting in a hole (transparent area) in the image.

- Use the **Freeze Mask Tool** to paint a protective mask over any areas that you do not want to be affected by the **Liquify** filter's various tools.

- The **Thaw Mask Tool** removes any protective masking created by the **Freeze Mask Tool**.

- Last, the **Hand Tool** and **Zoom Tool** allow you to magnify and navigate around your image as you work.

The Mesh

A *mesh* is a grid that helps you see how the image was changed with the **Liquify Filter** tools. You can view the changes you made to your file as a mesh by placing a check mark in the **Show Mesh** check box in the **View Options** section of the dialog box. You can hide the actual image by removing the check mark in the **Show Image** check box. This gives you a better view of the mesh, which is helpful in some situations. The size of the mesh can be adjusted by choosing one of the options in the **Mesh Size** drop-down list, and you can change the color by selecting a new color from the **Mesh Color** drop-down list.

You can also save a mesh as a file and load it later, when another image is open in the **Liquify** dialog box. In other words, you can apply saved **Liquify** filter tool effects to another image. This is done using the **Load Mesh** and **Save Mesh** buttons at the top of the dialog box.

Liquify Tool Options

The **Tool Options** section of the **Liquify** dialog box contains adjustable controls for the **Liquify** filter tools. Certain settings may be grayed out depending on the tool that is selected. You can use the **Brush Size** slider to change the size of the area affected by each stroke or click of the **Liquify** filter tool. The **Brush Density** slider controls how "thick" the brush is (similar to controlling the softness of the edges of a brush), and the **Brush Pressure** slider controls how intensely the brush effect is applied. The **Brush Rate** slider is available only for tools that are applied repeatedly when the mouse button is held. This setting determines the rate at which the tool application is repeated. The **Turbulent Jitter** slider setting determines the degree of uniformity in the distortions created in the mesh by the **Turbulence Tool**. The **Reconstruct Mode** drop-down list contains several options for the way the **Reconstruct Tool** is applied to the mesh. The **Revert** option restores the mesh to its original shape and position. The remaining options in the drop-down list restore the mesh, but use different methods to do it.

Reconstruct Options

The options available in the **Mode** drop-down list from this section of the dialog box are nearly identical to the options in the **Reconstruct Mode** drop-down list in the

Tool Options section. However, instead of adjusting the effect of the **Reconstruct Tool**, these settings are applied to the entire image.

After selecting the desired reconstruction mode from the drop-down list, you can click the **Reconstruct** button to apply the selected reconstruction mode to the entire image. You can also choose to click the **Restore All** button, which removes all of the distortions in the image, regardless of the reconstruction mode selected from the drop-down list.

Mask Options

If you wish to only "liquify" part of your image, you can create a protective mask using the **Freeze Mask Tool** and **Thaw Mask Tool**. The buttons in the **Mask Options** section can be used in conjunction with these tools, but they are confusing to use, and you will probably never need them. Instead, simply use different brush sizes with the **Freeze Mask Tool** and **Thaw Mask Tool**. This will give you plenty of flexibility while creating a protective mask.

Note	Masking is discussed further in Chapter 11, *Additional Layer Techniques*.

View Options

The final section of the **Liquify** dialog box is the **View Options** section. As previously discussed, this section has controls for displaying and adjusting the appearance of the mesh and for turning on and off the display of the image. It also contains controls for displaying and adjusting the appearance of any masks. When the **Show Mask** option is active, the mesh is displayed as a semitransparent color over the selected portions of the image. The color of the mask can be changed by selecting a new mask from the **Mask Color** drop-down list.

When the **Show Backdrop** option is active, the original image (or only one layer from it) is displayed in the preview window of the dialog box. This backdrop allows you to see at a glance how the altered image differs from the original, or can be used as a visual aid when trying to adjust one layer of the image to match another.

You can select the layer(s) to display as a backdrop from the **Use** drop-down list. The option chosen in the **Mode** drop-down list determines whether the backdrop is displayed in front of the layer being modified or behind it. The **Opacity** slider sets the level of transparency for the layer in front, regardless of whether that layer is the backdrop or the layer being modified.

GRAPHIC DESIGN

Focal Point and Visual Hierarchy

Usually, one part of a graphic design is dominant. It is the center of interest, the part of the design that the viewer's eye is attracted to the most. Occasionally, a design may use repetitive patterns instead of a single focal point. Then, the entire design attracts the attention of the viewer.

The greater the emphasis, or *visual weight*, placed on part of a design, the more the viewer will notice it. The most obvious way to give more visual weight to

a design element is to make it larger than the other design elements. Here are some other tips for creating more visual weight to a design element:

- Use vivid colors that contrast with the background.

- Add a special effect such as a shadow, highlight, or distortion to the subject.

- When working with text, make the text bolder or use appropriate decorative fonts.

- Rotate design elements so they are not perfectly horizontal or vertical.

- Position other design elements to effectively contrast with the element that is the focal point.

The focal point of the poster in **Figure 6-33** is the "Farmer's Market" text. It carries more visual weight than any other design element on the poster. The text is white, a color that contrasts well with the background. A drop shadow and a black border (stroke) were also added to help the text "jump out" at the reader. Notice that the text is sans serif, creating easily-read headlines.

After the reader's eye jumps to the focal point of the design, elements of the design should be organized in such a way that the reader does not have to search for important information. The designer should assign a visual weight to the next important item in the design. A *visual hierarchy* is the order in which design elements are presented from the greatest amount of visual weight to the least.

Designers can use color, size, and the position of objects to create a visual hierarchy. For example, lighter and duller colors carry less visual weight than bright, vivid colors. It is also important to not crowd design elements together. Some white space (empty space) is needed to make absorbing the information easy.

Imagine driving along a freeway and seeing the billboard shown in **Figure 6-34**. Most people would agree that the focal point of this design is the large ostrich—it is a huge, unusual image. The "Ostrichville" title text is the next item in the visual hierarchy. Its size, color, and special effects give it almost

Figure 6-33. _____
The Farmer's Market poster (actual size 11″ × 17″) can easily be read from several feet away because of the visual weight assigned to the text.

Figure 6-34.
This billboard demonstrates a visual hierarchy scheme.

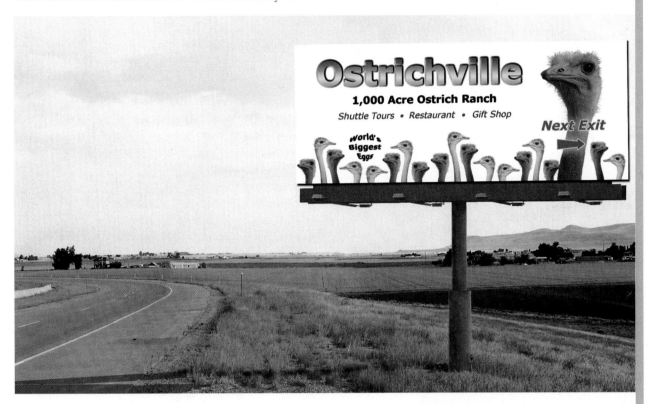

as much visual weight as the large ostrich image. Next, the reader's eye would flow to the bold text that reads "1,000 Acre Ostrich Ranch." The text that informs drivers how to get to the ranch is also bold, and could be considered next on the list in the hierarchy. The repetitive pattern of ostriches adds interest to the entire design. Some viewers might regard it as a decorative border of the billboard; others might see all of the ostriches as a group (including the large ostrich).

Summary

When you have a few extra minutes, take a close look at all of the brushes in the **Brushes** panel. You will need to choose a brush shape and size when using many of Photoshop's tools. Knowing what brushes are available can save you time—by choosing just the right tool shape for a quick, easy edit.

Filters can adjust images in amazing ways. Some filters can help clean up problem photographs. Others can be used in combination to create interesting textures and patterns from scratch. Photoshop users have discovered (and continue to discover) a vast amount of filter techniques. These techniques are shared on the Internet as Photoshop tutorials or found in more advanced books or Photography, Graphic Design, and Digital Imaging magazines.

CHAPTER TUTORIALS

Note The files needed to complete the tutorials in this book can be downloaded from the *Learning Photoshop CS4 Student Companion Web Site*. Refer to the "Using the Companion Web Site" section of the book's Introduction for more information.

You will try a couple of painting methods in these tutorials. You will be asked to try out each filter and save your results into a folder. You will also use painting tools and filters to make further modifications to projects you have already begun in previous chapters.

Tutorial 6-1: Exploring Filters and Styles

In this tutorial, you will be asked to save almost 100 small files. In the process, you will discover the power and flexibility of Photoshop's filters and styles. The effects produced by these tools are so widely varied that the only way to familiarize yourself with them is through hands-on experience.

Part 1: Filters

Photoshop's filters can be used to add a variety of effects to an image. The effects range from very subtle color changes to absurd distortions of the image.

1. Create a new folder named Filters and save each file in this new folder.

2. Open the file named Buster.jpg.

3. If the grid is showing, turn it off by choosing **View > Show > Grid**.

4. Choose **Window > Workspace > Essentials (Default)**.

5. Choose **Filter > Artistic > Colored Pencil…**.

6. Experiment with the filter settings. Once you have the filter settings the way you want them, click **OK**.

 Choose settings that do not "destroy" the original photo. Your settings should make Buster look like he was drawn with colored pencils.

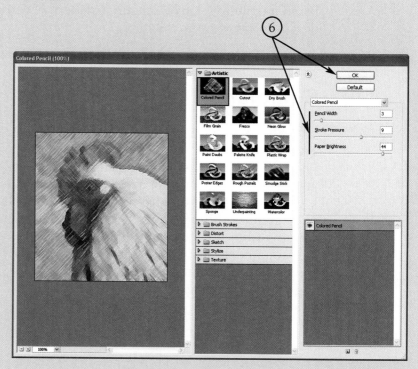

7. Choose **File > Save As…**.

8. Name this file Colored Pencil.jpg, make sure it will be saved in the Filters folder you created, and click **Save**.

9. In the **JPEG Options** dialog box, click **OK** to accept the default settings.

10. Choose **Edit > Step Backward** to remove the colored pencil filter.

11. Choose **Filter > Artistic > Cutout…**.

12. Experiment with the filter settings and click **OK**.

13. Choose **File > Save As…** and name the file Cutout.jpg.

14. In the **JPEG Options** dialog box, click **OK** to accept the default settings.

15. Try out the rest of the filters in the **Artistic** category in the same way. As you experiment with the filters, keep the following things in mind:

 • Save each file as you did in steps 7–9, using the filter name as the name of the file.

 • Change the foreground color to get different results with the **Neon Glow** filter.

16. When you have tried all of the filters in the **Artistic** category, choose **Filter > Blur > Blur More**.

 Skip the first two filters in the **Blur** category.

17. Experiment with each of the blur filters and save each result.

18. Try out each filter in all of the remaining categories except for the following:

 • Skip the **Video** category.

 • Skip the **Sharpen** category. You will learn more about the sharpen filters in Chapter 8, *Restoring and Retouching Photos*.

 • Keep in mind that the **Stained Glass** filter and most of the filters in the **Sketch** category make use of the foreground color (so experiment with different foreground colors).

 • The **Neon Glow, Clouds,** and **Fibers** filters use both the foreground and background colors.

 After experimenting with the filters, you should have almost 100 files saved in your Filters folder. There are several more files you will create and save to this folder.

19. Close all files on your screen and open the original Buster.jpg file again.

20. Use the **Magic Wand Tool** to select the sky behind Buster.

21. Choose **Filter > Texture > Texturizer…**.

22. Select **Burlap** from the **Texture** drop-down list. Set the **Scaling** slider to 115% and the **Relief** slider to 5. Click **OK**.

 The filter is applied to the selected area.

23. Choose **File > Save As…**. Name the file Buster with burlap.jpg and save it in the Filters folder.

24. Close Buster with burlap.jpg file.

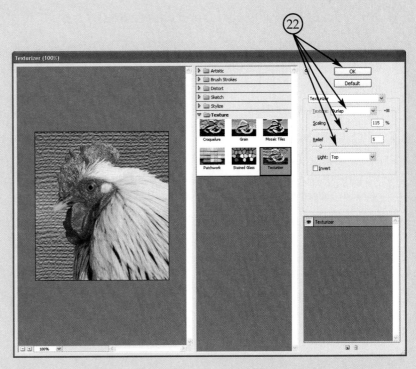

Part 2: Styles

Some of Photoshop's styles work very well with image files. Some of these styles are similar to some of the filters you have used.

1. Open the original Buster.jpg file again.

2. Click the **Styles** panel tab.

3. Double-click the **Adjustments** panel tab to collapse the panel tab group.

4. Position the cursor over the bottom edge of the **Styles** panel. When the cursor changes to double arrows, click and drag to increase the length of the panel.

5. Open the **Styles** panel menu and choose **Photographic Effects**.

6. Click **OK** in the dialog box that appears to replace the styles in the panel.

7. Open the **Styles** panel menu again and choose **Image Effects**.

8. In the dialog box that appears, click the **Append** button to add the **Image Effects** styles to the panel without deleting the **Photographic Effects** styles.

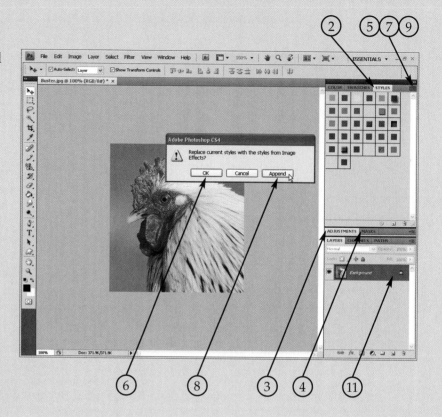

9. Open the **Styles** panel menu and choose **Small List**.

This changes the style list from a thumbnail display to a list of names with tiny thumbnails.

10. Click on one of the styles. Nothing happens because the layer is locked.

11. Unlock the layer in the **Layers** panel by double-clicking the Background layer in the **Layers** panel. In the **New Layer** dialog box, click **OK** to accept the default name for the layer.

12. Click each of the effects you have loaded into the **Styles** panel and save each result into the Filters folder. Use the style name as the file name.

13. When you have saved an image adjusted with each of the styles, open the **Styles** panel menu and choose **Reset Styles**. Click **OK** in the box that appears.

14. Choose **Window > Workspace > Essentials (Default)** to reset the workspace to its default settings.

Tutorial 6-2: Coloring a Photo with the Brush Tool

In this tutorial, you will use the **Brush Tool** with the **Hue** blending mode to change the color of a selected part of an image. This technique is useful for calling attention to one element within an image.

1. Open the peppers.jpg file.

2. Choose **Layer > Duplicate Layer...**. Name the new layer Paint.

 You will paint this layer and leave the original layer untouched, in case you need to start over.

3. Select the bottom center pepper, but not its stem.

 To select the pepper, zoom in far enough so you can use the selection tools easily. Use the **Magnetic Lasso Tool** to start. Then, switch to the **Lasso Tool** with the **Feather** option set to 0. Use the **Add to selection** and **Subtract from selection** buttons to fine-tune your selection border.

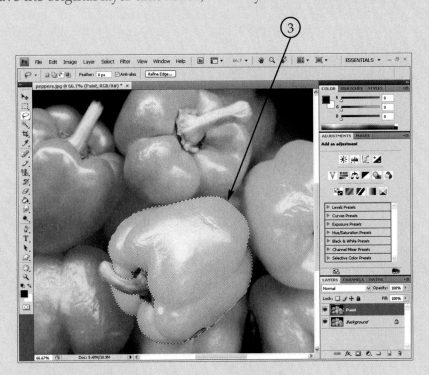

4. Click the **Brush Tool** in the **Tools** panel.

5. Enter the following settings in the options bar:

 - In the **Brush Preset Picker**, set the **Master Diameter** to 250 pixels and **Hardness** to 100%.

 - Select **Hue** in the **Mode** drop-down list.

 - Set the **Opacity** slider to 100%.

6. Click the **Set foreground color** button in the **Tools** panel and select any bright color except for red, yellow, or orange.

 Since orange is already the color of the pepper, and red and yellow are its component colors, you should *not* select these colors because they will produce less predictable results.

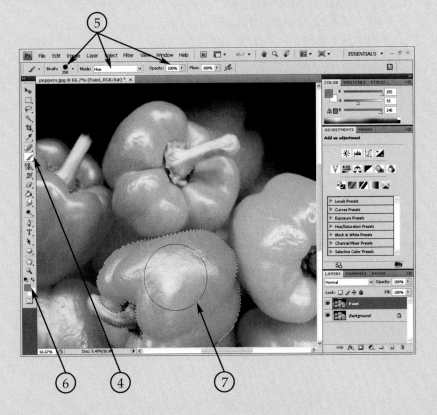

7. Without releasing the mouse button, paint the pepper.

 If you release the mouse button before you finish painting, the brush strokes will overlap and appear too dark.

8. Choose **File > Save As...** and name the file 06peppers.psd.

9. Close 06peppers.psd. You will make other changes to this file later.

Tutorial 6-3: The Paint Bucket and Gradient Tools

In this tutorial, you will use the **Paint Bucket Tool** to add a solid fill of the foreground color to a selected area. You will then add a gradient from foreground color to transparency to create a glow effect around the filled area.

1. Open the 04leafy.psd file that you created in a previous chapter.

2. Collapse the **Adjustments** panel tab group by double-clicking the **Adjustments** panel tab.

3. In the **Layers** panel, click the Background layer to make it active.

4. Click the **Elliptical Marquee Tool**.

5. Create a selection border around the "sunshine" shape, as shown.

 Remember to hold [Shift] to create a circle instead of an ellipse and [Alt] to create the circle from the center outward.

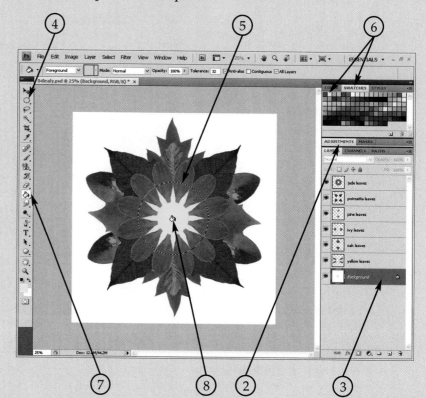

6. Click on the **Swatches** panel tab and click on the yellow-colored box in the top row.

 Notice that the foreground color is now yellow.

7. Click the **Paint Bucket Tool** in the **Tools** panel.

8. Click inside the selected area to dump yellow on the background layer.

9. In the **Layers** panel, click on the layer at the very top of the stack to make it active.

10. Click the **Create a new layer** button in the **Layers** panel or choose **Layer > New > Layer…**.

11. Name the new layer gradient.

12. Select the **Ellipse Marquee Tool** in the **Tools** panel.

13. Click and release anywhere in the image to clear the previous selection.

14. Select the **Gradient Tool** in the **Tools** panel.

15. In the options bar, click the small down-arrow to open the **Gradient Picker**.

16. In the **Gradient Picker**, pick the small arrow button to open the **Gradient Picker** menu. Select **Reset Gradients…** from the menu, and click **OK** in the dialog box that appears. If a second dialog box appears asking if you want to save current gradients before replacing them, choose **No**.

17. Choose the second gradient, which is always the foreground color (in this case, yellow) and transparency.

18. In the options bar, click the **Radial Gradient** button.

19. Starting in the center of the leafy design, drag a line as shown to add a sunglow effect.

20. Choose **File > Save As…** and name this file 06leafy.psd. Close the file when you are done.

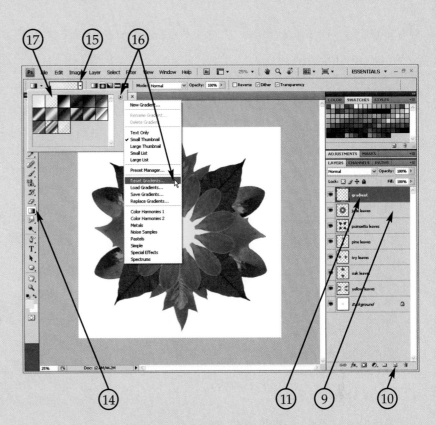

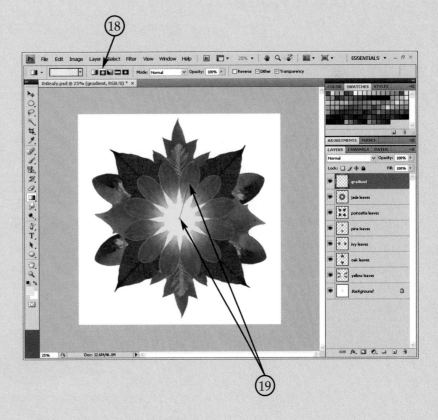

Tutorial 6-4: Add a Filter and Layer Style to a Shape

Once a shape has been rasterized, you can apply a filter to it. In this tutorial, you will apply filters and layer styles to various shapes in a design.

1. Open the 05CDfront.psd file that you created previously.

 The layer containing the red donut shape should be active. You have already rasterized this layer in a previous tutorial. Because you have done this, you will be able to apply a filter to the layer.

2. Choose **Filter > Distort > Ripple...** and enter the following settings:

 - **Amount:** 600%

 - **Size:** Large

 Many of Photoshop's filters won't work on areas where all of the pixels are the same color (such as the red donut shape), but the **Ripple** filter is an exception.

3. Click **OK**.

4. Choose **Layer > Layer Style > Bevel and Emboss....**

5. In the **Layer Style** dialog box, set the **Depth** slider to 120%, the **Size** slider to 10 px, and click **OK**.

 The distorted red donut shape now appears to rise slightly from the background.

6. On the **Layers** panel, click the layer containing the blue shape.

7. Choose **Filter > Distort > Ripple...** and enter the following settings:

 - **Amount:** 400%

 - **Size:** Medium

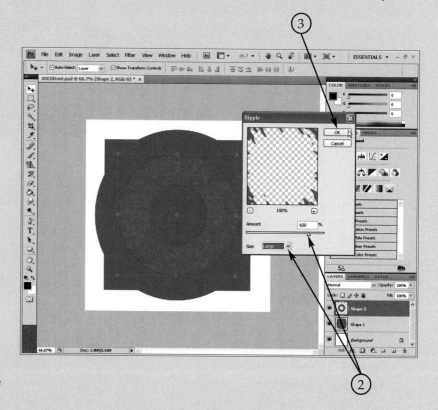

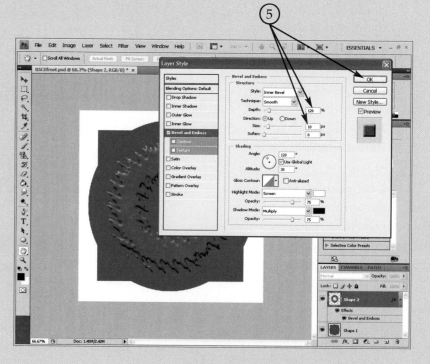

8. Add an inner bevel style to this layer by repeating steps 4 and 5.

 Your design should look like the example on the right.

9. On the **Layers** panel, click the Background layer.

10. Reset the foreground and background colors to black and white.

11. Click the **Paint Bucket Tool** in the **Tools** panel.

12. Click any white area of the image to fill the Background layer with black.

13. Make the top layer active in the **Layers** panel.

 You are about to add text, and the new text layer will be created above the active layer.

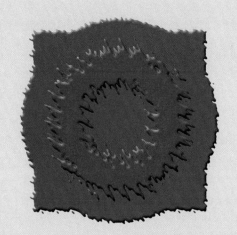

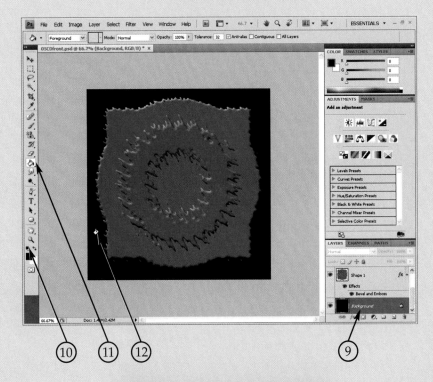

14. Add the text shown in the example on the right. Choose your own font and layer styles.

15. Choose **Layer > Flatten Image**.

16. Choose **File > Save As…** and name the file 06CDfront.psd.

17. If you are going to continue on to the next tutorial, leave the file open. If you are *not* going to continue on to the next tutorial, close the image.

 You will sample colors from this image as you create the back insert for the CD jewel case in the next tutorial.

Tutorial 6-5: The Eyedropper and Gradient Tools

In this tutorial, you will define a gradient and apply it to a CD insert design. You will use the **Eyedropper Tool** to select colors from one image to use in creating a gradient in another image. This technique is useful for keeping color schemes consistent, visually tying together multiple documents.

1. Open the 06CDfront.psd file, if it is not already open.

2. Choose **File > New...** and enter the settings shown. Name the image 06CDback.

3. Click the **Arrange Documents** button and choose **Float All in Windows** from the menu. Move the new file window so you can see the 06CDfront.psd window behind it.

4. Click on the **Eyedropper Tool** in the **Tools** panel.

5. Click on a non-beveled portion on the red ring.

 The **Eyedropper Tool** changes the foreground color to red.

6. Choose **View > Rulers**.

7. Click the **Rectangular Marquee Tool**.

8. In the options bar, make sure that the **Feather** option is set to 0 px.

9. In the options bar, choose the **Fixed Size** option from the **Style** drop-down list.

10. Enter .25 in in the **Width** box and 4.75 in in the **Height** box.

11. Click near the left side of your file to create the rectangular selection.

12. Use the arrow keys if necessary to place the selection so it touches the left edge and top and bottom of your file.

13. Use the **Paint Bucket Tool** to fill the rectangular selection with red.

14. Choose **Edit > Copy**.

15. Choose **Edit > Paste**.

 Another red rectangle is pasted exactly on top of the first rectangle. Notice that a new layer was created automatically.

16. Click the **Move Tool** in the **Tools** panel, hold down [Shift], and use the arrow keys to move the second rectangle exactly into position.

 Holding [Shift] while you move the selection helps speed up the process. However, you will need to release [Shift] and use just the arrow keys to position the selection precisely at the other edge of the image.

17. Choose **Layer > Flatten Image** to add the red rectangles to the Background layer.

18. Reposition the 06CDback image window as needed so that the 06CDfront.psd window is visible behind it.

19. Click the **Gradient Tool**, located behind the **Paint Bucket Tool** in the **Tools** panel.

20. In the options bar, click the down arrow to display the **Gradient Picker**.

21. Click the arrow that opens the **Gradient Picker** menu and choose **Color Harmonies I**.

22. In the dialog box that appears, click **OK** to replace the gradients in the picker.

 If another dialog box asks you if you want to save changes to the current gradients, click **No**.

23. Click the first gradient listed in the picker.

24. Click the gradient in the options bar to display the **Gradient Editor**.

 When the **Gradient Editor** opens, the **Eyedropper Tool** is automatically selected.

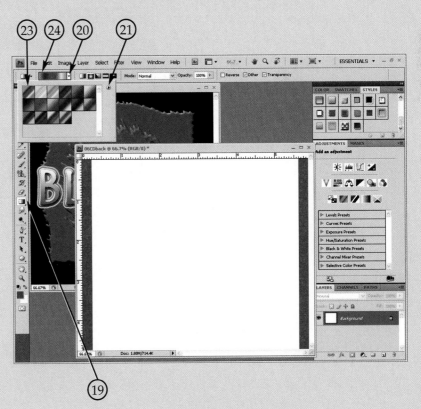

25. Click the color stop at the far left end of the color slider. This color stop is light blue by default.

26. Click a portion of the black background in the 06CDfront. psd image to choose the black color.

27. Click the next color stop.

28. Click the blue area of the 06CDfront.psd image with the **Eyedropper Tool** cursor.

29. Click the third color stop and select a red part of the design with the **Eyedropper Tool**.

30. Click the fourth color stop and make it blue.

31. Click the fifth color stop and make it red.

32. Click the last color stop and make it black.

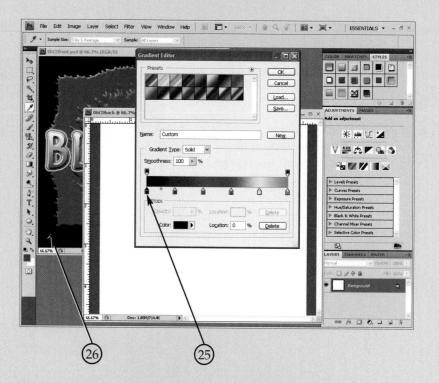

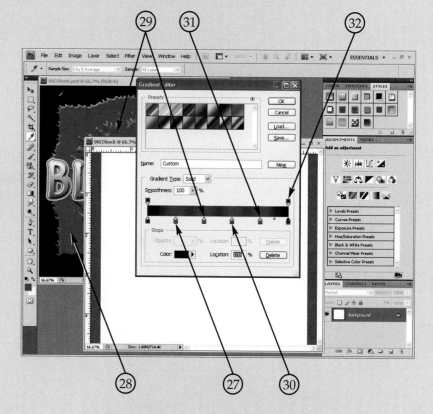

33. Add a color stop by clicking between the fifth and last color stops. Change its color to blue.

34. Drag the color stops until they are evenly spaced.

Watch the value displayed in the **Location** text box as you drag each color stop. The **Location** values that will give you evenly spaced color stops are shown.

35. Click **OK** to accept the changes and close the **Gradient Editor**.

36. Reposition the 06CDback window so that it is not blocked by any other windows or panels.

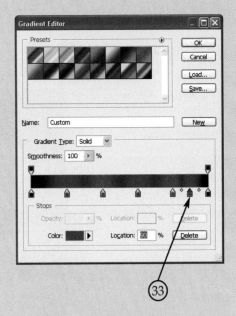

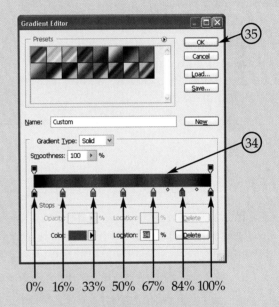

0% 16% 33% 50% 67% 84% 100%

37. Use the **Magic Wand Tool** to select the white area between the red rectangles in the 06CDback image.

38. Click the **Gradient Tool**.

39. In the options bar, click the **Radial Gradient** button, select **Normal** in the **Mode** drop-down list, and set the **Opacity** slider to 90%.

40. Drag a line in the selected area, as shown.

41. Choose **Select > Deselect**.

42. Choose **View > Rulers** to hide the rulers.

43. Click the **Rectangular Marquee Tool**. In the options bar, set the **Style** drop-down list back to normal.

44. Close the 06CDfront.psd image. Then, save and close the 06CDback.psd image. You will add more to it later.

Tutorial 6-6: Using the Clouds Filter (and Creating a Panorama)

A panorama is a large image made up of several smaller ones. Even though you have not been introduced to creating panoramas in Photoshop, you will find it is easy to do. In this tutorial, you will create a panoramic view of scenery and then fix the sky with the **Clouds** filter.

1. Click the **Launch Bridge** button on the Application bar.

 This opens Bridge, Photoshop's built-in file browsing application. See Chapter 12, *File Management and Automated Tasks*, for more information about Bridge.

2. If a dialog box appears asking if you want Bridge to automatically launch at login, click **No**.

3. Find the folder named panorama and open it.

4. Drag the **Thumbnail size** slider to the right until the nine image thumbnails fill the window.

 Can you tell that the photographer stood in one spot while capturing all of these images? Since the images overlap somewhat, and were taken from a shared vantage point, Photoshop's **Photomerge** feature will automatically assemble all of these photos into one panoramic photo.

5. Select all of the images by dragging a window around them. You may need to make the thumbnail size smaller again before doing this.

6. Choose **Tools > Photoshop > Photomerge....**

 The **Photomerge** command can also be launched directly from within Photoshop by choosing **File > Automate > Photomerge....** The image files would then need to be located and loaded by clicking the **Browse** button in the **Photomerge** dialog box.

7. In the **Photomerge** dialog box, the images are listed and the **Auto** radio button is enabled. Leave these settings as they are.

8. Click the **OK** button.

 It may take more than a minute for Photoshop to open, analyze, overlap, and blend each photo into a single image.

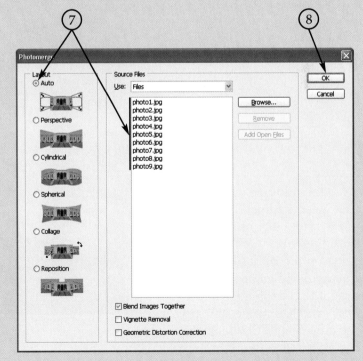

9. Your final image should look like the scene to the right.

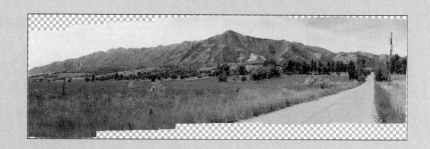

 The checkerboard pattern means no color is there—only transparent, empty space.

10. Choose **Layer > Merge Visible**.

11. Choose **File > Save**.

12. Name the file 06hillside.psd.

13. Close the Bridge program.

14. In Photoshop, click the **Crop Tool**.

15. With the **Crop Tool** selected, drag a box like the one shown at the right.

16. On the right side of the crop box you just created, grab the middle handle on the right edge and drag it to the right edge of the image.

17. Grab the middle bottom handle and adjust the bottom of the crop box until it is flush with the bottom of the *actual image* on the right side. Grab the top middle handle and drag it to the top edge of the *image area*. Continue adjusting the crop box until it looks like the example to the right.

 The very bottom portion of the image area should be the only part that does not have the crop box around it.

18. Click the **Commit** button in the options bar or press [Enter].

 The word "crop" means "to remove an unwanted portion." Everything that was inside the crop box stayed, and the rest of the file was removed.

19. Click the **Magic Wand Tool.**

20. In the options bar, set the **Tolerance** to 20. Make sure the **Contiguous** check box is checked.

 The **Contiguous** option prevents sky-colored pixels from being selected in the mountains or on the road.

21. Click anywhere on the sky.

22. Click the **Add to Selection** button.

23. Continue clicking until all of the sky and the transparent (checkered pattern) areas are selected.

24. In the **Tools** panel, click the **Set foreground color** button.

25. In the **Color Picker**, choose a very light blue color by adjusting the color slider and then picking a light blue color from the color field.

26. Click **OK.**

27. The background color box should already be white. If not, you can choose white by clicking on the background button in the **Tools** panel and then clicking the extreme upper-left corner of the color field in the **Color Picker** dialog box.

28. Choose **Filter > Render > Clouds.**

 This command blends the blue and white colors into a cloud-like pattern.

29. Choose **Select > Deselect**.

 The selection border
 disappears.

30. Make sure the layer
 containing the panoramic
 view is selected in the **Layers**
 panel, and then choose **Layer
 > New > Background From
 Layer**.

31. Save and close the image. You will add more to this file later.

Tutorial 6-7: Turn a Photo into a Painting

In this tutorial, you will use the **Find Edges** filter to essentially trace an image, and then use the **Brush Tool** to apply paint to the image. You can use this technique to quickly create a "hand-painted" design from a photo.

1. Open the Buster.jpg file.

2. Choose **Layer > Duplicate Layer...**. Accept the default layer name in the **Duplicate Layer** dialog box.

3. Choose **Filter > Stylize > Find Edges**.

4. Choose **Image > Adjustments > Desaturate**.

 Desaturate means to remove the color.

5. Choose **Layer > New > Layer...**.

6. Name the new layer Paint and click **OK**.

7. In the **Layers** panel, set the opacity of this new layer to 45%.

8. Use the **Brush Tool** to paint new colors over Buster. Experiment with different brush styles and sizes.

Because you will be painting on a separate layer, you can use the **Eraser Tool** to erase paint that goes outside of the lines. You can also use the **Edit > Undo** and **Edit > Step Backward** commands.

9. When you think you have the image the way you want it, increase the opacity of the Paint layer to 100%.

10. Since the image may look different once the opacity of the layer is increased, make any needed adjustments to the image. You may want to add a layer directly below the Paint layer and fill it to make the painted areas stand out.

11. Choose **File > Save As...** and name the file 06Buster.psd.

12. Close 06Buster.psd.

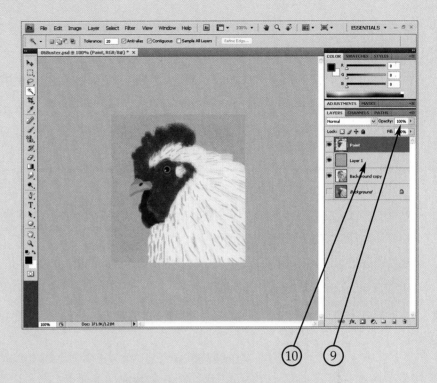

Key Terms

brush marks	gradient	steps
canvas	jitter	tiled
color stops	mesh	visual hierarchy
contiguous	sample	visual weight
filters		

Review Questions

Answer the following questions on a separate sheet of paper.

1. How do you create a perfectly straight line with the **Brush Tool**?

2. List three different ways you can change the brush size.

3. If you set the **Opacity** of the **Brush Tool** under 100%, how will the paint appear?

4. When using an **Opacity** setting of less than 100%, how can you avoid darkening areas where the paint overlaps itself?

5. What setting in the **Brush Preset Picker** controls how soft the edges of a brush are?

6. In the **Brush Preset Picker** and the **Brushes** panel, how do you restore the default brushes (the brushes that appear when Photoshop is first installed)?

7. Which blending mode only paints in transparent areas?

8. Which blending mode changes an object's color, but preserves shadows and highlights?

9. Briefly describe how the **Brushes** panel is different than the **Brush Preset Picker**.

10. What does *jitter* mean?

11. How do you reset all of the settings in the **Brushes** panel?

12. Describe how to create a custom brush tip.

13. What is the main difference between the **Pencil Tool** and the **Brush Tool**?

14. When using the **Pattern Stamp Tool**, how can you create your own pattern?

15. When the default gradients are loaded in the **Gradient Picker**, what will the very first gradient look like?

16. What difference results from creating a gradient by dragging a long line and creating a gradient by dragging a short line?

17. Why should you avoid creating gradients in files that have a low resolution?

18. How do you open the **Gradient Editor**?

19. What two kinds of fill can you add with the **Paint Bucket Tool**?

20. What does the **Tolerance** setting in the **Paint Bucket Tool**'s options bar do?

21. What is the difference between the **Point Sample** option and the **3 by 3 Average** option for the **Eyedropper Tool**?

22. What other tools are affected when you change the **Eyedropper Tool**'s **Sample Size** setting?

23. What is Photoshop's **Canvas Size** command used for?

24. What tool can you use to make a file's canvas size smaller?

25. What is the purpose of the mesh feature in the **Liquify** filter?

7

Erasing, Deleting, and Undoing

Learning Objectives

After completing this chapter, you will be able to:

- Use the **Eraser Tool** to remove unwanted pixels.
- Explain how the **Eraser Tool**'s function is dependent on whether layer transparency is locked or not.
- Use the **Eraser Tool** to create partially-transparent areas.
- Use the **Background Eraser Tool** to delete pixels.
- Use fill layers to identify "garbage pixels" after using the **Background Eraser Tool** and **Magic Eraser Tool**.
- Compare the similarities between the **Magic Eraser Tool** and the **Magic Wand** selection tool.
- Use the **Magic Eraser Tool** to remove unwanted pixels.
- Explain three different ways you can use the **History** panel.
- Explain how the **History Brush Tool** works together with the **History** panel.
- Use the **History Brush Tool** to restore part of an image to a previous condition.
- Use the **Art History Brush** and the **History** panel to add paint stroke effects to an image.
- Explain the purpose of the **Reveal All** command.
- Compare the **Trim** command and the **Crop Tool**.

Introduction

A common task in Photoshop is to erase or delete part of an image. The terms delete and erase mean almost the same thing. However, the term *erase* refers to using a tool to remove pixels, while the term *delete* refers to pressing a key or choosing a menu command to remove something. You have already learned that one way to delete pixels is to use any of the selection tools to select an area and then press [Delete]. Photoshop has three different eraser tools that are used to remove parts of an image. Each tool has its strengths and weaknesses. This chapter discusses these tools and other related tools and commands.

Eraser Tools

There are three different eraser tools found in the **Tools** panel, Figure 7-1. Each of the three eraser tools has different attributes, and each is the best choice under certain circumstances. The three eraser tools are discussed in detail in the following sections.

The Eraser Tool

The **Eraser Tool** functions much the same as the **Brush Tool** that you learned about in the previous chapter. The options bar of these two tools share many similarities.

If you use the **Eraser Tool** on a layer with locked transparency, it does not actually erase anything. Instead, it paints the background color over your image. If your background color is white, then it looks like it is erasing pixels, leaving white paper behind. If you erase on a layer that is not locked, all of the pixels are deleted, leaving behind a transparent area. See Figure 7-2.

The **Mode** setting on the options bar is set to **Brush** by default. In other words, you can use the **Brush Preset Picker** in the options bar to set the size, shape, and hardness of the **Eraser Tool**. In situations where you want to leave behind a crisp, straight edge while erasing, you can change the **Mode** setting to **Pencil** or **Block**. The **Pencil** mode allows you to use the **Brush Picker**, but your brushes will have crisp edges, even if you change the **Hardness** setting. The **Block** mode disables the **Brush Picker** and changes the cursor into a square brush that *does not change size* as you zoom in and out. This is a good mode to use if you want to zoom in at 1600% and carefully erase one pixel at a time, because the **Eraser Tool** becomes the same size as a single pixel at that magnification level.

When erasing around an object, zoom in so you can accurately erase along an edge. Using brushes with **Hardness** set at 100% can make your edges look too crisp, while a

Figure 7-1. _____

Three different eraser tools are available in the **Tools** panel.

Brush Preset
Picker

Determines whether your
eraser acts like a brush,
a pencil, or a block

Click and hold to
reveal available
eraser tools

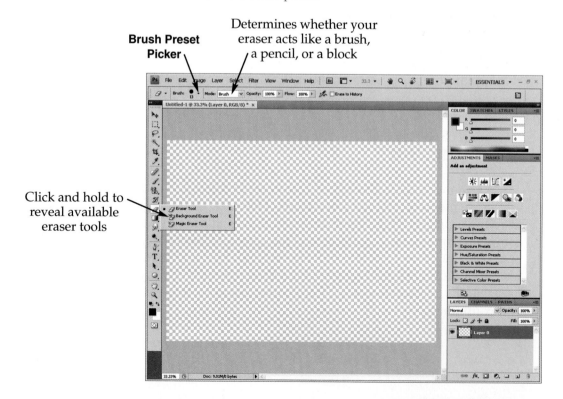

Hardness setting of 0% can create a bit too much of a feather effect as you erase, especially when using large-diameter brushes. Try using a **Hardness** setting of around 50% as you begin using the **Eraser Tool**.

If the **Opacity** setting in the options bar is set to 100%, the pixels in the **Eraser Tool**'s stroke are completely removed, making the area fully transparent (or completely

Figure 7-2.
The **Eraser Tool** is affected by layer transparency. **A**—When layer transparency is locked, the **Eraser Tool** paints the background color over an image. **B**—When layer transparency is unlocked, the **Eraser Tool** removes pixels, leaving behind a transparent area.

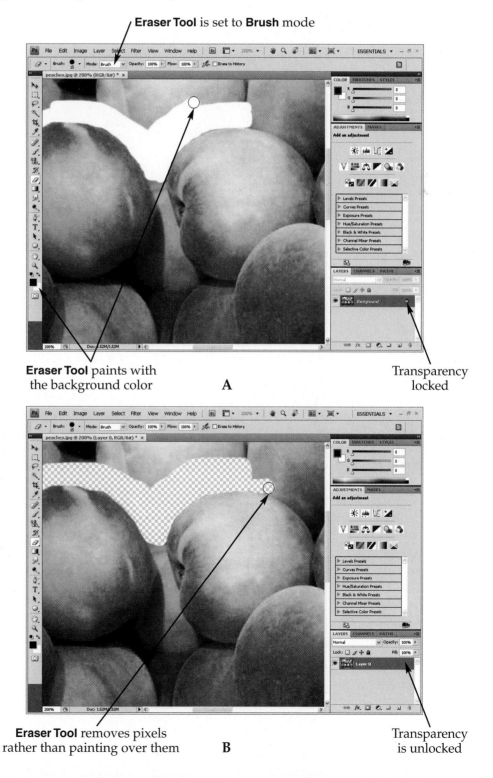

Eraser Tool is set to **Brush** mode

Eraser Tool paints with the background color **A** Transparency locked

Eraser Tool removes pixels rather than painting over them **B** Transparency is unlocked

replaced with the background color, if transparency is locked). If the **Opacity** setting is lowered, the **Eraser Tool** causes areas to become *partially* transparent, or partially covered with the background color (if transparency is locked). See **Figure 7-3**.

Figure 7-3. _____

Partially transparent areas can be created by lowering the **Eraser Tool**'s **Opacity** setting. If the mouse button is released while erasing, the effect of the **Eraser Tool** is multiplied where the strokes overlap. **A**—When transparency is locked, a semi-opaque background color is applied in the erased areas. **B**—When transparency is unlocked, some pixels are deleted to create semi-transparent areas.

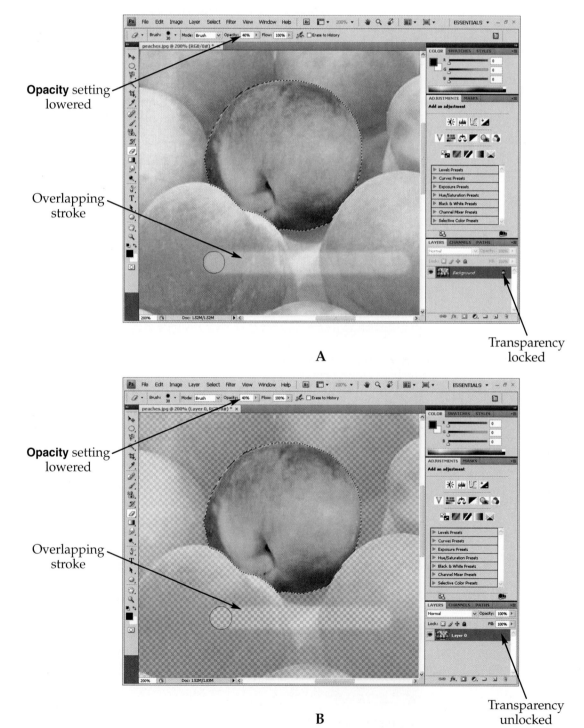

Note If the opacity level is lowered and you release the mouse button between eraser strokes, areas of the eraser strokes that overlap will have a lower opacity than areas that do not overlap.

When the **Erase to History** option is activated, the **Eraser Tool** restores the image back to its original state (the state it was in the last time it was saved). If you are removing pixels and accidentally erase a bit too much, turn on the **Erase to History** option, change the brush size if necessary, and drag over the area that was accidentally erased to bring it back to its original condition.

Note The **Opacity** setting affects the **Eraser Tool** even when the **Erase to History** option is active. If you want to restore a portion of an image that was erased accidentally using the **Eraser Tool** with the **Erase to History** option active, you may need to set the **Opacity** setting back to 100%. Otherwise, the area will be only partially restored.

The Background Eraser Tool

This is the second eraser tool found behind the **Eraser Tool** in the **Tools** panel. The **Background Eraser Tool** is designed to remove the background from around an object in an image. The simpler the background, the easier it is to use this tool. However, the various controls in its options bar let you fine-tune its performance so it will work on multicolored backgrounds as well. See **Figure 7-4**.

Figure 7-4. _____
The **Background Eraser Tool** removes a selected color (and closely similar colors) from the brush area, but does not erase dissimilar colors.

Determines how similar a color must be to the sampled color in order to be deleted

Colors similar to the color under the crosshairs are removed from the brush area, all other colors remain

Click to access the brush settings

Sampling options

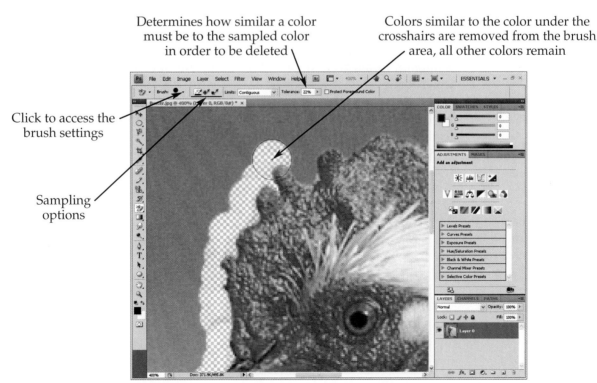

The **Background Eraser Tool** can use only round or oval brushes. Clicking on the **Brush** sample or the down-arrow button next to it opens a pop-up box with a variety of brush controls, **Figure 7-5**. The **Diameter** slider controls the size of the brush, and the **Hardness** slider controls how soft the edges of the brush appear. The **Spacing** setting controls how often this tool samples and deletes a color as you click and drag. The **Roundness** setting lets you transform a round brush into an oval brush. Decreasing the percentage entered in this text box flattens the brush, making it more oval. The value in the **Angle** text box determines the angle of the brush. Changes to this setting are only noticeable with an oval brush. The **Size** and **Tolerance** settings in the **Brush** pop-up box are functional only if you are using a graphics tablet instead of a mouse. They allow you to vary the **Diameter** and **Tolerance** settings of the tool based on stylus input.

When you use the **Background Eraser Tool**, you will see crosshairs (a small + symbol) in the middle of the brush. Hold the crosshairs over a color in the background that you want to delete, and then click. That background color is removed within the brush area. The **Tolerance** setting in the options bar controls how many closely-related colors are removed when you click. See **Figure 7-6**.

There are three sampling buttons on the options bar (look for the eyedropper icons). These settings control how the crosshairs sample a color. In order, the sampling buttons are:

- **Sampling : Continuous** option (look for two eyedroppers on the button): As you click and drag the **Background Eraser Tool**, Photoshop continuously looks at the color under the crosshairs and deletes closely-related colors according to the **Tolerance** setting. You will see the background color change continuously in the **Tools** panel as you erase. This setting works well if a background is multicolored and the object you want to keep is a different color that stands out.

- **Sampling : Once** option (the middle button): Click once to tell Photoshop what color you would like to delete. As long as you drag the mouse without clicking again, the **Background Eraser Tool** deletes only colors that are closely related to the pixel you first clicked on. This option works well when the entire background is nearly the same color. It also works well in situations where you must click precisely on a small area of colored pixels before erasing. You may need to zoom in and out as you do this kind of erasing.

- **Sampling : Background Swatch** option: This setting is not used often. To use this setting, choose a color by temporarily activating the **Eyedropper Tool** by pressing [Alt] (or [Option] for Mac). After selecting the color, switch it with the background color by clicking the **Switch Foreground and Background Colors** icon on the **Toolbar**. When this option is active, the **Background Eraser Tool** only deletes colors that are closely related to the background color you chose.

Figure 7-5. _____
The **Brush Preset Picker** for the **Background Eraser Tool** is shown here.

Figure 7-6.

The **Background Eraser Tool** with a large, soft (**Hardness:** 50%) brush was used to remove the background in both parts of this figure. **A**—When the **Tolerance** is set to 20%, the results look good. **B**—When the **Tolerance** is set to 70%, too much hair is deleted along with the background.

A

B

The **Limits** setting on the options bar controls how closely-related colors are deleted. You have three choices:

- The **Background Eraser Tool**'s default setting is **Contiguous**. When the colored pixel under the crosshairs is deleted, only similarly colored pixels *that are connected to the selected pixel in an unbroken group* are deleted from the brush

area. Similarly colored pixels that are separated from the selected pixel by a band of dissimilar color remain in the image. See **Figure 7-7A**.

- The **Discontiguous** setting deletes from the brush area *all* pixels that are similar in color to the pixel under the crosshairs. See **Figure 7-7B**.

- The **Find Edges** option is very similar to **Contiguous**, except it preserves the edge detail of an object in the foreground more effectively. Use this option if the object you want to keep has crisp, well-defined edges.

> **Note** Regardless of the **Limits** setting chosen, only pixels within the diameter of the brush are removed.

The last setting on the **Background Eraser Tool**'s options bar, the **Protect Foreground Color** option, is used in tricky situations where the **Tolerance** setting does not provide enough control. When this option is active, you can temporarily activate the **Eyedropper Tool** by pressing [Alt] (or [Option] for Mac) and sample a color that you want to protect as you erase. If you still cannot get effective results, the foreground and background colors you are working with are probably too closely related. You may need to zoom in, use the **Lasso Tool** to carefully select the troublesome areas, and press [Delete] to remove the pixels.

The **Background Eraser Tool** leaves behind garbage pixels that need to be cleaned up. These pixels are often hidden by the checkerboard pattern. Checking a deleted area of an image for garbage pixels only takes a moment. Begin by creating a new, blank layer. Move it below the image layer in the **Layers** panel and fill it with a bright color such as yellow, **Figure 7-8**. Then, select the image layer, use the **Lasso Tool** to draw a selection around the unwanted pixels, and press [Delete]. If careful deleting is needed, use the **Eraser Tool** with a small brush size.

Figure 7-7. _____

The **Background Eraser Tool**, with the same brush settings, was used to delete portions of both images in this figure. The same pixel was clicked on in both examples. **A**—When the **Contiguous** option is active, fewer pixels are removed. All of the pixels that are removed border each other. **B**—When the **Discontiguous** setting is active, similarly colored pixels are removed from the entire brush area, whether they border one another or not.

A B

Figure 7-8.

Areas deleted with the **Background Eraser Tool** often have garbage pixels in them. **A**—The garbage pixels can be difficult to see against the transparent background. **B**—The garbage pixels can be easily spotted by adding a temporary new layer and filling it with a bright color.

A B

The Magic Eraser Tool

The **Magic Eraser Tool** is similar to the **Background Eraser Tool**, except it does not use a brush and crosshairs. This tool works just like the **Magic Wand Tool**, but instead of selecting pixels, it deletes them. The **Magic Eraser Tool**'s options bar contains the same settings that are found on the **Magic Wand Tool**'s options bar, **Figure 7-9**.

Because this tool works just like the **Magic Wand Tool**, you should already be familiar with most of the controls in the options bar. If you would like a detailed reminder of how all of the options work, refer to "The Magic Wand Tool" section in Chapter 3, *Selection Tools*.

In addition to the controls found on the **Magic Wand Tool**'s options bar, the **Magic Eraser Tool**'s options bar also includes an **Opacity** slider. The **Opacity** setting, when lowered, will cause areas to appear partially transparent instead of completely removed.

You should remember from the discussion of the **Magic Wand Tool**, that when the **Contiguous** option is off, similar-colored pixels will be deleted throughout the entire image, **Figure 7-10**. In Figure 7-10B, the **Contiguous** option was turned off before deleting the sky, and this removed the blue color showing through the trees. However, it also deleted part of the windows that were reflecting the blue sky. An easy way to restore the deleted portions of the windows is to use the **Eraser Tool** with the **Erase to History** option active.

Always check for garbage pixels after using the **Magic Eraser Tool**. Quite often, you will find them.

Figure 7-9.

The **Magic Eraser Tool**'s options bar is shown here.

| ⌖ ▾ | Tolerance: 32 | ☑ Anti-alias | ☑ Contiguous | ☐ Sample All Layers | Opacity: 100% ▸ | |

Figure 7-10. _____

When using the **Magic Eraser Tool**, the blue sky can be deleted with a single click. **A**—When the **Contiguous** option is active, only the main part of the sky is removed. The sky peeking through the branches of the tree remains. **B**—When the **Contiguous** option is off, the blue sky is also deleted from within the tree branches. Unfortunately, the reflection of the sky in the house's windows is also removed.

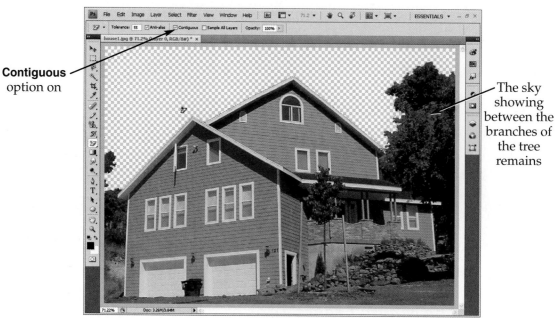

Contiguous option on

The sky showing between the branches of the tree remains

A

The reflected sky in the windows is removed along with the sky itself

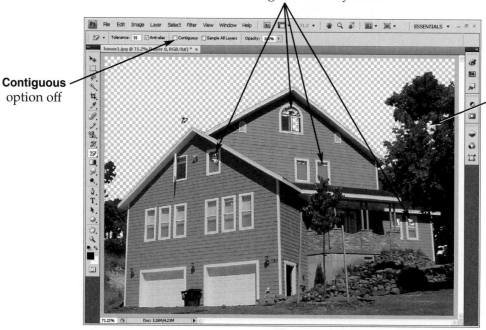

Contiguous option off

The sky showing through the tree is removed

B

The History Panel

You have learned about using **Edit > Undo** (or pressing [Ctrl][Z]) to undo the last tool action or command you used in Photoshop. You also know about the **Edit > Step Backward** command (or pressing [Ctrl][Alt][Z]), which is used if you need to undo more than one action. The **History** panel provides another way to undo the work you have done.

As you create and edit a file, the **History** panel shows you the last 20 actions (default setting) you applied to your file, **Figure 7-11**. Each action listed in the **History** panel is called a *state*, because your file is in a different state of existence after each adjustment you make to it. If your computer has plentiful memory, you can change the **History States** setting in the **General** category of Photoshop's **Preferences** to have the software remember more than 20 actions.

Using the **History** panel is optional. You can use it in the following ways:

- *You can go "back in time" to any state* by clicking on its description in the **History** panel. By comparison, when you use the **Step Backward** command, you are turning off one state at a time on the **History** panel. You can also delete actions from the **History** panel by either dragging them on top of the **Delete current state** (trash can) button, selecting them and clicking on the **Delete current state** (trash can) button, or right-clicking on them (or pressing [Ctrl] and clicking for Mac) and choosing **Delete**. If you use the **History** panel to delete an action that has other actions listed below it, all actions below are also deleted, unless you activate the **History** panel menu, choose **History Options** from the menu, and then place a check mark in the **Allow Non-Linear History** check box.

- *You can create "snapshots" of your image.* Since the **History** panel only shows a limited number of states, you can create a *snapshot* (a temporarily-saved version of your file) whenever you are satisfied with your progress on an image. You can also create a snapshot before trying out complex effects that might ruin your work. A snapshot is created by first selecting the state of the image you would like to make a snapshot of and then clicking the **Create new snapshot** (camera) button at the bottom of the **History** panel. Snapshots can be renamed and are listed in the upper portion of the **History** panel. However, when you close your file, all information on the **History** panel is lost, including snapshots, even if the file is saved.

- You can also use the **History** panel to create a new document instead of a snapshot. This is a helpful feature because snapshots and states are deleted when you close a file. To use this feature, select a state or a snapshot in the panel and click the **Create new document from current state** button in the **History** panel. This opens the selected state in a new document window and makes it active.

Figure 7-11. _____
The **History** panel lists each action performed, up to a maximum number determined by the **Preferences** settings. Each action is referred to as a state.

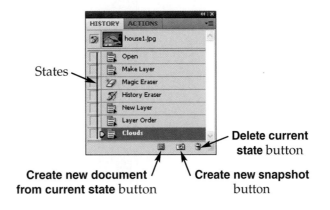

At times you may want to clear the **History** panel. Choose **Clear History** from the **History** panel menu or choose **Edit > Purge > Histories** (this command will purge the **History** in all open documents). The **Clear History** command can be undone, but the **Edit > Purge > Histories** command cannot. These commands remove the states in the **History** panel but do not undo the changes made to the image.

On other occasions, you may wish to *reset* your file and start all over. Choosing **File > Revert** resets your file to *the condition it was in when you last saved it*. When you use this command, the states are not deleted from the **History** panel. Instead, a new state named Revert is added at the end of the stack. You can jump back to a previous state (before the image was reverted) by clicking on the desired state in the **History** panel.

Some Photoshop users do not bother using the **History** panel. You should regard it as an optional way of saving your efforts while you care-fully experiment with complicated adjustments on a project.

History Brush Tools

The history brush category of tools are found just below the brush tools on the **Tools** panel, **Figure 7-12**. This category includes the **History Brush Tool** and the **Art History Brush Tool**.

The History Brush Tool

The **History Brush Tool** is designed to be used with the **History** panel. Its options bar is exactly the same as the **Brush Tool**'s. However, this tool does not apply paint. Instead, its purpose is to restore an image back to its original condition or a particular state that you specify in the **History** panel.

On the left side of the **History** panel, are small squares next to each state and snapshot, **Figure 7-13**. The **History Brush Tool** icon can be moved from state to state by clicking on those squares. The **History Brush Tool** icon indicates that when you paint with the **History Brush Tool**, it will restore the image to that state or condition.

By default, the **History Brush Tool** restores the image to its original state. Coincidently, there is another tool and option you have learned about in this chapter that does exactly the same thing—the **Eraser Tool** with the **Erase to History** option active.

Figure 7-12. _____
The history brush tools are located below the brush tools on the **Tools** panel.

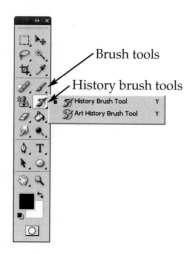

Brush tools

History brush tools

History Brush Tool Y
Art History Brush Tool Y

Figure 7-13. _____ **299**

Interesting effects can be created by using the **History Brush Tool** to restore a portion of an image after modifying it with filters. **A**—The original image is shown here. **B**—The Background layer has been duplicated and two filters have been applied to the duplicate layer. **C**—The **History Brush Tool** was used to restore the subject's face to its original condition.

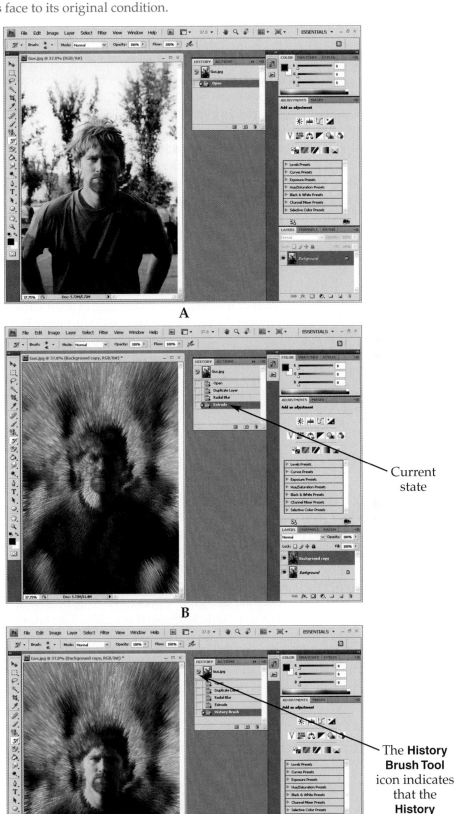

A

Current state

B

The **History Brush Tool** icon indicates that the **History Brush Tool** will restore the image to this state

C

The Art History Brush Tool

The **Art History Brush Tool** does not erase or delete pixels, but it is explained in this chapter because it is closely related to the **History Brush Tool**. The **Art History Brush Tool** works like a filter that is applied to your image with a brush. This bizarre tool adds a "paint stroke" special effect as it restores an image to a state or snapshot that you select in the **History** panel.

Along with the **Brush**, **Modes**, and **Opacity** settings, you will find a **Style** setting in the options bar, **Figure 7-14**. This menu lists several methods of applying the paint stroke effect. You can get some interesting effects as you change the **Tolerance** and **Area** setting. The best way to get familiar with this tool is to experiment with the settings for a few minutes. It produces effects that are similar to the **Glass** filter (**Filter > Distort > Glass...**).

Finding Extra Pixels with the Reveal All Command

When you drag images from one file to another, Photoshop remembers the entire image even if part of it extends past the edge of your canvas. Choosing **Image > Reveal All** shows you all layers that extend past the document's bottom edge, **Figure 7-15**.

To save hard disk space, you can crop the image by first undoing the **Reveal All** command. Next, choose **Select > All**. Lastly, choose **Image > Crop**. This permanently removes the portions of the image that extend beyond the canvas, making the file size smaller. However, today's hard drives are large enough that you will probably never need to worry about this issue.

The Trim Command

The **Trim** command is nothing more than a fancy version of the **Crop** command that considers objects in your image and the background color before cropping. Choosing **Image > Trim...** opens a dialog box that lets you crop one or all four sides of an image. The setting in the **Based On** section of the dialog box tells Photoshop what color to trim away. The settings in the **Trim Away** section determine what part(s) of the image the selected color is trimmed from.

For example, the design in **Figure 7-16** was begun by drawing some custom shapes. A decision was then made to make the canvas size smaller. In Figure 7-16A, the **Top Left Pixel Color** option is selected in the **Based On** section of the dialog box. This means that all areas that are white (because that is the color of the top left pixel) will be cropped to the edge of the custom shapes, except for the top of the image, Figure 7-16B. The top of the image is not cropped because it was deselected in the **Trim Away** section.

Figure 7-14. _____

The **Art History Brush**'s options bar is shown here.

Figure 7-15. ───

Layers that are moved to another image and extend past the canvas take up unnecessary file space. **A**—Portions of the layers that extend past the canvas are not visible. **B**—The **Reveal All** command causes the image to become large enough to display all pixels.

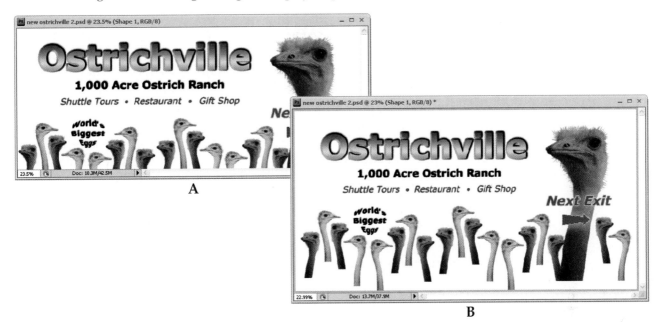

Figure 7-16. ───

Choosing **Image > Trim...** lets you crop your image according to how objects in your image are positioned. **A**—In the **Trim** dialog box, you specify a corner of the image to use as a color reference and the areas of the image that are to be cropped. **B**—After you click **OK** in the **Trim** dialog box, the background is trimmed away on the specified sides of the image.

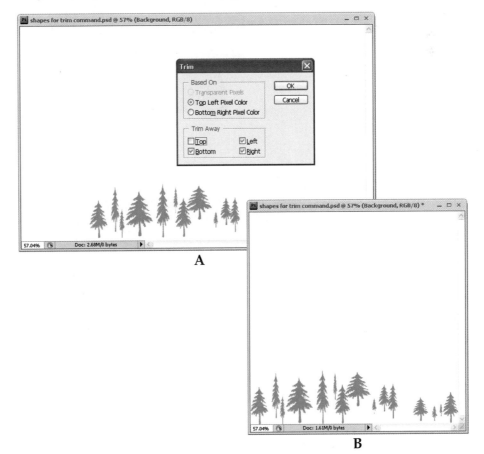

GRAPHIC DESIGN

Balance in Symmetrical and Asymmetrical Designs

A graphic designer should be concerned about *balance* (the equal distribution of visual elements) as the design takes shape. It is visually pleasing if design elements in one area of the design are complemented by other elements in the opposite area of the design. There are two fundamental types of designs that portray different balance strategies.

If a line were drawn down the center of a *symmetrical design*, both sides of the design would appear equal. This creates a visual harmony—one side perfectly balances the other side of the design, **Figure 7-17**. Symmetrical designs create a more conservative, formal, and calm mood.

Asymmetrical means "not symmetrical," and many designs fall into this category. Comparatively speaking, asymmetrical designs evoke dynamic, energetic, and even tense moods. The postcard design in **Figure 7-18** is an asymmetrical design. However, a sense of balance is maintained because the

Figure 7-17. _____
The "leafy" design is symmetrical—if a line were drawn down the middle, one side would be a mirror image of the other.

Figure 7-18. _____
Balance is created in this asymmetrical design by positioning design elements with significant visual weights opposite from one another.

bright red "Wildflower" text in the upper-left corner is balanced by the two inset images in the lower-right corner. Applying a bright red stroke around each inset image helps create a visual weight that approximates the weight of the "Wildflower" text.

The postcard example in **Figure 7-19** is an asymmetrical design that is not balanced. Most of the visual weight sits heavily at the left side of the design.

Figure 7-19.
This version of the postcard is not balanced.

Summary

Even though the three eraser tools and the **Extract** filter are powerful ways to remove unwanted pixels, they are not the only way. There are situations where the most effective way to delete a challenging area of pixels is to zoom in, use the **Lasso Tool** to select the area, and then press [Delete].

There are additional ways you can isolate parts of your image. You will learn those techniques in Chapter 11, *Additional Layer Techniques*.

CHAPTER TUTORIALS

Removing unwanted pixels requires a lot of patience. These tutorials will give you plenty of practice using the tools discussed in this chapter. There are several images that you will delete portions of and then add to projects you have started in previous chapters.

Tutorial 7-1: Creating a Blended-Photo Poster with the Eraser Tool

In this tutorial, you will combine several images into a single composite image. You will use the **Eraser Tool** to remove partially cut off objects in each image so that they blend together naturally when they are combined.

1. Open Photoshop.

2. Choose **File > New…**.

3. Name the new file 07poster and enter the settings shown at the right. Click **OK** when you are finished.

4. Open the apples1.jpg file, located in the food folder.

5. Click the **Arrange documents** button and select **Float All in Windows** from the menu.

6. Use the **Move Tool** to drag and drop the apples into 07poster image. Move the apples to the location shown.

7. Close the apples1.jpg file.

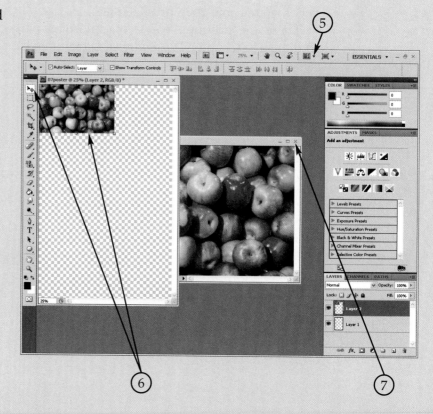

8. Choose **Window > History** to display the **History** panel.

9. Arrange the **History** and **Layers** panels as shown.

10. On the **History** panel, click the **Create New Snapshot** button.

 Creating a snapshot allows you to use the **Eraser Tool**'s **Erase to History** option or the **History Brush Tool**, if necessary. If you need to use these tools, make sure you activate the snapshot you just created by clicking next to it in the **History** panel.

 The history tools would also work if you save, close, and re-open the poster file each time you drag a new food image over to it, but this is much more cumbersome.

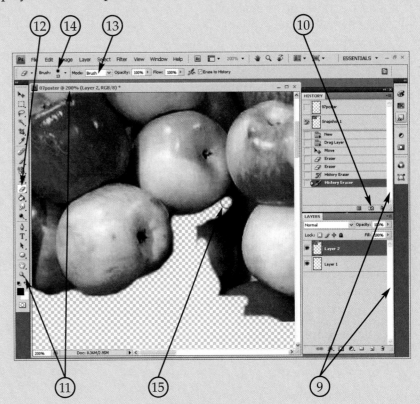

11. Use the **Zoom Tool** to enlarge the 07poster image until you see 200% in the title bar.

12. Click the **Eraser Tool**.

13. In the options bar, select **Brush** in the **Mode** drop-down list.

14. In the **Brush Preset Picker**, change the **Master Diameter** slider setting to 13 px and the **Hardness** slider setting to 50%.

 A small brush with a hardness of 50% leaves behind a slightly feathered edge when you erase.

15. Begin erasing apples that are cut off along the bottom and right side until all of the partial apples are removed.

 Press [Spacebar] to temporarily activate the **Hand Tool** to pan around the image as you work. If you make a mistake, click Snapshot 1 in the **History** panel and use the **Eraser Tool**'s **Erase to History** option to correct the mistake.

16. When you are done erasing apples, choose **View > Fit on Screen**.

17. Open the apples2.jpg file.

18. Click the apples2.jpg image window tab and drag it to the side to create a new image window for the apples2 image.

19. Use the **Move Tool** to drag the apples over to the 07poster image.

20. Close the apples2.jpg image window. Do not save the changes.

21. Rename the layers and arrange them so the green apples layer is below the apples layer in the **Layers** panel. Then, drag the green apples layer to upper-right corner of the image window.

22. Create a new snapshot in the **History** panel.

23. Click the small box to the left of the new snapshot.

 This will cause Photoshop to restore the image to the state recorded in the snapshot if you need to correct a mistake using the **Eraser Tool**'s **Erase to History** option.

24. Zoom in and begin erasing the green apples that are cut off along the bottom.

 As you work, change your brush size as needed. Small brushes with **Hardness** settings of about 50% work best for this type of work, because they leave a slightly feathered edge.

 Windows users: Change brush sizes while painting by holding down [Alt] and right-clicking and dragging. Change brush hardness by holding down [Alt][Shift] and right-clicking and dragging.

 Mac users: Change brush size while painting by holding down [Ctrl][Option] while clicking and dragging. Change brush hardness by holding down [Ctrl][Option][Command] while clicking and dragging.

25. Open the melons2.jpg file and drag it over to the 07poster image.

26. Close the melons2.jpg image window. Do not save the changes.

27. Since all of the cantaloupes along the bottom of the photo are cut off, rotate the image by choosing **Edit > Transform > Rotate 90° CCW**.

28. Rename the new layer melons2 and move it below the green apples layer in the **Layers** panel stack.

29. Scale the melons2 layer to 115% and move it to the right edge of the image, just below the green apples.

30. Create a new snapshot in the **History** panel so you can use the **Erase to History** option.

31. Erase the cantaloupe layer as shown.

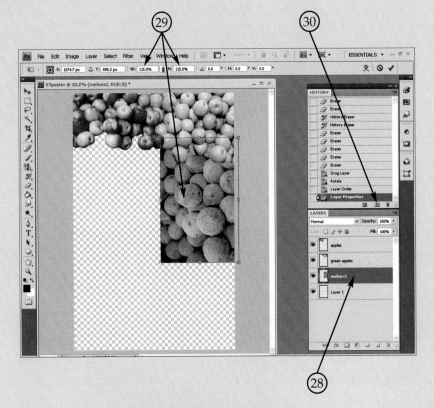

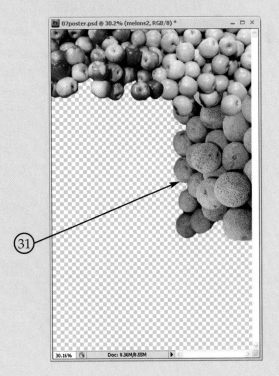

32. Continue adding, positioning, scaling, and erasing parts of the other photos in the food folder. Try to make your poster look as close as possible to the completed poster shown on the right.

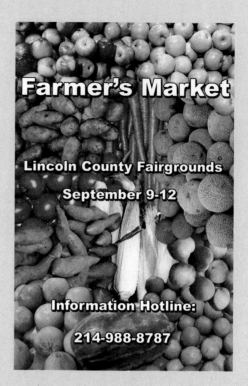

The carrots.jpg image needs no erasing, because it is positioned at the very bottom of the stack in the **Layers** panel. Remember that each layer's position in the **Layers** panel determines how it will overlap adjacent layers. You will also need to rotate some of the images to match the orientations shown in the sample.

33. Add the text shown. Because this is a poster, use a font that can be easily read from 10′ away. Add layer styles to help the text stand out.

In this example, after text was entered with the **Horizontal Type Tool**, two layer styles were added—a stroked border (black) and a drop shadow.

34. After you are satisfied with how the text and images are arranged on your poster, choose **Layer > Flatten Image**.

35. Choose **View > Actual Pixels** to view your poster at actual size.

36. Save the 07poster image in PSD format and then close it.

Tutorial 7-2: Removing the Background from an Image

In this tutorial, you will use a number of methods to remove the backgrounds from around key objects in an image. You will then combine the objects in a single design.

Part 1: Using the Background Eraser Tool

In this part of the tutorial, you will use the **Background Eraser Tool** to remove the background surrounding a subject. You will eliminate garbage pixels by adding a fill layer and using the **Eraser Tool** to clean up the background. Once the subject is isolated in the image, you will drag and drop it into another image.

1. Open the file named Frankie.jpg.

2. Choose **View > Fit on Screen**.

3. Choose **Select > All**.

4. Click the **Lasso Tool**.

5. Click the **Subtract from selection** button in the options bar.

6. Drag a selection border all the way around Frankie.

7. Press [Delete].

 The background color (white) replaces the deleted part of the file. If your file does not look similar to the example, choose **File > Revert** and try the preceding steps again.

8. Double-click on the Background layer in the **Layers** panel.

9. In the **New Layer** dialog box, click **OK** to rename the layer Layer 0.

 You have just unlocked the layer transparency by renaming the background layer.

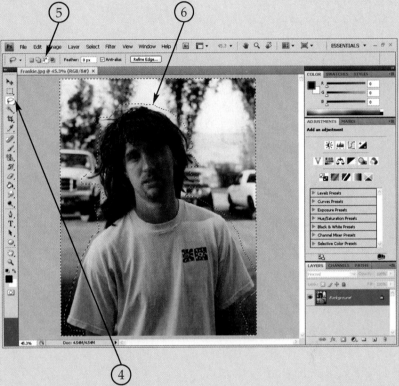

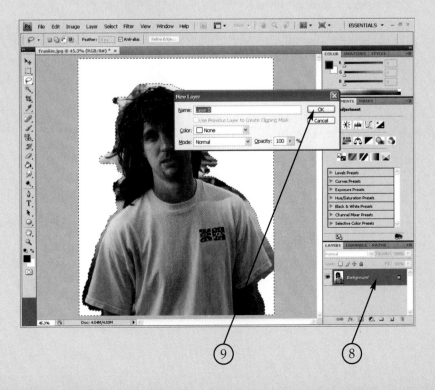

10. Press [Delete] again.

 Instead of white, a checkerboard pattern shows around Frankie. This pattern means there is no color there.

11. Choose **Select > Deselect** to clear the selection.

12. Zoom in on Frankie's head.

13. Click the **Background Eraser Tool** and enter the following settings in the options bar:

 • Set the brush **Diameter** to 80 px (use the bracket keys to change brush sizes as you work).

 • Set the brush **Hardness** to 60%.

 • Make sure the **Sampling : Continuous** button is selected (depressed).

 • Select **Discontiguous** in the **Limits** drop-down list.

 • Set the **Tolerance** slider to 20%.

14. Place the crosshairs that appear in the center of the **Background Eraser Tool** cursor on the background right next to Frankie's hair and click.

15. Continue erasing the background around Frankie, observing these tips.

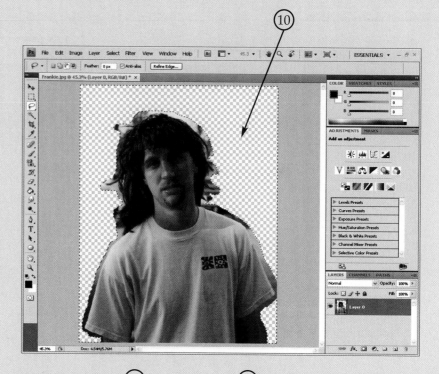

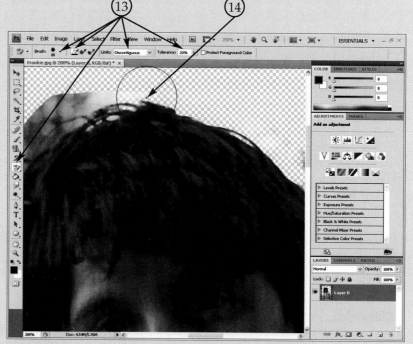

 • Erase one click at a time. If too much is deleted when you click, press [Ctrl][Z] to undo the action, lower the **Tolerance** setting, and try again. Also, experiment with making the brush size smaller or setting the **Limits** setting to **Contiguous** in problem areas.

 • In areas where the background is the same color as Frankie's hair, use the **Lasso Tool** to select and delete the background.

16. Choose **Layer > New > Layer…**. In the **New Layer** dialog box, accept the default name by clicking **OK**.

17. In the **Layers** panel, drag the new layer so it is below the layer that contains Frankie.

18. Make sure the new layer is active, and then choose **Edit > Fill...**.

19. In the **Contents** section of the **Fill** dialog box, choose **Color** from the **Use** drop-down list.

20. In the **Color Picker**, choose a bright, vivid color and click **OK**.

21. In the **Fill** dialog box, click **OK** to fill the layer with the selected color.

22. In the **Layers** panel, select the layer containing Frankie. This should be Layer 0.

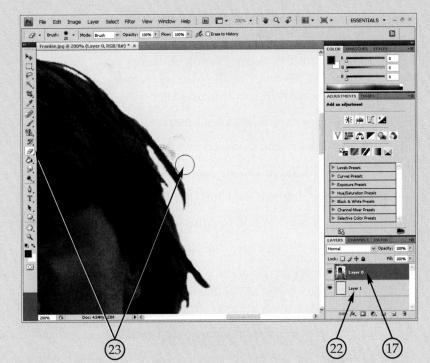

23. Check closely for any garbage pixels that appear around Frankie. Use the **Eraser Tool** to delete them.

You can also use the feathered edge of the **Eraser Tool**'s brush to smooth out any jagged edges on Frankie, such as edges of his T-shirt and wisps of hair.

24. When you have removed all of the garbage pixels, delete the new, color-filled layer.

25. Open the 06CDback.psd file you created in the previous chapter.

26. Move Frankie over to the 06CDback.psd image and scale him to 80% (choose **Edit > Transform > Scale**).

27. Click the **Commit** button in the options bar to end the **Scale** command.

28. Move Frankie to the location shown.

29. Use the **Rectangular Marquee Tool** to select the part of Frankie that covers the red rectangle at the left.

30. Press [Delete].

31. Save your changes to the 06CDback.psd file.

32. Close the Frankie.jpg file. It is not necessary to save the changes.

Part 2: Add Two More Band Members

While completing the tutorials in Chapter 3, you used quick mask mode to select a leaf by painting a pink mask around it. Some Photoshop users may prefer selecting the band members using quick mask mode, so in this part of the tutorial, you decide whether to use the eraser tools or quick mask mode to continue working on this project.

1. If necessary, open the 06CDback.psd image.

2. Open the Gus.jpg and Chris.jpg files.

3. Choose one of the following methods to remove the background from these files:

 A: Follow the steps in Part 1 of this tutorial.

 B: Use quick mask mode to paint a pink mask over the background.

 Refer to Tutorial 3-3, Part 4 for reminders about using quick mask mode.

 Do not use large brush sizes when you are painting a mask right next to your subject. You will get best results using small brushes with a **Hardness** setting of around 50%. When necessary, use keyboard shortcuts to change brush sizes and **Hardness** settings as you paint.

4. After moving the band members over to the 06CDback.psd image, scale both of them to 40%.

5. Make sure your layers are stacked as shown.

 Gus' arms were cut off in the image. Make sure you position him so that the missing portion of his arm is hidden behind Frankie.

6. Save your changes to the 06CDback.psd file.

7. If the Gus.jpg or Chris.jpg files are still open, close them and do not save the changes.

Part 3: Adding a Shape and Text to the Back of the Jewel Case Design

In this part of the tutorial, you will add a custom shape to the back of the CD jewel case design. You will then use the **Horizontal Type Tool** to add the band's name and a playlist to the design.

1. If necessary, open the 06CDback.psd image.

2. Click the **Custom Shape Tool**.

3. Click the down-arrow next to the **Shape** box in the options bar to open the **Custom Shape Picker**.

4. Click the arrow button in the upper-right corner of the **Custom Shape Picker**.

 This opens the **Custom Shape Picker** menu.

5. Choose **Shapes** from the **Custom Shape Picker** menu.

6. Click **Append** in the dialog box that appears.

7. Select the Triangle Frame shape in the **Custom Shape Picker**.

8. In the options bar, make sure the **Shape Layers** option is active.

9. Click the color box on the options bar and choose black.

10. Hold down [Shift] while dragging a triangle the size shown.

11. In the **Layers** panel, right-click on the shape layer that was just created and choose **Rasterize Layer** from the shortcut menu.

12. In the **Layers** panel, drag the new shape layer so it is just above the bottom layer in the stack.

13. On the **Layers** panel, set the opacity of the shape layer to 30%.

14. Before adding text, click the top layer in the **Layers** panel.

 You click the top layer on the stack so that your new text layer will be created on top of all the other layers.

15. Click the **Horizontal Type Tool** in the **Tools** panel.

16. In the options bar, choose the Arial font with the Bold style and set the font size to 12 pt.

17. Click the color box on the options bar and select white in the **Color Picker**.

18. Type Blister in the location shown.

19. If the text is difficult to read, try changing the anti-aliasing option applied to the text.

20. Choose **Edit > Transform > Rotate 90° CW**.

21. Drag the rotated text to the center of the left-hand red bar.

22. Choose **Layer > Duplicate Layer...**. Accept the default name.

23. Drag the text you just duplicated to the other red bar.

24. In the options bar, make sure the Arial font with the Bold style is selected. Add the song titles shown.

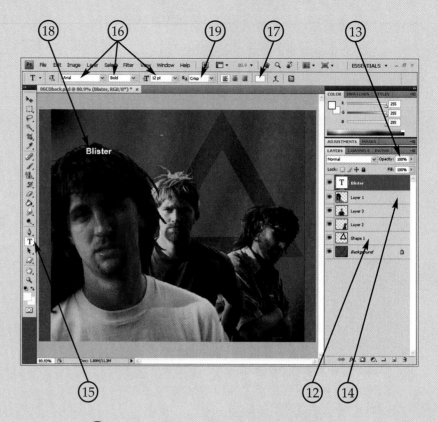

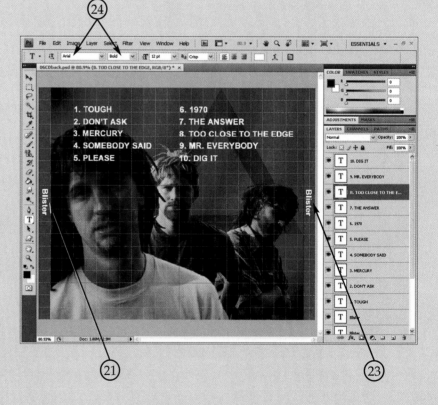

Use the grid to help you line the elements up evenly. In the example, major gridlines are spaced every 1″, with four subdivisions. This creates a minor gridline every .25″. You may need to adjust the tracking of the title for song number 8 to get it to fit in the desired space.

25. Hide the grid by choosing **View > Show > Grid**.

26. Choose **File > Save As...** and name this file 07CDback.psd. Then, close the file.

 This completes the design.

Tutorial 7-3: Using the Magic Eraser Tool

In this tutorial, you will combine a panorama of an undeveloped landscape with three separate images of homes. The result will show how the area will look with several homes built on it. You will use a variety of methods to remove the backgrounds surrounding the homes. Architectural firms and developers use similar techniques to create conceptual drawings for new building projects.

Part 1: Removing the Background from the First House

In this part of the tutorial, you will use the **Magic Eraser Tool** to delete the sky from the image of a home. You will then drag and drop the image of the house into the panorama. After the house has been added to the panorama, you will scale it to the desired size and move it into the proper position.

1. Open the 06hillside.psd file that you created in an earlier chapter.

2. Open the file named house1.jpg.

3. Click the **Magic Eraser Tool**.

 The **Magic Eraser Tool** is found behind the **Eraser Tool** in the **Tools** panel.

4. In the options bar, set the **Tolerance** to 35.

5. Make sure the **Contiguous** check box has a check mark in it.

6. Click the blue sky above the house.

 Notice that the **Magic Eraser Tool** deletes the blue sky color until it reaches the outside edge of the tree. However, some blue sky is still showing through the tree branches.

7. Choose **Edit > Undo Magic Eraser** to bring back the sky.

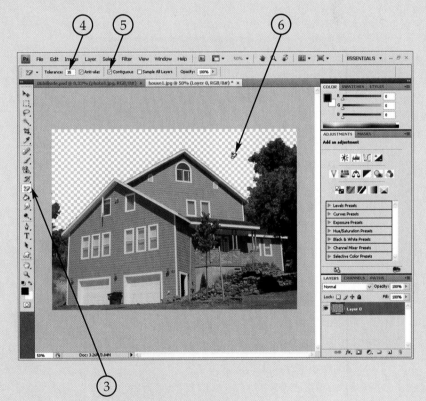

8. In the options bar, remove the check mark from the **Contiguous** check box.

9. Click in the same spot (see step 6) to delete the sky.

 The blue sky color is deleted from the entire photo.

10. Zoom in on the windows of the house and check for blue pixels that were accidentally removed.

 You will likely find that some blue pixels were accidentally deleted from the windows. If the image were going to be used at somewhere near full scale, the missing pixels in the house windows would have to be fixed using the **Eraser Tool** with the **Erase to History** option active. However, in this tutorial, the house is going to be scaled down to the point where the missing pixels will not be noticeable.

11. Use the **Move Tool** to drag the house over to the 06hillside.psd image.

12. Choose **Edit > Transform > Scale** and enter 30% in the **W** and **H** boxes.

13. Click the **Commit** button in the options bar to end the scale command.

14. Move the house to the location shown.

15. Zoom in on the house and make sure it is properly positioned. Look at the house's position relative to the trees and hills in the background, and move the house so it is positioned like the one in the example.

16. Close the house1.jpg file. Do *not* save the changes.

17. Save the 06hillside.psd image. If you are not going to continue on to the next part of this tutorial right away, close the image.

Part 2: Removing the Background from the Second House

In this part of the tutorial, you will use the **Magic Eraser Tool** and the lasso tools to remove the background in the image of a house. You will then drag and drop the house into the panorama.

1. If necessary, open the 06hillside.psd image.

2. Open the house2.jpg file.

 Look at the **Layers** panel. Notice the layer that opened automatically with this image is named Background and is locked.

3. Click the **Magic Eraser Tool** in the **Tools** panel.

4. In the options bar, set the **Tolerance** to 25.

5. Make sure the **Contiguous** option is not active (no check mark).

6. Click in the upper-left corner of the image to delete some of the sky.

 When you use the **Magic Eraser Tool**, the Background layer is unlocked automatically (the padlock symbol is gone).

7. Delete the rest of the sky with the **Magic Eraser Tool**.

8. Click on the road to delete it.

 Some parts of the house were deleted too, because they were similar in color to the road.

9. Choose **Edit > Undo Magic Eraser**.

10. Turn on the **Contiguous** option (place a check mark in the check box).

11. Delete the road and the mountains.

12. Choose **Layer > New Fill Layer > Solid Color…**. Click **OK** in the **New Layer** dialog box to accept the default settings. In the **Color Picker**, select a bright color.

13. Choose **Layer > New > Background from Layer**.

 This is an alternative method for creating a fill layer to check for garbage pixels. You can also create a new layer, fill it with color using the **Paint Bucket Tool** or the **Edit > Fill** command, and drag it to the bottom of the stack in the **Layers** panel.

14. Look for pixels that were not deleted. Use the **Eraser Tool** or the **Lasso Tool** to draw a selection border around the garbage pixels, then press [Delete].

 Make sure the layer with the house is active, otherwise you will delete the brightly colored fill.

15. Use the **Lasso Tool** to draw a selection around the large tree in the front yard.

 Select the foliage part of the tree, but not its trunk. Also, make sure that your selection does not include any part of the main house.

16. Select the **Magic Eraser Tool**. Set the **Tolerance** to 115 and make sure the **Contiguous** check box is unchecked.

17. Zoom in on the tree, and then click one of the nearly white pixels near the top of the tree.

 This deletes most of the light-colored pixels within the selection while leaving the foliage intact. If too many pixels are deleted, press [Ctrl][Z]. Then, try selecting a lighter pixel or decreasing the **Tolerance** setting.

18. Select the **Eraser Tool**.

19. In the options bar, select **Brush** from the **Mode** drop-down list.

20. Change the brush diameter to 2 px and the **Hardness** setting to 100%.

21. Use the brush to erase any leftover bits of sky showing through the tree leaves.

22. Choose **Select > Deselect**.

23. Erase other items until your house looks like the example shown on the right. Use different brush sizes as needed.

To clean up the edges of the roof, you will need to erase in a perfectly straight line. To do this, click the starting point with the **Eraser Tool**. Release the mouse button, move the cursor to the end point, press [Shift], and then click the end point. This erases a straight line between the two points you clicked.

24. Zoom in on the driveway.

25. Select the **Polygonal Lasso Tool**.

26. Click the topmost point of the concrete driveway. Then, follow these guidelines:

 - Click every time you change direction.

 - To finish the selection border, hold the **Polygonal Lasso Tool** over the exact point where you began. When you see a small circle appear next to the **Polygonal Lasso Tool cursor**, click to finish the selection.

27. When you have selected the driveway, press [Delete].

28. Use the **Move Tool** to drag the house over to the 06hillside.psd image.

29. Move the house to the location shown.

30. Close the house2.jpg file. Do *not* save the changes.

31. Save the 06hillside.psd image. If you are not going to continue on to the next part of this tutorial right away, close the image.

Part 3: Isolating the Third House

In this part of the tutorial, you will flip the image of a third house so it better suits your needs. You will remove the background surrounding the house and copy the house to panorama. You will then skew the house so that its perspective matches the other houses in the image.

1. If necessary, open the 06hillside.psd image.

2. Open the house3.jpg file.

3. Press [Ctrl][A] to select the entire image.

4. Choose **Edit > Transform > Flip Horizontal**.

5. Open the **History** panel and click the **Create new snapshot** button at the bottom of the dialog box. Next, click the box to the left of Snapshot 1 and then close the **History** panel.

This step sets Snapshot 1 as the source for the **History Brush Tool**, which means the **History Brush Tool** will restore the image to its flipped position, not its original position. This will be very helpful if you need to use the **History Brush Tool** to fix a mistake in the following steps.

6. In the **Layers** panel, double-click the Background layer and click **OK** in the **New Layer** dialog box.

 This unlocks transparency for the layer.

7. Delete the background and the road until the house looks like the example.

8. If you added a colored layer to help you identify garbage pixels, delete it now.

9. Use the **Move Tool** to drag the house over to the 06hillside.psd image.

10. Choose **Edit > Transform > Scale** and enter 300% in the **W** and **H** boxes.

Note When you make an image larger, you will start to see individual pixels unless the image has a high-quality resolution. The house3.jpg image has a resolution high enough to allow it to be enlarged by 300% without a *noticeable* loss in quality.

11. Click the **Commit** button in the options bar to end the **Scale** command.

12. Move the house to the location shown.

13. Choose **Edit > Transform > Skew**.

14. Find the middle handle (square) on the right side of the bounding box. Hold the mouse cursor near the middle handle until the double arrow cursor appears.

15. Click and drag upward until the sidewalk appears to be running parallel to the road.

 Making the road and sidewalk *appear* to be parallel is n*o*t the same as making their edges parallel in the image. The road and sidewalks should converge at a point in the distance, called the *vanishing point*. If the road were straight and level, the centerline of the sidewalk and the centerline of the road would converge at the horizon. However, in your image, the road changes direction and elevation slightly, making the lines of convergence dog-legged.

16. Click the **Commit** button in the options bar to end the **Skew** command.

17. Make sure that the layer containing the house closest to the viewer is at the top of the stack in the **Layers** panel. The layer containing the middle house should be next in the stack, followed by the layer containing the farthest away house, and, lastly, the background layer.

18. Choose **File > Save As...** and name the file 07hillside.psd. Close this file when you are done.

 You will work on this scene again later.

19. Close the house3.jpg file. Do *not* save the changes.

Key Terms

asymmetrical
balance
delete

erase
snapshot
state

symmetrical design
vanishing point

Review Questions

Answer the following questions on a separate sheet of paper.

1. Briefly describe the difference between erasing and deleting, as explained by the author.

2. How can you use the selection tools to delete part of an image?

3. The **Eraser Tool**'s options bar is almost identical to what other tool's options bar?

4. What does the **Eraser Tool** do if you use it on a locked layer?

5. What does the **Eraser Tool** do if you use it on an unlocked layer?

6. What brush **Hardness** setting is recommended when using the **Eraser Tool**?

7. What does the **Eraser Tool**'s **Erase to History** option do?

8. What does the **Background Eraser Tool**'s **Tolerance** setting control?

9. What is the difference between the **Background Eraser Tool**'s **Sampling : Continuous** and **Sampling : Once** sampling options?

10. Describe the difference between the **Background Eraser Tool**'s **Contiguous** and **Discontiguous** options.

11. How do you check for garbage pixels after deleting an area with the **Background Eraser Tool** or **Magic Eraser Tool**?

12. How does the **Contiguous** option affect the **Magic Eraser Tool**?

13. How many states does the **History** panel remember (unless you change the setting)?

14. When referring to the **History** panel, what is the difference between a snapshot and a state?

15. What command resets your file to its condition the last time you saved it?

16. What does the **History Brush Tool** do?

17. How is the **Art History Brush** different from the **History Brush Tool**?

18. What does the **Reveal All** command do?

19. When using the **Trim** command, explain what happens when you choose either the **Top Left Pixel Color** or the **Bottom Right Pixel Color** option in the **Based On** section of the **Trim** dialog box.

20. Describe the function of the four check boxes in the **Trim Away** section of the **Trim** dialog box.

8

Restoring and Retouching Photos

Learning Objectives

After completing this chapter, you will be able to:

- Explain the differences between restoring and retouching a photo.
- Explain what happens to a photo when it is sharpened.
- Use the **Unsharp Mask** or **Smart Sharpen** filter to sharpen a photo.
- Use the **Sharpen Tool** to sharpen a small portion of an image
- Use the **Blur Tool** to blur a small part of an image.
- Explain the term "noise" as it applies to an image.
- Compare the four filters that remove noise from an image.
- Use the **Spot Healing Brush Tool, Healing Brush Tool,** and **Patch Tool** to remove blemishes from an image.
- Compare the **Spot Healing Brush Tool, Healing Brush Tool**, and **Patch Tool**.
- Use the **Red Eye Tool** to correct red eye problems in a photo.
- Use the **Clone Stamp Tool** to retouch and manipulate photos.
- Describe how the **Clone Source** panel can be used along with the **Clone Stamp Tool** or the **Healing Brush Tool**.
- Use the **Vanishing Point** filter to maintain the proper perspective while retouching images that contain rectangular objects.

Introduction

Photos that have been ripped or damaged by sunlight, dirt, or grime can be scanned on a flatbed scanner, restored with Photoshop's tools, and printed. The term *restoring* refers to returning a photo to its original condition. The term *retouching* means to alter a photo from its original appearance. This could be a slight adjustment, like removing a pimple or a stray wisp of hair from a portrait—or a significant overhaul, such as completely removing a person from a group photo.

Photos that need to be restored or retouched should be scanned at a resolution of 300 spi (dpi) or higher. The smaller the pixels are in an image, the easier it is to repair problem areas. For accuracy, you should also zoom in on your image (at least 200%) when restoring or retouching it.

Photoshop has some amazing tools and techniques that are used to restore and retouch photos. We will begin with a simple retouching technique that many photos need—sharpening.

Sharpening an Image

Photoshop has several sharpening filters that can improve the appearance of images that are *slightly* out of focus. Unfortunately, Photoshop cannot sharpen an image that is considerably blurry.

When Photoshop sharpens an image, it causes dark pixels to get even darker, while light pixels become lighter. Most of the seashells shown in **Figure 8-1** have clearly defined edges that are slightly shadowed. When this image is sharpened, the edges become easier to see, or *sharper*, because the shadows get darker and the bright parts of the edges get even brighter. However, sharpening does not just affect the *edges* of objects—it can affect *all* of the detail in an image.

The Unsharp Mask Filter

The **Unsharp Mask** filter was used to sharpen the image in Figure 8-1B. One advantage of this filter is it lets you control the amount of sharpening. When you choose **Filter > Sharpen > Unsharp Mask...**, the **Unsharp Mask** dialog box appears, **Figure 8-2**. A preview of how the settings affect your image is displayed in the large window inside the dialog box. You can adjust this view using the zoom buttons (**+** and **−**) and the **Hand Tool**, which appears automatically when you move the cursor into the preview window. To help you see how the sharpening settings affect your image, each time you click on the preview of your image with the **Hand Tool**, your image is displayed in its original condition. When you release the mouse button, the sharpening settings are applied to the preview again.

Figure 8-1. _____

Sharpening can bring out the details in an image. **A**—The original image is slightly blurry.
B—Applying the **Unsharp Mask** filter causes light pixels to become lighter and dark pixels to become darker, causing the edges of objects to appear crisper.

A B

Figure 8-2. _____
A preview window in the **Unsharp Mask** dialog box shows how the current settings would affect the image.

> | Note | The controls and techniques used to move around the preview window of the **Unsharp Mask** dialog box are common to many filter dialog boxes, including most of the dialog boxes described later in this chapter.

In addition to the preview window, the dialog box also has a **Preview** check box. When this check box is checked, the current settings are temporarily applied to the actual image. The effect on the image is updated every time the settings change. However, if you cancel out of the dialog box, the image is automatically restored to its original condition.

The **Amount** slider setting determines how much darker the dark pixels become and how much lighter the light pixels become. Adjust this setting higher or lower depending on your personal preference, but a setting between 150 and 300 works well in most cases.

The **Radius** slider setting determines the width of the effect. The higher the **Radius** setting, the wider the sharpening effect appears along the object edges in your image. This setting is often best left between .5 and 1.5 pixels. A higher **Radius** setting creates more extreme edges when the image is sharpened. Settings above 2 are usually not recommended, unless a special effect is desired.

The **Threshold** slider setting tells Photoshop how sensitive it should be when searching for "edges" in an image. A low **Threshold** setting causes Photoshop to sharpen almost all of the pixels in the image. A higher setting will sharpen only *high-contrast* edges, such as a bright, colorful object with a very dark shadow along its edge.

A recommended way to begin using the **Unsharp Mask** filter is to keep the **Radius** slider set at 1.0 pixels. Then, jump back and forth between the **Amount** setting and **Threshold** setting until the effect looks good to you. Remember, lower **Threshold** settings cause details in the entire image to become sharper; higher **Threshold** settings cause obvious edges to become sharper.

The Smart Sharpen Filter

The **Smart Sharpen** filter is more complex than the **Unsharp Mask** filter. It is "smart" because it can help correct more than one kind of blur, such as *Gaussian blur* (a slight blur that is evenly distributed across the entire image) and *motion blur* (caused by camera movement or subject movement when the photo was captured).

When you select **Filter > Sharpen > Smart Sharpen...**, the **Smart Sharpen** dialog box appears. You can navigate around the preview window of this dialog box the same way you navigate the preview window in the **Unsharp Mask** dialog box. This dialog box also uses the same **Amount** and **Radius** settings that are used with the **Unsharp Mask** filter, plus several additional settings, **Figure 8-3**.

After you sharpen an image by adjusting the **Amount** and **Radius** settings, you can fine-tune the results by separately adjusting either the shadows or highlights. This is done by clicking the **Advanced** radio button, which causes the **Shadow** and **Highlight** tabs to appear. On each of these tabs is yet another **Amount (Fade Amount)** and **Radius** slider, along with a **Tonal Width** slider, which is similar to a tolerance control. The **Tonal Width** slider controls how many closely-related colors found in the shadows (or highlights) are affected by the other two sliders.

If you are sharpening several images that have very similar blur problems, it may be helpful to save your current filter settings by clicking the **Save current filter settings** button, which looks like a floppy disk, and then naming the settings in the **New Filter Settings** dialog box. Filter settings that you have saved are available in the **Settings** drop-down list. The **Delete current settings** button, which looks like a trash can, is used to delete the currently loaded settings from the **Settings** drop-down list.

The **Remove** drop-down list, which is available when the **Basic** radio button or the **Sharpen** tab is selected, lets you select the type of blur to remove. The default setting is **Gaussian Blur**, which is the same blur setting used automatically by the **Unsharp Mask** filter. Try the **Lens Blur** option when sharpening images with lots of fine detail—you may get slightly better results. If the camera or the subject moved slightly when the image was captured, try correcting the problem with the **Motion Blur** option. When you choose the **Motion Blur** method, the **Angle** setting becomes active. Enter a new value in the **Angle** text box, or click and drag the compass icon to match the direction that the camera was jerked while shooting the picture.

Placing a check mark in the **More Accurate** check box causes Photoshop to take more time when calculating the sharpening effect. On some images, you may not be able to see a difference between using this option and leaving it off.

Figure 8-3.
The **Smart Sharpen** filter gives you the most control when sharpening an image.

Click to delete the currently loaded settings

Click to save the current settings

Click and drag to adjust the angle of the blur filter

Other Sharpening Filters

There are several other filters in the **Filter** menu. The **Sharpen**, **Sharpen Edges**, and **Sharpen More** filters do not have any settings—they just apply an automatic dose of sharpening to an image. It is recommended that you use the **Unsharp Mask** filter or the **Smart Sharpen** filter instead of the **Sharpen**, **Sharpen Edges**, or **Sharpen More** filters because they allow you to view the results of your adjustments before clicking **OK**.

Sharpening Tips

Sharpening can be applied to only one layer at a time. If you want your entire image to be sharpened, save an unflattened copy of your file and then flatten it. After flattening the image, you can apply a sharpening filter to the entire image at once.

It is important to remember that sharpening will correct only *minor* blur problems. If an image is too blurry, do not use it—obtain another image.

As a general rule, sharpening your image should be the *last* thing you do before printing. For example, if you sharpen your image and then scale it to a larger size, the edge detail will become exaggerated. Professional Photoshop users do not sharpen until they know what type of printing device will be used to print the image. Images used in a newspaper ad, for example, need to be sharpened more than images that will appear in a high-quality magazine. Occasionally, trial and error is necessary when learning how much sharpening is ideal for a particular printing medium.

The Sharpen Tool and the Blur Tool

When you only need to sharpen a small area of an image, you can create a selection around the area and use one of the sharpen filters. A feathered selection causes the filter effect to gradually blend into the surrounding areas of the image.

You can also sharpen a small area using the **Sharpen Tool**. The **Sharpen Tool** is found in Photoshop's **Tools** panel, just below the eraser tools, **Figure 8-4**. The **Sharpen Tool**'s options bar contains a **Brush Picker** and a **Mode** drop-down list, which should be familiar to you from your study of the brush tools. It also contains a **Strength** slider, which controls how much sharpening is applied when you click and drag over the image. The final control in the **Sharpen Tool**'s options bar is the **Sample All Layers** check box. When this option is active, the **Sharpen Tool** will simultaneously sharpen the current layer and all layers *below* it in the **Layer** panel's layer stack.

The **Blur Tool** is grouped with the **Sharpen Tool** in the **Tools** panel. The way the **Blur Tool** is used and its available options are exactly the same as those for the **Sharpen Tool**. However, as its name suggests, the tool blurs an image instead of sharpening it.

Figure 8-4.

The **Sharpen Tool** and **Blur Tool** are found below the eraser tools in the **Tools** panel.

Filters That Remove Dust, Scratches, and Noise

Have you ever set your digital camera's ISO setting to 800 or 1600? These high ISO settings cause your camera's image sensor to be more sensitive to light. In other words, at these settings you can get better results when capturing images in poorly-lighted or dim locations, such as a indoor gym or an auditorium. The higher your ISO setting is, however, the more likely your images will contain *noise*. In the realm of digital photography, noise means "inappropriate pixels that appear all over your image." Noisy images are often described as "grainy" images. Noise also occurs if you use highly sensitive film in traditional photography. The filters described in this section can greatly reduce problems with noise.

Dust and scratches are another problem that you will encounter if you scan old photographs with the intent to restore them. Old photos are not the only images that can have dust problems, however. If you have ever made photographic prints in a traditional darkroom, you know it can be difficult to keep dust from getting on your negatives and appearing on your prints.

As a general rule, if your image has only a few dust marks or scratches here and there, you should not correct the problem with filters—use Photoshop's blemish-removing tools (discussed later in this chapter) instead. But if your image is speckled all over with problems, it can be improved with the filters explained in the following sections.

The image in **Figure 8-5** has both dust and noise problems—dust on the negative caused the larger white specks to appear, and the tiny gray specks that cover the entire image are noise.

When you choose **Filter > Noise**, you will see several filters listed. The first filter, **Add Noise**, *adds* noise to an image as a special effect. The other filters in the **Noise** category *remove* unwanted specks and noise by slightly blurring your image in various ways. They are described in the following sections.

Figure 8-5. _____
When this image was developed, there was dust on the negative, which caused the white specks to appear. The tiny gray specks over the entire image are called noise, and were caused because the photographer used film with a high speed rating.

The Despeckle Filter

The **Despeckle** filter removes noise by blurring an image slightly. This filter finds edges of objects in the image and avoids blurring those areas so that edges remain sharp. The **Despeckle** filter was applied to the image in Figure 8-6.

The **Despeckle** filter has no settings to adjust. Other noise-removing filters have sliders that control both the blurring and sharpening effects. So, in cases where you need more precise control, use those instead of the **Despeckle** filter.

The Dust & Scratches and Median Filters

The **Dust & Scratches** and **Median** filters are very similar. Selecting **Filter > Noise > Dust & Scratches...** opens the **Dust & Scratches** dialog box, and selecting **Filter > Noise > Median...** opens the **Median** dialog box, Figure 8-7. Both dialog boxes have a preview

Figure 8-6. _____
The **Despeckle** filter removed much of the noise from this image, but the large white dust specks are too large to be removed by the filter.

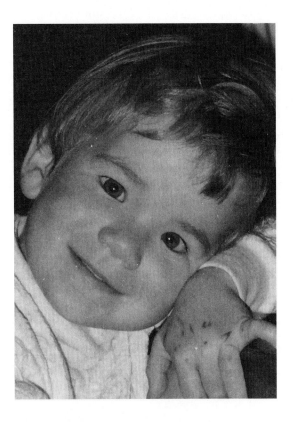

Figure 8-7. _____
Both the **Dust & Scratches** and **Median** filters let you control the blurring effect with the **Radius** slider.
A—The **Dust & Scratches** filter adds a **Threshold** setting, which controls how much noise is blurred.
B—The **Median** filter does not have the **Threshold** setting. Instead, it automatically blurs all of the pixels in the image.

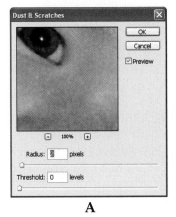

A

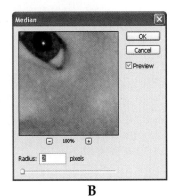

B

window and preview controls, which should be familiar to you from your study of the **Unsharp Mask** filter's dialog box. In addition, both dialog boxes have a **Radius** slider, which controls how intense the blurring effect will be to remove the noise. A **Radius** setting greater than 2 is *not* recommended for most images.

The **Dust & Scratches** filter has a control that the **Median** filter does not have, the **Threshold** slider. If this slider is set to 0, all pixels in the image will be blurred. This is what occurs automatically if you use the **Median** filter. As the **Threshold** setting is increased, only the most obvious specks are eliminated. After setting the **Radius** setting to 1 or 2, use the highest **Threshold** setting that makes your image look good. Usually, **Threshold** values above 128 are not used.

The Reduce Noise Filter

The **Reduce Noise** filter gives you the most precise control when removing noise from an image. When you choose **Filter > Noise > Reduce Noise...**, the **Reduce Noise** dialog box opens, **Figure 8-8**. This dialog box has the familiar preview window, zoom buttons, and **Preview** check box. It also has a number of other controls not found in the other noise filter dialog boxes.

At the top of the dialog box are two radio buttons, **Basic** and **Advanced**. When the **Advanced** radio button is selected, tabs labeled **Overall** and **Per Channel** appear under the **Settings** drop-down list. If you select the **Per Channel** tab, you can adjust the noise-reduction setting on one *channel* at a time. This is helpful because occasionally a particular channel may contain more noise than other channels. Select the appropriate channel from the **Channel** drop-down list, adjust the **Strength** slider to provide the desired level of noise reduction, and adjust the **Preserve Details** slider to retain an acceptable level of edge detail in the image. Channels are discussed further in Chapter 10, *Advanced Color-Correction Techniques*.

Figure 8-8. _____

The **Reduce Noise** filter gives you the most flexibility when attempting to clean up noise in an image.

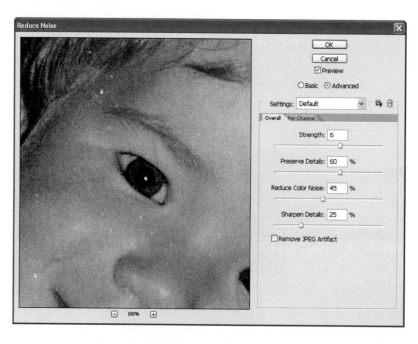

When the **Overall** tab is selected, the dialog box is configured the same way it is when the **Basic** radio button is selected instead of the **Advanced** radio button. All of the basic controls are available, and changes to the settings affect the entire image, not just one channel.

Beneath the **Basic** and **Advanced** radio buttons are the **Settings** drop-down list, the **Save current filter settings** (floppy disk) button, and the **Delete current settings** (trash can) button. If you are working with several images that have the same noise problem, you can use these controls to save filter settings and then easily apply them again to another image.

The **Strength** and **Preserve Details** sliders are the first sliders you should adjust. These controls serve the same functions as their counterparts in the **Per Channel** tab, but apply the filter to the entire image instead of a single channel. You should start adjusting the filter effect by moving both of these sliders until you find a combination that removes the most noise. The higher the **Strength** setting, the more noise is eliminated. The higher the **Preserve Details** setting, the greater the preservation of edges and textured areas in your image. If *color noise* (speckles or blotches of inappropriately colored pixels) is still visible after adjusting the first two sliders, adjust the **Reduce Color Noise** slider.

The **Sharpen Details** slider serves the same function as a sharpening filter. You can use this slider to sharpen the image, or ignore it and use one of the sharpen filters instead.

The **Remove JPEG Artifact** option removes noisy pixels that appear when images are saved as low-resolution JPEG files. These stray pixels, or *artifacts*, can be scattered throughout the image or appear as light-colored halos around edges in an image.

Blemish-Removing Tools

The large white dust specks that are visible in the image of a smiling little girl are too large to be effectively removed by any of the noise filters. The blurring techniques simply do not hide such large specks. However, Photoshop has several tools in the **Tools** panel that will easily remove these large blemishes.

The Spot Healing Brush Tool

The **Spot Healing Brush Tool** is used to fix *blemishes* (small imperfections, such as dust specks) in a photo. It does this by automatically sensing where the blemish is when you click on it. Then, the pixels that surround the blemish are analyzed. The "undamaged" pixels are blended into the problem area, causing the area to "heal."

This tool works best if the area around the blemish is *not* highly detailed. Sometimes, it takes two or three clicks to completely fix a blemish with this tool. There are other situations where this tool will not fix the problem at all. However, because it is such an easy tool to use, it is worth trying first. You can also drag with this tool (over a scratch, for example), but you will get the best results by clicking in a single area at a time. If you make a mistake while using this tool, an easy way to correct it is to use the **History Brush Tool** to paint the area back to its original state. Then, try again.

Like many of Photoshop's tools, the **Spot Healing Brush Tool** has a **Brush Picker** and **Mode** setting in its options bar, **Figure 8-9**. You should choose a brush size that is a bit larger than the area you want to fix.

The two radio buttons in the **Type** area of the options bar determine how the **Spot Healing Brush Tool** fills in the blemish. The **Proximity Match** option tells the tool to fill

Figure 8-9. _____

Most of the white specks on this image can be removed by clicking on each of them with the **Spot Healing Brush Tool**.

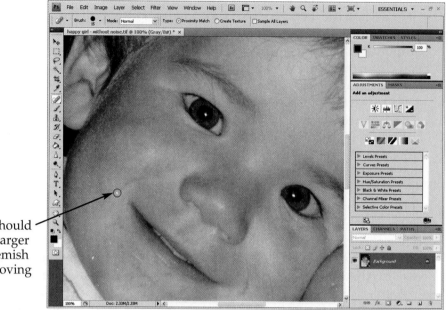

Brush size should be slightly larger than the blemish you are removing

the blemish with a blend of pixels that appear around the blemish, including pixels that extend past the limits of the brush. If you do not get satisfactory results with this option, try the **Create Texture** option, which acts more like a blender. When this option is active and you click on a blemish, everything that is contained within the limits of the brush is mixed together and textured somewhat. When using the **Create Texture** option, try starting with a brush size that is about twice as large as the blemish.

Unless the **Sample All Layers** option is checked, the **Spot Healing Brush** will only sample a source point from a single, active layer.

The Healing Brush Tool

The **Healing Brush Tool** is similar to the **Spot Healing Brush Tool**. The main difference is that instead of clicking on the problem area, you first take a sample by choosing a *source point (or sampling point)*, an area that Photoshop will refer to when fixing the problem.

To use the **Healing Brush Tool**, you set the brush size to be slightly larger than the area you are going to clean up. Then, you press [Alt] (or [Option] for Mac) and click on a source point—an area that the blemished area *should* look like. As you release the [Alt] key and begin dragging the mouse elsewhere, you will see a helpful preview of the source point inside of your brush. When you reach the area you want to "heal," begin painting. Photoshop hides the blemish by creating a blend of the source point area and the blemish area you are healing. The lighting and texture of the area you sample will be recreated over the problem area, so choose your sampling area carefully.

The **Healing Brush Tool**'s behavior depends on the settings in the **Clone Source** panel (explained later in this chapter). For example, if the **Show Overlay** and **Clipped** check boxes are not checked in the **Clone Source** panel, a preview will not appear inside the brush after pressing [Alt] and clicking a source point.

The **Healing Brush Tool**'s options bar offers several different blending modes from the **Mode** drop-down list. One of the modes, **Replace**, causes this tool to act like the **Clone Stamp Tool**. The other modes create lighter, darker, or more colorful blending results.

The **Source** area contains two radio buttons, **Sampled** and **Pattern**. See **Figure 8-10**. So far, you have read how this tool works with the **Sampled** option active. If the **Pattern** option is selected instead, you do *not* choose a source point to begin the process. Instead, you begin by selecting a pattern from the **Pattern Picker**. As you click in the image with the **Healing Brush Tool**, Photoshop blends the selected pattern with the area in the brush radius. This creates a *textured* effect.

When the **Aligned** check box is checked and the **Pattern** option is selected, a *tiled* pattern is created as you use the **Healing Brush Tool**. If the **Aligned** option is turned off, clicking the mouse occasionally as you paint creates a pattern that is *not tiled*. If the **Sampled** option is selected, the **Aligned** check box determines whether the sample area is continuous or resets every time the mouse is clicked.

Next on the options bar is the **Sample** drop-down list. Use it to specify which layers you will sample from when you [Alt]-click to define a source point. Choices include the **Current Layer**, **Current and Below**, or **All Layers**. The **Current and Below** option samples pixels from the active layer and all layers beneath it. The **All Layers** option samples all pixels contained within the brush cursor, regardless of what layer they belong to.

Next to the **Sample** drop-down list is a small, circle-shaped icon called the **Turn on to ignore adjustment layers when healing** toggle. If you have adjustment layers in your image (discussed in a later chapter), turning on this toggle causes the **Healing Brush Tool** to ignore the effects of adjustment layers when the **All Layers** or **Current and Below** option is selected.

The Patch Tool

The **Patch Tool** is similar to the **Healing Brush Tool**. However, the procedures for hiding a blemish are quite different. Instead of using brushes to do repair work, you select an area called a patch and use it to heal a different area. Patches behave differently, depending on the radio button that is selected in the **Patch** area of the options bar. When the **Source** radio button is selected, you begin by drawing a selection around the problem area. Then, you drag the problem area to a good area and release the mouse, **Figure 8-11**. Photoshop analyzes the good area and blends it with the problem area, preserving the shadows and texture of the problem area. Clicking the **Destination** radio button causes the tool to work in the opposite manner. A good area is selected first and dragged on top of the problem area.

The **Patch Tool** creates selections just like the **Lasso Tool**. If necessary, you can use the **Add to selection**, **Subtract from selection**, and **Intersect with selection** buttons on the options bar to fine-tune a selection before dragging it. When you want to add or subtract an area from the **Patch Tool** selection, make sure you start your additional selection outside of the existing selection. Otherwise, you will adjust the contents of the patch rather than alter the shape of the selection.

Figure 8-10. _____

The **Healing Brush Tool**'s options bar is shown here.

Click to access the
Pattern Picker

Figure 8-11. _____

When the **Patch Tool**'s **Source** option is active, a selection is drawn around the blemish and then dragged to a good area of the image. The selected area around the blemish is automatically updated as the selection is moved.

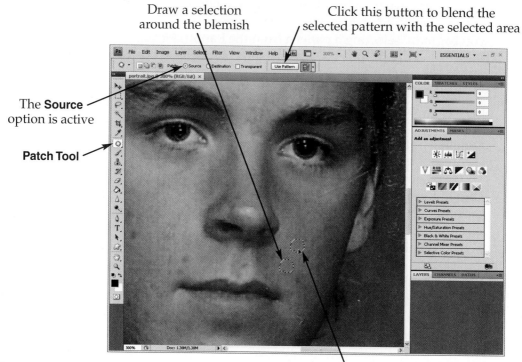

Draw a selection around the blemish

Click this button to blend the selected pattern with the selected area

The **Source** option is active

Patch Tool

Drag the selection to a good area in the image—the blemish area is updated dynamically

The **Transparent** option, when on, causes the finished patch to end up being a bit lighter than it would be if this option were not checked. This option could be useful if you wanted to combine two features. However, you will want to leave this option off in most cases.

If you click the **Use Pattern** button, the pattern selected in the **Pattern Picker** is blended with the selected area, resulting in a *textured* look.

The Red Eye Tool

Red eye is caused when a camera's flash bounces off the inside of the eyeball and reflects back toward the camera. The light reflects off blood vessels in the back of the eye, causing a person's pupils to appear bright red.

The **Red Eye Tool** is one of Photoshop's easiest tools to use. It automatically senses the red area of the eye when you click on it, and changes all the red and pink pixels to black (since most people's pupils are nearly black). Shiny spots (highlights) in the eye are preserved, maintaining a realistic appearance.

The options bar of this tool has only two settings, **Figure 8-12**. There are no brush sizes to set with this tool. The **Pupil Size** setting determines how large of a pupil area Photoshop attempts to create. That area is

Figure 8-12.
To fix red eye, simply click once on the red pupil area with the **Red Eye Tool**. The **Red Eye Tool's** options let you specify how large the pupil should be and how dark the pupil becomes.

Determines how large
the pupil will be

Determines how dark
the pupil will be

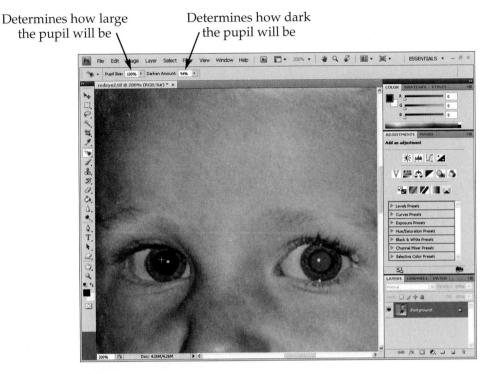

changed to black. The remainder of the red/pink area is changed to a dark gray, which helps blend the pupil area into the rest of the eye. The **Darken Amount** setting controls how dark the grays and blacks appear in the pupil area.

The Clone Stamp Tool

Before discussing the **Clone Stamp Tool**, think of how similar the **Patch Tool**, **Healing Brush Tool**, and **Spot Healing Brush Tool** are. Each of these tools fix a problem by blending or "healing" the problem area.

The **Clone Stamp Tool** works differently. The term *clone* means to create a copy of something. The **Clone Stamp Tool** copies pixels from one area to another in an image, using any brush size and style that you select. This tool can be used to remove unwanted areas from a photo by copying desirable areas on top of the unwanted areas. For example, you could remove an old, junky car from a scenic photo by cloning grass and shrubs found in other areas of the image over the old car until it completely disappears.

Using the Clone Stamp Tool

To use the **Clone Stamp Tool**, you first choose a source point. As with the **Healing Brush Tool**, the source point is selected by pressing [Alt] (or [Option] for Mac) and clicking the crosshairs cursor that appears on the area you want to copy. The **Clone Stamp Tool** and the **Healing Brush Tool** are both controlled by settings in the **Clone Source** panel (explained later in this chapter). If the **Show Overlay** and **Clipped** options are turned on in the **Clone Source** panel, a helpful preview appears inside of your brush as you move the cursor to another area. As you start painting (copying), a small crosshair symbol

also appears on your screen, showing you exactly where you are copying from—it moves along with your brush that is "painting" the copied pixels. For best results, clone a little at a time, release the mouse button, and choose another source point—even if it is near the same spot as the previous source point. When you clone a little at a time, you can easily undo a mistake without losing a lot of your work.

Since the **Clone Stamp Tool** copies pixels, layers that contain vector shapes or text must be rasterized before you can use this tool. With that in mind, you can use the **Clone Stamp Tool** several different ways:

- Select a source point and clone on the same layer.

- Specify a source point on one layer and clone to a different layer. Use the **Layers** panel to make the layer you sample from active first, then make the layer you are cloning to active after choosing a source point.

- Specify a source point on one image and clone to another image.

- Use the **Clone Source** panel (explained later in this chapter) to specify up to five source points on several open images and clone to another image.

The Clone Stamp Tool's Options Bar

The **Clone Stamp Tool**'s options bar contains the same settings as the **Brush Tool**'s options bar, plus the **Aligned** and **Sample** settings, Figure 8-13. When the **Aligned** option is turned off, the **Clone Stamp Tool** starts copying from the same exact source point over and over again, every time the mouse is clicked. This is useful if you want to reproduce the same small area of the source image multiple times in the target image. If the **Aligned** option is active, the source point is always the same distance from the brush, even if you released the mouse button and have jumped to a different location. In essence, the **Clone Stamp Tool** continues painting the same "big picture." This is useful if you want to reproduce different areas of the source image, but you want them to keep their spatial relationship. In most cases, you will need to click on several different source points as you clone, so it does not matter whether this option is off or on.

The **Sample** drop-down list and the **Turn on to ignore adjustment layers when cloning** toggle are used to control which layers the **Clone Stamp Tool** copies from. These settings are also found on the **Healing Brush Tool**'s options bar and were discussed in "The Healing Brush Tool" section of this chapter.

To get realistic results when cloning, you must pay attention to the lighting and shadows that help define an object. A correct and incorrect source point selection are shown in Figure 8-14. The fingers all have similar shadows. The top of each finger is well-lit. The sides of the fingers are somewhat in shadow, and toward the bottom of each finger, the shadows are darker still. To successfully remove the ring from the finger, you must clone the right skin color over the ring.

There are other ways you can adjust the **Clone Stamp Tool** to match the brightness and darkness of the areas you are retouching. You may try lowering the **Opacity** setting in the options bar to help create a blended look. You may also try experimenting with the blending modes available in the **Mode** drop-down list, especially the **Darken** and **Lighten** modes.

Figure 8-13. _____

The **Clone Stamp Tool** has the same options as the **Brush Tool**, plus the **Aligned** check box and **Sample** drop-down list.

Figure 8-14. _____
You must choose your source point carefully when using the **Clone Stamp Tool**. **A**—A light area of the finger is being cloned to an area that should be somewhat shaded. This results in unacceptable mismatch between the original skin tone and the cloned areas. **B**—The ring can be removed successfully by cloning the correct shade of skin over it. Note that the source point and the brush are at the same horizontal level.

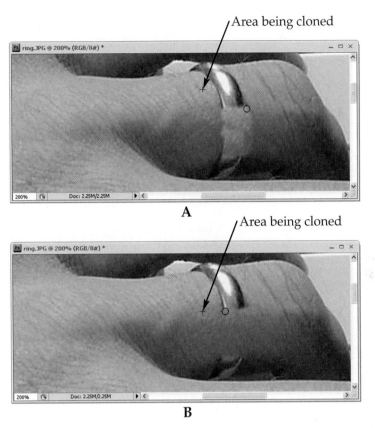

The Clone Source Panel

The **Clone Source** panel can be used to *align* (line up precisely) two similar images, and then clone from one to the other. See **Figure 8-15**. Additionally, the **Clone Source** panel has several settings that control the performance of both of Photoshop's tools that rely on source points: the **Clone Stamp Tool** and the **Healing Brush Tool.** The **Clone Source** panel can be opened by choosing **Window > Clone Source**.

At the top of the panel are five buttons that record and store source points. The source points can all be in the same image or in several different images (as long as all of the images are open). To save a source point, click on one of the five buttons and then [Alt]-click in the desired image to create a source point. As you work, you can switch between the various saved source points by clicking the appropriate buttons.

The **X** and **Y** text boxes found in the **Offset** section of the panel show how far your brush cursor is from a source point that you specify. When cloning from one image to another, the **X** and **Y** values show how much the source image will be moved in order to line up with the target image. In **Figure 8-15**, the source image pixels must be moved up roughly 50 pixels to the right and 275 pixels upward in order to line up with the target image. It is usually easier to align images visually by using an overlay, and this process will be explained later in this section. As an alternative, you can manually enter values

Figure 8-15. _____
The **Clone Source** panel makes it easy to copy features from one image to another.

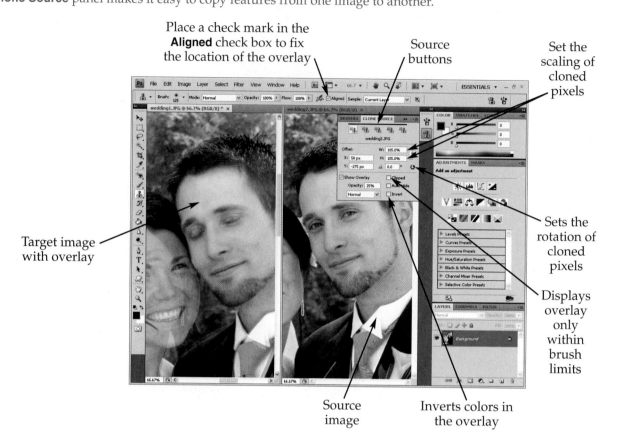

Place a check mark in the **Aligned** check box to fix the location of the overlay

Source buttons

Set the scaling of cloned pixels

Target image with overlay

Sets the rotation of cloned pixels

Displays overlay only within brush limits

Source image

Inverts colors in the overlay

in the **X** and **Y** text boxes to change the position of the source image in relation to the target image. This technique is also useful for making fine adjustments after the overlay position is initially set.

Also found in the **Offset** section of the panel are settings that can scale and/or rotate cloned pixels as you paint them. Use the **W** and **H** text boxes to increase or decrease the size of what you are cloning. This is useful if you are cloning from one image to another and the source image is a different size than the target image. If the **Maintain aspect ratio** toggle is turned on, the two dimensions will be scaled by the same amount. If desired, cloned areas can also be rotated as they are painted from the source area by entering a value in the **Rotate the clone source** text box. The **Reset transform** button to the right of the rotate box, when clicked, resets the scaling and rotation settings to 0. Each of the five **Clone Source** buttons can remember different scaling and rotation values.

Checking the **Show Overlay** check box causes Photoshop to superimpose the source image on the target image, as shown in Figure 8-15. This is very helpful when cloning from one similar image to another. The **Clipped** option causes the overlay to only appear inside of the brush cursor. If this option is disabled, an overlay of the entire image appears as you clone (or use the **Healing Brush Tool**). The setting in the **Opacity** text box determines how visible the overlay is. By default, this is set to 100% opacity, which is useful when the **Clipped** option is on. If you disable the **Clipped** option and see an entire image as an overlay, adjust the **Opacity** setting down to 50% or less so you can see the image you are cloning to beneath the overlay.

You can further control the appearance of the overlay in several ways. A drop-down list at the bottom of the panel lists several blending modes that change the appearance

of the overlay. The **Auto Hide** option hides the remainder of the semitransparent overlaid image as you clone, and the **Invert** option inverts the colors in the overlay, resulting in a negative-like overlay image.

Once you have displayed the overlay, simply move the mouse without clicking to reposition it. You should note that the values in the **X** and **Y** text boxes change as you move the overlay. When you have the overlay where you want it, click once to set the overlay position. After setting the overlay position, use the **Clone Stamp Tool** to clone the desired pixels from the source image to the target image.

> **Note** When using the **Clone Source** panel, you will most likely want to activate the **Aligned** option for the **Clone Stamp Tool**. If the **Aligned** option is not active, the overlay will be repositioned every time you release the mouse button.

The Vanishing Point Filter

The term *vanishing point* refers to the point at which parallel receding lines of a rectangular object, such as a box or a building, converge (or *would* converge if they were extended) in a perspective drawing. A ***perspective drawing*** is a drawing that creates the illusion of depth.

The **Vanishing Point** filter is used to help you retouch images in the proper perspective. For example, long ago, someone started painting the barn shown in **Figure 8-16**, but never finished. Suppose you are working on a project that requires an image of an old red barn, but this is the best image you have been able to come up with. You can use the **Vanishing Point** filter to help you finish painting all of the walls, including the upper wall that is shaded and slants away from the front of the barn. Keep in mind that it is always a good idea to create a duplicate layer, so the original image is not affected by the filter.

> **Note** You can use any method to select an area of your image *before* choosing **Filter > Vanishing Point....** Changes made with the **Vanishing Point** filter will only affect the area that you selected.

Figure 8-16.
The **Vanishing Point Filter** can be used to alter this image so that the barn appears to be completely painted. It could also be used to copy windows to the shaded wall.

Creating and Adjusting Planes

Choosing **Filter > Vanishing Point...** opens the **Vanishing Point** dialog box. Your first task is to help Photoshop recognize the different sides of this barn. This is done by creating planes on your image. The **Create Plane Tool** is the second tool from the top of the dialog box toolbar. It looks like a slanted rectangular grid with a plus sign on it. Use this tool to create a plane by clicking four corners of the most obvious surface of the barn. In this case, the front wall of the barn is the most obvious surface. When you have clicked to establish four corners, a grid-covered plane is created. Click on the corner points of the plane with the **Edit Plane Tool** (the first tool in the dialog box toolbar) to adjust the plane, if necessary. You can also move the plane by clicking and dragging it with the **Edit Plane Tool**. If desired, you can change the **Grid Size** setting to change the number of grid lines. In the **Figure 8-17**, the first corner of the plane was placed at the intersection of the barn's wall and roof. The bottom of the plane was lined up with the barn's foundation and the sides were lined up with the edges of the walls. The final corner was adjusted so that the top line of the plane was parallel to the bottom of the hayloft door and intersected the roof at the same place on both sides.

Correctly-drawn planes are blue. If a plane is red or yellow, Photoshop cannot analyze it. Correct the problem by adjusting the corner points with the **Edit Plane Tool** until the plane turns blue.

The dialog box toolbar includes **Zoom Tool** and **Hand Tool** so you can adjust your view until you can easily see the area you are working on. You can also *temporarily* zoom in by pressing [X].

To help Photoshop recognize a structure, you must create additional planes. To do this, click the **Create Plane Tool** again and grab a side handle (not a corner handle) of the

Figure 8-17. _____

The first step when using the **Vanishing Point** filter is to create a plane on the most obvious surface of the structure. Once the proper place has been established, you can grab the center handles to resize the plane without changing its perspective.

Drag the center handles to resize the plane

Drag the corner handles to change the plane's perspective

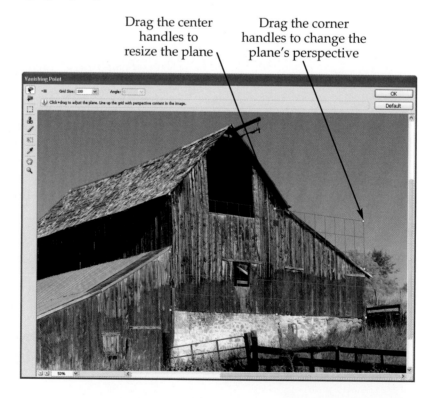

first plane you created. Drag the handle in the desired direction to create an additional plane. This process is called "tearing off" another plane, and by default, *perpendicular* planes (planes that are at a 90° angle to the first plane) are created. To create a plane that is any other angle, enter a value in the **Angle** slider immediately after tearing off the plane. In **Figure 8-18**, a perpendicular plane was dragged along the upper, shadowed wall of the barn. Then, the **Edit Plane Tool** was used to adjust the corners of the plane until it followed the barn's roof line.

At this point, Photoshop can calculate where two different barn walls are located and how they relate to each other. You are now ready to retouch this image, using several familiar-looking tools. However, in the **Vanishing Point** filter, these tools behave differently than what you might expect.

The Vanishing Point Filter's Marquee Tool

The **Vanishing Point** filter's **Marquee Tool** can be used to select an area, which can then be moved, transformed, or copied and pasted. This tool can also function like the **Patch Tool**. Its options include some familiar controls, **Figure 8-19**.

Increasing the **Feather** setting creates a selection with a feathered edge instead of a crisp edge. You can adjust this setting before or after creating a selection. The **Opacity** setting controls the transparency of an area that you copy and paste or drag to a new location.

Using the Marquee Tool to Patch an Area

When using this tool to patch an area, **Luminance** (a lighter blending mode) or **On** (a darker blending mode) must be selected in the **Heal** drop-down list. If you are only copying and pasting content, leave the **Heal** setting to **Off**. The **Move Mode** drop-down list becomes available just after you create a selection. As with the **Patch Tool**, this option can either be set to **Destination** or **Source**.

Figure 8-18.

After creating a plane, you can adjust its size and position by clicking and dragging the handles with the **Edit Plane Tool**.

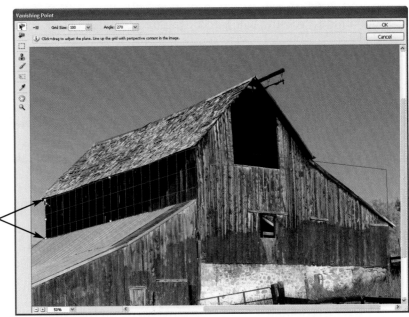

Drag the corner handles to adjust the perspective

Figure 8-19.
The **Vanishing Point** filter's **Marquee Tool** is a combination of a selection tool and a version of the **Patch Tool**.

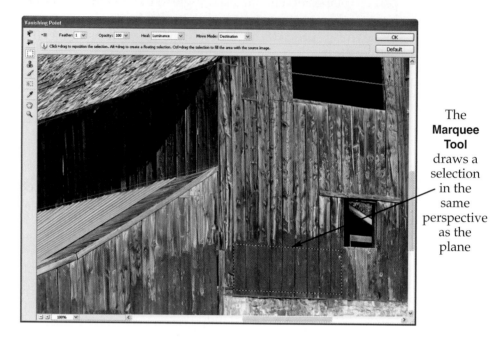

The **Marquee Tool** draws a selection in the same perspective as the plane

The **Destination** mode is straightforward—you press [Alt], click, and drag the selected area to a new destination. If you drag from one plane to another, the selection adjusts to the proper perspective. A blended area will result if the **Heal** option is set to **On** or **Luminance**. Once you have placed the patch, the **Transform Tool** becomes available in the toolbar of the dialog box, **Figure 8-20**. With this tool, you can scale or rotate your selection by dragging handles that appear around it. You can also flip or flop (a vertical version of flip) the selected area.

The **Source** mode is more complicated. When this mode is active, you cannot move the selected area elsewhere. Instead, the selected area is filled with the area under the cursor. The pixels inside the selection are updated as you click and drag the cursor around your image. Again, a blended effect results if the **Heal** option is set to **On** or **Luminance**. Pressing [Ctrl], and dragging is the shortcut to selecting **Source** mode.

Note You only get one chance to select the **Destination** or **Source** mode. If you use one mode and then undo the action, you cannot switch modes. The only way to change modes is to redraw the selection.

The Vanishing Point Filter's Stamp Tool

When the **Heal** option is off, the **Vanishing Point** filter's **Stamp Tool** works just like Photoshop's **Clone Stamp Tool**. When **Heal** is set to **Luminance** or **On**, it works like the **Healing Brush Tool**.

To begin cloning an area, first select the source point by pressing [Alt] (or [Option] for Mac) and clicking the desired area. Next, set the brush controls for the **Stamp Tool** to the desired values. Then, click and drag to reproduce the sampled area with the **Stamp Tool**.

Green crosshairs mimic the movements of the cursor, continually showing you the area being sampled. If the **Aligned** check box is checked, the crosshairs follow the cursor

even when the mouse button is released. This allows you to continue painting the same image with multiple strokes. When this check box is unchecked, the crosshairs remain stationary every time the mouse button is released, essentially resetting the tool.

If you clone in a different plane, the cloning adjusts to the proper perspective. In **Figure 8-21**, a rectangular selection was created on the upper, unpainted barn wall.

Figure 8-20. _____

The **Transform Tool** becomes available when you copy and paste or press [Alt] (or [Option] for Mac) and drag a selected area.

Once the patch is placed, the **Transform Tool** becomes available

The selected area is blended with the existing image

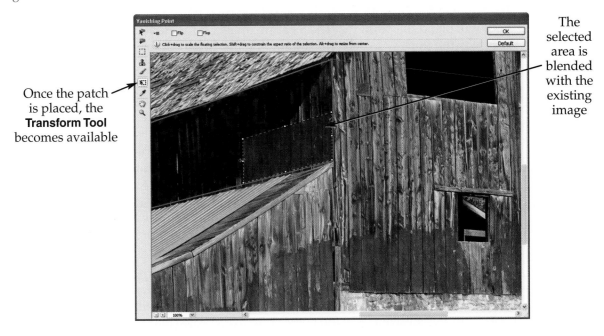

Figure 8-21. _____

The **Vanishing Point** filter's **Stamp Tool** is a combination of the **Clone Stamp Tool** and the **Healing Brush Tool**.

The **Stamp Tool** reproduces the sampled area

Area being sampled

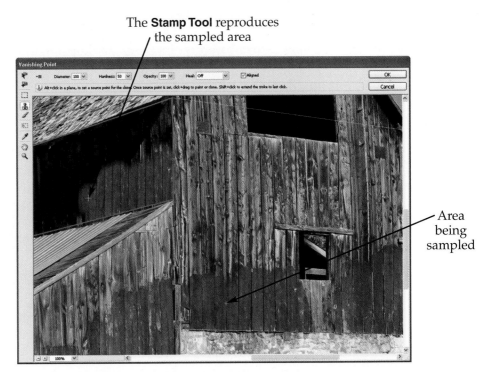

Then, the **Stamp Tool** was used to sample a painted area on the front of the barn. The painted area is being cloned within the selection border, which protects the two roofs from being edited. Because the **Heal** option is set to **On**, the cloned area will blend somewhat with the shadowed unpainted area behind it when the mouse button is released.

The Vanishing Point Filter's Brush Tool

The **Vanishing Point** filter's **Brush Tool** applies color that you select in the options bar of the dialog box. You can specify how transparent the paint appears by adjusting the value in the **Opacity** slider. If you set the **Heal** option to **Luminance** or **On**, the **Brush Tool** will blend the paint into the existing image. If the **Heal** option is set to **Off**, the paint replaces the image. To select a color, click the **Brush Color** box or double-click on the **Brush Tool** itself. Or, you can use the **Vanishing Point** filter's **Eyedropper Tool** to sample a color in the image you are editing.

For the example of the barn, a very effective way to make it appear freshly painted is to draw a selection around the areas you want to paint and then use the **Eyedropper Tool** to select the red paint color. Next, use the **Brush Tool**, with the opacity lowered, to paint the bare wood on the front wall. The opacity should be lowered yet again to paint the shadowed wall. The texture of the wood and the shadows show through the paint that is applied, giving the barn a realistic appearance. The advantage of doing this in the **Vanishing Point** filter is that it allows you to quickly create selections in perspective, protecting the areas that you do not want to paint, **Figure 8-22**.

Figure 8-22. ⎯⎯⎯⎯⎯⎯⎯⎯⎯⎯⎯⎯⎯⎯⎯⎯⎯⎯⎯⎯⎯⎯⎯⎯⎯⎯⎯⎯⎯⎯⎯⎯⎯⎯⎯⎯⎯⎯

The **Brush Tool** is being used to paint one side of the barn. Note that the brush shape is adjusted for the perspective. Also, a selection protects the surrounding areas from accidental painting. In addition to applying color, the **Vanishing Point** filter's **Brush Tool** can blend color if the **Heal** option is set to **Luminance** or **On**.

Click to open the
Vanishing Point filter menu

A selection is drawn around
the wall to be painted

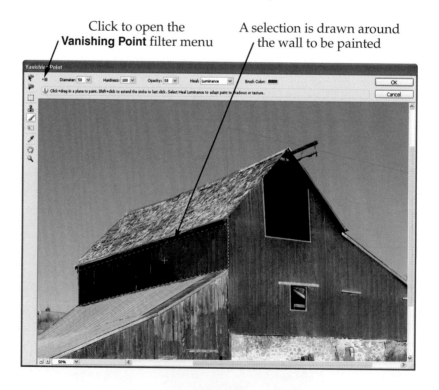

Another benefit of painting in the **Vanishing Point** dialog box, is that the brush shape and size are automatically adjusted for the perspective. As the brush moves over areas of the image that are farther away from the viewer, the brush size automatically shrinks. As the brush moves from one plane to another, its shape changes accordingly.

Other Tips for Working with the Vanishing Point Filter

The following are some other points to consider before you experiment with the **Vanishing Point** filter:

- The **Vanishing Point** dialog box does not have menu commands. If you want to copy something from another image and paste it into the **Vanishing Point** dialog box, copy it to the clipboard (choose **Edit > Copy** or press [Ctrl][C]) before you open the image you want to edit in the **Vanishing Point** filter. When you are ready to paste, press [Ctrl][V].

- Create a new layer before choosing **Filter > Vanishing Point**. All of your work done with the **Vanishing Point** filter will be saved on this new layer, and your original image will be preserved.

- When you close the **Vanishing Point** dialog box by clicking **OK**, the changes are applied to your image. The planes that you defined to establish the perspective of your image are saved to memory. If you select the **Vanishing Point** filter again in the same session, the grids will already be there. If you save the image after modifying it with the **Vanishing Point** filter, the grids you defined are saved with the image. That means that you can use the **Vanishing Point** filter on the image again in a completely different session, and the planes will already be defined.

- To temporarily hide planes while working within the **Vanishing Point** filter, turn off the **Show Edges** option in the **Vanishing Point** filter menu. To open the menu, click the arrow button located near the upper-left corner of the dialog box.

GRAPHIC DESIGN

Using a Grid

Another way to create a sense of balance, especially in multiple-page designs such as magazine articles or brochures, is to use a grid. To use this approach, the design area is divided up horizontally and vertically, forming a grid of rectangular shapes. Then, design elements are shaped and placed according to the grid. When a designer uses the same grid as a guide when designing each page, a consistent look is created throughout the entire document.

Refer to the sample grid shown in **Figure 8-23** as you consider the following guidelines:

- Do not create the grid where page margins should appear.

- Leave channels of white space between each grid area so design elements are not crowded together when placed on the grid.

Figure 8-23.

Grids are extremely useful for designing a document. **A**—A simple grid containing three equally-spaced horizontal and vertical areas has been created on an 8.5″ × 11″ document. **B**—The grid is then used as a guide when placing elements in the design.

A B

- There are many possible grid configurations. The horizontal and vertical areas can be spaced equally as shown in Figure 8-23, but grid styles can vary. Elaborate grid systems can be used, but the design will most likely appear overcrowded if a grid containing more than seven rows and seven columns is used.

- Photoshop's rulers and guides or rectangular shapes can be used to create a grid.

Figure 8-24 shows two slightly different page designs based on the same grid. When placing design elements according to a grid, consider these tips:

- Text areas and photographs can occupy more than one grid area, as long as they do not partially cover any grid area.

- Care should be taken when breaking text up into sections. For maximum readability, text should be placed in columns.

Grids can be created and stored as templates and brought out later to help a designer create a quick design. Using grids is also a good practice when a team of designers is assigned to a project. Consistency is easier to obtain when each team member refers to the same grid.

Figure 8-24.
This two-page article was based on a simple grid pattern of three columns and three rows.

Summary

The restoring and retouching tools discussed in this chapter can help you improve the appearance of almost any photo. However, your best choice may be to obtain another image if your image is extremely blurry, damaged, or has severe lighting problems (large areas of dark shadows or bright highlights that completely drown out the details). Of course, if you are restoring old photographs, you must use the image you have—just do the best you can.

Remember that if you scan an image to restore or retouch it, set the scan resolution to a minimum of 300 spi for best results.

CHAPTER TUTORIALS

These tutorials will provide opportunities for you to practice sharpening images, manipulating photos with the **Clone Stamp Tool**, removing red eye, and retouching portraits and old photos, including one old photograph that is very difficult to restore.

Note	The files needed to complete the tutorials in this book can be downloaded from the *Learning Photoshop CS4 Student Companion Web Site*. Refer to the "Using the Companion Web Site" section of the book's Introduction for more information.

Tutorial 8-1: Sharpening (and Blurring) an Image

In this tutorial, you will use the **Unsharp Mask** filter to bring out detail in the foreground object of an image. You will also apply a **Gaussian Blur** filter to the background of the image, to add emphasis to the object in the foreground. This technique is useful when you want to draw attention to one object in an image.

1. Open the quarter.jpg file.

2. The entire image (canvas), needs to be rotated. Choose **Image > Image Rotation > 90° CCW**.

3. Select the **Elliptical Marquee Tool** in the **Tools** panel.

4. Hold down [Alt] (or [Option] for Mac) and click in the center of the quarter. Drag to create a selection around the quarter.

 As you drag, hold down [Shift] to force a perfect circle. Press [Spacebar] to drag the selection as you are creating it.

5. When you have created a selection around the quarter, choose **Filter > Sharpen > Unsharp Mask…**.

6. In the **Unsharp Mask** dialog box, set the **Amount** slider to 200%, the **Radius** slider to 1.2 pixels, and the **Threshold** slider to 6 levels. When the settings are adjusted, click **OK**.

7. Choose **Select > Deselect**.

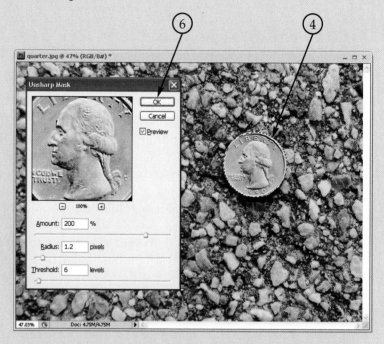

8. Create another circular selection around the quarter with the **Elliptical Marquee Tool**. This time, make it roughly two and a half times the diameter of the quarter.

9. On the options bar, click the **Refine Edge** button. Drag the **Feather** slider until the feather effect almost touches the quarter (somewhere between 90–150 px). Then, click **OK**.

10. Choose **Select > Inverse**.

11. Choose **Filter > Blur > Gaussian Blur**.

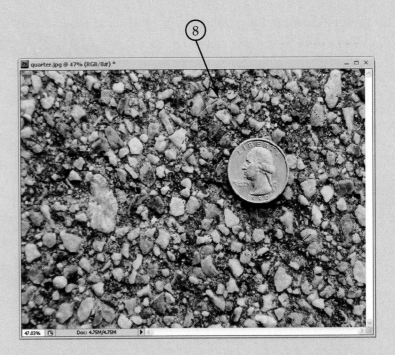

12. In the **Gaussian Blur** dialog box, set the **Radius** slider to 3.5 pixels.

13. Click **OK**.

14. Choose **Select > Deselect**.

 Because of the feather setting you created, the blur effect gradually blends into the area of the image that is in focus.

15. Choose **File > Save As...** and name this file 08quarter.psd.

16. Close the 08quarter.psd file.

Tutorial 8-2: Retouching a Damaged Portrait

In this tutorial, you will use the **Spot Healing Brush Tool**, the **Healing Brush Tool**, and the **Patch Tool** to remove blemishes from a photo.

1. Open the file named portrait.jpg.

2. Zoom in on the image as shown.

3. Click the **Healing Brush Tool**.

4. Set the brush **Diameter** to 15 px and the **Hardness** to 50%. Make sure the **Sampled** radio button is active.

5. Hold down [Alt] (or [Option] for Mac) and click on a clear area of skin that has the same color and lighting as the area surrounding the blemish.

6. Release [Alt].

7. Click on the most prominent pimple in the image.

 The blemish area is blended with the sampled area, hiding the pimple.

8. Click the **Spot Healing Brush Tool** in the **Tools** panel.

9. Improve the image by clicking on pimples, dust, and scratch marks with the **Spot Healing Brush Tool**. Continually adjust the brush size as needed.

 If the **Spot Healing Brush Tool** fails to fix an area after clicking on it twice, switch to the **Healing Brush Tool** and follow steps 5–7 to fix the area. Do not worry about fixing the background. You will fix that with a different tool.

10. Zoom into the upper-left corner of the portrait.jpg image.

11. Click the **Patch Tool** in the **Tools** panel.

12. In the options bar, click the **Destination** radio button. Make sure the **Transparent** check box is *not* checked.

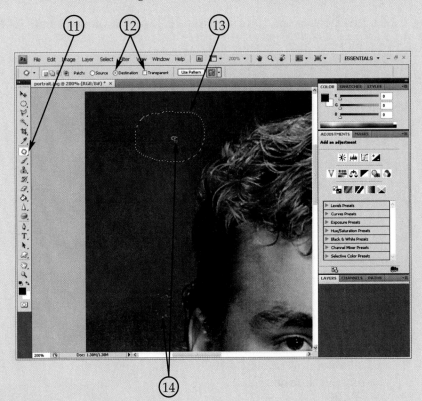

13. Use the **Patch Tool** to draw a small selection border on the background, where there are no dust specks.

14. Move the cursor inside of the selected area and drag the selection border on top of some dust specks. Then, release the mouse button.

15. Drag the selection border over another area with dust specks.

16. Continue using the **Patch Tool**, the **Healing Brush Tool**, and the **Spot Healing Brush Tool** to remove all of the dust specks and scratches from the entire photo.

17. Choose **File > Save As...** and name this file 08portrait.jpg.

18. Close the 08portrait.jpg file.

Tutorial 8-3: Manipulating Photos with the Clone Stamp Tool

In this tutorial, you will use various image-editing tools to remove unwanted objects from the panoramic mountain image. You will also use the tools to add some realistic new features to the image. These techniques are used extensively in the creation of photo simulations.

Part 1: Using the Clone Stamp Tool to Remove Utility Poles

In this part of the tutorial, you will use the **Clone Stamp Tool** to remove unwanted objects in the image.

1. Open the 07hillside.psd file that you edited in the last chapter.

2. Arrange your workspace so the **Navigator** and **Layers** panels are visible, as shown.

3. In the **Layers** panel, make sure the layer containing the background is selected. This layer should be called Background.

4. Zoom in on the utility pole.

5. Click the **Clone Stamp Tool** in the **Tools** panel.

6. In the options bar, set the brush **Master Diameter** to 100 px and the **Hardness** to 0.

7. Hold down [Alt] (or [Option] for Mac) and click a portion of the sky near the pole.

8. Release the [Alt] key.

9. Paint a small area of the utility pole.

 The crosshairs symbol (+) shows where you are cloning (copying) from.

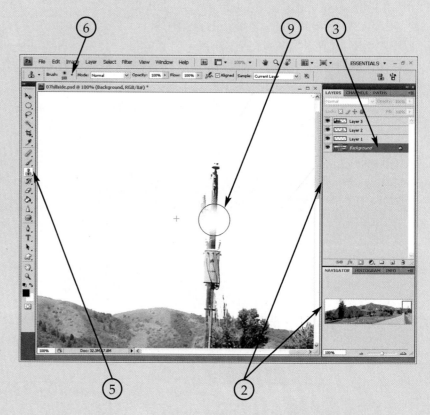

10. Hold down [Alt] and click in a different place in the sky.

11. Release the [Alt] key.

12. Clone (paint) sky over another small area of the pole.

 Whenever you use the **Clone Stamp Tool**, you should only do a little bit at a time. That way, you will not lose too much work if you need to undo any of it. You should also be aware of the crosshairs. They show you exactly where you are copying from.

13. Continue cloning sky over the pole until you get to the horizon (where the mountains meet the sky).

 You may need to reduce the size of the brush as you begin to work closer to the horizon. Also, make sure you clone out the wires.

14. In the options bar, change the brush **Hardness** to 50%.

15. Hold down [Alt] and click an area of the tree to the right of the pole.

 Begin by selecting a source point in the treetop. As you create the new tree, you will select source points farther down in the existing tree.

16. Paint tree leaves over a small area of the utility pole.

 You may need to adjust your brush size to create the desired effect.

17. Hold down [Alt] and click in a different place on the existing tree.

18. Release the [Alt] key.

19. Clone (paint) trees over another small area.

 When you clone from different areas, you avoid creating tree branches that look exactly the same, something you would never see in nature.

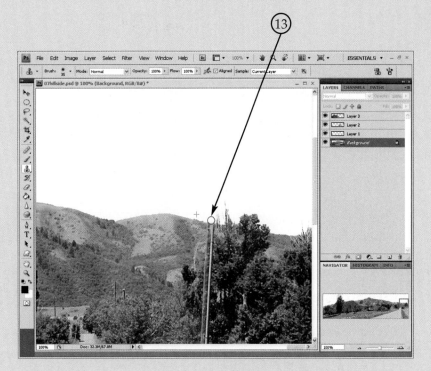

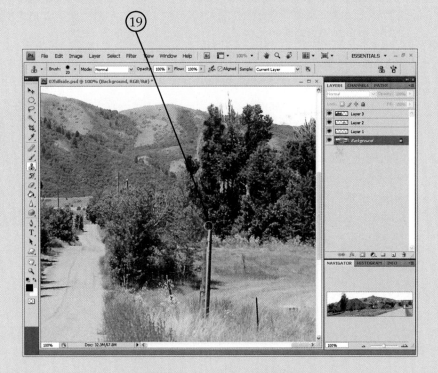

20. In the options bar, set the brush size to 3 pixels and the **Hardness** to 100%.

21. Clone the sky over the fuzzy edges of the tree.

22. Change the brush size to 50 pixels.

23. Continue to remove the utility pole with the **Clone Stamp Tool**. Use the images at the right as a guide.

24. Use the **Clone Stamp Tool** to remove three other utility poles that are farther up the road (zoom in to find them).

25. Save the file as 08hillside.psd. If you are not going to continue on to the next part of the tutorial right away, close the image window.

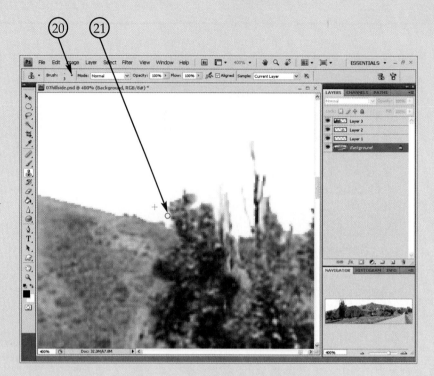

Before

After

Part 2: Using the Clone Stamp Tool and Clone Source Panel to Add Objects to the Image

In this part of the tutorial, you will carefully draw selections and use the **Clone Stamp Tool** to create new features in the image based on existing features. You will use the **Clone Source** panel to add additional features.

1. If necessary, open the 08hillside.psd image.

2. Click the **Arrange Documents** button and choose **Float All in Windows** from the menu.

3. Choose **View > Fit on Screen**.

4. Zoom in on the front lawn of the middle house.

5. Use the **Polygonal Lasso Tool** to create a selection border like the one shown.

6. In the **Layers** panel, make sure the layer containing the background is selected. This layer should be named Background.

7. Click the **Clone Stamp Tool**.

8. Press [Alt] (or [Option] for Mac) and click on the road. Then, clone the road inside the selection border until the selection is completely filled.

9. Choose **Select > Deselect**.

10. The concrete curb needs to be longer. Use the **Polygonal Lasso Tool** to select the good portion of the curb in front of the middle house.

11. Make sure the layer containing the middle house is selected and then choose **Edit > Copy**.

12. Select the top layer in the **Layers** panel, and then choose **Edit > Paste**.

 The curb section has been pasted into the image on a new layer.

13. Choose **Edit > Paste** four more times.

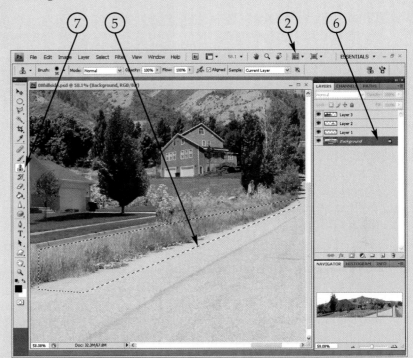

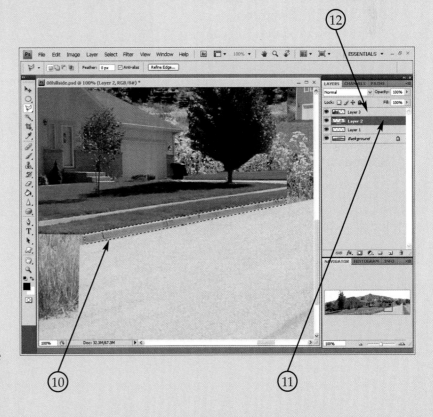

14. Select the **Move Tool**. In the options bar, make sure the **Auto-Select** option is on and set to **Layer**. Also, make sure there is a check in the **Show Transform Controls** check box.

15. Use the **Move Tool** to spread out the curb sections. Then, resize them as necessary using the bounding box until they form a continuous curb.

 When you resize the bounding boxes, press [Shift] to keep the proportions the same.

16. When the curb looks good to you, choose **Layer > Flatten Image**.

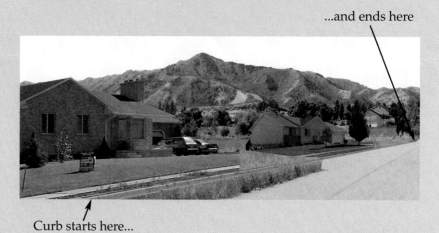

...and ends here

Curb starts here...

17. Continue using the **Clone Stamp Tool** and careful selections to create natural-looking curbs, driveways, and sidewalks.

18. Check for bits of blue sky around the tree in front of the middle house. Use the **Clone Stamp Tool** to cover any blue spots with leaves.

19. Zoom in close and check around each house for other bits of color that do not belong. Use the **Clone Stamp Tool** to eliminate these spots. You can also use the **Clone Stamp Tool** to clean up and add foliage to the large tree in the front yard of the third house.

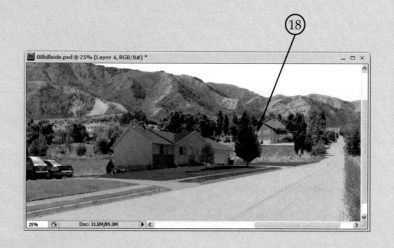

18

20. Next, choose **Window > Clone Source** to display the **Clone Source** panel.

21. Open the vegetation.jpg file.

22. Tile the image windows horizontally.

23. Make sure the first **Clone Source** button is active in the **Clone Source** panel.

24. With the **Clone Stamp Tool** selected in the **Tools** panel, [Alt] click on the shrubs in the vegetation.jpg image and enter 75% in the **W** and **H** text boxes.

25. Click the second **Clone Source** button in the **Clone Source** panel.

26. [Alt] click on the flowers in the vegetation.jpg image and enter 30% in the **W** and **H** text boxes.

27. Click the title bar of the 08hillside.psd file to make it active.

28. Choose **Layer > New Layer**. Accept the default name for the new layer.

Cloning the shrubs and flowers to this new layer allows you to easily erase any mistakes.

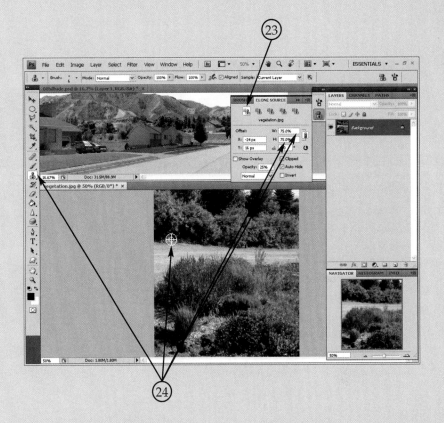

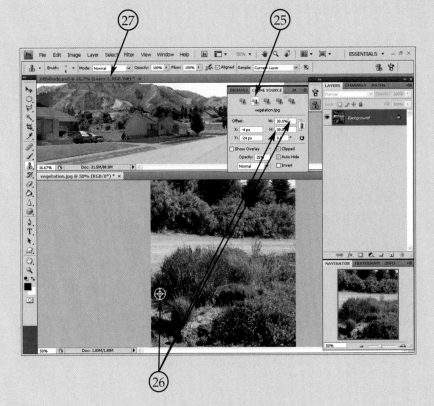

29. Select the **Clone Stamp Tool** and make sure the **Aligned** option is turned off.

 Normally, you would want the **Aligned** option turned on when using the **Clone Source** panel. However, in this instance, you are using the **Clone Source** panel to add multiple copies of the same objects. By turning off the **Aligned** option, you eliminate the need to resample the source multiple times.

30. Use the **Clone Stamp Tool** and the first **Clone Source** button on the **Clone Source** panel to add shrubs along the driveway between first and second houses.

31. Use the **Clone Stamp Tool** and the second **Clone Source** button to add flowers between the sidewalk and curbs.

 Because you are cloning on a new layer, you can "clean up" your cloning if necessary by zooming in and using the **Eraser Tool**.

32. Make any additional tweaks you want, and then choose **Layer > Flatten Image**.

33. Choose **Window > Workspace > Essentials**.

34. Choose **File > Save**.

35. Close the 08hillside.psd and vegetation.jpg files.

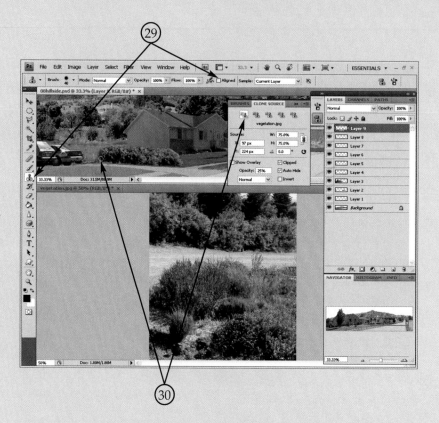

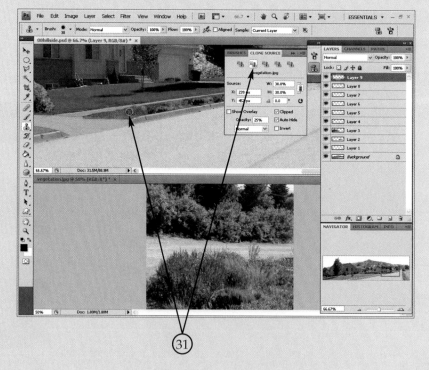

Tutorial 8-4: Using the Clone Stamp Tool to Remove an Object from an Image

In this tutorial, you will use the **Clone Stamp Tool** to remove a person's ring in a photo. The photo illustrates good hand position at a keyboard, and the ring is slightly distracting. By cloning areas with the same lighting conditions, you will ensure that your alterations will blend well with the original image and look completely natural. This is a common photo touch-up technique.

1. Open the file named ring.jpg.

2. Zoom in closer to the ring

3. Click the **Clone Stamp Tool**. In the options bar, select a soft round brush and make it 10 pixels wide.

4. Start by cloning the lightest part of the finger over the upper part of the ring.

5. Clone the darker parts of the finger over the lower part of the ring.

 The finger will look real if you pay attention to the lighting and shadows as you clone.

6. Use the **Clone Stamp Tool** to remove the rest of the ring

 Use the bracket keys ([,]) to change brush sizes as you work.

7. Choose **File > Save As...** and name this file 08ring.jpg.

8. Close the 08ring.jpg file.

Tutorial 8-5: Using the Clone Source Panel to Alter a Photograph

In wedding portrait A, the groom's eyes are shut. This problem can be corrected quickly by cloning the groom's face from portrait B. This tutorial will demonstrate how to swap the groom's face from one image to another.

1. Open the wedding1.jpg and wedding2.jpg images.

2. In the Application bar, click the **Arrange Documents** button and choose the **2-Up** vertical option from the menu. Or, choose **Window > Arrange > Tile.**

A B

3. Arrange your images as shown. In each image, zoom in on the groom's face.

4. Click the **Clone Stamp Tool** in the **Tools** panel.

5. In the options bar, make sure that the **Aligned** check box is checked.

6. Choose **Window > Clone Source** to open the **Clone Source** panel.

7. Use the following settings in the **Clone Source** panel:

 • **Show Overlay:** on

 • **Clipped:** off

 • **Opacity:** 25%

8. With the **Clone Source** panel visible and both images open, [Alt]-click to set a source point at the inside corner of the groom's left eye (on the right-hand side of the image).

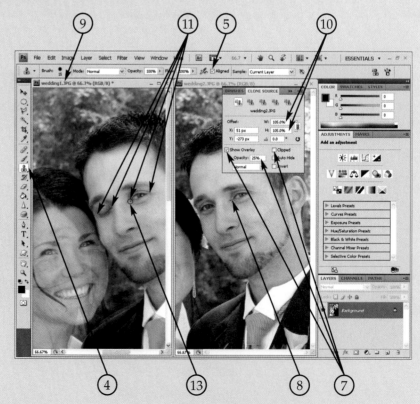

9. Click the title bar of the other image (the one that will be corrected) to make it active.

 The other image appears semitransparently, at the opacity you specified, on top of the image you are about to adjust.

10. Enter 105% in the **Clone Source** panel's **W** (width) and **H** (height) text boxes.

 The groom's face is slightly smaller in the first image because the camera was farther away. Increasing the scaling causes the **Clone Stamp Tool** to increase the size of the cloned material.

11. As you do the next step, watch the corners of the groom's eyes in both the overlay and original image.

12. Move the cursor without clicking until the images match in the location you are watching (see previous step).

13. When you have the images lined up properly, click once to start cloning.

 The overlay image no longer moves. Because there are very slight differences in the way the groom's face angles toward the camera, it is important to clone most of the groom's face. Clone the eyes, nose, mouth, hair, and surrounding areas.

14. When you are happy with the results, choose **File > Save as…**. Name the image 08wedding and save it in JPEG format. Accept the default settings in the **JPEG Options** dialog box.

15. Close both images.

Tutorial 8-6: Fixing Red Eye

In this tutorial, you will use the **Red Eye Tool** to remove red eye from an image taken by flash photography. Red eye is caused when a camera's flash illuminates blood vessels in the back of the eye. The **Red Eye Tool** makes it extremely easy to correct red eye.

1. Open the redeye.jpg file.

2. Zoom in on the child's eyes.

3. Click the **Red Eye Tool**.

4. In the options bar, set the **Pupil Size** slider to 90% and the **Darken Amount** slider to 92%.

5. Click on the red area of each eye once.

6. Choose **File > Save As...** and name this file 08redeye.jpg.

7. Close the 08redeye.jpg file.

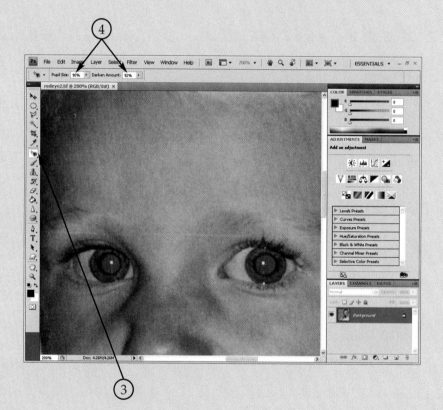

Tutorial 8-7: Restoring a Damaged Photo

In this tutorial, you will restore a photo that had previously been ripped in half. The two pieces were placed on a scanner and scanned at a resolution of 300 dpi. Unfortunately, the two halves were not properly lined up before the image was scanned. You will select one half of the photo and move it into proper alignment. You will then use the **Spot Healing Brush Tool** and the **Clone Stamp Tool** to hide the tear and repair the defects in the photo.

1. Open the buggy.jpg file.

2. Select the **Rectangular Marquee Tool** in the **Tools** panel.

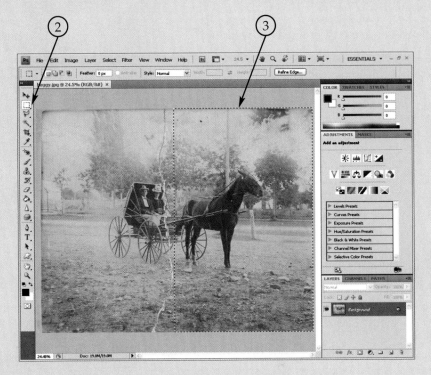

3. Select the right half of the photo, as shown. Get close to the tear, but do not select it yet.

4. Zoom in on the tear.

5. Select the **Magnetic Lasso Tool** in the **Tools** panel.

6. Click the **Add to selection** button in the options bar.

7. In the options bar, set the **Width** to 4 px, the **Edge Contrast** to 20%, and the **Frequency** to 80.

8. Follow these tips as you use the **Magnetic Lasso Tool** to finish selecting the right half of the photo.

 - Carefully follow the tear in the *emulsion* (the top, glossy part that contains the image) of the photo rather than the tear in the paper backing (called the *substrate*).

 - Press the [Spacebar] to temporarily activate the **Hand Tool** and pan the image as you work.

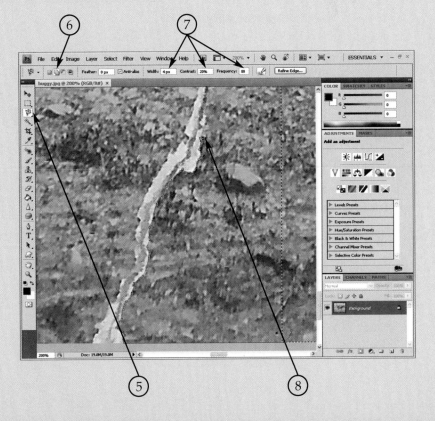

9. Zoom in as needed and carefully check your selection along the edge of the tear. Use the **Lasso Tool** and the **Add to selection** and **Subtract from selection** options to fine tune the selection, if necessary.

10. When you are happy with your selection, choose the **Move Tool** in the **Tools** panel.

11. Use the arrow keys on your keyboard to precisely position the right half of photo.

As you position the photo half, keep your eye on the features of the photo that span across both halves, such as the buggy's rear wheel, leaf springs, and axle, as well as the reins and whip higher in the image. You will need to move the selection approximately 17 pixels to the left, and 2 pixels down.

There will be a few large holes in the image. These are areas where the emulsion flaked away from the substrate. You will use the **Clone Stamp Tool** to correct these areas.

12. When the image is properly positioned, choose **Select > Deselect**.

You will notice that there is still a very thin rift between the two halves of the photo. You will use the **Spot Healing Brush Tool** to fix the areas of the rift that are surrounded by less detail or are very thin, and the **Clone Stamp Tool** to fix the larger problem areas and areas that require a higher degree of detail.

13. Choose **View > Fit on Screen**.

14. Select the **Crop Tool** in the **Tools** panel. Drag a crop box as shown and press [Enter] to crop the image.

15. Select the **Spot Healing Brush Tool** in the **Tools** panel.

16. In the options bar, set the brush size to 10 pixels, and the **Hardness** to 50%.

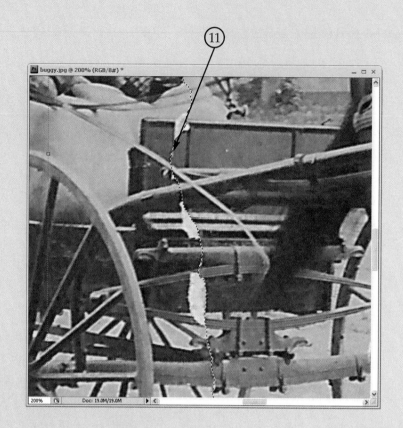

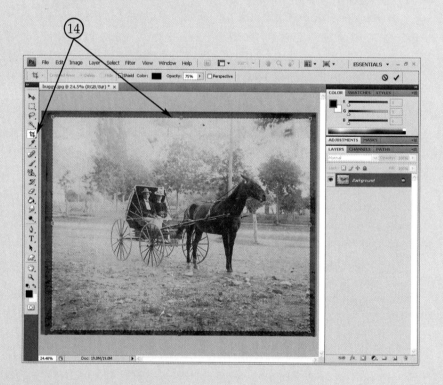

17. Zoom in on the upper third of the image and use the **Spot Healing Brush Tool** to hide the thin line separating the two halves of the image.

 Fix only the top third of the image, from the top of the image to the location shown, with the **Spot Healing Brush Tool**. Skip over any large areas of missing emulsion. Since the remaining areas that need to be fixed contain more detail and harder edges, you will use the **Clone Stamp Tool** to fix them.

18. Select the **Clone Stamp Tool** in the **Tools** panel.

19. Choose **Window > Clone Source**. In the **Clone Source** panel, make sure the **Show Overlay** and **Clipped** check boxes are checked.

 When the **Show Overlay** and **Clipped** options are active in the **Clone Source** panel, the sampled area is previewed within the brush diameter. This feature makes it easy to line up the details and edges in the sampled area with details and edges in the repair area.

20. Using a soft, small brush, fix the rest of the photo with the **Clone Stamp Tool**.

 As you work, remember to change your sampled areas frequently to prevent a noticeable repeating pattern. When you use the **Clone Stamp Tool** to fix the buggy, sample areas that are adjacent to the area being fixed. If you choose your sampled areas carefully, your repairs should be nearly undetectable.

21. Choose **File > Save As...** and name the file 08buggy.psd.

22. Close the 08buggy.psd file.

Tutorial 8-8: Using the Vanishing Point Filter

In this tutorial, you will use the **Vanishing Point** filter to copy a set of speakers from one side of a speaker box to another side. If you make a mistake while working on this tutorial, press [Ctrl][Z].

1. Open the speaker.tif file.

2. Choose **Filter > Vanishing Point...**.

 The **Vanishing Point** dialog box opens, and the **Create Plane Tool** should be automatically selected.

3. Click the four corners of the front of the speaker in clockwise or counterclockwise order to create a plane.

 If necessary, use the **Edit Plane Tool** to adjust the corner handles until the plane fits perfectly over the front of the speaker.

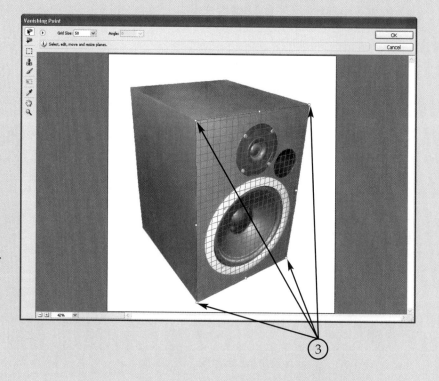

4. Make sure the **Create Plane Tool** is selected in the dialog box toolbar.

5. Click and drag handle A (the middle left handle) to the left and slightly upward to "tear off" a new plane.

6. Press [X] and the [Spacebar].

 Use the **Edit Plane Tool** to adjust the corner handles until the grid fits as closely as possible to the two sides of the speaker. Make sure you switch back to the **Create Plane Tool** when you are finished adjusting the grid.

7. Click the **Vanishing Point** filter's **Marquee Tool**.

8. In the dialog box's options bar, set **Feather** to 3 and **Heal** to **On**.

9. Create a rectangular selection around the speaker components.

10. In the options bar, select **Destination** in the **Move Mode** drop-down list.

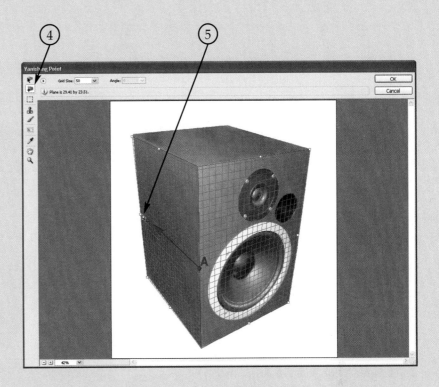

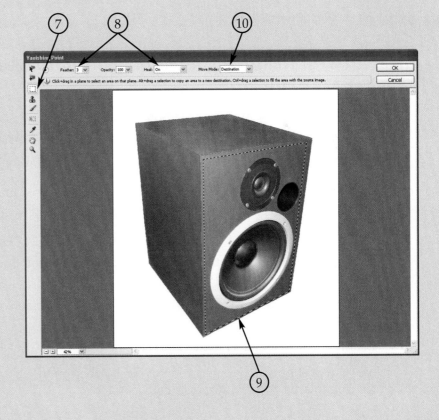

11. Press [Alt] (or [Option] for Mac) and drag the selected area to the side of the speaker.

Pressing [Alt] and dragging creates a selection that is floating, or separate, from the rest of the image.

12. Click the **Transform Tool** in the dialog box toolbar.

13. In the options bar of the dialog box, place a check mark in the **Flip** check box.

14. Click the **OK** button in the top right corner of the **Vanishing Point** dialog box.

15. Choose **File > Save As...** and name this file 08speaker.tif.

16. Close the 08speaker.tif file.

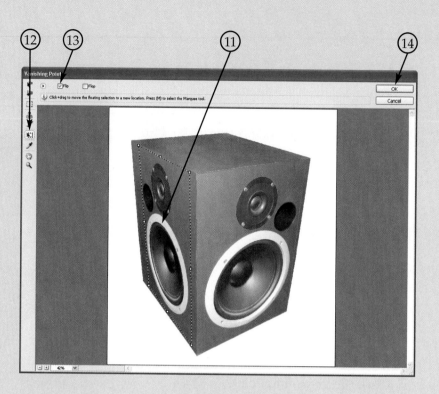

Tutorial 8-9: Restoring a Damaged Photo (Advanced Level of Difficulty)

In this tutorial, you will restore a photo that has been damaged by pencil marks and a rip. The photo is also faded. Parts of the photo are out of focus, making this a difficult restoration project.

1. Open the 02bball.psd file that you cropped in an earlier chapter.

2. Before continuing, read the following tips:

 • When you repair damaged photos, stay zoomed in at least 200% for best results.

 • You will need to use the **Clone Stamp Tool** to make most repairs to this photo.

 • When necessary, change the **Opacity** setting of the **Clone Stamp Tool** to create the most blended look possible.

 • Use the **History Brush Tool**, the **History** panel, or the **Undo** command if you make any mistakes.

 • Be patient, it will take at least an hour to do a high-quality job.

3. Select (with a slight feather) a portion of the bottom-middle boy's jersey and patch it over the top of the ripped area of the bottom-right boy's torso.

4. Use the **Clone Stamp Tool** and the **Spot Healing Brush Tool** to remove the pencil marks and any other blemishes from the entire photo.

 Because sharpening should be the last edit you make before printing, you will sharpen this photo in a later chapter, after you adjust its color and brightness.

5. Choose **File > Save As...** and name this file 08bball.psd.

6. Choose **File > Close**.

Before

After

Key Terms

artifacts
blemishes
clone
color noise
emulsion
Gaussian blur

motion blur
noise
perpendicular
perspective drawing
red eye
restoring

retouching
sharper
source point (or sampling point)
substrate
vanishing point

Review Questions

Answer the following questions on a separate sheet of paper.

1. What is the difference between restoring a photo and retouching a photo?

2. What resolution should a scanned image be if it is going to be restored or retouched?

3. When restoring or retouching an image, you should zoom in at least _____%.

4. Briefly describe what happens when Photoshop sharpens an image.

5. When using the **Unsharp Mask** filter, what does the **Threshold** setting do?

6. Why is it recommended to use the **Unsharp Mask** filter instead of the **Sharpen** or **Sharpen More** filters?

7. When using the **Smart Sharpen** filter, in what situation would you select the **Motion Blur** option?

8. If your image is made of several layers, what must you do to sharpen the entire image at the same time?

9. As a general rule, at what point in the Photoshop session should you sharpen an image?

10. What is image noise, and what causes it?

11. How does the **Despeckle** filter work?

12. What does the **Dust & Scratches** filter's **Threshold** setting do?

13. What filter gives you the most precise control when removing noise from an image?

14. What are JPEG artifacts?

15. How does the **Spot Healing Brush Tool** repair a blemish?

16. What is the difference between the **Spot Healing Brush Tool**'s **Proximity Match** and **Create Texture** options?

17. What is the main difference between the **Spot Healing Brush Tool** and the **Healing Brush Tool**?

18. What is the main difference between the **Patch Tool** and the healing brush tools?

19. Name the two settings available for the **Red Eye Tool** and briefly describe their function.

20. How is the **Clone Stamp Tool** significantly different from the **Patch Tool**, **Healing Brush Tool**, and **Spot Healing Brush Tool**?

21. What is a source point?

22. Why is it a good idea to clone a little at a time, release the mouse button, and then do a little more cloning?

23. How many different source points can be stored in the **Clone Source** panel?

24. When using the **Vanishing Point** filter, what do you need to do before using the filter's retouching tools?

25. How do you copy something from another image and paste it into an image being edited with the **Vanishing Point** filter?

9

Introduction to Color Correction

Learning Objectives

After completing this chapter, you will be able to:

- Explain the advantage of using an adjustment layer to correct color in an image.
- Summarize three different ways you can create an adjustment layer.
- Use the **Adjustments** panel to apply color adjustments to an image.
- Use the **Variations** adjustment to adjust color, contrast, and brightness.
- Explain the difference between shadows, midtones, and highlights.
- Explain how to use an RGB/CMY color wheel to determine how to correct a color cast.
- Differentiate between brightness and contrast.
- Differentiate between hue and saturation.
- Use the following adjustments to adjust the colors in an image:

Color Balance	**Photo Filter**
Brightness/Contrast	**Gradient Map**
Hue/Saturation	**Match Color**
Vibrance	**Posterize**
Replace Color	**Invert**
Shadows/Highlights	**Desaturate**
Black & White	**Selective Color**

- Use the **Color Replacement Tool** to change colors of objects in an image.
- Use the **Sponge Tool** to remove or intensify color.
- Use the **Dodge** and **Burn Tools** to lighten or darken colors in an image.
- Use painting tools and blending modes to adjust the color in an image.

Introduction

You are the judge of how the colors in your image should look. If the sky looks too light in one of your favorite scenery shots, you must decide how blue to make it as you correct the color. See **Figure 9-1**. To make good decisions about color correction, you must have a good sense for color as it appears in the natural world. This awareness will strengthen with careful observation and experience.

Figure 9-1. _____

Which shade of blue best represents the sky? You must make decisions such as this one as you adjust the color of images.

Adjustments: Photoshop's Color-Correction Commands

Photoshop offers 24 color-correction commands, called *adjustments*, along with a few related tools in the **Tools** panel. Some of these adjustments are very simple to use. Others are quite sophisticated and require some background knowledge before they can be used effectively. You will find that there is a lot of overlap—settings associated with some adjustments are also associated with others. There are so many different adjustments to choose from that you will probably never use all of them.

Most of these adjustments and tools will be explained in this chapter. A few of them are more advanced and will be explained in later chapters. The **Levels**, **Curves**, **Channel Mixer**, and **Threshold** commands will be explained in Chapter 10, *Advanced Color-Correction Techniques*. The **Exposure** command will be explained in Chapter 12, *File Management and Automated Tasks*.

The Adjustments Panel and Adjustment Layers

The **Adjustments** panel is designed so that several different color adjustments can be applied to an image quickly and easily. However, only about two-thirds of Photoshop's adjustments are available on this panel. In the **Image** menu, you will find a total of twenty-four color-adjustment commands, **Figure 9-2**, with all but three of those grouped together in the **Adjustments** submenu. Your first guess might be that the **Adjustments** panel contains only the most popular or user-friendly commands. This is not necessarily the case, however. The fifteen adjustments on the **Adjustments** panel were placed there because they can be used as a special kind of layer called an *adjustment layer*.

Figure 9-2.
Color adjustment commands can be found in the **Image** menu and the **Adjustments** panel. The commands highlighted in pink are those commands that will be explained in Chapter 10, *Advanced Color-Correction Techniques*. The command highlighted in yellow will be explained in Chapter 12, *File Management and Automated Tasks*. **A**—The **Image** menu. Note that all but the three "auto" adjustments are found in the **Adjustments** submenu. **B**—The **Adjustments** panel.

 A B

An adjustment layer lets you apply a color adjustment to a layer, but keeps the corrections you make separate from that layer. In other words, the pixels you are correcting *look like* they are changing color, but they are not permanently changed unless you flatten the image or merge the adjustment layer with the layer(s) you corrected. The use of adjustment layers is one type of **non-destructive editing**, a type of editing in which the image's original pixels are protected. Another benefit of adjustment layers is the fact that the settings can be changed at any time by simply double-clicking on the *adjustment layer thumbnail* in the **Layers** panel and entering new values.

When you create an adjustment layer, it appears in the **Layers** panel just above the layer that is active. Adjustment layers can affect either the layer immediately below it or *all* layers that appear beneath it in the **Layers** panel stack.

If you do not use the **Adjustments** panel to make color adjustments, but instead select an adjustment from the **Image > Adjustments** submenu, no adjustment layer is created. Your changes are permanently applied to the layer you are correcting, unless you undo your work. For this reason, you should create a duplicate layer before making an adjustment with the **Image > Adjustments** submenu. Whether or not you use adjustment layers, it is always a good idea to keep an untouched backup copy of your image files.

Although using the **Adjustments** panel is the easiest way to create an adjustment layer, you can also choose **Layer > New Adjustment Layer** and then select the desired color-adjustment command from the submenu. A third way to add an adjustment layer is to click the **Create new fill or adjustment layer** (small black-and-white circle) button at the bottom of the **Layers** panel.

Note If only *part* of the image needs to be adjusted, consider *feather-selecting* the area, so the color correction will blend into the rest of the image. You can control what portion of an image is adjusted by applying a layer mask using soft brushes and the **Masks** panel (discussed in Chapter 11, *Additional Layer Techniques*) to protect the area of the image you do not want to change.

The Adjustments Panel's Settings

Fifteen adjustment buttons appear on the **Adjustments** panel. There is also a list of time-saving presets that can help you see what a particular adjustment is capable of. When you click one of the adjustment buttons, the panel changes appearance so that you can change settings. In **Figure 9-3**, the first adjustment, **Brightness/Contrast**, has been clicked. This caused a new adjustment layer to appear in the **Layers** panel and the **Adjustments** panel changed appearance, displaying the **Brightness/Contrast** settings (described in the next section) and several more buttons that appear at the bottom of the panel.

The **Return** button, an arrow, toggles between the **Adjustments** panel's default appearance and the settings of the individual adjustment you have chosen from the panel. This toggle button makes it simple to quickly apply multiple adjustments to an image. It is much faster than using the menus to apply adjustments one at a time.

The **Switch** button, which looks like a folder, is a toggle that causes the **Adjustments** panel to be displayed at a larger size, if desired. Clicking the button again returns the panel to its default size.

The **Clip** button has an image of overlapping circles on it. This button controls whether the **Adjustment** layer you just created affects *all* layers beneath it (the default setting) or if it only affects the layer *immediately below* it. When you are viewing the **Adjustments** panel in its default appearance, the **Clip** button appears at the far

Figure 9-3. _____

The **Brightness/Contrast** adjustment panel is shown here. The seven buttons at the bottom of the panel are common to all adjustment panels.

bottom right corner of the panel and has an image of three sets of overlapping circles instead of a single set. However, the button functions the same in both versions of the **Adjustments** panel.

The **Layer visibility** button hides or displays the **Adjustment** layer you have just applied. You can get the same results by clicking the **Layer visibility** toggle next to the **Adjustment** layer in the **Layers** panel.

The **Previous State** button is similar to the **Layer visibility** button because it gives you a temporary look at how your image looked just before you started changing settings on an adjustment layer. It is different than the **Layer visibility** button because it is only active as long as the mouse button is held. Releasing the mouse button causes the current adjustment settings to be redisplayed. You may find it helpful to use this button in more complex situations where you are working on projects with multiple layers and more than one adjustment layer.

The **Reset** button is like an **Undo** command. It can be used to set an adjustment layer back to its default settings. However, if you have already changed some of the settings and come back later to edit the adjustment layer, the icon on this button looks slightly different, reminding you that you can now only reset the adjustment layer to the settings that existed when you returned to do some tweaking.

Finally, you can use the **Delete layer** button either on the **Adjustments** panel or the **Layers** panel to delete an adjustment layer.

Learning the Adjustments: Charting a Course

In this textbook, you will *not* be learning about the adjustments in the same order that they appear in the **Image > Adjustments** submenu or on the **Adjustments** panel. Instead, we will start with one of the most user-friendly adjustments, **Variations**, and from there chart a course that gradually builds on what the **Variations** adjustment has to offer. Remember that several of Photoshop's adjustments share similar commands, while others are more unique. After you become acquainted with these adjustments and tools, you will probably find you use only a few of them regularly; there may be a few that you never use at all.

In this chapter and the next, one of the two graphics shown in **Figure 9-4** will appear next to each section title that introduces an adjustment. These graphics indicate whether the adjustment is included in the **Adjustments** panel or is only available through the **Image** menu. If the adjustment is available in the **Adjustments** panel, you should apply it that way rather than using the **Image** menu. Using the **Adjustments** panel allows you to apply the adjustment nondestructively—as an adjustment layer.

Figure 9-4. ⎯⎯⎯⎯⎯⎯⎯⎯⎯⎯⎯⎯⎯⎯⎯⎯⎯⎯⎯⎯⎯⎯⎯⎯⎯⎯⎯
Throughout this chapter and the next, these graphics appear next to the titles of sections that introduce adjustments. The graphics indicate whether the adjustments are available in the **Adjustments** panel or must be applied through the **Image > Adjustments** submenu. A—This graphic indicates the adjustment is available in the **Adjustments** panel. B—This graphic indicates that the adjustment is not available in the **Adjustments** panel. The adjustment must be applied through the **Image > Adjustments** submenu.

A B

The Variations Adjustment

The **Variations** adjustment includes helpful, built-in visual examples that guide you through the color-correcting process. It is not necessarily one of Photoshop's most precise adjustment tools, but it is very effective in certain situations. The **Variations** adjustment is introduced first in this chapter because it gives you a quick, visual explanation of several different ways that Photoshop can adjust color. Read this section carefully. You will see many of these terms again and again when reading about Photoshop's other adjustments and tools.

To use the **Variations** adjustment, open an image and choose **Image > Adjustments > Variations…**. This opens the **Variations** dialog box, Figure 9-5. The **Original** image thumbnail is displayed in the upper-left corner of the dialog box. This thumbnail shows you what your image looked like before you made any modifications, and clicking it returns the image to its original condition. The **Current Pick** thumbnail is displayed to the immediate right of the **Original** thumbnail. It shows you how all of the changes you have made will affect your image. Clicking this thumbnail has no effect.

The **Fine/Coarse** slider controls how powerful each adjustment is. Each time the slider is moved up a notch, the adjustment effect is doubled the next time a thumbnail is clicked. When the **Show Clipping** check box is checked, areas that will be *over-adjusted* (so bright or dark that image detail is being lost), are shown in a solid, contrasting color in the thumbnails. It is important to realize that the colors that indicate clipping in the thumbnails will *not* appear in the actual image when it is adjusted.

Note	Since clipping shows areas that are becoming too light or too dark, it is not displayed when midtones are being adjusted.

Figure 9-5. _____
The **Variations** command provides a user-friendly interface for making color adjustments.

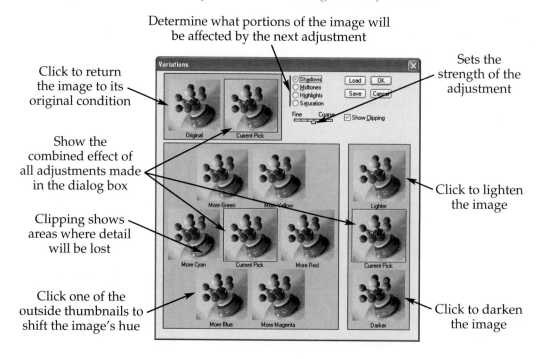

Determine what portions of the image will be affected by the next adjustment

Click to return the image to its original condition

Sets the strength of the adjustment

Show the combined effect of all adjustments made in the dialog box

Clipping shows areas where detail will be lost

Click to lighten the image

Click one of the outside thumbnails to shift the image's hue

Click to darken the image

If you are working with several images that need similar adjustments made to them, you can click the **Save** button to store your modified settings in a file. Then, you can click the **Load** button and reload saved settings at a later time, or even in a different session. This allows you to apply the same variation adjustments to different images.

Adjusting Shadows, Highlights, and Midtones

To begin using the **Variations** adjustment, you must first choose what areas of your image you want to adjust. This is done by selecting one of the radio buttons in the top-right section of the dialog box. If the **Shadows** radio button is selected, only *shadows* (the darkest areas in an image) are adjusted. Selecting the **Highlights** radio button causes only the *highlights* (the brightest areas in an image) to be adjusted. Highlights include places where light is reflecting off a shiny surface, objects that are pure white, and other bright, vivid colors. *Midtones*, areas of an image that are not shadows or highlights, make up the largest percentage of most images. Selecting the **Midtones** radio button causes only these areas to be adjusted.

Adjusting Hue and Fixing a Color Cast

When the **Shadows**, **Midtones**, or **Highlights** radio button is selected, seven thumbnails appear in one section in the lower part of the dialog box. The **Current Pick** (center) thumbnail shows the combined effects of all of the adjustments made in the dialog box. The six thumbnails that form a circle around the **Current Pick** thumbnail offer different options for changing the hue of the image. These thumbnails show you what your image will look like once the adjustment is made. To adjust the color in your image, simply click on one or more of these thumbnails. The same thumbnail can be clicked more than once.

If your image has a *color cast* (an unnatural tint, usually caused by bad lighting when the image was captured), a different color cast can be applied to correct the problem. An RGB/CMY color wheel, **Figure 9-6**, can be used to figure out how to correct a color cast. For example, suppose you have an image with a slight *blue* color cast, such as the color cast caused by fluorescent lighting. Find the color on the RGB/CMY color wheel that is *opposite* of blue. In this case, the color is yellow. Clicking the **More Yellow** thumbnail in the **Variations** dialog box once or twice will help correct a blue color cast. The color-correcting thumbnails in the **Variations** dialog box are arranged in the same order as the colors on a RGB/CMY color wheel.

Lightening and Darkening an Image

At the right edge of the dialog box is another section that contains a column of three thumbnails. These thumbnails can be used to help correct problems caused by the lighting conditions under which the image was captured. In other words, they can be used to make the image lighter or darker. The degree of lightness of an image is referred to as *brightness*, or *luminosity* in other areas of Photoshop. Again, the center thumbnail is the **Current Pick** thumbnail, which shows the combined effects of the adjustments previously made in the dialog box. Clicking the **Lighter** thumbnail lightens the image, and clicking the **Darker** thumbnail will darken it.

Figure 9-6. _____
Cyan is directly opposite red on a RGB/CMY color wheel.

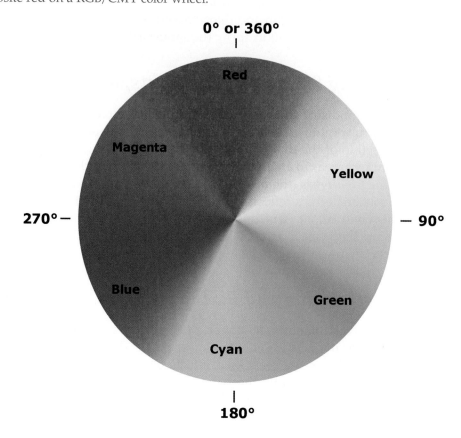

Adjusting Saturation

The term *saturation* refers to how intense colors appear. When the **Saturation** radio button is selected at the top of the **Variations** dialog box, three thumbnails appear in the bottom section of the dialog box, **Figure 9-7**. Again, the **Current Pick** thumbnail appears in the center. If the **Less Saturation** thumbnail is clicked, the intensity of colors in the image is diminished. If it is clicked several times, the image will become desaturated (grayscale). Clicking the **More Saturation** thumbnail increases the intensity of colors in the image. When the **Saturation** radio button is selected, you cannot choose to affect only shadows, highlights, or midtones. Instead, the entire image is adjusted, Figure 9-7.

The Color Balance Adjustment

Using this adjustment is similar to using the **Variations** adjustment to correct color casts. You can choose whether to shift the colors of the shadows, midtones, or highlights. See **Figure 9-8**. However, you drag sliders to adjust color rather than click on thumbnails, as you do when using the **Variations** adjustment. The **Color Balance** adjustment can be applied using the **Adjustments** panel or the **Image > Adjustments** submenu.

There are three radio buttons in the **Tone** section of the panel or dialog box that allow you to specify which tonal areas of your image are affected by the adjustments. When the **Preserve Luminosity** check box is checked, the adjustments made do not affect the original brightness of the image while the colors are being adjusted.

Figure 9-7. _____
The **Variations** command can also be used to adjust saturation in the image.

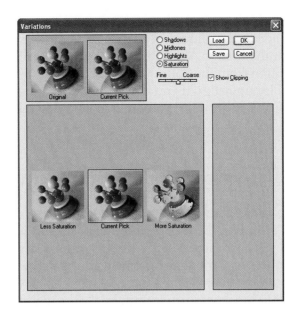

Figure 9-8. _____
The **Color Balance** adjustment has been used to darken the background, causing the bright stop sign to stand out more. Note that the adjustment was applied through the **Adjustments** panel. This adjustment could also be applied through the **Image > Adjustments** submenu, in which case the settings would appear in a floating dialog box and no adjustment layer would be created.

Determine which tonal range is affected

Controls for adjusting color

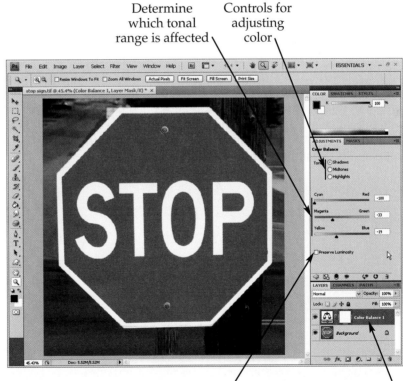

When checked, the brightness levels in the image are unaffected by the adjustments

An adjustment layer is created if the adjustment is applied through the **Adjustments** panel

After selecting which luminosity levels to adjust (shadows, midtones, or highlights), adjust the sliders in the **Color Balance** section of the dialog box to shift the colors in the image. After adjusting one range of luminosities, you can select another radio button from the bottom of the dialog box and repeat the process to adjust another range of luminosities. If you have added the adjustment using the **Image > Adjustments** submenu, click **OK** when you are done making adjustments to apply the changes to the image.

The Brightness/Contrast Adjustment

The **Variations** adjustment you read about earlier can be used to adjust the brightness of an image, but not its contrast. The **Brightness/Contrast** adjustment provides a simple way to adjust both the brightness and contrast of an image, **Figure 9-9**. The **Brightness/Contrast** adjustment can be applied using the **Adjustments** panel or the **Image > Adjustments** submenu.

This adjustment is quite simple; there are only two sliders and one check box. The **Brightness** slider lightens or darkens your image. The degree of lightness of an image is referred to as brightness or *luminosity* in other areas of Photoshop. Without supplemental lighting, many images captured indoors with a digital camera are a bit too dark, so increasing the brightness of images can be a common task. As you adjust the brightness, keep an eye on the fine details in the image, such as the textured wall behind the toy in Figure 9-9. If details start to disappear, or if colors become wildly different, you have adjusted the image too much.

If the colors in an image seem a little dull, a slight boost in *contrast* can help. When the **Contrast** slider is dragged to the right, lighter colors become lighter and/or less

Figure 9-9. _____

As its name suggests, the **Brightness/Contrast** adjustment can be used to adjust both the brightness and the contrast of an image. This adjustment can be applied through the **Adjustments** panel or **Image > Adjustments** submenu. **A**—The original image appears a bit dull and dark. **B**—The colors in the image appear much richer and vivid after adjusting the **Contrast** slider. Because the original image was a bit dark, the **Brightness** slider was also adjusted.

A

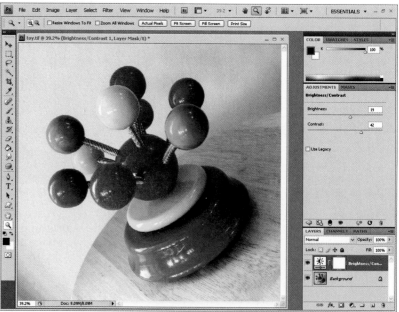

B

intense while darker colors become darker and/or more vivid. This causes colors to stand out more from one another. This is also referred to as increasing the tonal range of an image.

An image with good contrast (a full tonal range) would have a few shadows that are perfectly black, a few highlights that are pure white, and a full range of midtones in between. For example, a black-and-white image that does not have enough contrast will have gray shadows (instead of near-black) and light gray highlights (instead of near-white), causing it to appear murky. Images that have too much contrast have too many white highlights and black shadows, but not enough different midtones in between. This decreases the detail in the image.

The **Use Legacy** check box causes the **Brightness/Contrast** adjustment to work as it did in version CS2 and earlier. In these versions of Photoshop, the **Contrast** slider could be adjusted to the point that image detail was lost. It is recommended that you leave this setting unchecked.

The Hue/Saturation Adjustment

The **Hue/Saturation** adjustment is a more precise color-adjustment tool than the **Variations** adjustment. The term *hue* means "a particular color," such as blue, orange-red, or sea green. And, as you learned earlier, saturation is how intense or vivid a particular hue appears. Using the **Hue/Saturation** controls, you can adjust the hues used in your image, and their level of saturation. You can apply this adjustment using the **Image > Adjustments** submenu or the **Adjustments** panel.

> **Note** You should be aware that "hue" is not the only term people use to describe a particular color. You may hear these closely-related terms used instead: "tone," "shade," and "tint." These terms, when used in technical contexts, usually describe other color qualities. However, they are often used as synonyms for hue in nontechnical situations.

The **Variations** adjustment, discussed earlier in the chapter, requires that you choose to adjust either the shadows, midtones, or highlights in an image. The **Hue/Saturation** adjustment is different—it breaks down your image according to pixel color. For example, if you select **Blues** from the **Edit** drop-down list, any adjustments you make will only affect the blue hues (and nearly-blue hues) in your image. You can adjust one hue by selecting the appropriate color in the **Edit** drop-down list, or all of the hues simultaneously by selecting **Master**. In **Figure 9-10**, the **Hue/Saturation** dialog box has been used to change the parts of the toy that used to be blue to a light green.

The **Hue/Saturation** adjustment's three sliders are used to change the hue, saturation, and lightness of particular colors in an image. Below the sliders are two color bars, which are basically color wheels that have been stretched out into a line. The top color bar represents the original colors in the image. As you drag the sliders, the bottom bar shows how colors are shifting, or changing. You can look at the top bar, identify a color, and then look at the same location on the bottom bar to determine how that color has changed.

In **Figure 9-10**, **Blues** has been selected from the **Edit** drop-down list, causing small triangles and a small, double-ended slider to appear between the color bars. You can adjust how many different hues of blue will be edited by changing the width of the double-ended slider. On each side of the double-ended slider is a small triangle. These two triangles are also adjustable; they show additional hues that will be *slightly* edited.

Figure 9-10.

The **Hue/Saturation** adjustment can shift the hues of all colors in the image, or a particular range of colors. A—Original image. B—Because **Blues** was chosen from the **Edit** drop-down list, all blue colors in the image were changed to a different hue by dragging the **Hue** slider. Two color bars at the bottom of the **Hue/Saturation** dialog box show what colors will be affected.

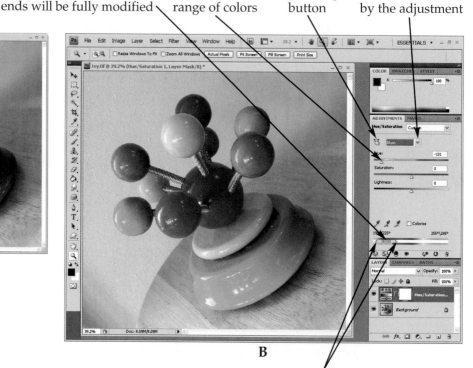

Colors on the top color bar that fall between the slider ends will be fully modified

Shifts the hue of the selected range of colors

Click and drag in image button

Selects the range of colors affected by the adjustment

A

B

Colors on the top color bar that fall between the ends of the slider and the outside triangles will be somewhat modified

The **Click and Drag in image** button, when activated, lets you change saturation by clicking and dragging to the right or left in your image. The color you first click on determines the color range that will be adjusted. After clicking a color, simply drag the mouse to the left to decrease saturation of that color range or right to increase saturation of the color range. You can adjust hue instead of saturation by pressing [Ctrl] and holding it while you sample a color. Then, dragging the mouse to the left will move the **Hue** slider to the left and dragging to the right will move the **Hue** slider to the right. As you make adjustments to either saturation or hue using the click and drag method, holding down [Alt] causes the adjustment to be more gradual; holding down [Shift] does just the opposite.

Using the **Eyedropper Tool**, **Add to Sample**, and **Subtract from Sample** buttons is yet another way to select the colors you want to edit. However, the eyedropper buttons are not available until a specific color range is already selected. If you want to change the range of selected colors, click the **Eyedropper Tool** button, and then click a different hue in the image. Then, use the **Add to Sample** and **Subtract from Sample** buttons to add or remove additional hues from your selection. As you pick hues in the image with these tools, the double-ended slider and small triangles change accordingly.

The **Colorize** check box is used to add a color tint to a grayscale image. It can also be used on a color image, in which case it strips existing color information from the image, turning it into a grayscale image, and then adds an overall tint to the image, based on the

foreground color. However, the **Black & White** adjustment, explained later in this chapter, is a more effective tool to use when converting images to black and white or tinting images.

There are a number of presets that can help you quickly accomplish common adjustments. If you applied the **Hue/Saturation** adjustment using the **Image > Adjustments** submenu, the presets can be found in the **Presets** drop-down list at the top of the **Hue/Saturation** dialog box. If you applied the **Hue/Saturation** adjustment using the **Adjustments** panel, the presets can be found in the **Hue/Saturation** drop-down list at the top of the panel. Selecting one of the presets automatically sets the preset values in the adjustments.

The Vibrance Adjustment

The **Vibrance** adjustment is a simple, yet powerful saturation adjustment with only two sliders. It should be one of the first adjustments you try if the colors in an image are a bit too dull or bright. Using this adjustment is also a recommended method for adjusting skin tones in portrait shots. You can apply the **Vibrance** adjustment using the **Image > Adjustments** submenu or using the **Adjustments** panel.

There is no difference between the **Saturation** slider in the **Vibrance** adjustment and the one found in the **Hue/Saturation** adjustment. Sometimes, the **Saturation** slider causes some colors to become over-saturated (clipped) too quickly, while other colors appear just fine after boosting the slider. The **Vibrance** slider is a more "mellow" way to adjust saturation. Colors that appear weak are adjusted much more than colors that are already vibrant, **Figure 9-11**. Sometimes, you will get great results using only the **Vibrance** slider. On other images, using both sliders will be helpful.

Figure 9-11. _____

The **Vibrance** adjustment allows greater control over saturation than the **Hue/Saturation** adjustment does. **A**—The original image. **B**—Increasing the **Vibrance** setting brings out the color in the leaves, without over-saturating the clover.

Adjusts saturation uniformly

Has more effect on weaker colors and less effect on stronger colors

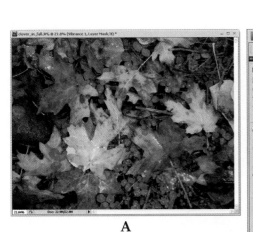

A

B

The Replace Color Adjustment

The **Replace Color** adjustment is similar to the **Hue/Saturation** adjustment, except instead of choosing hues, such as **Reds** or **Blues**, from a drop-down list, you use eyedropper tools to select hues in your image.

To begin, choose **Image > Adjustments > Replace Color....** This opens the **Replace Color** dialog box. See **Figure 9-12.** In the dialog box, click the **Eyedropper Tool** button in the dialog box. Then, *click* on the color you want to change in the image window. You can also select the color in the preview window of the dialog box, but this is not recommended because the preview is in grayscale and is much smaller than the actual image.

Next, drag the **Fuzziness** slider (which is really a *tolerance* setting) to select additional hues that are closely related to the first color you clicked on. The **Preview** window of the dialog box shows, in white, what areas of the image you have selected. You can use the **Add to Sample** and **Remove from Sample** buttons to add hues to or remove hues from your selection. Once you have selected the hues of color you want to adjust, tweak the **Hue**, **Saturation**, and **Lightness** sliders to produce the effect you want.

The Shadows/Highlights Adjustment

The **Shadow/Highlight** adjustment can do a remarkable job correcting shadows that are too dark or highlights that are too light. Choosing **Image > Adjustments > Shadow/**

Figure 9-12.
The **Color Replacement** adjustment allows you to replace colors in an image. **A**—The original image. **B**—The eyedropper tools and the **Fuzziness** slider were used to select the blue shades. Then, the **Hue** and **Saturation** sliders were adjusted. The result was that the blues in the image were changed to purples.

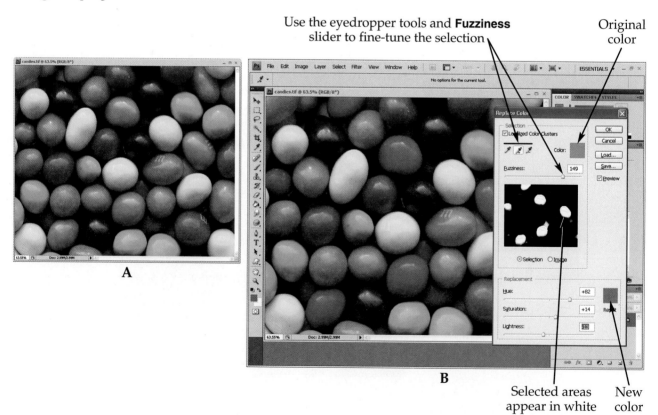

Use the eyedropper tools and **Fuzziness** slider to fine-tune the selection

Original color

A

B

Selected areas appear in white

New color

Highlight... opens the **Shadow/Highlight** dialog box. From this dialog box, you can change the characteristics of shadows and/or highlights in the image. See **Figure 9-13**.

Adjust the appropriate **Amount** slider first as desired. In the **Shadows** section of the dialog box, the **Amount** slider lightens the shadow areas. In the **Highlights** section of the dialog box, the **Amount** slider darkens the highlights. When the **Show More Options** check box is checked, two more options are available in the **Shadows** and **Highlights** sections of the dialog box. The **Tonal Width** slider in each section controls how many different luminosity levels are affected. The **Radius** slider in each section controls how much the changed areas of the image blend with the rest of the image.

At the bottom of the dialog box is the **Show More Options** check box. When this check box is checked, the **Adjustments** section is added to the dialog box. From this section, you can adjust the color of the affected shadow or highlight areas by dragging the **Color Correction** slider. The contrast of the midtones in the image can be tweaked by adjusting the **Midtone Contrast** slider. In effect, this changes the overall contrast in the image.

The **Black Clip** and **White Clip** text boxes control how much of your image turns pure white or pure black. Higher settings in the **White Clip** text box, for example, will result in greater amounts of highlight areas turning pure white.

A button at the bottom of the dialog box allows you to save the current settings as the default settings. The original default settings, shown in Figure 9-13B, were designed for correcting images in which detail is lost in shadow because of excessive backlighting.

The Black & White Adjustment

The **Black & White** adjustment changes a color photo into a grayscale image, and gives you a lot of flexibility while doing so. When you choose this adjustment, your image becomes grayscale and the **Black & White** controls appear. The **Black & White** adjustment has several different sliders that let you control how light or dark gray each

Figure 9-13. _____
The **Shadow/Highlight** command is useful for correcting problems in an image's shadow or highlight areas. **A**—The original image contains dark shadows. **B**—The settings needed to correct the image are made in the **Shadow/Highlight** dialog box. **C**—After adjusting the shadows and adding a little color correction, the image looks better.

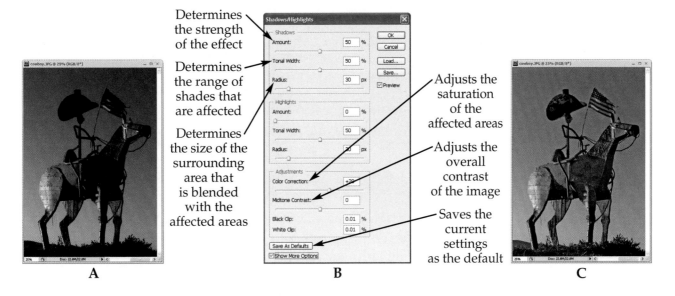

color group becomes. See **Figure 9-14**. For example, you can lighten the portions of the image that *used to be* green and yellow to brighten leaves and foliage, or darken the blues and cyans to create more contrast between the sky and clouds. These sliders give you an incredible amount of control over the final contrast of your new black-and-white image. This adjustment can be applied using the **Adjustments** panel or the **Image > Adjustments** submenu.

The **Click and Drag in Image** button, when activated, lets you click and drag on areas of closely-related colors in your image instead of dragging the sliders. Clicking and dragging to the right or left on an area of blue sky, for example, moves the blue slider to the right or left.

There are several presets available for the **Black & White** adjustment. Some of these settings mimic the effect of certain photographic filters (for more about photo filters, see the section entitled "The Photo Filter Adjustment"). If you applied the adjustment using the **Adjustments** panel, the presets are found in the **Black & White** drop-down list at the top of the **Adjustments** panel. If you applied the adjustment using the **Image > Adjustments** the presets are found in the **Preset** drop-down list at the top of the **Black and White** dialog box. One approach to using the **Black & White** adjustment is to try the presets first. When you discover one that is close to what you would like, you can further adjust the sliders. Another approach is to click the **Auto** button, letting Photoshop adjust the settings for you, and then adjust the sliders to your liking. You can save or load your own custom settings by clicking the **Preset Options** button, located at the right of the **Preset** drop-down list in the **Black and White** dialog box or from the **Adjustments** panel menu.

Figure 9-14. _____

The **Black & White** adjustment has controls that allow you to fine-tune the appearance of an image when converting it to grayscale. There are also controls for adding a tint to the image.

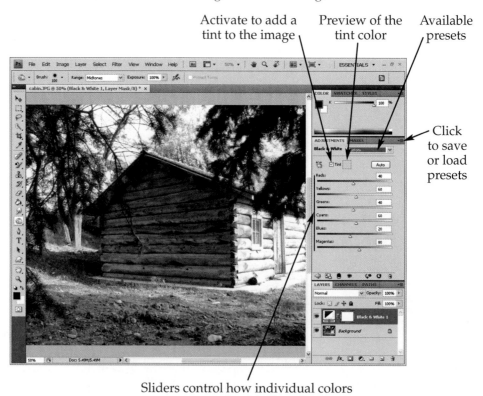

Activate to add a tint to the image

Preview of the tint color

Available presets

Click to save or load presets

Sliders control how individual colors are converted to black and white

Adding a Tint to an Image

The **Tint** check box lets you add a tint to your new black-and-white image. This technique is very useful for replicating the popular tinting effects produced by conventional photographic printing, such as sepia prints, cyanotypes, and Van Dyke Brown prints. After placing a check mark in the check box, simply click on the color box and select a color from the **Color Picker**. If you have applied the adjustment using the **Image > Adjustments** submenu, you can fine tune the color using the **Hue** and **Saturation** sliders at the bottom of the **Black and White** dialog box. If you have applied the adjustment using the **Adjustments** panel, you must click the color box and make adjustments to the tint color in the **Color Picker**.

The Photo Filter Adjustment

If you have ever used lens filters with a camera, you will enjoy this tool. Traditional *photo filters* are translucent colored lenses that are placed at the end of the camera lens. The filter allows light of the same color to pass freely to the image sensor (or film), but absorbs light of different colors. The filters can be used to correct for lighting problems, to increase contrast, or for artistic effect. The **Photo Filter** adjustment in Photoshop emulates the effect of these powerful tools. You can also think of the **Photo Filter** adjustment as a creative way to apply a color adjustment to an image. This adjustment can be applied from either the **Image > Adjustment** submenu or the **Adjustments** panel.

If you activate the **Photo Filter** adjustment's **Filter** radio button, you can choose one of twenty different predefined filters from the drop-down list to the right of the radio button. The predefined filters include warming, cooling, and several other different-colored filters. If you activate the **Color** radio button, you can use any color you desire for the filter. To create your own color filter, simply click the color box next to the **Color** button and choose a color from the **Color Picker**.

The **Density** slider determines how much light the filter blocks. Remember that light that is the same color as the filter passes through it freely, so only dissimilarly colored light is blocked. Therefore, as the filter density increases, more of the image takes on the hue of the filter, and other colors disappear from the image. See **Figure 9-15**.

Since filters block light, increasing the density of a filter darkens the image. You can overcome this by checking the **Preserve Luminosity** check box. When this check box is checked, the luminosity (lightness) of the image remains constant even if the filter density or color changes.

Note When you use a filter in conventional photography, the whites in the image take on some of the filter color. In Photoshop, however, pure white is unaffected by the filter when the **Preserve Luminosity** option is active.

The Gradient Map Adjustment

The **Gradient Map** adjustment provides a quick way to apply a wild color scheme to an image. This adjustment analyzes the image as if it were a grayscale image, and then assigns the colors of a selected gradient to the grayscale image. The shadows (darkest colors) in the image are replaced with the colors at the left end of the gradient while the highlights (lightest colors) in the image are replaced with the colors at the right of

Figure 9-15. _____

The **Photo Filter** adjustment in the **Adjustments** panel was used to apply a cooling filter with a density of 33% to the image in the top image window. When you compare it to the original image in the bottom image window, you can see the colors in the image are shifted to the blue range.

Click to select a filter color from the **Color Picker**

Click to select a predefined filter from the drop-down list

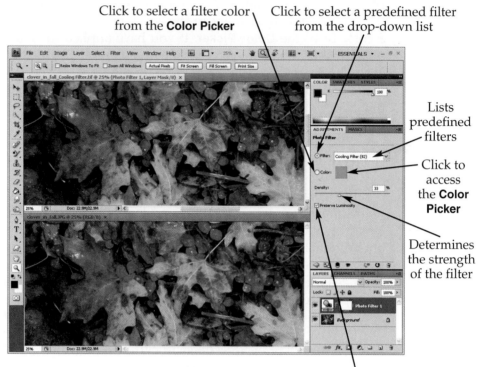

Lists predefined filters

Click to access the **Color Picker**

Determines the strength of the filter

When checked, luminosity levels remain constant regardless of filter density

the gradient. The midtones are replaced with the colors in the middle of the gradient. However, the order in which the colors are assigned can be reversed. This adjustment can be applied using either the **Image > Adjustments** submenu or the **Adjustments** panel.

After choosing the **Gradient Map** adjustment, select a gradient from the drop-down list. See **Figure 9-16.** If you want to use your own gradient, you must create it using the **Gradient Editor** before choosing **Gradient Map**. As you may recall, the **Gradient Editor** is accessed through the options bar of the **Gradient Tool**. If you need to review the **Gradient Tool**, refer to Chapter 6, *Painting Tools and Filters*.

Placing a check mark in the **Dither** check box causes Photoshop to add noise to the image to smooth out the transitions from one color to the next. Placing a check mark in the **Reverse** check box reverses the order in which the gradient colors are assigned to the image.

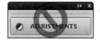

The Match Color Adjustment

This adjustment is fairly versatile. It is used to match colors between a *target image* (the image that will be adjusted) and a *source image* (the image that provides the colors). The **Match Color** adjustment can also be used to adjust color in a single image, match colors between layers of an image, or match colors between selections.

When you use this adjustment to match colors between images, the adjustment copies the colors in one image and applies them to another image, replacing the original colors. This

Figure 9-16. _____
In the top image window, a **Gradient Map** adjustment from the **Adjustments** panel has been applied to the image. Compare the adjusted image to the original image in the bottom image window to see how colors are replaced.

Select a gradient from the drop-down list

Original image

Adds noise to smooth color transitions

This option reverses the order in which colors are assigned to the image

technique is useful when trying to create a consistent look and feel between several images, such as creating the same vivid look between several images of sunsets, for example. It can also be a fun and creative way to adjust the color scheme of an entire image.

To match colors between images, you must have two or more images open in Photoshop. Activate the image in which you want to change the colors; this image will be the target image. Next, choose **Image > Adjustments > Match Color...**. This opens the **Match Color** dialog box, **Figure 9-17.** All of the open images are displayed in the **Source**

Figure 9-17. _____
When matching colors between images, you choose the source of the new colors and fine-tune the command's effect in the **Match Color** dialog box.

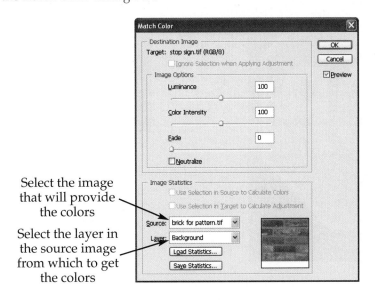

Select the image that will provide the colors

Select the layer in the source image from which to get the colors

drop-down list. From this drop-down list, select an image to use as the source of the new colors. If the source image has several layers and you want to use a specific layer as the color source, select the layer in the **Layer** drop-down list. Then, click **OK**. The colors in the target image are matched to the colors in the source image. See **Figure 9-18**. You can fine-tune the color match by experimenting with the **Luminance**, **Color Intensity**, and **Fade** sliders, found in the **Image Options** section of the dialog box.

If you would like to attempt to match the color between selected areas on both images, make sure both check boxes at the top of the **Image Statistics** section of the **Match Color** dialog box are checked. Also, make sure the **Ignore Selection when Applying Adjustment** check box at the top of the dialog box is *unchecked*. Photoshop will consider only the selected area of the source image and will attempt to match the color in only the selected area of the target image. Matching color between selections can be tricky. You will get different results depending on how many shadows, midtones, and highlights are contained in the selected areas of both images.

You can also use this adjustment to adjust a single image. When **None** is selected in the **Source** drop-down list, the sliders in the **Image Options** section of the dialog box will fine-tune the appearance of a single image. You can remove a color cast from the image by placing a check mark in the **Neutralize** check box.

Figure 9-18. _____

The **Match Color** command has been used to apply the colors from the brick image to the stop sign image. **A**—The original image. **B**—The brick image is the source of new colors. **C**—The stop sign is the target image and takes on the color of the bricks.

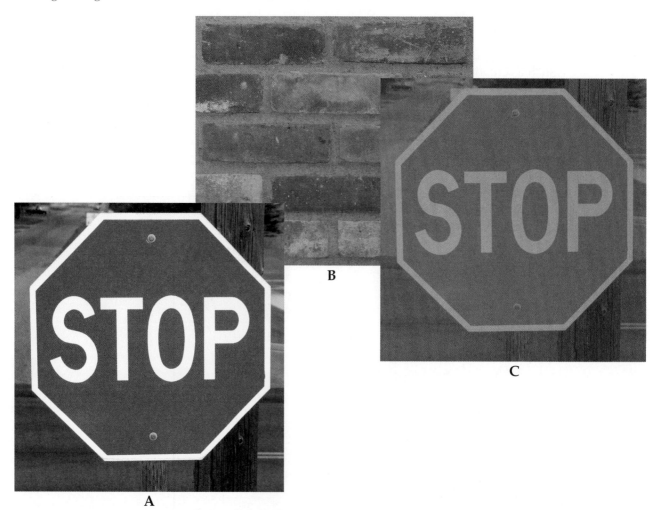

The Posterize Adjustment

The **Posterize** adjustment is used to reduce the number of tonal values (brightness levels) allowed for each color in the image. This results in an image that is simplified and typically has large areas of uniform color. This adjustment is used to create a special effect rather than actually adjust an image's color.

After choosing the **Posterize** adjustment, enter a value in the **Levels** text box. The value entered in the text box determines the maximum number of shades allowed for each color in the image, **Figure 9-19**. For example, if a color image is posterized and 4 is entered in the **Levels** text box, there will be a maximum of four shades of each color in the image. If the image is grayscale, there would simply be four shades of gray in the image.

The Invert Adjustment

The **Invert** adjustment changes each color in the image to the opposite color on the color wheel, called the *complementary color*. The effect that is created resembles a photographic negative, **Figure 9-20**. This adjustment can be applied using either the **Image > Adjustments** submenu or the **Adjustments** panel. It has no adjustable settings.

The Desaturate Adjustment

The **Desaturate** adjustment removes color from an image. The result is a grayscale image. It should be noted that although the image appears in grayscale, the image file is still in a color mode, meaning that color can be added to it later.

To apply this adjustment, choose **Image > Adjustments > Desaturate**. It has no adjustable settings.

Figure 9-19.

The **Posterize** command lessens the variety of colors in your image, depending on the amount set in the **Levels** slider. Compare the adjusted image in the top image window with the original image in the bottom image window.

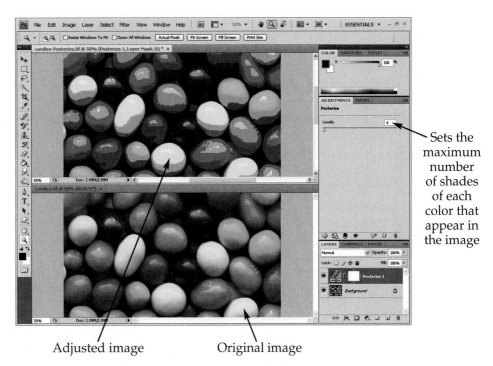

Sets the maximum number of shades of each color that appear in the image

Adjusted image Original image

Figure 9-20.

The **Invert** adjustment is used to swap colors in the image with their complementary colors. The result is an image that resembles a film negative. **A**—The original image. **B**—The inverted image.

A B

The Equalize Adjustment

The **Equalize** adjustment adjusts the brightness of an image—often drastically. The adjustment equally distributes brightness levels throughout the image. If the majority of colors are bright, the adjustment has a darkening effect on the image. If the majority of the colors in the image are dark, the adjustment lightens the image. For this reason, the adjustment does not work well for images with a light background. However, the adjustment can improve the appearance of some images that are too dark. To apply this adjustment, choose **Image > Adjustments > Equalize**. It has no adjustable settings.

The Selective Color Adjustment

The **Selective Color** adjustment allows you to choose and adjust a single color component in an image. This adjustment is especially useful for adjusting images that will be printed on commercial printing presses, because cyan, magenta, yellow, and black inks are used. You will learn more about CMYK color mode in the next chapter. You can apply the adjustment using the **Image > Adjustments** submenu or the **Adjustments** panel.

Begin using this adjustment by choosing the range of colors you want to affect from the **Colors** drop-down list. Your choices are **Reds**, **Yellows**, **Greens**, **Cyans**, **Blues**, **Magentas**, **Whites**, **Neutrals**, or **Blacks**. Drag the **Cyan**, **Magenta**, **Yellow**, and **Black** sliders to adjust the selected colors. See **Figure 9-21**.

If the **Relative** radio button is active, colors are adjusted based on how much of the component color (cyan, yellow, magenta, or black) they already contain. In other words, if you choose to adjust the blues in the image and then increase their yellow levels by dragging the **Yellow** slider to the right, the blues that have more yellow in them to begin with are affected to a greater extent than those that begin with less yellow. Pure whites are not affected at all.

If the **Absolute** radio button is active, the component makeup of the color does *not* affect the extent to which it is adjusted. In the example of the blues in an image being

Figure 9-21.
The **Selective Color** command was used to make the red stop sign a darker, deeper red. **Reds** was chosen in the **Colors** drop-down list and the **Black** slider was dragged to the right until the desired color was achieved. Compare the adjusted image in the top image window to the original image in the bottom image window.

Adjust the sliders to change the component makeup of colors in the selected range

Pick the range of colors to be affected

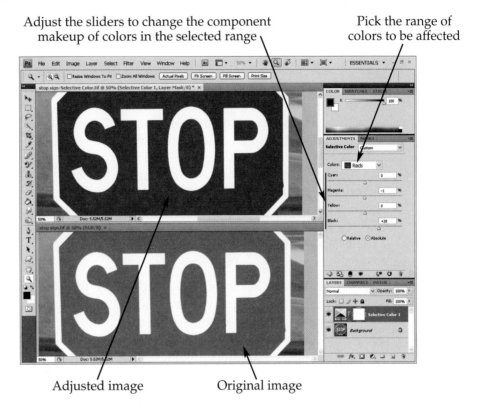

Adjusted image

Original image

adjusted, the same amount of yellow would be added to all colors within the blue range, regardless of how much yellow they had to begin with. Generally speaking, this option provides more dramatic (but less natural) color shifts than the **Relative** option.

After making the adjustments to the selected color range, you can select a new color range in the **Colors** drop-down list and repeat the process to change a different range of colors. If you have applied the adjustment using the **Image > Adjustments** submenu, click **OK** when you are done making adjustments to apply the desired changes to the image.

Color Adjustment Tools

With the adjustments described in this chapter so far, you must adjust settings in a dialog box or panel to change colors in an image. The following sections explain cursor-based tools that can apply similar adjustments to specific areas of your image.

The Color Replacement Tool

The **Color Replacement Tool** lets you *paint* an area to change its color. You do not need to be absolutely accurate with this tool, because only the color under the brush's

crosshairs will be changed within the brush area. This allows you to use a brush that is larger than the area you want to change.

This tool is grouped with the **Brush Tool** and **Pencil Tool** in the **Tools** panel, **Figure 9-22**. The **Color Replacement Tool** is *almost* identical to the **Background Eraser Tool** you learned about in Chapter 7, *Erasing, Deleting, and Undoing*. However, instead of deleting color from an image, this tool replaces colors with the foreground color shown in the **Tools** panel. Most of the settings on the options bar are the same as those for the **Background Eraser Tool**, **Figure 9-23**. The two exceptions are the **Mode** settings and the **Anti-alias** option. The **Anti-alias** option smoothes the edges of the brush stroke and should be left on in most cases.

The **Mode** drop-down list offers four choices:

Figure 9-22. ⸺
The **Color Replacement Tool** is grouped with the **Brush Tool** and **Pencil Tool** in the **Tools** panel.

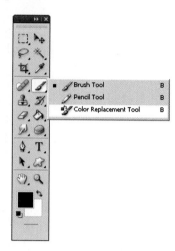

- The **Hue** option is similar to adjusting the **Hue/Saturation** adjustment's **Hue** slider. When you paint over a color with this option active, only the color's hue is changed. The hue is adjusted to match the hue of the foreground color selected in the **Tools** panel, but the luminosity (lightness) and saturation (intensity) of the color remain unchanged.

- The **Saturation** option is similar to adjusting the **Hue/Saturation** adjustment's **Saturation** slider. When you paint over a color with this option active, only the saturation of that color is changed. The hue and luminosity of the color are *not* altered.

- The **Color** option is similar to adjusting *both* the **Hue** and the **Saturation** sliders found in the **Hue/Saturation** adjustment. When you paint over a color with this option active, the color's hue and saturation are adjusted to match those of the foreground color selected in the **Tools** panel. This is the best option in most situations.

- The **Luminosity** option is not often used. This option is similar to adjusting the **Hue/Saturation** adjustment's **Brightness** slider. If the selected foreground color is light, your image will be lightened when you paint over it. The opposite is true if a dark foreground color is selected.

If you need a reminder about how the other options in the **Color Replacement Tool**'s options bar work, review "The Background Eraser Tool" section in Chapter 7. Remember, these tools work the same, except the **Background Eraser Tool** *deletes* color and the **Color Replacement Tool** *replaces* color.

Figure 9-23. ⸺
The **Color Replacement Tool**'s options bar is similar to the options bar of the **Background Eraser Tool**.

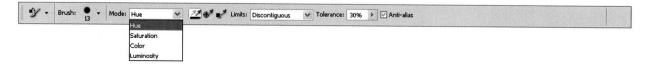

The Sponge Tool

The **Sponge Tool** could also be called "the saturation tool" because it alters the color saturation level within the brush area. See **Figure 9-24**. If the **Mode** setting in the **Sponge Tool**'s options bar is set to **Desaturate,** color is removed from the image as you paint over it. If you paint long enough, you will cause your image to be grayscale. If the **Mode** setting is set to **Saturate,** colors in the image will intensify as you paint over them. The **Flow** slider controls how quickly the image is altered as you paint over it. The **Airbrush** option is available with the **Sponge Tool,** as it is with most tools that use brushes. The **Vibrance** check box, when turned on, causes the **Sponge Tool** to affect weaker-appearing colors more drastically than colors that are already vibrant.

The Dodge Tool and Burn Tool

The **Dodge Tool** and **Burn Tool** are named after traditional darkroom printing techniques used by photographers. In the darkroom, dodging and burning techniques involve changing the *exposure* (amount of light applied to the photosensitive paper) to lighten or darken parts of a photograph so the overall image appears more balanced. In Photoshop, the **Dodge Tool** *lightens* areas of an image by adjusting luminosity. The **Burn Tool** does just the opposite—it *darkens* colors in an image.

The options bar settings for both tools are the same, **Figure 9-25.** The options bars for both tools have the **Brush Picker**, **Range** drop-down list, **Exposure** slider, and the **Airbrush** option. The **Range** drop-down list lets you choose what portions of your image will be affected as you paint with these tools. The available options are **Shadows**, **Midtones**, or **Highlights**. The **Exposure** setting controls how drastically your image is lightened or darkened as you paint over it. High **Exposure** settings can cause an image

Figure 9-24. _____

The **Sponge Tool** can be used to intensify or diminish the color in an image.

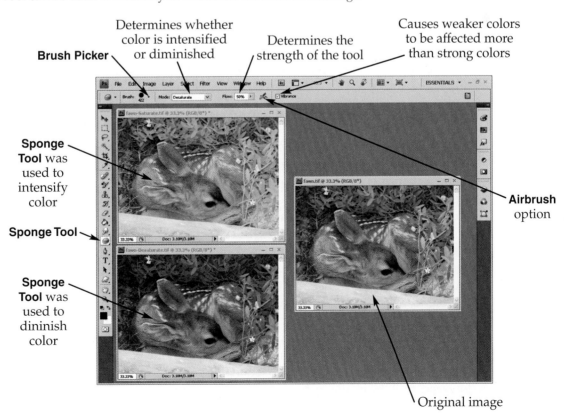

Figure 9-25.
The **Dodge Tool** is used to lighten areas in an image, and the **Burn Tool** is used to darken them. The two tools have identical options bars.

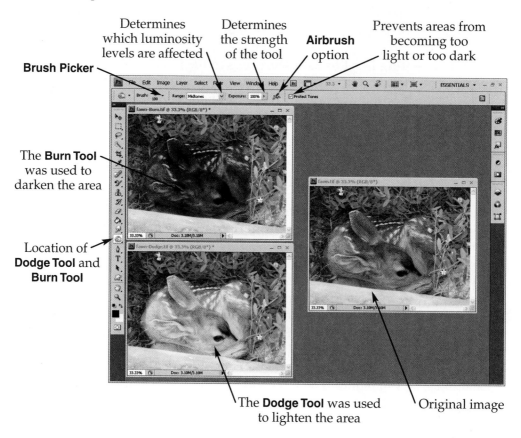

Determines which luminosity levels are affected

Determines the strength of the tool

Airbrush option

Prevents areas from becoming too light or too dark

Brush Picker

The **Burn Tool** was used to darken the area

Location of **Dodge Tool** and **Burn Tool**

The **Dodge Tool** was used to lighten the area

Original image

to change too rapidly; settings between 20–40% are adequate in many cases. You can activate the **Airbrush** button to change the behavior of the brush, if desired. Leave the **Protect Tones** check box turned on. This setting helps protect darker areas from becoming too dark and light areas from becoming too light. It also tries to prevent unwanted colors from appearing when dodging or burning.

Painting Tools with Blending Modes

In Chapter 6, *Painting Tools and Filters*, you learned about using blending modes with the **Brush Tool**. You probably recall that you can adjust the color in an image by using a painting tool and one of the blending modes. Several tools that are not considered painting tools can be used with blending modes, as well. Refer back to Chapter 6 for a visual review of how blending modes interact with an image.

The color of the image in **Figure 9-26** was adjusted using a purple-and-transparent gradient. The **Gradient Tool** was used in this example because only part of the image needed color correction. The purple portion of the gradient blended with and enhanced the image, and the transparent portion had no effect on the image. Most importantly, the blend between the corrected and non-corrected portions of the image is gradual enough to be unnoticeable.

To create the effect in Figure 9-26, the **Eyedropper Tool** was used to select a purple color from one of the flowers. Next, the **Gradient Tool** was selected and the **Color Dodge** blending mode was chosen from the options bar. The **Opacity** setting was lowered to 30% in the options bar so the **Color Dodge** blending effect would not be

Figure 9-26.
The colors of the original image (left) become much more vivid (right) after dragging a purple-and-transparent gradient using the **Color Dodge** blending mode.

The **Color Dodge** blending mode is selected

The **Opacity** setting determines the strength of the effect

Gradient Tool

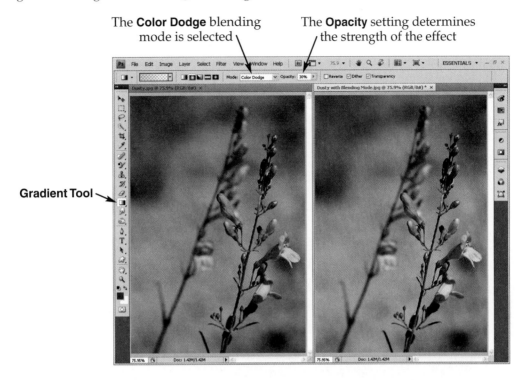

too overpowering. A duplicate layer was created in the **Layers** panel to preserve the original image. Last, a gradient was dragged from the bottom-right corner (because the purple color appears first in the gradient) to the upper-left corner of the image. The **Color Dodge** blending mode caused the purple paint to blend with and enhance the colors in the area of the flowers. The transparent portions of the gradient had no effect on the remainder of the image.

There are endless ways to adjust color with gradients and blending modes. Remember that the longer you drag a line with the **Gradient Tool**, the more gradual the transitions are between colors in the gradient—and gradual gradients tend to give you the smoothest results.

The **Brush Tool**, **Paint Bucket Tool**, and the **Edit > Fill** command can also be used with blending modes to adjust the color in an image.

GRAPHIC DESIGN

Color and Mood

Warm, Cool, and Neutral Colors

Colors can be grouped into three basic categories: warm, cool, and neutral. See **Figure 9-27**. Warm colors are those associated with fire and heat: yellows, oranges, reds, and pinks. Other colors are perceived as cooler by the viewer. These cool colors are shades of blue, green, and purple. Shades of brown and gray are considered neutral—they seem neither warm nor cool.

Advancing and Retreating Colors

Warm colors in a design seem to jump out toward the viewer, creating an energetic mood. Cool colors do just the opposite—they retreat from the viewer, creating a more placid feeling. See **Figure 9-28**.

Figure 9-27.
Colors can be divided into three categories: warm colors (top), cool colors (middle), and neutral colors (bottom).

Warm Colors

Cool Colors

Neutral Colors

Figure 9-28.
The types of colors (warm, cool, or neutral) influence the way the viewer perceives a design.
A—Warm colors, such as the yellow sun shape in this design, appear to advance toward the viewer.
B—Cool colors, like the blue sun shape in this design, seem to move away from the viewer.

A B

Impressions Inspired by Colors

Graphic designers should be aware that there are certain moods and qualities associated with each individual color. The following is a list of moods and qualities associated with common colors. As you read through the list, think of brightly colored new cars and the impression or mood you feel when you see one drive by. Then, see if you agree with the impressions listed. Perhaps you can add to the list.

- **Blue:** strong, peaceful, stable, loyal, determined.
- **Green:** refreshing, invigorating, calm, natural.
- **Purple:** imaginative, noble, unpredictable.
- **Red:** powerful, attention-getting, angry, aggressive.
- **Yellow:** happy, vigorous, vibrant, comfortable.
- **Orange:** creative, spunky, warm, energetic.
- **Gray and Brown:** neutral, drab.

Brightness and Saturation

When any of these colors are at full saturation and brightness, they appear more energetic. Lower brightness and saturation settings appear less energetic and more subdued, traditional, dignified, or even neutral. See **Figure 9-29.**

Figure 9-29. _____

Compare the shades of yellow in these two designs. **A**—The brighter shade of yellow causes the entire design to appear more energetic and dynamic. **B**—The less intense shade of yellow makes the design appear dull and unenergetic.

A B

You can tell if a color is at full saturation and brightness as you select a color with the **Color Picker**. The saturation and brightness settings are at full strength when 100% appears in the text boxes next to the **S** and **B** radio buttons, **Figure 9-30**.

Figure 9-30. _____

Check the **S** and **B** settings in the **Color Picker** to determine if a particular shade has full-strength saturation and brightness.

Hue
Saturation
Brightness

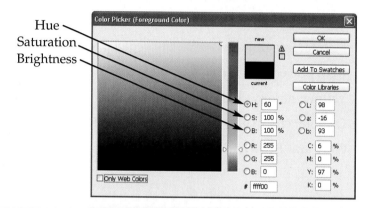

Summary

Using the tools and commands discussed in this chapter, you can improve the appearance of most images. However, more powerful color-correction commands are discussed in the next chapter.

CHAPTER TUTORIALS

> **Note** The files needed to complete the tutorials in this book can be downloaded from the *Learning Photoshop CS4 Student Companion Web Site*. Refer to the "Using the Companion Web Site" section of the book's Introduction for more information.

In the tutorials that follow, you will adjust the color of a few images. During the process, you will get a chance to try out several of the tools and adjustments discussed in this chapter.

Tutorial 9-1: Exploring Photoshop's Adjustments

In this tutorial, you will use four different adjustments to change the color of objects in an image.

1. Open the 06peppers.psd file.

 You used the **Brush Tool** with the **Hue** blending mode to paint one of the peppers in an earlier chapter.

2. Zoom in and use the **Magnetic Lasso Tool** and **Lasso Tool** to select the pepper directly above the one that is already painted. Do *not* include the stem.

3. Click the **Refine Edge** button on the options bar. Adjust the settings to expand and slightly feather the edge of the selection.

 Watch the image window as you make the adjustments to get an idea of how the settings will affect the selection. The feathered edge of the selection will soften the **Hue/Saturation** adjustment at the edges of the pepper, making it look more natural.

4. If the **Adjustments** panel is not visible in your workspace, choose **Window > Adjustments.**

5. In the **Adjustments** panel, click the **Hue/Saturation** adjustment.

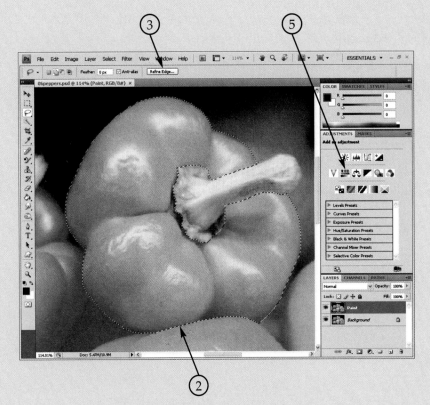

6. In the **Adjustments** panel, drag the **Hue** slider so –114 appears in the **Hue** text box.

 The color adjustment you just created is separate from the other layers. It can be readjusted at any time by double-clicking the white and black circle icon to the right of the adjustment layer's **Layer visibility** (eye) toggle in the **Layers** panel.

7. Click the **Return** button at the bottom left of the **Adjustments** panel to return to the panel to its default appearance.

8. Select the upper-left pepper and use the **Adjustments** panel to add an **Invert** adjustment.

 Remember to use the **Refine Edge** command to feather the selection before applying the adjustment.

9. Click the **Return** button on the **Adjustments** panel to return to the panel to its default appearance.

10. Select the pepper at the right and use the **Adjustments** panel to add a **Gradient Map** adjustment. Choose any gradient you like.

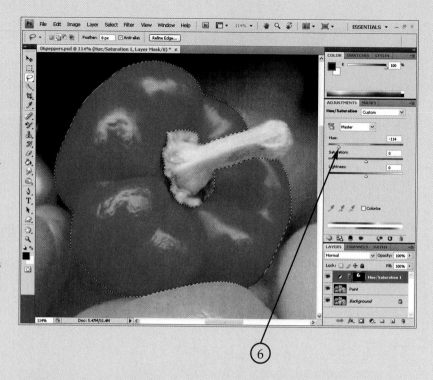

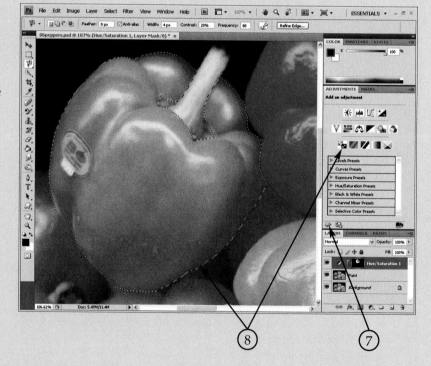

11. Click the **Return** button on the **Adjustments** panel to return to the panel to its default appearance.

12. Select the pepper near the bottom-left corner and use the **Adjustments** panel to add a **Black & White** adjustment. Use the sliders to try making the pepper look dark black without losing the highlights.

13. Choose **File > Save As...** and name this file 09peppers.psd.

14. Close the 09peppers.psd file.

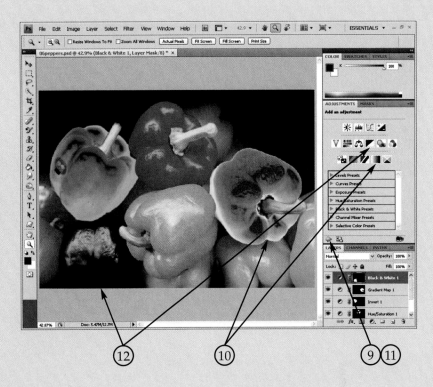

Tutorial 9-2: Replacing Color

In this tutorial, you will use the **Color Replacement Tool** and the **Hue/Saturation** command to change the colors of objects in an image. Unlike the **Hue/Saturation** command, the **Color Replacement Tool** allows you to select an existing color to match, taking the guesswork out of adjusting the color settings. Also, it is applied with a brush, which allows for greater control. The **Hue/Saturation** adjustment affects all similarly colored objects in the image, so a careful selection must be created before the command is used.

1. Open the toy.tif file.

2. Choose **Layer > Duplicate Layer...**. In the **Duplicate Layer** dialog box, click **OK** to accept the default settings for the new layer.

 You will do all of your color correction on this layer. That way, if you make a mistake, the original layer will be preserved.

3. Zoom in on the green sphere at the left side of the photo.

4. Click the **Eyedropper Tool** in the **Tools** panel.

5. With the **Eyedropper Tool**, click on a midrange (not too dark or light) shade of blue on the blue sphere.

 This sets the foreground color to blue.

6. Click the **Color Replacement Tool**, found behind the **Brush Tool** in the **Tools panel**.

7. Change the following settings in the options bar:

 - Set the brush **Diameter** to 60 px.

 - Set the **Mode** to Color.

 - Click the **Sampling: Continuous** button.

 - Set the **Limits** to **Find Edges**.

 - Set the **Tolerance** to 50%.

8. Zoom in further on the green sphere.

9. Paint the sphere to replace the color. As you paint, do *not* allow the crosshairs to touch anywhere outside of the green sphere.

10. Zoom in on the other green sphere in the image.

11. Use the **Color Replacement Tool** to change this sphere to blue, also.

12. Choose **View > Fit on Screen**.

 In the following steps, you will adjust the yellow spheres using the **Hue/Saturation** command. Before doing so, notice that the wooden table beneath the toy contains some hints of yellow. Since you want the table to remain the same color, you need to exclude it from the effects of the **Hue/Saturation** command by deselecting it.

13. Choose the **Quick Selection Tool** in the **Tools** panel.

14. Use the **Quick Selection Tool** to paint the wall and the wooden table until only the toy is not selected.

 If necessary, use the **Lasso Tool** with the **Add to selection** and **Remove from selection** options to fine tune the selection.

15. Choose **Select > Inverse**.

16. Click the **Hue/Saturation** button in the **Adjustments** panel.

17. Choose **Yellows** from the drop-down list that is just above the **Hue** slider.

18. Drag the **Hue** slider to –23.

19. Drag the **Saturation** slider to +10 to boost the intensity of the new orange colors.

20. Click the **Return** button in the bottom-left corner of the **Adjustments** panel to return the **Adjustments** panel to its default appearance.

21. Click the **Brightness and Contrast** button in the **Adjustments** panel.

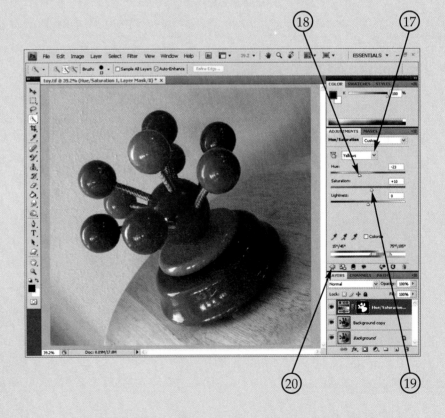

22. Drag the **Contrast** slider to +55.

 This intensifies the toy's colors even further and causes it to stand out from the background.

23. Choose **File > Save As...** and name this file 09toy.tif in the **Save As** dialog box.

24. Close the 09toy.tif file.

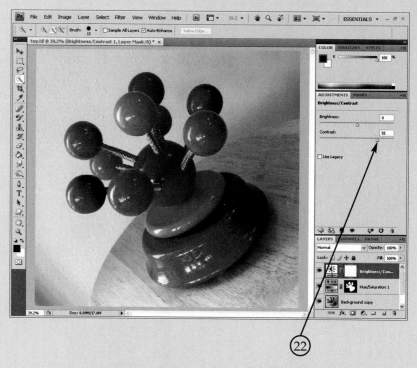

Tutorial 9-3: Adjusting Shadows and Highlights

In this tutorial, you will use the **Shadow/Highlights** command to correct excessively heavy shadows in an image.

1. Open the cowboy.jpg file.

2. Choose **Layer > Duplicate Layer...**. In the **Duplicate Layer** dialog box, click **OK** to accept the default settings for the new layer.

3. Choose **Image > Adjustments > Shadow/Highlight...**.

4. If the **Show More Options** check box at the bottom of the **Shadow/Highlight** dialog box does not have a check in it, check it now.

5. In the **Shadows** section, change the following settings:

 Amount: 40%

 Tonal Width: 45%

 Radius: 90

6. Click **OK**.

 This closes the **Shadow/Highlight** dialog box and applies the settings to the image. The shadows in the image are much lighter now.

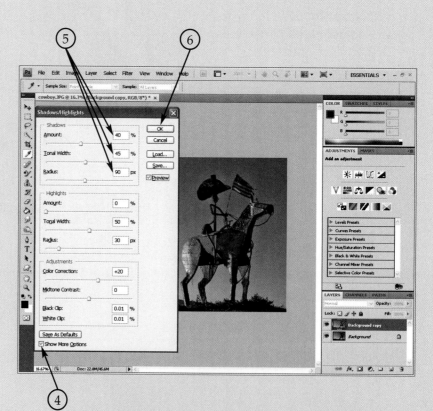

7. Zoom in on the cowboy's face.

8. Click the **Dodge Tool** in the **Tools** panel.

9. In the options bar, set the **Exposure** to 30% and choose a soft round brush, size 35 pixels.

10. Dodge the entire cowboy's face without releasing the mouse button. Do not dodge the sky. Repeat this process two more times.

 The reason the **Dodge Tool** is used three times at a 30% exposure rather than one time at a 90% exposure is that it helps soften the edges of the effect.

11. Use the **Lasso Tool** to make a selection around the cowboy's facial features.

12. Click the **Refine Edge** button and feather the selection a little.

13. On the **Adjustments** panel, click **Brightness/Contrast**.

14. Set the **Contrast** slider to +25.

15. Click the **Return** button at the bottom left of the **Adjustments** panel to return the panel to its default appearance.

16. On the **Adjustments** panel, click **Vibrance**.

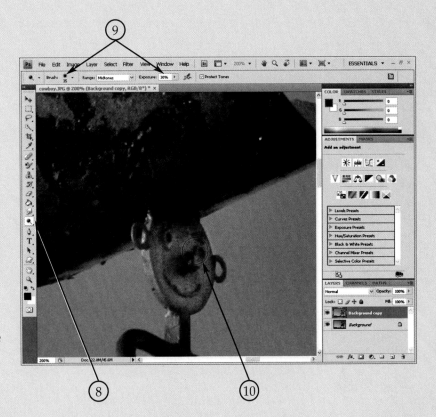

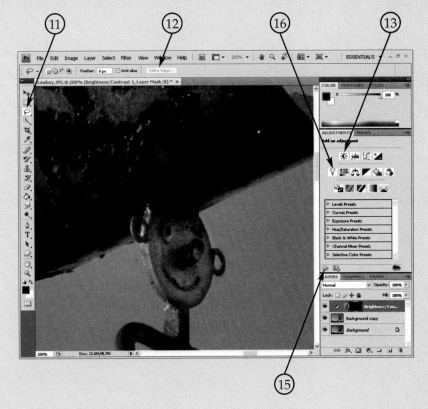

17. Drag the **Vibrance** slider to +35 and the **Saturation** slider to +10.

18. Choose **View > Fit on Screen**.

19. Choose **File > Save As...** and name this file 09cowboy.tif.

20. Close the 09cowboy.tif file.

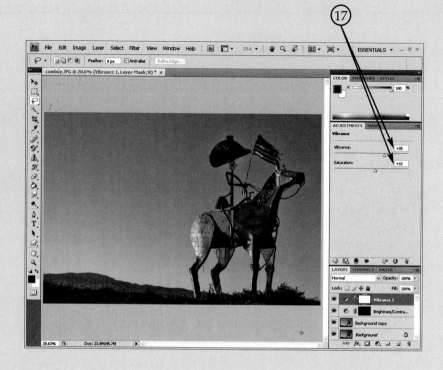

Tutorial 9-4: Use Blending Modes and Painting Tools to Adjust Color

In this tutorial, you will use the **Gradient Tool** with the **Color Dodge** blending mode to enhance the colors in an image. Similar effects can be achieved with the other painting tools and blending modes.

1. Open the penstemon.jpg file.

2. Choose **Layer > Duplicate Layer...** and click **OK** in the **New Layer** dialog box to accept the default settings.

3. Zoom in on one of the flowers.

4. Click on the **Eyedropper Tool** in the **Tools** panel.

5. Use the **Eyedropper Tool** to sample the darker purple area of the flower.

6. Choose **View > Fit on Screen**.

7. Click the **Gradient Tool** in the **Tools** panel.

8. In the options bar, click the down arrow next to the gradient sample to open the **Gradient Picker**. Choose the second gradient on the top row, which should be a blend of the dark purple color you chose and a transparent area.

9. In the options bar, choose **Color Dodge** in the **Mode** drop-down list and set the **Opacity** to 30%.

 This selects the blending mode that will be used with the **Gradient Tool** and determines how visible the effect will be.

10. Beginning in the lower-right corner of the image, drag the gradient to the upper-left corner of the image.

11. Choose **Edit > Undo Gradient** and use this image to experiment with different gradients and blending modes. You should also try out the **Brush Tool** on this image using different blending modes.

12. After experimenting, choose **File > Revert** and apply the gradient described in steps 7 through 10 of this tutorial.

13. Choose **File > Save As...** and name the file 09penstemon.jpg.

14. Close the 09penstemon.jpg file.

Tutorial 9-5: Removing a Color Cast

Color casts are a common problem in photography. Adjusting the white balance setting on your camera can help, but this does not always entirely correct the problem. This image in this tutorial has slight red color cast. You can see it around the edges of the yellow candies.

1. Open the candies.tif file.

2. Choose **View > Actual Pixels** to zoom your image to 100%.

 This will make it easier to see the adjustments you are about to make.

3. In the **Adjustments** panel, click the **Color Balance** adjustment.

 Each slider contains two colors that are opposite each other on the RGB/CMY color wheel, making it easy to correct color casts (similar to the **Variations** adjustment).

4. In the **Adjustments** panel, leave the **Midtones** radio button selected and drag the first slider in the **Cyan** direction until the value reads about –15.

5. Click the **Return** button in the bottom-left corner of the **Adjustments** panel.

6. Click the **Vibrance** adjustment in the **Adjustments** panel.

7. Drag the **Vibrance** slider all the way to 100%.

8. In the **Layers** panel, turn on and off the adjustment layers to compare this image to how it used to look.

9. Choose **File > Save As...** and name this file 09candies.psd.

10. Close the 09candies.psd file.

Tutorial 9-6: The Sponge, Dodge, and Burn Tools

In this tutorial, you will put the finishing touches on the panoramic image that you began in Chapter 6. You will use the **Sponge Tool** to remove an unnatural tint from the road by desaturating it. You will also use the **Burn Tool** to darken one of the houses so that it more closely matches the other houses in the image. You will use the **Dodge Tool** to do a little touching up as well.

1. Open the 08hillside.psd file that you edited in a previous chapter.

2. Choose **Layer > Duplicate Layer...**.

3. Zoom in on the road.

 Most of the road has a pinkish-orange color cast that looks unnatural.

4. Click the **Sponge Tool** in the **Tools** panel.

5. In the options bar, enter the following settings:

 - Select a soft round brush, and set the **Master Diameter** to 200 px.

 - Set the **Mode** to Desaturate.

 - Set the **Flow** to 100%.

6. Bit by bit, drag the **Sponge Tool** over the entire road until it is gray. For accuracy, use a smaller brush on the edges of the road.

 Use the **Navigator** panel or the **Hand Tool** to move around as you work.

7. Zoom in on the farthest house.

8. Click the **Burn Tool**.

9. In the options bar, enter the following settings:

 - Select a soft round brush, and set the **Master Diameter** to 40 px.

 - Set the **Range** to Midtones.

 - Set the **Exposure** to 15%.

10. Darken the house with the **Burn Tool**. For best results, do *not* release the mouse button until you are finished burning the entire house.

 Be careful to darken the house uniformly.

11. Click the **Dodge Tool**.

12. In the options bar, enter the following settings:

 - Select a soft round brush, and set the **Master Diameter** to 150 px.

 - Set the **Range** to Midtones.

 - Set the **Exposure** to 30%.

13. The largest trees in front of the two closest houses have areas that appear too dark. Use the **Dodge Tool** to lighten them. This time, you will need to apply the dodging effect 2 or 3 times by releasing the mouse button and painting over the area again.

 Be careful to not dodge the image to the point that colors start looking unnatural. Also, you have to resize your brush when dodging the smaller of the two trees.

14. Choose **Layer > Flatten Image**.

15. Choose **File > Save As...** and name this file 09hillside.jpg. Then, close it.

Key Terms

adjustment layer	highlights	photo filters
brightness	hue	saturation
color cast	luminosity	shadows
complementary color	midtones	source image
contrast	non-destructive editing	target image
exposure	over-adjusted	

Review Questions

Answer the following questions on a separate sheet of paper.

1. What is an adjustment layer?

2. List five of Photoshop's adjustments that are not available as an adjustment layer (they are only available in the **Image > Adjustments** submenu).

3. If only a portion of an image needs to be adjusted, what must be done to ensure that the color correction will blend in with the rest of the image?

4. Which button on the **Adjustments** panel controls whether an adjustment layer controls *all* layers beneath it or only the layer *immediately below* it?

5. List the four radio buttons in the **Variations** dialog box, which allow you to select the color qualities of your image that are to be adjusted.

6. What is the **Fine/Coarse** slider in the **Variations** dialog box used for?

7. How can an RGB/CMY color wheel be used to determine how to correct a color cast?

8. Briefly describe how some of the thumbnails found in the **Variations** dialog box are similar to a color wheel.

9. If an image has a blue color cast, what color will help correct it?

10. What is saturation?

11. What happens to an image if the contrast is boosted?

12. What is the definition of the term *hue*?

13. What do the two colored bars found at the bottom of the **Hue/Saturation** dialog box represent?

14. The **Vibrance** adjustment has two sliders that adjust saturation. What is the difference between these two sliders?

15. What does the **Fuzziness** slider in the **Replace Color** dialog box do?

16. Explain how the **Black & White** adjustment is different from the **Desaturate** adjustment.

17. Describe how the **Photo Filter** adjustment is similar to using traditional photo filters.

18. How are the shadows, midtones, and highlights of an image changed when using the **Gradient Map** adjustment?

19. Which adjustment can be used to replace the colors in one image with the colors from another image?

20. What does the **Posterize** adjustment do to an image?

21. What does the **Invert** adjustment do to an image?

22. The **Color Replacement Tool** shares many of the same options with what other tool?

23. In what two ways can the **Sponge Tool** affect the colors in an image?

24. Briefly describe what the **Dodge** and **Burn Tools** do.

25. List three painting tools that can be used along with blending modes to adjust an image's color.

10

Advanced Color-Correction Techniques

Learning Objectives

After completing this chapter, you will be able to:

- Explain how a computer monitor displays color.
- Summarize how color is created in the printing industry.
- Differentiate between an additive and subtractive color system.
- Compare Photoshop's different color modes.
- Explain how Photoshop measures both RGB and CMYK color.
- Explain the various settings on the **Color Picker**.
- Explain what out-of-gamut colors are.
- Use the **Channels** panel to view color information or save a selection.
- Explain what a histogram is.
- Use the **Threshold** adjustment to find highlights in an image.
- Use the **Color Sampler** tool to mark highlights in an image.
- Use the **Levels** adjustment to adjust an image.
- Use the **Curves** adjustment to adjust an image.
- Use the **Camera Raw** dialog box to adjust a Camera RAW, JPEG, or TIF image.
- Explain bit depth.
- Explain the purpose of the **Info**, **Color**, and **Swatches** panels.
- Describe the recommended sequence you should follow when adjusting color in an image.
- Summarize the basic steps of color management.
- Use the settings in the **Print...** dialog box to print an image on a desktop printer.

Introduction

The previous chapter focused on color-correction tools and techniques that are not too difficult to use. Before introducing you to some of Photoshop's more advanced color-correction tools, this chapter will provide you with some background knowledge about color.

You have learned that Photoshop can be used to create projects that will be displayed either on a computer screen or in printed form. There are some significant differences between the manner in which a computer monitor and a printing press produce color, and Photoshop users must understand these differences.

Different Shades of Color

Computer monitors and television screens create color by shining light at our eyes. Most of these display screens are capable of producing millions of shades of colors, an impressive number. Some video displays, such as certain high-end plasma-screen televisions, are even capable of producing billions of different shades of color!

Printers and printing presses use inks to create color on a page. By mixing four different shades of ink, printing presses are able to produce as many as 6,000 different shades of color. This number may seem insignificant when compared to the millions (or billions) of colors that monitors or televisions can display, but think about it—a printing press can produce hundreds of different shades of red, hundreds of different shades of blue, and so on. This level of color detail is more than enough to produce photo-realistic images in printed materials.

Red, Green, and Blue Light (RGB Color)

A computer monitor or television screen is made of thousands of tiny, glowing squares. Each of these squares is capable of displaying a different color. How is this done? Within each tiny square, there are actually three different elements that emit light—a red, green, and blue element. Using different combinations of red, green, and blue light, each tiny square on a typical computer monitor or television screen can display over 16 million different shades of color.

Combining different wavelengths of light together to create color is called an *additive color system. White light* is created when red, green, and blue light are added together at full strength. You can begin to see how additive color works by placing a red, green, and blue light source so that their beams overlap. See **Figure 10-1**.

Cyan, Magenta, Yellow, and Black (CMYK Color)

Color is created differently in the printing industry. If you are creating color by applying inks to white paper, you must use cyan (a light blue), magenta (a purplish-pink), and yellow. Mixing cyan, magenta, and yellow ink does not create black (instead, a dark brown color is produced), so black ink must be added to the other three colors to properly reproduce dark areas in an image.

Note The letter K in CMYK represents black, because the letter B is used to represent blue in RGB.

Using CMYK inks, around 6,000 different colors can be created on a printed page. Next time you change the printing cartridges in your inkjet printer, you will notice that CMYK inks are used, **Figure 10-2**. Many consumer-level printers use more than the four standard CMYK inks so that more shades of color can be produced.

Figure 10-1. _____
When red, green, and blue light mix, other colors are created.

Figure 10-2. _____
Consumer-level and professional-level printers both use CMYK inks.

In the professional printing industry, if a project requires a color that cannot be represented by CMYK inks (such as fluorescent orange or metallic silver), a separate, premixed ink called a *spot color* is used. Spot colors must be added separately during the printing process. An additional printing plate must be created for the spot color and each page with spot color must pass through the printing press again. This causes a printing project to become more expensive.

Creating color by applying inks to paper is called a *subtractive color system*, because of the way our eye perceives color when we look at an object. For example, when you look at a red apple (either a picture of an apple or a real apple), the apple's color causes the red wavelengths of light to be reflected back into your eyes. Other wavelengths of light, such as blue and green, are absorbed (or *subtracted*) by the color of the apple and they do not reflect into your eye. As a result, your eye sees red.

Color Modes

In Photoshop, you can create files in different *color modes*. Color modes determine which shades of color are available for your image. As a general rule, if you are a beginning or intermediate-level Photoshop user and you wish to create a full-color project, it is recommended that you create it in RGB color mode.

As mentioned earlier, the *RGB color mode* creates color by combining red, green, and blue. This color mode is capable of producing all shades of color that a computer monitor can display. If your project was created in RGB color mode but will be printed on a commercial printing press, it can be converted to CMYK mode before printing.

The *CMYK color mode* produces color by combining cyan, magenta, yellow, and black. These are the same four colors that are used by most printing presses. Since this color mode is primarily used for projects that are intended to be printed, it permits the image to include only those colors that are reproducible by a printing press. If an image was created in RGB mode and converted to CMYK, Photoshop will locate any colors in the image that cannot be printed and substitute the closest printable color instead. Furthermore, the **Color Picker** will warn you if a color cannot be printed. See the "Non-Web-Safe and Out-of-Gamut Colors" section later in this chapter.

The *grayscale color mode* uses only combinations of black and white to create numerous shades of gray. If your project is black-and-white or grayscale, it should be created in (or converted to) grayscale color mode to minimize file size. While in grayscale color mode, you can choose from only white, black, and shades of gray when selecting a color.

Color modes are assigned to images in one of two ways. When creating a new image file, you can select a color mode from the **Color Mode** drop-down list in the **New** dialog box, Figure 10-3. You can also convert an existing file to a different color mode by choosing a color mode from the **Image > Mode** submenu. When you change color modes in your image, Photoshop automatically adjusts the colors in the image. So, to preserve as much color detail as possible, you should only change color modes when absolutely necessary.

In addition to the RGB, CMYK, and grayscale color modes already discussed, you will find several additional color modes in the **Image > Mode** submenu, Figure 10-4. Most of these are used in specialized printing situations.

Figure 10-3.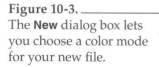
The **New** dialog box lets you choose a color mode for your new file.

Color modes

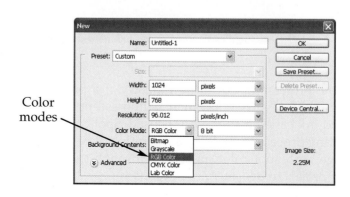

Figure 10-4. _____

These color modes are not used as frequently as RGB, CMYK, or grayscale.

Color Mode	Brief Description
Bitmap	Converts a file in grayscale mode to black and white dots. All shades of gray are replaced by either black or white.
Duotone	The duotone mode is used for projects that will be printed in 2 colors. However, once the duotone mode is selected, the **Duotone Options** dialog box opens. From this dialog box, you can choose to convert the image to monotone format (for printing with 1 color), tritone format (for printing with 3 colors), or quadtone format (for printing with 4 colors). You also specify the ink colors in this dialog box.
Indexed Color	Limits the colors in an image to 256. Used in situations where file space must be small, such as multimedia projects and web pages. When an image in indexed color mode is active, a color table (that shows all 256 colors) can be displayed by choosing **Image > Mode > Color Table....**
LAB Color	An alternative to RGB and CMYK color modes, this mode separates an image into three channels: a lightness/darkness channel (L), a red-green channel (A), and a blue-yellow channel (B). Its gamut (see next section) is more expansive than the gamuts of RGB and CMYK modes.
Multichannel	Used to create spot channels for specialized printing situations.

Note All of Photoshop's tools and features work in RGB mode. When an image has been converted to another color mode, you will find there are a few tools that will not work, simply because the technology does not allow them to. This is especially true of tools and adjustments in the color-correction category. If you need to use a certain adjustment that is unavailable in the current color mode, and you cannot think of another way to accomplish the same task, you will need to convert your image back to RGB mode to use the tool.

Identifying and Matching Colors in Photoshop

As a graphic artist, you will often be called upon to use a specific color in your designs. For example, you might be asked to use a client's corporate colors in a marketing brochure or use the colors specified by an architect in a rendering of a new building. "Eyeballing" colors is not a good enough method for matching colors in many professional situations. You must be able to *precisely* reproduce the colors requested by the client.

Fortunately, Photoshop has a strong set of tools for matching and identifying colors. These tools provide a means for precisely matching desired colors and communicating color specifications to others.

How Photoshop Measures Color

To understand how Photoshop measures color, we will use Photoshop's **Color Picker** to choose white. A few of the **Color Picker**'s settings were discussed in Chapter 1, *The Work Area*. The remainder of them will be introduced here. Remember, the **Color Picker**

is displayed by clicking the foreground or background color box in the **Tools** panel. One way to choose white in the **Color Picker** is to click in the extreme upper-left corner of the color field, **Figure 10-5**.

Reading RGB and CMYK Values in the Color Picker

After selecting white, look at the RGB values in the **Color Picker**. They show that white is represented by a value of 255 for each color: red, green, and blue. A value of 255 is the *maximum* setting for RGB values. In other words, when red, green, and blue light are each at maximum strength, white light is created.

The CMYK values are to the immediate right of the RGB settings in the **Color Picker**. These color values are shown in percentages (0%–100%), representing how much of each of the four inks is applied to the paper to create a certain color. These values show that to create white, *no* ink is used. Since no ink is applied, blank paper is visible in those areas.

The opposite is true if black is chosen in the **Color Picker**. RGB values would each be 0, meaning no light is emitted by the monitor. CMYK values, on the other hand, would show values between 65% and 90% for each color—a combination of inks that prints a deep black.

> **Note** To quickly choose black or white in the **Color Picker**, click and drag into a black or white corner of the color field. Do not stop dragging until the cursor will not move any farther. This should result in pure white or black.

Reading H, S, and B Values in the Color Picker

The **H**, **S**, and **B** settings in the **Color Picker** represent the hue, saturation, and brightness of the selected color. As you learned in the previous chapter, these qualities can be adjusted to shift the color in an image. The same qualities can also be used to define a specific color.

Figure 10-5. _____

When white is selected in the **Color Picker**, RGB values are at their maximum, and CMYK values are at their minimum.

In the HSB color model, a saturation of 0% and brightness of 100% produces white, regardless of the hue

Click to add the currently defined color to the **Swatches** panel

Click to access libraries of predefined colors

Click in the extreme upper left corner of the color field to select white

In the Lab color model, a luminance of 100% and a balance of red to green (**a** = 0) and blue to yellow (**b** = 0) produces white

Color field

In the CMYK color model, white is produced by an absence of cyan, magenta, yellow, and black

Maximum values for red, green, and blue

Hexadecimal code for the selected color

The **H** (hue) value describes the color's position on a color wheel or the linear color bar in the **Color Picker**. Red appears at both ends of the **Color Picker**'s color bar, equating to the positions of 0° and 360° on a color wheel. As you know, the RGB color mode divides the spectrum into three primary colors, and those colors are located 120° apart on the color wheel (a complete circle of 360° divided by 3). Red is at 0° (or 360°), green is at 120°, and blue is at 240°.

Cyan, magenta, and yellow are the complementary colors for red, green, and blue, and are located directly across (or 180°) from them on the color wheel. Cyan, which is the complement of red, is located at 180° (0°+180°) on the color wheel. Magenta, which is the complement of green, is located at 300° (120°+180°). Yellow, which is the complement of blue, is located at 60° (240°−180°).

The **S** (saturation) setting determines the intensity of a color. The minimum value of 0% indicates that the color is a shade of gray, with no trace of the hue specified by the **H** setting. As the saturation increases, so does the percentage of hue in the color. The maximum value of 100% produces a color with the maximum amount of hue.

The **B** (brightness) setting determines how light or dark the color is. When this value is set to 0%, the minimum, the color is black, regardless of the other settings. As the brightness increases, the level of black in the color decreases. When this value is set to its maximum, the color has no black in it.

Reading L, A, and B Values

The **L**, **a**, and **b** settings allow you to see color values in Lab color mode, a mode more complex than RGB or CMYK. Lab mode describes color based on how the human eye perceives color, rather than how a monitor displays color or how ink looks on a printed page. One benefit of the Lab color mode is that it has a larger gamut (range of colors) than RGB or CMYK mode. Sometimes, images are converted to Lab mode, adjusted, and converted back to RGB mode.

The **L** (luminance) setting determines how light a color is. This setting is basically the same as the brightness setting in the HSB color model. The **a** setting determines how much red and green are in the color, and the **b** setting determines the amount of blue and yellow.

Locating the Hexadecimal Code in the Color Picker

A text box simply labeled with a number sign (#) appears at the bottom of the **Color Picker**. This box displays a *hexadecimal code* (alphanumeric code using characters 0–f) for the selected color. If a new color is selected in the color field or the current color's settings are altered, the hexadecimal code is automatically updated. This code is especially useful for web designers, who have to use hexadecimal codes to specify colors in HTML code.

Using the Add to Swatches Button to Save Defined Colors

Often you will want to save the colors you define in the **Color Picker** for later use. Clicking the **Add to Swatches** button opens the **Color Swatch Name** dialog box. If desired, you can rename the color in this dialog box and then click **OK** to save the color to the **Swatches** panel. You can then click the color in the **Swatches** panel at any time to reload it into the **Color Picker** or select it as the foreground color. The **Swatches** panel will be discussed in greater detail later in this chapter.

Using Color Libraries

Clicking the **Color Libraries** button opens **Color Libraries** dialog box. This dialog box gives you access to a vast collection of spot colors. The spot colors are organized into groups according to color matching books, such as those from Pantone® and TRUMATCH®. See **Figure 10-6**. Scroll through the choices and select a spot color, which becomes the selected color in the **Color Picker**. Click **OK** to accept the color, close the dialog box, and return to the image window. If you would rather return to the **Color Picker**, click the **Picker** button.

Using the Color Settings to Specify and Match Colors

All of the **Color Picker** settings described so far make it possible to exactly match colors, or to provide exact color specifications when creating colors. After you have created a color that you want to share with others, all you need to do is record and provide the appropriate set of color specifications. For example, if you have designed a sign in Photoshop and want to have it mounted in a frame that is the same color as the background, you would select the sign's background color with the **Eyedropper Tool**, open the **Color Picker**, click the **Color Libraries** button, and select a color matching book like **Pantone® solid coated**. The Pantone equivalent of the background color would be automatically selected. Then, you would simply write down the name of the Pantone color so you could take it with you to the paint shop.

If you clicked the **Picker** button in the **Color Libraries** dialog box, you would see the RGB, CMYK, Lab, HSB, and hexadecimal settings for the selected Pantone color displayed in the **Color Picker**. If you were working with a web designer instead of a painter, the designer may request HSB, RGB, or hexadecimal specifications instead of a Pantone number for the color. A printer may request the CMYK specifications.

If you are on the receiving end of a color specification, all you need are one of the following: the RBG values, the CMYK values, the HSB values, the Lab color values, the hexadecimal value, or the color matching system number for the color. See **Figure 10-7**. In the **Color Picker**, simply enter the values in the appropriate text boxes or access the appropriate color library and select the desired color.

Figure 10-6.

The **Color Libraries** dialog box gives you access to collections of predefined colors. When you select a library from the **Book** drop-down list, proprietary names and color samples are displayed in the left side of the dialog box. Also, a CMYK equivalent is displayed for the selected color.

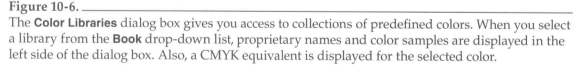

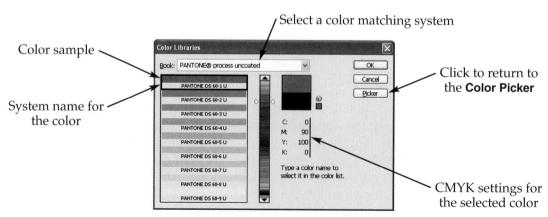

Select a color matching system

Color sample

System name for the color

Click to return to the **Color Picker**

CMYK settings for the selected color

Figure 10-7. _____
There are many ways to specify a color. The best way to identify a color depends largely on how it is going to be output.

Color sample

Values Used to Describe or Create the Color

PANTONE® process uncoated: PANTONE DS 6-4 U

CMYK color model: C: 0, M: 10, Y: 100, K: 5

RGB color model: R: 245, G: 209, B: 0

HSB color model: H: 51, S: 100, B: 96

Lab color model: L: 85, a: 2, b: 85

Hexadecimal (HTML): f5d100

Note If you want to see a better visual representation of what each color setting does in the **Color Picker**, try activating the radio button next to the setting as you adjust it. The color field and color bar change to give you a better idea of how to adjust the setting to get the desired result.

Non-Web-Safe and Out-of-Gamut Colors

Remember, millions of color shades can be created by using red, green, and blue light (RGB). Unfortunately, not all web browsers can display the full range of colors that can be created in RGB mode. If a color is chosen in the **Color Picker** that will not display properly in _all_ web browsers, a small cube icon appears next to the color sample. See **Figure 10-8**. This is a warning for anyone developing content for the web, indicating that the color is not web-safe. The most similar web-safe color is displayed in a color box under the icon. Clicking on the icon (or the color box under it) replaces the currently selected color with a web-safe color in the color box.

Similarly, a printing press using CMYK inks cannot produce anywhere near the number of color shades that can be defined in RGB mode. If you use the **Color Picker** to select a color that cannot be produced on a four-color printing press, a triangular out-of-gamut icon appears. The term _gamut_ means "the range of colors that can be produced." Just underneath the out-of-gamut icon is a color box that displays the closest in-gamut color. You can choose the suggested in-gamut color by clicking on the out-of-gamut icon (or color box below it), or you can pick a different shade in the color field.

Figure 10-8. _____
If the selected color is not web-safe, a small icon appears next to the color sample. Similarly, an out-of-gamut icon appears if you choose a color that cannot be printed using CMYK inks.

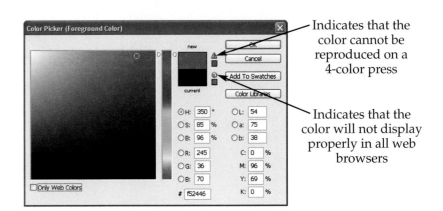

Indicates that the color cannot be reproduced on a 4-color press

Indicates that the color will not display properly in all web browsers

Most images captured with a camera or scanner contain out-of-gamut colors. To see the colors that are out-of-gamut, open any image and choose **View > Gamut Warning**. All out-of-gamut pixels are temporarily covered with gray, **Figure 10-9**. To hide the gamut warning, choose **View > Gamut Warning** again.

Out-of-gamut colors may seem like a significant problem until you consider these facts:

- Even though consumer-level printers (like inkjets and photo printers) use CMYK inks, they are designed to print RGB files. The printer driver software converts the colors from RGB to CMYK automatically. You only need to worry about using Photoshop's CMYK color mode if your project will be printed commercially. Your print service provider can help if you encounter problems.

- When you use Photoshop to convert a file from RGB mode to CMYK mode, out-of-gamut colors are automatically replaced with the nearest possible match. The image usually looks very close to (but less vibrant than) the original.

- Photoshop users can force the colors on their monitor to match what comes out of their printer. This advanced-level process is called *color management*, and is briefly described at the end of this chapter.

The Channels Panel

The **Channels** panel is used to store two different types of information. First, it displays how much of each color (RGB, CMYK, etc.) is used to create an image. Second, the **Channels** panel can be used to store and modify selection and masking information.

Color Channels

If you view the **Channels** panel immediately after opening an RGB image, you will see three *color channels* (red, green, and blue) and a *composite channel* (RGB), **Figure 10-10**. Each color channel shows a grayscale thumbnail image that represents

Figure 10-9. _____

A—This RGB image, captured with a digital camera, contains many out-of-gamut colors.
B—Choosing **View > Gamut Warning** reveals the out-of-gamut colors in the image by replacing them with gray pixels.

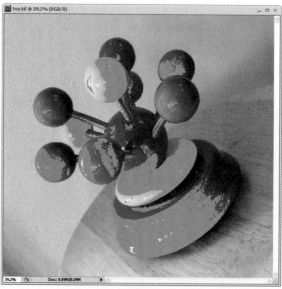

A B

Figure 10-10. —————————————————————————————
The three color channels and composite channel of an RGB image are shown here. Notice the difference in tones from channel to channel.

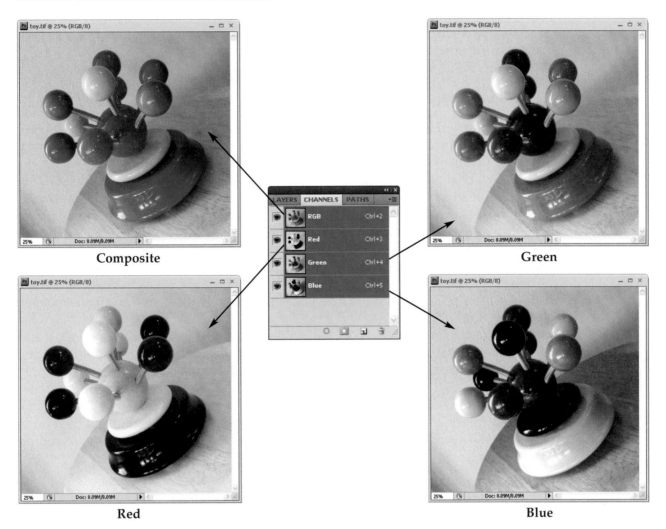

how much of that specific color is being used to produce the image. For example, in Figure 10-10, the white and gray areas in the Red channel show areas where red light is required to create the image on a computer monitor. Black appears where no red light is required. If the image you have open is in CMYK mode, you will see four color channels instead of three. Each of these channels represents how much of each ink color is necessary to produce the image on paper.

You can display a specific color channel in the image window by turning off the **Visibility** toggle for all channels except the channel you want to display. You may wonder why the default settings display the channels as grayscale instead of the primary color they represent. This is done because it is often easier to judge the density of gray than the density of some of the lighter primary colors, like yellow or cyan.

| Note | You can display the color channels in their actual color by choosing **Edit > Preferences > Interface** and putting a check mark in the **Show Channels in Color** check box. |

If you turn on the **Visibility** toggle for two or more color channels, the channels are displayed in their true colors in the image window. This allows you to see how specific color channels interact. The composite channel at the top of the list in the **Channels** panel is really a shortcut you can click to select all color channels and make their combined effects visible in the image window. You can hide the effects of each channel by turning off its **Visibility** (eye) toggle.

Alpha Channels

In Chapter 3, *Selection Tools*, you learned how to use quick mask mode to first paint a mask and then convert that mask into a selection. Whenever you use quick mask mode, the **Channels** panel automatically creates a new *alpha channel* that stores the mask. Alpha channel thumbnails look like small grayscale paintings. By default, the black areas in an alpha channel represent the unselected (masked) areas of the image, the white areas are selected (unmasked), and the gray areas represent areas that are partially masked. A partially masked area may be created by the edges of a soft brush, by painting the quick mask with a shade of gray rather than black or white, or by adjusting the brush's opacity while creating the mask. The darker the shade of gray, the more completely the area is masked. Alpha channels and spot channels, which are discussed later in the chapter, are listed after the color channels in the **Channels** panel. See **Figure 10-11**.

Both alpha channels and color channels can be edited using Photoshop's tools and filters. For example, after creating a mask in quick mask mode, you could select the new, automatically-created alpha channel (which will be named Quick Mask) and apply the **Wind** filter. This can produce an effect where one side of the mask appears more feathered than the other. You will really notice the effect if you press the **Edit in Quick Mask Mode** button on the **Tools** panel to convert the mask to a selection and then press [Delete]. Many special effects can be created by using filters to alter masks stored on alpha channels.

Figure 10-11. _____

The **Channels** panel displays color information about an image. It can also be used to save selections.

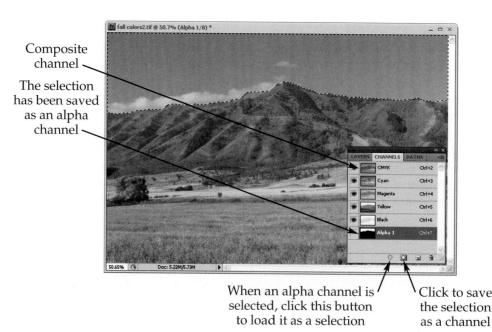

Composite channel

The selection has been saved as an alpha channel

When an alpha channel is selected, click this button to load it as a selection

Click to save the selection as a channel

Two other types of alpha channels are created automatically, when using methods that are explained further in Chapter 11, *Additional Layer Techniques*. You will see an alpha channel appear in the **Channels** panel when you create a layer mask or when you create a filter mask by converting a layer for smart filters and applying a filter to that layer.

If you would like to view the alpha channel as a mask, turn on the **Visibility** toggle for the alpha channel. This displays the alpha channel as a tinted mask overlaying the image. Click the **Visibility** toggle again to hide the alpha channel.

Saving a Selection as an Alpha Channel

If you create a mask using quick mask mode, a new alpha channel is automatically created. If you close and save your image, the alpha channel is preserved. However, if you exit out of quick mask mode before saving, your mask is converted to a selection, which *will not be automatically saved*. Unlike a mask, a selection disappears when you save and close the image file, unless you save the selection as an alpha channel.

After making a selection in the image window, you can save the selection by choosing **Select > Save Selection...**. The **Save Selection** dialog box appears, allowing you to name the selection. When you click **OK**, a new alpha channel is created that stores the selection information as a mask. If you have already created an alpha channel for this image before using the **Save Selection** command, you will have the option of selecting the existing alpha channel from the **Channel** drop-down list instead of automatically creating another new alpha channel, **Figure 10-12**. If you do this, you will be able to specify in the **Operation** section how the new selection should interact with the existing selection in the channel. When you click **OK**, the selection will be saved as a new alpha channel or combined with an existing alpha channel, depending on the settings you chose.

You can also save selections as a new alpha channel directly from the **Channels** panel. To do this, simply open the **Channels** panel when the selection is made, and click the **Save selection as channel** button at the bottom of the panel. This saves the current selection as a new alpha channel.

As long as you save the file after adding the alpha channel, you can retrieve the selection at any time by choosing **Select > Load Selection**. You can also load the selection from the **Channels** panel by selecting the alpha channel containing the selection and clicking the **Load channel as selection** button at the bottom of the panel.

Figure 10-12. _____

In the **Save Selection** dialog box, you can specify an existing channel in which to save the selection, or create and name a new channel in which to save it.

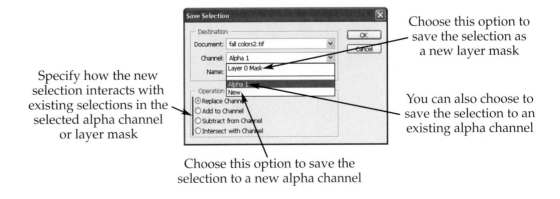

Specify how the new selection interacts with existing selections in the selected alpha channel or layer mask

Choose this option to save the selection as a new layer mask

You can also choose to save the selection to an existing alpha channel

Choose this option to save the selection to a new alpha channel

Spot Channels

Spot channels are special color channels that indicate where spot color is to be applied to the image. Creating spot color channels is relatively easy. To create a new spot channel, make a selection of the area you want to fill with spot color. Then, open the **Channels** panel. Click the small arrow button in the top right corner of the panel to open the **Channels** panel menu. Choose **New Spot Channel…** from the menu. This opens the **New Spot Channel** dialog box. See **Figure 10-13**.

Note You can also create a new spot channel by pressing [Ctrl] ([Command] for Mac) and clicking the **Create new channel** button at the bottom of the **Channels** panel.

In the **New Spot Channel** dialog box, click the **Color** box to open the **Color Picker**. It is recommended that you select a spot color from a color library rather than select a color in the **Color Picker**. This will make it easier for the printer to match the ink. As soon as you pick a color, the image window is updated with the spot color applied to the selection. If the color is satisfactory, close the **Color Picker** by clicking **OK**.

Back in the **New Spot Channel** dialog box, enter a percentage in the **Solidity** text box. This setting has no effect on the separations that will be prepared for the image, but, in some fine-art printing processes, spot color inks can be thinned or thickened to make them more opaque or less opaque. The **Solidity** setting can be used to simulate onscreen the ink that will be used in the printing process. This setting also controls the maximum opacity of the spot color when the image is printed from a desktop printer. However, in most commercial printing processes, the spot color inks are opaque, and the density is controlled entirely through the dot pattern on the printing plate.

Figure 10-13. _____
You can add a spot color channel to an image through the **Channels** panel menu.

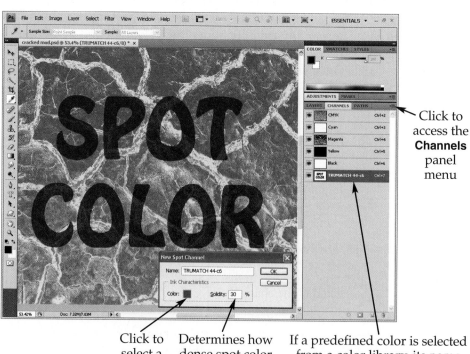

Click to access the **Channels** panel menu

Click to select a spot color

Determines how dense spot color is onscreen

If a predefined color is selected from a color library, its name appears as the channel name

If a predefined color was selected from a color library, the default name of the spot channel is the same as the color that was picked. Otherwise, the channel is named **Spot Color** followed by a number. You can rename the channel by typing a new name in the **Name** text box if you like. When you are happy with the settings, click **OK** to create the spot channel.

The new spot channel appears in the **Channels** panel. Spot colors can be hidden or displayed in the image window by clicking the **Visibility** (eye) toggles next to the spot channel thumbnails. If spot colors are being used for a professional print job, a spot channel can be created for each spot color. Photoshop supports up to 56 channels, including color channels, spot channels, and alpha channels.

As mentioned earlier, the spot color's **Solidity** setting does not control the density of the spot color when it is printed. The actual density of the spot color on the printing plate is controlled by the shade of color used to create the spot color's mask. If black is used, which is the default when simply converting a selection to a spot color channel, the ink is applied at 100% density. White indicates that no spot color will be printed. Shades of grey cause the spot color to be applied in varying densities.

| Note | This section explained how to convert a selection into a spot color channel, but keep in mind that you can also create a spot color channel with no selection made. This creates an empty mask. You can then paint the desired mask using the painting tools and the various shades of gray. Whether you create a spot color mask from a selection or from scratch, you can edit the spot color's mask by turning off visibility for all channels except the spot color channel and then using the painting tools to modify the mask. |

The Channel Mixer Adjustment

The **Channel Mixer** adjustment allows you to adjust images by changing the amount of color information that displays on each channel. Printing professionals may find this adjustment handy when tweaking certain CMYK images, but most Photoshop users prefer more straightforward color-adjustment tools.

The **Channel Mixer** can be used to convert a color image into black and white. However, the **Black & White** adjustment (discussed in Chapter 9, *Introduction to Color Correction*) is a much better choice for this task.

The Histogram Panel

A *histogram* is a graph that shows you how balanced an image is. In other words, a histogram shows you whether the image has a good mixture of shadows, midtones, and highlights.

By default, the **Histogram** panel shows the color information from each channel displayed in a different color. This can be confusing because it is difficult to read the histogram in areas where the colors overlap. You can simplify things a bit by viewing a histogram that combines each channel's data into a single, averaged histogram. This is done by switching the panel to **Expanded View** by choosing it from the **Histogram** panel menu. Then, change the **Channel** menu that appears to RGB.

The **Histogram** panel shows you how shades of color are distributed in an image. The extreme left side of the graph shows how much pure black is in an image. As you move farther right, the graph represents brighter and brighter shades. The extreme right side of the histogram represents how much of the image is pure white.

The histogram for the stop sign image, **Figure 10-14**, shows a tall spike toward the left side of the graph. This represents the *red* shades in the image. The red shades found on the stop sign are nearly all the same brightness, that is why there is such a large spike in the histogram. The increases in the middle of the histogram represent the midtones in the background behind the stop sign. There is another spike in the histogram at the extreme right side. This means that there are a lot of white and near-white shades in this image (the lettering and edges of the stop sign). However, notice that the graph fades away at the extreme left side of the histogram, indicating that the image contains very few black or near-black shades.

The Histogram Panel Menu

The **Histogram** panel menu gives you access to other display options. Click the small arrow button in the upper right corner of the **Histogram** panel to open the **Histogram** panel menu. The first option in the **Histogram** panel menu is **Uncached Refresh**.

Refreshing the Histogram

As you work with an image, its histogram will be derived from cached information rather than the actual image information. This allows for quicker updates, but results in less accurate graphs. When the graph is being calculated from cached information rather than current image information, a small triangular warning icon appears in the upper right corner of the graph. The first option in the **Histogram** panel menu, **Uncached Refresh**, recalculates and updates the graph based on the actual image information rather than cached information. The same thing can be accomplished by clicking the small, triangular **Uncached Refresh** button in the **Histogram** panel.

Figure 10-14. _____

The **Histogram** panel displays a graph that represents how darker and lighter shades of color are distributed in an image.

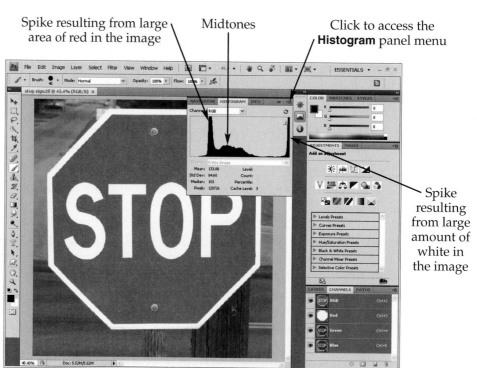

Spike resulting from large area of red in the image

Midtones

Click to access the **Histogram** panel menu

Spike resulting from large amount of white in the image

Compact View, Expanded View, and All Channel View

The **Compact View** option in the **Histogram** panel menu is the default way of displaying the **Histogram** panel. It shows only the histogram. The **Expanded View** and **All Channel View** options in the panel menu display a **Channel** drop-down list, **Source** drop-down list, and **Uncached Refresh** button in addition to the histogram. The **All Channel View** option offers all of the features of the **Expanded View** option, but adds separate histograms for each of the color channels. See **Figure 10-15**.

By default, the histogram displays the combined luminosities from all color channels. You can display information about a particular channel by choosing it from the **Channel** drop-down list. Selecting **Luminosity** in the drop-down list causes the histogram to display information about the composite channel, which is different than the combined information displayed by default. When **RGB** or **CMYK** is selected in the **Channel** drop-down list, the components that make up a color are considered. For example, in the stop sign image, the red is made up of one part midtone red, one part dark green, and one part dark blue. The result is a spike toward the left (dark) side of the histogram when **RGB** is selected in the **Channel** drop-down list. When **Luminosity** is selected in the **Channel** drop-down list, the histogram does not take the component parts into consideration, only the final result. In the case of the stop sign, the red is simply a midtone red. As a result, the histogram is shifted more toward the center. The **Colors** option in the **Channel** drop-down list displays histograms of all of the color channels superimposed over one another.

Figure 10-15. ───

Through the **Histogram** panel menu, you can choose to display an expanded version of the **Histogram** panel. You can also choose to add displays of the individual color channel histograms and color statistics for the image.

Selects the type of information to display in the histogram

Click to update the histogram with current image data

Position the cursor inside the histogram to display statistics about a certain range of pixels

Indicates that the histogram is generated from cached data

Statistics for the overall image or selected layer

Statistics for the current cursor position in the histogram

Specifies whether the histogram is based on a specific layer or the entire image

Histograms of the individual color channels

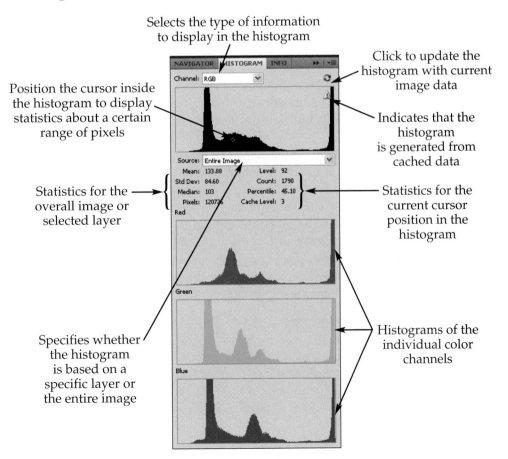

The **Source** drop-down list appears under the histogram when the **Expanded View** or **All Channels View** option is selected for the **Histogram** panel. If the image has more than one layer, you can use this drop-down list to specify whether the histogram is to be calculated from a specific layer or from the entire image.

The Show Statistics and Show Color Options

When the **Show Statistics** option is selected in the **Histogram** panel menu, two columns of statistics are displayed beneath the **Source** drop-down list in the **Histogram** panel. The left column displays some statistics for the entire image, including the total number of pixels used to calculate the histogram (**Pixels**) and the mathematical average of their luminosities (**Mean**). Half the pixels in the image have luminosity levels higher than the **Median** value and half have luminosity values that are lower. The **Std Dev** (standard deviation) value is a measure of how luminosity values are distributed throughout the pixels.

As you place the cursor in the histogram and move it through the full range of luminosity levels (0 at the far left to 255 at the far right), the right column of statistics displays information about the number of pixels in each luminosity level. As you move the cursor in one direction, the **Count** value shows you how many pixels in the image fall into each luminosity level, and the **Percentile** value shows you the percentage of pixels in the image that have lower luminosity values, or are darker.

When the **Show Channels in Color** option is selected in the **Histogram** panel menu, the histograms of color channels are displayed in the color of the channel. When this option is turned off, color channel histograms are displayed in black. This option does not affect the histogram that is displayed when **Colors** is selected in the **Histogram** panel's **Channel** drop-down list.

The Threshold Adjustment

The **Threshold** adjustment shows a histogram of your image and a slider directly underneath the histogram. As you move the slider, a higher or lower luminosity level (displayed in the **Threshold Level** text box) is selected in the histogram. All of the pixels in the image with a luminosity value lower than the **Threshold Level** value are changed to black. All pixels with luminosity levels higher than the **Threshold Level** value remain white.

The **Threshold** adjustment can be used for two purposes. First, you can drag the slider and turn your image into a simple-looking black-and-white image. You will probably never need to do that, unless a special effect is your goal.

You can also use **Threshold** adjustment to locate the brightest highlights and darkest shadows in an image. Finding highlights, for example, can help you set the white point when using the **Levels** or **Curves** adjustments, explained later in this chapter. To find the brightest highlights, drag the slider underneath the histogram almost all the way to the right. Then, slowly keep dragging to the right until just before the last black dots appear, **Figure 10-16**. The remaining white spots are the brightest areas in your image.

Note In some cases, the brightest highlights are only a handful of pixels scattered throughout the image. In such cases, you may need to lower the threshold by dragging the slider to the left until there are enough white pixels to accurately mark and sample.

Figure 10-16. _____
Adjusting the slider in the **Threshold** dialog box all the way to the right helps you find the brightest highlights in an image. Adjusting the slider all the way to the left helps you find the darkest shadows.

This mark indicates one of the darkest points in the image

Color info for sample #1

Color info for sample #2

This mark indicates one of the lightest parts of the image

After placing a color sampler mark, you can click and drag it to a new location

Slider

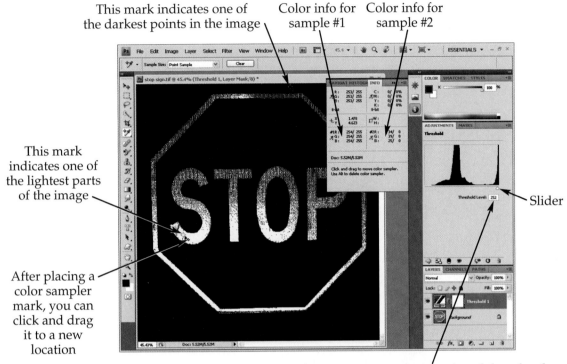

The **Threshold Level** was reduced three levels so enough pixels would be available to sample

To help you remember where the brightest and/or darkest areas of your image are, _color sampler marks_ can be placed on your image. To mark highlights and shadows in an image, choose the **Threshold** adjustment from the **Adjustments** panel. Next, select the **Color Sampler Tool** that is grouped with the **Eyedropper Tool** in the **Tools** panel. Click on an area of highlight or shadow to mark it so you can find it again if you use the **Levels** adjustment or **Curves** adjustment (discussed later in this chapter) to adjust the image. When you do this, the **Info** panel (also discussed later) pops up automatically. This panel shows you RGB and CMYK values of the pixel under the tip of the eyedropper, making it easier to find the brightest or darkest spot in an image.

After placing a color sampler mark (you can place up to four in an image), you can move it by clicking on the mark and dragging it to the desired location. You can remove color sampler marks by making sure the **Color Sampler Tool** is active and clicking on the **Clear** button in the options bar. After you have marked the most extreme highlight and shadow in your image, delete the **Threshold** adjustment layer in the **Layers** panel.

The Levels Adjustment

The **Levels** adjustment allows you to adjust the shadows, midtones, and highlights in an image, **Figure 10-17**. If desired, the **Levels** adjustment can edit a single channel. This provides an alternative way to remove color casts or enhance the color in an image. The **Levels** adjustment is especially useful when adjusting grayscale images or line art (drawings).

Figure 10-17.

You can increase the tonal range and contrast in an image using the **Levels** adjustment. **A**—The original image is somewhat flat, meaning that it has a limited range of tones. **B**—The image is improved after adjusting the black point and gray sliders. The white point needed no adjustment in this image.

Applies the **Levels** adjustment

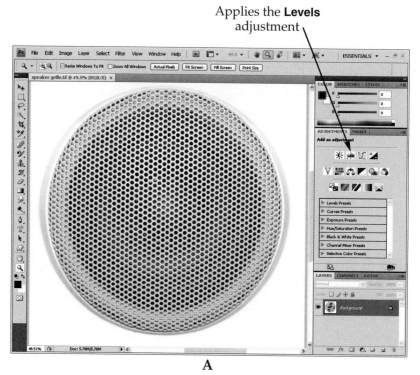

A

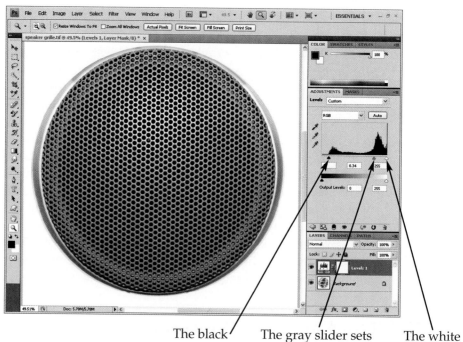

The black slider sets the black point

The gray slider sets the overall brightness of the image

The white slider sets the white point

B

The **Levels** adjustment can be applied through the **Adjustments** panel or **Image >
Adjustments** submenu. When the **Levels** adjustment is applied, it displays a histogram
of your image, Figure 10-17B. At the bottom of the histogram are three sliders. When
adjusting your image, the first sliders you should move are the white and black sliders
directly under the histogram. These sliders are used to set the image's *white point*
(lightest pixels) and *black point* (darkest pixels). As the black slider is adjusted to the
right, all of the shades to the left of the black slider become *pure* black. In other words,
the dark areas of the image become even darker until they reach pure black. The white
slider works the same way—all the tones represented in the histogram that are on the
right side of the white slider will become *pure* white. This can enhance the contrast of an
image considerably, but keep in mind that subtle details in an image (such as textures
or wood grain) are lost when areas become too dark or light. As you move these sliders,
the gray slider is automatically adjusted to maintain its relative position between the
black and white sliders.

You can view what areas of your image are *clipping* (turning pure white or black)
as you adjust the sliders. To do this, press [Alt] (or [Option] for Mac users) as you drag
the white or black slider. If you press [Alt] or [Option] and drag the black slider, a low-
resolution view of your image appears. Any black areas you see as you adjust the slider
will become pure black, and all other tones in the image are represented by white in the
preview. If you press [Alt] or [Option] while dragging the white slider, the white areas in
the preview represent areas that will be pure white in the image. All areas of the image
that will be shadows or midtones are represented by black in the preview. As with the
Threshold adjustment, the **Color Sampler Tool** can be used at this point to create color
sampler marks, if desired.

Another way to set the black and white points is to use the eyedropper tools that
appear in the **Adjustments** panel or **Levels** dialog box. Before doing this, you may want
to use the **Threshold** adjustment to determine where the darkest and lightest pixels in
your image are located. Use the **Set Black Point** eyedropper to select the part of your
image that should be pure black. The black slider moves automatically when this is
done. Use the **Set White Point** eyedropper to select the part of the image that should be
pure white.

When adjusting color images, the **Set Gray Point** eyedropper can be used to remove
a slight color cast in the image. To use this feature, locate an area of the image that
should be true gray (have a saturation of 0) in your image and click on it with the **Set
Gray Point** eyedropper. When you click on the pixel, Photoshop shifts the saturation and
hue of all the colors in the image so that the selected pixel becomes gray, with a satura-
tion of 0. If you click on any pixel that already has a saturation of 0 (middle gray, white,
or black, it does not matter), the **Set Gray Point** tool has no effect on the image. Only if
the selected pixel has a saturation above 0, does the tool work.

Note	The **Set Gray Point** eyedropper is used only to compensate for minor color casts created by common lighting problems. Selecting a vivid color with the tool creates unpredictable results.

After setting the black and white points, use the gray slider under the histogram to
adjust the overall brightness of the image, if necessary. Dragging the slider to the right
darkens the image, and dragging it to the left lightens the image.

The **Output Levels** section of the **Levels** dialog box consists of a gradient bar with
two sliders and two text boxes. These controls are used to keep the shadows from being
too dark and the highlights from being too light for different types of print jobs. Printing
a newspaper will require different **Output Levels** settings than printing a magazine, so
consult with your print service provider for the actual settings to use.

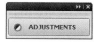

The Curves Adjustment

The **Curves** adjustment is Photoshop's most technical adjustment. This adjustment allows you to fine-tune your image by adjusting tonal values at up to 16 points along the tonal range for each of the image's color channels. Theoretically, the **Curves** adjustment provides Photoshop users the most control over correcting an image. However, in many cases, images can be adjusted just as effectively with simpler adjustments.

The **Curves** adjustment can be applied through the **Adjustments** panel or the **Image > Adjustments** submenu. When the adjustment is applied, it displays a graph that represents the tonal range of the image in its current state. The overall shape of the curve determines how the color in the image is adjusted. You can begin to see what this graph represents by pressing the **Click and drag in image...** button, and then moving the eyedropper cursor that appears around in your image without clicking. When the tip of the eyedropper is over a shadow, for example, a temporary marker appears near the bottom of the graph. Hovering over highlights will cause a temporary marker to appear near the top of the graph line. If you click in the image while the **Click and drag in image...** button is active, a control point will be placed on the graph; dragging in your image moves this control point. You can also move the control point by clicking and dragging it directly.

The best way to see how the **Curves** graph affects an image is to try out the curve presets. These presets can be used as a beginning point when adjusting an image. If you applied the **Curves** adjustment using the **Adjustments** panel, you can select a preset from the **Curves** drop-down list at the top of the panel. If you applied the **Curves** adjustment using the **Image > Adjustments** submenu, the presets are located in the **Preset** drop-down list at the top of the **Curves** dialog box. After selecting a preset, you can further adjust the curve to achieve the desired results. **Figure 10-18** shows the effects of several of these presets.

Adjusting Color in the Curves Dialog Box

The horizontal gradient bar is the scale representing the image's current tonal range. The vertical scale represents the tonal range in the adjusted version of the image. Before you make any adjustments, these values are identical, resulting in a straight diagonal graph line. By changing the graph line, you change the way the colors in the original image relate to colors in the adjusted image.

Suppose you wanted to adjust the brightness and color of a somewhat flat image, **Figure 10-19**. Begin by selecting a channel to affect from the **Channel** drop-down list. In most cases, you will want to adjust the RGB or CMYK channel, which affects the entire image. If your image has a color cast, you may want to adjust a specific color channel instead.

Next, with the **Click and drag in image** button active, position the cursor in the image window. A small circle appears on the curves graph. As you move the cursor, the small circle is repositioned on the graph to represent the tone currently under the cursor. If you click in the image window, a control point is created at the small circle's location on the graph. If you release the mouse button, you can continue to select additional control points. However, if you hold the mouse button and drag the mouse up or down, the control point on the graph is moved straight up or down, changing how bright or dark that tone becomes.

Once you release the mouse button, you can no longer edit the control point using the **Click and drag in image** feature. If you click and drag in the image window again, a

Figure 10-18.

The **Curves** presets provide good starting points for image adjustment. **A**—The original image is shown here for comparison. **B**—The **Darker** preset adds an editing point in the middle of the graph and moves it downward. This darkens all tones but the lightest and darkest, with increasing effect toward the middle of the tonal range. **C**—The **Lighter** preset adds an editing point in the middle of the graph and moves it up. This lightens all tones in the image except the lightest and darkest, with increasing effect toward the middle of the tonal range. **D**—The **Negative** preset inverses tones in the image, resulting in a graph that is the mirror image of the original. The effect is the same as choosing **Image > Adjustments > Invert**. **E**—The **Strong Contrast** preset adds three editing points to the graph. The editing point at the far right is moved upward, making the light tones lighter. The editing point at the far left is moved downward, darkening the shadows and dark midtones.

Figure 10-19.

When you apply a **Curves** adjustment to an image, begin by selecting a channel to adjust. Then, select the tone in the image that you want to adjust. When the **Click and drag in image** option is active, simply click in the image window to select a color to adjust, and then drag the mouse up or down to adjust the color.

The **Click and drag in image...** button Select a channel to affect Temporary marker shows the location of the sampled tone on the graph

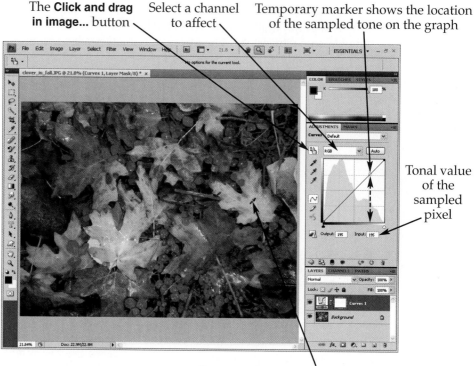

Tonal value of the sampled pixel

Position the cursor in the image to select a color to use as a control point

new control point will be created. Any additional adjustments to a tone after the mouse button has been released must be made by clicking and dragging the control point in the graph in the **Curves** dialog box or the **Adjustments** panel.

To understand how the control points relate to the tones in the image, move your eye from the control point straight down to the gradient bar (a black, gray, and white gradient) below the diagonal line. This will tell you how dark or light the area represented by the control point was before it was adjusted. The exact tonal value of sampled pixel is displayed in the **Input** box. This value refers to the sampled shade's tonal value on a scale of 0–255 (if your image is in RGB mode) or 0–100% (if your image is in CMYK mode). You can think of this number as the color's "brightness rating."

Then, look at the gradient bar on the left side of the graph. Determine whether you want the selected tone to be lighter or darker, and drag the mouse up or down to move the control point up or down until it is straight across from the desired tone. The exact tonal value of the adjusted shade is displayed in the **Output** box. See **Figure 10-20**. If you move the control point right or left instead of up or down (which can be done if you move the control points by dragging them on the **Curves** graph), you are actually selecting a different tone in the original image to edit.

| Note | When you move a control point in the graph line to change a tone, all non-white and non-black tones in the image are adjusted. However, the amount the tones are adjusted depends on how close they are to the selected tone. The closest tones are affected the most, and the farthest tones are affected least. |

Figure 10-20. _____
You can see what a control point's initial tonal value was by looking straight down from it. By looking straight to the left of the control point, you can see what its tonal value will be once the adjustment is applied. In this example, the lighter midtones have been lightened further by moving B up. The darker midtones have been further darkened by moving A down. This increases the tonal range and contrast in the image.

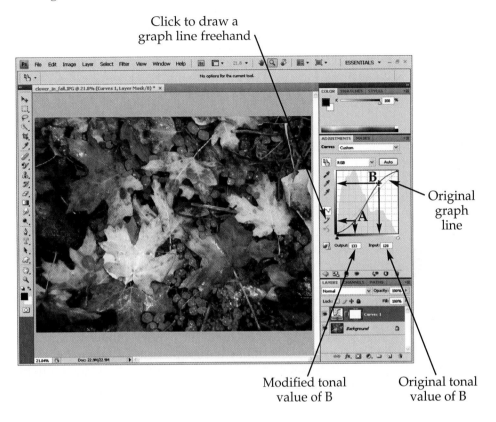

In the previous paragraphs, you learned how to use the **Click and drag image** option to create control points on the graph by clicking colors in the image window. As an alternative, you can add control points to the graph by simply clicking along the graph line in the **Adjustments** panel or **Curves** dialog box. You can then click and drag those points up and down to adjust their value. As you work, you can [Alt]-click in the graph to toggle between a large grid pattern and a small grid pattern. The additional gridlines in the small grid pattern make it easier to see the spot on the graph line that lies directly above the tone you want to adjust. When you have located the point on the graph line, click there to add a control point.

If the image you are working with is flat, meaning that it lacks a full range of tones, you will need to adjust two or more points along the graph. Notice in Figure 10-20 that control point A on the graph was moved down to a darker tone, and that control point B was moved up to a higher tonal value. The result is a darkening of some of the midtone grays, a lightening of some of the midtone grays, and an increase in the contrast of the image.

Advanced users can draw a curve instead of (or in addition to) clicking points to create control points to shape the graph line. To do this, click the **Pencil** button and then use the cursor to draw the graph line (or just sections of it) freehand. Position the cursor at the point where you want to start drawing freehand, click and hold, and drag the mouse to draw the desired line. You do not have to begin drawing on the existing line; you can begin anywhere in the graph. As you drag the mouse left or right, the line segment you draw replaces the corresponding section of the existing graph line.

Using the Eyedropper Tools and Black and White Sliders

The eyedropper tools or the black and white sliders in the **Curves** dialog box are very similar in function to the eyedropper tools found in the **Levels** dialog box. However, after using these tools in the **Curves** dialog box, you can further adjust the curve by adding more control points to it. Use the **Set Black Point** eyedropper to sample the darkest pixels in the image and the **Set White Point** to sample the lightest pixels in the image. Or, use the black and white sliders to set the black and white points. As with the **Levels** adjustment, if you put a check mark in the **Show Clipping** check box or press [Alt] or [Option] while dragging the black or white slider, a clipping display appears. Keep dragging the slider until the darkest or lightest areas stand out. [Shift]-click to set color sampler marks, if desired.

For color images, the **Set Gray Point** eyedropper works the same as the **Set Gray Point** eyedropper in the **Levels** dialog box. It changes the hue and saturation of the image's colors until the selected pixel becomes gray. The tool is not available for grayscale images.

Curve Display Options

If you applied the **Curves** adjustment using the **Image > Adjustments** submenu, the **Curve Display Options** toggle is located just below the eyedropper tools on the **Curves** dialog box. Activating this toggle expands the dialog box to include a number of display options. Clicking the toggle again hides the display options. If you applied the **Curves** adjustment using the **Adjustments** panel, the same options can be accessed by selecting **Curves Display Options** from the **Adjustments** panel menu. See **Figure 10-21**.

The first display control is the **Show Amount of** radio buttons. These radio buttons set the scale used to define the graph line. If you are adjusting an RGB image, the **Light** radio button is selected by default. When the **Light** radio button is selected, the tones described by the graph range from 0 (black) to 255 (white). The **Input** and **Output** values displayed at the lower-left corner of the graph reflect this scale.

If you are adjusting a CMYK image, the **Pigment/Ink** radio button is selected by default. When the **Pigment/Ink** radio button is selected, the horizontal and vertical tone bars are the reverse of those displayed when the **Light** radio button is active: they progress from white to black instead of black to white. When the **Light** radio button is active, the tone bars represent the amount of light emitted by the monitor, but when the **Pigment/Ink** radio button is active, the tone bars represent the amount of ink deposited on the page. In addition to reversing the tone bars, selecting the **Pigment/Ink** radio button also changes the scale of the graph from 0–255 (black to white) to 0%–100% (white to black). The change in scale is also reflected in the **Input** and **Output** values displayed near the graph.

In this same area, there are two buttons that control the appearance of the grid in the graph window. When the button on the left is selected, the grid is divided into 16 subdivisions. When the button on the right is selected, the grid is divided into 100 subdivisions. You can also switch between grid configurations by [Alt]-clicking in the graph window.

If you have adjusted one or more channels separately, placing a check mark in the **Channel Overlays** check box will display a non-editable graph line for each channel that was individually adjusted. Keep in mind that these individual channel graph lines will only appear when you reselect RGB or CMYK in the **Channel** drop-down list.

Activating the **Histogram** option displays a histogram for the channel selected in the **Channel** drop-down list. If RGB or CMYK is selected, a histogram for the entire image is displayed. These histograms help you see the distribution of shadows, midtones, and

Figure 10-21. _____

The **Curves** display options. **A**—If the **Curves** adjustment was applied through the **Image >
Adjustments** submenu, the **Curves** display options can be revealed or hidden by clicking the
double arrow button on the **Curves** dialog box. **B**—If the **Curves** adjustment was applied using
the **Adjustments** panel, the **Curves Display Options** can be accessed by choosing **Curves Display
Options** from the **Adjustments** panel menu.

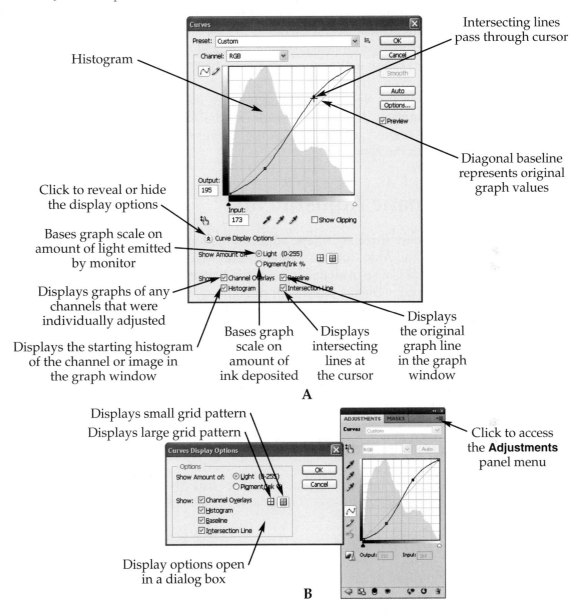

highlights on each channel or in the image as a whole. It should be noted that these
histograms represent the state of the image before the **Curves** adjustment was applied
and do not change as the image is adjusted.

Placing a check mark in the **Baseline** check box displays the original, diagonal line
that was the default "curve". By comparing the modified curve to the default curve, you
can get a better sense of the tonal ranges affected and the amount of change.

Last, placing a check mark in the **Intersection Line** check box displays crosshairs as
you click to add a point or adjust a curve. By following the crosshairs to the horizontal

and vertical tone bars, you can see how the selected tone in the adjusted image (at the intersection of the crosshair and vertical tone bar) relates to the original tone (at the intersection of the crosshair and horizontal tone bar).

Using Blending Modes to Limit an Adjustment's Effects

If color changes are too drastic when adjusting an image with the **Curves** adjustment (or other adjustment layers), blending modes can be used to mellow or restrict the adjustment. If colors in an image change too quickly and vividly when adjusting the image's curves, first cancel out of the current operation. Create a new **Curves** adjustment layer by choosing it from the **Adjustments** panel or by choosing **Layer > New Adjustment Layer > Curves...**. In the **New Layer** dialog box, set the **Mode** to **Luminosity**, which will allow only brightness values be adjusted, not the hue or saturation of colors in the image. Make the desired adjustments in the **Curves** dialog box, and click **OK** when you are happy with the results.

Automatic Adjustments

There are three automatic adjustments found in the **Image** menu: **Auto Tone**, **Auto Contrast**, and **Auto Color**. An **Auto** button (which has the same effect as the **Auto Tone** adjustment) is also available in both the **Levels** and **Curves** adjustment settings. These automatic adjustments work well in some cases, but in general, it is better practice to become familiar with manually adjusting color-correction settings.

You can adjust the behavior of these automatic adjustments by changing some advanced settings found in the **Levels** or **Curves** adjustments. Click the panel menu of either of these adjustments and choose **Auto Options...** Then enter new values in the **Auto Color Correction Options** dialog box. For more information about the technical nature of these settings, search for "auto adjustment" in Photoshop Help.

Color-Related Panels

Photoshop has several panels that are directly related to image color. These panels allow you to select and adjust color and review color and tool information.

The Info Panel

Regardless of what tool you are currently using in the image window, the **Info** panel, **Figure 10-22**, displays information about the pixel directly underneath your cursor. The **RGB** and **CMYK** sections show color information about the pixel. The other sections in the panel show other information relating to the tool being used and the cursor's location.

Bit Depth and Other Color Information

Two sections at the top of the **Info** panel display color information about the pixel under the cursor. The pixel's color composition (its RGB, CMYK, or Lab values) is displayed in the left section. The equivalent CMYK values are displayed in the right section. However, the CMYK information in this section may be replaced with other types of information when certain tools are used. If you have added one or more adjustment layers, two color values appear, separated by a forward slash (/). The first value represents the original color of the pixel, and the second represents the pixel color in its adjusted state. The bit depth of the image is displayed at the bottom of these sections.

Figure 10-22. _____
The **Info** panel displays information that includes tips about the currently selected tool, image color under the cursor, cursor location, selections, and image file size.

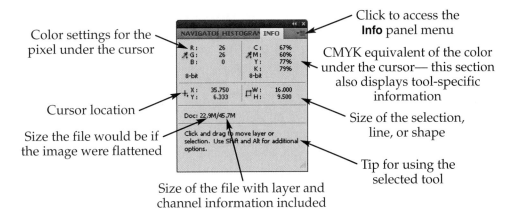

Color settings for the pixel under the cursor

Click to access the **Info** panel menu

CMYK equivalent of the color under the cursor— this section also displays tool-specific information

Cursor location

Size the file would be if the image were flattened

Size of the file with layer and channel information included

Size of the selection, line, or shape

Tip for using the selected tool

Bit depth is a measurement of how many different shades of color a Photoshop file can display. A *bit* is a tiny scrap of computer data that has two possible values: a one or a zero. In Photoshop, each pixel in a 1-bit image is strictly black or white.

In an 8-bit-per-channel image, a combination of eight bits is used to describe one pixel. Because an RGB image is divided into three channels (red, green, and blue), each pixel in the image is capable of displaying 2^8 (or 256) possible color values per channel, *simultaneously*. Think about using the **Color Picker**, where you can set red, green, or blue values anywhere between 0 and 255—a total of 256 different settings. If you do the math, each pixel in an 8-bit image can actually produce well over 16 million different color values when the three channels are combined to form a particular hue ($256 \times 256 \times 256 = 2^{8 \times 3} = 2^{24}$). That is generally considered a greater number of unique colors than human vision is capable of distinguishing. It also far exceeds the number of distinct colors that can be printed.

So why are some images captured at (as when shooting in RAW mode) or converted to bit depths higher than 8? The answer is that the greater number of colors allows more flexibility and reliability in editing. By increasing the initial number of colors in the image, you increase the mathematical precision used to calculate edits and decrease the risk that an edit or adjustment will produce an undesirable result.

Often an image is referred to by the number of its color channels times its bit depth. This can be confusing if you are not aware of it. For example, an RGB image with a bit depth of 8-bits per channel will often be referred to as a 24-bit RGB image (8-bit color depth times 3 color channels). If the same image were in CMYK mode, it would be referred to as a 32-bit CMYK image (8-bit color depth times 4 color channels).

For advanced-level, high-end photo retouching, images can be converted into a 16-bit-per-channel image (and in some cases, a 32-bit-per-channel image) by choosing the appropriate color depth from the **Image > Mode** submenu. This increases the number of different shades of color that can be produced. In many cases, images you work with in Photoshop will be 8-bits per channel. If you work primarily with RAW files, your images may be 16-bit. Not all of Photoshop's tools work with 16-bit- and 32-bit-per-channel images. 16-bit-per-channel images have up to 65,536 (or 2^{16}) shades for each color channel. 32-bit-per-channel HDR (or high dynamic range) images can contain more shades of color than a typical computer monitor is capable of displaying.

Note The title bar of an image window displays the color mode and per-channel bit depth of the image.

Location and Selection Size

Beneath the color information sections, you will find two sections that display cursor location and selection measurements. In the section on the left, the **X** and **Y** values show exactly where your cursor is. The **Y** value is the cursor's distance from the bottom of the image, and the **X** value is the cursor's distance from the left side of the image. Photoshop's **Ruler Tool**, grouped with the eyedropper tools in the **Tools** panel, also displays this information, along with distance and angle data if the cursor is dragged.

The right section displays **W** (width) and **H** (height) values as you create selections or vector shapes. In addition, the upper-right section of the dialog box, which displays CMYK color settings by default, will display different information when certain tools are selected or commands are run. This information may include anchor point location, change in position (ΔX and ΔY), angle (**A**), and distance (**D**). The exact types of information displayed in this section depend on the tool or command that is selected, and usually match the info displayed in the tool's options bar.

Other Information

Beneath the location and measurement sections in the **Info** panel, you will see a section that displays the *document size*, or file size. The number on the left represents the size the image file would be if it were flattened. The number on the right is the file size of the image with all layer and channel information included. If the image has only a single layer and only color channels, these numbers will be the same. Beneath the document size section is a section that displays tips about using the currently selected tool.

You can change the information that is displayed in the **Info** panel by opening the panel menu and selecting **Panel Options....** This opens the **Info Panel Options** dialog box. From this dialog box, you can choose new or additional types of information to display in the **Info** panel. You can also use this dialog box to change the units that certain information is displayed in.

The Color Panel

The **Color** panel, **Figure 10-23**, can be used instead of the **Color Picker** to choose a foreground color. From the **Color** panel menu, you can select from several different slider configurations that will produce RGB, CMYK, and other color mode combinations. The sliders work the same as the sliders in the **Color Picker**.

Colors can also be chosen from the spectrum (the colored bar at the bottom of the panel). This is essentially the same as picking a color by clicking in the color field of the **Color Picker**. You can change the spectrum by selecting a different option in the **Color** panel menu.

Figure 10-23. _____
You can use the **Color** panel to select a new foreground color.

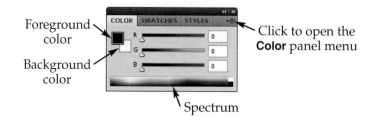

Foreground color

Background color

Click to open the **Color** panel menu

Spectrum

To set a foreground color with the **Color** panel, simply adjust the sliders to produce the desired color, or select it from the spectrum. The foreground color is automatically updated as you adjust the settings. If you want to select a new background color, you must first switch the foreground and background colors. Then, make the desired changes. When you have the color you want, switch the foreground and background colors again.

The Swatches Panel

Clicking on a color in the **Swatches** panel, Figure 10-24, is yet another way to choose the foreground color. *Swatches* are a collection of color samples, like you might find at a paint store.

In its default state, the **Swatches** panel displays six RGB colors on the top row: red, yellow, green, cyan, blue, and magenta. These colors are at full brightness (values of 255). These swatches are followed by a series of ten swatches that progress from white to 50% gray. The next six swatches display the same colors as the first six swatches, only in CMYK mode, using maximum ink settings. These six swatches are followed by a series of 10 swatches that progress from 55% gray to black. The next series of 16 swatches in the default **Swatches** panel is a collection of light, pastel colors. The next four series of 16 swatches are increasingly dark versions of the same colors. The final ten swatches in the default **Swatches** panel are a collection of brown colors.

The **Swatches** panel menu displays a long list of colors that can be loaded into the panel, including spot colors. When you select one of these other collections of swatches, a dialog box appears asking if you want to append the existing swatches with the new swatches or replace them. If, after loading a new set of swatches, you want to restore the default swatches, select **Reset Swatches...** from the **Swatches** panel menu.

You can add any color to the **Swatches** panel by clicking the **Add to Swatches** button on the **Color Picker** dialog box. Or, after selecting the color in the **Color Picker**, select **New Swatch...** from the **Swatches** panel menu. Both of these methods let you assign a name to the color before saving it to the **Swatches** panel. You can store your customized collections of swatches using the **Save Swatches** command in the panel menu. If you want your collection of swatches to be available to other Adobe CS4 applications, use the **Save Swatches for Exchange** command instead of the **Save Swatches** command. After saving a collection of swatches, you can use the **Load Swatches** command to add a saved collection of swatches to the current swatch collection, or the **Replace Swatches** command to replace the current swatch collection with a saved collection.

Figure 10-24. _____
Colors can also be selected using the **Swatches** panel. This figure shows the **Swatches** panel in its floating state. When the panel is docked, two additional swatches are included in each row, shifting the arrangement.

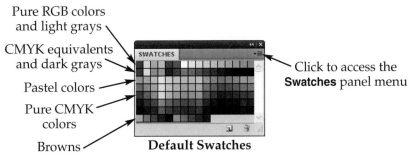

The Kuler Panel

The **Kuler** panel helps you create, share, or browse for color themes. A color theme is a collection of a few colors that work well together. An Internet connection is required to use all of the features on this panel. To open the Kuler panel, choose **Window > Extensions > Kuler**.

The **Kuler** panel connects you to Adobe's Kuler website. If you click the **Browse** button on the panel, you can browse for color themes that have been created and shared by other Photoshop users. Buttons at the bottom of the panel allow you to add the selected color theme to your **Swatches** panel or load the theme into the **Create** section of the **Kuler** panel so you can edit the color theme. See **Figure 10-25**.

The **Create** section of the Kuler panel is a color picker with several different built-in "rules" that are different ways to aid you while creating or editing a color theme. You can save your edited color themes to the **Swatches** panel or upload them to the Kuler website.

Camera RAW

Many digital cameras can capture images in a high-quality format called *Camera RAW* in addition to the JPEG format (file formats are discussed further in Chapter 12, *File Management and Automated Tasks*). When images are captured as Camera RAW files, the image is saved exactly as the camera saw it. JPEG images, on the other hand, are compressed in the camera right after being captured. As a result, some of the original

Figure 10-25. _____

If you have an Internet connection, you can use the **Kuler** panel to select, edit, and load color themes into your swatches panel. **A**—The **Browse** section of the **Kuler** panel allows you to browse through predefined color themes. **B**—New color themes can be created in the **Create** section of the **Kuler** panel. You can also edit color themes selected in the **Browse** section.

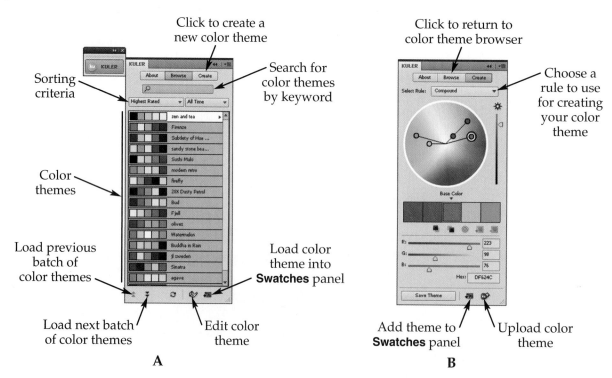

Click to create a
new color theme

Click to return to
color theme browser

Sorting
criteria

Search for
color themes
by keyword

Choose a
rule to use
for creating
your color
theme

Color
themes

Load previous
batch of
color themes

Load color
theme into
Swatches panel

Load next batch
of color themes

Edit color
theme

Add theme to
Swatches panel

Upload color
theme

A

B

color data is lost. The benefit of the JPEG format is that file sizes are much smaller than Camera RAW files. RAW, JPEG, or TIFF images (that do not contain more than one layer) can be fine-tuned using the **Camera Raw** dialog box. Photoshop's **Camera Raw** dialog box is more advanced than a typical dialog box. It is a *plug-in*, an additional piece of software that functions together with Photoshop and expands Photoshop's capabilities.

The Camera Raw Dialog Box

The **Camera Raw** dialog box is loaded with color-adjustment settings and several powerful tools. Many of these additional settings are photography-related, such as the **Temperature**, **Exposure**, and **Fill Light** sliders. You will recognize many other settings that are similar to those found in other adjustments you have already learned about.

When you open a Camera RAW image in Photoshop, the **Camera Raw** plug-in opens and a dialog box appears, Figure 10-26. **Camera Raw** lets you color-correct your image *non-destructively*, always preserving the original image data and keeping track of your adjustments separately. This means that you can make adjustments to an image, click the **Done** button, return to the same image at a later time, and restore the image to its original settings or adjust the settings further without any loss in image quality. If you click the **Open Image** button, the **Camera Raw** dialog box disappears and Photoshop's familiar workspace returns, letting you edit the image as you would any other file.

Figure 10-26.

The **Camera Raw** dialog box offers a variety of tools and settings for adjusting the appearance of your image.

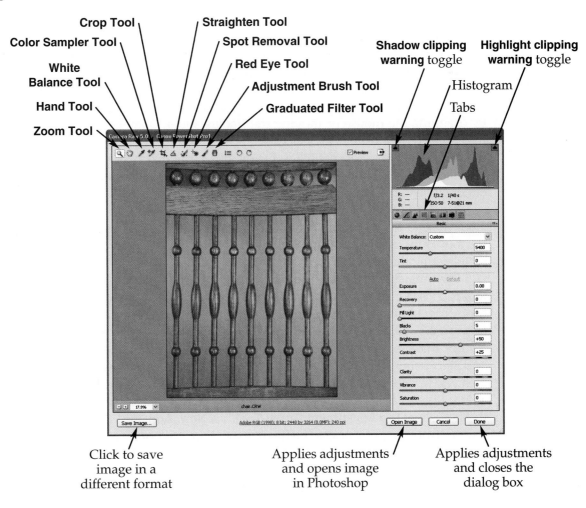

To open and edit JPEG or TIFF images in **Camera Raw**, first choose **File > Browse in Bridge...** to open Bridge (another plug-in program, explained further in Chapter 12). Bridge is a file-management tool that makes it easy to view and organize your images. Select the image in Bridge (either JPEG, TIFF, or Camera RAW) and choose **File > Open in Camera Raw....** After editing your image, click the **Done** or **Open Image** button.

Camera Raw Settings: Toolbar Overview

At the top of the **Camera Raw** dialog box are several tools, starting with a **Zoom Tool** and **Hand Tool**. Next is the **White Balance Tool**, which provides a good starting point when adjusting an image. Use this tool to click on an area that is gray or white. In many images, white or gray areas will have a slight color cast, and the **White Balance Tool** adjusts the entire image to correct for this problem. The **Color Sampler Tool**, which is just to the right of the **White Balance Tool**, creates color sampler marks and displays the RGB values of the sampled pixels.

Next are the **Crop Tool** and **Straighten Tool**, which is really a **Crop Tool** that can produce a rotated crop. After dragging a crop box with either of these tools, you can adjust the handles to resize the crop box as desired. The unwanted portions of the image outside the crop box are covered with gray. When you click the **Open Image** button, the gray (cropped) area will be gone. You can also choose to save the crop information by choosing the **Done** or the **Save Image...** button. As mentioned previously, edits made in the **Camera Raw** dialog box are non-destructive. When you reopen an image that has been cropped in the **Camera Raw** dialog box, it reopens in the **Camera Raw** dialog box. The entire image is visible, with gray covering the areas that are hidden. You can resize the crop box by clicking on the **Crop Tool** and adjusting the crop box handles. You can completely remove the crop box by clicking the **Crop Tool** and then pressing [Esc]. In order to permanently crop the image, you must crop it in the **Camera Raw** dialog box, click the **Open Image** button, and then save the cropped image in Photoshop.

The **Spot Removal Tool** is effective at removing blemishes caused by dust specks that accumulate on a SLR digital camera's image sensor. These specks often get on the sensor when you change the camera's lenses. This tool works differently than Photoshop's other retouching tools. When you click on a blemish, a red circle appears, which you can resize by dragging the mouse or moving the **Radius** slider. **Camera Raw** automatically finds a undamaged area from which to clone, places a green circle around that area, and heals the damaged area. You can click inside either the green or the red circle and drag to relocate either the source point or the repair. You can also click and drag the perimeter of either circle to resize both.

The **Red Eye Tool** is similar to Photoshop's equivalent tool, except you drag a rectangle around the red pupil instead of clicking on it. You can increase the area affected by the tool by increasing the **Pupil Size** slider setting, and you can darken or lighten the pupil by adjusting the **Darken** slider.

The **Adjustment Brush Tool** is a powerful and flexible adjustment tool. When this tool is chosen, its settings appear at the right side of the **Camera Raw** dialog box. You can control brush size with the **Size** slider, brush strength with the **Flow** and **Density** sliders, and brush hardness with the **Feather** slider. This tool works by applying a mask similar to a quick mask, but invisible. However, each time you change the color adjustment settings and start using the **Adjustment Brush Tool** again, **Camera Raw** remembers the previous area you worked on and marks it with a "pin" symbol. You can click on these pin symbols at any time to adjust previously-edited areas of the image. Similar to other tools found in Photoshop, the **Adjustment Brush Tool** has **New**, **Add**, and **Erase** (or subtract) buttons that control whether a new adjustment mask is created or an existing mask is added to or

subtracted from. It should be pointed out that when you create a new mask, the existing masks remain in the image and an additional mask is created.

You can make the mask visible by placing a check mark in the **Show Mask** check box. If you put a check mark in the **Auto Mask** check box, the program automatically detects areas of similar color in the image and creates a mask that conforms to those areas. You can change the color of the mask by clicking the **Mask overlay color** box and picking a new color in the **Color Picker**. See **Figure 10-27**. When you are done making the adjustments, you may want to turn off the mask display so you can clearly see the changes in the image.

The **Graduated Filter Tool** is similar in function to the **Adjustment Brush Tool**. It is named after a lens-mounted filter that has a gradient applied to it. As a result, this filter causes less light to pass through certain areas of the filter. When capturing scenery shot with a bright sky, for example, the graduated filter can be placed on the camera lens so that less light from the sky area reaches the image sensor. The **Graduated Filter Tool** uses a gradient mask (instead of a brush) to apply any of the same adjustments that the **Adjustment Brush Tool** can apply. You can drag the gradient at any angle. A green circle appears where you begin dragging a gradient, and a red circle appears where the gradient ends (or, has completely faded out). More than one **Graduated Filter** adjustment can be applied by clicking the **New** button. When the **Edit** button is pressed, you can adjust a gradient.

The remaining tools in the **Camera Raw** dialog box's toolbar are straightforward. The **Open Preferences** button opens the **Camera Raw Preferences** dialog box. In this dialog box, you can adjust the program's cache, the way certain functions are performed, and

Figure 10-27. ——
The **Adjustment Brush** is being used to darken the chair's slats. A green color has been selected for the mask, and the **Auto Mask** and **Show Mask** options are turned on.

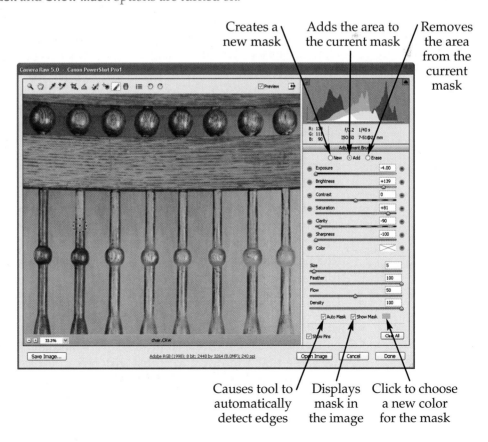

the way the plug-in handles DNG, TIF, and JPEG images. Next to the **Open Preferences** are two **Rotate** buttons that allow you to rotate the image clockwise or counterclockwise. The **Preview** check box allows you to toggle between a display of the original image and the adjusted image. When this check box is unchecked, the edits you made to the image are still there, but their effects are not shown in the image window. The **Toggle full screen mode** button is used to change the **Camera Raw** dialog box from a floating dialog box to a full screen and back again.

A histogram appears in a small window to the right of the toolbar. This histogram is very similar to the **Histogram** panel in Photoshop. It displays the distribution of tones in the image and is updated as the image is adjusted. A button in the upper-left corner of the histogram toggles clipping display for shadows. When this feature is turned on, shadows that are too dark are displayed in blue in the image window. A button in the upper-right corner of the histogram toggles clipping display on and off for the image's highlights. When this feature is turned on, highlights that are too light are displayed in red.

Beneath the histogram, information about the camera settings used to capture the image is displayed. This information is known as metadata. If the cursor is currently positioned in the image window, color information about the pixels under the cursor is displayed just to the left of the metadata. Just below the metadata and color information is a series of panel tabs. The function of these tabs are explained in the following section.

Camera Raw Settings: Tabs Overview

When adjusting the color of an image in the **Camera Raw** dialog box, it is good to work systematically. After adjusting the white balance, as with the **White Balance Tool**, start with the first tab (called **Basic**) and experiment with the sliders, moving from top to bottom. Then move left to right through the remaining tabs, experimenting with the sliders on each tab. Almost all of the sliders found on each tab are color-coded, giving you a visual clue about how the slider will affect your image.

Entire books have been written about adjusting images in **Camera Raw**. As you gain experience making adjustments in this dialog box, you will find that some of the sliders are critical, while others are strictly optional. Rather than discuss each slider in detail, a brief overview of what each tab offers is presented here. Sliders that are especially useful are briefly described.

- **Basic** tab: These sliders are used for color correction, tinting, and toning. The **Temperature** slider can make an image appear cooler (by adding more blue) or warmer (by adding more yellow). The **Exposure** slider can do a remarkable job correcting a poorly exposed image. The **Recovery** and **Fill Light** sliders enhance the effectiveness of the **Exposure** slider.

- **Tone Curve** tab: These sliders are used to further adjust the color-correction settings you have previously made. Rather than being divided into just highlights, shadows, and midtones, the tonal ranges in your image are controlled by four sliders: **Highlights**, **Lights**, **Darks**, and **Shadows**. A curve is generated as you fine-tune each of these settings.

- **Detail** tab: Sharpening and noise-reduction controls are available from this tab.

- **HSL/Grayscale** tab: Color-correction sliders are found here. When you select either the **Hue** tab, **Saturation** tab, and **Luminance** tab, eight sliders become available that allow you to adjust different color ranges for the portion of the image you are adjusting. When the **Convert to Grayscale** check box is checked, this tab is similar to the **Black & White** adjustment, but provides even more precise control.

- **Split Toning** tab: The sliders in this tab let you create a two-toned tinted image from a grayscale image. You can assign one color to the shadows, another to the highlights, and then control the balance between the two tints.

- **Lens Corrections** tab: From this tab, you can correct fringes that appear around a subject (chromatic aberration). The **Lens Vignetting** slider darkens or lightens the corners of the image. This creates an interesting special effect in portrait images, for example. The **Post Crop Vignetting** section is used to apply a vignette to an image you plan on cropping later. The settings in this section create a vignette that automatically adjusts when the image is cropped.

- **Camera Calibration** tab: This tab contains advanced settings for adjusting color, based on the manner in which your particular camera captures color.

- **Presets** tab: As its name implies, this tab is a place to save **Camera Raw** dialog box settings. To save your settings, click the small **Save** button at the bottom right of the panel. This opens the **New Preset** dialog box. After naming your preset, you can select the settings to save by placing or removing check marks from the setting check boxes. You can apply those settings to another image by opening the image in **Camera Raw**, clicking the **Presets** tab, and then clicking on a preset in the list.

The Camera Raw Menu

In the top-right corner of each of the **Camera Raw** dialog box's tab panels is a button that opens the **Camera Raw** menu, **Figure 10-28**. At the top of the menu are different groups of settings that you can choose from. You can quickly apply the various settings to the image by clicking the appropriate settings in the menu. The **Image Settings** option applies the settings that were saved with the image. The **Camera Raw Defaults** option applies the **Camera Raw** default settings to the image. Depending on the way **Camera Raw**'s preferences are set up, default settings can apply to images captured by a specific

Figure 10-28.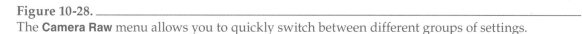
The **Camera Raw** menu allows you to quickly switch between different groups of settings.

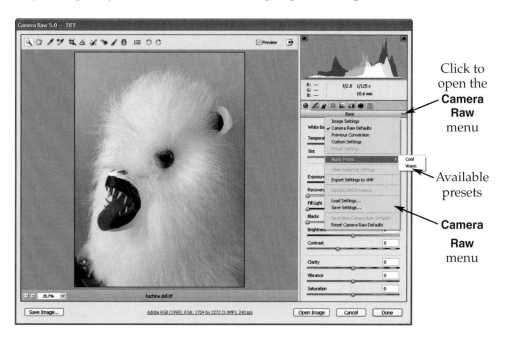

camera or at a particular ISO setting, or can apply to all images. The **Previous Conversion** option applies the same settings that were used on the last image. The **Custom Settings** option applies the settings that are currently set in the various tabs. From this menu, you can also save and load preset settings, save current settings to an XMP file, set current settings as default, and reset default settings.

Camera RAW Format vs. JPEG Format

If you own a digital camera that can capture both RAW and JPEG formats, you may be wondering in what situations you should use each format. It boils down to personal preference. If you shoot in RAW format, the colors in your image are in a more pure state than if you shoot in JPEG, but the differences are sometimes very hard to see. Fine-art photographers and other professionals who desire as much control as possible over the colors in their images will enjoy the benefits of shooting in RAW format. Other photographers are satisfied when capturing with their camera's highest-quality JPEG settings. Keep in mind that RAW, JPEG, or TIFF files can all be edited non-destructively using the powerful tools in the **Camera Raw** dialog box. If you are the type of photographer who evaluates the color quality of their captured images very closely, you should experiment with both formats and decide for yourself in what situations you will use each format.

Recommended Sequence for Color Correction

Now that you have been introduced to Photoshop's color-correction tools, you may wonder if there are certain steps you should follow as you correct color in an image. Adobe has recommended the following sequence:

Use tools of your choosing to accomplish the following tasks in the specified order:

1. Correct any color casts first.

2. Correct oversaturated (too intense) or undersaturated (too weak) problem areas.

3. Adjust highlight and shadow areas as needed.

4. Set overall tonal range of the image by adjusting white and black points.

5. Make other color adjustments that please your eye.

6. Sharpen the image, if necessary.

Color Management

Have you ever printed an image from Photoshop and found that the colors looked quite different from the way they appeared on your monitor? This is a common problem that Photoshop users face.

Another challenge is that there are inconsistencies in the way that various devices handle color. Different printer models print colors differently. Digital cameras and scanners can produce slightly different results when capturing color. And, the colors displayed on a computer monitor can vary slightly from one model to the next.

Steps can be taken to ensure that colors are reliable when capturing, editing, displaying, and printing images or other colored documents. This can be controlled

through a process called color management. Color management is a highly technical procedure. Entire books have been written about the subject. Because many readers of this text are not professional Photoshop users yet, color management procedures will be briefly introduced here, but not thoroughly explained.

Color management requires you to do the following:

- *Calibrate* your monitor. This means that you set your monitor to display colors using certain brightness and contrast settings, etc. Information on how to calibrate a monitor can be found in Photoshop's help files.

- Choose an RGB color workspace. An *RGB color workspace* is a generic setting that controls how your monitor will display RGB colors. You can view the different choices by choosing **Edit > Color Settings...** and then clicking the **RGB** drop-down list in **Working Spaces** section of the **Color Settings** dialog box. **Adobe RGB** is a highly recommended all-purpose setting. The **sRGB** workspace has a more limited range of colors and is better suited for working with images that will be displayed on screen rather than printed.

Note By default, Photoshop CS4's RGB color workspace is set to sRGB IEC61966. Unless you are a web designer, it is recommended that you change this setting to Adobe RGB as described above.

- Create ICC profiles of your monitor, printer, and image capture devices. *ICC profiles* are small computer files that describe how your monitor, printer, and other devices display or capture color in terms of standards set by the International Color Consortium. ICC profiles may ship with a device, or you may be able to download them. However, the most accurate ICC profiles are created using third-party color-calibration hardware and software. For example, you can create several different profiles for the same inkjet printer—each on a different kind of paper. You will find there are many color-calibration products and packages available if you search for "color calibration" at your favorite online technology supplier. Another option is to hire someone to do color calibration for you. Your print service provider may be able to recommend a qualified individual. There are also online companies that provide color-management services.

- After ICC profiles have been created and stored in the proper folders on your hard drive, you must assign profiles and convert from one profile to another as you work. These commands are found under Photoshop's **Edit** menu. For example, after scanning an image, you can choose **Edit > Assign Profile...** and choose the ICC profile you created for your scanner. Because of the scanner's ICC profile, Photoshop understands how your scanner captures color and adjusts the colors in your image appropriately, although the differences may be subtle. If you want to apply color correction to your image, you will next need to convert the image to working RGB mode (the RGB color workspace you chose previously). When you are ready to print, choose **File > Print....** In the **Print** dialog box, you can choose **Photoshop Manages Colors** from the **Color Handling** drop-down list. Then, you will be able to select the correct profile from the **Printer Profile** drop-down list.

Printing to a Desktop Printer

When you choose **File > Print**, you will see many settings in the **Print** dialog box, **Figure 10-29**. These settings are described in the paragraphs that follow.

At the left is a rectangular area that contains a preview of your image. The *entire rectangular area* represents the paper size you have chosen. This can be changed by clicking the **Page Setup...** button when the correct printer is selected from the **Printer** drop-down list. The *white area inside the rectangular area* represents the *printable area*. Printers typically cannot apply ink or dye at the very edges of a piece of paper, due to mechanical limitations. The three check boxes that appear under this preview window are explained near the end of this section.

Page setup, image position, and scaling settings are found in the central area of the **Print** dialog box. If you remove the check mark from the **Center Image** check box, you can move your image to another location on the page either by dragging it in the preview area or entering numeric values in the **Top** and **Left** boxes.

The **Scaled Print Size** section lets you adjust the size either by entering values in the **Scale** or **Width** and **Height** boxes. You can also drag the corners or edges of the bounding box in the preview area. If you want the image to print as large as possible on the paper selected, place a check mark in the **Scale to Fit Media** check box. The print resolution of the image displays and automatically updates as you scale your image. Scaling an image in the **Print** dialog box does not permanently change the resolution of your image—it is a temporary adjustment that applies to the current printout only.

The **Print Selected Area** check box is available if you selected part of your image with the **Rectangular Marquee** tool before printing. When this check box is checked, only the selected portion of the image will print.

Figure 10-29. _____

The **Print** dialog box has controls for resizing the printed image and relocating it on the page. It also includes controls for color management and creating crop marks, registration marks, and other marks used by commercial printing services.

Placing a check mark in the **Bounding Box** check box creates a box with adjustable handles around your image in the preview window. You may not see the bounding box if your image is too large. If this is the case, scale the image to a smaller size using the **Scale** settings. Then, the box should appear. You can drag the handles or edges of the bounding box to scale the printed image.

At the top of the far right section of the dialog box is a drop-down list, from which you can select **Color Management** settings or **Output** settings. The settings that appear in this section when **Color Management** is selected are primarily for Photoshop users who employ color management in their workflow. Because color management settings are quite technical, when your mouse is over a particular setting, a helpful explanation appears in the **Description** area in the bottom-right of the **Print** dialog box. In this section, you can choose to print your image "normally" by leaving the **Document** radio button selected. A default color profile is listed next to this button, unless you chose a profile yourself using the **Edit > Color Settings...** command. As an alternative, you can select the **Proof** radio button to simulate how the image might look on a different kind of printer, such as a commercial press. In the **Proof Setup** drop-down list, you can choose between **Current CMYK** and **Current Custom Setup**. The type of equipment to be simulated by the **Current Custom Setup** option can be changed using the **View > Proof Setup > Custom...** command.

If the **Color Handling** drop-down list is set to **Printer Manages Colors**, your printer driver determines how colors are interpreted from Photoshop and applied to the printed page. If you select **Photoshop Manages Colors** (recommended), you can choose a specific printer profile that you obtained from the manufacturer or, better yet, created yourself. When you select this option, a warning appears, reminding you to turn off color management (if available) in the printer dialog box. This refers to the printer-specific dialog box that appears when you click the **Print...** button. If you are printing a CMYK image, the **Separations** option can be chosen from the **Color Handling** drop-down list. This option will cause four separate images to print (one of each color) that show the ink necessary to create the image on an offset press.

Now, back to the three check boxes that appear under the preview window on the left side of the **Print** dialog box. When the **Photoshop Manages Colors** option is enabled and the correct **Printer Profile** is selected, these three check boxes, when checked, will change the appearance of the preview window. The **Match Print Colors** option shows how the colors in your image will appear when they are printed. This allows you to evaluate the image's appearance onscreen prior to printing, a technique known as *soft proofing*. The **Gamut Warning** option is a different way to view what colors will change when the image is printed: it displays a gray overlay over colors that cannot be reproduced properly by your printer. The **Show Paper White** option shows how your image will appear based on the paper type specified in the printer profile you have selected.

The **Rendering Intent** drop-down list offers different ways colors are converted during color management, and you can read the technical descriptions of each displayed in the **Description** section. The default choice, **Relative Colormetric,** is a good all-purpose setting. The **Saturation** setting can be used for non-photographic images, such as charts and graphs, because colors become very vivid.

The settings that are available when **Output** is selected in the drop-down list at the top-left corner of the dialog box are primarily used for preparing documents for commercial printing. One exception is the handy **Border...** button, which you can use to create a black border up to 10-pixels wide around your image.

GRAPHIC DESIGN

Color Harmony and Contrast

As you create various combinations of color in a design, be aware that different moods can be created by placing particular colors next to each other. Color combinations can be grouped into two basic categories. *Analogous colors* are colors that look good together, creating a sense of harmony and tranquility. *Complementary colors* are extremely different from each other and cause each other to stand out.

As you read this section, refer to the RYB (red-yellow-blue) color wheel shown in **Figure 10-30**. This traditional color wheel is slightly different than the RGB/CMY color wheel you were introduced to in Chapter 9, because it represents a subtractive color system (such as different shades of paint). In a traditional color wheel, red, yellow, and blue are *primary colors*. When two primary colors are mixed, a *secondary color* is created. Secondary colors are orange, green, and violet. When a primary and secondary color are mixed, a *tertiary color* is created (such as red-violet or yellow-green). You may find it useful to know that *cyan* is near in color to green-blue on the traditional color wheel and *magenta* is near in color to red-violet.

Analogous colors are next to each other (or very near to each other) on a color wheel. They blend well together and can help create a calm, peaceful mood in a design. Using a color combination such as blue and violet is an example of an analogous color scheme. See **Figure 10-31**.

Complementary colors are opposite from each other (or near-opposite) on a color wheel. Complementary colors, when used together, cause each other to stand out vividly. Examples of such color combinations are blue and orange or red and green.

The CD liner design in Figure 10-31B uses a combination of red and blue; these colors are *almost* opposite from each on a color wheel. Red and blue contrast vividly and are much more complementary than analogous, so they create a sense of energy when used together.

Graphic designers should use good judgment when using complementary colors. If designs are too attention-grabbing, some viewers might be repelled by the design instead of attracted to it.

When text is placed on a design, it must contrast sharply with the background so it can be easily read. In most cases, black or white text stands out better than colored text. Even if black or white text is used, consider using layer styles such as drop shadows to help the text contrast more with the background.

Examine the versions of the Farmer's Market poster in **Figure 10-32**. This design is extremely varied and colorful—and busy. When text is added without any layer styles, none of the colors stand out well from the multicolored background. In the second example, a drop shadow has been added to each text entry. In the last example, both a drop shadow and a stroked border have been added to each text entry. Which text example is easiest to read? Do you agree that the easiest text to read is white with both a drop shadow and a stroked border added?

Figure 10-30. _____
A traditional (RYB) color wheel can be used to determine whether colors are analogous or complementary.

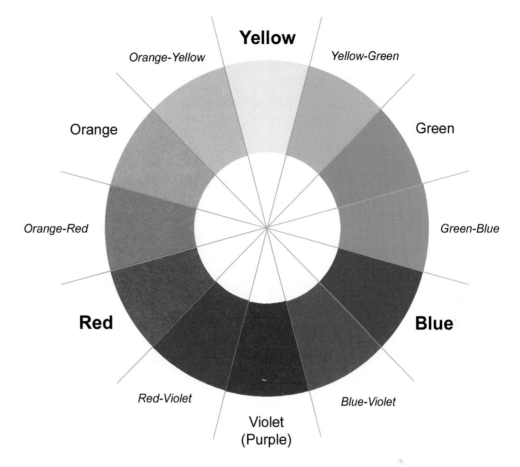

Figure 10-31. _____
The color combination used in a design affects the mood of the design. **A**—When analogous colors are used in a design, a calmer mood is created. **B**—The original design uses contrasting colors, red and blue, to create a more energetic feeling.

A **B**

Figure 10-32. _____
Which of these text examples most effectively contrasts with the background colors? **A**—Plain text of various colors. **B**—Various colors of text with drop shadows. **C**—Various colors of text with stroked borders and drop-shadows.

A B C

Summary

In the last two chapters, you learned about Photoshop's color correction tools and panels. Because many of these tools and panels are closely related, it is seldom necessary to use *all* of them. Think about different ways to accomplish the same color adjustment, and choose the color correction tools that help you get the best results.

In this chapter, you have been introduced to some of the deeply technical issues that advanced Photoshop users must be familiar with. With practice, experience, and further training, you will become more comfortable with these topics. For Photoshop users who are preparing projects for commercial printing presses, remember to seek the advice of knowledgeable staff at printing companies with whom you do business.

CHAPTER TUTORIALS

> **Note** The files needed to complete the tutorials in this book can be downloaded from the *Learning Photoshop CS4 Student Companion Web Site*. Refer to the "Using the Companion Web Site" section of the book's Introduction for more information.

In the tutorials that follow, you will use the **Levels** adjustment and **Curves** adjustment to adjust some images. You will also correct an image using the sequence recommended in this chapter.

Tutorial 10-1: Adding a Levels Adjustment Layer

In this tutorial, you will add a **Levels** adjustment layer to darken an area of the design behind text. This will help the text to stand out and make it more legible.

1. Open the 05cardfront.psd file you edited in an earlier chapter.

2. Choose **Edit > Preferences > Guides, Grid & Slices**.

3. In the **Preferences** dialog box, make sure the controls in the **Grid** section are set up to display a gridline every 1" with 4 subdivisions. Click **OK** when finished.

4. Turn on the grid by choosing **View > Show > Grid**.

5. Choose **View > Snap To** and, in the submenu, make sure there is a check mark next to **Grid**. Then, make sure there is a check mark next to **Snap** in the **View** menu.

6. Use the **Rectangular Marquee Tool** to select the area shown.

 The selection border snaps to the gridlines.

7. Choose **View > Snap** to turn off snap.

8. Choose **View > Show > Grid** to turn off the grid.

9. In the **Layers** panel, click the layer that contains the yellow flowers to make it active.

10. Click the **Create New Fill or Adjustment Layer** button on the **Layers** panel and choose **Levels** from the list that appears.

11. In the **Adjustments** panel, drag the gray (midtones) slider at the bottom of the histogram until the middle text box below the histogram reads .55.

 You can accomplish the same thing by entering .55 in the middle text box.

12. If necessary, use the **Move Tool** to position the text so it fits attractively in the area you just darkened.

 Make sure you select the text layers in the **Layers** panel or you will move the adjustment layer instead of the text.

13. Choose **File > Save As...** and name this file 10cardfront.psd. Close the file after you have saved it.

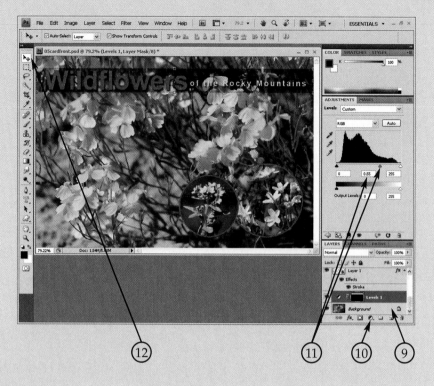

Tutorial 10-2: Correcting an Image Using Levels

In this tutorial, you will add a **Levels** adjustment layer and use it to set a new black point. The result is better contrast and an increase in the tonal range of the image.

1. Open the speaker2.jpg file.

2. Click the **Levels** adjustment on the **Adjustments** panel.

3. Click the **Set Black Point** button and then click on an area inside the speaker grille that is dark gray. Do not click on the grille itself.

 Notice that the image and histogram are adjusted automatically when the gray is sampled.

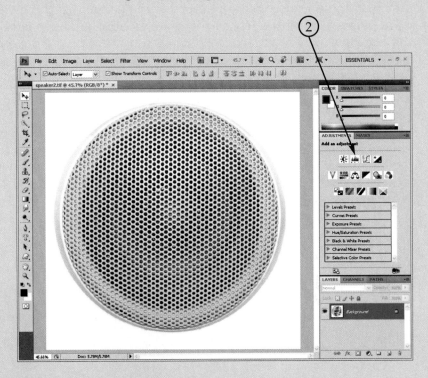

Note When using the **Eyedropper Tool** to sample a color, make sure the bottom-left tip of the eyedropper cursor is positioned over the pixel you want to sample.

4. Drag the white slider at the right corner of the **Output Levels** gradient bar until the amount in the corresponding **Output Levels** text box is 245.

5. Choose **File > Save As…** and name this file 10speaker2.tif.

6. Close the 10speaker2.tif file.

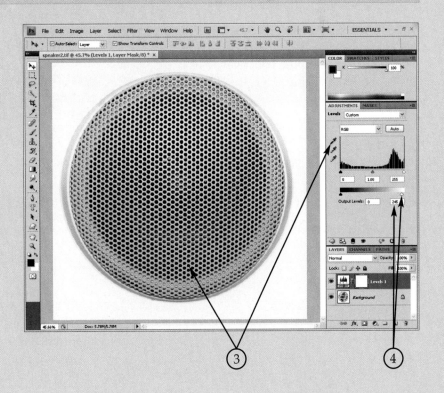

Tutorial 10-3: Correcting an Image Using Curves

In this tutorial, you will convert an image to grayscale color mode. Instead of using the **Show Clipping** technology built into the **Curves** adjustment, you will use the **Threshold** adjustment to determine the lightest and darkest portions of the image, which you will then set as the white point and black point of the image. You will improve contrast and expand the tonal range of the image using a **Curves** adjustment layer. You will remove heavy shadows from one subject using a **Levels** adjustment layer and finally sharpen the image using the **Unsharp Mask** command.

1. Open the 08bball.psd file that you began restoring in an earlier chapter.

 This image has a heavy, brownish-yellow color cast. Because it is an old photo, you will turn it into a grayscale image.

2. Choose **Image > Mode > Grayscale**. Click **Discard** when asked if you want to discard color information.

3. In the **Adjustments** panel, click the **Threshold** button.

4. In the **Adjustments** panel, drag the slider to the right until only the lightest areas remain.

 For this image, a value of 143 in the **Threshold Level** text box is about right.

5. Choose **Window > Info**.

6. In the **Tools** panel, choose the **Color Sampler Tool**. Make sure the **Point Sample** option is selected.

 The **Color Sampler Tool** is grouped with the **Eyedropper Tool**.

7. Carefully position the tip of the **Color Sampler Tool** over a group of white pixels in the image and click.

 This places a color sampler mark on one of the brightest spots in the image.

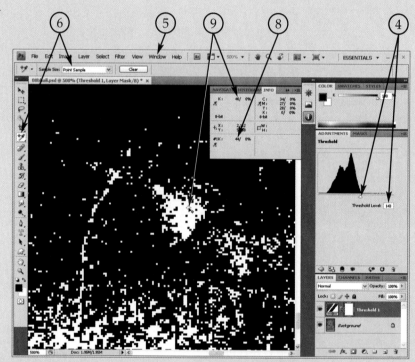

8. Look at the **#1K** value displayed in the **Info** panel. This is the brightness value of the sampled pixel. For this image, make sure the **#1K** value is between 0 and 42.

9. If you need to adjust the position of the color sampler mark, make sure the **Color Sample Tool** is selected, and then click and drag the mark. As you drag the mark, watch the **K** value in the upper-left corner of the **Info** panel. This is the brightness value of the pixel under the point of the cursor. When you find a pixel that falls into the recommended brightness range (0–42), release the mouse button.

 You may find it helpful to zoom in on the light-colored pixels if you need to adjust the position of the mark. This will make it much easier to place the mark on the pixel you want. Zoom back out when you are done.

10. In the **Adjustments** panel, drag the slider to the left until only the darkest areas of the image are visible.

 For this image, a value of 43 in the **Threshold Level** text box is about right.

11. Make sure the **Color Sample Tool** is selected and then click on one of the very darkest areas of the image to place a color sampler mark. Look at the **#2K** value in the **Info** panel and make sure it is between 84 and 100.

12. If you need to adjust the position of the mark, make sure the **Color Sample Tool** is selected and then click and drag the mark. Watch the **K** value in the **Info** panel and release the mouse button when you find a pixel with a **K** value in the 84–100 range.

 Again, you may find this step easier to accomplish if you zoom in on the dark pixels. Zoom back out when you are done.

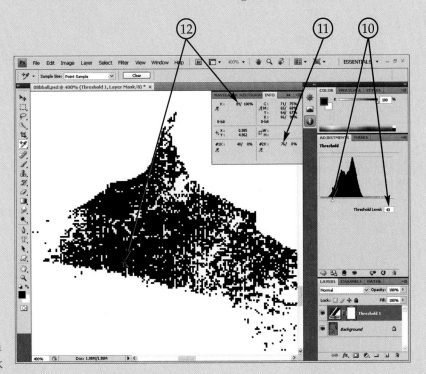

13. In the **Layers** panel, delete the **Threshold** adjustment layer.

14. Choose **Window > Histogram** or click the **Histogram** panel tab.

 The current histogram in the **Histogram** panel shows that most of the grays in this image are dark midtones. There are no bright highlights or black shadows.

15. In the **Adjustments** panel, click the **Curves** button.

16. In the **Adjustments** panel, click the **Set Black Point** button.

17. Use the **Eyedropper Tool**, which automatically appears when you position the cursor over the image, to click inside the color sampler mark you placed over the darkest part of your image.

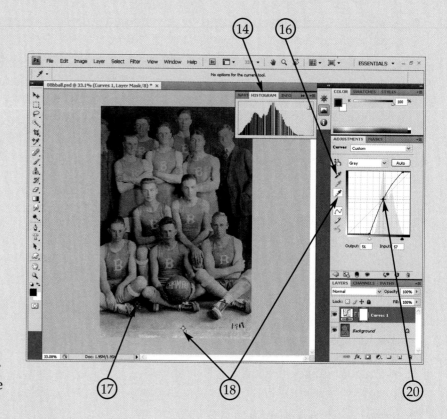

18. Click the **Set White Point** button in the **Curves** dialog box, and then click on the color sampler mark you placed over the brightest part of your image.

19. If necessary, click and drag the editing points on the **Curves** graph line horizontally until there are no spikes in the histogram on the extreme right or left side.

20. In the **Adjustments** panel, click to place another point in the middle of the graph line. Click and drag the center editing point slightly to adjust the contrast of the image, as desired.

21. Now that you can see the image more clearly, you will most likely need to retouch a few blotchy areas that are distracting.

 Since the adjustment layer is active, you will need to select the image layer before making your adjustments. The following are the suggested tools to use:

 - Use the **Patch Tool** to create more consistent skin textures.

 - Use the **Dodge Tool** with soft brushes and a low **Exposure** setting to lighten dark blotches in the image.

 - Use the **Burn Tool** with soft brushes and a low **Exposure** setting.

22. Zoom in on the face of the boy in the bottom center of the image.

23. Click the **Lasso Tool** and create a selection around the dark shadows on the boy's face.

24. Click the **Refine Edge...** button and change the **Feather** setting to 10. Click **OK** to close the **Refine Edge** dialog box.

25. In the **Adjustments** panel, click the **Levels** button.

26. In the **Adjustments** panel, drag the midtones (gray) slider to lighten the dark gray shadows on the boy's face.

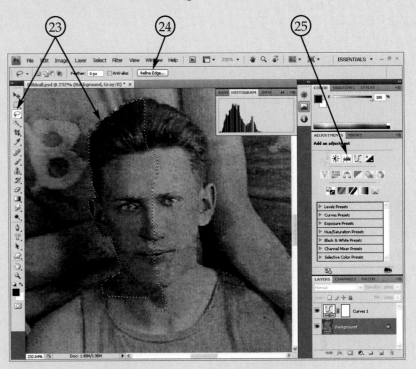

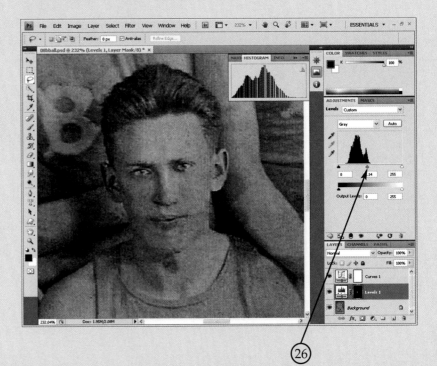

27. Choose **View > Fit on Screen**.

28. Select the Background layer and then choose **Filter > Sharpen > Unsharp Mask…**.

29. In the **Unsharp Mask** dialog box, set the **Amount** slider to 40%, the **Radius** slider to 1.5 pixels, and the **Threshold** slider to 10 levels. Then, click **OK**.

 The sharpening settings improve most of the image. However, two of the basketball players and one of the coaches are so out of focus that no amount of sharpening can improve them. Those subjects were probably moving as the camera exposed this image.

30. Zoom in and make one final check for areas that need retouching.

31. If possible, print this image at a high-quality setting so you can accurately see the results of your efforts.

32. Flatten the image, and then choose **File > Save As…** and name this file 10bball.tif. Then, close the file.

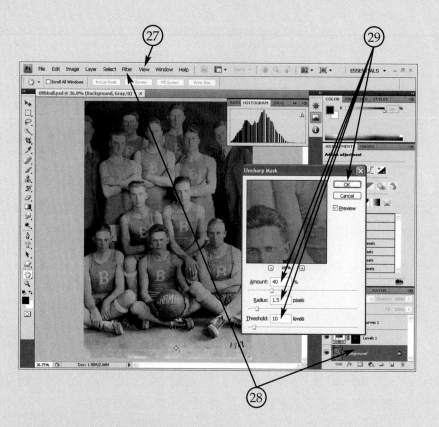

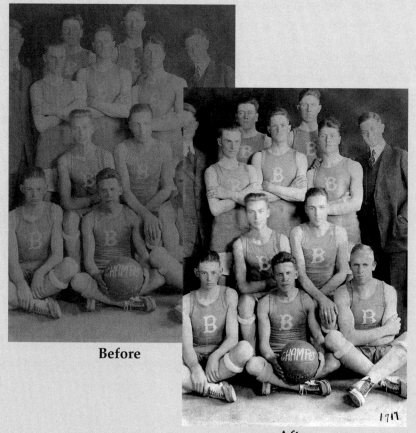

Before

After

Key Terms

additive color system	color modes	primary colors
alpha channel	color sampler marks	RGB color mode
analogous colors	complementary colors	RGB color workspace
bit	composite channel	secondary color
bit depth	document size	soft proofing
black point	gamut	spot channels
calibrate	grayscale color mode	spot color
Camera RAW	hexadecimal code	subtractive color system
clipping	histogram	swatches
CMYK color mode	ICC profiles	tertiary color
color channels	non-destructively	white light
color management	plug-in	white point

Review Questions

Answer the following questions on a separate piece of paper.

1. Which can contain a greater number of colors, an image printed on a printing press or an image displayed on a typical computer monitor?

2. An additive color system combines different _____ of light to create color.

3. How is white created in an additive color system?

4. What are the four colors represented by CMYK?

5. What is a spot color?

6. Briefly describe how a subtractive color system (used to create a printed page) is different from an additive color system (used to create an onscreen image).

7. As a general rule, what color mode should new, full-color documents be created in?

8. How do you convert an image to a different mode?

9. In RGB color mode, red light at maximum strength would be represented by an **R** value of _____.

10. In CMYK color mode, what value would appear in each of the **C**, **M**, **Y**, and **K** boxes to represent white?

11. In the **Color Picker**, what button do you click to select a spot color?

12. What is an "out-of-gamut" color?

13. What happens when you print a RGB file to a consumer-level inkjet printer?

14. When an image in RGB color mode is converted to CMYK color mode, what happens to the out-of-gamut colors in the image?

15. What is a color channel?

16. What is a histogram?

17. What is the most useful purpose of the **Threshold** adjustment?

18. How do you delete color sampler marks?

19. What does the gray slider in the **Levels** dialog box do?

20. In the **Curves** dialog box, what do the horizontal and vertical gradient bars represent?

21. How do you open a JPEG or TIFF file into the **Camera Raw** dialog box?

22. List two panels that can be used instead of the **Color Picker** to select the foreground color.

23. When color-correcting an image, what is the very last thing you should do?

24. What is the purpose of color management?

25. List three ways you can adjust the final printed size of an image using the **Print** dialog box.

11

Additional Layer Techniques

Learning Objectives

After completing this chapter, you will be able to:

- Apply blending modes to a layer.
- Use the **Fade** command to apply blending modes after applying a filter or color adjustment.
- Use a layer mask to a blend layers together.
- Apply a vector mask to blend layers together.
- Use the **Masks** panel to create, edit, and manage layer and vector masks.
- Apply clipping masks to combine layers in creative ways.
- Use content-aware scaling to transform a layer without distorting important content.
- Explain how the **Auto-Align Layers** and **Auto-Blend Layers** commands can be used to align and blend layers with similar content.
- Use layer style blending options to mask dark or bright portions of an image.
- Explain how to permanently delete masked areas of an image.
- Apply smart objects and smart filters to perform non-destructive editing.
- Use layer comps to store multiple versions of a design.
- Use the **Align** commands to line up multiple layers.
- Use the **Distribute** commands to create equal amounts of space between layers.

Introduction

In Chapter 4, *Introduction to Layers*, you learned how to create, organize, and manage layers. In this chapter, you will learn about other useful layer techniques that allow you to manipulate and blend layers together in creative ways. You will also learn about layer comps, a feature that helps designers quickly save multiple versions of a design. Lastly, you will learn how to line up objects on various layers and distribute equal amounts of space between each object using the **Align** and **Distribute** commands.

Blending Modes

You were introduced to blending modes in Chapter 6, *Painting Tools and Filters.* In that chapter, you learned that blending modes control how colors applied with a painting tool (such as the **Brush Tool**) blend with colors that already exist in the image.

Using Blending Modes with Layers

Blending modes can also be used to blend entire layers with each other. A blending mode can be assigned to any layer that appears above another layer in the **Layers** panel. This causes the colors in the top layer to blend with, and change, the appearance of the colors in all layers beneath it, **Figure 11-1**.

To use a blending mode on a layer, begin by accessing the **Layers** panel. Select the layer that you want to affect that is uppermost in the layer stack. If the stack includes

Figure 11-1. _____

Blending modes are used to change the way layers blend with one another. **A**—Gravel. **B**—Drum. **C**—These two images were combined by dragging the gravel image over to the drum image, creating a new layer. The **Soft Light** blending mode was then assigned to the gravel layer, resulting in the blend of the two images.

A

B

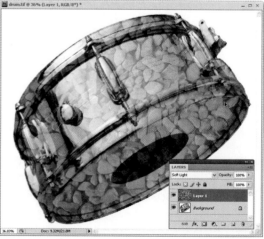

C

layers that you do *not* want to affect, you may need to reorganize your image to ensure that those layers are listed above the selected layer. Then, select the desired blending mode from the pop-up menu in the upper-left corner of the **Layers** panel.

As shown in Figure 11-1, the **Soft Light** mode is a good choice when blending a layer with another layer containing an object with shiny surfaces, such as the drum. The **Soft Light** blending mode causes the contents of the blending layer to blend with and lighten the lighter colors in the layer(s) beneath it. At the same time, it blends with and darkens the darker colors in the layer(s) beneath it. The white background around the drum was not affected by this particular blend because pure white cannot be lightened any further.

There are endless creative possibilities when using blending modes with layers. For example, photographers can intentionally underexpose and overexpose the same image with their camera, combine both layers within a single file, and then blend the two layers to create unique lighting effects in the image. Blending modes can even be used for color correction.

To review the basic characteristics of each of the blending modes, refer to the "Brush Tool Blending Modes" section in Chapter 6, *Painting Tools and Filters*. Keep in mind that the **Clear** and **Behind** blending modes are not available for layers.

Note If a layer group is selected in the **Layers** panel, **Pass-Through** appears as the default blending mode. Pass-through means that no blending modes have been set for that particular layer group, and it allows adjustment layers and blending modes within that group to work properly.

Using Blending Modes with Filters and Color Adjustment Tools

It is also possible to add a blending mode when using any of the following: a filter, an adjustment, a painting tool, or an eraser tool. *Immediately* after applying one of these tools, choose **Edit > Fade (*previous command or tool*)....** You can then choose a blending mode from the **Mode** drop-down list to adjust the filter or tool you just used. Or, you can adjust the **Opacity** setting to fade the previous filter or tool used. The lower the **Opacity** setting, the less influence the filter, tool, or adjustment has on the image. See **Figure 11-2**.

For example, suppose you use the **Levels** adjustment to adjust the colors in an image and the results are close to what you want, but a bit too extreme. You can mellow (or intensify) the color adjustment by using the **Edit > Fade** command and experimenting with different blending modes and **Opacity** settings.

Figure 11-2. _____
The **Fade** command lets you apply a blending mode or change the opacity of a filter, painting tool, erasing tool, or color adjustment.

Controls the strength of the filter's effect Selects the blending mode

Introduction to Masks

In a tutorial in Chapter 3, you learned how to create a quick mask. You used Photoshop's brush tools to paint a pink *mask* over part of an image that you did not want to keep. Then, when you exited out of quick mask mode, the mask changed into a selection around the other part of the image—the part you wanted to select.

Layer masks and *vector masks* are similar to, but more flexible than, quick mask mode. When you create one of these masks, it looks like you have deleted part of a layer. However, the entire layer is still there, and the hidden portions can easily be made visible again. Creating these masks are particularly useful when two or more images need to be blended together. And, just like a quick mask, you can convert either of these masks into a selection.

The **Masks** panel contains helpful tools that make it easy to create and refine layer masks and vector masks. In the sections that follow, these two types of masks and the **Masks** panel will be introduced.

Layer Masks

A *layer mask* is really a black, gray, and white "painting" that is created with the **Brush Tool**. This grayscale painting tells Photoshop which parts of a layer should be hidden. Areas of a layer mask that are painted black hide the image. White areas allow the image to show normally. Painting with various shades of gray creates various levels of opacity in the layer mask. An easy place to choose various shades of gray is from the top two rows of the **Swatches** panel. Another way to create various opacity levels is to leave black as the foreground color and adjust the **Brush Tool**'s opacity setting as your work. Gradients made from black, white, and gray can also be used to create layer masks that "fade out."

Before creating a layer mask, the layer that will have a mask applied to it must be selected in the **Layers** panel. If the layer transparency is locked, you cannot create a mask. If necessary, unlock the layer by renaming it (if it is a background layer) or by using the lock buttons on the **Layers** panel (if those buttons have previously been used).

After selecting the layer and ensuring that layer transparency is unlocked, open the **Masks** panel by clicking the **Masks** panel tab or by choosing **Window > Masks**. To add a layer mask, click the **Add a pixel mask** button on the **Masks** panel. You can also add a layer mask by clicking the **Add a layer mask** button at the bottom of the **Layers** panel or by choosing **Layer > Layer Mask > Reveal All**.

Adding a layer mask using any of these three methods causes a layer mask thumbnail to appear in the **Layers** panel. If you need to return to a layer mask and edit it, the layer mask thumbnail must be clicked in the **Layers** panel (causing a white border to appear around it). See Figure 11-3. As you paint with black, shades of gray, and white, the layer mask thumbnail is automatically updated in both the **Masks** panel and the **Layers** panel to show any changes to the masked areas. See Figure 11-4.

Note If part of your image is selected just before you create a layer mask, the selected areas are made white on the resulting mask, and the unselected areas become black on the mask.

Figure 11-3. _____
A layer mask has been created on this layer, hiding (but not deleting) some of the rocks.

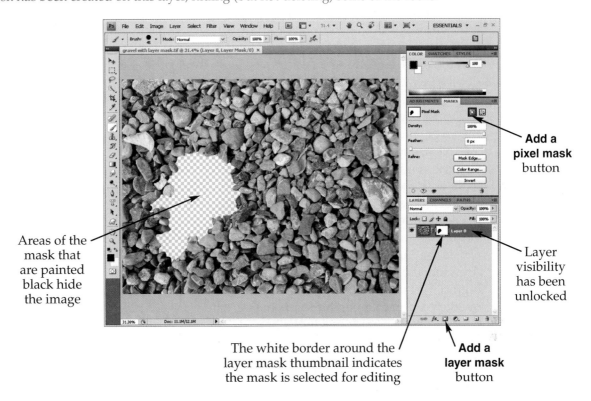

Areas of the mask that are painted black hide the image

The white border around the layer mask thumbnail indicates the mask is selected for editing

Add a pixel mask button

Layer visibility has been unlocked

Add a layer mask button

Figure 11-4. _____
Areas of the layer containing the gravel image are hidden by applying a layer mask. This reveals the metal frame of the drum, resulting in a drum that looks as if it contains the rocks. Note that the right side of the layer mask has not been painted, so the rocks are still visible through the drum frame.

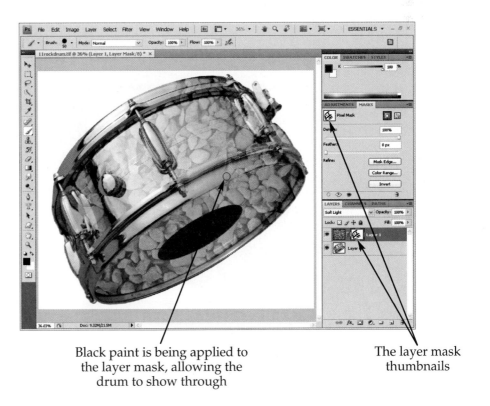

Black paint is being applied to the layer mask, allowing the drum to show through

The layer mask thumbnails

Vector Masks

A *vector mask* is similar to a layer mask, but uses a path rather than black, gray, and white pixels to define masked areas. Vector masks are not created with painting tools. Instead, they are created with tools that create vector paths—the shape tools and pen tools. After creating a vector mask, you can feather its edges or adjust it in a variety of other ways.

To begin creating a vector mask, click the **Add a vector mask** button in the **Masks** panel or choose **Layer > Vector Mask > Reveal All**. This creates an empty (white) vector mask on the layer, and adds a vector mask thumbnail to the **Layers** panel.

Next, choose one of the shape or pen tools to draw the boundaries of the layer mask. Color is not important; it is the vector path that creates the mask. When using the pen tools or shape tools, make sure the **Paths** button is selected in the options bar. As long as the vector mask is selected in the **Layers** panel (a white border appears around the vector mask thumbnail), you can refine it. In **Figure 11-5**, a custom shape is used to create a vector mask on the drum layer, causing the side of the drum to appear damaged.

If the **Subtract from path area** button is active in the options bar when you begin drawing the vector mask boundaries with a pen or shape tool, the area inside the boundaries will be hidden. If the **Add selection to path**, **Intersect path areas**, or **Exclude overlapping path areas** button is active when you first begin to draw the vector mask boundaries, the areas inside the boundaries will be displayed, and the rest of the layer will be hidden. These four buttons can be used in combination as you create a vector mask.

Figure 11-5. ——————————————————————————————————————

This image now has a layer mask and a vector mask. The vector mask is hiding part of the drum layer, causing it to appear damaged.

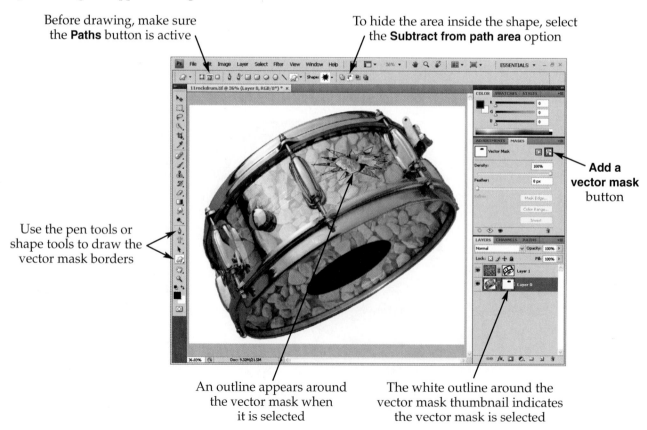

Before drawing, make sure the **Paths** button is active

To hide the area inside the shape, select the **Subtract from path area** option

Use the pen tools or shape tools to draw the vector mask borders

Add a vector mask button

An outline appears around the vector mask when it is selected

The white outline around the vector mask thumbnail indicates the vector mask is selected

The path thumbnails in the **Paths** panel and the vector mask thumbnails in the **Layers** panel show you what areas of the layer are hidden and which areas are displayed. The dark areas represent those parts of the layer that are hidden and the white areas are the areas of the layer that are visible.

The Masks Panel

The **Masks** panel contains commands that are frequently used when working with vector masks and layer masks. The **Masks** panel refers to layer masks as *pixel masks* because they are created with Photoshop's painting tools. The **Masks** panel displays information about the masks on the currently selected layer. It can also be used to add new masks and edit existing masks on that layer.

The buttons at the top of the panel can be used to add a new layer mask or vector mask, but only when a plus sign appears in the button. It is possible to create both a layer mask and a vector mask on a single layer. Once a layer mask has been added to a layer, the plus sign is removed from the layer mask button. See **Figure 11-6**. The same is also true for vector masks. Once a mask has been added, you can click on the appropriate button to select the mask. Mask thumbnails also appear in the **Layers** panel, and the masks can be selected by clicking on those thumbnails as well.

The **Density** slider adjusts the opacity of any mask that you create. Lowering the density allows hidden areas to show through more and increasing the density once again hides the areas. You can use the **Feather** slider to soften edges of a mask, just as you have done when working with selections.

The three buttons in the **Masks** panel are available only when working with layer (pixel) masks. You will see a familiar dialog box if you click the **Mask Edge** button. This displays the **Refine Edge** dialog box (introduced in Chapter 3), however, its name has

Figure 11-6. _____

The **Masks** panel can be used to add or edit masks to the currently selected layer. Note that the vector mask button in the upper-right corner of the panel has a plus sign in it. This indicates that a vector mask can be added to the layer. The layer (pixel) mask button does not have a plus sign, indicating that this layer already contains a layer mask.

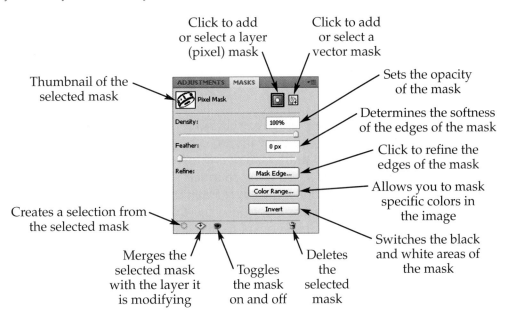

been changed to the **Refine Mask** dialog box. The **Color Range** command is a selection tool (similar to using the **Magic Wand Tool**) that can refine a mask or create one from scratch by selecting colors in an image. You cannot use the **Color Range** command to add white areas to a mask—only black areas. See Chapter 3 for more on this command. Last, the **Invert** button "flips" the black and white colors in your mask, causing the mask to behave in an opposite way.

At the bottom of the **Masks** panel are four helpful buttons. Before clicking any of them, be sure you have selected the correct mask by clicking the correct button at the top-right of the **Masks** panel or by clicking the layer thumbnail in the **Layers** panel.

The **Load Selection from Mask** button is similar to using quick mask mode—it converts the selected mask into a selection. The **Apply Mask** merges the selected mask with the layer it is hiding. The layer is modified to reflect the effect of the mask, and the mask itself is deleted, making it no longer possible to adjust the effect. For this reason, you should not use this option until you are absolutely sure the mask and masked area will require no further changes.

The **Disable/Enable Mask** button has a familiar-looking eyeball icon. This button toggles the effect of the selected mask on and off, allowing you to temporarily disable the mask without deleting it. Last, the **Delete Mask** button discards a mask if you no longer need it or want to start over.

Other Mask-Related Techniques

The **Masks** panel contains many helpful tools that help you work with masks. However, there are additional mask-related tools and techniques that cannot be accessed from the **Masks** panel. Several of these techniques are explained in the following sections.

Linking and Unlinking Masks

In the **Layers** panel, a chain (linking) icon appears between the layer mask thumbnail and the layer thumbnail. This icon indicates that the layer mask is linked to the layer. In other words, if you use the **Move Tool** to move the layer in the image window, the mask will move with it. Linking can be turned on or off by clicking on the linking icon (or the empty spot where the icon used to be). When linking is off, the layer mask and layer can be moved independently of each other in the image window.

Displaying Layer Masks

So far, you have only been able to see the effects of a layer mask rather than the mask itself. However, there is a way you can display the mask on screen. When you open the **Channels** panel, a thumbnail of any layer mask assigned to the currently selected layer is displayed below the color channels in the channel list. If you double-click on the layer mask thumbnail, the **Layer Mask Display Options** dialog box opens. In this dialog box, click in the color box to use the **Color Picker** to assign a color to the layer mask. In some cases, you may want to make the layer mask easier or harder to see through. To do this, enter the desired value in the **Opacity** text box. Click **OK** to close the **Layer Mask Display Options** dialog box when you have entered the settings you want. In the **Channels** panel, click the layer mask channel's **Visibility** toggle to turn the layer mask display on or off. See **Figure 11-7**.

Figure 11-7. _____
Visibility for the layer mask has been turned on. The masked areas are reddish.

Click to set the color
of the layer mask

Determines how easy it is to
see through the layer mask

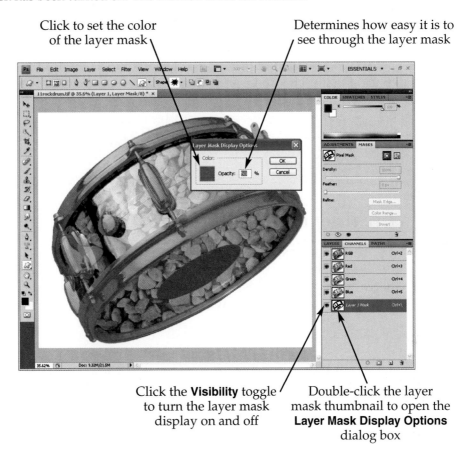

Click the **Visibility** toggle
to turn the layer mask
display on and off

Double-click the layer
mask thumbnail to open the
Layer Mask Display Options
dialog box

Reveal All vs. Hide All

When you use the buttons on the **Masks** panel to add a layer mask or vector mask, you create a new mask that is completely empty. Nothing is actually masked until you start painting or drawing paths. The same commands are found by choosing **Layer > Layer Mask > Reveal All** or **Layer > Vector Mask > Reveal All**. Creating an empty mask is the best option if you have only a few objects on the layer that you want to hide.

Choosing **Layer > Layer Mask > Hide All** or **Layer > Vector Mask > Hide All** does the exact opposite. These commands create a new mask that is completely filled, and therefore hides all of the content on the selected layer. If you use this option to create a layer mask (pixel mask), you must then erase areas of the mask (or paint them with white) in order to reveal objects on the layer. Using the **Hide All** command is recommended if you only want to keep a few objects on the layer visible and hide the rest.

Convert a Vector Mask into a Layer Mask (Pixel Mask)

A vector mask can be converted into a layer mask, allowing you to take advantage of the buttons in the **Mask** panel's **Refine** section or modify the mask with painting tools. To do this, right-click on the vector mask thumbnail in the **Layers** panel and choose **Rasterize Vector Mask**.

Converting a Selection into a Vector Mask

Because a selection can be converted into a path, you can also convert any selection, including text created with the type masking tools, into a vector mask. To do this, create the selection, then open the **Paths** panel. In the **Paths** panel, click the **Make work path from selection** button. In the **Layers** panel, choose the layer on which to create a mask. Finally, choose **Layer > Vector Mask > Current Path** to create a vector mask from the existing path. See **Figure 11-8**.

Note To quickly select all visible (unmasked) areas of a layer, press [Ctrl] and click a mask thumbnail. Press [Command] and click for Mac.

Creating Layer Masks with the Paste Into Command

Using the **Paste Into** command is another way to "punch holes" out of one layer so the layer behind it shows through. Layer masks are created automatically during this process. You can use this technique with any image that contains at least two layers, but it is actually easier to work with two separate image files, as explained in this section.

Figure 11-8.

A gradient layer was created on top of the gravel background. Then, a selection was made using the **Horizontal Type Mask Tool**. The selection was converted into a working path. Then, the working path was changed into a vector mask by selecting **Layer > Vector Mask > Current Path**. The result is gradient text on top of the gravel layer.

After converting the selection and selecting the desired layer, choose **Layer > Vector Mask > Current Path**

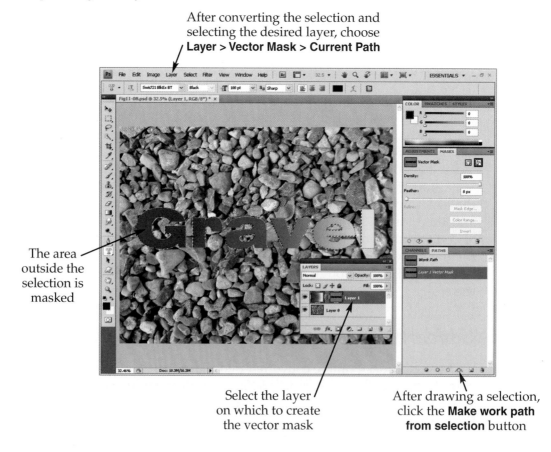

The area outside the selection is masked

Select the layer on which to create the vector mask

After drawing a selection, click the **Make work path from selection** button

With both image files open, use the selection tools to create areas that will eventually become punched-out holes. Next, activate the image that will show through the holes and choose **Select > All** and then **Edit > Copy**. This image will be referred to as the *source image*. You do not need to select the entire source image, but keep in mind that the source image is usually larger than the *target image* (the first image), allowing you to move the content around behind the holes until it looks good to you.

To complete the punched-out look, activate the target image again and choose **Edit > Paste Into**. This copies the material to a new layer, just like normal pasting. However, it also creates a layer mask on the new layer that matches the selection made on the target image. Only this portion of the copied content is visible. You can then use the **Move Tool** to move the copied content around in the new layer so that different parts of it appear through the layer mask.

Clipping Masks

Instead of using painting tools or paths to create masks, *clipping masks* use the entire contents of a layer to mask another layer, **Figure 11-9**. In the **Layers** panel, the layer you want to use as a mask must be *just below* the layer that will have the mask applied to it. Then, select the layer you want to be visible through the mask and choose **Layer > Create Clipping Mask**. In the **Layers** panel, the masked layer becomes indented, reminding you that a clipping mask has been created.

After adding the clipping mask to one layer, you can repeat the procedure to add it to the layer directly above that layer. Continue the process until you have assigned the clipping mask to all of the layers that you want to trim. See **Figure 11-10**.

Note	Photoshop allows you to have more than one type of mask on a single layer.

Figure 11-9.

Clipping masks are easy to apply. **A**—A text layer was created on top of the Background (gravel) layer. **B**—The Background layer was unlocked by renaming it. Then, the gravel layer was positioned above the text, allowing the text layer to become a clipping mask by choosing **Layer > Create Clipping Mask**.

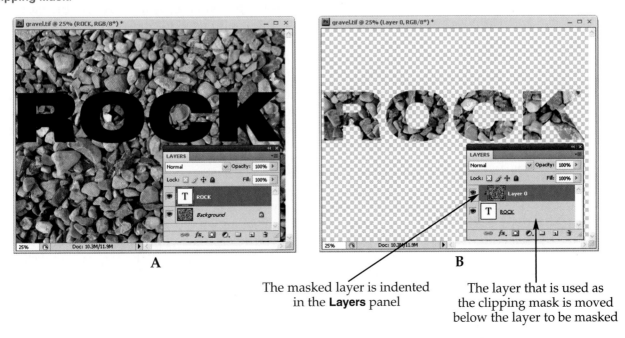

The masked layer is indented in the **Layers** panel

The layer that is used as the clipping mask is moved below the layer to be masked

Figure 11-10.

A clipping path can be applied to multiple layers. Here, four different images on four separate layers were trimmed by the same clipping mask.

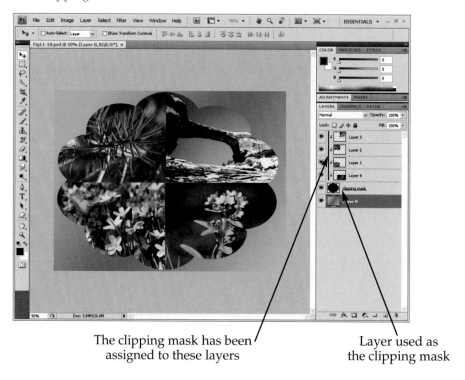

The clipping mask has been
assigned to these layers

Layer used as
the clipping mask

Controlling the Visible and Hidden Areas of a Clipping Mask

Controlling the transparent and opaque areas created by clipping masks is similar to controlling them in a layer mask. As you recall, when you create a layer mask, the shades of gray you use determine how much or how little you can see through the masked area. Where the mask is black, the layer is transparent. Where the mask is white, the layer is completely opaque. The opacity level of the paint also plays a role. As the opacity of the paint increases, the paint's effect on the layer mask also increases.

Unlike a layer mask, the tonal level of the paint used to draw a clipping mask does not influence how much of the layer can be seen through the mask. For clipping masks, the visibility of the masked layer depends entirely on the *opacity* of the paint used to create the clipping mask. In other words, gray paint will have the same effect on a clipping mask as white paint or black paint. The masked layer will be completely visible in areas where the clipping mask is completely transparent. Areas of the clipping mask that are more opaque will create areas on the masked layer that are more transparent.

Releasing Clipping Masks

The clipping mask can be disabled by selecting the appropriate layer and choosing **Layer > Release Clipping Mask** or by right-clicking on the layer in the **Layers** panel and selecting **Release Clipping Mask**. When you release the clipping mask on a layer, the clipping mask is also released on all layers above that layer in the **Layers** panel stack.

Note	Be aware that clipping masks can become accidentally deleted when rearranging the stacking order of layers in the **Layers** panel.

Content-Aware Scaling

If you have been completing the tutorials in this book, you have scaled layers several times by dragging the bounding box around the layer or by entering scaling values in the **W** and **H** text boxes in the options bar. When you keep the aspect ratio the same while scaling a layer (in other words, changing the width and height by the same percentages), the layer simply becomes larger or smaller. But if the width and height values are changed by different percentages when you scale, objects in your image become distorted.

Content-aware scaling is a feature that tries to keep the most important details in a layer from becoming distorted as you scale using width and height percentages that do not match. Photoshop looks for areas that have redundant detail and color and lets them become distorted. At the same time, it tries to avoid scaling more detailed content (such as subjects that stand out from their backgrounds), Figure 11-11. Using content-aware scaling can be a very effective way to add or reduce the amount of space around important subjects in an image.

To use content-aware scaling, first select the appropriate layer in the **Layers** panel. If you want to scale an entire image, open it and choose **Select > All**. Then, choose

Figure 11-11. _____
Content-aware scaling can prevent distortion in important parts of your image. **A**—The original image. **B**—Traditional scaling causes features in the image to stretch out. Notice the distortion of the billboard, highway, and buildings. **C**—Content-aware scaling reduces distortion in the billboard, but still distorts the buildings and the road. Notice that the lower-left corner of the billboard is also distorted. **D**—A selection was drawn around the billboard, road, and buildings and saved as an alpha channel. That alpha channel was then used to protect those areas from becoming distorted.

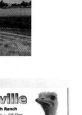

A

B

C

D

Edit > Content-Aware Scale. If you are planning on scaling an image or layer to a larger size, you may need to increase the overall size of your image file by using the **Image > Canvas Size** command before doing anything else.

When you use content-aware scaling, your results are usually not perfect. For this reason, you can protect parts of a layer so they will not be affected at all during the scaling process. After content-aware scaling your image and noticing which important areas are becoming distorted, undo the scale. Then, use the selection tools to select these areas. Next, save the selection by choosing **Select > Save Selection** and naming the new alpha channel (when you save a selection, a new alpha channel is created, storing the selection). Finally, choose the alpha channel you just created from the **Protect** drop-down list that appears on the options bar when you choose **Edit > Content-Aware Scale**.

In addition to the **Protect** drop-down list already mentioned, the options bar that appears when you use the **Content-Aware Scale** command also has two other useful options, **Figure 11-12**. The **Protect Skin Tones** button also appears on the options bar when you use this command. When this option is active, Photoshop attempts to protect areas of your image that contain skin tones, such as a person's face in a portrait. The **Amount** slider essentially determines the balance between traditional scaling and content-aware scaling. A setting of 0% produces completely traditional scaling and a setting of 100% produces completely content-aware scaling.

Auto-Aligning and Auto-Blending Layers

Photoshop's **Auto-Align Layers** command does a remarkable job of analyzing two or more similar layers and then lining them up as closely as possible. The **Auto-Blend Layers** command can then be used to automatically heal any flaws that show up in areas where layers overlap. The following are some scenarios in which the **Auto-Align Layers** and **Auto-Blend Layers** commands are used:

- Combining similar photographs (portraits, for example) and using layer masks to combine the layers in such a way that unwanted facial expressions or closed eyes are hidden, **Figure 11-13**.

- Creating a panoramic image from several photos with overlapping content. This is done automatically when the **Photomerge** command is used. The **Photomerge** command will be discussed later in this chapter.

- Combining photographs of the same scene that were captured at several different exposures. See also "The Merge to HDR Command" section in Chapter 12, *File Management and Automated Tasks*.

- Combining photographs of the same scene that were captured at several different focal points (for example, close-up shots of small objects), **Figure 11-14**.

Figure 11-12. _____

The options bar for the **Content-Aware Scale** command is shown here. The **Amount** slider set the balance between traditional scaling and content-aware scaling. The **Protect** drop-down list allows you to select an alpha channel containing areas to protect. Activating the **Protect skin tones** button causes Photoshop to automatically protect any areas containing skin tones.

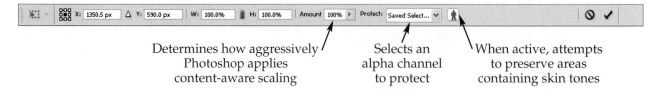

Determines how aggressively Photoshop applies content-aware scaling

Selects an alpha channel to protect

When active, attempts to preserve areas containing skin tones

Figure 11-13. _____

This figure shows how the **Auto-Align Layers** command can be used to create one good portrait from two flawed portraits. **A**—In one image, the groom's eyes are closed. **B**—In the other image, the groom's eyes are open, but the bride is not smiling. **C**—The second image is dragged and dropped as a layer into the first image. The layers are aligned using the **Auto-Align Layers** command, and a layer mask is carefully created to select just the groom's head. This superimposes the groom's head from the second image onto the first image, creating the perfect portrait.

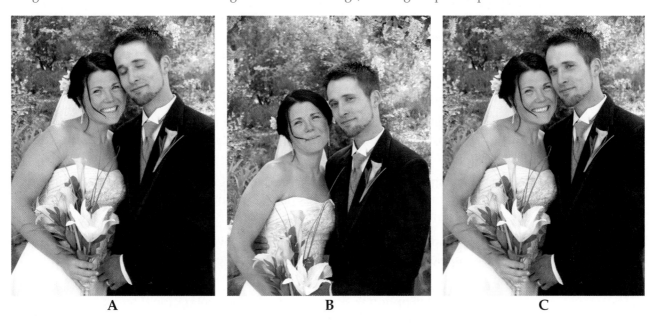

A B C

Figure 11-14. _____

This figure shows how the **Auto-Align Layers** command can be used to create an image with an increased depth of field. **A**—The front chess piece is in focus, the rest is out of focus. **B**—Only the middle chess piece and surrounding area is in focus. **C**—Only the farthest chess pieces are in focus. **D**—The images are combined, the layers are aligned with the **Auto-Align Layers** command, and the layers are then blended with the **Auto-Blend Layers** command to create an image with an increased depth-of-field.

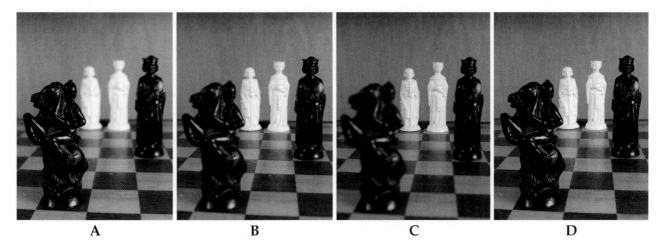

A B C D

The Auto-Align Layers Command

To use the **Auto-Align Layers** command, you must first prepare a Photoshop document that has at least two similar layers. For example, after opening two similar portrait shots in Photoshop, drag and drop the best portrait into the other file with the **Move Tool**. This creates an image with two layers, with the best layer on the top of the other. Next, select the layers that you wish to align in the **Layers** panel and then choose **Edit > Auto-Align Layers…**. This opens the **Auto-Align Layers** dialog box. See Figure 11-15.

In the **Projection** section of the dialog box, there are two rows of radio buttons, allowing you to choose from six slightly different methods of aligning images.

- Selecting the **Auto** option is a good beginning point. After Photoshop analyzes the layers, it will assign either the **Perspective** or **Spherical** method automatically.

- The **Perspective** option instructs Photoshop to change the shape of each layer to help it line up better, if necessary. This can cause the corners and sides of each layer to be altered.

- The **Collage** option causes Photoshop to align layers by moving, scaling, and rotating them. However, it does not allow content on the layer to be distorted by changing perspective.

- The **Cylindrical** option manipulates layers even more intensely to get them to line up. Not only are corners and edges moved, but the entire layer can also be warped to help align similar content.

- The **Spherical** option is similar to the **Cylindrical** option. Layers can be heavily warped to get layers to line up as much as possible.

- The **Reposition Only** option does not manipulate the shape of each original layer like the previous two options. It lines things up the best it can while keeping all layers their original size and shape.

Figure 11-15. _____

In the **Auto-Align Layers** dialog box, you can choose a method for aligning the selected layers. There are also options for correcting vignettes and distortion caused by some lenses.

Six different alignment methods are available

Removes dark edges caused by some lenses

Attempts to compensate for lens distortion

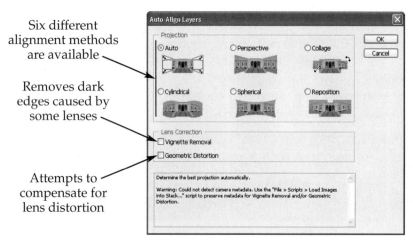

In most cases, you will want to keep the **Auto** radio button selected. The **Auto** option automatically assigns either the **Perspective** or the **Spherical** option after analyzing your images. If you do not get good results with the **Auto** option, experiment with the **Collage**, **Cylindrical**, and **Reposition** options. After an alignment method is chosen, Photoshop will use the selected method to reposition the layers so they align as closely as possible.

The **Vignette Removal** option is designed to help remove darkened edges created by some lenses, and the **Geometric Distortion** option tries to compensate for distortion problems caused by certain lenses with very short or very long focal lengths. These options are especially useful when creating panoramas (see "The Photomerge Command" section later in this chapter).

Portrait shots where the subject(s) are posing in a similar manner are good examples of images that can be aligned. Panoramic photos can also be aligned with this command, provided there are enough common areas from photo to photo. To ensure this is the case, overlap each photo by 25% or so when you take photos that you intend to blend into a single panoramic image. The **Photomerge** command, which is explained a little later in this chapter, can create panoramic images automatically for you.

In a previous chapter, the **Clone Source** panel and **Clone Stamp Tool** were used to combine two wedding photos. As you can see in Figure 11-13, the same result can be achieved using the **Auto-Align Layers** command and layer masking by following these steps:

- Open both images and use the **Move Tool** to drag one image on top of the other, so that one Photoshop document contains both images on two separate layers.

- In the **Layers** panel, select the layers that you want to align.

- Choose **Edit > Auto Align Layers…** and select one of the six options in the **Projection** section of the **Auto-Align Layers** dialog box

- Next, create a layer mask and paint a mask to hide the portion of the image you want to replace. If the subject's angle toward the camera is slightly different in both images, a careful mask must be created to achieve a realistic retouch. If necessary, you can rearrange the stacking order of your layers and adjust layer opacities during this step.

- If areas of the image have different lighting, the **Auto-Blend Layers** command should be used.

The Auto-Blend Layers Command

When capturing photos for a collage or a panorama, your camera encounters slightly different lighting conditions as you turn your body while shooting. Later, when you assemble your image in Photoshop, you can see obvious transitions where one image was metered differently from the previous image. This change in lighting causes certain colors (the sky in a panorama for example) to appear differently in each photo. Choosing **Edit > Auto-Blend Layers…** causes Photoshop to analyze and color-correct the layers you have combined using the **Auto-Align Layer** command, and it does a remarkably good job.

This command can also be used to combine the same image taken with different areas in focus in each image. In such cases, the command automatically masks each layer to allow only the portions that are in focus to show through. It also adjusts the colors in the image to make sure the visible portions of each layer look natural together. For example, the three original images (A, B, and C) in Figure 11-14 all have slightly different lighting. The **Auto-Blend Layers** automatically masked the layers so only the areas in focus in each layer are visible. The command also adjusted the color in each layer to create a natural looking composite image.

The **Auto-Blend Layers** command can also be used to combine identical images taken at different exposures. However, to blend images that are captured in tricky lighting situations, the **Merge to HDR** command is more effective. The **Merge to HDR** command will be discussed in Chapter 12, *File Management and Automated Tasks*.

Before running the **Auto-Align Layers** command, make sure that you have aligned the layers you wish to blend and selected them in the **Layers** panel. When you choose **Edit > Auto-Blend Layers…**, a dialog box appears, **Figure 11-16**. Use the **Panorama** blend method if your images overlap around 25% or so. Use the **Stack Images** method if the images are nearly the same composition from shot to shot. The best blending will occur if you leave the **Seamless Tones and Colors** option on.

The Photomerge Command

The **Photomerge** command can be used to create a panorama out of images that overlap anywhere between 25-40%. For additional tips on capturing images that will be assembled into panoramas, search for "Photomerge" in Photoshop Help. If you have been completing the tutorials in this book, you have already had an opportunity to try out the **Photomerge** command in Tutorial 6-6 in Chapter 6, *Painting Tools and Filters*. The **Photomerge** command can be launched from Photoshop by choosing **File > Automate > Photomerge…**. It is also available within Bridge, Photoshop's built-in file browsing application.

When you run the **Photomerge** command, it opens the **Photomerge** dialog box, which is very similar to the **Auto-Align Layers** dialog box, **Figure 11-17**. In the **Layout** section of the **Photomerge** dialog box, select an option for aligning the images that you selected in the **Source Files** section of the dialog box. A simple way to begin is to leave the **Auto** radio button selected, and if you are not satisfied with the results, experiment with the other alignment options. When the **Blend Images Together** check box is checked,

Figure 11-16. _____

In the **Auto-Blend Layers** dialog box, you can choose the blending method to use.

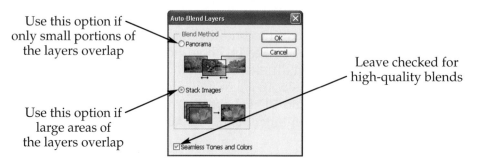

Use this option if only small portions of the layers overlap

Use this option if large areas of the layers overlap

Leave checked for high-quality blends

Figure 11-17. _____
In the **Photomerge** dialog box, select the files and alignment method used to create the panorama.

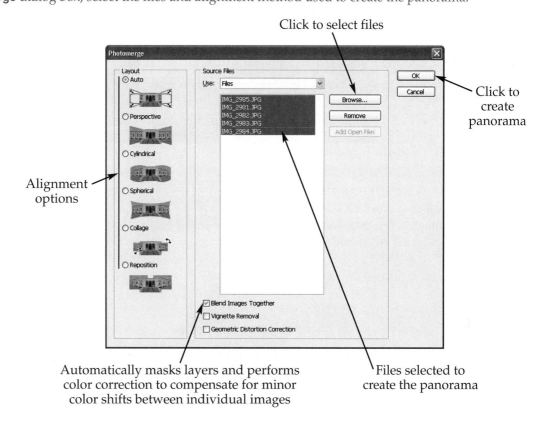

Click to select files

Alignment options

Automatically masks layers and performs color correction to compensate for minor color shifts between individual images

Click to create panorama

Files selected to create the panorama

the **Photomerge** command will automatically mask and blend the layers in the newly created panorama. When this check box is unchecked, the **Photomerge** command will align the layers in the panorama, but will not mask them or adjust their color to blend them together. In most cases, you will want to leave the **Blend images together** check box turned on, so that the layers in the panorama will be blended.

When you click **OK** in the **Photomerge** dialog box, the **Photomerge** command actually runs a series of other Photoshop commands. It starts by running the **Load Files into Stack** command, which is a script found in the **File > Scripts** submenu. This script loads the selected images and places them on individual layers in a new file. In this case, it creates a new image and fills it with layers made out of the files selected in the **Photomerge** dialog box. The **Auto-Align Layers** command runs next. This command uses the alignment option you selected in the **Photomerge** dialog box to align the layers in the image just created by the **Load Files into Stack** command. If the **Blend Images Together Option** is active, the layers are masked to remove redundant details and allow only the sharpest details from each layer to show through. It also corrects any lighting differences between layers.

After a minute or two, Photoshop will show you the results of the **Photomerge** command, **Figure 11-18**. If you are unhappy with the results, close the image, choose **File > Automate > Photomerge...**, and select different options in the **Photomerge** dialog box.

Figure 11-18.
Five individual images have been combined into a single panoramic image. **A**—The five original images are shown here. **B**—Note the way the **Cylindrical** alignment option has distorted the original images in order to get them to fit together properly.

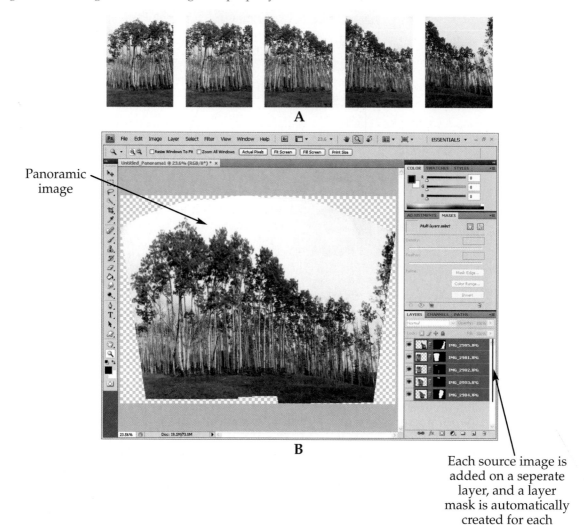

Panoramic image

A

B

Each source image is added on a seperate layer, and a layer mask is automatically created for each

The Layer Style Dialog Box: Blending Options

The **Blending Options** portion of the **Layer Style** dialog box contains advanced layer-blending controls. An amazing amount of creative control is possible when using these settings, because you can specify what channel(s) will be affected by your adjustments. These settings are found by choosing **Layer > Layer Style > Blending Options...**; by selecting a layer in the **Layers** panel, right-clicking, and selecting **Blending Options...** from the shortcut menu; or by clicking the **Layer Style** button at the bottom of the **Layers** panel and selecting **Blending Options...**. Any of these methods opens the **Layer Style** dialog box.

The controls in the **General Blending** section of **Layer Style** dialog box are identical to the **Blending Mode** drop-down list (discussed earlier in this chapter) and the **Opacity** slider found at the top of the **Layers** panel (discussed in Chapter 4). However, as you adjust these controls, you can do channel-specific adjustments by toggling the channel

check boxes in the **Advanced Blending** section. As you work on projects that are more artistic or experimental, try enabling and disabling different channels as you change blending modes and adjust the **Opacity** slider. You may be pleasantly surprised at some of the results you get.

Creating a Knockout

The term *knockout* refers to an area of an image that is removed so a layer below it can show through. In Photoshop, knockouts are similar to clipping masks. Knockouts use one layer to create transparent areas in another layer, like clipping masks. Also like clipping masks, knockouts can be applied to numerous layers. In this section, you will learn how to create the simplest type of knockouts. There are several other ways that layers can be arranged and knockouts set up that make the technique even more versatile. You are encouraged to review Photoshop's help files to learn about alternative ways to set up knockouts.

To create a knockout in an image, begin by arranging your layers in the **Layers** panel. The layer that is going to create the knockout must be above all of the layers that are going to be affected in the layer stack. The layer that is going to show through the knockout must be a background layer, otherwise, all of the layers beneath the knockout layer (including the bottom layer) will have a knockout, and transparency will show through. If you need to convert a layer to a background, select the layer in the **Layers** panel and choose **Layer > New > Background From Layer**.

Once you have the layers set up as needed, select the layer that will create the knockout in the **Layers** panel, right-click on the layer, and select **Blending Options...** from the shortcut menu. In the **Advanced Blending** section of the **Blending Options** dialog box, place check marks in the **Channels** check boxes to specify what color channels you want to use to create the knockout. Next, select the style of knockout to create from the **Knockout** drop-down list. With the setup that is being explained here, both the **Shallow** option and the **Deep** option hide the image all the way to the background. However, if you use one of the alternative setups described in the Photoshop help files, the **Shallow** option will only knockout to the first possible stopping point and the **Deep** option will knockout all the way to the background. After selecting a knockout style, adjust the **Fill Opacity** slider to produce the desired effect. See **Figure 11-19**. A setting of 0% makes the knockout completely transparent.

Underneath the **Fill Opacity** slider are five check boxes that allow you to adjust the knockout further. If you position the cursor directly over one of these check boxes, a tool tip appears that explains the function of the check box.

The Blend If Sliders

At the bottom of the **Blending Options** section of the **Layer Style** dialog box are the **Blend If** sliders. These sliders give you further control over layer blending, allowing you to hide or show portions of a layer based on luminosity values (how bright or dark the pixels are). For example, dragging the black or white **This Layer** sliders will hide dark or light areas of the active layer. The tonal range between the sliders remains visible while the tonal range outside the sliders is masked. See **Figure 11-20**.

Each slider can be split apart by holding down [Alt] (or [Option] for Mac) and dragging half of the slider to the desired setting. The tonal range between the two halves of the slider is partially masked. This allows you to soften the appearance of the mask edges.

Figure 11-19. _____
Knockouts create similar effects to clipping masks. **A**—The controls in the **Advanced Blending** section of the **Layer Style** dialog box allow you to apply a knockout to an image. **B**—The knockout in this image hides portions of two layers to reveal the gradient background in the knockout area.

Determines how transparent the knockout is

Determines which color channels are used to create the knockout

Determines whether the knockout stops at the first available spot, or penetrates all the way to the background

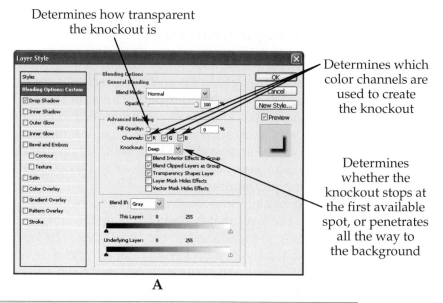

A

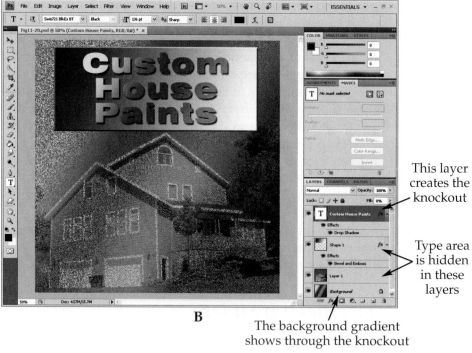

This layer creates the knockout

Type area is hidden in these layers

B

The background gradient shows through the knockout

The **Blend If** drop-down list lets you isolate a particular channel before adjusting the sliders. The **Gray** option in this drop-down list represents the composite channel. Remember that the colors in the image are composed of a mixture of the primary colors found in the color channels. Therefore, adding masking based on one of the color channels may have a farther-reaching effect than you might expect.

You can also use the controls in this section of the **Layer Style** dialog box to mask the selected layer based on the colors and tonal values of the layer *underneath* it. The

Figure 11-20. _____

The bottom section of the **Layer Styles** dialog box contains controls that can be used to quickly mask extremely dark or light areas in an image. **A**—This image has a strongly contrasting background and subject. **B**—The **This Layer** sliders can be split in half to set tonal ranges that will be partially masked. **C**—Note that the darkest tones in the layer are completely masked (hidden).

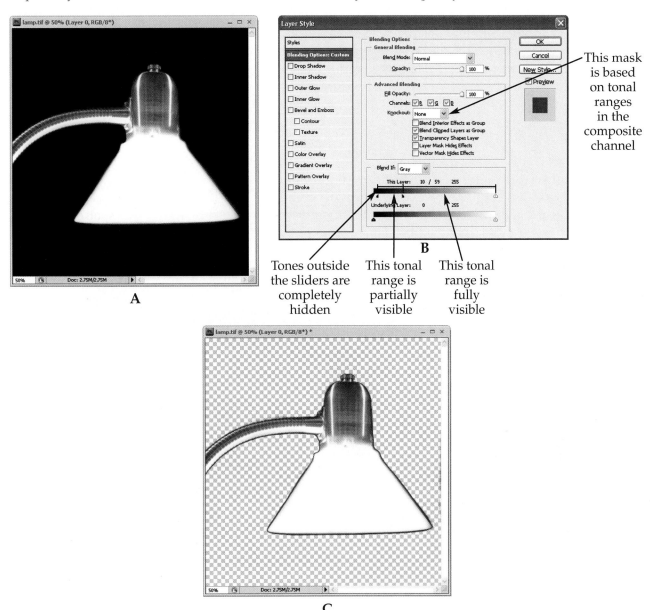

A

B

This mask is based on tonal ranges in the composite channel

Tones outside the sliders are completely hidden

This tonal range is partially visible

This tonal range is fully visible

C

Underlying Layer sliders control what portions of the layer below the active layer will be used to mask the active layer. This slider is useful if you have an object that stands out against its background on the layer below the current layer and you want to be able to see that object through the current layer. By selecting the necessary channels in the **Blend If** drop-down list and carefully adjusting the sliders, you can make the object or areas on the lower layer visible through the current layer. See **Figure 11-21.**

Figure 11-21. _____
The blending options can also use the tonal ranges of a layer to mask the layer above it. **A**—You can select a channel to use from the **Blend If** drop-down list and set the tonal range to use for masking using the **Underlying Layer** sliders. **B**—Through careful selection of channels and tonal ranges, all areas but the blue sky were masked on Layer 1.

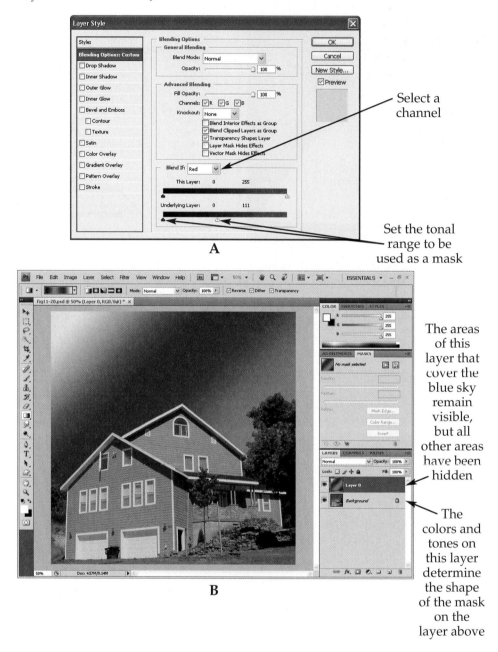

Select a channel

Set the tonal range to be used as a mask

A

The areas of this layer that cover the blue sky remain visible, but all other areas have been hidden

The colors and tones on this layer determine the shape of the mask on the layer above

B

 Unlike the other methods used to mask a layer, the blending options method does not create a layer mask thumbnail in the **Layers** panel. The only way to cancel this effect is to choose the menu command again and reset the blending sliders to their original positions. Or, if you have not performed other tasks since changing the blending options setting, you can undo the **Blending Options** command or delete it from the **History** panel.

Smart Objects

A *smart object* is a separate file that can be added into a Photoshop document as a separate layer. However, because the original condition of the file is kept separate and always remembered by Photoshop, you can adjust your edits at a later time without a loss in quality. This is called *non-destructive* editing. For example, if you import into Photoshop a vector graphic (such as a company logo) that was created in another application such as Adobe Illustrator®, you can resize it again and again without rasterizing it until your design is completely finished. A raster graphic, such as a Camera RAW or TIFF image, can be inserted as a smart object as well. This is a good idea if you think you will need to resize the image several times as you work on a particular design. Furthermore, if the image is in Camera RAW format, you can adjust all of the Camera RAW settings at any time.

The transform commands can be used to edit a smart object. Also, layer styles and filters can be applied non-destructively, as well. Pixel-altering tools such as the **Clone Stamp Tool** and the painting tools cannot be used on smart objects. However, once you have taken advantage of all of the special features that smart objects offer, you can rasterize the smart-object layer by converting it into a regular layer, allowing you to use any tool you wish.

The following is a partial list of commands associated with smart objects. Additional commands are found in the **Layer > Smart Objects** submenu:

- **Layer > Smart Objects > Convert to Smart Object**: this command converts layer(s) you have selected in the **Layers** panel into a single smart-object layer.

- **Layer > Rasterize > Smart Object** or **Layer > Smart Objects > Rasterize**: this command converts a smart-object layer into a regular, rasterized layer.

- **File > Open As Smart Object...**: this command opens a file, including files created in another application, as a new Photoshop document with a single smart-object layer. If you open an image file, for example, it opens up as a smart-object layer instead of a locked background layer.

- **File > Place...**: this command inserts another file as a smart object into an image that you already have open in Photoshop. A similar command is also available in Bridge.

Smart Filters

When using filters in Photoshop, a common practice is to make a duplicate layer before applying the filter. This method is adequate for many projects, but using smart filters can give you much more flexibility.

If you apply a filter to a smart-object layer, it automatically becomes a smart filter. If you have not created any smart-object layers, select the layer (or layers) in the **Layers** panel that you wish to apply the smart filter to. Then, choose **Filter > Convert for Smart Filters**. A message appears, telling you that your layers will be converted to a smart object. Next, apply a filter (or more than one filter), adjust the settings as desired, and click **OK**. In the **Layers** panel, you can click the down-arrow to view and adjust your smart filter settings, **Figure 11-22**.

Figure 11-22. _____

In this image, the canyon layer was converted to a smart object. An **Unsharp Mask** filter was applied, and the filter mask was edited to protect the lower portion of the image from the filter effect.

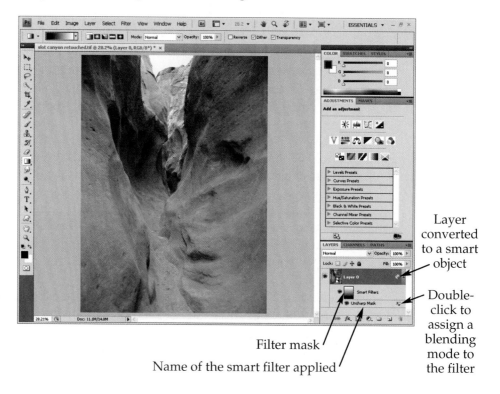

Layer converted to a smart object

Double-click to assign a blending mode to the filter

Filter mask

Name of the smart filter applied

A white filter mask icon appears underneath the smart-object layer on which you have applied filters. If you click on this icon to activate it, you can use the **Brush Tool** (with black, white, and shades of gray) to create a mask. The mask causes some parts of the original image to not be affected by the filter. The same mask will apply to all filters listed below it.

You can change filter settings at any time by double-clicking on the name of the filter. A blending mode can be assigned to the filter or changed by double-clicking the small icon to the right of the filter name. If you have assigned more than one smart filter, you can change the order of the filters by dragging them up or down in the **Layers** panel stack. Each filter also has a **Visibility** (eyeball) toggle, which will hide or show the effects of the filter when clicked.

Note Previews for smart filters take extra time to refresh. When you change a filter setting or rearrange the filter order, make sure the preview has finished updating before assuming more adjustment or further rearrangement is needed.

Layer Comps

As graphic designers work on a project, they usually create more than one version of their design ideas, called *comps* (short for *compositions*), to show to their client. This helps the designer and client communicate more effectively, and allows the client to make decisions about the design as it evolves.

One way to create comps is to create duplicate files and make changes to each file. When highly complicated designs are being created, this may be the best method. But for many projects, the **Layer Comps** panel can help you to save more than one version of your design *within the same file.*

The Limitations of Layer Comps

What the **Layer Comps** panel really does is let you save various states of the **Layers** panel. However, there are some limitations. Layer comps can only keep track of the following information:

- The *position* of each layer on the canvas.
- The *visibility* of each layer.
- The *blending mode* of each layer.
- Any *layer styles* that have been added to a layer.

If you make changes to your image other than those listed above, the changes are applied to all layer comps you have created. For example, if a layer is added or deleted from an image, the same layer will be added or deleted from all layer comps. Similarly, any change to the content of a layer will also be made to all of the layer comps. As mentioned previously, only the position, visibility, layer styles, and blending modes of the layers can vary from layer comp to layer comp.

You can sometimes work around these limitations by duplicating the layer, turning off visibility for the original layer, making the desired changes to the content of the layer, and then saving the layer comp.

Creating a New Layer Comp

The **Layer Comps** panel is simple to use. When the layers are adjusted the way you want them, within the limits described above, choose **Window > Layer Comps**. This opens the **Layer Comps** panel. Next, click the **New Layer Comp** button at the bottom of the panel. The **New Layer Comp** dialog box appears, **Figure 11-23**. Enter a name for the layer comp in the **Name** text box. You may find it useful to assign a name that will help you remember which design variation is saved in the layer comp.

The three check boxes in the **Apply To Layers** section, **Visibility**, **Position**, and **Appearance (Layer Style)**, do not affect *what is saved* in a layer comp. Instead, they control *what is displayed* when a layer comp is selected. You can turn on or off layer visibility, position, or appearance data for a particular comp by right-clicking on that comp in the **Layer Comps** panel, choosing **Layer Comp Options...** from the shortcut menu, and adjusting the check boxes. Any feature that is turned off will not change when the layer comp is selected; it will continue to look the same as it did in the previously selected layer comp.

Comments, such as questions for the client, can be added in **Comments** text box and saved with the layer comp. The comments can be displayed by clicking the small arrow icon next to the layer comp in the **Layer Comps** panel, or accessed and edited by right-clicking on the layer comp and choosing **Layer Comp Options...** from the shortcut menu.

Once you have made the desired settings in the **New Layer Comp** dialog box, click **OK** to save the layer comp and close the dialog box. The new layer comp is added to the bottom of the list in the **Layer Comps** panel. To create another comp, make adjustments to your design and repeat this process.

Figure 11-23.

The **Layer Comps** panel can be used to store different versions of a design. **A**—The original design is saved as a layer comp. The layers are then adjusted as desired, and the **New Layer Comp** dialog box is opened again. In this dialog box, you name the layer comp and specify which types of alterations it will display. **B**—After saving a layer comp, you can quickly toggle between the various layer comps by clicking their names in the **Layer Comps** panel. The panel shown here has two layer comps.

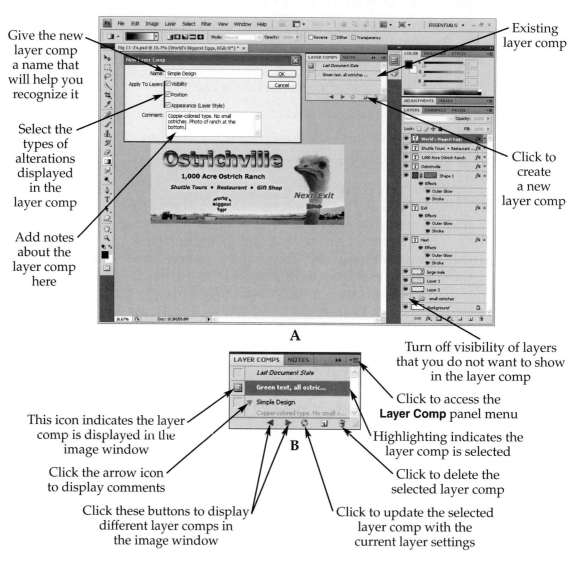

Give the new layer comp a name that will help you recognize it

Select the types of alterations displayed in the layer comp

Add notes about the layer comp here

Existing layer comp

Click to create a new layer comp

A

Turn off visibility of layers that you do not want to show in the layer comp

This icon indicates the layer comp is displayed in the image window

Click the arrow icon to display comments

Click these buttons to display different layer comps in the image window

B

Click to access the **Layer Comp** *panel menu*

Highlighting indicates the layer comp is selected

Click to delete the selected layer comp

Click to update the selected layer comp with the current layer settings

Editing Layer Comps

If you want to make changes to a comp, select the layer comp in the **Layer Comps** panel, make the changes to your image, and then click the **Update Layer Comp** button. The arrow buttons at the bottom of the panel can be clicked to view different comps, or you can click the icon at the left of each comp to view it. You can delete an unwanted layer comp by selecting it and clicking the **Delete Layer Comp** (trash can) button at the bottom of the panel.

You can access these and other functions in the **Layer Comps** panel menu by clicking the arrow button in the upper-right corner of the panel. This menu provides all of the functions available in the buttons at the bottom of the dialog box, plus a few others.

Choosing the **Duplicate Layer Comp** command in the panel menu creates a copy of the currently selected layer comp, and makes it active. This is a useful option if you want to make slight modifications to an existing layer comp, and save it as a new comp. The **Apply Layer Comp** command simply makes the selected comp active, and displays it in the image window. Choosing the **Restore Last Document State** command is the same as clicking the box to the left of the **Last Document State** entry in the **Layer Comps** panel. Choosing the **Layer Comp Options** command opens the **Layer Comp Options** dialog box, which is identical to the **New Layer Comp** dialog box. From this dialog box, you can rename the layer comp, change the types of alterations the layer comp will display, and change the comments associated with the layer comp.

Note	It is possible to select a layer comp in the **Layer Comps** panel while displaying a different layer comp in the image window. For this reason, you want to make sure that the layer comp is both selected and displayed before making changes to it. The selected layer comp is highlighted in the **Layer Comps** panel, and a small icon appears next to the layer comp that is currently displayed in the image window.

Presenting Layer Comps

There are a number of different ways to show clients layer comps. If your client is nearby, you can show the comps on your computer by opening the file, opening the **Layer Comps** panel, and clicking the icon to the left of each layer comp. If your client is far away, you can quickly convert layer comps into various types of files and send them to the client on CD or electronically.

Comps can be saved as individual documents in PSD, JPEG, TIFF, and other image file formats. File formats will be discussed further in the next chapter. Comps can also be converted to PDF files or even WPG (web photo gallery) format using the **File > Scripts** submenu.

Saving Layer Comps as Individual Image Files

To save the layer comps in an image as individual image files, choose **File > Scripts > Layer Comps To Files**. This opens the **Layer Comps To Files** dialog box, Figure 11-24. Enter the path to the target folder (folder in which to save the images) in the **Destination** text box or by clicking the **Browse...** button and selecting the folder in the Explorer-style dialog box. In the **File Name Prefix** text box, enter any text that you want to appear at the beginning of each file name. By default, the prefix is set to the filename of the image containing the layer comps. If you want to save only the layer comps that are currently selected in the **Layer Comps** panel, put a check mark in the **Selected Layer Comps Only** check box. Otherwise, all layer comps in the image will be saved. Select an image file type from the **File Type** drop-down list. The advantages and disadvantages of each file type are discussed in Chapter 12, *File Management and Automated Tasks*. The section beneath the **File Type** drop-down list contains settings for the specific type of image file selected.

Once you have made the desired settings, click the **Run** button. This executes a script (a series of commands that run automatically) that converts the layer comps into individual image files without altering the original. Depending on the number of comps being converted, this process could take a while. A dialog box appears when the script is finished running, and notifies you whether the process succeeded or failed. The procedures for saving layer comps as PDF files or WPG files are very similar, but have settings relating to those specific file types.

Figure 11-24. _____

In the **Layer Comps To Files** dialog box, you specify the folder in which to save the image files generated from the layer comps, and the image file type they should be saved as.

Folder in which the new image files will be saved

When this check box is checked, only selected layer comps are saved

This section has settings related to the file format selected

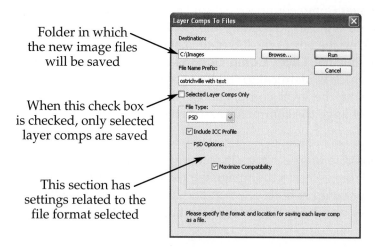

Aligning and Distributing Layers

In Photoshop, aligning layers can mean two different things. In this chapter, you have already learned that Photoshop can automatically align and blend images that overlap. But Photoshop has other aligning tools that are used in a different way.

The term *align* means "to arrange in a straight line," and the term *distribute* means "to spread out evenly over a given distance." In Chapter 4, *Introduction to Layers*, you learned that one way to align layers is to drag them with the **Move Tool**, using Photoshop's rulers, grid, or guides to help you line everything up. When the **Snap** command is active, objects jump into place next to a grid line or guide line as you drag them with the **Move Tool**.

Using Photoshop's **Align** and **Distribute** commands is an alternative way to line up objects without displaying Photoshop's guides or grid. Furthermore, the **Align** and **Distribute** commands allow you to do something else—line up objects *in relation to each other*. If your goal is to straighten a row (or column) of objects (such as photos or shapes) and place equal amounts of space between each object, then using the **Align** and **Distribute** commands may be the quickest way to accomplish this. When the **Align** and **Distribute** commands are used, a selection (usually rectangular or square) can be used as a reference for layers to align to.

The Align Commands

The **Layer** pull-down menu has a submenu that contains six **Align** commands. The name of the submenu and the function of its commands change depending on whether there is a selection made in the image or not.

If no selection is made in the image and at least two layers are selected in the **Layers** panel, the **Align** submenu appears in the **Layers** menu. The commands in this submenu align the layer(s) relative to each other. The reference point used to align the layers depends on which command is used. If the command aligns the layers to an edge, the outermost edge on the outermost layer in the given direction becomes the reference point. For example, if left edges are aligned, all of the selected layers will align with the left edge of the leftmost layer. If the layers are aligned by vertical centers, they align at

the midpoint between the topmost layer and the bottommost layer. If they are aligned by horizontal centers, they are aligned at the midpoint between the layer at the farthest left and the layer at the farthest right.

If a selection has been made in the image and at least one *non-background* layer is selected in the **Layers** panel, the **Align To Selection** submenu appears in the **Layers** menu. The commands found in this submenu align the selected layers to a reference point on the selection. For example, the following steps were used to align the small red squares in a column at the exact center of the image in **Figure 11-25**:

- The red squares were dragged to their approximate desired location.

- The entire image was selected by choosing **Select > All**.

Figure 11-25. _____

The layers in this image are being aligned to a selection. **A**—A selection border was created around the entire file. **B**—Then, the square shapes were aligned to the center of the selection.

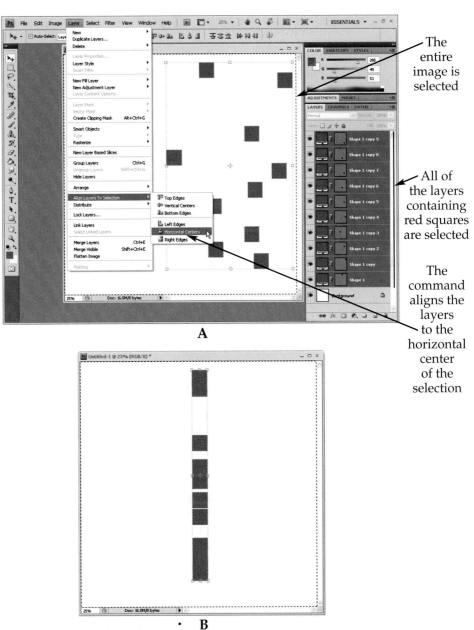

The entire image is selected

All of the layers containing red squares are selected

The command aligns the layers to the horizontal center of the selection

A

· B

- All layers (except the Background layer) were selected in the **Layers** panel by holding down [Ctrl] and clicking on each layer.

- The **Layer > Align Layer to Selection > Horizontal Center** command was chosen, aligning the layers to the center of the square-shaped selection that surrounds the entire image.

Note Layers can also be aligned to the top, bottom, right side, left side, or horizontal centers of a selection.

The Distribute Commands

In the example shown, the red squares are aligned in the center of the image, but they are not evenly spaced. The **Distribute** commands are used to create equal spacing between layers. Since the **Distribute** commands place objects at equal intervals over a given distance, three or more layers must be selected in the **Layers** panel before these commands will become available. The two layers farthest away from each other in the direction selected determine the distance through which the remaining layers will be distributed. For example, if the selected layers are being distributed in relation to top or bottom edges or vertical center points, the uppermost selected layer and the bottommost determine the distance. If the layers are being distributed in relation to left or right edges or horizontal centers, the leftmost and rightmost layers determine the distance. The two layers that determine the distance of the distribution are *not* moved by the command. In **Figure 11-26**, the red squares were equally distributed by following these steps:

- Because the selection was no longer needed, it was removed by choosing **Select > Deselect**.

- The layer containing the top square shape was selected in the **Layers** panel. The rest of the layers were unselected.

- The top square was moved to its desired final position using the up and down arrow keys. Using only the up and down arrow keys preserved the center alignment of the square.

- The previous two steps were repeated for the bottom square.

- All of the layers containing red squares were then selected in the **Layers** panel.

- **Layer > Distribute > Vertical Centers** was chosen. This command caused Photoshop to analyze where the center of each square was and evenly distribute those center points between the first and last shapes in the column.

Note For best results, remember to first arrange the layers approximately where you want them to end up. Then, use the **Align** and **Distribute** commands to adjust them perfectly.

The Align and Distribute Buttons on the Options Bar

The **Move Tool**'s options bar contains **Align** and **Distribute** buttons that provide the same functionality as the commands discussed in the previous sections, **Figure 11-27**. The **Align** buttons only become available if two or more layers are selected in the **Layers** panel, and the **Distribute** commands only become available if three or more layers are selected.

When using the **Move Tool** to align or distribute layers, select the layers that you want to adjust in the **Layers** panel. Then, click the appropriate button on the options bar. The layers are aligned to the outside edge of the outermost layer in the direction of alignment. Because this method can be confusing, it is recommended that you use square or rectangular selections to align layers, as explained earlier.

Figure 11-26.
Now that the squares are centered in the file, they need to be spaced evenly. **A**—The top and bottom squares are moved to their desired location. **B**—All of the shapes are evenly distributed between the top and bottom squares when **Layer > Distribute > Vertical Centers** is chosen.

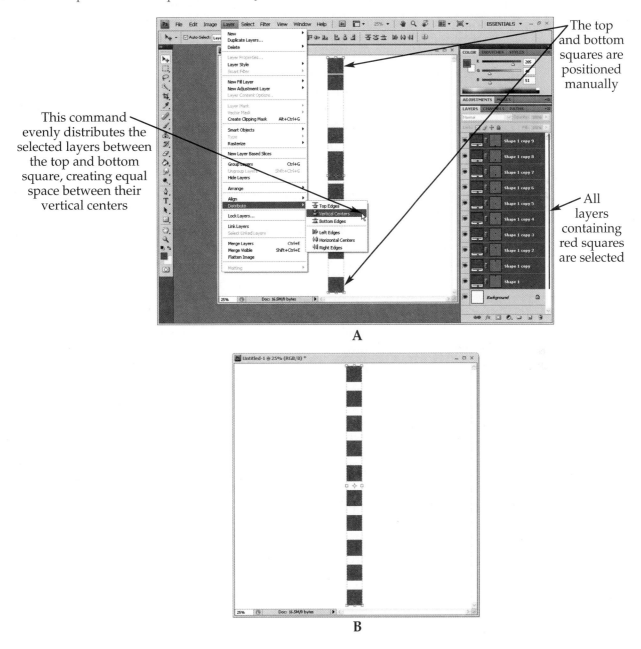

This command evenly distributes the selected layers between the top and bottom square, creating equal space between their vertical centers

The top and bottom squares are positioned manually

All layers containing red squares are selected

A

B

Figure 11-27.
The **Move Tool**'s options bar contains the same **Align** and **Distribute** commands found in the **Layer** menu.

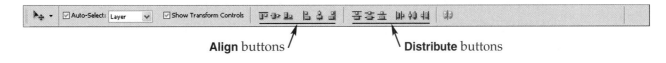

Align buttons　　　　　　**Distribute** buttons

GRAPHIC DESIGN

The Prepress Process—Preparing Documents for Print

Complex printed projects, such as a brochure, can be many pages in length and contain various graphics, images, and text. Such projects need to be created in a page layout application such as Adobe InDesign® or QuarkXPress®. These programs allow you to create multi-page documents at a page size you specify. Then, you can easily place images created in other programs (such as Photoshop) and sections of text exactly where they will appear when printed. Page layout applications have many tools that allow you to enhance the look of your documents with decorative borders and graphics. They also provide precise typography and general layout controls.

Before you prepare any kind of document for print, consult with your print service provider to be sure you are using a compatible page layout program. If you plan on using an old version of Adobe PageMaker® for example, chances are your provider no longer uses the old software and may not be able to open your file.

When you have finished creating a document in your page layout program, your next step is to package the project. When you use the package command, all necessary fonts and graphic files that are linked to your document are copied into separate folders. You submit this package of folders along with your multi-page document to your print service provider.

Page layout programs have a built-in feature called a *preflight check* that makes sure that all necessary support files are packaged. After receiving your package, a prepress professional at your print service provider uses the same software to run a preflight check to ensure the document is ready to print. Because images that you placed in your document are actually linked to the document rather than embedded in it, all of these links are checked to be sure there are no missing graphic files. Preflight also checks all of the fonts used in the document, and makes sure no font files are missing. The most common problems encountered by prepress professionals are missing image files and missing fonts. See **Figure 11-28**.

For simpler projects that are not multi-paged, you may need only Photoshop to create a file that will be delivered to your print service provider. In these cases, be sure to send a flattened image (this ensures no guesswork is required at the printing company) and submit the file in a format preferred by the printer. Some print service providers recommend that if you use Photoshop to create a project that includes small text, create the project at up to 600 dpi to ensure that even the smallest text characters have crisp edges. In most situations, however, 300 dpi documents are acceptable.

After the print service provider does a preflight check, further preparations must be made if the document will be printed on a 4-color offset press. First, software is used to create *color separations*, separate files that show what portions of the image will be cyan, magenta, yellow, and black. Then, these files are printed onto plates. Each plate is loaded into a 4-color press. The plates apply ink to the paper in turn as the paper moves through the press. See **Figure 11-29**.

For certain low-quantity or specialty printing runs, many print service providers are moving toward using digital printing processes, which do not require color separations. Rather, files can be sent directly to the digital printer. Think of digital printers as much larger and more powerful versions of the desktop printer you probably have at your desk, **Figure 11-30**. Such printers are becoming more common as the need for publishing-on-demand increases.

Figure 11-28. _____
These are InDesign's preflight check screens. Other programs have similar screens. **A**—The summary screen indicates how many fonts are missing, how many images are missing, and how many images are in RGB mode. **B**—A detailed screen lists information about the fonts that are missing. **C**—Another page lists detailed information about the images in the design, including images that are missing or are in RGB color mode.

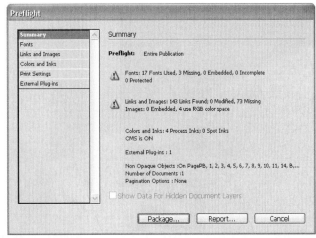

A

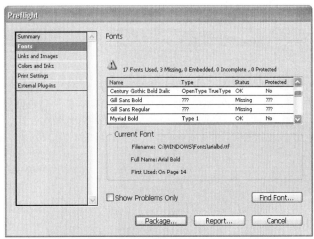

B

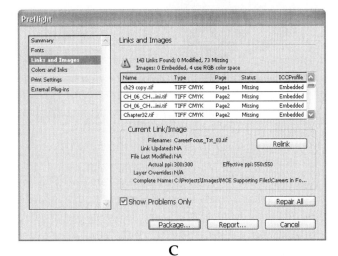

C

Figure 11-29.

Offset-press printing is a multi-step process. **A**—A printing plate is made for each of the colors to be printed. The machine shown here prints each color in the separation directly to a printing plate, simplifying and speeding the process. **B**—A completed printing plate is shown here. **C**—The printing plates are loaded into a press, like this 4-color offset press. **D**—In offset lithography, which is used for the majority of commercial printing, the printing plate transfers ink to a rubber cylinder that, in turn, applies ink to the paper.

A

B

C

D

Figure 11-30. _____

Digital presses, like the iGen3 Digital Production Press from Xerox, offer high-speed full color printng and a variety of finishing options, such as collating, hole-punching, stapling, laminating, and various binding methods. (Image courtesy of Xerox Corporation)

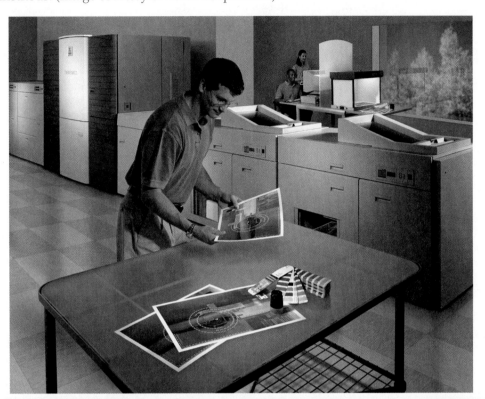

Summary

When should you use masks to hide parts of a layer, and when should you delete parts of a layer instead? Use masks if there is any chance that, at a later time, you may want to change the amount or portion of the layer that is hidden. You should only *erase* portions of a layer when you are absolutely sure you never want to see those portions again.

In your spare time, experiment with blending modes, using different layer combinations. You will probably find techniques that are appealing to you and complement your design tastes. Keep a watchful eye for tips about blending modes found on the web and in other publications.

CHAPTER TUTORIALS

> **Note** The files needed to complete the tutorials in this book can be downloaded from the *Learning Photoshop CS4 Student Companion Web Site*. Refer to the "Using the Companion Web Site" section of the book's Introduction for more information.

In the tutorials that follow, you will be guided through the process of creating the drum and rocks blend shown in this chapter. You will modify an image using content-aware scaling, and you will use the **Align** and **Distribute** commands to arrange elements of a design.

Tutorial 11-1: Blending Modes and Layer Masks

In this tutorial, you will use blending modes and layers to make gravel look as if it is contained inside a drum. You will add a layer mask so that the gravel cannot be seen behind the metal frame of the drum, but is still visible through the sides and skins of the drum. Lastly, you will add a vector mask to make the drum appear ruptured at one location.

1. Open the drum.tif and the gravel.tif files.

2. Use the **Move Tool** to drag and drop the gravel.tif image into the drum's image window.

3. Use the **Move Tool** and arrow keys to move the new gravel layer so the drum image is completely covered.

4. Close the gravel.tif image window.

5. With the gravel layer active, choose **Soft Light** from the **Mode** drop-down list at the top left of the **Layers** panel.

6. Begin the process of creating a mask on the gravel layer by choosing **Layer > Layer Mask > Reveal All**.

7. In the **Tools** panel, click the **Default Foreground and Background Colors** button to reset the colors to black and white.

8. In the **Tools** panel, click the **Switch Foreground and Background Colors** button so that black is the foreground color.

9. Make sure the mask thumbnail in the gravel layer is still selected in the **Layers** panel, then use the **Brush Tool** with a **Hardness** setting of 50% to mask the parts of the drum that you do not want to be transparent.

 If you need to erase part of the mask, switch the colors so white is the foreground color. This will cause the **Brush Tool** to remove the mask. As you paint the mask, adjust the brush size as needed using the left bracket ([) and right bracket (]) keys.

10. Double-click the Background layer and, in the **New Layer** dialog box, click **OK** to accept Layer 0 as the new name.

 This unlocks the layer transparency for the Background layer. Notice that the padlock icon is gone. Unlocking transparency allows you to add a mask.

11. With Layer 0 (which contains the drum) still active, choose **Layer > Vector Mask > Reveal All**.

 This adds an empty vector mask to the layer.

12. Click the **Custom Shape Tool** in the **Tools** panel. In the options bar, make sure the **Paths** option is selected.

 The **Custom Shape Tool** may be hidden behind another shape tool in the **Tools** panel.

13. Make sure the **Subtract from path area** button is selected in the options bar.

 If you are unable to select the **Subtract from path area** option, make sure the vector mask is selected. A white border around the thumbnail indicates the vector mask is selected.

14. In the options bar, click the **Shape** icon or the arrow button next to it to open the **Custom Shape Picker**.

15. Open the **Custom Shape Picker**'s panel menu and choose **Reset Shapes**. Click **OK** in the dialog box that appears. If you are asked if you want to save the current shapes, choose **Don't Save**.

16. Select the Starburst shape.

 If you hold your cursor over the shape icons in the **Custom Shape Picker**, a tool tip appears with the name of the shape.

17. Draw the shape on the side of the drum.

18. In the **Layers** panel, click the vector mask thumbnail to deselect the vector mask and hide the outline of the path.

19. Choose **File > Save As...** and name this file 11rockdrum.tif.

20. Close all open image windows.

Tutorial 11-2: Create a Clipping Mask

In this tutorial, you open the same gravel image used in the previous tutorial. You will then add a text layer to the image and apply that layer as a clipping mask to the gravel image. Next, you will merge the layers and stroke the text to finish the filled text.

1. Open the gravel.tif file.

2. Click the **Horizontal Type Tool** in the **Tools** panel.

3. In the options bar, enter the following settings:

 • **Font:** Tahoma

 • **Font Style:** Bold

 • **Font Size:** 140 pt

 • **Text Alignment:** Center text

4. Click in the center of the gravel image and enter ROCK. Click the **Commit** (check mark) button in the options bar when finished.

5. If necessary, click the **Move Tool** and center the text in the image window.

6. Unlock transparency for the Background layer by double-clicking on it. Then, in the **New Layer** dialog box, click **OK** to accept Layer 0 as the layer name.

 In order to apply a clipping mask to a layer, the layer must be unlocked.

7. In the **Layers** panel, drag the text layer below the gravel layer.

 The layer that is going to be used as the clipping mask must be below the layer(s) that are going to be clipped.

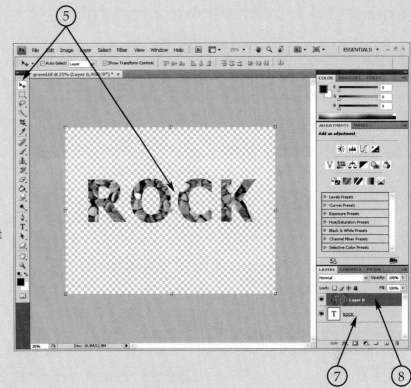

8. Make sure the gravel layer (Layer 0) is active in the **Layers** panel.

9. Choose **Layer > Create Clipping Mask**.

10. Combine the two layers by choosing **Layer > Merge Visible**.

 This permanently applies the clipping mask by eliminating any hidden parts of the layers. The layers must be merged to achieve the desired effect when the text is stroked in the step that follows.

11. Choose **Edit > Stroke…**. This is similar to choosing **Layer > Layer Style > Stroke…**. In the **Stroke** dialog box, enter the following settings and click the **OK** button:

 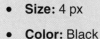

 • **Size:** 4 px

 • **Color:** Black

 • **Position:** Outside

 This creates a black outline 4 pixels wide around the text, helping it to stand out.

12. Choose **File > Save As…**. Name this file 11rocktext.tif, and then close it.

Tutorial 11-3: Content-Aware Scaling

In this tutorial, you will work with a composite image of a freeway scene, a billboard, and the ostrichville project. When the billboard was inserted into the freeway scene, there was not room to place it far enough away from the road to look realistic. You will use content-aware scaling to create more distance between the billboard and the freeway.

1. Open the billboard.psd file.

2. In the **Layers** panel, double-click the Background layer, name the layer billboard, and click **OK**.

3. Choose **Layer > New Fill Layer > Solid Color...**.

4. Click **OK** to accept Color Fill 1 as the name of this new layer.

5. When the **Color Picker** appears, drag the cursor into the upper-left corner to select white. Then, click **OK**.

6. Choose **Layer > New > Background from Layer**.

 Now that the billboard image is on its own layer, it will be easier to experiment with content-aware scaling.

7. Choose **Image > Canvas Size...** and enter the following settings:

 - **Width:** 9 inches.

 - **Anchor:** select the right-center anchor so the image will expand to the left.

 - **Canvas extension color:** White.

8. Click **OK** in the **Canvas Size** dialog box.

9. Choose **View > Fit on Screen**.

10. Choose **File > Save As...** and name this file 11billboard2.psd.

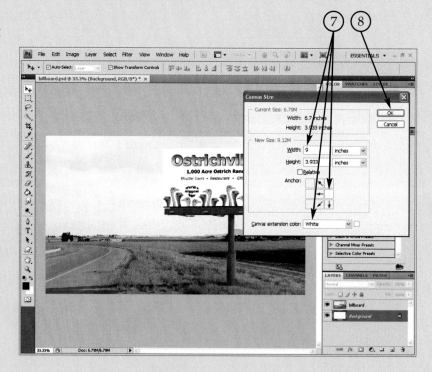

11. Click the **Move Tool** and, in the options bar, make sure the **Auto-Select** and **Show Transform Controls** check boxes are checked and **Layers** is selected in the **Auto-Select** drop-down list.

12. Click on the billboard image with the **Move Tool**.

13. Scale the billboard layer by dragging the left-center handle all the way to the left side of the image.

 Notice how the billboard, freeway, and buildings in the background become distorted.

14. Press [Esc] or click the **Cancel transform** button on the options bar to cancel the scale. If necessary, choose **File > Revert**.

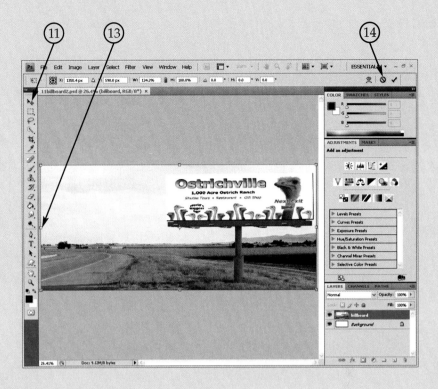

15. Choose **Edit > Content-Aware Scale**.

16. Drag the left-center handle all the way to left and release the mouse button.

 Notice that the billboard only distorts slightly, but the freeway and buildings become too distorted.

17. Press [Esc] or click the **Cancel transform** button on the options bar to cancel the scale. If necessary, choose **File > Revert**.

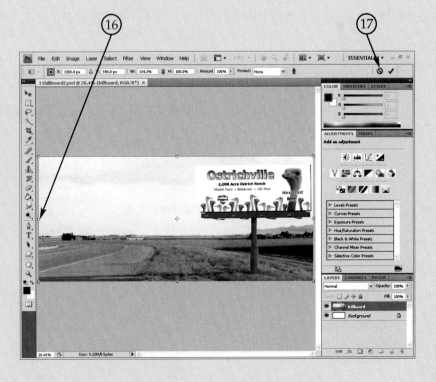

18. Use the **Lasso Tool** to select the areas shown.

 Use the **Add to selection** button on the options bar to select the second area without deselecting the first area.

19. Choose **Select > Save Selection....** Name the selection my selection and click **OK**.

 This saves your selection as an alpha channel in the **Channels** panel.

20. Choose **Select > Deselect**.

 This removes the selection from your image so it will scale correctly. It does not affect the selection you saved.

21. Make sure the billboard layer is selected.

22. Choose **Edit > Content-Aware Scale**.

23. In the options bar, choose my selection from the **Protect** drop-down list.

 This causes the selection you saved to protect the billboard layer.

24. Drag the left-center handle and scale the image as shown.

25. If the sign, road, and buildings are not distorted, click the **Commit** button to accept the scale. If you still see some distortion in the sign, buildings, or road, click the **Cancel transformation** button on the options bar. Choose **Window > Channels**, double-click on the my selection alpha channel, and use the **Eraser Tool** to make the mask a bit larger in areas where distortion was visible. Then, repeat steps 21–24.

26. If necessary, use the **Clone Stamp Tool** to repair small areas of distortion that are noticeable.

27. Choose **File > Save** to save the image. Close the image window when you are done.

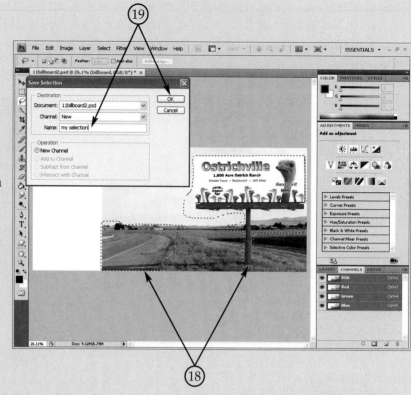

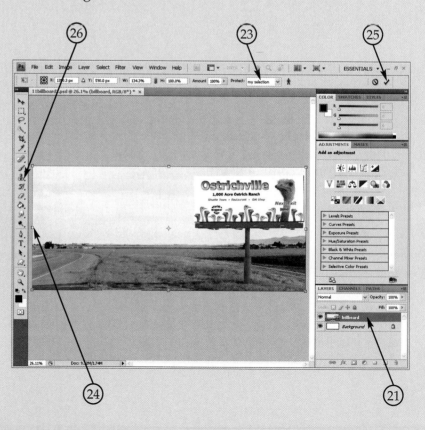

Tutorial 11-4: Using the Align and Distribute Commands

In this tutorial, you will make multiple copies of a single layer, then use the align and distribute buttons found on the **Move Tool**'s options bar to quickly line the layers up and distribute equal amounts of space between them.

1. Choose **File > New...** and enter the following settings. Click **OK** when you are done:

 Name: 11woodwork

 Width: 8 inches

 Height: 6 inches

 Resolution: 200 pixels/inch

 Background Contents: White

2. Open the wood.jpg file.

3. Click the **Magic Eraser Tool** in the **Tools** panel.

4. In the **Magic Eraser Tool**'s options bar, set the **Tolerance** to 10 and make sure the **Contiguous** button is checked.

5. Delete the white background that surrounds the wooden object.

6. Click the **Move Tool** in the **Tools** panel.

7. Drag the wooden object and hold it on top of the 11woodwork image window tab until the image window opens. Then, drag the wooden object down into the white image area and release the mouse button.

8. Use the **Move Tool** and/or the arrow keys to place the wooden object at the left side of the 11woodwork image, as shown.

9. While holding down [Alt], click and drag nine copies of the wooden object, so that you have ten total.

10. Drag one of the layers you copied over to the right side of the 11woodwork image, as shown.

11. In the **Layers** panel, select all of the layers that contain the wooden object. Do *not* select the background layer.

 Hold down [Ctrl] ([Command] for Mac users) to select more than one layer, or to deselect a layer. You can also select multiple layers by clicking the first layer, pressing and holding [Shift] and then clicking the last layer you want to select. This selects the first layer you click, the second layer you click, and all layers in between.

12. The **Move Tool** should still be active. Click the **Align vertical centers** button on the options bar.

13. Click the **Distribute horizontal centers** button on the options bar.

14. Choose **Layer > Group Layers**.

15. Duplicate the group you just created by dragging it on top of the **Create a new layer** button in the **Layers** panel.

16. In the **Layers** panel, double-click on the Group 1 copy and rename it small group.

17. Hide the Group 1 layer group by clicking the **Visibility** (eyeball) toggle next to it in the **Layers** panel.

18. Click on the small group layer group in the **Layers** panel.

19. Choose **Edit > Transform > Scale** and enter the following settings in the options bar and then click the **Commit** button:

 • **W:** 28%

 • **H:** 28%

 • **Rotate:** 75°

20. In the **Layers** panel, restore visibility to Group 1 layer group.

21. Choose **View > Fit on Screen**.

22. Make sure the **Move Tool** is selected in the **Tools** panel and **Group** is selected in the **Auto Select** drop-down list.

23. Move the small group layer group to the location shown.

24. In the **Layers** panel, click the arrow next to the small group folder, so all of the layers are visible.

25. Select all of the layers in the small group folder.

26. In the options bar, click the **Align left edges** button.

27. In the **Layers** panel, click the arrow next to the small group folder again to close it.

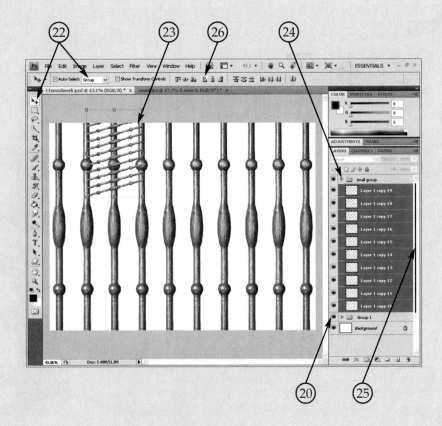

28. Duplicate the small group layer group two times by dragging it on top of the **Create a new layer** button in the **Layers** panel twice.

29. In the image window, drag the two new groups to the locations shown.

30. In the **Layers** panel, select all three of the small group folders.

31. In the options bar, click the **Align horizontal centers** button and then the **Distribute vertical centers** button.

32. In the **Layers** panel, click the Group 1 folder to select it.

33. Choose **Layer > Arrange > Bring to Front**.

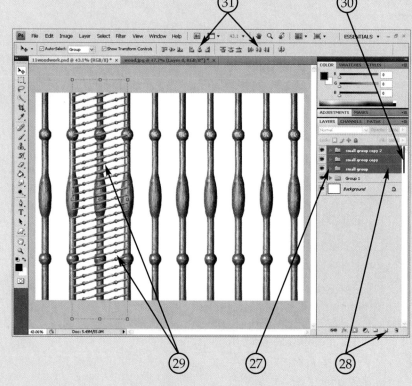

This moves the large layer to the top of the stack in the **Layers** panel. The **Arrange** command was used here because sometimes, when dragging groups in the **Layers** panel, it is easy to accidentally drag a group inside of another group.

34. Expand the Group 1 group so you can see all the layers it contains. Find and select the layer containing the wooden object that passes through the center of the small groups. This layer should be named Layer 1 Copy 2.

35. With the layer selected in the **Layers** panel, set the **Opacity** slider at the top of the **Layers** panel to 80%.

36. Zoom in on the top of the design.

37. Click the **Eraser Tool** and enter the following settings in the options bar:

 • **Mode:** Brush

 • **Master Diameter:** 9

 • **Hardness:** 50%

38. Erase the wooden object that covers the small groups, so that every other small wooden object looks like it overlaps the large wooden object, as shown.

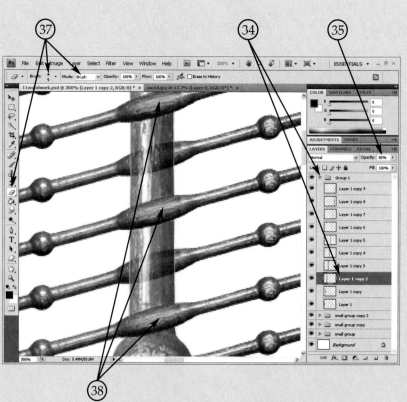

39. When you are done, increase the **Opacity** setting for the selected layer back to 100%.

40. Choose **View > Fit on Screen** and check your work.

41. Click the **Gradient Tool** in the **Tools** panel.

42. Click the **Gradient Picker** in the options bar and choose the Orange, Yellow, Orange gradient.

43. In the **Layers** panel, click on the Background layer.

44. Change the settings in the options bar as desired and create an orange and yellow gradient any way you like.

45. Save and close the 11woodwork file.

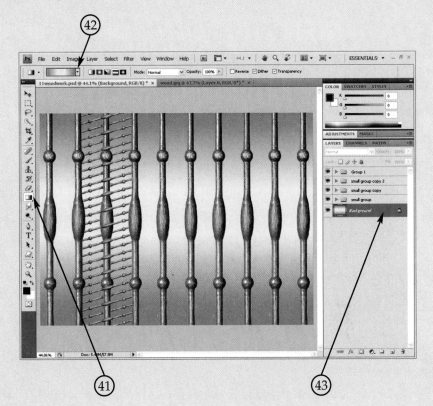

Key Terms

align

clipping masks

color separations

compositions

comps

content-aware scaling

distribute

knockout

layer mask

pixel masks

preflight check

smart object

vector mask

Review Questions

Answer the following questions on a separate piece of paper.

1. If a blending mode is assigned to a layer, what other layer(s) are affected by the blending mode?

2. What blending mode is a good choice when blending an image with another layer that contains a photo of a shiny surface?

3. Name four different types of tools that can have a blending mode applied to them when **Edit > Fade (*previous command or tool*)...** is chosen immediately after using the tool.

4. Can a layer mask be applied to a layer that has transparency locked?

5. What tools can be used to apply a layer mask?

6. Explain what happens when each of the following colors is applied to a layer mask: black, gray, and white.

7. What button on the **Masks** panel is used to permanently delete the masked (hidden) areas of a layer?

8. If you do not need a layer mask anymore, how do you delete it?

9. What tools are used to create vector masks?

10. How are clipping masks different from layer masks or vector masks?

11. When using content-aware scaling, how do you protect parts of an image from becoming distorted?

12. Before using the **Auto-Align Layers** command, what must you do in the **Layers** panel?

13. What kinds of problems does the **Auto-Blend Layers** command fix automatically?

14. What is a smart object?

15. What is non-destructive editing?

16. What can you do so that a smart filter only affects part of your image?

17. When the **Layer Comps** panel is used to create different versions of a project, what four layer characteristics can be adjusted and saved in the layer comps?

18. Explain how the Photoshop's **Align** commands are different from the **Auto-Align Layers** command.

19. Describe two techniques for aligning layers using the **Align** commands.

20. When you use the **Distribute** commands to distribute layers, which two layers do not move?

12

File Management and Automated Tasks

Learning Objectives

After completing this chapter, you will be able to:

- Explain what happens to an image when it is compressed.
- Explain the difference between saving a JPEG image with high-quality and low-quality compression settings.
- Differentiate between lossy and lossless compression.
- Recognize commonly used file formats used to save image files.
- Recognize commonly used file formats used to save other types of graphic files.
- Differentiate between scripts and actions.
- Explain the features of Bridge that make it easy to organize and sort files.
- Use Bridge to automatically create PDF contact sheets or picture packages from your images files.
- Use Bridge to automatically create web galleries from your images.
- Use the **Actions** panel to record an action.
- Describe the tools that are available in the **File > Automate** submenu.
- Use the **Note Tool** to add comments to a project.

Introduction

This chapter wraps up your exploration of Photoshop's many features and tools. Several important topics are discussed in this chapter, including file formats and compression. You will also be introduced to Bridge, Photoshop's built-in file browser application. In addition, you will learn about actions and scripts, which let you program Photoshop to accomplish specific tasks.

File Formats

When you save an image, the file format you choose to save it in can make a big difference in the quality of the image, the file size of the image, and other image characteristics. There are numerous file formats available in Photoshop. Knowing a little bit about the various options will help you choose the option that gives you the quality level and characteristics that you need, while minimizing file size.

JPEG Images and Compression

You have probably noticed that many digital cameras and scanners save images in the JPEG file format by default. This is because the JPEG format compresses image files, making them smaller. For digital camera users, this means that more images will fit on a memory card.

To *compress* a file means to reorganize the file data in a more efficient way. When an image is compressed, the computer does not keep track of each pixel anymore. Instead, the computer records groups or patterns of similarly-colored pixels. Because the image file now keeps track of "clumps" of pixels instead of each individual pixel, there is less information to keep track of, resulting in smaller file sizes.

When you save a JPEG image in Photoshop, a dialog box appears, allowing you to choose between varying degrees of compression quality. High-quality compression settings leave you with an almost unnoticeable decrease in the quality of the image, and the image's file size becomes smaller than it would be without any compression. When low-quality compression settings are chosen, the file size becomes *much* smaller, but the quality of the image worsens considerably. This is because the effects of compression become so intense that some pixels actually change color, allowing them to be more easily grouped into patterns. This is referred to as *lossy* compression, because some of the original colors of the image become lost. Heavy compression results in distracting square patterns in the image. See **Figure 12-1.**

As you save a JPEG image, you can actually see the effects of dragging the compression slider, especially if you have zoomed into an area of your image that has fine detail. These changes are not actually applied to the image, however, until you save and close it. When working with a JPEG image, keep in mind that every time a JPEG image is opened and re-saved, a bit more of the original image quality is lost.

Other file formats (such as TIFF) are capable of compressing images using a *lossless* method. In other words, some compression takes place, but colors in the image are not sacrificed during the process. As you might expect, file sizes do not become as small after using lossless compression, but the quality of the image is not compromised.

Figure 12-1. _____

Compression quality makes a big difference in the appearance of images. **A**—This is a close-up of an image saved with high-quality JPEG compression. **B**—When the same image is saved with low-quality compression, the image becomes blocky.

A B

If you are after the highest image quality possible, consider these tips:

- If your digital camera only captures files in the JPEG format, use the highest quality JPEG compression setting available. Then, save the image as a TIFF immediately after importing it into Photoshop. After editing the image, you can then resave it as a JPEG to reduce the file size.

- Check your scanner software to see if you can capture images in TIFF format instead of JPEG.

- Avoid saving any file as a JPEG until you are completely done editing it in Photoshop.

- If your digital camera uses the Camera RAW format (discussed in Chapter 10, *Advanced Color-Correction Techniques*), you can use that setting to capture images without any further processing from the camera. You can then edit it using Photoshop's **Camera Raw** utility.

Common File Formats

When saving a Photoshop file for the first time, or when choosing **File > Save As...**, you have probably noticed that there are many different file formats to choose from, Figure 12-2. Here is a quick breakdown of the most commonly used file formats:

Commonly used formats for photographic image files:

- *PSD* (Photoshop Document): This is the *default* file format used to save Photoshop projects. Layers and other data are all preserved. These files are intended to be opened within Photoshop or other graphics-related software packages that support the PSD format.

Figure 12-2.
After **File > Save As...** is chosen, a file can be saved in many different file formats.

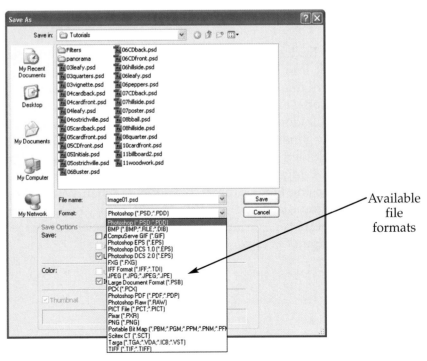

Available file formats

- *TIFF* (Tagged Image File Format): This is the industry standard for saving images that will be printed commercially. This format is also used for high-quality archival (storage) purposes. The TIFF format saves layer information, so an image does not need to be flattened before being saved in this format.

- *JPEG* (Joint Photographers Experts Group): This is the most popular format for lowering file sizes of photographic images, especially for use on the web. JPEG 2000 is an improved version of JPEG (available as a Photoshop plug-in). The JPEG format does not save layer information.

Commonly used file formats for web graphics (other than photos):

- *CompuServe GIF* (Graphics Interchange Format): This format converts images to indexed color (256 colors) and is commonly used in web design. It also compresses images to create very small file sizes.

- *PNG* (Portable Network Graphics): This format is similar to GIF, but is newer and contains more features and flexibility.

Commonly used formats for printing/publishing (check with your print service provider to determine the most appropriate choice):

- *Photoshop PDF* (Photoshop Portable Document Format): This is a version of Adobe's popular PDF format. Photoshop PDF can save Photoshop data such as layers, spot color information, and alpha channels. Other advanced options are available that prepare files for large commercial printing presses.

- *EPS* (Encapsulated PostScript): Almost any page-layout, illustration, or graphics program can open a graphic file saved in this format. A PostScript printer must be used to correctly print EPS files.

- *DCS 1.0 and 2.0* (Desktop Color Separations): When saving CMYK images, the DCS formats (which are versions of the EPS format) can save each color channel as a separate file. The DCS 2.0 format can save spot color channel information.

Bridge

Bridge is a powerful file browser application that is built into Photoshop. It is also built into other Adobe Creative Suite applications, such as Adobe Illustrator. Bridge offers many ways to organize and view your images, but using it for this purpose is optional. You may prefer to use Bridge if you deal with large numbers of image files and folders. There are very useful commands, available only in Bridge, that automatically generate collections of your images in PDF or HTML format. These commands are explained later in this section, after a general overview of Bridge's other features.

Bridge is opened by clicking the **Launch Bridge** button on the Application bar or by choosing **File > Browse in Bridge....** When you first open Bridge, the amount of information displayed can be overwhelming. Keep in mind that much of what you see is various types of information about a selected image and where it is located on your computer.

File Management

Bridge offers more than one way to organize and browse for images, **Figure 12-3**. New folders can be created using the **Create a new folder** button at the right side of the **Path Bar** or by using the **File** menu. You can move images by dragging and dropping them into different folders, or by cutting, copying, and pasting them into new folders using the **Edit** menu. Image files can be renamed by clicking on the filename under the appropriate thumbnail and entering a new name, and you can open an image in Photoshop by double-clicking on its thumbnail.

The **Camera Raw** dialog box opens if you double-click on a RAW image in Bridge. Or, you can open a JPEG or TIFF (with a single layer) into Camera RAW by selecting the image and then clicking the **Open in Camera Raw** button (or by choosing **File > Open in Camera RAW**). If a thumbnail of a Camera RAW image has a small symbol with two small arrows on it, this means the image has been adjusted in the **Camera Raw** dialog box. You can double-click the symbol to further adjust those settings.

Bridge offers several ways to organize and browse images. There is a **Favorites** panel where you can drag frequently-used folders, a **Folders** panel that displays folders in a more traditional way, an **Open recent file** drop-down list, and more. The **Adobe**

Figure 12-3. ──
Bridge, Photoshop's file browser, offers many ways to organize and sort files.

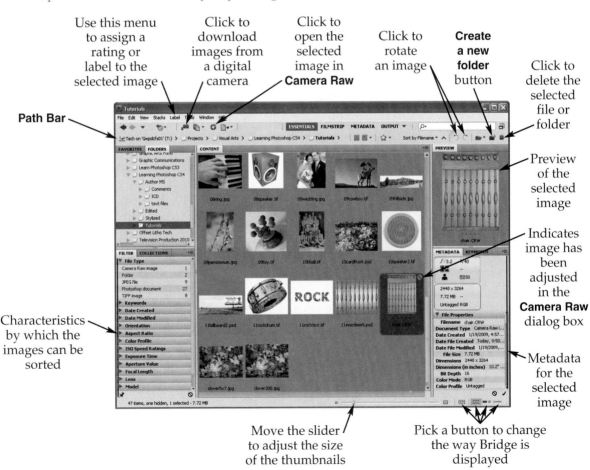

Use this menu to assign a rating or label to the selected image

Click to download images from a digital camera

Click to open the selected image in **Camera Raw**

Click to rotate an image

Create a new folder button

Click to delete the selected file or folder

Path Bar

Preview of the selected image

Indicates image has been adjusted in the **Camera Raw** dialog box

Characteristics by which the images can be sorted

Metadata for the selected image

Move the slider to adjust the size of the thumbnails

Pick a button to change the way Bridge is displayed

Photo Downloader can be used to import images from your digital camera. This feature can be accessed by clicking the **Get Photos from Camera** button.

You can rotate images without opening them by clicking the rotate buttons on the path bar or an image thumbnail and choosing one of three rotate commands from the **Edit** menu. The next time you open the image, it will be rotated.

Viewing Images in Bridge's Workspace

The slider at the bottom of the **Bridge** dialog box allows you to change the size of image thumbnails. This allows you to see the details of the image without actually opening it in Photoshop. Next to this slider are four buttons that change how images are displayed in Bridge.

Bridge's workspace is very similar to Photoshop's. The **Window** menu can be used to hide or display panels, and several workspace configurations can be chosen by clicking the **Essentials**, **Filmstrip**, **Metadata**, or **Output** buttons or the drop-down arrow next to the **Output** button, which lists several more workspaces.

Using commands in the **View** menu, you can set up and view slideshows of your images, or view them in **Review Mode**, which lets you preview images in a refreshing, three-dimensional manner, **Figure 12-4**.

Figure 12-4.

Choosing **View > Review Mode** allows you to review your images in a unique environment. It includes a magnifying glass that you can move around the current image to view areas of it at 100% zoom.

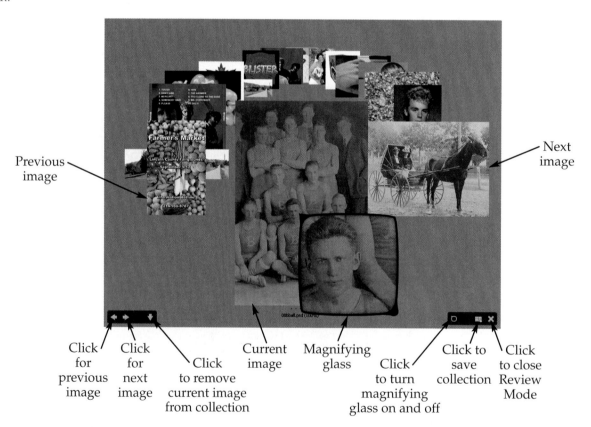

Previous image

Next image

Click for previous image

Click for next image

Click to remove current image from collection

Current image

Magnifying glass

Click to turn magnifying glass on and off

Click to save collection

Click to close Review Mode

Metadata

Details about each image, called *metadata*, is displayed in the **Metadata** panel. Metadata can be entered and viewed at any time by choosing **File > File Info...** in the **Bridge** dialog box. The **Metadata** panel also serves this purpose. Some metadata is automatically created and attached to the file when it is captured. This includes file size and resolution information. If the image was captured with a digital camera, information about the camera settings can be automatically recorded, depending on the camera. Other metadata can be added manually by choosing **File > File Info...** and entering information such as copyright notes and author (photographer) information.

When browsing for files on your computer, you may notice that for each RAW file, there is another file that shares the same name, except it will have a XMP file extension and be very small in size. This is the metadata file that was saved when the image was captured.

Sorting

So that you can easily organize and categorize your images, Bridge lets you apply labels or ratings that appear next to each image thumbnail. Then, images can be sorted according to these labels. The most straightforward labeling method is to rate each image from one to five stars. This can be done by selecting the thumbnail and then selecting the rating from the **Label** menu or by selecting the thumbnail and holding [Ctrl] (or [Command] for Mac users) while pressing the 1–5 keys. You can label an image as rejected by selecting the thumbnail and pressing [Alt][Delete].

Another labeling system is color-coding that corresponds to the following ratings: Approved, Review, Select, Second, and To Do. These labels are found in the lower portion of the **Label** menu. Using either (or a combination) of these two labeling methods, you can rate your photos in any way you desire. At any time, you can instantly filter (sort) images according to their labels using the **Filter Items by Rating** drop-down list in the **Path Bar** or the **Filter** panel. This panel also lets you sort your images in many other ways, including using such characteristics as file size, date created, and resolution. The **Sort by...**drop-down list in the **Path Bar** offers similar sorting choices. See **Figure 12-5**.

Keywords are yet another way that images can be categorized and sorted. The **Keywords** panel allows you to assign keywords to an image and displays the assigned keywords.

The **Collections** panel is a way to group images together without actually moving them from the folder they are stored in; instead it "remembers" where your images are. There are two types of collections, and each can be created using buttons at the bottom of the **Collections** panel. Images are added to an **Arbitrary** collection by dragging them onto the appropriate icon in the **Collections** panel. When smart collections are created, sorting criteria for the collection is specified in the dialog box that appears. Images are automatically added to the smart collection based on that sorting criteria.

Automatically Generated Image Configurations (PDF and HTML)

When you select **Output** from the **Output** drop-down list in the **Path Bar**, the **Filter**, **Collections**, **Metadata**, and **Keywords** panels close and the **Preview** and **Output** panels open, **Figure 12-6**. Bridge's **Output** panel is used to create high-quality PDF files that showcase your images in several ways. You can create contact sheets and picture packages (the same image shown multiple times on a sheet). Multi-page PDFs can be set up

Figure 12-5. _____

The sorting and filtering tools in Bridge make it easy to organize your images.

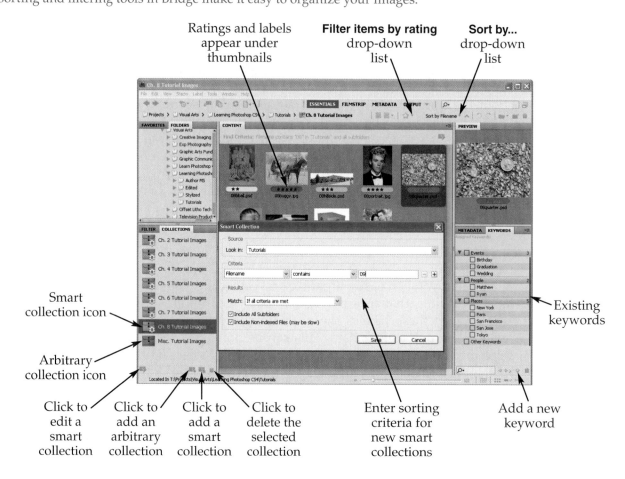

Ratings and labels appear under thumbnails

Filter items by rating drop-down list

Sort by... drop-down list

Smart collection icon

Arbitrary collection icon

Click to edit a smart collection

Click to add an arbitrary collection

Click to add a smart collection

Click to delete the selected collection

Enter sorting criteria for new smart collections

Existing keywords

Add a new keyword

to play as a slideshow. The PDF format is popular because anyone can view a PDF file as long as they have Adobe Reader® (formerly Adobe Acrobat Reader) installed on their computer.

You can also use the **Output** panel to create web galleries (web pages that display your images in a variety of configurations, complete with hyperlinks).

PDF Options

Start creating a PDF file by selecting the images you want to include. If you want to hand-select the files to include, open the appropriate folders in the **Folders** panel and select the desired files in the **Content** panel. If you want to generate a PDF of a collection of images rather than hand-selected files, choose **Window > Collections Panel** and then select the files in the **Contents** panel.

After selecting the desired files, choose one of the several templates listed in the **Template** drop-down list. You can then modify the template so that more or fewer images are displayed, if desired. Some of the template names are a little confusing. Think of them as settings that specify how many images will display on each PDF page. The contact sheet templates will display your images in rows and columns (for example, the 4*5 Contact Sheet template will display the selected images in a grid of four columns and five rows).

Figure 12-6. _____
When the **Output** workspace is selected in Bridge, tools for creating PDFs and web galleries become available.

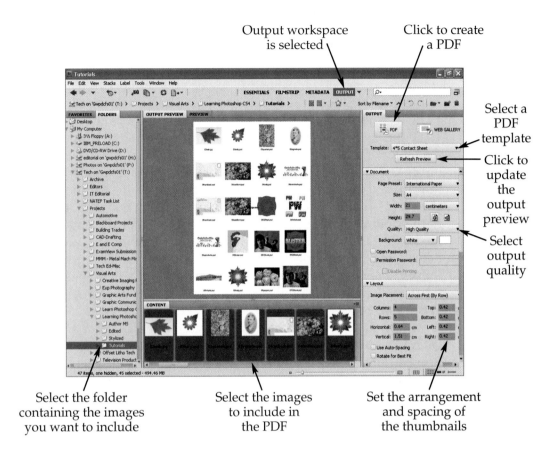

Output workspace is selected

Click to create a PDF

Select a PDF template

Click to update the output preview

Select output quality

Select the folder containing the images you want to include

Select the images to include in the PDF

Set the arrangement and spacing of the thumbnails

Click the **Refresh Preview** button after choosing each template (or changing any other settings) to see an updated view of how the first page of your PDF document will look. After choosing a template, change the remainder of the settings in the **Output** panel to modify the contact sheet as desired.

The **Document** section of the **Output** panel is used to specify paper size and choose between **High Quality** and **Low Quality** image quality settings. Both quality settings produce images at 300 dpi, but the **Low Quality** setting uses more image compression, creating smaller file sizes. A password can be entered in this section if you wish to create a password-protected document.

In the **Layout** section, you can change how many images appear per page. If you are creating a picture package and want the same image to appear again and again, place a check mark in the **Repeat One Photo per Page** check box.

The controls in the **Overlays** section determine how the text (filenames) appears in your PDF file. Using the controls is the **Playback** section, you can set up a multi-page PDF file to play as a slideshow, if desired. The controls found in the **Watermark** section can add a line of text in front or behind the images in the PDF to help prevent unauthorized use of the file. To create the PDF once you have the setting adjusted the way you want them, click the **Save** button at the very bottom of the **Output** panel.

Web Gallery Options

For photographers or web designers who wish to create a photo gallery of images, the **Web Gallery** option can save a lot of time. After creating a web gallery, it is possible to directly upload it to your website if you know the information required to access your web server. If you will be saving the gallery to your own computer, a new folder must be created. This new folder, called the destination folder, is selected at the end of the creation process. The destination folder will contain all of the optimized images and linking information required for the photo gallery to function properly on the web.

Creating a web gallery is similar to creating PDF documents, as explained above. To begin, click the **Web Gallery** button at the top of the **Output** panel, **Figure 12-7**. Open the folder or collection containing the files you want to include, and then select the files in the **Content** panel. Next, select a template from the **Template** drop-down list. Enter information about the gallery and your contact information in the **Site Info** section. If you want to change from the color scheme used in the template, you can use the controls in the **Color Palette** section to select new colors for the gallery's components. You can adjust the size preview window, size of the thumbnails, and the type of slide transitions using the controls in the **Appearance** section. As with the PDF option, click the **Refresh Preview** button to see the effects of any changes you have made to the gallery's settings. You can also preview the gallery in your web browser by clicking the **Preview in Browser** button.

In the **Create Gallery** section, you can save the gallery to your hard drive by activating the **Save to Disk** radio button, entering a filename for the gallery, clicking the **Browse** button and choosing a location for the file, and then clicking the **Save** button. If you choose to upload the gallery to your web server rather than saving it to your hard drive, activate the **Upload** radio button. Next, enter the address of your FTP server, your user name and password, the name of the folder you want to put the gallery in, and then click the **Upload** button.

Figure 12-7. _____

When the **Web Gallery** option is selected in the **Output** panel, the selected images are saved in a web gallery, complete with navigational controls and slide transitions.

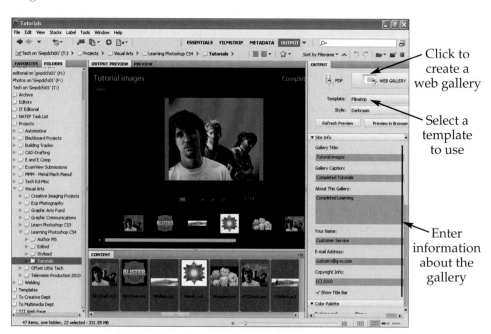

Scripts and Actions

Occasionally, you might be required to use Photoshop to perform a repetitive task. For example, imagine you have been asked to place a decorative border around 500 image files. Rather than do one file at a time, you can use actions or scripts to perform this task automatically for you. The terms *scripts* and *actions* both refer to a programmed series of commands that accomplish a particular task. The difference between the two is that actions are a series of Photoshop commands that can be recorded using simple techniques, while scripts are typically commands created with a programming language, such as Visual Basic, AppleScript, or JavaScript. Scripts are more flexible than actions, because they are not limited to using only commands found within Photoshop. Scripts can process images using more than one application (such as Photoshop and Illustrator). Furthermore, scripts can be written so that different outcomes occur, based on particular conditions being met.

Using Scripts

Photoshop's **File > Scripts** submenu provides a few scripts that have already been created. In the previous chapter, you learned that three of these scripts can be used to convert layer comps into separate files in various formats. The **Export Layers To Files** script, which is similar to the layer comp conversion scripts, can be used to convert any number of layers selected in the **Layers** panel to separate files. The **Load Files into Stack** script does the opposite. It creates a new file, opens a folder full of images, and places each image on a separate layer in that new file.

Another script is named **Image Processor**. Running this script opens an interface similar to a wizard, **Figure 12-8**. Using this interface, you can convert a folder of images into JPEG, PSD, or TIFF format, at various sizes.

Scripting is an advanced skill, but instruction is provided for those who wish to learn. When Photoshop CS4 is installed, a folder named Scripting is placed with the rest of Photoshop's program files. This folder has a subfolder named Guides, which contains guides that explain how to create scripts, as well as sample scripts and their descriptions.

Figure 12-8. _____
The **Image Processor** script can be used to convert an entire folder full of images to a different file format or perform an action on a batch of files.

Recording and Using Actions

The **Actions** panel can be used to record a series of Photoshop commands. This is extremely useful when using Photoshop to edit numerous files in exactly the same manner. For example, suppose you are assigned to prepare images to display on a particular website. The website's design requires that all images be exactly the same size. The images also need to be sharpened slightly and saved in JPEG format. To create an action that will run these commands automatically, the following steps should be followed:

- Open an image.

- Open the **Actions** panel by choosing **Window > Actions**.

- Optional: Create a new set by clicking the **Create New Set** button in the **Actions** panel. Enter a new name in the **New Set** dialog box and click **OK**. The set is added to the **Actions** panel. Sets are basically folders in which you can group related actions, such as all of the actions that need to be applied to a group of images in a particular project.

- Click the **Create new action** button at the bottom right of the **Actions** panel.

- In the **New Action** dialog box, name the action. Use the **Set** drop-down list to select a set in which to save the action. If desired, assign a hot key combination to execute the action using the **Function Key** drop-down list and the **Shift** and **Control** check boxes. Click the **Record** button when you are done.

- Edit the image using the **Image Size** command and add the desired sharpening filter.

- Use the **Save As** command to save the file in JPEG format with desired compression settings. Select a different folder in which to save the image and click **OK**. Do *not* rename the file, or the action will automatically rename all files with the same name, and they will overwrite one another.

- Click the **Stop playing/recording** button in the **Actions** panel.

- Open another image, make sure the desired action is selected in the **Actions** panel, and then click the **Play selection** button. This automatically runs all of the commands recorded in the action.

Once you have recorded an action, it is added to the **Actions** panel and is available for all images that you open in the future. You can also go back and edit the action at any time. Clicking the arrow next to the action reveals all of the steps in it. If any of the steps has an arrow next to it, you can click that arrow and reveal further details about that step. See **Figure 12-9**.

If you want to disable, but not permanently remove, steps in the action, click on the check mark next to the step in the **Actions** panel. Clicking the check box again turns the step back on. Clicking the check mark toggle at the action or set level turns all of the steps in the action on or off at the same time.

Clicking a box just to the right of the check mark toggle will cause the dialog box related to that step to appear when you play the action. This is a good feature to enable if the files you are processing need to be handled differently. For example, if some of your images need to be resized to 3″ × 4″ and some need to be resized to 5″ × 7″, you should enable the **Image Size** dialog box so you can manually enter the different sizes when the action is played back. Clicking the box again disables the dialog box for that step.

If you want to permanently remove steps from the action, simply highlight the step(s) to be removed in the **Actions** panel and click the **Delete** button at the bottom of

Figure 12-9. _____

The **Actions** panel records Photoshop commands, which can be replayed at any time, and in any image, by selecting the action in the panel and pressing the **Play selection** button.

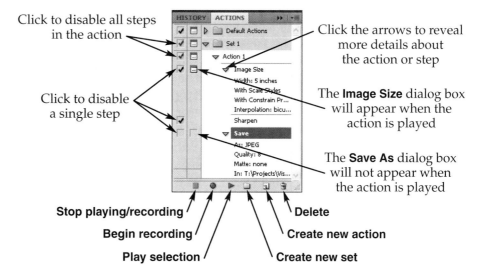

the panel. If you want to add a step, select the step in the action that you want to come right before the step you are about to add. Then, click the **Begin recording** button in the panel and perform the task. Click the **Stop playing/recording** button as soon as you are done. The new task is added to the action just below the selected step.

You have been shown just one example of the many types of tasks that can be automated using the **Actions** panel. With some practice, you will find this feature very useful for processing large batches of images.

The Automate Submenu

The **Automate** submenu contains several powerful, action-based commands. To run any of these commands, choose **File > Automate** and select the command. After entering your desired settings, Photoshop uses actions to create the final result. The following are brief explanations of the commands found in the **File > Automate** submenu.

The Fit Image Command

The **Fit Image** command is used to quickly resize an image to fit within the pixel dimensions you specify. The values entered represent a maximum size of the image for each dimension. Photoshop will *not* change the aspect (width-to-height) ratio of the image to fill the area specified, but will change the image size until one dimension matches maximum value, and the other is equal to or less than the maximum value. The image is resampled during the process, so the resolution of the image remains the same. See **Figure 12-10**.

The Crop and Straighten Photos Command

When a group of photos have been placed crookedly on a scanner and scanned, the **Crop and Straighten Photos** command can be used to separate and straighten them. First, the image to be straightened is surrounded with a selection. Sometimes

your selection will need to slightly overlap another image in order to completely select the desired image, and this is acceptable. If the overlap area is small and there is white space between the images, Photoshop will crop and straighten the selected areas of both images separately.

After the selection is made, choosing **File > Automate > Crop and Straighten Photos** automatically rotates the cropping box to create a straight-edged image. A new image containing the result is automatically created. The process can be repeated for other images in the group. See **Figure 12-11**.

Figure 12-10. _____
The **Fit Image** dialog box allows you to set maximum values for the image's dimensions. Photoshop will automatically resize the image, but maintain its proportions, until it is as large as possible without exceeding either of the dimensional limits that were set.

The Merge to HDR Command and the Exposure Adjustment

The **Merge to HDR** command is used to combine multiple images into a single *HDR image*. HDR stands for high dynamic range. HDR images are created by capturing the same image at different exposures with a camera, resulting in different shadows and highlights in each image. Then, the images can be combined with the **Merge to HDR** command, resulting in a single image with a greater range of shadows and highlights. It is recommended that you mount your camera on a tripod and capture the photos remotely, so that the images are exactly the same composition.

You can further adjust the tonal range of your HDR images using the **Exposure** command (**Image > Adjustments > Exposure...**). The **Exposure** and **Offset** sliders adjust the highlights and shadows, respectively. The **Gamma Correction** setting further adjusts the exposure of the image using unique mathematical calculations. Although the **Exposure** command is intended to be used for adjusting HDR images, it can be used with other images as well; however, you will probably prefer using other adjustments.

Note Capturing, creating, and editing HDR images requires background knowledge and skill that is beyond the scope of this textbook. Search Photoshop's Help pages for additional information about using this feature.

Other Commands in the Automate Submenu

The **Photomerge** command directs Photoshop to automatically align and blend together a group of photos to create a panoramic view. It is discussed in Chapter 11, *Additional Layer Techniques*.

Use the **Batch** command when you have multiple images that require the same action. The **Batch** dialog box lets you choose the source folder (where the images are), the destination folder, and the action.

Have you ever opened Photoshop by dragging an image file on top of the Photoshop icon on your desktop? The **Create Droplet** command creates a droplet, which works the same way. The droplet looks like an application icon, and it runs an action when you drag an image (or images) onto it. The **Create Droplet** dialog box is similar to the **Batch** dialog box. You must choose where the droplet icon appears (the desktop is a good place), a destination folder in which the edited image will be placed, and what action will be performed.

Figure 12-11. _____
Straightening and cropping an image is a relatively easy task. **A**—One of the crookedly scanned photos is selected. Do not worry if the selection slightly overlaps the image you want to crop. **B**—The **Crop and Straighten Photos** command automatically creates a new file containing the straightened result.

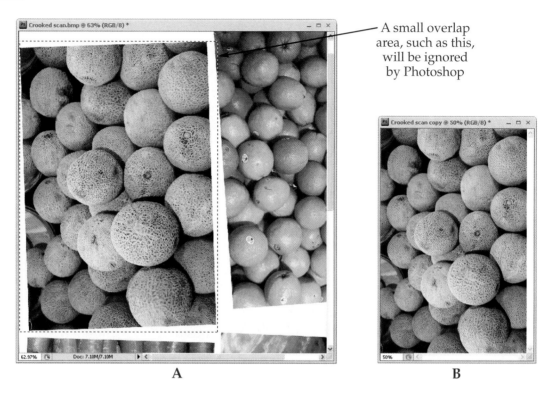

A small overlap area, such as this, will be ignored by Photoshop

A B

The **Conditional Mode Change** command needs to be used when recording actions that involve converting images in various color modes to another color mode. See Photoshop Help for more information if you record an action that contains a task such as this.

The Zoomify Command

You have probably seen large images on the web (such as maps or aerial photos) that you can zoom in on and pan around to view details. To display quickly on the web, these images are subdivided and loaded section by section as you pan around the image. The **File > Export > Zoomify...** command breaks up a large, high-quality image into individual JPEG files at a quality level and overall size that you specify. All of the necessary files are then saved in a chosen folder and are ready to be incorporated into a website.

The Image > Variables Submenu

If you need to produce a large number of documents that share some common characteristics but require different data to appear on each piece (such as nametags or business cards), the commands found in the **Image > Variables** submenu can create these documents for you automatically. Before this can happen, a great deal of setup is

required. Layers that will change during this process must be defined. Also the different data that will appear in each document, such as names and addresses, must be entered and saved in a comma-delineated text file or a spreadsheet file. If you would like to try automating document creation using these advanced features, you can search Photoshop's Help pages for the topic or find more information in other publications.

The Note Tool

Busy designers can attach important notes to a Photoshop file. In the **Tools panel**, grouped with the **Eyedropper Tool**, is the **Note Tool**, **Figure 12-12**. When this tool is used to click anywhere in an open file, an icon is placed at the cursor's location and the **Notes** panel opens. Simply type the text you want associated with the note in the text box in the **Notes** panel. If necessary, you can click on another location to add another note. You will notice that the icon for the previous note changes, indicating that it is no longer selected. You can reposition a note icon at any time by dragging and dropping it in the desired location.

You can display the text associated with a note icon by clicking its icon. The icon will change to the selected note icon and the text associated with that note will be displayed in the **Notes** panel. You can also switch between notes by clicking the arrow buttons at the bottom of the **Notes** panel. A note can be deleted by clicking the icon to select it and then pressing [Delete] or clicking the **Delete note** button in the **Notes** panel. You can delete all of the notes in the image by clicking the **Clear All** button in the options bar. Notes can be displayed or hidden by choosing **View > Show > Notes**.

Figure 12-12. _____
The **Note Tool** can be used to easily add comments to a Photoshop project.

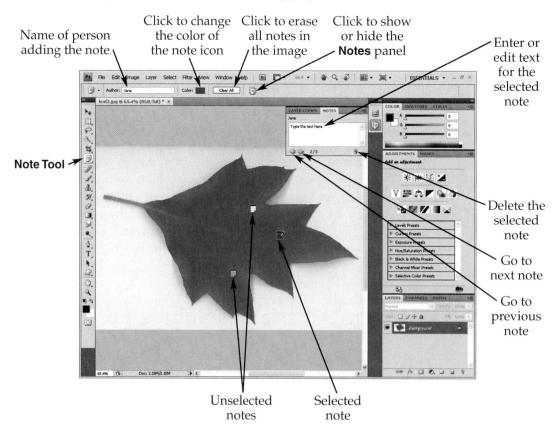

Using the controls in the options bar, you can change the color of the note icon and change the size of the text in the note. If multiple people are working on or reviewing the image, each can leave individualized notes by changing the name in the **Author** text box and the color of the note icon.

Note Annotations can only be saved for images in the PSD, PSB, PDF, and TIFF file formats.

GRAPHIC DESIGN

FAQ—Graphic Design Careers

What kinds of designs do graphic designers create?

Most design work is published either in printed form or on the Internet, **Figure 12-13**. The following are some examples from both categories:

Internet-Based

- Graphics for web pages.
- Web-based animations.
- Overall layout schemes for websites.
- Site navigation strategies.

Print-Based

- Business cards.
- Company and product logos.
- Stationery.
- Posters.
- Brochures.
- Book and periodical covers.
- Illustrations (artistic and technical).
- Product packaging.
- Large banners.
- Car wraps.
- Photography.
- Any other type of printed advertising.
- Outdoor signs and billboards.
- Signage systems (such as the directional signs found in grocery stores, corporate buildings, and cultural centers).

Figure 12-13. _____
A graphic designer must be able to present information in a visually alluring package. These tri-fold brochures are typical of the types of materials a graphic designer might be asked to develop. (Courtesy of the Xerox Corporation)

What kinds of companies employ graphic designers?

A wide range of businesses and organizations employ graphic designers, **Figure 12-14**. The following are a few of the more common places where graphic designers find employment:

- Graphic design agencies.
- Advertising agencies.
- Printing and publishing companies (magazines, newspapers, etc.).
- Any other company that produces graphic designs in-house, such as manufacturers and companies that create packaging materials.
- Television, video, and movie industries.
- Educational institutions (teachers of graphic design).
- Some graphic designers are self-employed and work on a contract basis.

What experience do I need to be hired as a graphic designer?

The graphic design field can be competitive. The more education and experience you have, the greater your advantage will be when you go in for an interview. The following are a few tips to keep in mind as you prepare for a career in the graphic design field.

Earning a bachelor's degree in Graphic Design from a college, university, or design school is strongly recommended. While there, you will study a variety of different art mediums, both traditional and computer-based.

A well-rounded general education is also important. Good language skills will help you when your designs involve text. Nothing is more embarrassing than a misspelled word or grammatical error in six-foot-tall letters on a billboard. Mathematics and geometry can come in handy for such things as sizing designs, locating centers of design elements, and creating geometric elements in a design.

Employers are always on the lookout for designers who are well-versed in various software packages, including image-editing programs (such as Photoshop), illustration software (such as Adobe Illustrator), and page layout programs (such as InDesign or QuarkXpress). Designers who have website design skills, especially experience with web programming languages, will have advantages over designers without these skills.

Figure 12-14. _____
This graphic designer is developing a cover for a new textbook.

The graphic design field attracts many artistically talented people. You must have a strong *portfolio* (samples of the best artwork you have created) to stand out from other job seekers. When you interview for jobs, carry the portfolio with you. Your portfolio will likely be one of the most influential factors that a potential employer will consider during the interview process.

How much do graphic designers earn?

The salaries earned by graphic designers vary depending on a number of factors, including the region where the artist is employed and the type of work the designer is doing. The U.S. Department of Labor's website, www.dol.gov, is a good place to find information about the latest salary statistics and other information about any career. Click the **Occupational Outlook Handbook** link, and then look for graphic designers in the **Professional > Art and design occupations** category.

What personal qualities are employers looking for?

Doing well in school can only make you look better in the eyes of your employers. Employers are aware that good study skills translate into good work habits. However, in addition to a good education and work history, there are certain personal qualities that will make you more desirable to employers. The following are qualities that employers look for in employment candidates. The same qualities are important for promotion and, ultimately, supervisory and leadership roles:

- Artistic ability—A strong portfolio will best communicate your abilities to a potential employer.

- A personality that is flexible and personable—A designer must be able to respond appropriately to constructive criticism. Many first attempts at a design must be reworked at the client's or supervisor's request.

- Ability to work well in team situations—Be aware of the impact (both positive and negative) that your actions and words have on others, and be sensitive to cultural and physical differences.

- Hard-working—Be willing to work extra time when necessary to meet deadlines.

- Willingness to learn—A designer must continually update their technology skills as new versions of software are released. Attending conferences, reading trade magazines, or taking classes are a few ways to stay current. Designers should also stay informed about current practices and trends in the design industry.

- Good interview skills—Learn all you can about how to prepare for and successfully participate in a job interview.

Once you are employed, how do you continue to grow professionally?

In many cases, productivity is one of the most important measures of job performance. With the pressures of looming deadlines, you may feel like you no longer have time to experiment with new tools and techniques. However, continued growth is essential for job satisfaction and for staying competitive in the workplace. Only by increasing your knowledge and skill set can you push beyond your current limitations. There are a number of things you can do to help you continue learning throughout your career.

You may want to obtain professional certification. Some employers encourage their employees to prove their understanding of design-related software by passing an industry-standard test. For example, Adobe offers such a test for Photoshop users called the Adobe Certified Expert (ACE) Exam. Successfully passing such an exam requires a thorough knowledge of the software. Designers who pass this test can place the ACE logo on their business cards or other publications that advertise their services.

You can also do volunteer work to give something back to the community. You may want to volunteer to visit schools and offer practical advice to students. You can donate your time and talents to worthy causes, such as designing banners for a community event or fliers for a youth organization. This is not only personally rewarding, but gives you an opportunity to experiment with new design techniques away from the pressures and restrictions of your daily job.

You may also want to consider becoming a member of a trade association. Typically, a yearly fee is required. In return for the annual fee, you can enjoy benefits like the following:

- Association with other professionals who share your interests.

- Subscriptions to trade magazines, journals, or newsletters that offer information on the latest trends and technology.

- Use of the association's name on your business cards.

- The opportunity to attend association-sponsored conferences that focus on graphic design trends and issues.

- The chance to enter association-sponsored design contests.

- Access to design-related Internet forums, where you can ask questions and share information with your peers.

Another way to continue your professional growth is to take advantage of the vast community of Photoshop users that share ideas, information, and content they have created online. A great place to start is Adobe Exchange (enter Adobe Photoshop Exchange as keywords in your favorite search engine). Here, you can download filters, brushes, layer styles, swatches, gradients, templates, and tutorials to expand your Photoshop capability, **Figure 12-15**.

How difficult would it be to start my own graphic design business?

An *entrepreneur* is a person who operates his or her own business. It takes a great deal of energy, initiative, patience, and stamina to take a business from a small beginning to a successful enterprise. A graphic designer who wishes to start an entrepreneurship faces the challenging task of finding clients. If the designer does excellent work and deals with clients in a highly professional manner, the client may seek the designer's services for future projects. Building up a client base to keep a successful designer busy full-time may take a year or two or more.

Summary

In this chapter, you learned that an image can be saved in a variety of file types, each with specific strengths and weaknesses. This knowledge will help you choose the best format to save your image in, so that you get the quality level and features you need with the smallest possible file size.

You learned that scripts are small programs that run a preprogrammed string of commands with a single click. You also found that actions, while similar to scripts, can be recorded by the user and played back at any time.

In addition, you were introduced to Bridge, a powerful tool for browsing and organizing images. In the **Bridge** dialog box, you can move files around, edit an image's metadata, and sort images in a variety of ways.

Now that you have read this entire book and completed the tutorials, you have been exposed to most of Photoshop's tools, panels, and menu commands. With this knowledge and further experience using what you have learned, you can consider yourself an intermediate-level Photoshop user.

Key Terms

actions	HDR image	PNG
compress	JPEG	portfolio
CompuServe GIF	lossless	PSD
DCS	lossy	scripts
entrepreneur	metadata	TIFF
EPS	Photoshop PDF	

Review Questions

Answer the following questions on a separate piece of paper.

1. Why do many digital cameras and scanners save captured images as JPEG files by default?

2. Briefly explain what it means to compress an image file.

3. If a JPEG image has distracting square patterns all over it, what likely caused the patterns to appear?

4. What is the difference between lossy and lossless compression?

5. Which compression method, lossy or lossless, results in smaller file sizes?

6. Why should you avoid unnecessarily re-saving a JPEG image?

7. If your camera can capture an image in only the JPEG format, what step should you take to preserve the quality of the image?

8. What is the recommended file format for archiving high-quality digital photos?

9. Which file formats are used to save web graphics, other than digital photos?

10. What file formats discussed in this chapter are capable of saving layer information?

11. List three advantages of using Bridge to manage image files.

12. What are the two kinds of labels you can apply to organize and sort image thumbnails in Bridge?

13. What is metadata?

14. Which panel in Bridge allows you to create a web photo gallery or various PDF files, using images that you select?

15. List three types of PDF documents that can be created in Bridge with images that you select.

16. What is the difference between scripts and actions?

17. What is the **Actions** panel used for?

18. List and briefly describe three of the commands found in the **File > Automate** submenu.

19. What is the **Zoomify** command used for?

20. What tool is used to add comments to a Photoshop document?

Glossary

A

actions: A series of Photoshop commands recorded to accomplish a particular task.

active: An image or area of an image that is selected and ready to work on. Also refers to a tool or option that is currently selected.

additive color system: Adding wavelengths of light together to create colors.

adjustment layer: A special type of layer that will apply a color-adjustment command to the image, but keeps the corrections you make separate from your image.

align: To arrange in a straight line.

alpha channels: Special channels that store information about selections and masks.

analogous colors: Colors that look good together, creating a sense of harmony and tranquility.

anti-aliasing: A selection tool option that creates a slight smoothing effect around the edges of the selection.

Application bar: A bar at the top of the workspace that contains Photoshop's menus and several other commonly-used tools to help you manage your workspace.

artifacts: Noise that appears when images are saved as low-resolution JPEG files.

asymmetrical: Not symmetrical. A design in which elements on one side of the design do not mirror elements on the other side of the design.

B

background color: Color that is revealed by the **Eraser Tool** when it is used on a layer that has transparency locked.

balance: The equal distribution of visual elements.

bit: A tiny scrap of computer data that has two possible values, one or zero.

bit depth: A measurement of how many different shades of color a Photoshop file can display.

bitmap graphic: An image that is captured by a digital camera or scanner and is made up of pixels. Also called a *raster graphic.*

black point: The darkest pixels in an image.

blemishes: Small imperfections, such as dust specks, in a photo.

body text: Complete sentences and paragraphs.

bounding box: A box that appears around all of the pixels in the active layer when the **Show Transform Controls** option is on.

brightness: The degree of lightness of an image.

brush marks: The individual patterns of paint created by the brush.

C

calibrate: Set the monitor to display colors using certain brightness and contrast settings, etc.

Camera RAW: High-quality format in which the image is saved exactly as the camera captured it.

canvas: In Photoshop, the entire area of an image.

capture: To cause data to be stored in computer memory.

clients: Businesses or individuals that hire outside services.

clipboard: Temporary computer memory that makes cut, copy, and paste operations possible.

clipping: Distortion that occurs when an image is over-adjusted, such as areas of an image that turn completely white or completely black as the image's brightness or contrast is adjusted.

clipping masks: Masks that use the entire contents of one layer to mask another layer.

clone: To create an exact copy of something.

closed (panel): A panel that is not displayed in the workspace.

closed paths: Fully enclosed shapes.

CMYK color mode: Color mode that produces color by combining cyan, magenta, yellow, and black.

color cast: An unnatural tint, usually caused by bad lighting when the image was captured.

color channels: Channels that show the distribution of the primary colors throughout an image, and use grayscale versions of the image to represent the amount of distribution.

color depth: The total number of colors that can be used in the image. This is expressed as the number of bits of data used to describe each color.

color management: Advanced-level process in which Photoshop users can force the colors on their monitor to match what comes out of their printer.

color modes: The different ways Photoshop creates colors in images.

color noise: Speckles or blotches of inappropriately colored pixels.

color sampler marks: Marks that can be placed on the image to indicate where the brightest and/or darkest areas are.

color separations: Separate files that show what portions of the image will be cyan, magenta, yellow, and black.

color stops: Color stops appear along the bottom of the sample gradient box in the **Gradient Editor**. They each represent one color in the gradient and indicate where the color shifts begin and end within the gradient.

complementary colors: Pairs of colors that are opposite of one another on the color wheel and cause each other to stand out.

composite channel: A shortcut you can click to select all *color* channels and make their combined effects visible in the image window.

compositions: Graphic designers' versions of their design ideas, which are prepared to show to clients.

compress: To reorganize file data in a more efficient way.

comps: Short for *compositions.*

CompuServe GIF (Graphics Interchange Format): Format that converts images to indexed color (256 colors) and is commonly used in web design. It also compresses images to create very small file sizes.

content-aware scaling: A type of scaling that tries to keep the most important details in a layer from becoming distorted during non-uniform scaling.

contextual menu: A menu accessed by right-clicking on an item. Contains commands directly related to the item being clicked on.

contiguous: Pixels that are touching or bordering each other.

contrast: The tonal range of the image.

crop: To cut off.

D

DCS 1.0 and 2.0 (Desktop Color Separations): Versions of EPS format that can save each color channel in a separate file when saving CMYK images.

decorative fonts: Fonts that are non-traditional in appearance.

default: How a computer program looks before any settings are changed.

delete: To remove content by pressing a key or choosing a menu command.

deselected: Selection border is removed.

design elements: Images, graphics, text, colors, and empty space on the page used to create different feelings or moods.

destination image: The image to which you want to copy a selection.

digital: A format that a computer can recognize.

digital camera: Camera that converts an image to a format a computer can recognize.

distribute: To spread out evenly over a given distance.

docked: A panel that is moved to the extreme right or left side of the workspace, and is automatically grouped with other panels.

document bounds: The edges of an image.

document size: File size.

dots per inch (dpi): Scale for measuring the resolution of a printed image.

drag a box: Click and hold the mouse button and drag the cursor to the opposite corner of a desired area before releasing the mouse button.

dye-sublimation printers: Printers that create very high-quality prints by heating dyes, causing them to melt into smooth, microscopic specks, which blend and solidify on the printed page.

E _____

ellipses: Ovals.

emulsion: The top, glossy part of a photo, which contains the image.

entrepreneur: A person who operates his or her own business.

EPS (Encapsulated PostScript): A file format used for printing/publishing. This format can be opened by almost any page-layout, illustration, or graphics program.

erase: Using a tool to remove pixels.

exposure: The amount of light applied to photosensitive paper. In Photoshop, the term refers to image adjustments that mimic the effects of exposure adjustments in traditional photography.

extract: To remove carefully.

F _____

fastening points: Points created by the **Magnetic Lasso Tool** that hold the selection border to the edges in the image.

feathering: A fading-out effect created at the edges of a selection.

filters: Special effects that can be applied to all or part of an image.

flagging: Assigning labels to images and sorting the images by their assigned labels.

flatten: Merge all layers in an image using a single command.

flip: To mirror an image so it appears as if you were looking at it from the other side.

font: A named set of text and numeric characters that share the same look and feel.

font family: A group of fonts that share the same name and characteristics, yet vary slightly from one another.

foreground color: The color applied by painting tools in Photoshop.

G _____

gamut: The range of colors that can be produced.

Gaussian blur: A slight blur that is evenly distributed across the entire image.

gradient: Two or more colors that gradually blend together.

graphic designer: Individual who arranges images, illustrations, and text to effectively and creatively communicate a message.

grayscale color mode: Color mode that uses only combinations of black, white, and numerous shades of gray.

grid: A pattern of horizontal and vertical lines that appears on your screen but does not print.

grouped: A panel that shares a window with one or more other panels. The individual panels in the group are accessed by clicking their panel tabs.

H

halftone: Type of printing done by laser printers and commercial printing presses. Creates rows of tiny dots that can be square, diamond-shaped, circular, and even cross-shaped, and are often printed at an angle.

handles: Small squares that appear around the selected area when cropping an image or transforming a layer.

HDR image: High dynamic range image, created by capturing the same image at different exposures with a camera and then combining those versions.

headings: Titles and subtitles.

hexadecimal code: Alphanumeric code using characters 0–f.

highlights: The brightest areas in an image.

high resolution: An image with pixels so small that the human eye cannot make out the individual pixels when printed.

histogram: A graph that shows the mixture of shadows, midtones, and highlights in an image.

hue: A particular color, such as blue, orange-red, or sea green.

I

ICC profiles: Small computer files that describe how your monitor, printer, and other devices display or capture color in terms of standards set by the International Color Consortium.

icon: A picture or symbol that represents the selected tool.

image capture device: Device that converts an image to a format that can be stored in computer memory.

inkjet printers: Printers that create an image by spraying microscopic dots of ink on paper.

inverse: Means "the opposite of." In Photoshop, refers to replacing the colors in an image with colors that are directly across from them on a color wheel.

J

jitter: Random fluctuation.

JPEG (Joint Photographers Experts Group): The most popular format for lowering file sizes of photographic images, especially for use on the web.

JPEG 2000: An improved version of the JPEG image format.

justification: The way the words in the paragraph align with the edges of the document.

K

knockout: An area of an image that is removed so a layer below it can show through.

L

layer group: A folder that can be created in the **Layers** panel. By clicking on the group, all layers within that group become active, allowing you to move or transform them simultaneously.

layer mask: A special type of mask, applied with painting tools. The mask makes part of a layer transparent, but protects the image information so the hidden area can be restored at any time. Also called a *pixel mask*.

layers: Parts of a Photoshop file that keep different parts of the design separate from each other.

layer stack: The ordered list of layers in the **Layers** panel.

layer styles: Special effects such as drop shadows, beveled edges, and colorful outlines that can quickly be applied to an entire layer.

ligatures: Small strokes that blend two letters together.

linking: A way of grouping layers without organizing them into folders.

lists: Bulleted or numbered groups of items.

lock: To protect a layer from being changed.

lossless: Type of compression in which colors in the image are not sacrificed during the process.

lossy: Type of compression in which low-quality compression settings are chosen, resulting in the loss of some of the original colors of the image.

low-resolution: Image with pixels large enough to be individually visible when printed.

luminosity: The degree of lightness of an image.

M

marquee: A large sign surrounded by blinking lightbulbs. Also refers to a set of Photoshop selection tools that create selections with fixed shapes.

megapixel: One million pixels.

menus: Lists of commands that are related to each other.

merging: Combining two or more layers into one.

mesh: A grid that helps you see how the image was changed with the **Liquefy Filter** tools.

metadata: Details about the image that are saved with the image file and can be viewed.

midtones: Areas of an image that are not shadows or highlights.

motion blur: Blur caused by camera movement or subject movement when the photo was captured.

N

noise: Inappropriate pixels that appear all over an image.

non-destructive editing: A type of editing in which the original image data is protected.

non-destructively: Done while preserving the original image data so it can be restored at will.

O

open path: A path that is not closed, such as a zig-zag line.

options bar: Located just below the Application bar. When you click on any tool in the **Tools** panel, the tool's options (or settings) appear here.

ordinals: The small, raised letters found in 1st, 2nd, etc.

over-adjusted: So bright or dark that image detail is lost.

P

panels: Small windows that contain a variety of related settings.

panning: Adjusting a magnified image so a different portion of it is displayed in the image window.

path: An adjustable outline of a shape.

perpendicular: At a 90° angle.

perspective drawing: A drawing that creates the illusion of depth.

photo filters: Colored translucent lenses that are placed at the end of the camera lens. The filter allows light of the same color to pass freely to the film, but absorbs light of different colors.

Photoshop PDF (Photoshop Portable Document Format): A version of Adobe's PDF format. Photoshop PDF can save Photoshop data such as layers, spot color information, and alpha channels.

pixel aspect ratio: Description of how wide a pixel is compared to how tall it is.

pixelated: An image in which individual pixels are visible.

pixel masks: See *layer masks*.

pixels: Tiny, colored squares that make up a digital image.

pixels per inch (ppi): Scale used for measuring the resolution of a digital image. Measured by counting a single row of pixels along one inch.

plug-in: A separate program that functions together with Photoshop and expands Photoshop's capabilities.

PNG (Portable Network Graphics): A format for web graphics similar to GIF, but newer and containing more features and flexibility.

point: A tiny unit of measure—1/72 of an inch.

portfolio: Samples of the best artwork a graphic designer has created.

preflight check: Built-in feature in page layout programs that makes sure all necessary support files are packaged.

primary colors: Red, yellow and blue.

printing presses: Machines that transfer ink from a printing plate to a sheet of paper.

printing resolution: The quality level that a printer produces.

PSD (Photoshop Document): The *default* file format used to save Photoshop projects.

R

raster graphic: An image that is captured by a digital camera or scanner and is made up of pixels. Also called *bitmap graphic.*

rasterize: To convert a vector graphic into a bitmap graphic.

red eye: Undesirable photographic effect in which a camera's flash reflects off of blood vessels in the back of the subject's eye, making the pupils appear bright red.

resampling: Changing the total number of pixels in an image.

resolution: Quality level of an image.

restoring: Returning a photo to its original condition.

retouching: Altering a photo from its original appearance.

RGB color mode: Color mode that creates color by combining red, green, and blue.

RGB color workspace: A generic setting that controls how your monitor will display RGB colors.

rulers: Graduated measuring devices that can be displayed along the edges of an image window.

S

sample: To choose a pixel or group of pixels on which to base settings.

samples per inch (spi): Technical term for scanner resolution.

sans serif fonts: Fonts that have no serifs.

saturation: Term that refers to how intense colors appear.

scale: To make larger or smaller.

scanner: A digital copy machine that shines a strong light on an image and analyzes the image with its sensors. A digital version of the image is created, which can be saved into computer memory.

scripts: A series of commands created with a programming language to accomplish a particular task.

scroll bars: Sliders that allow you to reposition an image in an image window that is too small to display the entire image at one time.

secondary color: Color created when two primary colors are mixed.

separated: A panel that has been removed from a stack by dragging its tab clear of the other panel's window.

serifs: Small flares or "tails" that decorate text characters.

shadows: The darkest areas in an image.

shapes: Vector graphics.

sharper: Having more apparent detail.

skew: To slant at an angle.

slices: Invisible boundaries that are placed on web images.

smart guides: Temporary guides that automatically appear as you use the **Move**

Tool to adjust the position of a layer or move a selection in the image.

smart objects: Layers that can also behave like a separate file, allowing a designer to edit the smart object separately, if desired.

snapshot: A temporarily-saved version of your file at a particular stage of development.

soft proofing: Using a properly calibrated monitor to evaluate print colors and layout.

source image: The image that provides the colors when using the **Match Color** command.

source point: A user-selected area that a blemished area *should* look like. Photoshop will refer to this area when fixing the problem.

spot channels: Special channels that indicate where spot color is to be applied to the image.

spot color: A separate, premixed ink used when a project requires a color that cannot be represented by CMYK inks.

state: Each action listed in the **History** panel.

steps: The regular intervals at which brush marks are created when a painting tool is being used.

stock photo agencies: Companies that keep large libraries of images, usually categorized by subject, that can be purchased for use.

stretched: Making a panel taller or wider by dragging its bottom-right corner to resize its window.

styles: A variety of effects, such as drop shadows and beveled edges, applied to text or shapes.

subpaths: Unconnected path fragments.

substrate: The paper backing of a photo.

subtractive color system: Creating color by applying inks to paper.

swatches: A collection of color samples, like you might find at a paint store.

symbol fonts: Fonts used in special circumstances in design work.

symmetrical design: A design in which both sides appear equal.

T _____

tab: A small tag at the top of the panel window that displays the panel's name.

target image: The image that will be adjusted when using the **Match Color** command.

tertiary color: Color created when a primary and secondary color are mixed.

thumbnails: Small pictures of what is contained on the layers.

TIFF (Tagged Image File Format): The industry standard for saving images that will be printed commercially. This format is also used for high-quality archival (storage) purposes.

tileable: Able to blend together seamlessly when placed edge to edge.

tiled: Pattern which repeats itself over and over, side by side, as you paint it.

toggle: Turn on and off.

tooltip: A brief description of each option.

type: A word referring to individual text characters that were set by hand, inked, and pressed against paper in the early days of the printing industry.

V

vanishing point: The point at which parallel receding lines of rectangular object, such as a box or a building, converge (or *would* converge if they were extended) in a perspective drawing.

vector graphics: Graphics composed of lines that are controlled by mathematical formulas.

vector masks: Masks that hide portions of a layer non-destructively. They are created with the same tools that create vector paths.

visual hierarchy: The order in which design elements are presented from the greatest amount of visual weight to the least.

visual weight: Emphasis of a design element.

W

white light: Light created when red, green, and blue light are added together at full strength.

white point: The lightest pixels in an image.

Z

zipped shut: When a panel or group of panels is zipped shut, its window is minimized and only the panel tab(s) are visible.

zoom percentage: Value between .01–1600% shown in the title bar when an image is open. It compares the size of the pixels in the image to the size of the glowing dots on the computer screen.

Index